Signs of Psyche in Modern and Postmodern Art examines the psychological dimension of visual culture in the twentieth century. Analyzing how psychoanalysis can be used to understand art and culture, Donald Kuspit argues that modern art affirms subjectivity; by contrast, postmodern art, which is characterized as cynical and glamorous, denies it, yet paradoxically is unable to escape it. Assessing the depth-psychological implications of works by, among others, Paul Gauguin, Henri Matisse, André Breton, Anselm Kiefer, and Gerhard Richter, this study persuasively demonstrates how the methods of psychoanalysis can be used to probe artworks created at critical junctures of this century.

SIGNS OF PSYCHE IN MODERN AND POSTMODERN ART

CONTEMPORARY ARTISTS AND THEIR CRITICS

General Editor

DONALD KUSPIT

State University of New York, Stony Brook

Advisory Board

MATTHEW BAIGELL, Rutgers University
DIANE KELDER, The College of Staten Island and the Graduate Center,
CUNY
ANN GIBSON, State University of New York, Stony Brook
SUSAN DELAHANTE, Museum of Contemporary Art, Houston
UDO KULTURMAN, Washington University
CHARLES MILLER, *Artforum*

Other books in the series

Building-Art: Modern Architecture Under Cultural Construction,
by Joseph Masheck
The Exile's Return: Toward a Redefinition of Painting for the Post-Modern Era,
by Thomas McEvilley
Psychoiconography: Looking at Art from the Inside Out, by Mary Gedo

SIGNS OF PSYCHE IN MODERN AND POSTMODERN ART

DONALD KUSPIT

*State University of New York, Stony Brook,
and Cornell University*

CAMBRIDGE
UNIVERSITY PRESS

Published by the Press Syndicate of the University of Cambridge
The Pitt Building, Trumpington Street, Cambridge CB2 1RP
40 West 20th Street, New York, NY 10011–4211, USA
10 Stamford Road, Oakleigh, Melbourne 3166, Australia

First published 1993

Printed in the United States of America

Library of Congress Cataloging-in-Publication Data
Kuspit, Donald B. (Donald Burton) 1935–
Signs of psyche in modern and postmodern art / Donald Kuspit.
p. cm. – (Contemporary artists and their critics)
Includes bibliographical references and index.
ISBN 0-521-44056-4 (hc). – ISBN 0-521-44611-2 (pb)
1. Psychoanalysis and art. 2. Art, Modern – 20th century.
I. Title. II. Series.
N72.P74K87 1994
701'.05 – dc20
 93–18347
 CIP

A catalog record for this book is available from the British Library.

ISBN 0-521-44056-4 hardback
ISBN 0-521-44611-2 paperback

Contents

v

CONTENTS

Illustrations

Publication Sources

Most of the essays in this book have been published elsewhere, as follows:

1 *Psychoanalytic Perspectives on Art* (Hillside, N.J.: Analytic Press, 1987), vol. 2, pp. 171–85
2 An expanded version of the Ernst Kris Memorial Lecture presented at New York University, 1989
3 *Artforum* 28 (September 1989):112–16
4 *Psychoanalytic Perspectives on Art* (Hillside, N.J.: Analytic Press, 1988), vol. 3, pp. 197–209
5 *Artforum* 22 (December 1983):56–63
7 *Artforum* 24 (September 1985):87–93
8 *Journal of Aesthetics and Art Criticism* 47 (Spring 1989):117–22
9 *New Art Examiner* 16 (May 1989):26–29
11 *New Art Examiner* 18 (January 1991):18–25
12 *Artforum* 27 (October 1988):133–40
13 *Artforum* 28 (February 1990):110–18
14 *Artforum* 29 (January 1991):93–101
15 *Artforum* 29 (Summer 1991):81–86
16 *Arts Magazine* 64 (Summer 1990):69–73
17 *Centennial Review* 35 (Fall 1991):461–78
18 *Contemporanea*, no. 1 (November–December 1988):50–57
19 *C Magazine*, no. 20 (Winter 1989):19–24
20 *Artforum* 28 (April 1990):129–32
21 *C Magazine*, no. 19 (Fall 1988):24–28
22 *Arts Magazine* 66 (December 1991):34–41
23 *Arts Magazine* 65 (November 1990):60–65
24 *Art Criticism* 6 (Fall 1990):32–42
25 *Art Criticism* 6 (Spring 1991):63–72
26 *Annual of Psychoanalysis* 19 (1991):25–32
27 An expanded version of the Richard Scharf Memorial Lecture

presented at the Psychoanalytic Institute of the New York
University Medical Center, 1991

28 *Art Criticism* 5 (Spring 1990):72–79
29 *Contemporanea*, no. 23 (December 1990):64–69
30 *Artforum* 29 (February 1991):100–1

PART I

Traditional Modern Art

1

The Pathology and Health of Art
Gauguin's Self-Experience

I wielded the ax furiously and my hands were covered with blood as I cut with the pleasure of brutality appeased, of the destruction of I know not what. . . . All the old residue of my civilized emotions utterly destroyed.

<div align="right">Gauguin, 1895</div>

A young man who is unable to commit a folly is already an old man.

<div align="right">Gauguin, 1892</div>

You will always find vital sap coursing through the primitive arts. In the arts of an elaborate civilization, I doubt it!

<div align="right">Gauguin, 1892[1]</div>

ON April 25, 1895, Gauguin wrote, " In art there are only two types of people: revolutionaries and plagiarists. And, in the end, doesn't the revolutionary's work become official, once the State takes it over?" (p. 109). Earlier, in 1889, Gauguin wrote: "Courier's words are still true: 'What the State encourages languishes, what it protects dies' " (p. 33). Gauguin saw himself as a revolutionary, trying to escape the fate of becoming official. He did not want his art to die, the primitive vital sap flowing through it to dry up. He did not want his art to be taken over by the old civilization and understood as a sophisticated new elaboration of it rather than a folly committed against it. For him, to make revolutionary art was to commit the folly of believing art could be young and uncivilized – directly instinctive – again, even eternally young in its evocative power. He did not want his art's character as folly to be forgotten when it was "understood" and recognized by civilization and taken for granted as though it was ancient. He was caught in a trap, because he wanted understanding and socioeconomic success – he busily explained himself, made his ideas public, for all his insistence on solitude – yet he also wanted to pursue the folly of his art to its limit. For it was at that limit that he was completely himself. To make primitive art for him was to experience his true, primitive self (Figure 1).

<div align="center">3</div>

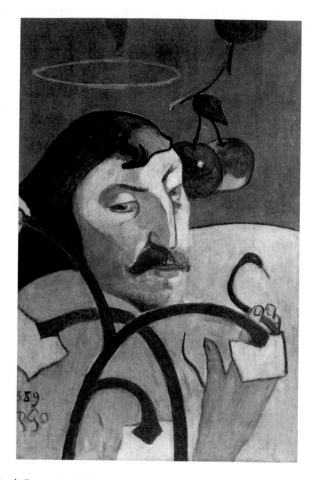

Figure 1. Paul Gauguin, *Self-Portrait* (1889). Oil on wood. 31¼ × 20¼ in. Courtesy of the National Gallery of Art, Washington, D.C., Chester Dale Collection.

On May 13, 1895, in an interview with Eugène Tardieu, Gauguin said: "If I did what has already been done, I would be a plagiarist and would consider myself unworthy; so I do something different and people call me a scoundrel. I'd rather be a scoundrel than a plagiarist!" (p. 112). Only "the people who have done something different from what their predecessors had done deserved the . . . label [of revolutionary], and it is those people who are the masters. Manet is a master, Delacroix is a master. When they first began, their works were called abominations" (p. 111). To begin an outcast scoundrel and to end an establishment master, to watch one's abominations become masterpieces, to watch one's revolution become the property of the state and the market – this irony was at the root of Gauguin's self-awareness and awareness of art. One at first was alone with one's newness and difference; then one was appropriated as one more platitude of official beauty. And the significance of

4

one's revolution, one's difference, was forgotten. Indeed, it was made official so that it could be overlooked, celebrated so that it could have no effect.

Moreover, all along, whether regarded as socially acceptable or unacceptable, a strange abomination or a glory of civilization, one's art remained subtly invisible, not really seen for all its presence. This is its modern, democratic condition. "People laughed their heads off over Delacroix's purple horse," wrote Gauguin. "I've looked everywhere in his work for that purple horse but in vain. But that's the way the public is" (pp. 111–12). That is, it is blind, and in the end indifferent. It is not interested in art, but in a conventional view of reality, which art must conform to, and so confirm, or be ridiculed and dismissed as nonsense. Gauguin wrote that one could be "seized" by the "magical harmony" of "a given arrangement of colors, lights, and shadows" – "the music of the painting" – even before one knew what its subject was (p. 131). But the public wanted that subject, with all its details accurately rendered, rather than its own imaginative perception of the world. It preferred a prescribed "inflexible perspective" (p. 131) to the actual, intimate workings of its own "natural" imagination. One actually sees musically, Gauguin argued, sees the magical whole before one sees the boring details, sees in a "dreamy," emotional way before one gets "down-to-earth," matter-of-fact. The problem of art is to recover the dreamy, emotional way of seeing – "vision" – from matter-of-fact perception, to recover the unexpected yet primary and simple from the expected yet secondary and elaborate – to recover the primitive core of the civilized perception, "insight" from sight.

Delacroix was caught in the struggle between these two modes of perception, and Gauguin admired him because of the victory of the emotional over the practical approach – the intimate over the social and scientific perspective – in his art. For Delacroix, art voices emotion, "inner nature," before it renders external nature – even at the expense of external nature, which art can bend to its expressive purposes. "His instinct rebels in spite of himself; often, at many points, he tramples on those laws of nature and yields to utter fantasy" (p. 130). In this new version of the old struggle for the soul of art, Delacroix represents a major victory for the forces of feeling over fact. Gauguin wanted to complete the liberation of fantasy from fact – of instinctive from naturalistic perception – and create an art whose "emotion is aimed at the most intimate part of the soul" (p. 131).

But to do so is to remove himself completely from almost every audience; the only audience that remains, that is possible, is a few other artists, with similar aspirations. The general public is blind to the special relationship of art to emotion, a magical power over emotion that Gauguin wants to make explicit once and for all, defending it against the masses who would turn art into something naive, even stupid. This is a crucial aspect of the modern condition of art: in a world which insists that art be accessible to and comprehensible by everybody, a world with a democratic conception of art, with the expectation that it appeal to the masses by showing them materialistic truth, by assuring them that there is no mystery, that what they see with their eyes is all that there is to be conscious of, only those who deny no feeling,

5

however strange and unexpected, however mysterious in origin, can perceive what is genuine in art – the unseen yet profoundly experienced emotion it conveys. This is the source of its supernaturalness or nobility. Gauguin regularly used the hierarchical metaphors of obsolete religion and aristocracy to articulate authentic art's "difference." For only those – the genuinely religious or aristocratic – who acknowledged the existence of invisible, inner power had the artistic freedom to feel. Gauguin was acutely aware of the "surprise" of emotion, apparently often had the experience of being overtaken by unexpected emotions spontaneously emerging from the depths of his being. He felt that the artist had to have a religious or aristocratic sensibility to follow the unfolding of emotion in life – to respect its power and rule, its direction of life.

Only the connoisseurs – snobs – of emotion can see art as something more than naive realism. Only those who have the "aristocratic" acuteness to be aware of the subtle presence of emotion can grasp its presence in art. Only they can know that it is the truth of life as well as art. The masses inevitably fall back on the naive realistic, materialistic conception of art, because they have not the subtlety to perceive its emotional subtlety, the sensitivity to receive its emotional effluvium, the wit to grasp its essentialization of emotion, sufficient awe for the mystery of emotion to respect art's mysterious power to articulate and instill emotion. Only those introspectively sensitive to emotion perceive art's special power over inner life. "I am a snob – as an artist. Art is only for the minority, therefore it has to be noble itself" (p. 70).

Increasingly rare in the modern, materialistic world, sensitivity to the emotional is the condition for perception of Delacroix's, and Gauguin's, art. Thus, Gauguin's art becomes completely alien just at the moment it articulates what is most intimate in the soul. Gauguin's argument is that what is ultimately at stake in Delacroix's, and his, art is emotional not stylistic – an attitude to feeling rather than a re-creation of fact, an attempt to catalyze instinctive feeling rather than to reproduce fact with all the technical sophistication that civilization is capable of. Gauguin confronted, and was perhaps the first to do so consciously, the problem of modern art, that is, the problem of making art in a democratic society: how to articulate and arouse feeling in a bourgeois world which stubbornly values obvious fact – in a world in which feeling seems beside the point because it is not always obvious, indeed often far from easy to perceive and analyze and distrusted because it is often disruptive and unpredictable. The bourgeois world is the last place that one would expect the cultivation of feeling for its own sake – "uncontrolled" feeling. (Of course, feeling can be civilized – its fluidity frozen, its contours fixed – by being sentimentalized. It can be banalized into fact, as psychoanalysis, a bourgeois invention, tends to do.)

Gauguin's primitivism – primitivism in its seminal form – was an effort to recover and sustain disappearing affect. It was a counterattack on the vision of a world without the mystery of feeling, a vision that Gauguin thought was implicit in the scientific world picture – in the "physics" of the eye pursued

by the Impressionists. They, he wrote, "will be the official painters of to-morrow, far more dangerous than yesterday's" – a prophecy that has turned out to be true (p. 141). Gauguin himself preferred the "metaphysics" to the physics of color – to the "materialism" of the Impressionists (p. 142). "This whole heap of accurate colors is lifeless, frozen; stupidly, with effrontery, it tells lies. Where is the sun that provides warmth, what has become of that huge Oriental rug?" (p. 145). Where is "color as living matter; like the body of a living being?" The Impressionists do not grasp, do not even see, color's "internal, mysterious, enigmatic power," do not even comprehend its "musical powers," its power to reach "what is most general and therefore most indefinable in nature: its inner power" (pp. 147–48). The Impressionists understand nothing about color's power over inner life, its power to evoke deep emotion, its general profundity. Gauguin turned the Impressionists' use of color against them: for him, it must serve feeling, not fact. For Gauguin, this was the fundamental task of art in the modern world: to preserve feeling, to give it a little room to breathe, in a world of fact that wanted to squeeze it out.

Gauguin's desperate, determined insistence on instinctive art – on an art whose music spoke and moved us before its subject, an art which seemed to absorb its subject into its music, an art whose subject finally seemed the dispensable emanation of its music – was for the health of art as well as for the health of the self. If art remained completely materialistic and matter-of-fact, it would lose its youth, its power of folly. If it did not become a sanctuary for feeling in a world of fact, a place of plenitude of feeling in the midst of the poverty of fact, it would lose all human significance. If art was not to become a refuge for sensitive feeling in an insensitive world, it would become as heartless and deathlike as civilization. Behind the aestheticism of primitivism – which I regard as the profoundest aestheticism – is a belief in the right to feel, and feel strongly and complexly and in an unprescribed way, in a world of fact. If art did not become fantastic, instinctive, trample on what was "naturally" expected of it – if it did not become all color, "a deep and mysterious language, the language of dreams" (p. 130) – it would remain profoundly sick, overcivilized, banal, feelingless, meaninglessly seductive. If it did not become "primitive and simple," "chaste, though naked," innocent and direct and uncensored in feeling, like a Tahitian Eve (p. 112), it would remain a "vice of civilization," making one old and all too knowing, poisoning the wellspring of feeling with a corrupting sophistication (p. 88). Civilized art has no fragrance – "*Noa Noa* means fragrant . . . the scent that Tahiti gives off" (pp. 112–13) – but smells of death. Art and feeling had to be stripped of all aesthetic pretense – the veils that supposedly made them seductive – so that their original power could become manifest. Art's only hope for rejuvenation was "barbarism" – "ruggedness," "primitiveness . . . without any thought of [civilized] polish" (p. 107). Only art that was "naked and primeval" and that bespoke a world in which everything was naked and primeval – without embarrassment, without coyness, without tempting us – could cure us of the

"civilization from which [we] suffer" (p. 107). Gauguin, in fighting for the health of art, was fighting for his own emotional health, looking for a cure to his own civilized character.

Behind the victory over "natural" representation that the Symbolists won – a victory renewed by every art that claims to be advanced today – stands the pursuit of art's health and vitality. Avant-gardism is haunted by the fear that art is becoming too civilized, becoming so old and sick that it will die. It must be made young and healthy again, rejuvenated. All the signs of death are there: people do not see or want art's vision of feeling, they see purple horses in Delacroix where there are none, they see only social success not revolutionary vision. All this is a sign that art has become irrelevant to life, that it has no real impact on life – a sign that it is losing its vital power, becoming a sign of death. It has become one more indifferent facade on a vulgar civilization. We are not moved by it: it plays no profound role in our lives. Our blindness to it corresponds to its emotional impotence, its general lack of vigor. Art must again become potent, moving, primitive, uncivilized, cutting against the grain of our European expectations. "Always keep your eye on the Persians, the Cambodians, and to a small extent the Egyptians. The big mistake is Greek art, no matter how beautiful it is" (p. 127). For Greek art is civilized, tried to civilize, illustrated and taught the idea of civilization – which must be unlearned. For our own survival, we must become primitive, plumb the depths of our emotional life. To be civilized is to accept the facts of material life as the only real ones – to stay on the surface of life and beautify or adorn it. This is living death, without hope of rebirth or rejuvenation. Greek art beautifies fact, which is to adorn death. "You will always find sustenance and vital strength in the primitive arts. (In the arts of fully developed civilizations, nothing, except repetition.) When I studied the Egyptians I always found in my brain a healthy element of something else, whereas my studies of Greek art, especially decadent Greek art, either disgusted or discouraged me, giving me a vague feeling of death without the hope of rebirth" (p. 132).

In his frustration, Gauguin seemed at times on the verge of giving up art. Instead, he practiced it in solitude. In 1891 Gauguin stated:

> I am leaving in order to have peace and quiet, to be rid of the influence of civilization. I only want to do simple, very simple art, and to be able to do that, I have to immerse myself in virgin nature, see no one but savages, live their life, with no other thought in mind but to render, the way a child would, the concepts formed in my brain and to do this with the aid of nothing but the primitive means of art, the only means that are good and true. (p. 49)

When Gauguin "definitely resolved to go live forever in Oceania" in 1894, he said his "good-by [to] painting, except as an amusement" (p. 106). Less than ten years later, in 1903, close to death, he wrote:

> I am a savage. And civilized people suspect this, for in my works there is nothing so surprising and baffling as this "savage-in-spite-of-myself"

8

aspect. That is why it is inimitable. . . . In art, we have just undergone a very long period of aberration due to physics, mechanical chemistry, and nature study. Artists have lost all their savagery, all their instincts, one might say their imagination, and so they have wandered down every kind of path in order to find the productive elements they hadn't the strength to create; as a result, they act only as undisciplined crowds and feel frightened, lost as it were, when they are alone. That is why solitude is not to be recommended to everyone, for you have to be strong in order to bear it and act alone. Everything I learned from other people merely stood in my way. Thus I can say: no one taught me anything. On the other hand, it is true that I know so little! But I prefer that little, which is of my own creation. (p. 294)

In *Avant et après* (1903) Gauguin wrote: "I believe that life hasn't any meaning unless you live it voluntarily. . . . To put yourself into your creator's hands is to nullify yourself and die" (p. 268). "Flight, isolation" became his watchwords (p. 119): flight from civilization, isolation in a primitive world. To be neither in God's nor society's hands is to live voluntarily and be alone. Not to use civilization's instruments of scientific understanding to make art is to make it voluntarily and by instinct alone. To be savage voluntarily is to be voluntarily alone. It is only in voluntary solitude that one can be oneself. Gauguin's life and art are a continual voluntary voyage inward to an ever more complete aloneness of the self – an isolation which seems the condition for the self to fully experience and vitally be itself – to have health.

The question is, what is health? Does being uncivilized or primitive automatically mean the self is healthy, vital? It is not so simple. This self, that ideally lives, as Gauguin said, "simply, and without vanity," in the "utmost silence" of solitude, spontaneously dreams of "violent harmonies in the natural scents" of intoxicating flowers. Was the extraordinarily heightened sensation of the dream the signature of health? Was the violent integration of the scents a metaphor for the integration of the feelings of the self in some unexpected harmony – a suggestion that the self, too, could be fragrant and whole? Was Gauguin's experience of "sacred horror, some immemorial thing . . . some unfathomable enigma" (p. 186) a sign of his fundamental health? Or were these primitive feelings the pathological "adornment" (in 1899 he jokingly called himself an "adornment-of-solitude type"; p. 189) of his solitude? In his primitive solitude Gauguin seemed to have experienced intense sensations he did not experience in civilized society, and even some sort of oceanic feeling – symbiotic fusion with his surroundings. His recurrent, awestruck descriptions of the sky and sea in Oceania, his experience of timelessness and infinite space as he contemplated his primitive world, his sense of experiencing "the Unknown" (p. 140) – all of this indicates that more than once he experienced a prototaxic state of "self-encounter," a state that Harry Stack Sullivan has described as one of primitive "wholeness of experience" and union with the ("mothering") world. Gauguin sought out such "momentary states," in which there was no sense of "before or after," infantile states in which he had "no

awareness of himself as an entity separate from the rest of the world," in which "his felt experience is all of a piece, undifferentiated, without definite limits . . . 'cosmic.' "[2] Paradoxically, the sense of autonomy Gauguin gained from his solitude became the condition for regressive union with nature – a transference representation of the nurturant, eternally young mother/sister/lover, the truly "primordial" all-in-one woman Gauguin attempted to find in the native women he copulated with, as though sexual union with them in and of itself proved their primordiality and as though the momentary ecstasy of orgasm, in which there seemed no before and after, could generate cosmic experience. Gauguin recovered this same cosmic, symbiotic sensation from the color music of his holistic decorative abstractions. Primitive decorative art, with its strange harmonies, afforded him the emotion of symbiotic union, abstracted from any human relationship or relationship with nature.

Modernism began with the attempt to effect a narcissistic integration of the self, healing it of the injuries wrought upon it by civilization, by fleeing from civilization and grandiosely isolating itself in order to reestablish intimate relations with a primordial nature that can make it primitively whole. The intimacy takes symbolic form in art but is experientially concrete, hands-on. I would venture to say, although I cannot demonstrate it in this context, that every significant avant-garde development is similarly primitivist in unconscious intention and that the nostalgia for primitivism that animates Postmodernist Expressionist art represents a yearning for a symbiotic experience that seems more necessary yet more impossible than ever in our world of pseudoautonomy – in a civilization which celebrates and idealizes autonomy, yet empties it of social or realistic as well as personal or emotional import. This is why primitivism today can only be conceived as an aesthetic fiction, whereas for Gauguin it was a real possibility of experience and could be the real substance of art.

What is the content of the "sacred horror" that Gauguin seemed most able to experience in the "unknown paradises" he moved to (p. 47), always moving again to a further unknown place that he hoped would be a paradise? It is the "terrible itch for the unknown that makes [him] commit follies" (p. 34), that is the source of the folly – the youthfulness – of his art. "What I want is a corner of myself that is still unexplored" (p. 33). The health of the self and the health of art require the same thing: maintaining this unexplored corner of the self – maintaining an uncivilized, unknown part of the self. What is needed for health is "a sense of the 'beyond,' a feeling heart" – a heart that gives one a sense of unknown feelings beyond civilized consciousness. Degas is faulted, despite Gauguin's great admiration for him, for lacking both. "When you come right down to it, painting is like man, mortal but always living in conflict with matter" (p. 34). Artists like Degas and the Impressionists, who did not live in this conflict with matter, who let matter dominate their art, who made their art a celebration of and homage to matter, lacked the heart that could sense the feeling beyond matter, in conflict with matter. Reason served matter by knowing it, the heart resisted it by insisting that there was something unknown – feeling – beyond it. Why are man and painting always

in conflict with matter? Because matter is dead and man is alive and must perpetually renew life and his feeling for life. The heart, not reason, is the instrument of this renewal. Life is a mystery from the point of view of reason and matter, but not of the heart, or rather the heart accepts the mysteriousness of its feelings as at the center of life's mystery.

Art, as an instrument of the heart rather than of reason, attempts to transfer feeling to matter, to make dead matter "live." To think one can overcome death – resolve the conflict with matter – by accurately rendering matter, by analytically articulating and "rationalizing" it, is only to confirm its deadness, its heartlessness, its unfeelingness, its indifference to man, as well as reason's own naïveté – and how beside the point of art's real purpose both matter and reason are. When, as in Bouguereau for Gauguin, the "entire artistic will consists only of that stupid accuracy . . . that binds us in the bondage of material reality," then the feeling of life in the depths of the heart – the unknown self – cannot be experienced (p. 182). That feeling is the only weapon we have against the death in matter.

Gauguin's art pits the unknown feelings of the deepest heart against the known deadness of matter and the reason that scientifically articulates dead matter. He wants eternal life – rejuvenation. Is he counting on an illusion to rescue him from death? Is rejuvenation really possible? That is the central question of Gauguin's art. For him, death was different in the paradise of the feeling heart which Tahiti was for him than in old Europe. In 1890, about to leave for Tahiti, he wrote: "In my hut in Tahiti, I will not think of death . . . but, on the contrary, of eternal life. . . . In Europe depicting death with a snake's tail is plausible, but in Tahiti it must be shown with roots that grow back bearing flowers" (pp. 43–44). There may be folly in this conception of death, but without this folly health cannot be restored to feeling – feeling cannot become free of the taste of death and evil embodied for Gauguin in European woman.

How can the heart, full of unknown feelings, fight matter, full of known death? How does the sensation of sacred terror counteract death? The feeling heart gave Gauguin the illusion of eternal life – rejuvenation, the goal of his art. How did it do this? How did the feeling heart and art fuse into a primitive, eternally youthful whole? How did the interaction or reciprocity of feeling and art rejuvenate both? In an 1898 letter to Daniel de Monfried, Gauguin wrote:

> Where does the painting of a picture begin and where does it end? At the instant when extreme feelings are merging in the deepest core of one's being, at the instant when they burst and all one's thoughts gush forth like lava from a volcano, doesn't the suddenly created work erupt, brutally perhaps, but in a grand and apparently superhuman way? Reason's cold calculations have not led to this eruption; but who can say exactly when the work was begun in one's heart of hearts? Perhaps it is unconscious. (p. 182)

This instant of spontaneous merger of extreme feelings that spontaneously create the work of art – the instant of depth when the material of the work is invested with the drama of one's most extreme feelings and self – is the moment

of sacred horror. It is the profoundest form of the sensation of violent harmony that Gauguin pursued in primitive abstract decorative art. It is a moment of triumphant if unexpected escape from reason (the accuracy that binds one to dead matter) to authentic "truth to nature," the truth of feeling, inner nature. The moment of immersion in and eruption of the unconscious is the moment of art's creation for Gauguin.

It is too easy to say that in the described experience of the emergence of his unconscious feelings Gauguin's last inhibitions are removed, that he sinks into the semistupor of an unconscious, "oceanic state," an infantile state, following Freud's idea that such a sense " 'of belonging inseparably to the external world as a whole' is nothing but a survival of the primitive ego-feeling which is normal to infancy."[3] Gauguin is quite consciously aware of his unconscious feelings. There is a sense of primitive merger with and belonging inseparably to the art object that is not different in kind from Gauguin's sense of merger with the primitive tropical environment in which he lived much of his life – an experience of merger he never had when he lived in civilized Paris, although he had strong intimations of it when he lived in primitive Brittany. But this inclination or predisposition toward "mystical" experience or primitive merger with an art object or world correlative with his own primitive feelings – a primitive object or environment which seemed to evoke, even catalyze his unconscious – is not only something Gauguin is conscious of, but something he consciously desires. He is extraordinarily conscious of the unconscious – waiting on it, trying to lure it out of hiding, "trap" it unawares, experience and spy on it if not expecting to capture it. He is fully aware of its protean, elusive character and of its tendency to appear unpredictably, often at the least opportune moment. He goes to Tahiti and art the way a patient goes to the inner sanctum of the analytic space in anxious expectation of finding out what is in his unconscious, of encountering the ghostly yet powerful feelings of his heart. His consciousness of the unconscious is deliberate because it is part of his consciousness of the problem of completing the painting: it cannot be completed, at least if it is to be a good, vital painting, without the aid of the unconscious, without its harnessing of unconscious feelings or the willingness of the unconscious to invest in and vitalize its material. This works both ways: Gauguin paints to experience the unconscious, for him the most intoxicating, sensual of all experiences, and he experiences the unconscious in order to make revolutionary paintings. This is the gist of his primitivism.

The only reason to make art in a materialistic world in which art itself tends to be materialistic is to make the revolution of experiencing the unconscious as consciously as possible – of experiencing the sensation of the vital sap powerfully flowing in the depths of our being. Such primitive experience is the only source of rejuvenation, self-renewal, transcendence of our deadly civilized selves. In a sense, Gauguin deliberately refused to consciously complete, that is, civilize, his painting so that the unconscious can come to its rescue. The unconscious began it; let the unconscious finish it. It is as though the unfinished painting is at once provocation and bait for the unconscious,

dead matter it could at once inhabit and consume. Gauguin's uncertainty about how to complete the painting is a way of forcing latent feelings to become manifest and articulating them in a transference representation – the painting, whose abstract decorative power comes from the free-flowing primitively expressive libido.

Gauguin wants to "depict" the unconscious. He does not simply want to express his unconscious feelings in the medium of painting but to articulate the unconscious through its signs. Prior to his description of his experience of tumultuous yet unified and concentrated unconscious feelings, Gauguin, commenting on "the big canvas" he is working on, presumably *Whence Do We Come? What Are We? Where Are We Going?,* notes that he realizes "its enormous mathematical defects; but not for anything will I fix them; it will remain just as it is, a sketch, if you like" (p. 182). After his description, he observes that it is "not a bad thing" to "leave verisimilitude behind and enter the realm of fable" (p. 182). The "defects" are signs of a "deflecting" unconscious presence, visual parapraxes, if one wishes, in the rational, consciously determined, structure of the picture. They are signs of unconscious feeling in its rationally organized matter. Similarly, the movement to fable is a move away from reality toward the realm of the unconscious. But the point is not simply to experience and explore the unconscious but to articulate and reveal it as directly and nakedly as possible. It is a seemingly impossible, or as Gauguin says, "superhuman" task, but it is the basic task of art in a materialistic civilization, the task that would rejuvenate art and the artist, supposedly the individual who most intensely suffers from civilization's insidiously death-dealing, death-loving character.

Gauguin is in a paradoxical position: to investigate and articulate the unconscious through art is to put art in a precarious position. It threatens to desublimate – to lose its character as art. Gauguin's position is the exemplary one of authentic vanguardism: to risk the destruction of art by attempting to make it a "representation" of the unconscious. This is the source of avant-garde anxiety about art-making. The anxiety is heightened by the fact that, unlike the depiction of consciously known external nature, such as Impressionism, which is in a sense the most deliberately naive of realisms, there is no scientifically grounded ideal of artistic accuracy to guide the depiction of inner or unconscious nature; it seems inherently impossible to have one. That is, for Gauguin no "physics" of the unconscious was possible; inherently "metaphysical," it was inherently unpredictable and variable in expression, for like all metaphysical or "supernatural" realities its articulation meant its emergence into a physical world of nature in which it was not at home, into a reality inherently alien to it. The unconscious could twist resistant external nature to its own transient expressive purposes – distort it, reshape its equilibrium into its own disequilibrium – but external nature would always remain too literally the case. The unconscious is primitive force not matter; it converts matter into signs of itself – the process of art for Gauguin – but those signs can easily be misread as odd, that is, not yet rationally understood, aspects of matter.

Gauguin had a vested interest in arguing for the ultimate unknowability of the unconscious, whatever its material signs, for only the constant pursuit of the unknowable – the sense that there was something more to explore – could keep art going. Art always needed the "beyond" to stay healthy and young, to rejuvenate itself. The danger in this is that pursuing the unknown so completely art could die, stop being art, and become an "investigation" into the unconscious carried on for its own sake. To pursue the unconscious may be art's folly in more ways than one, since it may imply the transcendence and superseding, or suicide, of art. Why bother making art when it is the unconscious that is of real interest? For Gauguin, art really only exists to report or intimate the merger of extreme feelings in the depths of his being – the spontaneous integration or consolidation of himself under the pressure to make art and to be revolutionary. Gauguin clung to art as an instrument to investigate the unconscious and to force it to become conscious. But what if he had discovered that art was not the only means of exploring or arousing it, not the royal road to the unconscious? Art was the only path to it he knew of, and it was a path he was not too happy with. He implicitly acknowledged the unfitness of European art as an instrument for the investigation and articulation of the unconscious by desperately trying to purge it of all traces of refinement, hyperconsciousness, and civilized character. What else did he have but dubious art to get him to the unconscious, to show him the crooked path to the healthy, whole self? Gauguin's primitivism was more fragile than is realized.

In conclusion, it is worth noting not only that Gauguin firmly established the avant-garde goal of guiltless revelation of the unconscious, that is, of radically free play with material to reveal the force of unconscious feeling, but that this goal is art's only source of self-esteem or self-belief in the modern world. In an 1888 letter to Emile Schuffenecker he wrote: "The self-esteem one acquires and a well-earned feeling of one's own strength are the only consolation – in this world. Income, after all – most brutes have that" (p. 22). Most brutes have material possessions; few have *self*-possession. For Gauguin self-esteem comes from the ability to endure and articulate the experience of instinct, to voyage in the underworld and to live to tell about it "artistically." Gauguin could esteem only those artists who conveyed the underworld experience despite themselves, who were savages-in-spite-of-themselves. He finds savagery in the most unexpected places, the primitive in the most civilized places, primitive emotion in the most sophisticated art, thus showing what a great "introspect" he was. (This neologism is more accurate than "visionary.")

Thus, in a letter to J. F. Willumsen (end of 1889), he suggested that the Danish artist "go to the Louvre and have a close look at old Ingres's portraits. In the work of this French master, you find inner life; the seeming coldness that puts people off hides intense heat, violent passion" (p. 45). This is the same Ingres whom Baudelaire, in his review of the Exposition Universelle of 1855, described as descended from the "icy star" of David[4] and characterized as pursuing an "ideal composed half of good health and half of a calm which amounts almost to indifference."[5] Gauguin, who "mistrusted" and "hated" the cold Dane in Willumsen but respected and was "amiable" with him because

he was an artist (Willumsen had visited Gauguin in Pont-Aven), was always finding the "tiger," as he called Velázquez, in the formalist, that is, in the artist "with a system," such as Baudelaire understood Ingres to have. Clearly, Gauguin was encouraging Willumsen to find the wild animal, the uncivilized passion, the primitive within himself. Gauguin had a gift for finding what Baudelaire called "the naturally poetic"[6] within what seemed absolutely alien to and irreconcilable with it, namely, artificial, even exaggeratedly artificial, style. For Baudelaire, such overcivilized style was the ultimate source of the "freakishness" of Ingres's images, the "negative sensation" of their charm. For Baudelaire, "Imagination, that Queen of the Faculties," had completely "vanished" from Ingres. Though "lost . . . amid [the] academic gymnastics" of "his great predecessors," it still lived in them.[7] But Ingres's turn to the academic gymnastics of style was so complete – he was so completely "carried away" by an "almost morbid preoccupation with *style*"[8] – that "a gap, a deficiency, a shrinkage in his stock of spiritual faculties" became evident (p. 204). Gauguin saw the same fatal attraction to style in Ingres, the same absolutization of form, the same engulfment by an "unearthly" ideal of beauty[9] – an absurd, unholy mix of noble antique and mincingly modern models – but he saw it positively as a sign of intense passion, a kind of alchemical distillation of passion. "Ingres has a love for the lines of the whole which is grandiose, and he seeks beauty in its veritable essence, which is form" (p. 45).

Similarly, Velázquez, another artist Gauguin claims as a spiritual ancestor, achieves his sense of "regal" passion "by the simplest type of execution, a few touches of color" (p. 46), that is, by an ability to make pure artifice seem spontaneous and primitive. Trivial touches in a lesser master – a master less in touch with the unconscious – in Velázquez these transient bits of color extract the natural passion or poetry from the subject "so that it may become more visible,"[10] so that we may become more conscious of it. For Gauguin, seemingly casual, incidental lines and touches could, calibrated and integrated by the hands of the master, become revolutionary – revelatory of and infused with invisible, unconscious feeling, instantly legible. It could even trigger a momentary state of self-integration and catalyze the violent harmony of the self, the merger of its extreme feelings. (The harmony is violent because there is no model of equilibrium in the modern world.) For Gauguin, a systematic pursuit of form, in an attempt to free it of the subject, could become revelatory of profound passion: form as such implied unconscious feeling as such, and above all, implied miraculous unity of the wildly fragmented (in contradictory feelings) self.

Baudelaire denied Ingres "temperament," but Gauguin found it in him in radiant purity. The Parisian surfaces of Ingres's paintings seem antithetical to the primitive surfaces of Gauguin's paintings. In February 1888 Gauguin wrote to Schuffenecker: "You are a Parisianist. I like Brittany; here I find a savage, primitive quality. When my wooden shoes echo on this granite ground, I hear the dull, muted, powerful sound I am looking for in painting" (p. 22). Ingres was also a Parisianist: what did the Parisian music of his paintings' surfaces have in common with the primitive sound of Gauguin's surfaces? The same

use of musical form as a stethoscope of introspection of unconscious feeling. The difference is that what seems unwitting in Ingres was self-conscious in Gauguin, part of the consciousness by which he achieved a sense of self-esteem.

Erich Fromm has written that

> the most fundamental problem . . . is the opposition between the love of life (biophilia) and the love of death (necrophilia); not as two parallel biological tendencies, but as alternatives: biophilia as the biologically normal love of life, and necrophilia as its pathological perversion, the love of and affinity to death.[11]

For Gauguin, civilization had become death-loving. Paris was an emotionally destructive place for him, a place where all life-loving feelings were monstrously mutated into death-loving feelings. He felt defenseless in Paris, for all the secret allies and spiritual ancestors he imagined he found in such eminently civilized artists as Ingres and Velázquez. They were not enough to turn the tide from necrophilia to biophilia, not enough to rejuvenate his love of life. He had to go to Tahiti for that, in effect to complete the self-analysis he had begun in Paris. Fromm has written that

> psychoanalysis can help people to spot the death lovers behind their mask of lofty ideologies . . . and to discover the life lovers, again not by their words, but by their being. Above all it can help to discover the necrophilious and biophilious elements in oneself; to see this struggle, and to will the victory of one's own love of life against its enemy.[12]

Gauguin saw this struggle in his life and art and willed the victory of his love of life in the being of both. But in his case it may have been a Pyrrhic victory, because in both life and art he could never clearly separate the necrophilious and biophilious elements. They were always elegantly intertwined; his works are as revelatory of a wish for death as they are of a celebration of the pleasure of living. He realized that even sex, a celebration of love of life in primitive society, had become a celebration of love of death in civilization and that, deeply infected by civilization despite his insistence on his primitive origins, he could never be certain that his pursuit of pleasure was not a disguised aggression against civilization that echoed its own destructive aggression. Desire had become radically ambivalent for Gauguin, at once expressive of love of life and love of death. The primitive in him loved life – the primitive he spent his life trying to recover and return to – but the civilized man loved death. But towards the end of his life he began to suspect that the love of death, evidenced by his aggression, was equally primitive.

Life and death copulate orgiastically in his best works, and in every work the prominence of the one is always shadowed by the other, in incomplete submission or repression. This is because the unconscious never forgets the one, however much it makes the other visible. This irresolution, with its implication of the need for conscious control of the unconscious (making it manifest only goes a short distance toward that control, as Gauguin came to realize), remains the problem of avant-garde life as well as avant-garde art.

The importance of Gauguin is that he was the first artist to run the gauntlet of this conflict with and within the unconscious, and thus the first truly modern artist. He is also the first truly modern artist because he understood that art had to deliberately decide to be on the side of life and how difficult such a decision was. Symbolism begins with his realization that, all appearances to the contrary, the Impressionists were on the side of death, by reason of their scientific method and attitude.

It is perhaps worth noting that today the history that began with Gauguin seems to be at an end. Art no longer knows whether it is on the side of life or death, whether it is biophilious or necrophilious, whether it is healthy or unhealthy, and most of it no longer seems to care. The only thing that seems to matter is that it continue to reproduce – that there is plenty of it. The real issue in the contemporary situation is not that there continue to be an abundance of works of art, but that art work through itself to a love of life, whatever stylistic form that may take. Art must once again become primitive, but it is not clear that it can ever again become so authentically, for we have become so civilized, so sophisticated about primitivism, that we know it is a fiction, an aesthetic construction, satisfying a variety of social as well as psychological needs. Especially does it satisfy the deep need for self-experience, leading to the illusion that we can heal the wounds civilization has inflicted on us – manifest in our conscious and unconscious discontent and protest – by experiencing, in a momentary, abstracted state of primitive awareness, the complex yet integrated currents of our own highly fluid unconscious. Witness to our unconscious, we can have the illusion that we can be made whole. But fragmentariness or partialness has been institutionally accepted – it suits social control – and almost nobody has Gauguin's desire to be made whole, or the illusion that it is possible, especially not through art. He has become one of those Romantic beacons Baudelaire poetically described as the last lights of intense feeling in our civilization.

2

The Process of Idealization of Woman
in Matisse's Art

I

It is well known that Matisse's major theme was the female model. Albert Elsen remarks on "the almost complete departure of the male model from Matisse's figural work" after 1906. Interpreting, Elsen states that Matisse "preferred to forsake the greater dramatic possibilities of masculine bodies for the beauty achievable with the feminine form."[1] This suggests that Matisse never treated the female body as dramatically assertive but always as passive form. Indeed, it implies that for Matisse woman is too ideal to have a body – that she is invariably a sublime, disembodied presence in his art. But Elsen has given us a half-truth, made Matisse into half a man: the other half was Matisse the Fauvist, representing woman as an intensely erotic child of nature, a kind of neo-pagan nymph (not to speak of the fact that Elsen perpetrates the cliché that man is drama, woman is beauty – that man exists to act, woman to be looked at).

Nonetheless, Elsen has a point, for after Matisse's Fauvist representation of woman as a primitive force of nature, she was never quite the same in his art. He felt compelled to idealize her flesh into pure form, as though in embarrassed reaction to it. He seemed to have turned against the body he so brilliantly dramatized in his Fauve paintings – a physicality he made into a painterliness so dramatic that it often seemed to be heaving in ecstasy. (Matisse's Fauvism made it clear that woman's body has as many dramatic possibilities as man's body. Also, the history of art, particularly ancient and Renaissance art, offers many instances in which more beauty is "achieved" with masculine form than with feminine form. Albrecht Dürer's 1504 *Fall of Man* is a classic example, almost a demonstration of the inferiority of Eve's female to Adam's male beauty.)

Matisse became more interested in the shape of woman's body than in its substance, abstracting it to create an emblem of her, as he said, but an emblem which, as he implied, ultimately had nothing to do with woman. Rather, it

was another triumph of art over matter, another demonstration of art's power to find unfamiliar new form in familiar old material – to transform an old theme so radically it became unrecognizable and ultimately beside the artistic point. Matisse's idealization of woman into pure form is another example of what is fundamental to art: the power to make a form that seems necessary in itself and that cannot be predicted or predetermined – cannot be anticipated by society and does not exist in nature (however quickly it is socially accepted, and thus comes to seem "natural"). It is a form that appears to stand on its own, and is thus experienced as perfect. Matisse's emblem of woman is an avant-garde invention: it bespeaks art's autonomy and radicality rather than represents woman.

It does seem as if the idealization that creates pure form was a deliberate purge of an erotically charged content for Matisse, or a kind of reaction formation to it. It was a way of cleaning the Augean stables of his intense impulses toward and turbulent feelings about woman's flesh: pure form decisively put all that once and for all behind him. It seemed necessary for Matisse, once he realized that he was a pure artist – not another storyteller or image maker, that is, a glorified illustrator – to deny that woman's body was erotically exciting and alluring. This is because for the pure artist the erotic sullies and diminishes the aesthetic. It is the last distraction before the frontier of transcendence, the last obstacle to the beyond. The erotic is ultimately beside the point of true, "high" art. The mature Matisse's denial of his Fauvism is not unlike the older Goethe's repudiation of his youthful *Werther,* another Sturm und Drang excess that was replaced by an idealizing or "classicizing" art.

In psychic fact, the pursuit of aesthetic purity is an attempt to demonstrate that art is not the expression of the erotic it often seems to be, but of ideality as such. The most authentic and absolute art is a tautologous demonstration of ingenious form making and nothing else. Not only does the erotic not fuel art; it subtly hinders art from coming into its own. The erotic may catalyze creativity but does not sustain it on the transcendental heights. Pure form implies that genuine art transcends instinct, declaring its unessentialness to being. The most serious art has an air of disinterestedness, hermeticism, silence, austerity. It is contemplatively remote and unapproachable rather than sensuously and emotionally engaging.

No doubt even the purest art is sensuously and emotionally engaging – instinctively appealing – but that is in large part a delusional projection. Nonetheless, even after the idealization or purification of form, instinct survives as its aura or emanation. This suggests that it cannot really be transcended: instinct is inescapable. Even the achievement of pure form is instinctive: it is after all only human to be instinctive, and pure form is a uniquely human achievement. Thus, however strong the intention to create form that is unconditionally ideal or instinct-free, it is impossible to do so: purification never completely succeeds. Nonetheless, the determination to transcend instinct counts for more aesthetically than the residue of instinct that remains from the idealizing effort that produces pure form. It is enough to sense that a form intends to be pure to believe that it is truly transcendent. Serious art affords the promise of

transcendence, strongly suggests a possible escape from instinct, holds out the hope of a pure life: this is enough to make it convincing. The promise is read in pure form: form absurd by the standards of society and nature, form unnamable by them, and so form that seems to resist and criticize them, and as such comes to seem beyond them. They seem to be blindly driven in contrast to its majestic autonomy. The sublime absurdity of pure form indicates a difference too great to be rationally mastered, which is what makes it transcendentally convincing.

Pure art has been understood as a new cabalistic way of conveying the old religious message that it is possible to exist without a body – the ultimate transcendence – but pure art's more immediate point is that it is better to live without the instincts that make life so troublesome. Matisse's ideal woman remains a body, however generalized, but she has lost the instinctive life she had in his Fauvist rendering of her. Reduced to an aura or emanation of idealized form, instinct becomes neutral: it is no longer a force that can make the body seem "savage." Aesthetic ideality not only neutralizes instinct, but implies its irrelevance to art. It becomes an artifact of the process of idealization – the illusory expressivity of the transcendental. Instinct's reification as elusive atmosphere castrates it and implies its lack of aesthetic necessity, not its haunting power. Instinct may be inescapable in life, but the message of purity is that one can escape it in art, through the ideal.

Pure art asserts that instinct does not belong in the temple of art, as little as the moneylender belongs in the temple of God. It suggests that the profoundest art is not an expression of instinct, however much life, after all the apologetic, sophisticated explanations of it, ultimately seems like the blind, dumb expression of instinct, which acknowledges that it is life's profoundest reality. At its most essential, art is an attempt to escape from a life that seems fated by instinct through the invention of a form that seems so ideal and transcendent as to seem self-determining, and as such to represent individuality that has constructed itself, in the process liberating itself from nature and society – from the way they have "construed" the self. The aesthete regards the expressive aura of pure form sceptically. It never distracts him from the feeling of transcendence that is pure form's extraordinary gift to the psyche.

However, Matisse, for all his yearning for purity, was not entirely happy with it. Buried instinct makes itself felt in perverse ways in his construction of the ideal woman. Woman's body posed endless formal, abstract problems for Matisse, and he ingeniously mastered them through the process of idealization. But he continued to be secretly excited by her recalcitrant flesh, ultimately resistant to idealization. His excitement made itself felt through and despite the idealization. For him, woman was more a creature of instinct than man, which no doubt suggests how alienated he was from his own instincts and how he could find them only through woman, whether conceived as elemental or ideal. Matisse defensively idealized woman, but he remained open to seduction by her, which meant that he was always ready to acknowledge and plunge into the depth of her instincts. For Matisse their strong rhythm appeared in the curves of her body – in the feminine shape he idealized into

an aesthetic signifer. His idealization of woman was thus less of a transcendence of her and the unadulterated instinctual life she represented than first appears to be the case.

Matisse the Fauvist did not even think of idealizing woman – taking formal control of her body. He found it far too "hot" and "sensational" to treat coolly and intellectually, even to perceive clearly. His Fauvist representation of woman's body makes it into a presence too overwhelming to gain any perspective on. (The collapse of perspective in Modernism suggests the overwhelming sensuous and emotional presence of things for the Modern artist, and the ultimately terrifying existential if also fresh – raw or naked – presence they acquired because of the demystification and invalidation of the traditional conception of their transcendental origin that is part of the awareness that inaugurates modernity. The collapse of the repression barrier built by the wish for transcendence [embodied in the process of idealization] opens the floodgates of sensuous and emotional experience and leads to a sense of the ultimate hollowness of existence, that is, depressing awareness of the abyss that it "really" is.) Woman was not so much a person as an impersonal power in Matisse's Fauvist paintings. Her body was not a safe form, presenting itself for detached contemplation. Indeed, none of the respectable styles of tradition ensured emotional safety when "applied" to it, nor did they seem adequate to its expressivity. For the Fauvist Matisse, woman's body was sexually disruptive and fantastic, an unmanageable projection, as it were, as his "wild" representation of it suggested.

Form means detachment, distance, clarity, perspective – the imposition of reason on the irrationally experienced, the domestication of the wild, the "sane-itization" of what would otherwise drive one insane or wild. Such art historians as Elsen, who emphasize the purity of Matisse's formal achievements, unconsciously downplay the Fauvism that first made his reputation, and still continues to do so – the Fauvism that, however suppressed, remained the invisible foundation of his art. He never really forgot it: it continued to inform, however subtly, virtually everything he subsequently did. Matisse came into his own with Fauvism. It was his breakthrough into avant-garde importance, and in a paradoxical way remains his most avant-garde work, for in Fauvism he first grasped the idea of sensuous purity and abstract expressivity, later refined in his idealizing practice. Yet Fauvism is about the failure of form to "bind" ambivalent flesh – the failure of form to afford transcendence of flesh. The fact of the matter is that Matisse lost his artistic innocence in instinctive response to woman's flesh, which he found too irresistible to ever completely transcend.

As I have said, even after he gained a good measure of aesthetic control of woman's body by idealizing it, it continued to remain subliminally instinctive in his post-Fauvist works, as its irksome and eccentric physiognomy suggests. Matisse could never completely reduce the female model to a rhetorical device, an alembic that could take the alchemical heat of his idealizing process without cracking, a kind of test tube in which he could distill the perfume of pure form. She never became a merely nominal subject matter, a lucky convenience of tradition, affording a space in which he could freely play with form, a

neutral zone reflecting his neutralization of his impulses, his ascent to sublime art. Matisse's ideal woman was never irreversibly pure form: she sometimes openly reverted to expressive impurity, if never again becoming as instinctive as in Fauvism. His instinctive response to woman's body – an animal body, as he said, that drew out the animal in him – continued to infect his ego demonstration of it as pure form. Matisse never escaped his conflicted attitude to woman: he consciously defended against the instincts she represented by transcendentalizing, with ever greater elegance, the physical body that expressed them in its very form, while unconsciously remaining in bondage to them and the body that was their vehicle.

Only in his short, happy life as a Fauvist did Matisse never even think of subsuming and stabilizing – "pacifying" – woman's body in ideal form, reducing it to restfulness. In his Fauvist paintings, woman's flesh is a restless, reckless prelapsarian substance – a wild organic growth. It threw the discretion of beauty to the winds (even if later on it was assimilated as a new, modern kind of beauty). Too impulsive to ever make a decorous appearance, Matisse's Fauvist woman ridicules the "thoughtfulness" and taste implied by good form. Indeed, his Fauvism revolted against the very idea of them (however much Fauvism later became a form of good avant-garde taste – a contradiction in terms) – and the idea of art as a mode of propriety, its duty being to make inherently good form manifest. The question is why Matisse's Fauvism is the major exception to the general ideal rule of his art, or rather, why he seemed determined to move beyond it (however much he could not entirely leave it). No doubt there are the issues of exhaustion and too much of a good thing, as well as developmental pressure. But Matisse wanted to put Fauvism decisively behind him, as though, if he kept it up, its intensity would sabotage his art and perhaps his person. The relation between the short-lived Fauvist sense of woman as a "wild beast" with which his art began and his subsequent lifelong attempt to idealize woman is the overarching issue of his development.

II

Gypsy, 1906, and *Blue Nude,* 1907 (Figure 2), among other Fauvist paintings (1904–7), show Matisse dramatizing the female body with almost willful abandon. This begins to occur in *Carmelina,* 1903, and remains basic to Matisse's art through the first decade of this century, which was also the first decade of his career. (No doubt this spurred him on to "make art new," as Ezra Pound proposed – as new as the new century.) Such works as *Nymph and Satyr,* 1909, and *Dance,* 1910, indicate this, despite the falling off of Fauvist intensity in them. One senses that one reason Matisse brought Fauvism to a close was to consolidate his success as an artist. He reified the expressive gains of Fauvism into a secure style, civilizing his disruptive color-confrontal images so that their material and emotional primitivism would be acceptable as unequivocally high art. Indeed, his primitivism came to be regarded (without irony) as an ultra-civilized art. In effect, Matisse turned the critical success of

his Fauvist primitivism into a social success by putting a good aesthetic face on it.

Matisse began his career as an unimaginative if highly skilled professional. He was a traditional Modernist, as it were – a belated and rather conventional Impressionist. He was a little behind – aware of the "advanced" art of his day, but not the most advanced, courageous, and outrageous art, that of Postimpressionism. In fact, Fauvism can be understood as an effort to catch up to and extend the Postimpressionist idea of color. Fauvism was the first and perhaps the only real artistic risk Matisse took, and the ground on which the equivocal riskiness of his late cutouts stands. Thus, before becoming a Fauvist, Matisse was an Impressionist when it was safe to be one. And after being a Fauvist, he became a professional avant-garde artist (another contradiction in terms). This meant that for him the making of avant-garde art became another, however superior, skill. He neither completely embraced nor understood the avant-garde attitude, with its emphasis on experiments that pushed the limits of what was acceptable as art, and reflected the "experimental" character of the times. He never really wanted to problematize art as avant-garde art did. It is not clear that he ever deeply felt avant-garde anxiety and uncertainty. He quickly returned to high artistic ground after his forays into avant-garde "no-

Figure 2. Henri Matisse, *Blue Nude* (*Souvenir de Biskra*) (1907). Oil on canvas. 36¼ × 55⅛ in. Courtesy of the Baltimore Museum of Art, the Cone Collection, formed by Dr. Claribel Cone and Miss Etta Cone of Baltimore, Maryland.

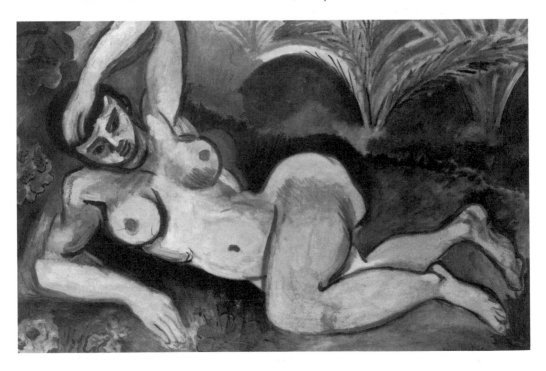

art-land" – into the zone of imagination in which art became a speculative enterprise with unpredictable results, indeed, in which it almost seemed to annihilate itself. It was as if Matisse was afraid that if he stood his avant-garde ground it would turn into artistic quicksand. It sometimes seems as though Matisse strayed into unexplored avant-garde territory against his better conservative judgment. The conflict between Matisse's avant-gardism and conservatism resembles that between his Fauvist and idealizing representations of woman. The unanswered question about Matisse's art is whether the compromise that resulted from the conflict was a creative triumph or self-subversion. Did he deliberately sell himself artistically short – curb his experimental tendencies, such as they were – by conventionalizing his avant-garde achievement for the sake of social acceptance – the success of being regarded as an approved master – or did he open new artistic horizons? Or are both beside the point, his real need being to spare himself further inner conflict about woman?

Matisse's conservatism and professionalism are evident even in the comparatively austere 1913–17 works, when he belatedly came to terms with Cubism, assimilating it as it was coming to an end. In a sense, Matisse performed the Cubist experiment when it was over, re-doing it in his own quasi-avant-garde way. He was always concerned to be orthodox, adopting an unorthodox style when it was on the verge of becoming acceptable, and giving it the final push toward complete orthodoxy by his refined simplification of it. Even his brief fling at Fauvist heterodoxy was subject to this conventionalization process. He swiftly academicized his Fauvism, making it less of a transgression of traditional sensibility than it originally was. Generalized into avant-garde orthodoxy, the once innovative method became an avant-garde style, a new standard and strategy of art making – an official part of the modern tradition, standardized in its newness. It is as if, after the disruptive creative breakthrough, in which all inhibiting caution was flung to the winds, Matisse became prematurely self-critical. He abruptly shut down to reconsolidate as well as heal the wound he unconsciously felt he inflicted on art by being an avant-gardist, however briefly.

In short, Matisse dropped his defensive professorial pose – to allude to the title "Professor" that stuck to him during his career – only during the brief period of Fauvism. But it should be noted that while "academic" implies inhibition and unoriginality, consolidation and conventionalization, it also implies, as Ad Reinhardt wrote, "high ideals . . . and a formal, hieratic, grand manner."[2] After Fauvism, Matisse tended toward such a manner, if never completely eliminating traces of Fauve excitement and energy.

The Fauvist Matisse, then, was overpowered by the female object: unable to resist it and the unexpected – and unexpectedly intense – emotions it aroused in him. His Fauvist art looked like an artless outburst attempting to overpower the object's unpredictable emotional effect on him while registering it. As I have said, it was as a Fauvist that Matisse first came into his own, but the important point is that his discovery of himself as an artist was inseparable from his Dionysian fantasy of the female body – his sense of the female body

as a hectic revelation rather than a well-regulated form, as conflicted in itself rather than beautifully balanced (as in traditional art). The struggle between the repressive propriety of the orthodoxy of ideal beauty and the impropriety and heterodoxy of instinct-ridden body pervades Matisse's art, and woman's form is the battlefield on which it is fought.

The body of Matisse's Fauvist woman is constituted by fragments of disruptive color, and while retaining the semblance of form – an erratic vigor of outline keeps it intact, technically integral – it tends to dissolve into turbulent magma. The fragmentation of woman's body suggests that it has not only become an infinitely malleable flesh that hardly lends itself to categorization as beautiful, but aggressively ugly. Indeed, her fragmented, violent appearance makes her nakedness more terrifying than appetizing. Matisse jumps from one lava flow of color to another, skillfully floating with the general drift of the female body, as it were. But that is not exactly mastery of it, intellectual or sexual.

If, as De Kooning said, "flesh was the reason oil painting was invented," and if, as Duchamp said, Matisse epitomized the practice of "physical painting," then the violent physicality and raw color of Matisse's Fauvist painting can be regarded as a way of ripping the traditional veil of beautiful form from female flesh, exposing its excitement. He undoes the traditional beautification of the body into ideal form in order to reveal – and revel in – its sensual immediacy. (De Kooning's remark is tailor-made for Matisse's Fauvism. Duchamp's remark, ostensibly contemptuous in import – his conceptualism, or intellectual irony [ironical intellectuality?], took Matisse's physicalism as its enemy – in fact reflects unconscious admiration of him, because his Fauve attitude to female flesh was less furtive and inhibited [conceptual, intellectual] than Duchamp's.) While Pierre Schneider correctly points out that Matisse's elevation of the nude shows his conservatism – for since the Renaissance, and its academic codification in the sixteenth century, "the nude has always been at the center of academic teaching," indeed "its pinnacle"[3] – the visual truth is that Matisse's nudes do not conform to the academic version of beauty.

They have a nonconformist – Modernist – beauty (if the idea of beauty still makes sense in modernity), indicating not only that Matisse was in revolt against the sense of beauty, but that he revolted because he experienced beauty as the imposition of artificial harmony on the body. He could not imagine a body that he experienced as an erratic sum of physically primitive, tenuously equilibrated parts as conceptually whole and constant. Fauvist authenticity has to do with a new psychological realism about the female body: Matisse's undisguised libidinous attitude to it was liberating after the traditional sublimation of it into beauty, and remained liberating despite Duchamp's conceptual banalization of it into a farcical machine. (Was it his persecuting, influencing machine, to allude to Tausk's conception?)[4] In contrast to Matisse's Fauvist sense of the female body as an erotic confrontation – as forcing the male artist to confront his own lust – both are defensive evasions of it. The question is why Matisse struggled against his libidinous attraction to woman's body by attempting to idealize it. Why did he attempt to renew its beauty, if in an

untraditional way? Can psychoanalytic understanding of idealization help us understand Matisse's idealization of the female body, as well as his aggressive eroticization or counteridealization of it in Fauvism?

III

Whether idealizing or Fauvizing his female model, Matisse usually positioned her in a dramatic way. Even when he tended more to conservative representation than radical abstraction, she was presented so that the drama of her convexes and concaves – the structure of contradictory curves that constituted her body – was shown to best advantage. Even when he cooled the female body with his clean line – an auratic contour that miraculously turned empty white space into voluptuously full, mystically luminescent flesh – it retained its subliminally hot, paradoxical character. Indeed, at their best Matisse's drawings articulate, with quasi-surgical precision, the anatomy of the contradiction that woman's body is with epigrammatic brevity. In such drawings as *Nude in the Studio*, 1935, and *Two Nudes on Divan*, 1937, Matisse's curiosity about the way the female body is composed strains at the limit. However, at the same time, the line's remarkable clarity and distinctness – intellectual acuity – is a barrier to the body it renders, that is, ambivalently inhibits and exhibits it. The same line that explores the female body eschews its sensuality – denies its sexuality in the very act of disclosing it. Even as it attaches us to the details of the female body, it detaches us from the body as an erotic whole.

As is obvious, Matisse's art is "hedonistic."[5] But it is not unequivocally hedonistic. It sometimes seems more like untouchable form than textured substance. While "Matisse gave the woman in his sculpture a greater sense of abandon" than was customary in "salon postures,"[6] he also tended to abstract her abandon into a calligraphic arabesque, a "plastic sign" or emblem as he called it in the 1939 *Notes of a Painter on His Drawing*.[7] It is as though if the body could be written its emotional effect could be controlled. The plastic sign is a "crystallization of memories," as Matisse said in 1947, analyzing the sign-images of *Jazz*.[8] In the 1908 *Notes of a Painter*, this crystallization was described more fundamentally as a "condensation of sensations"[9] – an act of quintessentialization. Matisse in fact explicitly regarded it as a process of realizing an essence.

Matisse often posed the female figure, whether seated, reclining, or standing, with arms raised over her head. Early sculptural examples include *Seated Nude*, 1904, *Reclining Nude I*, 1907, and *Standing Nude with Arms Raised over Head*, 1906. The position was an "emblem of femininity" for him.[10] It thrust the breasts that are the visible sign of femaleness forward, dramatically asserting them. At the same time, however unwittingly, the position de-emphasized her loins. The more prominent her breasts became, the more irrelevant her loins seemed. They became merely nominal – not even an unspeakable secret. It is as though they had no sexual purpose: as though Matisse had forgotten – or did not want to know – that they were a passageway, which the penis could enter and the baby exit. An unbridgeable chasm existed between breasts

and loins. The overstatement of the former and the understatement of the latter effected a peculiar defeminization – falsification – of femaleness. Matisse was arguing, as it were, that woman was not really woman – "castrated" – because she had phallic breasts. The emphasis on her breasts in effect forbid entrance into her body and ultimately denies that it has any entrance. If Matisse posed woman more conventionally, with her arms at rest by her sides, her breasts would be subsumed in the total configuration of her body, making them one more interesting shape in a fascinating pattern of female shapes. They would be part of the whole, not the whole. Breasts are an aspect of femaleness, but they do not define it. Matisse's focus on them indicates that he has a peculiar kind of female unconsciously in mind – the phallic woman, that is, the omnipotent mother. He is happy to find succor and nurture at her freely given breast, for it seems to give more than sexual intercourse with other women does. The issue of his art is why an immature, generally erotic relationship to woman came to make more emotional sense to him than a mature, specifically sexual one.

The crouching nude was the other major category of female figure for Matisse. The loins altogether disappear in it, and their absence is not missed. It is forgotten in the reassuring bulk of her body as a whole. It is as though Matisse must deny the terrifying absence of the loins to the childish part of his mind any way he can. Of course, in the nude with raised arms, the female loins reappear in symbolic form: in the vulva shape made by the raised arms. But this very indirect route of return of the repressed genital does not truly engage its reality. Matisse's female body remains a contradiction in terms: a powerful convexity and a pointless concavity. Moreover, raising its arms elongates it, so that it seems larger than life. Matisse's woman was an idol, as *Idol,* 1906, acknowledges. Even the crouching woman is idolized. As Schneider writes, " 'beautiful inertia' and 'necessary richness' " – qualities idealization confers – are always bestowed on woman by Matisse.[11]

Her arms raised, woman becomes a particularly striking example of the arabesque form Matisse prefers to give his female figure. For him, the arabesque bound the sensations of her body into a unity of feeling. In other words, to condense woman's body into an arabesque is to implicitly idealize it, as well as to intensify its excitement. For Matisse, the arabesque's "expressive twisting of the body in depth"[12] epitomized not only woman's power by representing her at the moment of maximum tension, like a coiled snake waiting to strike and release its energy, but the tension of modernity. For him, to be modern was to be unresolvably tense, in the same way woman's body was. The experience of woman and of modernity were unconsciously equated by Matisse: the problem of being modern posed the same impossible problem as dealing with woman did. Both modernity and woman were overstimulating, almost to the point of trauma. They threatened an explosive disintegration of self. To prevent this, their tension was given rhythmic "decorative" form, a form as "calm" as an "Egyptian statue."[13] Woman and modernity acquired "relative eternity."[14] Made rhythmic, tension seemed under control: woman and modernity seemed manageable. Through the new decorum created by

idealizing abstraction, Matisse avoided relating to woman and modernity while acknowledging their existence. The abstract arabesque was his compromise representation of them. It reified woman's body into a peculiarly monumental memory, making it safe, and offered a reified, and thus equally predictable, trustworthy modernity. Matisse performed an astonishing aesthetic feat: by giving tension the abstract rhythmic form of the arabesque, he limited it to the extent of making it seem a new kind of equilibrium.

While more urgent and dramatic than traditional harmony – because more twisted in on itself – this peculiar modern harmony is also more precarious, more vulnerable to disintegration. Thus, Matisse wrote:

> In the antique, all the parts have been equally considered. The result is unity, and repose of the spirit. In the moderns, we often find a passionate expression and realization of certain parts at the expense of others; hence, a lack of unity, consequent weakness, and a troubling of the spirit.[15]

In the traditional nude all the parts of the body are equally considered and combine in an obvious, calm unity. In Matisse's modern nude certain bodily parts are more passionately expressed than others. The female body is presented as at odds with itself, in a state of irreducible tension, resulting in a troubled unity, if it can be called that. The modern female's body was essentially a disturbing if "poetic" sum of part-objects that did not add up to a "prosaic" whole for Matisse. Wholeness had to be forced on it by stylistic fiat, and even then the result was eccentric – unbalanced – rather than a true balance or equilibration of parts. Matisse's abstract arabesque makes the discrepancy of parts seem like a dialectic: emotionally incommensurate parts seem to form an ironic intellectual whole. But more to the point, Matisse created a new kind of beauty, at once female and modern – the paradoxical beauty of tension. Out of the trauma of woman's self-contradictory body he created modern traumatic beauty. His Fauvist woman, and to a lesser extent his female arabesque, are versions of what André Breton called convulsive beauty. The latter is no doubt a somewhat more stylized convulsion.

IV

Elsen observes that when Matisse dropped the male model in favor of the female model, he also stopped using literary or allusive titles, as he did with the male model.[16] This suggests that the female model did not need the fig leaf of a secondary cultural meaning to cover up its primary sensuous and emotional meaningfulness. It is to articulate the primary reality of the sensuous and emotional that Matisse let "women . . . reign as mistresses over his painting," although they were not femmes fatales, as in the case of his teacher Gustave Moreau.[17] This experience of woman's body as a sensuous and emotional end in itself announced the primacy of subjective over objective reality for Matisse. His idealization of woman's body was peculiarly similar in purpose to the traditional use of literary labels to allegorize it – to turn its physical reality into an intellectual symbol, and thus to escape absorption by its charms.

Both were made in fear of the rank subjectivity that woman's naked body evoked. Thus, while "the morbid atmosphere, languid with impotence, that characterizes not only Moreau but all Symbolism, vanishes" in Matisse's art, to be replaced by a bright atmosphere full of phallic gestures, Matisse was as morbidly disturbed by woman as was Moreau.[18] Matisse may have had "no use for Moreau's masochistic . . . myths," but he too was aware of the cost of submitting to her, whatever the pleasure it afforded. Submission meant that the wild subjectivity she represented would rein supreme in his psyche, undermining his autonomy as both man and artist. He was afraid of losing himself in woman's body, as it were, which was in effect fear of losing himself in the labyrinth of sensuous and emotional reality it represented. It was this fear of woman as a disturber of the emotional peace – anxiety about disintegrating into a subjective mess in her absorbing presence – that led Matisse to objectify her body as ideal form. He could escape the chaos of his own subjective depths only by making her body submit to a purely aesthetic order. This was an even more thorough allegorization and acculturation of her than was achieved by the literary labeling of her for social and intellectual purposes. In fact, Matisse idealized woman, making her virtuous, as much as traditional personifications of her as one or the other virtue did. Only his style of idealization was different.

The process of idealization, involving transition from the representation of her as a subjectively intense, instinctively alive, sensuously and emotionally rich presence to a pure, numinously rational, well-regulated form, occurs again and again in Matisse's art, with almost compulsive regularity. It is as though he had to repeat it over and over to prove to himself that he did indeed have mastery of his own subjectivity, and thus his response to woman. He had to repeat his escape from her, as though it was not real. And indeed, the repetition suggested just how possessed by and obsessed with her he remained.

Matisse's *Jeannette* series, 1910–11(?), and *Back* series, 1909–29, are almost didactic demonstrations of this escapist process of idealization. These sculptures also show how it failed, that is, how deeply attached Matisse was to a certain kind of woman. For his ideal, pure woman ironically turned out to be the omnipotent phallic woman – the most attractive, secure woman of all to the child in every man. In the former series, the head of a woman becomes slowly but inevitably and irreversibly phallicized. In the latter series, the same occurs to a much larger part of the body.[19] Thus, the idealizing process unexpectedly turns out to be a fetishistic process: the final works in both series are unequivocal, full-fledged fetishes – phallic substitutes. Castration anxiety is overcome in a regressive way: the phallus of Matisse's art can function to create only the mother's imaginary phallus. That is, Matisse is artistically powerful only when he is re-creating the mother's power. To put this another way, his process of idealization is a self-deceptive way of identifying with his mother's power, an identification confirming that the power of art is with him. And yet the idealization is not self-deceptive on an unconscious level, because the mother is ideal to the child, in part because she is all-powerful and all-giving to him. What, then, does Matisse's mother have to do with his art?

So much testifies to his mother's secret presence in it. Jack Flam speaks of

Matisse's attempt to achieve "complete, almost mystical, fusing of the impulses inherent in the model [with] those received by the painter,"[20] suggesting symbiotic merger with her. Her body aroused "emotional interest," which was transferred to "the lines or the special values distributed over the whole canvas or paper, which form its complete orchestration, its architecture,"[21] suggesting that she pervades his art, indeed, becomes its very substance. In fact, this "spontaneous translation of feeling," as Matisse called it,[22] led him to conceive of his model as a kind of Mother Nature, as his equation of a dancing woman and an acacia, equivalent by reason of their "svelte grace,"[23] suggests. Her pelvis becomes an amphora, suggesting that the liquid of life pours from it, that is, confirming that woman is the source of life. Her body becomes a cathedral, suggesting her cosmic proportions, such as she has to a child.[24] Matisse finds woman everywhere, just as a child looks for its mother everywhere – just as things become significant because they are associated with her. Matisse is not simply metaphorically reconstructing certain aspects of female form – analogizing them into visual puns – but displacing the feelings it arouses in him onto the universe, in effect making it universal. Matisse has said that parts of the model's body became "decorative motifs" or "ornaments" for him,[25] which is to suggest their generalization into Platonic ideas, as it were, giving them universal significance. Woman is the whole universe for Matisse, and the whole universe is woman, as the mother is the universe of the child.

In *Notes of a Painter* Matisse spoke of the "purely instinctive way" color "imposes" itself on him and, simultaneously, the "almost religious awe towards life" he felt. It was best expressed "neither [through] still life nor landscape, but the human figure," that is, the female model, whose "first appearance suggests nothing but a purely animal existence," although her body does have "essential qualities."[26] How does this conflict between the model's animal existence and essential qualities – the tension between her instinctive and ideal aspects – translate itself into Matisse's attitude to his mother, whom the model subliminally represents? How does this split in Matisse's attitude to his model translate into his split attitude to his mother? What does the fact that he felt himself a "slave" to his model's "unself-conscious" pose, but also experienced it as a "troubling or depressing subject matter," have to do with his mother?[27] In his famous statement that he dreams of "an art of balance, of purity and serenity, devoid of troubling or depressing subject matter,"[28] it is clear that the troubling or depressing subject is the unselfconscious animality of his model – the animality that becomes apparent when she is unselfconscious (i.e., uninhibited in her pose). The model's animal existence stands to her essential qualities as troubling or depressing subject matter stands to an art of balance, purity, and serenity. They are all mentioned in the same breath.

V

Despite his wish for an art of tranquil repose, all his life Matisse suffered from what he himself called "inner conflict." As late as 1949 he thought it "will be resolved only when our tribulations on earth come to an end."[29] Art was for

him at least a temporary cure for inner conflict. As Schneider writes, "The task of art" for Matisse "is not to isolate itself – not even in perfect mastery – in an artificial and neutral space (or its concrete expression, the museum) but to 'participate in our life.' " In a letter to Sister Jacques-Marie, Matisse wrote that "its goal is 'useful,' not the beautiful."[30] Schneider comments:

> Its role is therapeutic rather than aesthetic. It seeks to "relieve," to "alleviate," to "heal." The instrument of its 'healing' is light. . . . That is why Matisse struggled to give his paintings and drawings the "power to generate the luminous." It was to become an overwhelming preoccupation as he grew older, until in the end it almost banished from his work reality with its train of shadows.[31]

Light, of course, is the most ideal substance, by reason of its substancelessness. Nonetheless, the themes of Matisse's late work are dark and tragic, as the images in the *Jazz* portfolio, 1947, and those made for the Chapel of the Rosary in Vence, 1950, indicate. These works suggest that there is no escape from suffering, only its artistic transfiguration – its aesthetic idealization. Art makes it possible to bear suffering by sublating it in decorative joie de vivre – in aesthetic esprit, as it were – but unmistakable signs (not unlike scars) of suffering remain. *Icarus* (No. 8) and the *Burial of Pierrot* (No. 10) of *Jazz,* as well as the Stations of the Cross of the Vence Chapel, crystalize tragic sensibility and are Matisse's perhaps most devastating images, for all their ideality and luminosity.

The Dominican Brother Rayssiguier was surprised that the Vence Chapel colors are "violent, brilliant, but they have no shadow." Matisse responded that sacred light was like that.[32] Similarly, in response to Rayssiguier's surprise at his extreme economy of means, Matisse said that "Gregorian chants consist of very few notes."[33] The intense light and extreme economy of means in Matisse's last work are the climactic precipitate of his process of idealization. They contrast sharply with the "brutality" of his Fauvist works, as they have been called.[34] In those early works he "sublimated sensual pleasure," as he said; in the perfectionist late works he achieved the "unity" of the "transformed, sublimated" as such.[35] But as if to emphasize the seriousness of suffering even in the works of pure light, Dominique Fourcade concludes her account of Matisse's Nice period (1917–29) with the paradoxical statement that it was "as if the light [Matisse] had to obtain resulted in nothing but solitude and demanded a fatal renunciation . . . a kind of insistent existential loss."[36]

In a 1938 letter Matisse wrote:

> There are so many things I would like to understand, and most of all *myself* – after a half century of hard work and reflection the wall is still there. Nature – or rather, *my nature* – remains mysterious. Meanwhile I believe I have put a little order in my chaos by keeping alive the tiny light that guides me and still energetically answers the frequent enough S.O.S.[37]

Matisse, who recognized that he "unconsciously projects on everything he sees,"[38] and who acknowledged, in a comment on his sculpture after Bayre's *Jaguar Devouring a Hare,* 1899–1901, that he "identified with the passion of the wild beast expressed by the rhythm of the masses," and who "in 1908 enjoined his students to empathize with the model's [animal] poses,"[39] could not yet comprehend the violence of his emotions and had to defend against that violence by idealization.

Matisse's perhaps most abrupt idealization of an irregular, crude female figure into a refined, decorative emblem-sign occurs in the two versions of *Le Luxe,* 1906, 1907–8, and in the two versions of *Danse,* one for Sergei Shchukin, 1909–10, the other for Albert C. Barnes, 1930–32. The process of idealization is intriguingly dissected in the twenty-two photographs of the *Pink Nude,* 1935, that show it at different stages of its development. Matisse's ultimately ideal images are perhaps the late cutouts. Intense instinct and the pursuit of purity unite to uncanny effect in them. The various blue nudes of 1952 are also major examples of such a perverse synthesis. They are perhaps Matisse's most eccentric emblem-signs: *Blue Nude Skipping Rope, Seated Blue Nude, Woman with Amphora and Pomegranates, Woman and Monkeys, Bather in the Reeds,* and *Venus.* These works are in effect Neo-Symbolist. Blue is the preferred Symbolist color. As Kandinsky said in *Concerning the Spiritual in Art,* blue has "the power of profound meaning" and creates an "ultimate feeling" of "rest," that is, the serenity and tranquillity – the soothing sense of the ideal – Matisse wanted from art. But the violence implicit in the act of cutting them suggests that they are still charged with instinct and, as such, far from tranquil.

VI

Matisse's wish for the ideal clearly has narcissistic import. Freud observed that idealization is "a process that concerns the *object*." It involves the exchange of "narcissism for homage to a high ego ideal."[40] "The object is being treated in the same way as our own ego, so that when we are in love a considerable amount of narcissistic libido overflows on to the object." It may serve "as a substitute for some unattained ego ideal of our own. We love it on account of the perfections which we have striven to reach for our own ego, and which we should now like to procure in this roundabout way as a means of satisfying our narcissism." The ego may become "more and more unassuming and modest, and the object more and more sublime and precious, until at last it gets possession of the entire self-love of the ego, whose self-sacrifice thus follows as a natural consequence."[41] This seems borne out by the pictures Matisse made of himself together with his model. In virtually all of them he looks unassuming, almost self-effacing. That is, he appears in his professorial mode, epitomized in a 1918 *Self-Portrait.* (This contrasts sharply with his aggressive appearance in his 1906 *Self-Portrait* as Fauve artist.) In *Luxe, Calme, et Volupté,* 1904–5, Matisse huddles in a corner covered with a robe, as though he was cold despite the heat of the beach. Its temperature is no doubt raised by the female models proudly displaying their naked bodies. Something similar

occurs in *Carmelina* and in 1919 and 1936 versions of the *Artist and His Model*. In all these works Matisse places himself inconspicuously to the side, indeed, almost beside the point of the models and their physical effrontery. It is too simple to say that in downplaying his presence Matisse is defending against his erotic impulses toward the model, although that is no doubt true. He acknowledged a problem of overstimulation – a tendency to ecstatic transport, emotional "hyperactivity" – and art's role in its regulation.[42] (It can be understood as a kind of surplus of sensitivity and feeling, general to Expressionists according to Clement Greenberg, and the reason for their art's failure to achieve the control of ideal unity. Matisse achieved it, but the goal of immediacy, involving the ability to create the effect of urgent sensuousness and instinctive feeling, remained subliminally basic for him.) The uninhibited, animal model undoubtedly contributed to this problem, but Matisse's withdrawn, pedantically attentive demeanor involves something more than an attempt to control himself in her stimulating presence.

Both Matisse's Fauvist hyperactivity and effort at control, which initially took the form of his "shy" placement and then of idealization, goes back to the fact that the female model is the mother of his art and his mother in disguise. As such, she cannot be his sexual love object. To protect her sanctity – to keep himself from incest – he must eschew any overt erotic, intimate relationship with her. But he clearly has a very intimate covert one. In the studio self-portraits Matisse is in effect the shy elder with the young Susanna – the Susanna as young as the youthful mother who remains alive in his imagination. The coarse animality of the Fauvist females, suggested by the awkwardness and textural density of their bodies – a 1906 ink sketch of a *Nude in a Folding Chair* and a 1907 *Figure Study* are examples – as well as the violence with which they are often distorted (as in *Blue Nude,* 1907), indicates the intensity of Matisse's animal interest in them. He struggles to bring this under control, and by the end of the Fauve period, in such works as *Bathers with a Turtle,* 1908, and *Bather,* 1909, he has effected the beginnings of self-control. The model's awkwardness – really a projection of the "awkward" feelings her nakedness unconsciously aroused in him – is subtly stylized. This is the first step in the idealization process, the first condensation or essentialization of the "sensation" of the female model. And it is the first step in achieving distance from his mother, who is associated with the Fauvist beginning of his art.

Matisse's mastery quickly becomes complete. In *Red Room,* 1909, and especially *Red Studio,* 1911, he created the field of completely shadowless color that is in effect the narcissistic, ideal substance out of which he makes his later cutout figures. These are perhaps his most completely decorative ones. That is, in a consummate act of aesthetic cannibalism, their bodies have become pure style. (The maid in the 1909 work and the figural elements in the 1911 work function as shadow. However, for Matisse blackness was a color, so that shadow is never real in his art.)[43] In *Red Studio* he dematerializes not only everyday objects into accents of the field of colored light, but also his own works. This ideal field disappears relatively soon after it is achieved, only to reappear later. We must wait for Matisse's final phase for it to become the

basic substance of every figure he makes – the eternal material of his art, as it were. This ideal field tends to disappear during the Experimental period – in the 1917 *Portrait of Yvonne Landsberg* it vanishes without a trace – although it has a strong residual resonance in the *Piano Lesson*, 1916–17. During the Nice period, it is entirely forgotten, except in Matisse's drawings. Idealization – purity – is hard to sustain: the material model returns, always insistently, if sometimes in a low-key way.

The oscillation between the instinctively felt figure and the transcendent field informs all of Matisse's oeuvre, even when they seem to fuse in his final works. It reflects the profound conflict caused by perhaps the most important event in Matisse's relationship with his mother. Both the material model and ideal field are equally representative of her, that is, of her split into libidinal and ideal parts in his psyche. In fact, without his mother's help, Matisse would probably not have become an artist. She gave birth to his art as much as gave birth to him. He felt doubly in her debt – for his existence as an artist as well as a human being. And thus her presence was inescapable in both his art and unconscious life. He could never separate from her, paradoxically because she gave him the art that gave him his autonomy. His every act of art became an unconscious re-creation of her presence: a return to her as the origin of his art, as well as a "proof" that she and Matisse were one in and through art.

"At the age of twenty" Matisse was "quite ill with appendicitis and during his slow convalescence . . . his mother gave him a box of colors to help him pass the time."[44] Before that event he had been interested in art, but it took the event to legitimate his interest. His mother had made it clear that there was no other possible career for him but artist. She in effect said that it was acceptable, indeed, desirable that he become an artist: it was permissible to pursue the "feminine" career of artist rather than the "masculine" career of lawyer his father preferred for him. That is, it was permissible for him to identify with her rather than his father. His mother's indulgence, acknowledging and encouraging his own inclination, won out over his father's will.

Marcelin Pleynet makes much of this gift;[45] I want to make even more of it: Matisse's art celebrates his mother's gift. It is about nothing but that gift and his grateful love for his mother, which initially took the form of sexual interest in her and ultimately led to her idealization. Through his art he possessed her in both the surrogate physical and later sublime form of the model. The pure field of luminous color that became his art's ultimate substance was the final form of his compromised yet peculiarly consummate possession of his mother, as well as of her universal presence in his art.

Receiving the bright colors that became emblematic of his mother's flesh and the paintbrush that was in effect her phallus, Matisse became an Oedipal winner. It was a complex victory. On the one hand, her gift of art was a sexual act, in which she in effect gave him her body. The paint and paintbrush were the sacrament that permitted him to partake of her body. It was a gift he could not refuse, an irresistible temptation that satisfied his childish desire for her. Through the gift, she and art became inextricably one: making art became "making" her. At the least, it made her more emotionally exciting than she

ordinarily was: indeed, it revived an old excitement. But her gift not only gave him sexual possession of her exciting body; it also represented her indomitable spirit, strong will – a force magically able to heal his sickness, liberate him from suffering. It was now his: internalized through her gift, his mother became his will to health, achieved through the making of art.

Thus, she gave both her softness and hardness, as it were: her physical passion and her emotional determination, equally necessary to triumph over adversity. In identifying with her body he healed his own, and in identifying with her determination he cured his depression. No doubt it was deepened by the enforced passivity of his convalescence, but it basically had to do with the crossroads he was at: should he choose art, as he wanted, or the law, as his father wanted? His mother in effect made the choice for him through her gift. A mother's love fulfilled her son's deepest wish, making the love between them more satisfying than ever.

In general, there is an air of profound satisfaction to Matisse's art, of frustration deliberately avoided, even denied. For him, simply looking at the female model was immediately gratifying, for unconsciously she was a sexual object (perhaps, in the Fauve works as though fantasied in a primal scene) as well as ideal being (the divine parent who takes good care of the child by satisfying its every wish). His acknowledged empathy for the female model led him to incorporate both aspects of her. She became a kind of auxiliary ego, a source of Matisse's ego strength as an artist, and the restatement of an archaic libidinous relationship. Thus, Matisse's mother was simultaneously the ideal pre-Oedipal phallic mother as well as the sexually exciting, seductive Oedipal mother. Indeed, her giving him the gift of art was an unconscious act of seduction intended to tie him to her forever, for it made her more attractive and ideal than ever.

Matisse's mother probably gave him the box of colors to defeat her husband, who had other plans for Matisse. She gave him art, which has the power to fulfill wishes – his art constantly dwelt on the wish to possess her, in whatever fantasy form – so that she would never lose him to the law of the father. Through a Machiavellian act, she won the power struggle with her husband for possession of Matisse. She indicated she preferred her son to her husband. As a result, he remained his mother's – model's – son all his life. The mother's defeat of the father – the defeat of colorless law by colorful art, of the reality principle by the pleasure principle – showed not only her power, but that she was all-powerful. She indicated that law was not absolute and even irrelevant. Matisse's Fauvism celebrated his mother's victory through its "lawlessness" and the fantasy fruit of that victory, sexual possession of her. His breakthrough as an artist is inseparable from his experience of the release of impulse through escape from the law, emotionally read as a victory over, even annihilation of the father. Hence the disappearance of the masculine principle from Matisse's art with the appearance of Fauvism. It has been regarded as an aggressive male appropriation of the female, but it in fact involves adulation of her. For the colorful Fauvist woman is the mother, who showed passionate concern for her son and taught him to respond creatively – artistically – to illness.

35

She taught him that to be an artist meant to be as sensitive, empathic, and responsive as a woman, but also as determined as a man. It meant to put oneself in a loving state of being in which one was open to inspiration, without losing the masculine will to act on it, work with it. Above all, it meant to have profound empathy, even passionate concern, for the spectator, who turned to art as a last resort: the last possible cure for his ailments, magically able to restore him to physical as well as mental health. The person who turned to art with great emotional expectations, as Matisse himself did, was its true believer. He was no longer a passive spectator but an active participant in it. He responded to art as though it was made for him personally. Illness falsified one's femininity, making one all too sensitive to oneself, too narcissistic and involuted, and destroyed one's masculinity by making one inactive, under-mining one's will to work. It altogether inhibited one, even undermined one's self-respect. The power of art was so great that it could not only restore one's femininity and masculinity to their proper character and bring them into cre-ative, harmonious relationship, but also make one experience the bad as good, as Matisse's experience of unpleasurable black as a pleasurable color indicated. Seen through art, a black state of mind became joyous. Indeed, Matisse's art, almost constantly directing attention to the colorful, pleasurable side of life, suggested there was nothing bad or black about it. Its blackness was not simply an illusion that could be wished away; it was an error in perception. (Prior to his mother's gift of color, Matisse had sketched in charcoal, among other colorless means. No doubt this was customary for a student, but it also sug-gested a certain unhappy frame of mind.)

Matisse's idealization of his mother, leading him to immortalize her as the ultimate model, was also his defense against the Oedipal gratification she afforded him. His art precluded that gratification in the very act of announcing it. As long as his mother remained ideal, in all her pre-Oedipal glory, she was sexually incognito. He felt safe and at peace with her in her role as ideal healer, but her box of colors was also license to break the law. Fauvism signaled this license, but it was short-lived. After it, Matisse's art tended to become defen-sively ideal, as noted – defensively concerned with healing, which became its law. His mother's gift of art led to a split in his sense of her: he had a bad and good love for her, that is, instinctive feelings for her leading to a desire to take license with her and feelings of grateful dependence on her as an all-powerful, good provider. After his brief "bad" Fauvist fling with her, good love won out over bad love – his art became identified as ultimately having more to do with the former than the latter (as his last religious works suggest) – because he identified with her goodness, in lieu of being unable to really be bad with her. At the same time, such identification suggests the failure of expressive release of impulse to satisfy desire when the object is more available in fantasy than in reality. Thus, while his idealization of his mother in a sense quarantines her as a sexually desirable object, it also recognizes that attachment rather than sexuality is of the essence of the relationship with her.

Nonetheless, idealization, while a symbol of sexual paradise lost – or rather not reached – offers a certain sublime satisfaction. The mother's body, idealized

36

as pure – untouchable – may no longer be a savage beast, but its sublime appearance is profoundly healing of the son's soul if not his body. Thus, his mother's gift of art led Matisse to sexualize and idealize her, but because she was in fact sexually unavailable – lawfully belonged to the father – he had to be satisfied with idealizing her gift and its intended purpose: art – personified in the allegorically ideal female model-muse – is the gift of healing, lovingly given to whoever wishes for it. Thus, by believing the idealization process of art to be an unfailing cure for "sick" desire, Matisse remained an innocent child. Art became a way of being untouched by desire while keeping the most desirable being of all in visionary sight.

Matisse's loving, considerate attitude to his viewer is one of the things that seems to make him not avant-garde or to compromise his avant-gardism. For to be avant-garde supposedly means to be critical of the viewer, indeed, opposed to his kind of existence, as though the avant-garde artist's existence is inherently superior to it. Matisse is often dismissed as "bourgeois," which says nothing about the conflicts of his or bourgeois life. Every life, even the avant-garde artist's life, is a compromise formation. The question is which is preferable, which compromises the intention behind the purity or ideality of art more, which is ultimately more avant-garde in attitude: Matisse's empathy for the bourgeois viewer, or the adversarial repudiation of the bourgeois viewer in the name of criticality as such. (The adversarial attitude is no longer uncompromising and critical because it has become stylishly bourgeois. It may have been too general in the first place – too ignorant about its target – to be genuinely critical.) The bourgeois viewer is after all in need of healing because he is human before he is bourgeois, and to condemn him in the kangaroo court of adversarial avant-garde art ultimately says more about it than about the reality of bourgeois existence. As Baudelaire said, however ironically, at the beginning of "The Salon of 1846," modern art is addressed to the bourgeois, and concerned to heal him. Matisse continues this attitude.

VII

The primitive, defensive split between the sexually exciting, "unhealthy" Oedipal mother, accessible in perverse fantasy, and the omnipotent, caring, health-giving pre-Oedipal mother, accessible in idealizing fantasy, informs Matisse's art at virtually every stage of its development. He repeatedly attempts to bring these incommensurate images of woman together, which explains the paradoxicality of his female model, who is at once voluptuous and ideal. While his art emulated the phallic wisdom that made his mother a kind of Athena, it also involved a strong voyeuristic component, in which the model is looked at with desire, however infinitely deferred. Thus, Matisse idealized art as therapeutic – a kind of ego fantasy of it – not only because his mother had a therapeutic intention in encouraging him to make art, but because it was an expressive release of his passion for her, however disguised by therapeutic idealism. In the last analysis, his art is an uncanny mix of the therapeutic law – always attempt to heal others – the mother laid down and the license she

37

permitted. Matisse was in effect seduced by his mother and impregnated by her phallus. He gave birth to art as a result, and forever after creativity came from identification with the mysterious, all-wise, all-powerful female phallus – the mothering phallus. She in effect gave him the gift of the creative female phallus. It is ultimately this that was exciting and ideal and that became a profound source of narcissistic satisfaction. The mother's phallus was freely given, which is in part what made it creatively potent and why Matisse spontaneously identified with it. This is in contrast to the father's phallus, which imposes its will like an iron law, declaring itself the only lawful phallus, for in contrast to the mother's phallus it is physically as well as emotionally real. Matisse would have had to castrate his father in an act of Promethean rebellion to make the father's phallus work creatively for him. His sickness, whatever its physical character, may have had to do with the fact that he could not rebel against his father. This is why his mother's gift of her phallus was a blessing in artistic disguise, for it rescued him from the necessity of revolt to come creatively into his own. Of course, it made his art a woman's art, until the very end of his life, when in a manly act he cut into feminine color.

Matisse's paternal appearance in most of his pictures with his model has to do with his discreet marriage to his mother. He plays the paternal, detached observer with his model, but this hides his incestuous love for her and his mastery of it through idealization. His process of mastery through idealization is perverse in more ways than one, for his fetishization of woman's body into phallic ideality involves a certain cannibalization of it. Idealization is destructive as well as constructive: to conceive the eternal female, one has to consume the sexually arousing one.

Matisse was preoccupied with health, was generally hypochondriacal, and lived, as a kind of convalescent, in a private sanatorium atmosphere.[46] His making of art was an act of recovery from possible self-annihilation, always implicitly with the help of his mother, who was both desirable model and the transcendental ground of color on which she stands. Thus, his idealization of her has a compensatory element. Hypochondria – a kind of narcissistic self-caring in exaggerated, anxious anticipation of sickness – involves regressive infantile leaning on and longing for a maternal caretaker. (The father is typically absent in the male hypochondriacal fantasy.) The point is made in a telling way early in Matisse's career, in *Luxe, Calme, et Volupté*, 1904–5, where a convalescent Matisse, wrapped in a bathrobe, is surrounded by his models, emanating the life-giving – healing – energy of color. The divisionist – "sensationalist" – character of the work suggests that Matisse cannot organize his chaotic feelings about the models, but simply bathes in their vital healing presence, unconsciously that of his mother. The picture is explicitly recuperative.

Heinz Kohut speaks of the fetish as "the substitute for the maternal self-object";[47] Matisse's fetishization of his model and of his color suggests their maternal character. It also suggests their idealization (fetishization and idealization are co-extensive); it is not only the father, but also the mother, who can be idealized – who can seem perfect, because she gives one a sense of one's

(possible) perfection, as Matisse's mother did with her empathic gift of healing color.[48] Matisse's blue nudes change from lascivious flesh, whose voluptuousness is articulated in a disruptive modern way – modern disintegrative style is more able to suggest feelings of conflicted desire than traditional integrative style – to an eccentric new kind of Madonna, an emblem-sign of unconditional caring. As is appropriate, for Matisse this emblem-sign was unconsciously associated with abstract prehistoric images of votive female figures, among them Cycladic figures.

Thus, Matisse's art deals with the change from sickness to health, more particularly from seemingly annihilative sickness to perfect health. Health is idealized because its agent was ideal – Matisse's mother (Figure 3). She became a goddess when she gave him the ideal gift, art, made with the ideal substance, color. Narcissistically investing in art and color, he loved his mother passionately as well as sublimely. The rebellious vigor of Matisse's Fauve works reflects resistance to the threat of incapacitating, potentially self-destructive sickness, as well as an affirmation of the healthy sensuousness and emotionality associated with bright color. For Matisse color was the ultimate cure for sickness, physical as well as mental, no doubt in part because it represented the caring mother.

The cutouts show Matisse's attitude to his mother at its final dialectical stage. Their color seems completely pure, signifying his unconditional idealization of his mother. But he violently cuts into the sublime color – aggressively draws in it with scissors. In effect, this castrates her, or rather loudly confirms the castration of her that was quietly going on all along through her idealization into pure form. At the end of his life, Matisse changed the female phallus into a male phallus – the soft brush into a hard scissors – and turned it against woman. The cutouts are a peculiar annihilation of her essence as well as the ultimate idealization of her existence.

The cut makes the drawn figure and color ground one and the same: Matisse had at last found a perfect, deceptively simple way of integrating drawing and color, overcoming what he once called "the eternal conflict of drawing and color."[49] This was his stated goal. In realizing it, and thus demonstrating his complete mastery of art, he finally became the father of his art, making it a law unto itself. The cutouts are his most autonomous works and the only ones made at the expense of his mother.

Ronald Fairbairn thinks that "an idealization of the love-object [is] motivated, in part at least, by a wish to establish dependence upon a more reassuring basis."[50] Matisse's mother reassured him of his health, and his practice of art was a way of reassuring himself of her subliminal presence. As long as she was unconsciously present in his art, it would be creative and pleasure giving, as she gave him pleasure with her gift of creativity. Matisse continued to paint with youthful hedonism throughout World War II, which was a depressing and troubling reality.[51] He intended to reassure people that they would survive its tragedy, the way his mother intended to reassure him that he would survive. Art was the magic means of reassurance in both cases.

According to Fairbairn, "The central ego's 'accepted object,' being shorn

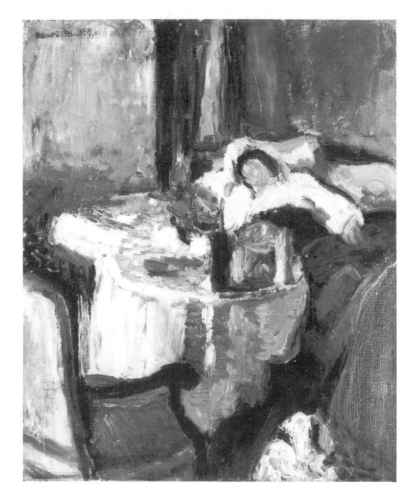

Figure 3. Henri Matisse, *The Sick Woman* (1899). Oil on canvas. 18⅛ × 15 in. Courtesy of the Baltimore Museum of Art, the Cone Collection, formed by Dr. Claribel Cone and Miss Etta Cone of Baltimore, Maryland.

of its overexciting and overrejecting elements, assumes the form of a desexualized and idealized object which the central ego can safely love after divesting itself of the elements which give rise to the libidinal ego and the internal saboteur."[52] Matisse desexualized and idealized his mother into pure form, making her not only "the ego-ideal" of his art, but safely lovable. However, the autonomous cutting edge of the cutouts bespeak her enduring sexual excitement. They confirm that her gift of art was a double-edged sword, for while it led him to idealize her it also led him to resexualize her. Idealization may be a way of resexualizing an already desexualized object – an object

desexualized in the first place because there is a law against sexually possessing it – and thus a way of disturbing rather than achieving emotional peace. Matisse's art shows that, ironically, sexual hope can spring eternal through idealization.

3

Cubist Hypochondria
On the Case of Picasso and Braque

CUBISM is widely regarded as the most innovative, most influential art style of the 20th century. "Perhaps the most important and certainly the most complete and radical artistic revolution since the Renaissance,"[1] in John Golding's words, it is in fact seen as more than a style: the "moment of Cubism," as John Berger called it, is often associated with a basic attitudinal change in Western culture, implying a renewal of human as well as artistic possibility. Daniel-Henry Kahnweiler, the early dealer in Cubist art, believed that during "those crucial seven years from 1907 to 1914" when Picasso and Braque developed Cubism, "a new epoch was being born, in which men (all mankind in fact) were undergoing a transformation more radical than any other known within historical times."[2] This transformation was supposedly experienced as a positive sense that the world could be and would be changed for the better. As Clement Greenberg wrote of Cubism, "one of the greatest of all moments in painting arrived on the crest of a mood of 'materialistic' optimism . . . a mood of secular optimism."[3] Indeed, "the generation of the avant-garde that came of age after 1900 was the first to accept the modern, industrializing world with enthusiasm."[4]

Similarly, Berger asserts that Cubism represents a happy revolutionary interlude between the old suffering of the previous centuries – "the suffering of hopelessness and defeat" – and the "new kind of suffering" that was born after World War I, "an inverted suffering" that "has persisted . . . until the present day," a counterproductive – counterrevolutionary – suffering in which "men fought with themselves about the meaning of events, identity, hope. This was the negative possibility implicit in the new relation of the self of the world. The life they experienced became a chaos within them. They became lost within themselves."[5] Coming in the middle of this shift from objective to subjective suffering, Cubism supposedly escaped both, offering a beacon of unequivocal identity and hope in the modern world.

My own sense of Cubism is that it was in fact far more ambivalent about modernity than this body of criticism suggests. It's true that the originators

of the style were apparently enthusiastic about the new age: when Picasso called Braque *mon cher Vilbure,* for example, referring to the aviation pioneer Wilbur Wright, and used the slogan *Notre avenir est dans l'air* (Our future is in the air) in some of his 1912 paintings,[6] he seemed to be embracing modernity in the form of the airplane, and wittily attaching Cubism to the then equally novel, equally promising mechanical flight. But there is a cruel, aggressive note of disharmony in Picasso's allusion (a matter of course in most of his work, which he once described as a sum of destructions). Wright had just died; did Picasso wish Braque dead, or intend to knock him off artistically? Presumably this ambivalent remark did not disturb the two artists' fraternal intimacy, their mutual dependence and shared adventure as, in Braque's words, "two mountaineers roped together,"[7] yet it is certainly suggestive of competition and conflict as well as of collaboration. More important, Picasso's quip signals the anxiety as well as the elation at the heart of Cubism, and in his relationship with Braque. It suggests the hypochondriacal artmaking that Cubism was.

There is a chaos within Cubism, and this art does express the "inverted suffering" of the modern world. In both its stern, tense, melancholy Analytic phase and its more self-accepting, if far from upbeat, Synthetic phase, Cubism articulates the "negative possibility" of modernity. It is a mistake to regard True Cubism (Douglas Cooper's term for the seminal Cubism of Picasso and Braque) as welcoming and assimilative of the modern world, unresistant to it. It is also a mistake to regard Cubism as essentially an intellectualizing art (as has been customary almost from the start of its creation, through the association of Cubist space with four-dimensionality, and in subsequent interpretations). If Cubism is intellectualizing, it is so in the psychoanalytic sense, as an attempt to use abstract thought to prevent the emergence and acknowledgment of emotions, inner conflicts, and fantasies – in effect to repress, even deny them. But a careful look at Cubist work shows that they do break through – are vehemently visible. Cubism is in effect a kind of expressionism.

The key to Cubism is the recognition that it dissolves traditional representation. This accomplishment has been widely acknowledged, and Cubism has been much congratulated for it, as though to dissolve traditional representation were in and of itself enough to be modern – that is, to accept the modern understanding that there is no one dominant sense of reality, and thus no one ultimately convincing mode of representation. Yet True Cubism does not simply dissolve traditional representation; indeed, although it may transform representation, it never quite gives it up. Instead, Cubism carries to an extreme the modern attack on the idealization of the body (and of the world it inhabits). This attack effectively began with the realism of Courbet; in a sense, Cubism is a reductio ad absurdum of the "cult of ugliness," to use the term applied to Courbet – an extreme form of that painter's realist refusal of beauty and harmony in favor of an unideal bodiliness. If modern realism is a recognition of the materiality of social and generally human reality, Cubism offers us a more ugly, more antiidealistic vision of reality than Courbet did – shows it to have a kind of depth ugliness, we might say. Indeed, Picasso's *Les Demoiselles*

43

d'Avignon, 1907, so crucial to the development of Cubism, was initially experienced by many artists of the period as more "pointlessly" ugly – a ridiculing hoax in its ugliness – than anything they had previously seen.

Cubism's shift from traditional, idealizing representation to modern, uglifying representation is in effect a shift from a conceptual, conscious, secondary-process articulation of reality to a nonrational, primary-process one. This art is a kind of deliberate disrupting, a near overcoming, of secondary-process pictorial thinking to get at the primary processes that are fundamental to picture-making. This makes it a kind of regression in the service of the ego of art. If expressionism can be defined as an art in which primary-process thinking tends to dominate secondary-process thinking, then the distance between the expressionist and the Cubist mentalities dwindles, even if expressionist and Cubist works are quite different on the stylistic surface. In fact, True Cubism makes explicit – but with a special twist – the project implicit in Fauvism: the articulation of bodiliness as such, or, more precisely, the representation of what Freud called the body ego, the first ego, the ego, as Phyllis Greenacre has said, that is the basis for all further constructions of identity.[8] In Fauvism the body ego is already less than ideal; as though in compensation, it becomes intensely vital. But in Cubism this reinforced vitality is lost. A dramatic change has occurred: the body – all bodies, the very bodiliness of the world – is shown in the process of disintegration.

Berger is no doubt correct to assert that Cubism is inseparable from the early-century feeling that the world was "on the eve of revolution"[9] and that Cubism was revolution's "prophecy, but prophecy as the basis of a transformation that had actually begun."[10] However, Berger misidentifies Cubism's revolutionary awareness: the superficially positive transformation he perceives was actually profoundly negative. Material reality and society were no doubt being reconceived, but so was the self, which was coming to be experienced as radically conflicted and precarious. It no longer seemed to have a hard indivisible core. By necessity of his Marxist and scientific materialism, Berger overstates the social-revolutionary dimension of Cubism, and the influence of technology on it. (At the most, the new technology gave Braque and Picasso the courage to change, or else to rationalize their innovations; their would-be social revolutionariness is no more than quasi-anarchistic disaffection with bourgeois existence and style.) In Cubism we find not only the sense of freshness that comes with the new realization of nature and society, but the articulation of the new suffering.

While there are elements of the old sense of helplessness at the hands of the world in Cubism, this art is essentially about the new suffering at one's own hands. Analytic Cubism – especially in the climactic, "negative Apollonian" portraits of 1911–12 – symbolically presents the modern sense of the divided self (Figure 4); Synthetic Cubism, coming later, can be understood as articulating that division in a spirit of what Nietzsche called Dionysian pessimism, that is, as playful habituation to what is eternally recurrent. Analytic Cubism shows the body ego perpetually defeating itself, caught in a kind of Sisyphean

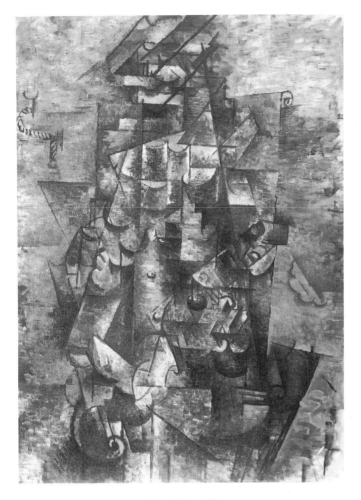

Figure 4. Georges Braque, *Man with a Guitar* (begun summer 1911; completed early 1912). Oil on canvas. 45¾ × 31⅞ in. Courtesy of the Museum of Modern Art, New York. Acquired through the Lillie P. Bliss bequest.

quandary in which its every attempt at self-unification leads to further self-splitting; in Synthetic Cubism we have an attempt at self-healing: the acceptance of the inevitability of self-divisiveness, but at the same time the attempt to make a pseudo-harmony out of it. If the seamless integration of opposites within the self is unattainable under modern suffering, then at least one can try to juggle opposites into the illusion of integration. Where Analytic Cubism's repeated attempts at integrity end in failure by generating fresh disintegrations, in Synthetic Cubism there is not only a resignation to disintegration as a fait accompli, but also an effort to create the nominal integration of a

judicious juxtaposition (not resolution) of opposites. Where an Analytic Cubist picture has a bitter, caustic aspect, a Synthetic Cubist picture is a species of dry, momentary wit, a formal shell with no kernel.

Cubism's negation of cohesive representation reflects the fact that the self is necessarily divided against itself in the modern world. Modernity initially seemed overloaded with possibilities, potentially offering to open up nature and society completely. There could be no representational closure in such a world; where everything is possible, anything is possible, and none of the old organizing structures can be expected to cohere. Neither self nor world can be intelligibly imaged any longer, and they are instead hallucinated, in a kind of disintegrative fury.

Heinz Kohut has argued that "the environment, which used to be experienced as threateningly close, is now [in the modern world] experienced more and more as threateningly distant."[11] One of the "psychotropic social factors," as Kohut calls them,[12] responsible for this modern sense of distance is modern industry, which duplicates and usurps the human gesture to the point where one feels depersonalized, even disembodied. In Cubism we are midway between the organic and the robotic – witness to the destruction of the body, but not yet arriving at its reconstruction as a kind of machine. Greenberg thinks that Cubism enthusiastically embraced industrialization, but the art's apparently positive response to industry and to the modernity it signals is superficial and preliminary – a blind response to novelty. The deeper reaction is the anxious discovery of the sense of distance that modern machinery creates, and the experiencing of this distance as threatening, annihilative.

A feeling of depersonalization and disembodiment – mistaken as intellectualization – appears in Cubism from the start. It is evident in the representation of rounded bodies by flat planes, of flexible, organic, intimate shapes by relatively rigid, geometrical, inorganic ones. These depictions annihilate the closed, personal, lived body. The body is not completely destroyed in Cubism, however; it survives as a field of fragments, sometimes eroticized, sometimes thanatopic. That is, the body endures as an eccentric balance of regressions, an inconclusive play of life-and-death forces, their balance always on the verge of being lost. In this sense, Cubist art is hypochondriacal, as John Gedo defines the term: "Hypochondriasis [is] a very early form of hallucinatory wish fulfillment . . . in which the recall of previous somatic experiences is used as a coping device when the individual is facing a threat. Because the *typical* danger situation at the dawn of self-awareness is the loss of the sense of self, hypochondriasis is most likely to be resorted to when the self-organization is on the verge of disintegration."[13] Cubism's hypochondriacal anxiety about the health of the body of the picture reflects an anxiety about the emotional health of the human body in a changing world. In other words, the Cubist picture shows madness – regression – in process: loss of control of representation, and finally of the power to represent – to integrate.

The near-representationless state achieved in Analytic Cubism is stabilized as a state of illusory representation in Synthetic Cubism, where regressive splitting becomes simply another picture-making code. Standardizing, or in-

stitutionalizing, or stylizing the abandonment of representation, Synthetic Cubism achieves a kind of mastery. It in effect regulates divisiveness and ambiguity rather than futilely attempting to overcome them. But the nature of the mastery confirms the trauma of the splitting. As Picasso said, comparing Cubist paintings to the first airplanes, "If one plane wasn't enough to get the thing off the ground, they added another and tied the whole thing together with bits of string and wood, very much as we were doing."[14] The cure is part of the problem; it confirms the representation's precariousness.

Cubist pictures are always being described as fragmented, discontinuous surfaces and spaces, fetishizing ambiguity. Thus Robert Rosenblum notes that already within the "apparently rudimentary vocabulary" of such an early Cubist work as Braque's *Houses at L'Estaque,* 1908, "there are the most sophisticated and disconcerting complexities." To Rosenblum, the painting builds a contradictory structure involving simultaneous "planar simplifications [to] suggest the most primary of solid geometries" and "contrary light sources that strongly shadow and illumine these planes [to] permit, at the same time, unexpected variations in the spatial organization. Suddenly a convex passage becomes concave, or the sharply defined terminal plane of a house slides into an adjacent plane to produce a denial of illusionistic depth."[15] The important words here are "at the same time" and "suddenly." Simultaneity and spontaneity – the spontaneous generation of and oscillation between opposites – suggest the sense of a perpetually changing, unfixed pictorial structure.

Rosenblum notes that Picasso's Cubist pictures have greater "vigor and energy . . . excitement and unpredictability . . . concreteness and particularity of objects" than Braque's,[16] but he also observes that "the impulse of fragmentation of surfaces" is equally strong in both. "The very core of matter seems finally to be disclosed as a delicately open structure of interlocking arcs and angles."[17] That can hardly be called a "core" in the traditional sense of the term. Despite "occasional ventures into the recording of specific sites" (indicating the token retention of a representational intention without substantial representational substance), both artists move away from "a literal description of reality" toward a fantasy of inner matter in motion. They create the first truly modern art: an art of discontinuity and rupture, an art in which representation fails at its task of rendering the seeming wholeness and stability of things. The fragmentation and spatial incoherence characteristic of the Cubist representation of reality is the visualization of what Freud called "expectant dread," or "anxious expectation." What is expected? The self-disintegration of which the anxiety is itself the harbinger. As Freud notes, the derivation of the word "anxiety" – from the Latin *angustiae,* a narrow place or strait – reflects the characteristic tightening of the body in the face of a threat. The tight, concentrated structure of Analytic Cubist art, I believe, reflects the anxious tightening of the self against the threat of its disintegration.

Under the pressure of anxiety – a danger signal from the ego – the ego constricts. If the danger is intense and persistent enough, the ego collapses into helplessness, into an unfocused, ill-formed, all-too-fluid group of fragments. Barely readable as ego, it is visible only the way the mythical figure

designated by a constellation of stars is visible. Indeed, just as the picking out of a particular group of stars as a constellation is a more or less arbitrary act considering the sea of stars, so the picking out of certain features as an ego becomes arbitrary. (We needn't even speak of giving the identity so "determined" a name or character.) This is why the key Cubist works are the portraits and, secondarily, the still lifes. In losing its constancy, the object loses its self-identity; in losing its self-identity, the figure collapses into a "set" of parts.

While Analytic Cubism is usually understood as evolving from primitivism – from Picasso's and his colleagues' now-notorious interest in tribal objects – it has also been seen as a challenge thrown down to the premier old master portrait painter, Rembrandt (who also haunts and is mocked by later Picasso).[18] Where primitivism aimed at a certain stark, harsh effect – a confrontational, transgressive, crude immediacy, as in *Les Demoiselles* – Analytic Cubism involves a return to a subtle nuancing of surface and space, to chiaroscuro and to finicky, often tactile detail – the gist, as it were, of painterly expressivity. Yet a key difference remains between Rembrandt and the Analytic Cubists. Rembrandt's portraits invite us to intimacy with the subject; those of Picasso and Braque forbid such closeness. They retain the impersonality of the primitivist figure – its distanced, uninviting character. (Again, *Les Demoiselles* is characteristic.) There is no way of achieving emotional intimacy with such forbidding and distant personages. One might say that expressivity exists for the sake of empathy, but in Analytic Cubist portraits fellow-feeling is eschewed: expressivity is alienating anxiety. The tight pictorial structure, with its dense matrix of splits, seems to invite one into the picture but in fact is a screen or veil shutting one out. Humanness goes incognito in Analytic Cubist portraits; indeed, Picasso's portraits are his first true monsters. Humanness becomes the unknown at the end of a pictorial labyrinth.

Rosenblum has argued that Analytic Cubism is more dependent on "the data of perception," "on a scrutiny of the external world," than Synthetic Cubism, although he is quick to point out that in the latter the "presumed independence of nature is more often of degree than of kind."[19] Analytic Cubism may observe the world closely, but only in order to shatter it; Synthetic Cubism is more reconstructive – more "arbitrary and imaginative," "subjective and symbolic" (very much as Post-Impressionism was in comparison to Impressionism). Synthetic Cubism, I would argue, completes what Analytic Cubism began, namely the movement away from objective to subjective representation. The two together realize Baudelaire's idea of the action of imagination, which "decomposes all creation," like Analytic Cubism, and then, "with the raw materials accumulated and disposed in accordance with rules whose origins one cannot find save in the furthest depths of the soul, it creates a new world,"[20] which is what Synthetic Cubism can be said to do. What is new is the sense of the inescapability of disintegration, the pervasiveness of anxiety, now made pictorial law. Where Symbolism used the objective to articulate the subjective, Cubism is freshly and explicitly subjective, if with a certain cabalistic flair.

48

Gedo writes, "The most profound regression in the function of human communication leads to the expression of a specific message by means of an affectomotor act alone. . . . The convulsions mimicking both epilepsy and sexual intercourse that may occur in the syndrome of hysteria are the most notorious examples of such use of 'body language.' "[21] Each fragment of a Cubist picture functions as an "affectomotor" act – an act reflecting the fundamental simultaneity of body and psyche – and the body language of the Cubist picture as a whole is convulsive. This is the beginning of the convulsiveness that André Breton said was the only beauty – that modern beauty which had been in the making since the perceptual convulsiveness of the landscape series painted by Monet and Cézanne (their compulsive repetitions are a kind of preliminary convulsiveness) and the conceptual convulsiveness of Seurat's Divisionism. It is the convulsiveness that reaches a premature crescendo in Duchamp's *Nude Descending a Staircase,* 1911, intensifies in Futurism, makes an appearance in aerodynamic Suprematism, becomes a kind of emotional violence in Surrealism, and reaches its apotheosis and stylization in Jackson Pollock's allover paintings, which are pure affectomotor acts – the essence of bodiliness.[22] Because there is no ideal that can stand as the core of the modern self, the self seems to be in perpetual desperate action. It looks stunningly vibrant, but in fact it is shaking itself to pieces. The Cubist picture is the first truly regressive communication from the disintegrating self. Its morbid message – and True Cubism is tangibly morbid – is the impossibility of coherent organization in a world of change that is as emotionally discomfiting as it is physically exhilarating.

All this makes Cubism the archetype of 20th-century creativity. Edgar Levenson describes creativity as "a binary process. That is to say, the keynote of creativity is the ability to hold incompatible ideas simultaneously, without resolution."[23] Cubism's pictorial ambiguity – of surface, space, scale – establishes irresolvability. It is not maintained for long: even in Picasso, after World War I, Cubism becomes a kind of Method acting, as in *Three Musicians,* 1921. The nihilistic obscurity of True Cubism – its frustrating, elated withdrawal from the world of objects – is worth all the later "clarification" of Cubism, which is beside the emotional point. True Cubism is a blow against the narcissistic smugness of art, the realm in which incompatible elements – both narrative and formal – are "ideally" reconciled to afford a fictional emotional security.

True Cubism involves the difficult acceptance of, in Freud's words, "contrasting – or, better, *ambivalent* – states of feeling, which in adults would lead to conflicts, [but] can be tolerated alongside one another in the child for a long time, just as later on they dwell together permanently in the unconscious."[24] In a sense, True Cubism is a regression from traditional adult to modern childlike or unconscious representation. Unexpectedly, it can be conceived as the major realization of the 20th-century ideal of childlike art. (Primitivism is one of the instruments of this ideal.) Such work involves the desublimation of well-organized secondary-process imagery into the primary-process affec-

tomotor visual acts that are the expressive basis of every significant art. They give it its evocative, hallucinatory impact, its connotative power. Freud held that primary process involves the tendency to discharge while secondary process involves the tendency to defer; in True Cubism we witness the transition from the traditional representational art of deferred action to the modern abstract art of action discharged. The transition articulates a hypochondriacal response to the modern world of change. The self-splitting that we see in True Cubism – the tightening of the object until it fragments, loses self-identity – is in a sense the subjective correlative of objective change, announcing the internal need to adapt to a metamorphic, conflicted external reality.

W. R. Bion, according to André Green, thought that the fundamental dilemma the psyche faces is "either flight from frustration by evacuation, or tolerance of it by elaborating it through thought. He said of the psychotic that he carries out projective identification with interstellar speed."[25] In the True Cubism of Picasso and Braque, the frustration generated by modern change is elaborated in visual thought. No flight from frustration seems possible, since change is everywhere, constituent of the modern world. And that frustration has a disintegrative effect – clearly at the danger level, as Cubist division suggests. (It is also a manic mask, hiding the danger.) Picasso and Braque projectively identify with and split objects with interstellar speed, preventing their frustration from making them altogether psychotic – from splitting their selves completely apart. Yet Cubist pictures show a strong psychotic tendency. Courbet's realism has become psychotic realism. True Cubism is its most masterful, refined, archetypal version.

4

Surrealism's Re-vision of Psychoanalysis

O NE never, never thinks of science as preparation for art, of psychoanalysis as preliminary to Surrealism, of the revolution of psychoanalysis paving the way for the revolution of Surrealism. Quite the contrary, it is the other way around: art is propaedeutic to science. Heinz Kohut, in his "hypothesis of artistic anticipation," gives "the great artist" credit for being "ahead of his time in focusing on the nuclear psychological problems of his era,"[1] but it is "the investigative efforts of the scientific psychologist"[2] that comprehensively and coherently realize the goal of understanding what the artist had only intuitively recognized. Art is reduced to (subtly trivialized as?) one among many realms of examples for psychoanalysis. Can one imagine that Surrealism might finish something that psychoanalysis began, that Surrealism might grasp the full ramifications of psychoanalysis better than psychoanalysis itself, that Surrealism might be an attempt to actualize the full potential of psychoanalysis, a potential it itself is unconscious of, or disavows through its reluctance to take a larger role for itself in society than it ordinarily has? Can one develop a "hypothesis of scientific anticipation," giving the great scientist credit for being ahead of his time in focusing on the nuclear epistemological problem of his era – the problem of his era's sense of reality – but holding that it is the communicative efforts of the critical-dialectical artist that reveal its dramatic lifeworld import, that is, its significance for individual and social life?

Accounts of Surrealism routinely acknowledge its debt to psychoanalysis, evident in Surrealism's self-definition as "psychic automatism in its pure state," that is, "thought" undictated to, free of "any control exercised by reason, exempt from any aesthetic or moral concern."[3] Who speaks of the debt that psychoanalysis should feel it owes to Surrealism for advocating, as a social practice, the relaxation of conscious control on the unconscious, especially when such advocacy misinterprets psychoanalysis, which does not regard the "free" expression of the unconscious as liberation from the "repression" of civilization? This misunderstanding of the meaning of repression[4] seems all the more grotesque in view of the fact that for Freud only civilization, with

its adult advocacy of reason, can liberate us from the unconscious forces that enslave us with their irrational, infantile determinisms. Freud advocated "the progressive strengthening of the scientific spirit" that, along with the maintenance of "the instinctual barriers," "seems to be an essential part" of civilization.[5] It is liberation from the unconscious that is necessary, however much, at certain times, liberation from the consciousness fostered by society seems necessary.

Prima facie, the questions asked above seem ridiculous and absurd. They should not have been asked, for psychoanalysis and Surrealism seem in irreconcilable conflict, despite the borrowings of the latter from the former. Yet the challenge of the questions shows psychoanalysis in a new light. The questions point to an unexpected flaw in it – not a structural defect, but a certain lack of clarity about the social consequences of its epistemology, a kind of self-castration in its conception of itself as no more than scientific research, an unexpected reluctance to make any serious change in the world (Freud suggests that one has to endure it, not change it), an unusual selling itself short as a revolutionary understanding of psychological reality and its pervasiveness, an odd reluctance to examine the full implications of psychological reality for the "common sense" of reality, which is left to society's control. To transform the basic sense of reality – to change fundamentally the commonsense consciousness of phenomenality – as Surrealism thinks psychoanalysis can do, and has done, is to revolutionize society.[6]

Like the Surrealists, psychoanalysts may, in André Breton's words, look like "strange animals" to enlist in a strange revolutionary cause – changing society by changing common sense, the ordinary social sense of reality – but Breton's appropriation of psychoanalytic theory is in effect an expression of faith that psychoanalysts can "prove [themselves] fully capable of doing [their] duty as revolutionaries."[7] The fact that, in retrospect, psychoanalysis has not done its revolutionary duty – made the most of its revolutionary sense of reality – can itself be psychoanalytically interpreted as a sign of psychoanalysis' immaturity or arrested development. It is not so much that psychoanalysis is socially reactionary while being psychologically revolutionary – as though it is inherently impossible to be both at the same time, the effort being too great (with no recognition that to be psychologically revolutionary is already to be socially revolutionary). Rather, psychoanalysis does not know itself as well as it thinks it does: its self-analysis – including the full understanding of its import and power – is incomplete. Surrealism can be understood as an attempt to further the self-understanding of psychoanalysis, to educate it more completely about its social import, to demonstrate, to psychoanalysis itself as well as to the world at large, the revolutionary power of psychoanalysis' "teaching" of psychological reality.

The apparently "nihilistic," disordered sense of reality Surrealism advocates – a sense of reality as irreducibly charged with unconscious content, inherently irrational – while seemingly derived from psychoanalysis, carries its ideas to a supposedly absurd extreme. Breton not only wants to make us conscious of our unconscious sense of reality as a dream but insists that we never lose this

sense; that is, however decipherable or analyzable, the experience of reality as a dream can never be entirely expunged from our psyche. This is in sharp contrast to psychoanalysis, which seems to be based on the assumption that it is once and for all possible to separate the infantile sense of living in reality as in a private dream from the adult sense of reality as what is objectively – ultimately scientifically – given. For Breton, the sense that reality is a dream – a dream that we cannot awaken from for all our interpretation of it, a childish sense of reality-as-dream that remains irreducible and ineradicable for all the adult consciousness of reality we develop, for all the success with which we "convert" pleasure principle into reality principle, id into ego – is our deepest experience of it. Thus, Breton, while accepting the psychoanalytic idea that the apparent absurdity of the manifest dream content, "upon closer scrutiny," reveals "a certain number of properties and of facts no less objective" for being latent or unconscious, maintains that the *"extreme degree of immediate absurdity"*[8] that the world subliminally appears to have – signalling that we always perceive it as implicitly a dream – whatever our efforts to demonstrate that it is far from absurd on reflection, can never be entirely overcome. For Breton, the world can never be seen with completely clear eyes, nor does it ever appear to be completely free of absurdity. (Surrealism deliberately cultivates this appearance of immediate, extreme absurdity.) This is no doubt because one never entirely overcomes one's childhood "sentiment of being unintegrated" in the world, which leads to the feeling "of *having gone astray,* which I [Breton] hold to be the most fertile that exists." It is in one's childhood that one "comes closest to one's 'real life' . . . childhood where everything . . . conspires to bring about the effective, risk-free possession of oneself," an "opportunity" that "knocks a second time" in Surrealism.[9] The "precious terror" of childhood indicates that in it reality and dream are integrated in a single "surreality," affording a sense of complete self-possession.

The Surrealist concept of surreality – "the great Mystery . . . the future resolution of these two states, dream and reality, which are seemingly so contradictory, into a kind of absolute reality, a *surreality*"[10] – is in part a major correction of the psychoanalytic assumption that unconscious and conscious thought can be clearly distinguished, even absolutely separated. Understood as directed to psychoanalysis, surreality announces that this assumption is erroneous. Psychoanalysis should know better, for its clinical evidence repeatedly demonstrates that the great mystery of surreality is always and already within us. Breton himself implicitly believes that surreality is all-pervasive, even if this is rarely realized (in true art) – that dream and reality have the same root in the psyche, are intertwined like the snakes of the caduceus, and that awareness of this has always been an aspect of genuine self-awareness. Surrealism, with its repeated demonstrations of the "unusual ferment" generated by the resolution of "the old antinomies" of dream (unconscious) and (conscious) reality,[11] is living proof of this, an attempt to make it self-evident. (Dali's "paranoiac-critical activity" is an experimental method for making manifest the surreality that is universally latent.) For Breton, surreality is absurd and nonsensical to psychoanalysis, which sharply divides unconscious

from conscious thought because of its reluctance to deny common sense, which would disrupt society. Common sense is Cartesian; it assumes that one can finally have clear and distinct consciousness of reality, that is, a consciousness free of all corrupting, obscuring taint of unconscious thought. Free of unconscious "guidance" and influence, thought can at last become truly adult – scientific. (A Comtean idea implicit to psychoanalysis.)

Breton would like, in effect, to liquidate the commonsensical Cartesian residue in psychoanalysis, not only because it is an epistemological error, but because it keeps psychoanalysis from realizing the full extent – sweeping character – of its revolutionary understanding of the sources of the sense of reality, which cannot help but have a major social effect. From Breton's point of view, psychoanalysis, in becoming more of a medical (psychiatric) than philosophical enterprise – although Freud spoke of it as positioned between medicine and philosophy – shows itself to be of commonsensical service to society rather than "absurdly" critical of it. It wants to cure the "sick" of their unconscious, uncommon, "mad" sense of society's reality – their intimate micropolitical experience of it as catastrophic, almost annihilating – and get them to believe that society is a healthy place that makes possible self-integration and self-fulfillment rather than a monstrous place that disintegrates the self. It wants to restore the sick to a supposedly healthy society – as though their perception of it as sick, that is, not conducive and even deliberately detrimental to self-integration and self-fulfillment, was an absurd delusion – with its "healthy" common sense of things: it wants to establish self and society in a mythical reciprocity, restore them to a lost paradise of trust. It never even seems to cross psychoanalysis' mind that the common point of view – common sense, with its emphasis on what is conscious and socially sanctioned – is invalid and insidiously unhealthy, fundamentally wounding, that is, dangerous to self-integration and self-fulfillment.

Apart from Breton, psychoanalysis' present self-imposed limitation of its efforts to the clinical situation suggests a subtly diminished self-regard, especially from the perspective of its original wide-ranging ambition. It is as though psychoanalysis has censored itself, is holding its tongue about the civilization it inhabits – as Freud never did, although Breton probably felt Freud never went as far in his critique of civilization as Surrealism. Breton thus offers Surrealism as a critique of psychoanalysis. Surrealism wants society – not only the individual – to become conscious of its unconscious determinisms. The facade of society's seemingly "successful" common sense should be shown to be a lie and shattered. For Surrealism, sickness is Dadaist disgust with common sense and a depth perception of the sickness of the world – of the world that makes the individual sick. Psychoanalysis should attend as much to cleaning out the Augean stables of the world's unconscious as to "curing" the sick individual – even more to society than the individual, if only to demonstrate to the individual that society is so sick that it is suicide to trust or accept on face value society's common sense. In a sense, Breton implies that psychoanalysis is in a double bind. Its theory of the power and workings of the unconscious is on target, but its cure of the sick returns them to a sick

world, and so is in a sense self-defeating, or at best a temporary reprieve. Is it that psychoanalysis does not want to stand up to and change the world – despite the world's profound sickness, manifest through the recurrent break-down of "compromise formations" (social contracts) and the tyrannization of one part of society over another – because psychoanalysis is part of that illness itself? As Karl Kraus wrote, "psychoanalysis is that mental illness which re-gards itself as therapy";[12] that is, psychoanalysis is another symptom of so-ciety's sickness, repeated breakdown.[13]

The heart of this sickness seems to be what Breton called, in 1956, the "crime" of "miserabilism": "the depreciation of reality in place of its exalta-tion."[14] When Breton noted, in *The First Surrealist Manifesto* (1924), "the hate of the *marvelous* which rages in certain men,"[15] he was already speaking of miserabilism, for the marvelous, which is "always beautiful . . . in fact only the marvelous is beautiful,"[16] is the imagination's exaltation of reality. Mi-serabilism means in effect, as Breton wrote in *The First Surrealist Manifesto,* "to reduce the imagination to a state of slavery," which "would mean the elimination of what is commonly called happiness" and "to betray all sense of absolute justice within oneself."[17] The Surrealists' moral understanding of the imagination is made clear by Louis Aragon's assertion, in the *Challenge to Painting* (1930), that "the relationship born of the negation of the real by the marvelous is essentially of an ethical nature, and the marvelous is always the materialization of a moral symbol in violent opposition to the morality of the world from which it arises."[18]

For Breton, society, with its commonsense morality, fosters miserabilism; psychoanalysis must foster the antimiserabilism of the imagination. When Breton wrote "that freedom, acquired here on earth at the price of a thousand – and the most difficult renunciations, must be enjoyed as unrestrictedly as it is granted, without pragmatic considerations of any sort, and this because human emancipation – conceived finally in its simplest revolutionary form, which is no less than human emancipation in *every respect,* by which I mean, *according to the means at every man's disposal* – remains the only cause worth serving,"[19] he was attacking miserabilism. The exaltation of reality through the enjoyment of freedom is the enemy of the depreciation of reality and experience of it as miserable. (Or banal. One recalls Baudelaire's assertion that "banality is the only vice.") When he insisted "that around himself each in-dividual must foment a private conspiracy, which exists not only in his imag-ination – of which it would be best, from the standpoint of knowledge alone, to take account – but also – and much more dangerously – by thrusting one's head, then an arm, out of the jail – thus shattered – of logic, that is, out of the most hateful of prisons,"[20] he was implicitly expressing his ambivalence about psychoanalysis, which at once takes account of the private conspiracy against public logic in the imagination but does not dare shatter the logic of the social jail, that is, encourage imagination to become critical action. This statement, originally made in 1928, of course goes far beyond Breton's ad-vocacy of "beloved imagination" in *The First Surrealist Manifesto,* which he liked because of its "unsparing quality."[21]

Breton gives us some sense of what such critical action would be when he speaks of Nadja's misunderstanding of it. Becoming "mad" because she "lost that minimal common sense which permits my friends and myself, for instance, to *stand up* when a flag goes past, confining ourselves to not saluting it,"[22] she apparently was incarcerated in a psychiatric hospital. It is worth noting that such conformity to common sense, in the letter if not the spirit, seems a pallid revolt – far from the *"complete nonconformism"* Breton advocated[23] – in sharp contrast to the "revolt [for which] none of us must have any need of ancestors," yet whose ancestors are Rimbaud, Lenin, Alphonse Rabbe, and Sade.[24] It seems a long way from Breton's conception, in *The Second Surrealist Manifesto* (1929), of Surrealism as "a tenet of total revolt, complete insubordination, of sabotage according to rule," a doctrine which "expects nothing save from violence. The simplest Surrealist act consists of dashing down into the street, pistol in hand, and firing blindly, as fast as you can pull the trigger, into the crowd."[25] For all his proclamations to the contrary, when it comes to concrete practice, Breton's theory of violence remains "idealistic," despite his insistence on "the necessity to put an end to idealism properly speaking."[26] Surrealism may "usher [us] into death," as he wrote in *The First Surrealist Manifesto,* but more by the violence of the imagination than literal violence. Death, after all, is for Breton, just another "secret society,"[27] which is what in effect he thought Surrealism was. Whatever he wrote, Breton retained his practical common sense – enough common sense of reality not to be incarcerated as mad.

For Breton, psychiatric places of "so-called social conservation" were "detestable," for they reinforce with a vengeance society's common sense of reality. "Madmen are *made* there, just as criminals are made in our reformatories," because, "for a peccadillo, some initial and exterior rejection of respectability or common sense, [society] hurl[s] an individual among others whose association can only be harmful to him and, above all, systematically deprive[s] him of relations with everyone whose moral or practical sense is more firmly established than his own."[28] Madness was a necessary alternative to common sense for Breton – the madness which gave one a sense of the marvelousness of reality that was missing from the commonsense awareness of it – but he never forgot that madness "has aptly been described [as] 'the madness that locks one up'. . . . We all know, in fact, that the insane owe their incarceration to a tiny number of legally reprehensible acts and that, were it not for these acts, their freedom . . . would not be threatened. I am willing to admit that they are, to some degree, victims of their imagination, in that it induces them not to pay attention to certain rules – outside of which the species feels itself threatened – which we are all supposed to know and respect."[29] Breton had no wish to be incarcerated – Surrealism did not mean to be a legally reprehensible act – or to become a victim of his imagination, however violent it might become, however possessed by the sense of the marvelous it might become. Nonetheless, despite his vacillation and restraint in acting out the violent impulses of the imagination as though they were marvelous in themselves – despite his retention of a minimum of common sense – Breton saw the rebellious possibilities of the imagination in a positive psychological

light, for they alone could overthrow miserabilism. Breton's revolt was against the "miserable" common sense of reality; the exaltation of the marvelous would slowly but surely lead to social ferment and change, to a society where, in Trotsky's words – quoted with approval by Breton in *The Second Surrealist Manifesto* – "man's liberated egotism – an extraordinary force – will be concerned only with the knowledge, the transformation, and the betterment of the universe. . . . But we shall reach this stage only after a long and painful transition, which lies almost entirely before us."[30] For the Breton of *The First Surrealist Manifesto* psychoanalysis is *the* instrument for the emancipation of imagination, in effect the liberation of man's egotism. For the Breton of *The Second Surrealist Manifesto,* Marxism seems to have become the major instrument of emancipation, but it is an imaginative Marxism – a Marxism with imagination as its center, a Marxism that does not forfeit the sense of imagination that can overthrow miserabilism, which is as great an enemy of knowledge and social change as of the marvelous. Breton may have turned to Marxism because he thought that psychoanalysis could not escape becoming a form of psychiatric miserabilism – psychiatric common sense about madmen, which demands that they be incarcerated, in theory as well as literally. For Breton, miserabilism was symbolized by psychiatric institutions' enforcing common sense, with its vulgar sense of reality.

Breton's attempt to turn psychoanalysis into a revolutionary Weltanschauung – or rather to demonstrate that in fact it was implicitly one – can be regarded as an extreme statement of a trend within psychoanalysis itself in the pre-American, pioneering days of the 1920s. Russell Jacoby has pointed out that "It is important to realize that the Freudians of the first and second generation were primarily cosmopolitan intellectuals, not narrow medical therapists." There was, among them, a sizable number of "political Freudians," including Siegfried Bernfeld, Otto Fenichel, Edith Jacobson, Henry Lowenfeld, and Annie Reich, "whose collective devotion to social theorizing . . . kept alive the breadth of classical psychoanalysis." "When American psychoanalysis embraced a neutral clinical theorizing, it simultaneously became inhospitable to cultural and political psychoanalysis,"[31] which was repressed.

The ideas of Otto Gross, who "preached a doctrine of sexual and cultural emancipation, based on psychoanalytic principles – or his interpretation of those principles"[32] – were repressed. Gross, who died in 1920 – the period of transition from Dadaism to Surrealism – held that "the psychology of the unconscious is the philosophy of revolution."[33] This is *in nuce* the position of Surrealism, which did not understand itself as inventing a new style or literary strategy for art-making – it has been trivialized into this by conventional art history – but as a revolutionary attempt to emancipate the unconscious in everyone, and thus to revolutionize everyone's sense of reality. This emancipation was regarded as the first step in the establishment of a new, nonauthoritarian personal and interpersonal space – in the liberation of the self and human relationships. While this liberation did not always lead to peaceful relations – the conflicts between the Surrealists indicate as much – it did attempt

to subvert the authoritarian or patriarchal structure of society. (It can be argued that Surrealism's "advocacy" of women – Breton in effect appropriates Nadja's "wisdom" the way Socrates appropriated Diotima's wisdom – was part of its rejection of authoritarianism, although the sometimes exclusively sexual terms in which woman is depicted suggests patriarchalism.[34] Surrealism can be understood as a transition from authoritarianism to antiauthoritarianism, that is, not entirely free of patriarchal attitudes if wishfully so.)

Gross, like the Surrealists later, regarded psychoanalysis as the basis of a "new ethic" directed against crippling "authoritarian institutions."[35] Gross even recognized an issue that was later to trouble Surrealism and such radical psychoanalysts as Wilhelm Reich: "authoritarianism infested and distorted the aims of the revolutionaries themselves. The revolutions of the past failed, Gross declared, because the revolutionaries harbored an authoritarianism bred by the patriarchal family. They secretly loved the authority they subverted and reestablished domination when they were able."[36] Just as "he proposed that psychoanalysis should help revolutionaries develop freer sexual relations that would break the chain of patriarchal authoritarianism," so Surrealism in effect proposed free emotional relations with others – openness about the character of one's inner feelings, images, thoughts, that is, about "emotional truth"[37] – to free one from common sense, implicitly authoritarian in its dismissal of many feelings, images, and thoughts as irrational, that is, beside the practical point of "reality." Indeed, common sense implicitly believes that one supreme authority – reason – can be established in the psyche. This establishes a master–slave dialectic in the psyche, a hierarchy in which reality principle triumphs over pleasure principle, ego dominates id. This simply reverses the natural (biological) hierarchy of the psyche – civilizes it, as it were. For Surrealism, the point is to transcend, through surreality, the contradiction embodied by this hierarchy and establish the reciprocity of the opposites. Only such reciprocity is truly antiauthoritarian.

Insistence on telling the emotional truth is the other side of Breton's attack on "what is vulgarly understood by *the real*."[38] In a sense, Surrealism is a strategy for not adapting to the vulgar view of reality yet surviving socially, that is, not being punished for the "madness" of nonadaptation by being incarcerated. Surrealism deliberately and subtly cultivates nonadaptability, or minimum adaptation – just enough so that the Surrealist will not be stopped externally and inhibited internally from telling the emotional truth. The sum and substance of the Surrealist revolution is the creation of a Weltanschauung of revolutionary emotional nonconformism. It is revolution with just enough commonsense conformity to prevent its suppression – a perverse case of what Philip Rieff has called "the triumph of the therapeutic."[39] In a mithridatic paradox, Surrealism internalizes just enough of society's authority to resist it inwardly, that is, not to allow it total domination of the psyche. That is, it conforms outwardly just enough not to be stopped inwardly, just enough for the inner revolution of the imagination to ferment and insidiously catalyze outer change. The Surrealists show that revolution is also a "compromise formation."

58

Joseph D. Lichtenberg, in attempting to answer the question, "Is there a Weltanschauung to be developed from psychoanalysis?" points out that psychoanalysis, in its mainstream form, can constitute a kind of Weltanschauung, despite Freud's denial that it does. In Freud's words, a Weltanschauung is "an intellectual construction which solves all the problems of our existence uniformly on the basis of one overriding hypothesis, which, accordingly, leaves no question unanswered and in which everything that interests us finds its fixed place," making one "feel secure in life, . . . know what to strive for, and how one can deal most expediently with one's emotions and interests."[40] According to Lichtenberg, the conception and use of psychoanalysis as a Weltanschauung is an abuse of it, in that it closes psychoanalysis down, closes it to scientific discovery and innovation.[41] It becomes a system of illusion not unlike religion, which Freud attacked as the main threat to – enemy of – the scientific approach, which is adult in its openness to new questions rather than closed because in complete possession of all answers.[42] Is Surrealism – and the notion of psychoanalysis as a means of social revolution and change – another misapplication of psychoanalytic understanding, closing it down into a religious Weltanschauung of salvation, insinuating it into every aspect of life as a miraculous method that can solve all problems?

Surrealism is not the Saint Paul of psychoanalytic belief. While refusing the idea that psychoanalysis can function as a Weltanschauung, Freud nonetheless asserted that psychoanalysis adheres "to the scientific *Weltanschauung*,"[43] falling into subtle contradiction. For by associating science and Weltanschauung, he unwittingly assumes that science will, if not solve all problems on the basis of one overriding hypothesis, function melioristically and thereby effect a discreet, civilizing revolution in life and society. This is exactly what Surrealism assumes. It attempts to show the melioristic – ethical – character of the epistemological revolution wrought by psychoanalytic science. Surrealism regards psychoanalysis as the most revolutionary of the human sciences, that is, the science with the greatest potential for effecting a fundamental beneficial change in human life and society because it demonstrates the fundamentality of the unconscious to the sense of reality.

For Surrealism, such a demonstration makes psychoanalysis a major weapon in the war against miserabilism. It benefits us because it shows our inherent tendency to romanticize, in Novalis's sense – to discover the extraordinary in the ordinary. As such, it is an art as well as a science; Surrealism can be understood to make explicit the implicit artistic character of psychoanalysis, to put it to full artistic use, to reap its artistic benefits. As a science, it is full of "classic pessimism," that is, it is a profound acknowledgment of the depth of the difficulty of achieving reason and realism, and thus of the limitations and incorrigibility of humanity. As an art, it shares the Rousseauian "romantic" belief that "man is by nature . . . of unlimited powers, and if hitherto he has not appeared so, it is because of external obstacles and fetters."[44] Psychoanalysis is shot through and through with this paradox, which Surrealism vividly articulates. It is extremely sensitive to the misery of life but believes in the possibility of "cure" – of a new "romantic" outlook on life, that is, a fresh

integration of personal power that can overcome obstacles with the cunning of reason, that is more than emotionally and intellectually equal to the challenge of reality. In a sense, the Surrealist transformation of the object – the discovery of "the *expectant* character that emanates from surrealist objects"[45] – affirms this romanticism in the very act of acknowledging the "pessimistic" character of the world. It involves a romanticizing of pessimistically perceived objects, that is, objects experienced as banal. They are "cured" by Surrealist experimentation with them – transfigured, so that their character is shown to be far from completely exhausted by their banal objectivity, richer in significance than might be imagined from a commonsense point of view. They become at once consciously (pessimistically) known and unconsciously (romantically) experienced, and as such signs of the great mystery of surreality.

It is worth noting that in the context of his discussion of psychoanalysis as a possible Weltanschauung, Freud, in examining "the three forces which can dispute the position of science," mentions art as "almost harmless and beneficent, [because] it does not seek to be anything but an illusion. Save in the case of a few people who are, one might say, obsessed by Art, it never dares to make any attack on the realm of reality."[46] But Freud's dismissal of art as an illusion – his careful distinction between "illusion (the results of emotional demands . . .) and knowledge" and his sense that art, like all illusion, "drains off . . . valuable energy which is directed towards [knowledge of] reality and which seeks by means of reality to satisfy wishes and needs as far as this is possible"[47] – ignores art's power to rejuvenate life by romanticizing it. Where common sense deadens, art's uncommon sense revitalizes. Without the energy to live – the energy repressed by common sense, incarcerated by special conformity – knowledge of reality is futile.

5

Dispensable Friends, Indispensable Ideologies

André Breton's Surrealism

SURREALISM has ripened into a burdensome, slightly blowsy cliché, mechanically used in much "new" art. Its manifestos have become all too official and academic; the movement has suffered more than most from popular success. Where abstract art derived from Cubism became boring through interminable refinement of the plane, representational art derived from Surrealism became boring by relying on a one-dimensional, overfamiliar, unrefined concept of the unconscious. Only attention to the combative, hypnotic personality of Surrealism's leader can restore our sense of the complexity and energy of its revolt. Today one turns to André Breton because he reminds us that art is a personal matter as much as an objective phenomenon; it is about the attaining of an attitude to life as much as the making of special, superior objects. If there is anything worth preserving in Surrealism, beyond the clichés of automatism and irrationality, it is the sense, epitomized by Breton, in which it regarded art as a way of establishing an identity in the world yet not of – rather, against – its daily drift. Art for Breton was a way of exploring the sources and resources of identity beyond those given in the ordinary world, which seem wildly inadequate to a sensitive appraisal of the self's possibilities. Dailiness is the reluctant starting part, revolt the "method" of creating "marvelous," "convulsive" beauty – of effecting that estrangement and bewilderment that is the necessary if not sufficient condition for the recovery of "psychic force." But the insecurity of the entire enterprise, the uncertainty of its results, is reflected in the tempestuous daily relations of Breton with his Surrealist group. Under his ministrations, the group itself became a perpetually vertiginous "forbidden zone," in which identity was an unstable *point de l'esprit* or *point sublime* for everyone but Breton. To explore the character of Breton's relations with his disciples is to recover the Surrealist sense of the absurd, enigmatic character of individual identity, which remains, as Breton himself did to his followers, a seductive ideal.

Victor Crastre describes Breton in 1924, age 28, having just produced the heroic first Surrealist manifesto, as already self-identified as "the Pope of

Surrealism!" The exclamation point conveys Crastre's astonishment at the aptness of the analogy, despite Breton's youth. "Spiritual authority emanated from his whole personality," Crastre continued. He had the "clear, . . . calm eyes of the thinker and of the poet lost in the interior dream." His whole bearing was calm, his gestures slow and deliberate, the unposed "attitudes of a pontiff. . . . But in the heat of a discussion all the violence of a storm was born in his glance and the blue of his pupils blackened like the water of a lake under a tempest."[1] Despite the partial mystification in this physiognomic reading of Breton, the point is clear: Breton had the hypnotic appeal of the self-important thinker who never doubted the truth of his ideas. He had a narcissism that was immune to the reproaches of self-criticism – he came to depend on the criticism of his enemies for the expansion of his conception of Surrealism, and to create them he regularly turned friends out of the Surrealist court. He had the aristocratic bearing of someone in sure command of hidden resources, entitled to a secret others could never fully share. This air of certainty gave him authority, and made it attractive to identify with him; he seemed personally, almost luridly magnetic, apart from the ideas he represented. It was as though they were so many scents to be picked up on the trail to the enigma of his personality. Yet they were substantial, and his identity as Pope – his infallibility – assured their dogmatic use, their subtle change from theory to ideology, from experimental to categorical. Breton's pontifical manner also assured revolt; those he had enchanted – converted – sooner or later had to attempt to recover their independent judgment, creativity, and private volition. But there was a paradox in their revolt against Breton, for it was he who had written, in 1926 in *Légitime Défense,* that "revolt alone is creative." Did revolt against him confirm this idea, or did it deny the principle of revolt for the sake of revolt? It was not clear whether revolt against him was a personal matter or an ideological matter, only that it was the sign of an identity crisis, as well as a crisis in creativity, in the rebel.

Many of the rebels against Breton were politically motivated. For them, the problem was not simply that his oppressive personality censored their free thought and creativity, but that they had outgrown Surrealism. They revolted not only because they could not grow in his shadow, but because they had a transformed conception of their creativity, and a new will to apply it realistically. Much as Auguste Comte had regarded religion and metaphysics as belonging to mankind's childhood, so these rebels came to regard Surrealism as a childish attempt to turn painful reality into pleasurable poetry – a naively utopian adventure. They preferred Marxist realism, as the philosophy and faith of maturity. They preferred the "positivism" and collectivism of Marxism to the negative individualism of Surrealism. They had gone beyond their own disillusionment and disaffection with the bourgeois world, and wanted now to change it. They came to view Surrealism as a first, inconclusive revolution; with Marxism they marched confidently, with authentic militancy. In a sense they were beyond art, at least as Breton understood it. They wanted social violence, not poetic license; concrete prosaic action, not fresh speculation on, and expressive formulation of, suffering. Breton, paradoxically, came to seem

bourgeois to them, for he appeared to embody the bourgeois world's worst trait in perverse form: an insufferable sense of its own rightness, a self-confidence that repressed all criticism. Breton may have regarded revolt as the ultimate criticism, but he had made it an *Art Moderne*. The political revolt against Breton was thus a call for proper action, an ethical response to his estheticization of revolt.

Even more perversely – to keep control in an increasingly uncontrollable situation – Breton welcomed and cultivated (to a point) the Marxist critique of Surrealism, for it forced Surrealism beyond its conventional borders. Breton was determined that it not be reduced to an esthetic insult to the obvious but become a truly comprehensive weltanschauung, in a way that Marxism – which according to him barely acknowledged psychological realities, reducing them entirely to social terms – could never be. The Marxists dismissed Surrealism; Breton encompassed Marxism. In fact, his attempt to synthesize Surrealism and Marxism foreshadows later attempts to synthesize psychoanalysis and Marxism. It has been cynically argued that Breton turned to Marxism to share in its power to convert the masses – Surrealism appealed only to individuals. But one could argue that Breton saw in the synthesis of Surrealism and Marxism the ground for a truly comprehensive, authentic human revolution, one that would restore unreduced experience of being – that exaltation inimical to any kind of reductive, "miserabilist" attitude.

Breton's personal relationships clearly had a conventional political aspect, but much more was at stake in them. He was determined to understand the role of intense personal relationships in the social contract, and the paradoxical role of personal revolt in sustaining it. Personal revolt, showing itself initially as the dissolution of these relationships, signified spontaneously chosen society – the voluntarily created rather than involuntarily endured social contract. Complex personal relationships are preliminary to, yet peculiarly inhibit, the lonely experience of pure surreality, which leaves behind the issue of human association. The intensely personal, Surrealist relationships with all the strains and utopianism implicit in them – relationships beyond ideology, yet inevitably relapsing into it – were a second-best measure, designed to replace the contractual relations of the bourgeois world with freer, more authentic ones. This idea is like the Buddhist belief in the necessity of caring for others before final individual enlightenment, and the freedom from the cycle of birth and rebirth which shows one to oneself as perpetually other, can be attained. The Surrealist personal relationship is difficult to sustain – inevitably it has its discontents, unhappiness, instability – but it must be seen as an attempt to repair the unhappy condition of personal relationships in conventional materialistic society. As a group movement, Surrealism was an attempt to find a revolutionary alternative to conventional social relationships in spiritual personal relationships, "elective affinities."

Such relationships inevitably collapse when they become self-conscious, i.e., when they acquire a conscious – ideological – rationale. Breton wanted human relationships to be surreal or unconscious in basis, which is partly why he encouraged revolt, which he thought is the most "expressive" or sponta-

neous manifestation of the unconscious. At the same time, he distinguished between kinds of revolt. The basis for the affinity the Surrealists felt with one another is their revolt against conventional social contract, their insistence on the unconscious basis of all authentic social relationships. Ultimately, personal revolt against Breton – their leader, and their symbol of the unconscious – implied the change from unconscious to the conscious, from the spontaneous to the ideological, and in Surrealist terms was regressive rather than progressive. The attitude toward Breton was necessarily ambivalent, because he represented the power and authority of the unconscious; ambivalence allowed for affinity in the first place, but eventually undermined it. Those who fell out of love with Breton – and love, for the Surrealists, is the "bringing together of two more or less distant realities" (Pierre Reverdy's description of the Surrealist image) – became positively everyday. They made a Marxist ethical commitment to everyday life, which means, from a Surrealist point of view, that they no longer experienced the alienation of the heterogeneous, its form as distance. Distance collapsed, as though it had never existed. There was no need to elect an affinity to overcome it; indeed, there was no spontaneity – personal unconscious power – to overcome it. The entire structure of alienation and the spontaneity that had (temporarily) eliminated it through love or affinity was replaced by a new positive sense of collective unity, i.e., the false consciousness of homogeneousness, which is potential in the Marxist version of the post-revolutionary world.

In "Sur la route de San Romano" ("On the road to San Romano"; in *Oubliés*, 1948), Breton wrote:

> The poetic embrace like the embrace of flesh
> While it lasts
> Protects against any glimpse of the misery of the world.

Breton wrote: " 'Transform the world,' said Marx; 'change life,' said Rimbaud: these two goals make only one for us."[2] One becomes a person by revolting against the conscious social contract – imposing rational, esthetic, and moral limitations on life – and recovering the unconscious, spontaneous roots of human being. Consciousness is misery, Breton seems to be saying; the state of unconsciousness that is poetic is as powerful as the state that is erotic in suspending our ordinary sense of the world, our inevitable unhappy involvement with it. The poetic like the erotic establishes another kind of social contract, establishes the basis for a sublime relationship, a sublime perception of the other. Indeed, the Surrealist *point de l'esprit* or *point sublime,* where opposites concur, is exemplified in the poetic love of elective affinity. Love is the spontaneous concurrence of opposites, the coming together of distant or alien human realities.

Of course, Breton himself never totally lost the control of consciousness, never altogether abandoned the conventional social contract, never completely fell in love, never established a truly elective affinity or absolute intimacy, never forgot limitations and alienation. He could not – by the very nature of what it meant to be an alienated artist, by the very fact that alienation was the

only way of assimilation in a world where the artist was, if not unwelcome, then not entirely at home, nor expected to be. He was the scapegoat token of the hidden heterogeneousness in everyone, even those who seemed most at home in the world because they were most homogeneous, who blended in because they unconditionally accepted the conventional social contract. Breton realized that contract encompassed and implicitly determined personal "contracts" on which the Surrealist group was built. I think much of the substance of his Marxism was based on this recognition. In what at times seems a Machiavellian way, he played along with both kinds of contract, which was ultrarealistic.

Breton's "very sinuous path" not only "passes through Heraclitus, Abelard, Eckhardt, Retz, Rousseau, Swift, Sade, Lewis, Arnim, Lautréamont, Engels, Jarry,"[3] but, even more intimately, through Jacques Vaché, Tristan Tzara, Philippe Soupault, Louis Aragon, Paul Eluard, René Crevel, Robert Desnos, Antonin Artaud, Pierre Naville, André Masson, Max Ernst. These, too, were living elective affinities that transformed the meaning of the dead social contract. There were many other spiritual ancestors, and many other disciple/friends, members not of a school or sect but of what Breton himself called a "set," understood as an "aggregation founded upon elective affinities."[4] Their multitude – Breton's pluralism – is in itself a sign of his ambivalence about affinity, the reluctance with which he accepts his own choices. These supposedly exemplary spiritual relationships were destroyed from within, by their very spiritual – unconscious, spontaneous – nature. Their profundity and transience were inseparable.

Breton repeatedly stated his belief in collaborative efforts, from his early experiments in the "*mise-en-commun des pensées*" ("pooling of thoughts") to his later insistence on "*la télé-poésie*" ("telepoetics") to create from "a group of individuals a *sur-moi positif*" ("a positive supra-self").[5] But the Surrealist *sur-moi* never became positive, not only because its "*mise-en-commun des pensées*" almost invariably had a content of negative thoughts (as in the exquisite corpses), but because its basic form was negative. This is shown by the most famous demonstration of Surrealist group sensibility, the so-called " '*époque des sommeils*' ['epoch of slumbers'], a veritable epidemic of hypnotic sleep, during which certain Surrealists . . . were immersed in a sea of dreams.'"[6] This already ironic group communion/communication – inherently ironic because the group forgot itself, did not know it was communicating, and existed as a group only in sleep, its members knowing their individuality only in the negative form of the dream – ended ironically when, at one seance, about ten Surrealists, led by Crevel, attempted mass suicide by hanging. (It was Crevel who in 1922 proposed hypnotic sleep to the group as a means of access to the marvelous; he committed suicide in 1935. He was the exemplary victim of the ideological group – of two groups, in fact, the Surrealists and the Communists, whose strained relations were enacted in his person. His self-destruction suggests the unresolvable self-contradiction each fell into in electing affinity with the other.) Another time Breton threatened Eluard with a knife.

The problem was that group efforts to achieve autonomy through "pure

psychic automatism," with its "absence of any control exerted by reason, outside of all esthetic and moral preoccupations" (as it was described in the *First Surrealist Manifesto, 1924*), led not to autonomy but to destructive group dynamics. Individuality came to exist only as the denial of the right of others to exist; it took only aggressive, negative form. Automatism, intended as a critique of the conventional, conscious social contract, became destructive of the possibility of any social contract, including the unconventional spontaneous personal one of Surrealism. Absolute automatist revolt became self-reflexive to the extent of becoming suicidal. Jacques Vaché was the classic example of its folly. It was Vaché who brandished a pistol, threatening to fire on the audience during the premiere of Guillaume Apollinaire's *Les Mamelles de Ti-résias: drama surréaliste* (June 24, 1917), presumably to show his dissatisfaction with the farce from which Surrealism later took its name. To shoot into a crowd became the exemplary Surrealist act for Breton, although he later repudiated such behavior when it became a terrorist cliché. It was Vaché also, with his notion of *"umour,"* defined as "a sense . . . of the theatrical uselessness (and joylessness) of everything,"[7] who ruthlessly prepared the way for automatism. Vaché's suicide in 1919 – his death was officially regarded as the result of an accidental overdose of opium – was regarded by Breton as a supreme example of "disengagement." The paradox is that Vaché did to himself what the war – Breton met Vaché when he was recovering from a war wound in the leg, later parading through the streets in a variety of military uniforms – did not. His demoralization by the war led to an insubordinate nihilism whose comic aspects could not protect him from himself, simply because he had become nothing but a rebel. Pure revolt finally meant revolt against the self, without which there was no point to life. Vaché's brief career, such as it was – and it would have been less than it was if it had not been immortalized by Breton to make a theoretical point – shows the destructiveness of revolt for its own sake.

The "full moment" of the "marvelous," of the complete commitment to the unconscious, may carry "within itself the negation of centuries of limping and broken history,"[8] but it turned out to be self-commitment to a madhouse. Most important, it turned out to be as collective an adventure as history, and perversely as full of "control" as any exerted by reason, with its own esthetics and morality expressed through "life-style." In fact, Surrealist "absence of any control" turned out to be submission to a more powerful, persistent control, a more dominant collective presence, than any conventional social contract would entail. Poetic and erotic violation of the social contract, which began with the violation of conventions of language and sexual behavior, and reached a climax with the attempt to overthrow the conventional idea that man was a kind of domesticated social animal (presumably the basis of civilization) – to achieve a total desocialization of man – unexpectedly showed that man was in the grip of unconscious collective conventions he could not violate with impunity. The Surrealists showed that to give oneself completely to these conventions was more personally devastating than to give oneself blindly to social conventions. Moreover, they showed, paradoxically, that the "freedom"

from social conventions that came with violation of them – freedom from conventional language and sexuality, a freedom to "feel" and experience in new ways – was nothing of the sort. It was rather a more profound slavery than any repression by convention, and the very tendency to violate convention was an instrument of enslavement to unconscious forces – a sign of the convention of violence or revolt that in a fundamental way structures the unconscious. The autonomy that one realized through revolt was a farce. Revolt against social conventions only tightened the chains of one's emotional bondage, made one all the more hostage to one's unconscious, which did not even turn out to be one's own – to be "personal."

The Surrealist group, then, came apart because of its own belief in revolt. The group itself, for all the elective affinities that constituted it, became a social contract that had to be violated, a convention that had to be "humorously" undermined. Surrealist revolt becomes poignant because its revolt becomes displaced; the world at large is no longer its target, its own group is. This "shrinkage" of target to oneself shows the result of sustaining negativity or criticality in pure form – as pure revolt. The myth of the possibility of totally changing oneself and the world turns out to be as specious as the idea that revolt is the only way to authentic individuality, which turns out to be corrupting and self-destructive. It assumes that individuality is separable from civilization, above the social contract. Not only are law and liberty only possible on the basis of social contract, as Thomas Hobbes wrote, but so is individuality, which is also a convention. This is a point of view more profoundly pessimistic and accurate than the Surrealist one, which assumes that individuality is rooted in the rebellion initiated by the unconscious. From a Hobbesian point of view individuality is an attempt to make the contract workable. Breton implicitly knew this, which is why he was repeatedly reformulating Surrealist individuality in terms of different groups and ideologies. He allowed complete experience of the absolutism and tyranny of the uncontrollable unconscious to others. He accepted the Dadaist recognition of the absurdity of a social contract perpetually collapsing in war – and the compensatory, simplistic Duchampian recognition that the work of art itself could be nothing but an ordinary object with which we had a personal "contract," i.e., an unconscious relationship or elective affinity – but he knew there was no real alternative to the conventional social contracts, and the deliberate effort to sustain it.

Breton repeatedly negated his spontaneous, "unconscious" individuality by returning, through Marxism and later occultism, to a rationalized, conscious, socialized Surrealism. Surrealism's group relations are caught up in this socialization of Surrealism, this demonstration that it is part of the universal social contract. Breton's perpetual purges and "regroupings" were an attempt to arrive at this universal, nonpartisan Surrealism. To dispense with the disciples associated with a particular manifestation of Surrealism was to further its universality. But this was not necessarily to popularize Surrealism, as Salvador Dali and others, who rationalized Surrealism by showing it to be a manipulation of commonplace meanings and thus a very social art, did. In

contrast, Breton showed that it could dissolve all kinds of systems of reason in its own primordial poetry, treating them as forms its own formlessness could feed off and temporarily adopt. This kept it subtly spontaneous and resistant or critical, and kept it from self-destruction by giving it an objective orientation. It was allowed its idealism as the critique of homogenizing realism.

Jean-Paul Sartre's assertion, in 1947, that Surrealism was "abstract and metaphysical, hence ineffective" and the Surrealists "parasites of the bourgeoisie they insulted,"[9] missed the point: the critical idealism of Surrealism. Just as Sartre argued that Surrealism was idealistic, "incapable of action when the moment came," so Theodor Adorno argued that Existentialism "remained in idealistic bonds" because of its emphasis on "spontaneity" as "the moment which the reigning practice will no longer tolerate."[10] But the possibility of idealistic spontaneity is just the point of Surrealism, which recognized that the social contract had lost its ideality if not its necessity (the lesson of World War I, the reason for Dadaist disgust, masking disappointment with ideals), and must now find a new home in the spontaneity of the alienated individual, who is radicalized by this very spontaneity into authentic heterogeneousness. The Surrealists rehabilitated the sense of the ideal that the Dadaists despised as treason against one's sense of reality. The Surrealists were restorationists, but in a mental, not a physical, sense. They were faith healers, while the Dadaists took what they thought was an already dead society – and art – and performed "miracles" with its carcass. Romantic infinity made fresh sense for the Surrealists as a perpetual reminder not only of continuing possibility but of unreduced experience. For them experience cannot be reduced to conventional terms, which is what saves it from becoming the basis for a new ideology, or appropriation by old ideologies. It is Surrealism that appropriates old intellectual and social conventions and dogmas and restores their experiential, spontaneous sense, making them sources of individuality.

To "codify" ideality and possibility Breton repeatedly spoke of the "chances for tomorrow," with the emphasis on "chances," which makes tomorrow less utopian. Belief in chances for tomorrow is part of that exaltation of reality that surreality enacts – part of Breton's rebuke against miserabilism, with its "depreciation of reality." "Chances for tomorrow" are the only way of opening the social contract. They are the ultimate criticism rising up from the unconscious against consciously conceived life. We must praise rather than despise Breton for his idealism, for it remains a concrete threat, however romantic, to the bureaucracy – the formalization and hardening of one particular social contract – that descends even upon revolutionary social contracts, as Adorno noted Sartre admitted of the Communists. We now recognize that Breton's progress through negativity is a positive process, not because it can be appropriated by the System but because it reminds the System of its insufficiency. His ideality is in this sense an accusation of insufficiency. The Surrealist group, then, never became a social system – could never be allowed to become one, which is why Breton was always changing its constitution, always showing it to be a group-in-process. If it had, it would have become sufficient unto itself, which would have meant it would forfeit its ideal of

heterogeneousness, and the possibility of spontaneity that is associated with it. The Surrealist group remained an ambiguous institution.

Breton cultivated disciples to the end of his life. His motives have been disputed, especially with regard to what Claude Mauriac called his "appreciation" – dare one say fetishization? – "of the new, of the young, of the revolutionary." Mauriac continued:

> Having been in the avant-garde, and having been unanimously recognized for its leader, he never stopped being afraid that he might be left behind. Whence his inconceivable indulgence in the face of the most frivolous attempts of an untalented youth, to whom he always tends to give credit, just because it is youth and because it claims to be revolutionary.[11]

Victor Crastre "contends that Breton's generosity to movements and persons which might have gone beyond Surrealism in some way" derives from his desire not "to lag behind in relation to some other current of thought," and is central to his Surrealist attitude.[12] But this generous Breton is past the peak of his self-definition, and looking for the renewal of lyrical revolt, or rather, "revolting" lyricism. This is Breton caught up in the ecstatic paradox of his position, the idealist in pursuit of the romantic infinite but also the realist in pursuit of political power, and so identifying with a possible constituency.

Instead, let us look more closely at the less generous, somewhat more particular Breton who excommunicated his former disciples, even assassinated their characters, preferring his place in history to respect for their personalities, for the individuality that Surrealism gave them. This is the Breton of the *Second Manifesto* (1929), who not only rejects all the "prophets" of Surrealism except for Lautréamont (John the Baptist to Breton's Christ) – including Poe, whose proto-Surrealist "chemical" conception of "pure imagination" he had praised in *Surrealism and Painting* (1928) – but who now (and in subsequent years) dismisses most of his colleagues as deserters and traitors. It is as though he is suffocated by his consciousness of his Surrealist colleagues, and must absent them to recover his unconscious spontaneity. In a self-conscious act of revolt he does violence to them, idealistically reconstructing his freedom. Breton was really much better at acts of "free hatred" than those of the "free love" he advocated. The refusal rather than acceptance of affinity really made of Breton a *"génie libre."* It was through elective hatred rather than through "mysterious, improbable, unique, confusing and indubitable" love that he made "progress toward the specific."

Thus, Max Gérard suffers from "congenital imbecility." Soupault, with whom he wrote the first truly Surrealist work, *Les Champs magnétiques* (The magnetic fields, 1921), is denounced " 'avec son agitation de rat qui fait le tour du ratodrome, dans les journaux de *chantage'* ['with his ratlike agitation circling the ratodrome, in the journals of blackmail']; [Roger] Vitrac, a 'véritable souillon des idées' ['a veritable scullion of ideas']; Jacques Baron, with his 'grâces de têtard' ['tadpole poises'], 'dans la forêt immense du surréalisme pauvre petit coucher de soleil sur une mare stagnante' ['in the immense forest

of surrealism a poor little sunset over a stagnant bay']; Naville, 'ce serpent boa de mauvaise mine' ['that foul-faced boa snake']; and others."[13] Naville, who had become a "militant Marxist dedicated to political action" and who in 1926 "denied the revolutionary efficacy of previous Surrealist activity," was accused by Breton of "realizing a selfish ambition by means of his father's fortune." This ad hominem attack hardly seems an adequate response to Naville's confrontation of Surrealist equivocation with a hard choice: "Either one believes that the liberation of the human mind is the most pressing concern and acts independently of Marxism, or one sees political revolution as the indispensable condition of all progress and embraces Communism unreservedly." For Naville, the second was the authentic choice. (Naville had previously caused Breton difficulty when, as one of the editors of La Révolution surréaliste, he had "denied the existence of Surrealist painting and so raised the crucial question of the possibility of a Surrealist art, pictorial or otherwise.")

Breton also quoted a newspaper account of Desnos' drunkenness, the same Desnos who was admired for his extraordinary susceptibility to hypnotic sleep and who was so profound a dreamer that he purported to have telepathic communication with Duchamp in New York. Breton described Artaud "comme on eût pu le voir . . . giflé dans un couloir d'hôtel par Pierre Unik, appeler à l'aide sa mère!" ("as one might have seen him . . . slapped by Pierre Unik in a hotel hallway, calling to his mother for help!"). Earlier, in 1926, as a result of one of the movement's self-examinations – in effect kangaroo courts held by Breton – Artaud, along with Soupault, was officially expelled for "the isolated pursuit of the stupid literary adventure." Desnos was also criticized for practicing bourgeois journalism. Later, in 1935, Breton slapped the Russian writer Ilya Ehrenberg several times in the face, responding to his assertion that the Surrealists, while claiming the heritage of Hegel and Marx and claiming to work for the Revolution, in fact "study pederasty and dreams," "study" implying participation. Breton even broke with his old friend Ernst for accepting the Grand Prize for Painting at the 1954 Venice Biennale, presumably putting money before principle. Breton himself had rejected the Grand Prize of the City of Paris in 1950.

Three other events are evidence of the depth of Breton's aggressive desire to determine what was thought of as authentic. He attempted to obliterate not only the individuality but the being of the inauthentic other. The first was the mock trial of Maurice Barrès for nationalism, a "crime against the soundness of the spirit" (May 13, 1921). Dadaistically, a wooden dummy represented the defendant and the Unknown Soldier appeared, speaking German. The second was the publication, on the occasion of Anatole France's death (1924), of Un Cadavre, denouncing France for his "stylistic perfection, common sense, 'génie français,' patriotism, a serene skepticism, and public honors from both Right and Left."[14] The third was the publication, in 1932, of Paillasse! (Fin de "l'Affaire Aragon") (What a mess! [end of the "Aragon affair"]), dealing with the complicated end of Breton's long relationship with Aragon, who, Breton and others felt, evasively and opportunistically became a Communist. Each event was not only a political action against a false prophet asking us to

reconcile ourselves with the existing society, or the utopian society to exist, but a critique of the psychology of a person implicitly claiming to be socially exemplary. For Breton, each had falsified Surrealism by identifying himself completely with society. They replaced its absorption in the unconscious with unconditional ideological commitment. This is why they were "liquidated."

The point is that in Breton's view Barrès, France, and Aragon failed as artists and thinkers because they never understood their pariah identities, instead proposing themselves as models of socially reconciled and so psychologically integrated selfhood. Their exemplary persons were meant to deny that there was anything eternally self-contradictory about existence. Paradoxically, this new wholeness meant that they had reduced themselves to signifiers of shopworn ideas. They were nothing but purveyors of empty abstractions; Breton's destructive depersonalization of them implicitly acknowledged this. Presumably beyond self-transformation, they saw no more need to transform the world. Hence their newfound "happiness" and public presence – their positive outlook. They did not really exist, so completely had they identified themselves with their outlook, so completely were they nothing but stable symbols. Thus they could no longer function as society's conscience, as radical individuality did. Their individuality was no longer a revolution of conscience, a realization of Marx's call for *"plus de conscience."* Breton thought Surrealism was a paradoxical way of creating conscience, for it was an attempt to exist completely poetically. Poetry from the unconscious calls attention to the insufficiency of conscience in society about the mental state in which existence is conventionally lived. This is Breton's radical social criticism, an antidote to the hypocritical inner harmony of officially great men.

Barrès, France, Aragon each tried hard to be homogeneous, an "ideal" unit of homogeneousness. They had forgotten that the critical task of the modern thinker and artist was to become the pariah who embodied heterogeneousness, an act of dissent in itself. Elisabeth Lenk describes the pariah as follows:

> Pariahs, like all people compelled to become members of a community, have no other choice but to share the values of the society which despises them, which considers them unclean and thereby excludes them from the in-group. Here are the origins of their self-contempt, their self-hatred. A process which takes place among everyone in homogeneous society is particularly apparent among pariahs: in order to gain approval everyone must hate the heterogeneous *per se,* or at least renounce it vigorously. ... This is what Hegel called 'bloodless annihilation.' The individual – viewed from without – does not perish. One need only give up one's heterogeneousness to be spared that tragic end.[15]

Breton's predicament was to retain his heterogeneousness in the face of intense efforts to assimilate him, whether into bourgeois society or into Marxist-sanctioned Revolution. In a sense, his contempt for his associates, his hatreds and purges and calculated irreverence toward all persons who came too close to him, attempting to turn Surrealism into an in-group of intimates, as well as his uneasiness with and eventual break with the Communist Party, were

all part of a vigorous attempt to maintain his heterogeneousness. He reaffirmed himself as a tragic pariah by publicly indulging in socially disapproved, unclean, despicable behavior and language, usually kept private in unspoken thoughts. Breton broke the code about the truly ineffable, the heterogeneous which at all costs is usually repressed in order to maintain the conventional social contract that gives the illusion of harmonious homogeneousness. Breton's personal attacks were revolts against the homogeneous, all the more intense because they were mostly against former Surrealists whose newfound social conventionality indicated abandonment of the project of becoming a pariah, articulating inherently unassimilable heterogeneousness.

Clifford Browder observed that one of the reasons Breton broke with Dadaism, "the arch foe of convention," was that it was becoming conventionalized, "stereotyped: its scandal, once familiar, amused more than it shocked." Dadaism's assimilation became self-evident with the appearance of Jacques Rivière's article in the August 1, 1920, *Nouvelle Revue Française* taking it seriously, thus "marking the end of the general hostility and a first step toward literary consecration. Under such circumstances the movement could not continue to thrive on gratuitous scandal." Breton and Aragon "felt it was time to adopt new tactics . . . thenceforth the group was threatened by its own dissensions."[16] Breton was determined to find a new strategy of heterogeneousness. Group dissension was a reserve strategy, to be used whenever the group itself threatened to become homogeneous, conformist, whether because of outside pressure or its own inertia. Soupault remarked that the Dadaists "were a group of friends who wanted to do something scandalous . . . against the academies."[17] When the Surrealists were about to become an academy they had to do something scandalous against themselves, to prevent the process. What better way than to go to the brink of dissolution?

Conventional group conflict – the latest group scandal – came to be crucial for Surrealism as a way of renewing faith in surreality, the living sign of the heterogeneous. It was also a traditional romantic idea, a radicalization of "difference." Surrealism unexpectedly turned out to be a revival movement, resurrecting an obsolete concept as the basis for a new individualism, dressed in modern clothes and used to make a modern point. Despite the best efforts to homogenize or master existence the heterogeneous is there all along; it must be archaeologically excavated from the unconscious. Surrealism symbolized a virulent new strain of the heterogeneous – the unconscious – in hypocritically and self-consciously homogeneous society. Surrealist group dissension implied dissent from the very idea of the group, the elementary social unit, for the group automatically meant assimilation, homogeneousness. The group meant the stereotyping of identity, which for Breton truly existed spontaneously only in the feeling of solitude that was the most precious – purest – form of the heterogeneous. He renewed this solitude through his conflicts within the elective affinity, his apocalyptic relations with the Surrealist group.

Pariah consciousness inevitably leads to a sense of radicality, or radical self-belief. Lenk continues:

For the pariah, there are only two possibilities: either a radical self-renunciation – the impure ones must permanently subject themselves to purification rituals; only then can they succeed in rising fairly high within the homogeneous social hierarchy – or a return to disavowed heterogeneousness, a rebirth of the (disavowed) convictions – the development of pariah consciousness. As a result of the latter choice, the pariah either begins a radical questioning of the values of the society which has devalued the pariah's 'otherness,' or the values are inverted in a manner distinctly characteristic of the pariah. To the degree to which pariahs have developed religions, Weber maintained, they are inclined to regard themselves and those like them as an elite class and to ascribe a nobler origin to themselves. A good example of this is the 'elite consciousness' of the Gnostics, who characterized themselves as sons and daughters of the king of an invisible realm who have fallen into the world as the chosen people of another, unknown god.[18]

Breton may have been a Pope within the Surrealist group, but in his radical questioning of the social contract that devalued unconscious otherness he acted like a pariah. He also turned Surrealism into a pariah, elitist religion. Indeed, he became sufficiently and explicitly gnostic or occult to believe that "above man in the scale of animals there may exist beings whose behavior is as foreign to him as his own is to the creatures below him – beings, indeed, whose very existence may escape his sense perception."[19] For Breton, art was the alchemical magic of the pariah, a way at once of maintaining personal pariah consciousness of heterogeneousness and of slipping it into society. Or rather, of subtly reminding society of the inherent heterogeneousness of its members, liable to break out epidemically at any moment – in a poetic or erotic moment that spontaneously becomes political, i.e., a revolutionary act. At the same time, art became Breton's way of rising high in the homogeneous social hierarchy. He lived long enough to see Surrealism become a matter, as he notes, for "school books" – academic – which is partly why he was so generous to the young; Surrealism's self-conscious pariah character could give substance to their unconscious pariah feelings, and they could revitalize it with their poetic and erotic uncertainty, the source of those feelings. It is also why violent dissension became a purification ritual for Breton; as long as it was violent and unsettled Surrealism could never become completely academic.

Revolt for revolt's sake became his credo, a tautologization of revolt – a reduction of it to nothing but revolt – which simultaneously stereotypes it once and for all, assimilating it as a caricature of itself, but also declares it the destined way of authentic autonomy. Revolt against the group is the profane form of sacred violence, affirming the internal necessity of eternal heterogeneousness. Breton's shamanistic violence is a "theatrical performance in which one actor plays all the roles at once."[20] He is both heterogeneous victim of homogeneous society, and homogeneous society reconciling itself with heterogeneousness in symbolic, individualized form. It is a ritual violence with

a fixed rhythm of elective dissension and elective reconciliation, making Breton a social system in himself, with all the contradictions of the larger social system. Revolt makes him a microcosm of the macrocosm. Thus the truth of Lenk's assertion that

> Pariah consciousness can only remain intact – or even come into being, for that matter – when a pariah has achieved some measure of individual upward mobility within homogeneous society. Clinging to their pariah status seems to be the only means available for protecting the personality in the contradictory situation in which pariahs, who have risen in a hostile society, find themselves.[21]

Breton rose in a hostile society because he embodied the secret feeling of being a pariah in the individual unconscious of all of society's members – the repressed feeling of heterogeneousness that he expressed. But he also rose because of his hostility to his disciples, which made society think he had authority. The Surrealist group had the same authoritarian hierarchical system of subordination as society as a whole, for all the attempts to avoid such a negative system through the achievement of a *sur-moi positif,* elective affinities. Breton thus perversely rose above the fracas, taking his place in society's leadership class. He liberated heterogeneousness by conceiving it to be a poetic embrace that transforms its everyday object – revealing that object's secret heterogeneousness. That made Surrealism redemptive of the everyday, made the conventional tolerable; Surrealism thus proved useful to the controlling class. Breton was allowed admission to it because he showed, in his person, leadership to be "vital." But he kept alive his autonomy by homogenizing his enemies, as well as society.

Breton's isolation was profounder than he knew. For it had to do with his own tragicomic assimilation as a utopian ornament of society, and his own convulsive, yet peculiarly conventional efforts – for his revolt mimicked the violence of the society it reflected – to maintain his integrity. Ultimately he could not find the alternative to both standard revolt and standard society, standardized heterogeneousness and thoroughly conventionalized society – he could not find the durable, willed friendship, the unstandardized I–Thou relationship, with its suspension of standardized, rolelike behavior. Elective affinity is not friendship; it is blind transference, whether negative or positive. It involves neither master nor disciple, consciously or unconsciously. Above all, this had to do with his failure to understand personal relationship, for all that he knew about authentic selfhood. The irony of Breton is that he understood homogeneous society better than it understood itself, but he hardly understood himself. He saw the rot in conventional society, and the rot in his disciples who wanted to pass for conventional, and he understood that rot to be the living form of the homogeneous. He also understood rot perversely: as paradoxically purgative of the very homogeneousness it seems to signal, preparing the way for the heterogeneous without guaranteeing it. But he did not understand the rot in himself – his lack of need for an I–Thou relationship, which is, ironically, the most radical form of heterogeneousness or individ-

uality there is, for it is relationship without rules. In Breton rot took the form of a need for disciples, which shows after all how homogeneous Breton was – how much he was like every other ideologue. Even disciples trivialized, pulverized, thrown out of court, have their value as shadows of the conventional self.

6

Choosing Psychosis
Max Ernst's Artificial Hallucinations

Who knows if we are not preparing ourselves in this manner to escape someday from the principle of identity?

André Breton, Preface to the catalogue for the
Max Ernst Exhibition, 1921

MAX ERNST's debt to psychoanalysis is well known. Elizabeth M. Legge has documented the direct connection of many major works to Freud's ideas, especially during 1921–24, the formative years of Surrealism, and the years of Ernst's closest association with André Breton, the mentor of the movement. Indeed, she has shown that some of these works can be regarded as conscientious illustrations of Freud's ideas. Not only is *Oedipus Rex*, 1922, an ingenious transcription of the Oedipus complex, but, less obviously, *Two Children Are Threatened by a Nightingale*, 1924, is heavily dependent on Freud's "Fragment of an Analysis of a Case of Hysteria," 1901, the Dora case.[1] Ernst, a student of psychology and psychiatry at the University of Bonn, first read Freud in 1911. While he later expressed aversion to the reductive psychoanalytic treatment of his art, he never denied its psychoanalytic premises and connotations. His notion of "collage-painting," a cryptic aggregation of incommensurate images – a visionary riddle – reconceives the visual work of art as the simulated manifest content of a dream, that is, a mock representation of inner rather than outer reality.

Moreover, as Legge points out, psychoanalytic understanding became a weapon in Ernst's rebellion against his authoritarian father, a stern disciplinarian and amateur artist, with a strong sense of both artistic and social propriety. Ernst's art, in its first phase, can be regarded as an attempt to "consume Sir Father . . . slice by slice";[2] psychoanalysis was the knife. Ernst generalized his personal problem into a social problem. Correlatively, he exaggerated the liberating power of psychoanalysis; it became the philosopher's stone solving all problems. World War I was the major object of his youthful discontent and scorn; to Ernst, it was fought for a dubious honor, that of the father. He held his father, and his father's generation, directly responsible for the war:

76

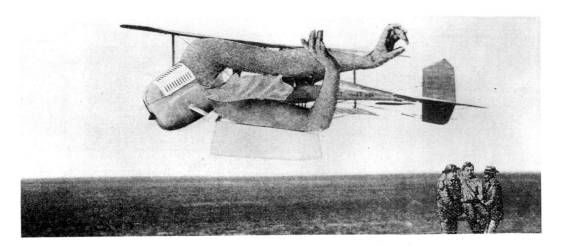

Figure 5. Max Ernst, *Untitled* (formerly *L'Avionne meurtrière*) (1920). Cut photo-offset reproductions mounted on paper. 2⅜ × 5¾ in. Photograph by Allan Mewbourn. Courtesy of the Menil Collection, Houston.

authoritarian father and authoritarian society converged in his mind. His father's tyrannical enforcement of social conformity proved their collusion. Ernst's art was in large part an expression of defiant, vengeful rage at the hypocrisy of personal respectability, which masked malevolent social tyranny.

Conformity betrays youth's sense of possibility, and war is the instrument of conformity, for it teaches discipline, in effect repressing the sense of possibility, which gives one the feeling of being eternally young. Even more crushingly, war is a real lesson in life, for it is an education in death, where all conform – all are "uniform." War is the ultimate means by which the fathers break their sons' will to live, betraying and wasting their substance. Ernst's art was psychological warfare in response to the social warfare created by the fathers to destroy their sons. Personally, his art restored his will to live after it was all but destroyed by World War I, which made him feel literally dead, one among many anonymous living dead[3] (Figure 5). Psychoanalysis was the ultimate weapon in his artistic war to the emotional death with his father and his father's society. Ernst took psychoanalysis out of the clinical situation, with its benign therapeutic intention, and used it to do violence – criticize, with absolute contempt – to violent society. He used it to violate a society that had violated him and his generation, to devour intellectually and emotionally the fathers who had literally devoured him and his generation – sacrificed the flower of their youth on the altar of power.

Thus, Ernst used psychoanalysis to make an art that was at once a kind of self-analysis and social analysis. He was the first artist-analyst; through his psychoanalytic art he attempted to free himself of his miserable personal and social past – his participation in World War I completed his upbringing by giving him a strong sense of reality – and confront society with the devastating

77

truth about itself, smashing through its hypocrisy, that is, its disavowal of its own reality. But he did not think that his artistic form of psychoanalytic confrontation would free society; no amount of psychological truth, in whatever form, could make it free. It was a hopeless case; for Ernst, the problem was to free one's own life, not society – to emotionally separate, as much as possible, one's own life from the stultifying life of society, that is, to live a kind of life that is different from everyday life. Ernst knew that society and the individual are inextricably entangled, even in conflict; but he also thought the power of the one existed in inverse proportion to the power of the other. Thus, the more power society had over the individual, the less power the individual had over and for himself, and vice versa. By resisting society, whether artistically and/or intellectually, one gained power for oneself, if not literally destroying society's power. In a sense, Ernst had to attack society – if only symbolically, that is, in and through art – for the attack was a way of emotionally distancing or extricating himself from society. The mental act of aggressive distancing was self-affirmative and gave Ernst a sense of personal freedom and artistic power.

Ernst attempted to subvert both society and his father – a tautology, for his father embodied society for him – by demonstrating the split between their respectable appearance and oppressive reality. He attempted to show them up artistically and psychoanalytically by disruptively scrambling their appearances and corrosively symbolizing their sordid character. Thus, he used a psychoanalytically informed art to tyrannize over the tyrant, to castrate the castrator – to gain an advantage over those who had put him at a disadvantage. He wanted neither his father nor society to be able to save face after being unmasked by him. Irritated beyond endurance and finally irreparably wounded and stripped of authority by being spitefully psychoanalyzed in a sardonic art, they could no longer harm him personally, and lost all influence on his life. In general, Ernst was less a social than a personal revolutionary; he did not want to radically transform society, but himself. Beyond self-repair, making no effort at self-healing, post–World War I society, Ernst thought, was utterly detestable. (A decade later Surrealism would endorse Communism as a means to social health.) But Ernst used psychoanalysis constructively as well as destructively, if always magically, that is, wishfully and artistically. While performing his psychoanalytic vivisection of his father and society, Ernst cleansed – restored – himself by immersion in the unconscious depths psychoanalysis discovered. For him, to simulate unconsciousness was baptism in the waters of new life and new art while also a way of partially blinding himself to his murderous intention.

But the task I have set myself is not to review the already well-known facts of Ernst's complex commitment to a psychoanalytic outlook. Instead, I want to deal with the one problem that remains in the interpretation of his art, namely, to understand the psychoanalytic import of its hallucinatory method. It is a problem more difficult than any associated with deciphering the riddles of Ernst's psychoiconography. A depth psychological interpretation of Ernst's consistent advocacy of a hallucinatory method of making art – his use of

frottage and grattage to create a seductively indeterminate, "irritating" surface or screen on (or rather in and through) which irrational images can appear – has not been made. Ernst's hallucinatory method has been accepted at face value as a means to the end of producing irrational imagery. It is the irrational imagery that has been interpreted, not the hallucinatory method, which involves mental submergence in – emotional submission to – unintelligible material, as happens in the use of frottage and grattage. That is, raw material had a psychological valence, one might say a psychological slipperiness, for Ernst; it was never neutrally – matter-of-factly – given. (If it was, it would be artistically insignificant; i.e., it could never catalyze images.) The imagery is latently intelligible, but the material is through and through unintelligible – chaotic. It catalyzes particular hallucinations, but it is itself generally – one might say generically – hallucinatory. More specifically, Ernst uses raw material as a hallucinatory matrix from which particular hallucinations spontaneously emerge and appear and in which they spontaneously submerge and disappear. These highly mutable images come and go, but the hallucinatory matrix that is their *fons et origo* remains. I submit that Ernst valued this hallucinatory matrix – this material unintelligibility, this vital chaos, this unmanageable fluid substance – more than any of the many images that emerged from and reflected it, echoing and symbolizing its qualities. The usual thinking about Ernst is that he used his hallucinatory method simply as a way of generating images, which were presumably what he was most interested in, as an artist and because by interpreting them he could learn about the current state of his psyche. But as his writings indicate, he valued the hallucinatory state as such;[4] he was interested in hallucinatory experience in and for itself. Only in a hallucinatory state did he feel completely alive, with no wish to apologize for the feeling. Hallucinatory contact with the material matrix was profoundly wish-fulfilling for him. It was a return to primordiality: it gave one the sensation of having just been born, and as such of being fresh with incalculable becoming. In the last analysis Ernst's art is the means by which he attempted to return to and lose himself in the hallucinatory matrix – dissolve in its raw unintelligibility, as though his existence was just another hallucination.

Another way of understanding what is ultimately at stake in Ernst's art – psychotic regression to the chaotic flux of psychic being – can be understood in terms of Surrealism's didactic, even dogmatic use of Leonardo da Vinci's "method" of making art. Leonardo, as Breton wrote, "taught . . . that one should allow one's attention to become absorbed in the contemplation of streaks of dried spittle or the surface of an old wall until the eye is able to distinguish an *alternative* world."[5] Breton regards the Surrealist method of generating images by way of frottage and grattage – "a recipe *within everybody's grasp*" – as perfecting "Leonardo's paranoiac ancient wall."[6] In *Beyond Painting,* Ernst himself quotes the two paragraphs in Leonardo's *Treatise on Painting* in which he argues that "the painter's genius can turn to good account" contemplation of "the spots on walls, certain aspects of ashes on the hearth, of clouds or streams," awakening to "new inventions in these indistinct things."[7] In my

opinion Ernst was more interested in the indistinct things on Leonardo's par-
anoiac ancient wall than in turning them to good artistic account, that is, using
them to compose novel pictures. Ernst was fascinated – completely seduced
– by indistinctness. He did not want to make clear and distinct things out of
the chaos of indistinct – unintelligible, inarticulate, inchoate – things but rather
to return clear and distinct things to obscurity and indistinctness. He wanted
to sink into indistinctness, in a total hallucinatory state. Such a state in fact
simultaneously realizes and articulates such raw indistinctness – chaotic, un-
intelligible flux. Ernst's artificial hallucinations were his means of pushing
toward this goal. Leonardo's wall represents the fundament and "origin" of
psychic being; Ernst wanted to reach it, in all its elusiveness, and merge with
it, to become elusive himself.

Leonardo's visionary wall represents the supreme hallucinatory state, on
whose foundation are built the secondary hallucinations created by accom-
plishing the official Surrealist task of bringing "two distinct realities"[8] together
to create a visual contradiction – a self-contradictory image. That unintelligible
joining of the unjoinable, or in Ernst's famous words, "the fortuitous encounter
of two distant realities on an unfamiliar plane"[9] – fortuitousness signals the
unintelligibility of the contradiction that results from the encounter – is possible
only because the original hallucinatory matrix is inherently unintelligible. In
contrast, the Surrealist contradiction is an artificial, contrived unintelligibility,
if a manifestation and mediation of the primordial unintelligibility or chaotic
flux. The Surrealist contradiction is a secondary, constructed unintelligibility,
whereas materially raw frottage and grattage – Leonardo's wall redivivus – is
directly experienced, primary unintelligibility. The one is the unintelligibility
of disjunction of recognizable parts, the other the unintelligibility of chaotic
flux in which there are no parts, no structure. The one signals the other, and
is derivative from it, but looks very different than it: standing to it as refined
stands to raw material, the formed – however incoherently – to the formless,
beyond coherence and incoherence.

Thus, the illogic of the strange encounter is not that of the raw hallucinatory
material, which in a sense is more alogical than illogical. The distinct or distant
realities emerge from the raw material of the paranoic wall and immediately
fall into conflict or contradiction, like Myrmidons rising from the earth. The
aesthetic novelty of the Surrealist contradiction has been much interpreted and
celebrated; I want to celebrate the power of the chaotic flux, the raw hallu-
cinatory material, and analyze its psychological function for Ernst. It is more
than the passive substratum of the self-contradictory Surrealist hallucination,
the theoretical ground of its possibility. Indeed, it is so powerful – dynamic
– that the Surrealist contradiction can be said to be a defense against it, even
while functioning as its symbolic form – as much of a symbolic form as it can
be given. Ernst wants to destroy this defense – deconstruct the Surrealist
contradiction, just as its irrationality can be regarded as a deconstruction of
ordinary appearances – and let himself be overrun by the chaotic flux, becoming
a total hallucinatory being.

As is well known, Surrealism in general aims at hallucination, that is, "the

breaking down of barriers between the real and the imagined," in Legge's words.[10] Dali proposed that this be accomplished by what he called the "paranoid-critical method" – after the fact, as Ernst reminds us, of his own invention of it. In my opinion only in Ernst's art does Surrealism realize, in a sustained way, its ambition of becoming "a hallucinating succession of contradictory images."[11] This is because Ernst regularly recurs to the chaotic flux of material unintelligibility, like Antaeus gaining strength from renewed contact with the earthly fundament. Ernst's images reveal the brokenness or fragmentation that is a quality of such chaos; traces of its material indeterminacy cling to them. A comparison of Dali and Ernst is instructive on this point. Dali's images are less paradoxical – self-contradictory – and thus have less hallucinatory effect than Ernst's. In part this is because they transcend their material origins in raw paint, so slickly applied by Dali as to become invisible. There are few signs of material process in Dali. In general, his images are all too carefully constructed; they lack the thrown-together look – signaling unintelligibility as much as raw material does – of Ernst's images. That is, Dali tends to harmoniously unite what Ernst leaves in an irreducible contradictory state. Dali makes a contradiction that is all too readily readable – intelligible, interpretable. Ernst's images remain peculiarly unanalyzable, even seem to lead us away from analyzing them. Their meaning never seems self-evident, making them more enigmatic than Dali's images. Dali creates a pictorial contradiction as slick as his paint, while Ernst's pictorial contradiction has a stark look. In sum, Dali creates a self-sufficient picture, which transcends its materiality and smoothly bridges the distance between the distant realities it represents. The distance between them is in effect closed by the same technical shrewdness that disavows the picture's materiality. This is why Dali's images quickly lose their uncanniness – their edge of irritability, that is, in Ernst's words, their power to "intensify the irritability of the mental faculties" – and end up looking like stage sets. Ernst's images also have a staged look – especially those not materially grounded in frottage or grattage – but their theatricality subserves the sense of self-contradiction – unintelligibility – rather than functions to create a sense of intelligibility.

In general, Ernst's union of opposite realities is unhappy – hardly a binding union. In Ernst's imagery, the sense of opposition – distance – between the parts is quite strong. Such absolute contradictoriness – absolutized "split consciousness," as it were – is the sign of a genuine hallucinatory image. To interpret this permanently split or contradictory state of Ernst's images in sexual and alchemical terms, as he suggests we do, is to foreclose its meaning. I doubt that Ernst understood the full import of his images. In general, his art's supposed sexual and alchemical meanings are a fig leaf on – rationalization of – the deep disturbance of which the absolute contradictoriness is symptomatic. This persistent contradictoriness – irresolution – indicates Ernst's lack of decisive identity or integral selfhood. Ernst's art, and by extension Ernst, articulates an identity crisis; its self-conscious, irreducible contradictoriness is symptomatic of a deep narcissistic pathology. This pathology is the enigmatic core of Surrealism. Surrealist mystery results from the absence of any integral

core to the picture and, by extension, to the self – the artist's existence in a seemingly permanently broken-down, split, and completely contradictory state. If Ernst is an indication, Surrealism articulates the difficulty of achieving an integral sense of self. More importantly, it articulates the (not so) unconscious unwillingness to be integrated. Not to have a clear and distinct sense of self is not to have a world – not to be in or belong to a world. This state is the profound wish latent in Ernst's art.

Ernst brings together, on one pictorial plane, realities that remain discontinuous and incongruous even as they exist simultaneously in the same space. Their spatial continuity suggests that they are parts of the same reality, a "higher" reality than that of the parts, while their discrepancy suggests the fragmented character of this reality. If, as Ernst himself has said, his collage-paintings are psychic self-portraits, then he represents himself in a state of unwhole(some)ness or incomplete identity, if not complete identitylessness (ironical selflessness). He seems to have successfully escaped from the principle of identity – the ultimate Surrealist ambition – to allude to the Breton epigraph to this chapter, written on the occasion of Ernst's first Paris exhibition. His work suggests incurable narcissistic disturbance, but he experienced such pathology, his loss of identity and/or selfhood, as liberating. His work reveals a quasi-psychotic state of seemingly irreparable disintegration, insurmountable splitting, but psychosis was happiness for him. What can we make of this strange attitude, which welcomes pathology as health, all the while denying that it has confused the two?

Splitting, as is well known, is a basic mechanism of the ego, allowing it, as Hanna Segal has written, "to emerge out of chaos and to order its experience."[12] Apart from the fundamental affective (expressive) splitting of the object into good and bad parts – splitting the object gives one power over it, while at the same time acknowledging identification with it, that is, its power over one – there is the splitting that occurs in all cognitive discrimination. This involves perceptual splitting of the object into figure and ground, the first step in its regulation and mastery through analysis, and correlatively, the conceptual splitting of the self into emotion and intellect (expression and reflection), the start of self-regulation and self-mastery. Affective splitting and cognitive splitting are in fact inseparable, for figure and ground as well as emotion and intellect are experienced as ambivalently bad and good. They oscillate in affective/expressive tone. In any case, the paradox of splitting is that while it seems inherently pathological in character, it is in fact psychically necessary for survival – for world control and self-control – and thus healthy. Splitting sets up the boundaries necessary for psychic and social survival; but when out of control, splitting produces too many boundaries, blocking the spontaneity that can surge across them, creating a sense of wholeness of being. More precisely, one can say that splitting is healthy when it is the means to a new whole(some)ness of self or of things, that is, when it is the "analysis" that precedes synthesis, the disintegration propaedeutic to "higher" integration. Thus, when disintegrative splitting is part of a dialectical process of re-integration, it can be said to be healthy, necessary to life. When splitting is

undialectical, when the psyche becomes bogged down in splitting, even enamored of the splits that constitute it – "enamored" is not too strong a word to describe Ernst's obsession with splitting, divisiveness, disintegration, and his fascination with chaos (the original hallucinatory material) – when it seems impossible to perceive and conceive the self and the object as fresh, new, whole(some) realities, then splitting can be said to have the hyperbole of pathology.

Ernst liberates splitting from any dialectical, integrative process, making it an end in itself; it becomes an uncontrollable sorcerer's apprentice, not just an aesthetic means of Ernst's art, but a compulsively repeated goal. Ernst uses splitting to debunk or discredit the integrity of the everyday object and the respectable, conforming self. That is, he splits – breaks – them "open" to show that inwardly they have no integrity (unity), that they are not held together by much, that their existence is precarious, in effect a lie, making them a pushover, easily pulverized. He thus demonstrates objects' pretentiousness and hypocrisy, undermines their legitimacy and authority, and frees us from the need and wish to be like or identify with them, to "con-form" as they do, to lead the life they lead. Relentlessly hammered home, with no sense of an alternative integrity, splitting is out of control in Ernst's art and thus self-defeating. He compulsively repeats splitting, in effect absolutizing it; self-contradictoriness seems fated in his art, suggesting the pathological character of its unintelligibility.

If splitting is a primitive defense, then what does it defend against for Ernst? James S. Grotstein points out that "psychotic defenses . . . are aimed at the annihilation of experience and the capacity to experience; thus, there is no postponement to the future but rather an eradication of the past and the future through the mechanisms of disavowal, negation, or negative hallucination." Psychotic splitting is "very costly to self-cohesiveness"; ultimately, it promotes a state of "mindlessness," that is, seemingly irreversible regression to infantilism.[13] Splitting is Ernst's way of forgetting – the relentlessness of splitting in Ernst's art indicates the desperateness of his need to forget. Indeed, it is a Sisyphean way of forgetting: over and over again Ernst splits appearances, creating irreal images that evoke primordial chaos, in which there is total forgetfulness, more total than in the unintelligible, self-contradictory images – total loss of reality. Ernst's hallucinatory contradictoriness is a demonstration of mindlessness, or rather an attempt to reach a state of complete mindlessness. It is his ultimate defense against the reality of the world – a defense by way of total obliteration of it. In and through his simulated hallucinations Ernst repeatedly and convulsively discards his mind so that it cannot and need not know reality. It of course boomerangs back to him, for he continues to "mind" his art, that is, to make his irreal images with ever more sophisticated chaos. Artificial hallucinations are his way of keeping bad thoughts about the world away. They are a massive denial of reality – a grandiose attempt to revoke it by destroying the capacity for experiencing it. Ernst's irreal images are a fabulous experiment in simulated psychotic withdrawal from reality to a state of absolute hallucinatory existence verging on chaos. As such, they are a

horrendous display of infantile omnipotence – an attempt to demonstrate the power of wish over reality.

Ernst's heroic effort to submerge his mind in a simulation of Leonardo's paranoiac wall – it is a recurrent effort in modern art, perhaps most successfully if all too elegantly realized in Pollock's allover paintings – expresses his loathing of and disgust with the reality of his father's world. He was willing to risk complete psychotic dissociation – self-dissolution – to escape from this world, to free himself of its power over his inner life. In a sense, Ernst's artistic use of the quasi-psychotic hallucinatory state to accomplish this psychic task shows the extent of his desperation. He was willing to risk his sanity – his hold on reality – to purge himself of a single internal object, which had grown into a whole internal world. In my opinion it was only because Ernst put hallucination to an artistic use – because he continued to make art – that he did not become completely psychotic. He was, as it were, incompletely psychotic. In my opinion his deliberate simulation of hallucination was simultaneously an acknowledgment of and attempt to control an experienced hallucinatory state of near mindlessness. Only art making permitted him to continue to have a mind.

Epistemologically speaking, it is as though Ernst, in his attempt to realize the Surrealist task of articulating inner reality and giving it complete dominance over external reality, realized that this task made one mindless, or that one had to be in a mindless state to realize it. All that is left of mind is compulsive and convulsive paradoxicality – the primitive tendency to see everything in oppositional terms, to split everything into irreconcilable opposites – such as exists in hallucination. It is the quasi-orgasmic – self-disruptive and world-destructive – convulsiveness that Breton said was the only beauty. Ernst came close to experiencing the hallucinatory fundament of mind. He realized that, at bottom, mind is disorganized, unstructured. It can best be described as a chaotic flux of sensorimotor material – such as is embodied in frottage and grattage. Emotionally speaking, through hallucination Ernst withdraws from the world of his father and the traumatic reality of World War I. Only by a calculated artistic psychosis could such withdrawal be effected – could the connection to the old reality be cut. (By withdrawing from – negating – that reality he also counteracts its negation of him. It, rather than he, becomes as though nothing.) It is possible that Ernst means such psychosis to be *the* dialectical means of rebirth, of generating a new self and world – a whole new reality. But it is not clear that psychosis can effect such a revolutionary change in the sense of reality. Certainly the same old reality continues to exist when one recovers one's senses, that is, from one's sense of – encounter with – unreality. The only new reality Ernst creates is that of his art – his simulated hallucinations, his "visions."

Ernst's ability to create his hallucinations, in an incredibly sustained way, suggests that he was at home in the psychotic core of his self. (Is this the privilege of the true artist: to regress to unreality without completely losing his sense of self and use that unreality to make progress in art – if not life – indeed, to make a psychologically "progressive" art?) Ernst's art can be re-

84

garded as a risky adventure in the psychotic core, in an attempt at self-healing correlate with an attempt to free art from its traditional commitment to represent pathological reality. Art must now represent unreality – live by the principle of unreality rather than reality, non-identity rather than identity. There is thus a kind of mithridatism to Ernst's artistic effort: if he can artistically assimilate the psychotic pathology of the world – its inhumaneness, or indifference to, even hatred of human reality, as evidenced in war – he can free himself from personal psychotic pathology. That Ernst was willing to undertake such an adventure, in which he risked the possibility of complete self-loss, that is, hallucinatory, quasi-mystical recognition and experience of the unreality of the self – even when the adventure is undertaken in a playful (simulated) spirit – is the measure of his abhorrence of his father's and society's reality, his traumatic sense of their horribleness.

Ernst was able to experience what it was like to lose touch with reality without losing touch with himself – with his art making. His artificial hallucinations could become fantastic reality at any moment. Surrealist simulation of psychopathology, in order to articulate an unconventional sense of self as well as attack respectable, hypocritical society through a rebellious gesture of nonconformist appearance, could easily become true psychosis. Ernst was in deeper psychological water than he knew. He was swimming, with the aid of his art, in a chaos that offered no resting place. That he survived is a tribute to the lifesaving and life-giving power of art.

7

Back to the Future

The future is behind us.
Mikhail Larionov and Natalya Goncharova,
"Rayonists and Futurists: A Manifesto," 1913

Does it make sense to create abstract art today? Several prominent abstract artists have themselves spoken of the ubiquitous bankruptcy of the mode. Most abstract art has now become either corporate or academic design, and thus necessarily emptied of challenging meaning. It is often only an arch breaking of the Modernist rules which fails to fundamentally change what a long time ago became a formalist game.

Nonetheless, belief in abstract art remains – not as a matter of blind faith in an aristocratic institution and an art-historically respectable stylistic language, but because abstract art was once the exemplary means of articulating – embodying – the experience and meaning of Modernity. (Is the way it developed – once violently resisted – inseparable from the conditions of its origins in Modernity?) The uncertainty as to whether it is a finished narrative in and of itself provokes the expectation of new possibilities. The question is whether it can be responsive to new conditions, especially the post-Modern situation of critically looking back at the Modern experience. The post-Modern situation involves a new kind of uncertainty of experience fraught with a freshly speculative anxiety, a vogue for an apocalyptic mentality, and a new sense of difficulty for the self – not the problems of keeping pace with a fast-moving, optimistic century, but those of surviving, and coming to terms with, its insecure end: of trying to catch its tail in its mouth and to understand the destiny inflicted upon it.

The enlightened experimentalism of the emergent abstract art was a complex response to the new analytic and technological dynamic that at the beginning of the 20th century began to pervade and Modernize – dominate – daily life as it never seemed to have done before. This dynamic was in part responsible for the pursuit of "novelty" inherent in experimental art, and for the deter-

86

mination to be Modern which itself resulted in the development of abstract art – the art appropriate to the Modern age. At the same time, an unconscious reaction to the Modern dynamic led the artistic experimentalists to attempt to articulate an alternative to it. They saw its destabilizing effect on the self, and repudiated it in a striking ambivalence. The pioneering abstractionists were sufficiently acute to glimpse the outline of the problem, and to articulate it in the visionary terms available to them. Since then, with almost a century of triumphant technology behind us, the problem has become more widespread and evident: the response to technology and Modernization, and the recognition that they have brought suffering as well as benefits in their wake, have created a general ambivalence to them. Can contemporary abstract art rise to the occasion of this new ambivalence as the original abstract art rose to the occasion of an earlier ambivalence? The problem is now explicit in society, not only implicit in the self – in its love/hate relationship with a Modern society whose dynamic seems to threaten it.

One is invariably struck, on reading the manifestos and articles in which the pioneer abstract artists asserted their views, by their tone of unrelieved grandiosity. Can it be that they had no second thoughts about going beyond the hitherto existing limits of art, no uncertainty about what they would find there, about the sense it would make? So intense was their self-assurance, so determined were they to display their confidence, that one can only believe the opposite: their explicit grandiosity hides a profound anxiety, for they were really much less secure than they gave out to be. These artists' boisterous dogmatism is a mask over an abyss of self-doubt. Self must have existed only as a dilemma to them, caught as it was between old and new worlds – neither of which, experientially, had complete credibility. For them, representational art belonged to the past. They advocated revolution – in art, they *were* revolution; extreme exhibitionism may be inherent to ideologies in a revolutionary phase, may be part of their force, the major way they generate conviction, create guilt in us for our own lack of fervor, or for our critical skepticism. No doubt the assertive, self-advocative, almost bossy style of revolution has been the same since the beginning of society, but in the case of the early abstractionists one cannot believe that this manner of social self-presentation directly reflected their psychology. Maybe they unconsciously expected to be martyrs for the new art, like early Christians. Their conscious sense of themselves as propagandists for a new faith, the new Jesuits of art-making, alternated with this unconscious feeling of martyrdom.

Perhaps in the end the early abstract artists wanted to generate an appealing sense of absurdity to allure the Tertullian hidden in each of us – the socially impotent intellectual who "believes" (who can join in) only because he can respect what is inherently absurd, contradictory, unbelievable. In the case of early nonobjective art, this involves the faith that little form can have much meaning. Yet something else lies hidden in the early abstractionists' tone of contempt and dogmatism, their unholy mix of destructive and constructive intentions, their fluctuation between unsavory delusions of grandeur and zealous attention to the nuances of an art that is actually fairly obvious in its

87

manipulations of simple gestalts. They attempted to create an appropriately Modern art – so controlled as to appear mechanized, and thus truly in harmony with its times, representing the artist's eager identification with those times – but their effort had unexpected results: the discovery and experience of a nuclear self, functionally timeless and "primitive" because, even though life without it seemed uncentered, it was beyond the reach of conscious memory. Nonobjective Modern form became a metaphor for an archaic rather than a Modern sense of self. Indeed, one might say the new form's unintended meaning took over its intended, overstated, ideological meaning. The type of language the artists used about it – emphasizing the newness of nonobjective art, and the "rebirth" of the representational artist as a nonobjective artist – may have indicated that the unconscious meaning was half known.

The new art won converts for its new look, not for the "old" meaning it unwittingly discovered. Now it becomes clear what its wildly vacillating tone (half malevolent, half ingratiating) was about, and why that tone is the central clue to what was fundamentally at stake in the intention to make nonobjective art: it reflects not only the art's attempt to ingratiate itself with its audience through its supposed Modernity and newness – appealing to our presumed Modernity and newness, our supposed happy engagement with living in the new, Modern world – but also the unconscious desire on the part of both art and audience to resist and undermine that same Modernity by articulating a forgotten sense of "transcendent," "absolute" self. For Modernity, with its mechanization of the world and implicitly of the self – its robotization of the self – unconsciously poses a threat to art-making, or, rather, to the artist's sense of special identity. The Modern world can take over the artist more easily and completely than any other world could, including the world of nature; the artist is happy to share symbolically in the Modern world's domination of nature through a nonobjective, mechanized style, but not to follow the style to conclusion in a complete submission to that world.

Mikhail Larionov and Natalya Goncharova wrote, "We exclaim: the whole brilliant style of modern times – our trousers, jackets, shoes, trolleys, cars, airplanes, railways, grandiose steamships – is fascinating, is a great epoch, one that has known no equal in the entire history of the world."[1] But behind the giddiness of their experience of Modernity, they also felt a desire, as Larionov asserted, to create images "of another order – that superreal order that man must always seek, yet never find, so that he would approach paths of representation more subtle and more spiritualized"[2] – more spiritualized even than those afforded by Modern dynamism (Figure 6). These paths were more old than Modern. Larionov and Goncharova, like the other nonobjectivists, passed through Futurism, with its belief in Modern dynamism,[3] to return to the belief in an eternal, subjectively resonant art. Modern dynamism demanded constant change, creating constant newness, and it was distrusted as much as it was welcomed; the self could not take a stand on it, for the self needed an "eternal" basis. This is what the nonobjectivists intended to supply. Nonobjectivity, they hoped, would make man's unconscious awareness of eternity conscious, through forms present neither in nature nor in history. Thus Malevich could

88

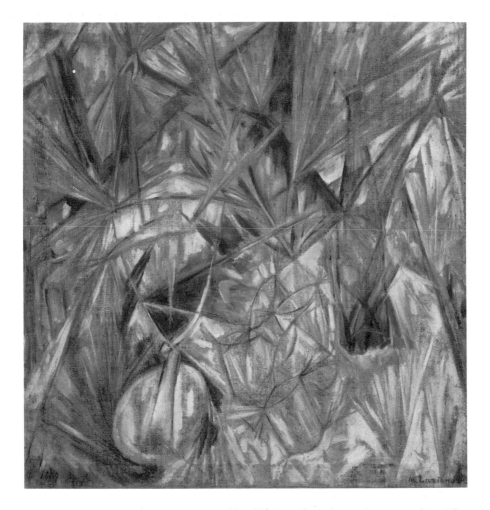

Figure 6. Mikhail Larionov, *Glass* (*Steklo*) (1912). Oil on canvas. 41 × 38¼ in. Photograph by Robert E. Mates, copyright © the Solomon R. Guggenheim Foundation, New York. Courtesy of the Solomon R. Guggenheim Museum, New York.

write, "I assure you that whoever has not trodden the path of futurism as the exponent of modern life is condemned to crawl forever among the ancient tombs and feed on the leftovers of bygone ages," and in the very same breath proclaim, "We have abandoned futurism, and we, bravest of the brave, *have spat on the altar of its art*."[4] Through geometry, the new art sought to articulate the feeling of eternity that transcends every movement, every dynamism, every age.

The essential ambiguity behind nonobjective art reflects the general crisis of Modern art-making, a crisis less in the making of the object (the creation of what Harold Rosenberg called the "anxious object") than in the question of how to retain an unshakable integrity of being in a world that not only

mechanizes and ruthlessly controls life, but also is so dynamic that it necessarily denies any being a sense of wholeness with the world. Paradoxically, in the attempt to eliminate the incommensurability between inward and outward life that Piet Mondrian said was the source of the tragic nature of the self, Modern art created a new tragedy for the self, amplifying the original one. The duality became not simply that between inward and outward life, but that between an outward stance more dynamic than inward desire; inward life wants to "slow down" to eternity to preserve itself, to retain its sense of stability and self-identity.

For Mondrian, technology was the major instrument of change, Modernity's instrument for eliminating tragedy. But he came to realize that art's role is not necessarily to be dynamically Modern or technically innovative. (What is innovative, after all, about geometrical form?) To its own surprise, Modern art found itself defending and preserving an archaic sense of "eternal" self in the face of the Modern world, of the Modernity it superficially resembled. I emphasize "superficially," for what began as Modern art's attempt to articulate what Theo van Doesburg called a "mechanical aesthetic" quickly turned into its rehabilitation of geometrical forms as credible containers of "eternal feeling" and the generalized feeling of eternity. It is as though, once art gave up the representation of nature and the "natural" look of things in general as its goal, it became capable of more than it intended: it created not simply an appropriate mode for representing the logic (rather than the look) of Modernity, but one that represented a more "universal" logic of being. Nonobjective art is not the Modern art that it seems; or, rather, it is more Modern than it seems, for it capsulates not simply the sophisticated mechanical logic of Modernity, but the determination of the Modern subject in the face of this logic. Once art freed itself of the superficiality of re-creating the look of things, it unexpectedly fell into the depths.

Even Kasimir Malevich spoke of the new art as not so much inventing something utterly Modern, never before seen, as recovering the "eternal" in "artistry."[5] The Modern, subjective meaning of this "eternal" concerned him much more than the geometrical form it took. He was not interested in contemplating geometrical form for its own elegant sake, as though its self-sufficiency were an object of blind admiration. Rather, he sought its unspoken eloquence, the affect buried behind its silence yet emerging through it. When he wrote that "any hewn pentagon or hexagon would have been a greater work of sculpture than the Venus de Milo or David,"[6] his interest was less in the monumentalization of a geometrical form comprehensible to everyone than in what, to him, that form stood for: "the square is a living, regal infant."[7] This way of characterizing it – as though it were a newborn child – has unconscious implications of which Malevich hardly seems aware. (It is the metaphor that betrays the unconscious sense.) The child is understood to exist in a natural state of fundamental selfhood; to play like a child with the building block of the square, a universally comprehensible form self-evident even to a child, and to let this simple form itself represent the child in oneself, one's most basic self – this was the goal of the new art. (At least it was the first,

primary goal; the second goal, as we shall see, was to create an equally simple, "harmonious" society.)

That Ivan Kliun, in 1915, called the new artists the "primitives of the twentieth century"[8] suggests not simply that they were the children of a century itself then still a child, but a self-conscious intention on Kliun's part to be primitive in a sophisticatedly mechanized age. This logic expresses the Modern artist's unconscious ambivalence toward the experience of Modernity, which is both desired, as a proof of enlightenment, and feared, as destructive of the eternal. Siting the eternal in an unfathomably primitive past, Kliun claims a 20th-century primitivism for himself as a solution to the contradiction. His aphorism also expresses the old Russian love/hate relationship with the West (the "Modern world") in still another form, a form paradoxically reflective of an ambivalence on the part of traditional, god-fearing Russians. Russia privileges itself as the ultimate eternal land, as if in compensation for its lack of Modernity – but also in defiance of that lack, which makes for too much awareness of the march of time. From the viewpoint of art, the eternalization implicit in early-20th-century nonobjective forms can be regarded as socially reactionary. But this does not belie its psychological meaning, nor its social import as a profound response to the disturbances in self-esteem caused by the dynamic Modern world. The basic self had been so annihilated by Modern dynamism that it had to be buttressed by a sense of eternity. (Whether this is not always the case is a larger issue.) The artist wanted to be like an eternal child – as Baudelaire suggested, the authentic primitive, who sees everything as though it were being seen for the first time and so as excruciatingly novel.

It is worth noting that the word "primitive" is also used in connection with certain non-Western cultures; to then make the leap that these cultures' art is childlike ("naive") is a mistake. However, the self in such cultures can be said, idealistically, to find its mirror in what to Western eyes may look like a timeless – and for that reason "primitive" – style. Perhaps culturally "primitive" objects appear to alien Western consciousness as unconscious of time. What looks to us like a different sense of time than our own we read as reflective of a paradisaic existence in eternity. "Primitive" style, then, is supposedly one of undeniable integrity, theoretically reflecting the integrity of the nuclear self. Already by World War I, when the West realized its own "primitive" character, the "primitive" was an overloaded concept. It referred simultaneously to an exhilarated sense of dynamic Modernity (Futurism); a sensibility for novel esthetic fundamentals (Cézanne, Cubism); a mentality (the "eternal outlook"); and "alien," non-Western art (for Picasso, Matisse, the German Expressionists, et cetera). The interplay of all these meanings gave the concept the weight of a black hole within which Western consciousness seemed eager to fantasize. The "primitive" became the mirror through which it saw itself darkly.

It is worth extensively quoting Vladimir Markov, one of the theorists of the neoprimitivism that immediately preceded and was so crucial to nonobjectivity, to make decisively the point that the basic goal of the new art was to induce, as it were, a state of selfhood in the artist (though this state had a

double, contradictory meaning). In 1912, Markov began a discussion of "the principles of the new art" with the sentences, "Where concrete reality, the tangible, ends, there begins another world – a world of unfathomed mystery, a world of the divine. Even primitive man was given the chance of approaching this boundary, where intuitively he would capture some feature of the Divine – and return happy as a child."[9] Later, Markov exclaimed, "how good it is to be wild and primitive, to feel like an innocent child who rejoices equally at precious pearls and glittering pebbles and who remains alien and indifferent to their established values."[10] From this viewpoint, the artist is implicitly a social revolutionary who denies all material values, for the paradisaic childlike state is all the value one needs in life. One can almost see Malevich on the beach, playing with the shells or squares – Markov's "features of the Divine" (Alfred North Whitehead has described geometrical forms as "eternal objects") – he has recovered from the mysterious sea. Two paragraphs later Markov wrote, "Playing a game compels us to forget about the direct, utilitarian purpose of things, and the artist, in realizing the principles of free creation, has a right to play with all worlds accessible to him: both the world of objects, and the world of forms, lines, colors, and light. He has a right to play with them as freely as a child who plays with pebbles, mixing them up and laying them out on the ground."[11]

The pursuit of archaic selfhood is perhaps clearest in the writing of Aleksandr Shevchenko. In 1913, in Moscow, Shevchenko observed:

> The world has been transformed into a single monstrous, fantastic, per-petually moving machine, into a single huge nonanimal, automatic or-ganism, into a single gigantic whole constructed with a strict correspondence and balance of parts. . . . We, like some kind of ideally manufactured mechanical man, have grown used to living – getting up, going to bed, eating and working according to the clock – and the sense of rhythm and mechanical harmony, reflected in the whole of our life, cannot but be reflected in our thinking, and in our spiritual life: in Art.[12]

Nevertheless, Shevchenko continued, "for the point of departure in our art we take the *lubok,* the primitive art form, the icon, since we find in them the most acute, most direct perception of life." The new artists are "fascinated by its simplicity, its harmony of style, and its direct, artistically true perceptiveness of life," that is, its articulation of "the aggregate of the forms of these things of which the world consists and of their movements."[13] Viewing this apparent contradiction – the recognition of the miracles of mechanical Modernity yet the desire to interpret and articulate them in primitive/eternal visual terms – no wonder that "the mob," in Shevchenko's phrase, insisted that "this artist has not defined himself yet." "But in this lies his life, his authenticity," responded Shevchenko; "The artist's vitality is determined by his search, and in searching lies perfection."[14] The search led to the creation of nonobjective art, which realized the goal of being childlike in Modern terms. Nonobjective art re-created a sense of an archaic self that seemed timeless and as such was peculiarly resistant to the mechanization process of Modernity, while also

reflecting it. It is as though, finding oneself seemingly in command of the machine – and consciously enjoying it, because it seems to give one control, though in fact one is being controlled – one also finds oneself spontaneously rebelling under unexpected unconscious pressure (signaling that unconsciously one isn't enjoying it) and discovering in oneself an ungovernable or uncontrollable archaic self – a depth self – that one didn't know one had in the first place.

Virtually all the nonobjectivists went through what they called a neoprimitivist phase; in Russia in particular, during the transitional moment, artists such as Goncharova and Larionov explicitly advocated both neoprimitivism and nonobjectivity. Nonobjectivity followed hard on the heels of neoprimitivism; in Russia, 1912 was the year of neoprimitivism, 1913 the year of nonobjectivity. (For the sake of economy, as well as because in my opinion the most important developments in nonobjective art were in Russia and the Netherlands, my examples will largely be drawn from the nonobjectivists in those countries.) The pushing of neoprimitivism away from the figure and toward pure shape arose as a solution to the quintessential problem of self-definition forced on the authentically, self-consciously Modern artist who experienced a radically untraditional, "unnatural," "inorganic" world. Indeed, part of the achievement of the pioneering neoprimitivist nonobjectivists, for which we shall always be in their debt, was their self-consciousness about being irreversibly Modern artists – their sense that the Modern world held no tradition, nothing "natural" to fall back on, a recognition that in large part was responsible for their fierce, vociferous rejection of representation or "objective art," and of nature as a subject matter. They were thus in an extreme situation, with no ideological supports, which forced them toward a confrontation with their repressed, archaic sense of self. The ban on being primitive was lifted by the groundlessness of their situation. Grist for the mill lay in the fact that the nonobjective realization of the neoprimitivist conception of the artist as Modern child created work that in intention was more timeless than Modern and timely.

It may be that one of the reasons that the archaic, deep-psychological character of nonobjective art was later widely dismissed as so much claptrap – at best, theoretical packaging to sell a New Look to a skeptical public – is that it goes against the grain of the subsequent art-historical perception of nonobjective art as the ne plus ultra of the formalist look of the future. But such a reduction of nonobjective art to eunuch status – to use another metaphor, to a purified gold of art that glitters only as design – follows directly from the relegation of radical ideologies to historical limbo, or from the impossible idealization of nonobjective art as utopian. It may be that our resistance to the nonobjectivists' idea of themselves follows from the fact that the problematic selfhood their art addressed – the self bound by the question of how it was to remain primitively secure while becoming dynamically Modern – remains as trenchant as ever. Our resistance to the nonobjectivists' feelings about their art is a repression of our own ambiguous, insecure sense of selfhood, despite our more comfortable, self-assured Modernity.

Certain observations by Mondrian and Wassily Kandinsky make explicit the deep-psychological point of nonobjective art. Mondrian repeatedly talked of the need to abolish tragic expression in art; his whole enterprise of Neo-plasticism existed to do so. *"The tragic adheres to all form and natural colour, for the struggle for freedom is expressed by the tensing of line and the intensification of colour as a striving against a stronger counter-striving. Only when line is tensed to the rectilinear and naturalistic colour is tensed to pure plane-colour – only then can tragic expression be reduced to a minimum."*[15] Again: "No matter how the duality of inward and outward is manifested – as nature and spirit, man against man, male and female, *or* in art as the plastic against representational content – so long as this duality has not achieved equilibrium and recovered its unity, it remains *tragic*. If this duality in art requires equivalent *plastic expression,* then the artist must be able to abolish tragic expression (so far as it is possible)."[16] It was clearly not completely possible for Mondrian: his sense of duality remained, as his retention of the purified horizontal and vertical makes clear, despite the dynamic equilibrium he created between these opposites. His refusal to let them be absorbed and neutralized in the greater unity of the diagonal left the equilibrium unstable, representative more of a pause in conflict than of its termination. Mondrian "controlled" tragic conflict by esthetically structuring it, which hardly means that he resolved it, since the opposites he set up never dissolve into a stable, permanent, pure unity. They are merely projected in a balancing act which can collapse at any moment. Equilibrium is conditional and transient, while conflict is the primary, the given mode of relationship. It was to counter eternal conflict that the nonobjectivists unconsciously sought out eternal selfhood; nonobjective art depicts a psychomachia between conflict and nuclear selfhood in the guise of the drama of Modern dynamism.

The necessity of finding ever-new ways of balancing inherently tragic relationships is made clear in two quotations from Kandinsky. Not only did Kandinsky insist on "Feeling" as the "ever-faithful guide" in art, but he felt that the new "spiritual" composition of "pure painting" – "however great or small its individual parts," however "infinitely fine and refined, infinitely complex and complicated" its painterly or linear details – must *"rest on the one great foundation – the* PRINCIPLE OF INNER NECESSITY.*"*[17] "Feeling" is the sign of this necessity. The discovery of inner necessity as the basis for art cannot help but remind one of Freud's discovery of instinctive drive as the basis for unconscious life. There is something even more "Freudian" in Kandinsky: the need for balance, manifested in the organization of competing instincts in, to use Kandinsky's term, an "absolute equilibrium." This organization is necessary if the psyche is to survive (or, in Kandinsky's case, if art is to survive). Kandinsky's equilibrium is not the same as Mondrian's; it goes one step further, insisting on parity between equilibrium and conflict – implying, in other words, that there is an eternal drive toward equilibrium as much as there is toward conflict. For Freud, ego struck the balance, created the equilibrium, but art was ego for Kandinsky, and had to equilibrate the opposing claims of "total abstraction" and "total realism" – the instinct for the "purely artistic" and the

instinct for the "objective."[18] In Freudian terms, this is the difference, the conflict, between the pleasure principle and the reality principle.

It is what Kandinsky called "incompletely developed feeling" that leads the ego to prefer abstraction or realism exclusively. "The custom of concentrating on form and the resultant behavior of the viewer who clings to the accustomed form of balance are the blinding forces that block free access to free feeling."[19] The viewer – ego – with "incompletely developed feeling" has been repressed by customary forms of balance, that is, by society's sense of what is normative art. "Civilized" or socially dominant forms of balance, which promise peace and eternal stability, are an illusion, but new, unaccustomed equilibrium does not carry with it the illusion of eternal equilibrium. Customary equilibrium and absolute equilibrium are not the same. While absolute equilibrium is never realizable, it is a goal that free feeling strives for eternally; as long as that eternal search continues, as long as feeling is dynamic, it is free. Eternal striving – the inherent drive – for absolute equilibrium is the sign of a dynamic self in a process of eternal becoming, all the more solid and "real," and paradoxically secure, for being dynamically on the move, for accepting and working through its conflicts. It is the drive to equilibrium that is eternal, not any one form of balance. Feeling moves on, moves beyond any societal equilibrium. Its forms of balance reflect its becoming; some are socially acceptable, some are not.

Kandinsky implied that unsocialized forms articulating an unaccustomed equilibrium are in a sense more attuned to the drive for absolute equilibrium than customary ones, and so more authentic. The nonobjectivist forms of equilibrium that were once regarded as antisocial were created using what David Burliuk called "displaced construction" involving "disharmony (not fluency)," "disproportion," "coloristic dissonance," and "deconstruction."[20] This is because "deviant" or abnormal – and thus more inherently "artistic" – forms imply an acceptance of eternal aspiration to unattainable absolute equilibrium as a necessary condition of existence and art. From this perspective, the static self-satisfaction that comes with customary equilibrium is a prelude to the enslavement of feeling.

Free feeling has within it the power or drive to create balanced form – to synthesize opposite drives. But such form, when it becomes dogmatic – habitual or conformist – loses its drive. What has been called the iron law of Freudianism can be applied to art here: the instinctual conflict – between abstraction and realism – that drives art is lost when one or the other becomes cultural law. Art tends toward, but never completely becomes, one or the other. The moment it does, it is no longer "art"; it is design (if it is purely abstract) or propaganda (if it is purely realistic). To avoid the self-destructive dogmatization of art, Kandinsky tried to keep it dynamically ambivalent. Freud wrote that "contrasting – or better, *ambivalent* – states of feeling, which in adults would lead to conflicts, can be tolerated alongside one another in the child for a long time, just as later on they dwell together permanently in the unconscious."[21] For Kandinsky, the artist in effect had to become childlike, in a kind of learned unconsciousness, so as to tolerate contrasting states of art, a kind of permanently ambivalent condition of art. It is when art is in this

state of "conflict" – a kind of balanced ambivalence – that it is in fact most healthy, dynamic, driven, and authentically "art." It is worth noting that Mondrian, in his own way, realized the dangers of abstract dogmatism. When his abstraction was in danger of becoming a habitual style, its equilibrium all too obvious, he changed the rhythm of the relationship between its irreducible or "primitive" variables. This is most strikingly evident in his last, New York – "new world" – paintings, in which equilibrium is precarious almost to the point of upset. The pulse of these '40s works is more rapid, dynamic, and urgent than in the European works of the late '30s; the energy or drive is not theatrically superimposed on an abstract "plot," but is a function of the immanent relationship between its parts. The new precariousness – ambivalence – of the relationship can be said to introduce a "realistic" note in the superficially perfect abstract balance, as it were subverting it. Simultaneously unfocused in their new "realism" and less securely abstract than the earlier work, they are thus more truly dynamic.

In completely free feeling that is not nihilistic, the drive to form and the drive to content cannot be differentiated. The differentiation of form and content, like the differentiation of light and dark, land and water, or figuration and abstraction, constitutes a short step toward creating equilibrium out of primordial chaos; Kandinsky was obsessed with the next step in the process: reintegration. His attempt to create an eternal balance was kept from being completely futile insofar as it set up symbols for equilibrium, symbols that he never assumed to be a reality, however much they are sometimes "religiously" mistaken for it. While Kandinsky's language may be often fervently religious, tending to generate the conviction that the symbol is the reality in order to create a heightened awareness of the process of integration, he did not see the symbol as literal. Rather, it was to be understood as the sign of "integrity."

An emphasis on feeling exists everywhere in the arguments rationalizing nonobjective art. "The Suprematists," wrote Malevich, "have found new symbols with which to render direct feelings (rather than externalized reflections of feelings), for *the Suprematist does not observe and does not touch – he feels.*"[22] Suprematism's goal is "to reach the summit of the true, 'unmasked' art and from this vantage point to view life through the prism of pure artistic feeling."[23] Such "nonobjective feeling has, in fact, always been the only possible source of art," yet it exists not as an end in itself but to set up "a genuine world order, a new philosophy of life."[24] It must be acknowledged that in 1915 it was enough for Malevich "*to attain the new artistic culture*," to show "creation as an end in itself."[25] By 1927, when his previously quoted remarks were published, the goal was explicitly extraartistic – it was to do with life, not exclusively with art. What remained constant was the insistence that nonobjective art is an art of feeling – an art that recovers feeling repressed in everyday life and conformist art, in the ordinary civilized "representation" of things. For Malevich, pure geometrical form was a vehicle of pure feeling – feeling in an unadulterated, crystalline, irreducible state.

Malevich's apparently new way of thinking about nonobjective art – not as a formal end in itself, but as the basis for a new philosophy and construction

of life – actually involved nothing new. Nonobjective art from the beginning was about art's relationship to the world of life; from its first formulation to its final phase, it can be understood as a profound meditation on the interaction of art and life in the Modern world. Initially, Malevich thought the world had changed, become Modern, and Art hadn't caught up with it and had to Modernize. Later, he realized that art, in its changed, Modern, nonobjective form, had potentially enormous influence on society, and was more eternal than simply Modern. It did not have to conform to the world, but could form it. No doubt this belief was a sign of its ego strength, the secure – "eternal" – sense of self it had achieved by becoming successfully, integrally nonobjective in the first place.

Malevich's optimistic attempt to create a "new philosophy of life" through Suprematism was essentially the same as Mondrian's attempt to achieve equilibrium through Neoplasticism, and had the same implicit goal: to end, through nonobjectivity or the "abstract-real," "the domination of the tragic in life," and to create the moment when "the 'artist' will be absorbed by the *fully human being*'" and society will achieve equilibrium.[26] This whole system of expectations depended on the assumption of art's power to liberate feeling, and thus to re-create "fully human beings." The belief was stated powerfully and clearly – perhaps given final form – by Naum Gabo in 1937: "The shapes we are creating are not abstract, they are absolute. . . . The emotional force of an absolute shape is immediate, irresistible, and universal. It is impossible to comprehend the content of an absolute shape by reason alone. Our emotions are the real manifestation of this content. By the influence of an absolute form the human psyche can be broken or molded. Shapes exult and shapes depress, they elate and make desperate; they order and confuse, they are able to harmonize our psychical forces or to disturb them."[27] When Malevich dramatically asserted, in 1915, "I have transformed myself in the *zero of form* and have fished myself out of the *rubbishy slough of academic art*,"[28] he was talking about a change not just of style, but of self. Notwithstanding the struggle of discovering the "zero of form," which is really greater emotionally than technically, its true importance lies in its power to liberate the self from old and customary modes of self-representation. It is in the zero of form that feeling is most free, and therefore that the artist is most fully human. It is in the zero of form that both the fully human and the internal necessity for art are discovered. The implicit fullness of the zero of form is inseparable from the nonobjectivist belief that only when art reaches the level of the irreducible does it become consequential – that less is always much more than what is conventionally thought of as more, that the minimum is the maximum.

There is a peculiar parallel between the development of nonobjective art and the development of psychoanalysis, a strange similarity in goals: the recovery of repressed feeling, involving the tracing of feeling back to its origin in instinct, and to its original drives. In nonobjective art, the instinctive feeling is incarnated in an irreducible form to match its own irreducibility. These forms are then "interpersonalized" in a symbolic image, an image that for a tantalizing moment in the early century was taken as a kind of beacon of

eternity, having significant – almost talismanic – effect in the world. In psychoanalytic terms, this is equivalent to taking a dream as reality, or at least as having magical effect on reality.

As Freud wrote, the object "is what is most variable about an instinct and is *not originally connected with it.*"[29] It is only everyday experience that connects the two; by severing the connection, the nonobjectivists recovered pure form. The purified – irreducible – instinct for abstraction articulates itself in irreducible marks or geometrical shapes. The similarly purified instinct for realism articulates itself by organizing these forms in a dynamic, unaccustomed equilibrium – in a more or less balanced or integrated "world" of forms. But a nonobjective image exhibiting this kind of organization is not a picture of the "objective" world. Rather, it is a representation/integration of the self. Each balancing/integrating act has its own character, which is part of an intrapsychic process of feeling. The nonobjective composition, whether its character is that of a Kandinsky or a Malevich painting (to name the antipodes), remains fundamentally "expressionistic," that is, a manifestation of drive. As such, it is inherently a form of tragic expression, despite the temporarily untragic look its dynamic equilibrium/integration gives it.

What about the goal of using nonobjectivity as a guide to social harmony in a technological world? Only the machine, wrote van Doesburg, can provide "constructive certainty. The new potentialities of the machine have given rise to an aesthetic theory appropriate to our age, which I have had occasion to call the 'mechanical aesthetic.'"[30] Malevich regarded Suprematism as inseparable from the big city's "metallic culture . . . of energy . . . machines, motors, and power lines."[31] The provincialism – "peace of the countryside" – repudiated by these artists is equivalent to tradition, with its storehouse of accustomed esthetic equilibriums, as well as to the empty utopianism of the pastoral version of the wish for social harmony. To the nonobjectivists, social harmony was to be achieved in technological, urban society, as Mondrian thought, and nonobjective art was to show, on an intrapsychic and psychoesthetic level, how harmony could be achieved. First it would be realized in art, then "in our outward surroundings and in our outward life."[32] Art would be a beacon signaling the task, first showing, in Mondrian's words, the new *"simplicity,"* sign of the "new harmony" which "will come automatically through the quest for efficiency in machinery, in transportation,"[33] and it would prod this new harmony to come into being, reminding society of its possibility.

One can understand the social ambitions – usually dismissed as naively utopian – of the pioneering nonobjectivists in terms of the development of psychoanalytic theory. Initially, the emphasis was on inner drive rather than on outward object, and on recovering free feeling. The initial withdrawal from everyday objects was made in order to restore a sense of instinct in art – even more fundamentally, to revive the drive or will in art, which had lost its willpower, even, in Nietzsche's words, the will to live dangerously. But the depth level necessary for pure instinctive production is hard to sustain – one must come up to the social surface for ordinary air (banality can be refreshing at times) – and "society" as a whole is too vague or abstract an entity for

instinct to embrace, or for that matter to reform. The nonobjectivists' social idealism cost them their instinct; losing concreteness by trying to generalize the meaning to society of what they had already accomplished instinctively, they lost the instinct for art. Once again it was destroyed by "worldliness" – by the attempt to flatter the world through telling it it could be a better place to live.

The world of the early 20th century was an anxiety-arousing, traumatic one. Conventional, illusory art was not doing its job – to keep the chaos (the contradictions) down, in what Harry Stack Sullivan has called a "security operation." The pioneering nonobjectivists fantasized their works as "diagrammatic fragments"[34] of an anxiety-free, harmonious society; in this ideal world, which ran like a machine, as the saying goes (a saying very pertinent to the mechanical esthetic), no object or self would threaten any other. Paradoxically, World War I intensified rather than obliterated the nonobjectivists' fantasies. The first large-scale technological war after the American Civil War, and a major example of the destructive use of technology, the first World War was deeply imprinted on these artists; but instead of creating images that could be regarded as diagrammatic fragments of the world of destructive technology and social conflict, they created images that turned that world upside down, ideal projections that put a constructive aura around technology out of a desire that it be socially integrative rather than disintegrative. The nonobjectivists could not recognize or accept the fact that the social conflict they saw reflected a deeper instinctive conflict. They acknowledged conflict in the microcosm of art, but could not carry their insight into its dynamics forward into the macrocosm of society. Instead, they idealized the new society.

The works of the nonobjectivists are as much unconscious wish fulfillments as Surrealist works are, but they embody what Ernst Bloch called "the principle of hope" rather than the principle of despair that motivated the Surrealists. Nonobjective works, initially projecting an image of dynamically integrated selfhood – selfhood conscious of its primitive instincts, and balancing them – became a representation of a dynamically integrated society. The artists' social ambitions confirmed their self-regard, gave their art a greater self-esteem than if it had merely been about art – or about themselves, their own egos. But that social estimation of their art was its downfall, because it led them to regard their original "experimental" forms as customary – socially acceptable, matter-of-fact. This eventually made for work as hollow as the representational forms that these artists had condemned, and made the balance or integration their work projected equally repressive of free feeling. While their works became museum-worthy, free feeling had to move on, abandoning the idea that it could redeem society – an illusion that, like all illusions, proved more monster than objective, conflictful reality. Because they could not face the madness of the world – its eternal discord, its perilous existence on the edge of chaos – the nonobjectivists' art died. Its deliberate use as social therapy undermined its spontaneously therapeutic use by the machine-haunted Modern self. The nonobjectivists could heal themselves, but not the world. They had not yet learned every revolutionary's hardest lesson: that nobody can.

8

A Freudian Note on Abstract Art

I

NONREPRESENTATIONAL or abstract art is generally regarded as the most significant innovation of twentieth century art. It involves, as Clement Greenberg has written, "pure preoccupation with the invention and arrangement of spaces, surfaces, shapes, colors, etc., to the exclusion of whatever is not necessarily implicated in these factors," that is, in "the processes of [the] medium."[1] It implies "the tendency toward 'purity' or absolute abstractness," which, while it "exists only as a tendency, an aim, not as a realization," informs every effort of abstract art.[2] Whether or not this description is adequate, there is always the eschewing of representational intention, however that might finally be defined. And whether abstract art is the necessary essentialization of art that Greenberg thought it was, there is the sense that the "concreteness" achieved by "renouncing illusion and explicit subject matter" establishes an unequivocal criterion for aesthetic significance.[3] There may be historical precedent for abstract art, and past art may have to be re-evaluated in modernist terms – in terms of its affirmation of the medium – as Greenberg does in his study of the later Monet and reassessment of Titian, but the fact is that in the twentieth century a distinctive canon of abstract art emerges.[4]

The understanding of abstract art has been expanded – most noteworthily, perhaps, its ideological import and intellectual content have been emphasized[5] – but there is little dispute that it epitomizes, aesthetically, the modern "faith in and taste for the immediate, the concrete, the irreducible."[6] This faith, affirmed by Impressionism in the context of the representation of nature, was clarified by Cubism as an end in itself. As Greenberg said, Cubism was the "purest and most unified of all art styles since Tiepolo and Watteau."[7] It first "defined and isolated" the "basic tendencies" of abstract art, however much other artists, such as Mondrian, carried them "to their ultimate and inevitable conclusions."[8] In fact, according to Greenberg, for the half century before the paintings of Clyfford Still, there were no "serious abstract pictures . . . that

were . . . altogether devoid of decipherable references to Cubism."[9] Abstract art brought to fruition what John Berger called the "affirmation" of Cubism, which "re-created the syntax of art so that it could accommodate modern experience."[10] Cubist innovation was inseparable from the modern "promise [of] a transformed world. The promise was an overall one. 'All is possible,' wrote André Salmon, another Cubist poet, 'everything is realizable everywhere and with everything.' "[11] Presumably Cubism reflected this promise unequivocally. As Greenberg wrote, "one of the greatest of all moments in painting arrived on the crest of a mood of 'materialistic' optimism . . . a mood of secular optimism."[12] The "vaulting modernity" of Cubism, and by extension of abstract art, reflected the fact that "the generation of the avant-garde that came of age after 1900 was the first to accept the modern, industrializing world with enthusiasm."[13]

Is this true? Part of the purpose of my paper is to dispute this assumption, from a Freudian perspective on art: to suggest that something more complex and equivocal – more resistant to the modern world – occurred in the artistic response to it that led to abstract art. I want to argue that the tendency towards purity or absolute abstraction does not indicate as much (blind) acceptance of the modern world as is customarily thought, but, on the contrary, a self-protective aesthetic disaffection with it. I think the first self-consciously abstract artists unconsciously experienced the modern world as a threat to art: it seemed to bring into question, by reason of its dynamic character, the "timeless" character of art, the source of its "absolute" value. In sweeping away traditional values, the modern world seemed to sweep away the traditional estimate of art's "higher" significance. More particularly, while the artists wanted to be as new as the world at the turn of the century promised to be, and thought they could be new by participating in the revolutionary changes in technology and outlook that being modern meant, they also realized that such participation would fundamentally change the conception and production of art – completely de-stabilize it. Like everything else in the modern world, art and its meaning would uncontrollably change, with unpredictable results. Once the revolution of being-modern started, it was a sorcerer's apprentice that could never be stopped. Most of all, it could no longer be assumed that art would transcend the world it reflected through the very act of representing it. It could no longer be taken for granted that art would establish a reflective distance from the world, a surrogate psychic space where its usual operation was suspended. The most advanced artists realized that the modern world threatened to diminish art in the very process of giving it new life. The modern world revitalized art, but it also made it insecure.

The modern world involves a strong sense of the dynamic reality of time. It could not be overlooked in the modern representation of space and matter. Time appears in the fragmented spaces of Cubism, which seem to be inherently dynamic because they are equally positive and negative, solid and empty, closed and open. They oscillate between these spatial poles, seeming to reconcile them, however unstably. After the initial flurry of conscious enthusiasm about the new sense of spacetime – the new unity of space and time, and the way

it changed the sense of extension – because it made spatial appearances more dramatic and exciting, modern artists experienced the new spacetime – epitomizing the general sense of dynamic change that the modern implied – as an assault on their unconscious belief in the omnipotence of art. This belief is signalled by the assumption of the timelessness of art. Psychoanalytically speaking, the sense of being immune to the vicissitudes of time is an infantile illusion, more precisely, an illusion of primary process.[14] The modern world made it difficult to sustain the fantasy of such "transcendence," all the more difficult if the artist was deliberately modern. Those artists who became abstract, because to do so was to acknowledge the modern sense of temporally dynamic reality, found themselves in an emotional double bind: the wish to be modern was at odds with the deeply held belief in the transcendence of art, with its denial of dynamic time, so crucial to being-modern. It seemed impossible to make an art that was both specifically modern, in that it reflected the reality of spacetime and the modern sense of dynamic change correlate with it, and that implied the timelessness of transcendence. From Cubism on, the abstract artists we most honor – through Mondrian to Still, and, one might add, Rothko, Newman, Ryman, and Held – are those who have struggled to articulate the dynamic subtleties of spacetime while suggesting the sense of transcendent timelessness that signals the omnipotence of art, affording the artist a sense of grandiosity.

It can be argued that the avant-garde artist sustained belief in the omnipotence of art by making it enigmatic. That is, to be advanced came to mean to make an art that does not seem to represent anything, that cannot be pinned down to any specific communication. It does not have any recognizable "message" – anything to say, as it were. What Greenberg described as purity is in fact a certain kind of unintelligibility – mystification. This is more than a matter of being anti-literary, as Greenberg thought. Adorno has said that:

> As the work (under the auspices of modernism) posits unintelligibility as expression, increasingly destroying its intelligible moment, the traditional hierarchy of understanding is shattered. Its place is taken up by the reflection on the enigmatic quality of art. . . . lack of meaning may well be the intention of the work.[15]

There is no doubt something ironical about this unintelligibility, or enigmatic quality of art, for abstract art is supposedly both modern and universal – simultaneously timely, or appropriate to and intelligible in terms of the modern world, and timeless, unequivocally transcendent. This contradiction – generalized to the assertion that the language of pure art is modern because it revolts against the traditional mimetic language of art, yet is also ahistorical and asocial because it has no representational purpose – is the core of abstract art's apotheosis of art as enigmatic. Abstract artists wrap the flag of an unintelligible language of art around themselves to affirm the mysteriousness of art as such, thus saving it for timelessness and transcendence, but they also claim that their language has a uniquely modern kind of intelligibility. This ambiguity suggests an ambivalent response to the modern world – defensive

as well as accepting and assimilative. It is the defensive aspect of the response that has particular psychoanalytic resonance. Let me restate it: the ambition of the first abstract artists was to create an ultimately unreadable, enigmatic language of art that, by reason of its unintelligibility, becomes a defense of their narcissistic belief in art's timelessness, correlate with their grandiose sense of its absolute uniqueness, and implying its omnipotence. They created a language of unintelligibility, as it were, that supposedly articulated art's essential enigmaticness, thereby reaffirming their sense of its special power, indeed, (magical) omnipotence. This was a fallback position from the onslaught of the modern world, as they experienced it.

To put this in other psychoanalytic terms, they defensively created an incommunicado art – a "mystified" art.[16] But this very same saving grace of new artistic "mysticism" – restoring the sense of art's absolute power – suggests the great anxiety inherent in the abstract artist's response to the modern world. Mystifying enigma saves art from modern life, but also implies the intense anxiety fueling the abstract artist's will to absolute power in the face of the revolutionary power of the modern. The pioneering abstract artists preserved the traditional sense of art's timelessness and transcendence, carrying with it the sense of art as an end in itself and serving their sense of the omnipotence of art, by proclaiming it as – indeed, seeming to explicitly show it to be – enigmatic, that is, "really" or substantively mysterious. But the enigmaticness of art also embodies the enigma of the modern artist's anxiety. The determination to make a manifestly enigmatic art is inseparable from the artist's determination to hide his anxiety: enigmaticness represses the anxiety while unwittingly articulating it. Indeed, it is the symptomatic form of the anxiety: the enigmatic correlates with the anxious the way a death mask fits the face from which it was made. Both enigma and anxiety are the fallout from the abstract artist's will to power – in the modern world, which threatens to undermine it. Together, enigma and anxiety signal the abstract artist's profoundly ambivalent response to it.

It should be noted that while Freud attempted to make the mysteries of the psyche intelligible, the abstract artists could not bear or did not dare to disclose (even to themselves) the anxiety that made their pursuit of enigmaticness intelligible. Where Freud made the apparently unintelligible language of dreams – and particularly unintelligible traditional art such as that of Leonardo da Vinci and Michelangelo's statue of Moses – intelligible, revealing the psychological sense behind their apparently mysterious character, the abstract artists cultivated enigma in art, in a deliberately obscurantist effort. The direct – easy? – path to enigma was through rejection of representation. Enigma became a point of honor, correlate with the elevation of anti-representation as the avenue of "new insight" into art. The abstract artists clearly had more of a vested interest in the enigmaticness of art than Freud had in the enigmaticness of the psyche.

Freud can be used to make intelligible abstract art's repressed anxious response to the modern world, with the post-Freudian proviso that the modern world is disturbing by reason of its fundamental effect on object relations.[17]

Freud always had a sense of the harshness of reality, as he called it in *Civilization and Its Discontents;* the modern world, for all its technological comforts, apparently made reality emotionally harsher for the pioneering abstract artists sensitive to its disruptive force. They responded by in effect repressing – refusing to represent (at least obviously) – modern reality in their art, suggesting the anxiety that it aroused in them. At the least, abstract art eschews the representation of directly observed reality. It is opposed to depiction in any form. This well-known censure of illustration, while seemingly in the name of sacred purity, also implies a less than enthusiastic response to the modern world. The anti-illustrative character of abstract art – and not to illustrate can be a facile way of implying enigma – suggests subjective difficulty in coping with the modern world. Abstract art's bias against illustration implies a dawning awareness of the difficulty of, in Abraham Maslow's words, having "to live in a world which changes perpetually, which doesn't stand still."[18] Illustrated things stand more or less still; in a sense, the refusal to depict things is a refusal to see them, let alone carefully observe them. The bias against depiction can be understood as a kind of resistance to the reality of living in an almost intolerably dynamic world – a world which changes perpetually in every detail. In a sense, the bias suggests that abstract art involves a deflection of direct experience of the world – a kind of shielding against it.

Clearly, abstract art implies an attitude to the modern world that is different in kind from that of representational art, attached to a traditional conception of the world, that is, to the assumption that it is fundamentally static. It may change in appearance but not substance. Paradoxically, abstract art seems to assimilate the most crucial aspect of the modern world in the very act of repudiating its appearances: its dynamism, with the fundamental change in the conception of the world it implies. On one level, the language of abstract art is an imaginative celebration of the modern sense of the fundamentally dynamic character of the world. But the celebration is fraught with anxiety, among other reasons because it puts art itself under the pressure of changing with the changing world – of being perpetually modern, dynamic.

It is worth emphasizing that pioneering abstract art implied that all representational art, including modern representational art – "modern" by reason of its assimilation of the language of abstract art, its secondhand use of abstract language – has a basically "traditional" conception of the world. It does not seriously accept – incorporate – the modern revolution in the sense of reality. The imagination of modern abstract art is different in kind from that of traditional representational art, modern representational art, and traditional abstract art, which existed in the service of a static religious world conception (the real world reflecting the mystery of God signalled by abstract symbols). Modern abstract art is unique as a frontier of response to the modern sense of reality, and in its depth of response. This depth has become obscured by the institutionalization – banalization – of abstract art. In Freud's archaeological spirit, I am dredging for what was psycho-dynamically significant in abstract art when it was still revolutionary and dynamic, which is why I will utilize

the statements of purpose of the pioneers of abstract art – the manifestos in which their ideas are manifest, and their feelings are latent.

II

In *Totem and Taboo* (1913), at the end of a discussion of "Animism, Magic and the Omnipotence of Thoughts," Freud remarked:

> In only a single field of our civilization has the omnipotence of thoughts been retained, and that is in the field of art. Only in art does it still happen that a man who is consumed by desires performs something resembling the accomplishment of those desires and that what he does in play produces emotional effects – thanks to artistic illusion – just as though it was something real. People speak with justice of the 'magic of art' and compare artists to magicians. But the comparison is perhaps more significant than it claims to be. There can be no doubt that art did not begin as art for art's sake. It worked in the service of impulses which for the most part are extinct to-day. And among them we may suspect the presence of many magical purposes.[19]

My claim is that at its origin abstract art – more particularly, nonobjective art, that is, abstract art which has cast off every vestige of dependence on nature, any hint of illusionism – was an attempt, on behalf of art as such, to retain "the principle of the overestimation of the importance of psychical reality, the principle of the 'omnipotence of thoughts,' " in the face of new pressure on it.[20] This was the pressure of modernity, with its new assertion of the reality principle – with, one might say, the new assertiveness the modern world gave the reality principle by reason of its new sense of reality. Modernity brought with it, and meant, a seemingly more thorough grasp and mastery of reality – nature – than had hitherto been achieved. (This was accomplished, in part, by the problematicizing of it, correlate with the process of desacralizing it. No longer untouchable, it could be investigated, and even changed. It no longer had to be helplessly endured, accepted as it was.) Whether the methods developed to gain this mastery are described as positivist or instrumentalist, or are more generally understood as empiricist, they carry with them the end of a superstitious attitude toward reality, that is, an end to the belief that it can be controlled by magic – supposedly magical acts or magical thoughts. In a sense, Freud's notion that "where there is id, there shall be ego," or that maturity means living on the basis of the reality principle rather than the pleasure principle, is a reflection of the success of what Freud himself called the scientific outlook and its technological rewards. For Freud, this was a success over the infantile religious attitude – an attitude which for him manipulated unconscious desire for infantile satisfactions – as well as success in understanding reality, dominating nature. In the last chapter of the *New Introductory Lectures on Psycho-analysis,* Freud upheld the scientific outlook as the only legitimate one, declaring "religion alone" as its "really serious enemy."

In the same breath, art was dismissed as "almost harmless and beneficent, [for] it does not seek to be anything else but an illusion. Save in the case of a few people who are, one might say, obsessed by Art, it never dares make any attacks on the realm of reality."[21] Art, for Freud, does not seriously threaten our sense of reality – undermine it the way religion does – because it unequivocally presents itself as illusion. Whereas religion offers us "another reality" – another world than this one, a supernatural (infantile) rather than natural world.

For Freud, the "incitement premium" afforded by "the perceptual pleasure of formal beauty" is hardly worth the trouble, for it in no way extends the reality principle – increases our knowledge and mastery of reality. Reality has nothing to do with beauty or ugliness, and there are profounder – more visceral – pleasures than that of art. Freud explicitly said that he "set a higher value upon [his] contributions to the psychology of religion" than to the psychology of art.[22] No doubt this was because religious belief was more of a neurotic – psychotic? – disorientation to reality than artistic belief (the obsession with art). While "the artist, like the neurotic, had withdrawn from an unsatisfying reality into [the] world of imagination . . . unlike the neurotic, he knew how to find a way back from it and once more to get a firm foothold in reality." This clearly contrasts with the true religious believer, who never finds a way back to reality for Freud. Freud does not quite say how the artist accomplishes his or her return to reality, but rather dwells on the dream-like character of works of art, which are also "imaginary gratifications of unconscious wishes" and "compromises . . . forced to avoid any open conflict with the forces of repression."[23] For Freud, one awakens from the dreams – the imaginary gratifications – of art, which one is less likely to do from the dreams of religion. They are more explicitly somnambulist narcissistic products, preventing the awakening to reality. With its militant unrealism and infantilism, religion, more than art, is a threat to mental health – a realistic attitude – for Freud.

Are the pioneers of abstract art religious or scientific in their attitude towards modernity? Neither; they are artistic. That is, they cloak modernity in illusion in the very act of celebrating it. They establish an excited fantasy relationship to it. They are ravished by surprise at the signs – satisfactions – of modernity. It makes them dizzy: one detects more than a hint of anxiety in the pleasure of their vertigo. They are about to spin out of control. In their 1913 manifesto on "Rayonists and Futurists," Mikhail Larionov and Natalya Goncharova exclaim:

> The whole brilliant style of modern times – our trousers, jackets, shoes, trolleys, cars, airplanes, railways, grandiose steamships – is fascinating, is a great epoch, one that has known no equal in the entire history of the world.[24]

But what is most interesting about this manifesto is not their exclamation of astonishment about the technological marvels of the modern world, but the way they put down the Futurists for retaining the appearance of this world in their pictures. In contrast, they, once Futurists and now more revolutionary

Rayonists, have kept the look of the modern world – the appearance of trousers, jackets, shoes, trolleys, cars, airplanes, railways, grandiose steamships – out of their pictures. Instead, they claim to have distilled the essence of "the whole brilliant style of modern times." This abstract distillation of the modern dynamic is not the same as the imaging of modern things.

How can we be sure they have accomplished this magical distillation of modernity? How can we be sure they have grasped the general dynamic of modernity if not the nature of its specific objects? We can't be. It makes no sense to say their art is positivist or instrumentalist, or generally empiricist or loosely scientific in outlook. It is not clearly "knowing." There is no obvious appearance of modern reality in their art, only their professed aesthetic articulation of their fascination with it. That is, they take pleasure in it. They are less interested in the novel appearance of modern objects – objects they hardly comprehend – than in narcissistically articulating the pleasure these objects give them. They want to remain in the waking dream of modernity, a rhapsodic dream full of such magical things as they list. They don't want to awaken from their dream: reality might be different – harsher – than it looks in their artistic dreams.

But there is more to their nonobjectivity – repudiation of representation of reality – than that. The deliberate elimination of art's representational function has been interpreted in a variety of ways. All in effect "prove" that nonobjective works are not, in Freud's words, "asocial," "narcissistic products of dreaming." Nonobjectivity has been celebrated as a return to artistic fundamentals or "purity," and as such an aesthetic and stylistic advance – an "avantgarde" move. In other words, it makes apparent – transparent – just those fundamental elements – lines, planes, colors, spatial relationships – that are repressed, as it were, by representation. It celebrates them for themselves – frankly declares them, as has been said, without reading them as constituent of a representation. They are seen in all their physicality, without any "metaphysical" overlay. Out of the wraps of representation, they ideally become ecstatically visible. By no longer serving the purposes of representation – no longer being subsumed in a depiction – they can be recognized as the elements of the universal, basic language of art. But this liberation, for all its implication of a new realistic attitude toward art, in no way changed the old belief in its magical character. On the contrary, the turn to nonobjectivity gave the archaic belief a new lease on life, even strengthened it. It was now the irreducible formal elements that were magical – omnipotent "thoughts" of art – not its representations, shown to be vulnerable because they could be reduced to these more fundamental formal elements.

Nonobjectivity was originally a kind of last-ditch attempt to retain a certain unrealistic psychological privilege for art: to maintain its magicality in defiance of the modern forces that threatened to deny it. By arguing that modernity made it possible to dispense with art's traditional task of representing reality in illusions – reality no longer being clearly representable from a modern point of view (giving that much to modernity) – the pioneers of abstract art attempted to save the illusion which art generically is, that is, the illusion of its magicality.

They sacrificed what they realized was superficial to strengthen their belief in what they knew was essential: the principle of omnipotence of (art) thoughts. That is, they renounced art's power to create illusions of the world to insist upon the principle of (infantile) illusion as such. Pure – nonobjective – abstract art is even more magical, they in effect claimed, than obviously illusionistic art: it affords deeper and subtler imaginary gratification. It is more successfully infantile, as it were. The formal elements, no longer the building blocks of representation, become magical toys played with for themselves, and through the process of play invested with the artist's infantile sense of omnipotence. It is because they are so invested that they seem magical – all-powerful in themselves. Nonobjectivity was a grandiose new way of insisting upon the omnipotence of art in the face of modern efforts to trivialize it, as in fact Freud does. It was a brave new attempt to make art irresistibly seductive – to show its irresistible power over the psyche. The new material frankness of non-objective art embodies the infantile refusal of the pioneers of abstract art to give up their belief in the magical power of art. They must refuse, for without its magical power art is emptily material – which is what, it has been argued by its detractors, so much of the abstract art Greenberg has endorsed has become. They knew that modern thinkers could represent reality better than they could, so that the sacrifice of illusionism was no great loss, but they also knew that the new reality represented by modern thinking would be less satisfying – harsher – than the old reality, so that there was greater need than ever for the consoling illusion of art. Secondary illusion could go, but primary illusion was more psychologically necessary than ever, and nonobjective art could supply it more directly than ever.

They saw their works as bunkers in which the psyche of art could defend its delusion of omnipotence. The pioneer abstract artist was like the creature in Kafka's story "The Burrow." Nonobjectivity was the burrow from which the abstract artist resisted imagined attack by the new "realists" of modernity. But they had already outflanked art, simply walked around it, leaving it bogged down in its absurd pocket of resistance. To put it another way, the abstract artists, behind their barricade of nonobjectivity, remained stuck in wishful thinking, while the forces of modernity swept around them to ever more realistic thinking. It is superficial to say that abstract art developed "on the crest of a mood of 'materialistic' optimism."[25] Its materialism may reflect modern materialism in general, but the materialism's nonobjective character – that is what is really new about it – is a desperate way of holding on to the mystique of art rather than of demystifying it. Only those who saw it entirely in terms of what has been called its literal order of effects could miss its unconscious import.

In the same manifesto previously cited, Larionov and Goncharova described their "rayonist picture" as follows:

> The objects that we see in life play no role here, but that which is the essence of painting itself can be shown here best of all – the combination of color, its saturation, the relation of colored masses, depth, texture.

...The picture...imparts a sensation of the extratemporal, or of the spatial. In it arises the sensation of what could be called the fourth dimension, because its length, breadth, and density of the layer of paint are the only signs of the outside world....At this juncture a kind of painting emerges that can be mastered by following precisely the laws of colors and its transference onto the canvas.

Hence the creation of new forms whose meaning and expressiveness depend exclusively on the degree of intensity of tone and the position that it occupies in relation to other tones. Hence the natural downfall of all existing styles and forms in all the art of the past – since they, like life, are merely objects for better perception and pictorial construction.

With this begins the true liberation of painting and its life in accordance only with its own laws, a self-sufficient painting, with its own forms, color, and timbre.[26]

There are certain basic features to this rationalization of abstract art (a cliché today): (1) the separation of painting (and by implication art in general) from life; (2) the separation of such nonrepresentational painting from the kind of painting that represents life; and (3) the belief that painting has laws of its own separate from those of life. From my point of view here – that nonobjective art, supposedly the ultimate modernization of art, in psychological fact implies a repudiation of reality for the sake of the idea of art as the realm of omnipotence of thought – the separation of art from life indicates its neurotic refusal to accept modern reality. Its fantasied power over reality – Karl Abraham and Melanie Klein note that omnipotence of thought partly involves the unconscious belief that fantasies are fact – correlates with its anxious withdrawal from modern reality.

For the pioneers of abstract art, nonobjectivity was in effect art's articulation of its creative integrity or autonomy. For them, nonobjectivity implied a fetishization of creativity. This involves the assumption that establishing a "creative" relationship between the purely formal ("unrealistic") elements of the work is the substance of what it means to be creative. For the nonobjective artist, these formal elements in and of themselves are all-powerful, to the extent that they have a kind of talismanic or magical power over life. While the nature of this power is rarely spelled out – Larionov and Goncharova dwell on the formal elements and their mysterious aura of power, without saying how the power works – the general point of art's omnipotence is clearly made. Art is interested only in its own reality – an explicitly narcissistic way of affirming its belief in its omnipotence. The modern sense of reality seems to infiltrate the explanation of nonobjectivity – in the form of an allusion to the "fourth dimension" – but it is not clear what Larionov and Goncharova understand by the fourth dimension. They use it for their own hermetic purpose: to declare their art four-dimensional adds a solemn note of enigma – intellectual mystification – to it. No doubt it is a natural scholarly mistake to assume that when the pioneers of abstract art spoke of the fourth dimension in their works – as they frequently did – they knew what they were talking about. But they

didn't. The concept had a narcissistic not realistic meaning and use for them. As the mediator of the "new reality" of the fourth dimension, the abstract artists imagined they had power over the three dimensions of the "old reality" – trumped it. In general, the pioneering abstract artists experienced what Jung called a crisis of individuation. They attempted through nonobjectivity to reconcile, in Jung's words, the conflict between their "archaic images of omnipotent selfhood" and "the demands made by social norms," that is, the new normative conception of reality as having a "fourth dimension."

It is worth remarking that Kandinsky began his essay "On the Question of Form" in *The Blaue Reiter Almanac* by equating "the creative *spirit*" and "the abstract spirit"; the former can be called the latter, he wrote. The artist searches for what a quite different but contemporaneous artist, Malevich, called "pure creation in art."[27] Malevich regarded the square – he described it variously as "the face of the new art" and "a living, regal infant" – as the first step of this creation.[28] He thought it, and other "nonobjective, pure" forms or "intuitive forms," as he also called them,[29] "arise out of nothing" rather than out of life or nature.[30] "Such forms will not be repetitions of living things in life, but will themselves be a living thing."[31] Malevich made his point strongly when, expressing his contempt for "the masters of the Renaissance," he said: "Any hewn pentagon or hexagon would have been a greater work of sculpture than the Venus de Milo or David."[32] Abstract form has a reality of its own – the reality of art as such – greater than the reality of the forms of life or nature.

The nonobjective insistence on pure or abstract creativity is a defensive measure against a reality that seems to have become "uncreative," as it were, because it has been understood all too well. That is, because it has been scientifically "realized," it is no longer the proper object for projection by unconscious fantasy. Artists feel "coldly" – uncreatively – towards it. They cannot delude themselves into imagining that they are secretly more powerful than it – that private thoughts can have mysterious power over it. Science is unconsciously experienced as more creative than art, and the modern reality science proposes is experienced as more powerful than the "reality" of art. Artists' belief in their omnipotence – on which their creative functioning depends – must go somewhere in a Freudian economy. Where it goes is away from reality, life, and science. Creativity, conditioned by unconscious belief in the omnipotence of the self over factual reality, hides out in "lifeless" forms, which it magically imbues with its life. Malevich cathects geometrical forms until they seem as omnipotent as he unconsciously imagines himself to be. This is why, for the pioneers of abstract art, pure creativity can be actualized only when it is separated from life and nature. The pioneers of abstract art may have imagined that their "detachment" was that of "abstract" science. Kandinsky, for example, used the argument that because the atom can be split – suggesting that reality isn't what it seems to be – his creation of a "new reality" of art, as he called it, was justified. But this is a gross misunderstanding of scientific abstraction. In general, nonobjectivity is a regression away from

the new reality and towards the old infantilistic assumption of art's magical omnipotence.

In forfeiting the illusion of nature and life, abstract art lost the minimum relationship to reality necessary for it to be art, at least in Freud's eyes. Illusion is perhaps an obvious and trivial relationship to reality, but it keeps art from altogether becoming a dream. It is in dreams that we are most omnipotent – that the omnipotence of thought completely reigns – as Freud remarked. By taking away illusion, the abstract artists took away the last barrier against overestimating the power of their art. (It is worth noting that Adorno thought that the "crisis of illusion" was the major one in modern art.)[33] It may be, as Malevich wrote, that "In repeating or tracing the forms of nature, we have nurtured our consciousness with a false conception of art," but the true conception that results when "skillful reproduction" is eliminated clearly implies that art is false to reality, and feels smugly *superior* to it.[34]

Malevich denied that pure composition – which "rests on the purely aesthetic basis of niceness of arrangement" – is a "creative process."[35] It is like "arranging furniture in a room," which was not creating "a new form for them."[36] Malevich regressed to a condition of absolute purity beyond art as well as nature, that is, beyond art understood in the conventional aesthetic sense as well as nature understood in the conventional perceptual sense. "For art is the ability to create a construction that derives not from the interrelation of form and color and not on the basis of aesthetic taste in a construction's compositional beauty, *but on the basis of weight, speed, and direction of movement*."[37] Malevich wanted neither aesthetic illusion nor the illusion of nature, but an enterprise he compared at one point to "the Divine ordering crystals to assume another form of existence."[38] What was at stake for the pioneers of abstract art was neither life nor art, but creation as such. The emphasis on creation as such is "unrealistic," a delusion of grandeur that is more than rhetorical.

It may be rhetoric for abstract artists to arrogate to themselves the creative power of God – it is certainly a long-standing trope. Nonetheless, this gesture confirms that the development of abstract art is a "regression" to an enigmatic core creativity – a mystification of art – rather than a "progressive" modernization of art. It is not about art or modernity at all. The euphoric sense of art's rebirth that the pioneers of abstract art felt – often with strong utopian overtones to it – was in fact a sign of their infantilism, that is, it carried with it the wishful thought of the omnipotence of art. Art is special to them just because it is unrealistic. The dregs of this affirmation of art's creative specialness, elevating it above all other creative enterprises – making it the exemplary form of creativity – appears in Greenbergian modernism:

> A modernist work must try, in principle, to avoid communication with any order of experience not inherent in the most literally and essentially construed nature of its medium. Among other things, this means renouncing illusion and explicit subject matter. The arts are to achieve con-

creteness, 'purity,' by dealing solely with their respective selves – that is, by becoming 'abstract' or nonfigurative. Of course, 'purity' is an unattainable ideal. Outside music, no attempt at a 'pure' work of art has ever succeeded in being more than an approximation and a compromise (least of all in literature). But this does not diminish the crucial importance of 'purity' or concrete 'abstractness' as an orientation and aim. [39]

This echoes and systematizes what the Russian pioneers of abstract art wrote. Similar statements abound in the early literature on abstract art. One might say that belief in the possibility of purity – it would not be an "orientation and aim" if it was not a possibility – reduces the principle of the omnipotence of artistic reality to an absurdity from which it has not entirely recovered. This is partly because the notion has become associated with the idea of an elitist conception of art. It is certainly connected to the snobbery displayed by many self-styled connoisseurs of abstract art, a manifestation in the realm of manners of the grandiose delusion of art's autonomy.

In the eighties there has been a vehement, if fitful, recovery of art from the fantasy of its omnipotence. There are serious artists who believe that art can help us understand reality, who cannot imagine it isolated in the ghetto of its own parthenogenetic creativity. One of the great misfortunes of the elevation of abstract art – for example, the work of Malevich, Mondrian, Pollock, Newman, and Rothko – to a position of apparently unchallengeable prominence, and the general conception of abstract art as a "stylistic advance," is that it has led to the categorization of much figural art – particularly Expressionist and Surrealist work – as "aesthetically" second rate. This has in part to do with the fact that they dare to "represent" – symbolize – unconscious forces. Indeed, one of the reasons abstract art is elevated in the canon is that it seems to mediate pure aesthetic pleasure, as though aesthetic pleasure was something unto itself – as pure as "pure art."

I have elsewhere maintained that so-called "aesthetic pleasure" is an umbrella term covering a complex variety of psychic satisfactions, specifically, the satisfaction of one or more of what Erich Fromm called "psychic needs" or "existential needs": "the need for relatedness, for transcendence, for rootedness, for a sense of identity, and for a frame of orientation and an object of devotion, [and] for effectiveness." [40] I would argue that one of the reasons figural art in general and so-called realistic art in particular are regarded as inferior to abstract art is that they nakedly reveal these needs, debunking the myth of pure aesthetic pleasure. They are overtly and honestly psychological, and as such anathema to abstraction. For one of the things the credibility of abstraction finally depends on is its power to repress the psychological – paradoxically, in the name of the psychologically primitive illusion of art's omnipotence. When T. S. Eliot states that "Poetry [art] is not a turning loose of emotion, but an escape from emotion; it is not the expression of personality, but an escape from personality," and that "the emotion of art is impersonal," he is articulating the "ethos," as it were, of aesthetically pure art. [41]

I have suggested that pure art is more psychological – and troubled – than

it appears to be. I have tried to show its psychological underside: it is uncon-
sciously motivated by belief in the omnipotence of art in the face of serious
modern evidence to the contrary. "Purity" is a code word for this omnipo-
tence, and the religion of art which purity implies puts art in the perilous,
unrealistic position of religion in general. It is genuinely debatable whether
purity has done art any good, which is part of the point of the resurrection
of expressionistic and other kinds of figural art in the eighties. These recent
forms of representation at least have the advantage of openly acknowledging
the psychic needs art can successfully address; this helps us to recognize the
psychological forces that influence our sense of reality, including the reality
of art's power. Nonetheless, I would hardly deny that the turn to nonobjec-
tivity early in this century – and even today, among the few artists for whom
nonobjectivity is not just another manner of matter-of-factly making art –
does not address a deep – perhaps the deepest – psychic need of the artist: the
narcissistic need to believe in the omnipotence of creativity, that is, to believe
that in being creative he or she is renewing a lost, magical omnipotence. In
this sense, the nonobjective artist remains the most serious artist.

9

The Will to Unintelligibility in Modern Art
Abstraction Reconsidered

AUTHENTICALLY modern (avant-garde) art has as its main thrust the articulation – indeed advocacy – of enigma or unintelligibility.[1] Where other critics have seen what used to be called the obscurity of modern art as something to be read away, I see it as modern art's desired end. Modern art wants to be obscure – it is not simply inadvertently obscure, or obscure because its codes have not yet been mastered and so it cannot be read. Modern art is not just a difficult text waiting to be interpreted, but it pursues uninterpretability in and for itself. In the contemporary situation represented by Post-modern art, the will to obscurity and mysteriousness has become more desperate and driven than ever because of the stronger than ever modern insistence on the clear, the straightforward, the matter-of-fact. (I am suggesting that "modern" has different implications in "modern art" and in "modern world." In the former enigma is cultivated, in the latter it is denied – stamped out as ignorant superstition.)

I contend that not only were the most outstanding modern artists motivated by a will to enigma, but if their works should lose that sense of keeping a secret that makes them mysterious, and lapse into the banality of outspoken-ness, they would instantly seem insignificant. There is much pressure to tri-vialize them into obvious meaning – to explain their mystery – because the inclination to enigma is generally suspect in the modern world, which is determined to be clear and distinct. What makes it even harder to recognize the special value placed on enigma in modern art is that there can be a failure of nerve, as it were, in art's will to enigma itself. It is easy to backslide to intelligible art, and art that was once recognized as enigmatic can easily be regarded as unenigmatic – banal – when it becomes habitual. Overfamiliarity even dulls the edge of mystery.

In the end, modern art is subject to the modern world, which administers the understanding of it, and in general prefers intelligibility to unintelligibility, for the one is enlightened while the other implies dim-wittedness. From the Enlightenment perspective which dominates the modern world, the sense of

enigma is atavistic nonsense – no doubt like art itself from a fully enlightened point of view. At best, enigma is novel expressive ornament, which from an enlightened perspective is not to give it much. It is worth noting that all these aspersive doubts cast on the desire for enigma may be counterproductive, for they are likely to inspire the will to enigma, which is in part a revolt against the world created by the Enlightenment, which as many have said is determined to "remove mystery."[2] To be authentically enigmatic, every enigmatic art necessarily recapitulates this original rebellious import. Thus, the effort to suppress the will to enigma may lead art to new heights of "impossible" unintelligibility: art will heroically fly in the face of Enlightenment resistance to enigma. But there is the strong possibility that the will to enigma may finally become extinct in the modern world. It may simply atrophy from lack of significant use.

What has psychoanalysis to do with all this? As I understand it, psychoanalysis is a reconceptualization and exploration of what Hegel in the *Phenomenology of Mind* called the "Freedom of Self-Consciousness," especially that aspect of it he called "The Unhappy Consciousness." The will to enigma in art – the insistence on unintelligibility at all costs, even at the cost of the sense of art itself, or at least of a clear consciousness of art – is a major form of unhappy unconsciousness as well as a basic self-consciousness about art, that is, an awareness of it as a certain kind of freedom. The descent into the maelstrom of unintelligibility, with the sense of chaos and exaltation it creates, is best comprehended in terms of psychoanalytic thinking about unhappy – inherently ambivalent – psychic process. The sense of enigma can be understood as the upshot of tragic conflict. It is inherent in what Hegel called "the inner essential world" and to the relations between that world and the "world of action." There are no concepts more useful for the understanding of tragic conflict than those of psychoanalysis.

Such major works of modern art as Monet's *West Facade of Rouen Cathedral, Morning* (1894), Van Gogh's *Cypresses* (1889), Picasso's *The Accordionist* (1911), and Mondrian's *Victory Boogie-Woogie* (1942–44) are each in their own exemplary way unintelligible – impenetrably enigmatic. The structure of the Mondrian may seem less obviously obscure than the structureless Monet and the fragmented structure of the Picasso, and the Mondrian conveys hardly any wildness in comparison to the hysterical textures of the Van Gogh, but the relations between the primary colors in the Mondrian are far from cordial. So-called "dynamic equilibrium" is really dynamic conflict. Mondrian plays on the irreconcilability of the colors. If one looks at the Mondrian without prejudice – without the lens of his wishful desire for equilibrium – one sees an unintelligible structure, even a kind of controlled chaos of disparate elements. Comparing another Mondrian of the same period, *Broadway Boogie-Woogie* (1942–44), with one of Barnett Newman's three versions of *Who's Afraid of Red, Yellow, and Blue?* (1967–68), the Newman appears more austere in its unintelligibility than the Mondrian, because Newman eliminated black and white, further reducing the terms of the picture. Finally, Jackson Pollock's

Full Fathom Five (1947) is an entropic field that is perhaps one of modern art's most obviously (conventionally) unintelligible – chaotic, inarticulate – works. So-called alloverness is a kind of disintegration, but also apparently pursued as an end in itself. Clearly, these works suggest that there are a variety of orders of unintelligibility in modern art, and that it is a cross-stylistic interest. If one brought Marcel Duchamp into the picture, one would have the modern unintelligibility of art itself, not only art as a platform for unintelligibility.

In all these works, to use T. W. Adorno's language, "the unintelligible is made to appear as if it were the most natural, self-evident thing in the world."[3] "The medium of the creative artists" seems to be, as Adorno suggests, an inevitable place for the demonstration of the unintelligible. Perhaps this is why they don't say much about it. But "a philosophy of art" – and, one might add, a psychoanalysis of art – "should not . . . explain away the unintelligible, as speculative philosophy has almost invariably been tempted to do," but try "to understand the unintelligible as it persists in the work, thus avoiding doing violence to art." A good start to understanding is Adorno's assertion that, "As the work (under the auspices of modernism) posits unintelligibility as expression, increasingly destroying its intelligible moment, the traditional hierarchy of understanding is shattering. Its place is taken up by reflection on the enigmatic quality of art." In many works "lack of meaning" – unintelligibility – "may well be the intention." One of the reasons for unintelligibility in art is implicit disbelief in the traditional ways of understanding, traditional codes of meaning. Enigma becomes alluring when intelligible meaning becomes trivial or hollow – seems beside the point, or seems to miss something essential. Let us jump the gun and call it the subjective, which works in archaic ways mysterious to ordinary meaning.

The modern history of art's demonstration of unintelligibility goes back to romanticism. It is then that art first began to feel threatened – illegitimate – in the face of instrumental and scientific reason. One might even say that it posited the unintelligible to disrupt instrumental reason and contradict – counteract – the intelligibility scientific reason afforded. Art's unintelligibility can be regarded as a kind of intellectual Ludditism, if not nihilism. In a sense the unintelligibility it asserted symbolized its illegitimacy. Art felt illegitimate because it had no clearly instrumental purpose and could not compete with scientific intelligibility. It in effect defied the Enlightenment. In the twentieth century an Enlightenment understanding of modern art's unintelligibility was imposed on art by Clement Greenberg's doctrine of modernism. Art's demonstration of unintelligibility was understood as the pursuit of so-called purity, but in my opinion the most important aspect of Greenberg's modernism is his distinction between art's literal order of effects and its preconscious and unconscious order of effects, and the elevation of the former and the dismissal of the latter as incoherent and inherently difficult to pin down, name – make intelligible. The unintelligibility of seminal abstract art is rationalized as the inadvertent consequence of the will to purity, and reduced to a matter-of-fact manipulation of the medium with purely so-called aesthetic consequences. This dismissal of a whole side of art's import, not to speak of the gross

misunderstanding of the preconscious and unconscious order of effects – what Greenberg once called "the depth" – it implies, is one of the great crimes perpetrated upon modern art. But it is highly suggestive: it tells us what door we must go through to truly understand the unintelligibility of modern art. We must look for the depth in the unintelligible.

There are several ways to psychoanalytically grasp the nature of the depth – the enigma – in unintelligible art. The concepts I bring to bear are by no means exhaustive. Nonetheless, I want to claim for them a certain appropriateness to the issue. They show that what seems to be a breakdown into unintelligibility, under external pressures, is in fact an internal deepening of art. Unintelligibility is not a catastrophe, but a new artistic opportunity. The external pressures turn art to new internal purpose: under the strain, it shows it is capable of making explicit preconscious and unconscious effects that are generally difficult to be conscious of, or to communicate in socially convincing form. The pressures of the Enlightenment outlook force art to use another kind of thinking, as it were, a kind of thinking that seems unintelligible to the Enlightenment way of thinking. What the psychoanalysts call primary process thinking is no doubt implicit in the best representational art, but it becomes explicit in the best abstract art. The paradox of abstract art is that it is primary process thinking at its most immediate – a seemingly spontaneous articulation of its process and precipitates – but apparently most cabalistically mediated, because of its non-representational form.

This is why the best abstract art has an enigmatic effect, that is, it seems to spontaneously locate us in the preconscious and unconscious order of effects. Its literal order of effects explicitly subserves the preconscious and unconscious order of effects, that is, its literal character works on us in a directly expressive way. (Greenberg refused to recognize this, repressing the major strength of abstract art, its power to directly move us, like music, as Gauguin, Kandinsky, and Mondrian said.) In working our way through an abstract work of art we seem to be feeling our way in the labyrinth of a preconscious and unconscious world of feelings. It is a highly ambivalent sensation, at once all too chaotic and exalted for Enlightenment reason. Such chaos and exaltation are at the core of primary process thinking. Clearly, abstract art's unintelligibility is psychologically intelligible.

D. W. Winnicott, discussing "why there exists a relationship between the deepest conflicts that reveal themselves in religion and in art forms and the depressed mood or melancholic illness," remarks that

> at the centre is doubt, doubt as to the outcome of the struggle between the forces of good and evil, or in psychiatric terms, between the benign and persecutory elements within and without the personality. At the depressive position in the emotional development of an infant or a patient, we see the building up of the good and bad according to whether the instinctual experiences are satisfactory or frustrative. The good becomes protected from the bad, and a highly complex personal pattern is established as a system of defence against the chaos within and without.[4]

Without this building up, chaos would reign, or the tendency to chaos would be the dominant force in the psyche, as it is in unintelligible art. It is impossible to tell what the good and bad parts of the unintelligible work are. All parts are indeed equivalent (which is entropic chaos), not just aesthetically – as Greenberg argues with his concept of alloverness, misleading us as to the significance of the collapse of the distinction between good and bad parts – but intellectually and morally. Being beyond good and evil – not even being evaluatable – the abstract work, whether gestural and geometrical, constitutes a free zone of primary process.

Winnicott has written that, "Behind all mental breakdown is theoretically a state of chaos but complete breakdown must be rare clinically, even if it is possible, as it would indicate an irreversible change away from personal growth towards fragmentation."[5] From this perspective, unintelligible art, which depends as much on fragmentation as dedifferentiation – Cubist fragmentation as the path to the dedifferentiation of allover or field painting – has an annihilative import: it implies the breakdown of art. Unintelligibility conveys disintegration, and the will to unintelligibility suggests art's embrace of its own death. Melanie Klein has written that, "One of the main factors underlying the need for integration is the individual's feeling that integration implies being alive, loving, and being loved by the internal and external good object; that is to say, there exists a close link between integration and object relations. Conversely, the feeling of chaos, of disintegration, of lacking emotions as a result of splitting, I take to be closely related to the fear of death. I have maintained . . . that the fear of annihilation by the destructive forces within is the deepest fear of all."[6] Unintelligible art apotheosizes the feeling of chaos, of disintegration, of lacking emotions. It directly conveys chaos and disintegration, and we cannot get an emotional fix on it. It is a drama of emotional dedifferentiation: no one emotion dominates. Putting Winnicott and Klein together, unintelligible art can be understood to articulate the destructive forces within – the forces which threaten breakdown from within. In terms of the sense of it as an attempt to negate the Enlightenment way of rational thinking, it is a kind of masochistic response to the modern world.

But the destructive forces are not simply acknowledged, for in the very act of being artistically – magically – rendered a kind of illusory control over them is asserted. Artistic articulation seems as primal as the destructive forces themselves, which is why it seems uncannily appropriate as a mode of articulation – why it conveys the forces with special immediacy. Moreover, the artistic rendering of the destructive forces has a manic quality which contributes to its impact. In unintelligible art the destructive and the manic mingle in an unholy mix, for the rendering of the destructive forces is as much a manic defense against them as a statement of their power. It is this manic aspect that gives unintelligible art its special air of exaltation, and is the sign of the artistic effort to control the destructive forces. As Winnicott said, the manic defense involves "the employment of almost any opposites in the reassurance against death, chaos, mystery, etc., ideas that belong to the *fantasy content* of the depressive position."[7] Thus unintelligible art, a fantasy of the destructive

forces, is an exuberant, even seemingly lyrical fantasy, as though unintelligibility was an upbeat, life-giving energy rather than simply a destructive expression. (It should be recalled that Pollock's allover paintings are frequently described as lyrical.) With the recognition of the manic component in unintelligibility, its full ambivalence is faced.

At its most extreme, unintelligible art may be an articulation of what Heinz Kohut has called "disintegration anxiety," characterized as "the deepest anxiety man can experience" and described as fear not of "physical extinction but loss of humanness: psychological death.'"[8] It reduces one to the "prepsychological" "fragments of the mind-body-self or the self-object,"[9] or to what he also calls "prepsychological flux." "The attempt to describe disintegration anxiety is the attempt to describe the indescribable,"[10] and unintelligible art heroically attempts to do just that. At the same time, the manic quality suggests its liberating character. For to enter the unconditioned flux is to regain the liberty of the life force itself. It is the old orders of understanding the human that are destroyed, putting one in a position to contemplate the enigma of the inner flux of being itself. The manic is a defense, but it is also a revelation of the rescuing life force. Thus, unintelligible art is as constructive as it is destructive. It reflects the uncertain outcome of the struggle between the destructive and constructive forces in the self. It is Manichean art.

Unintelligible art represents what Roger Fry in 1912 called a "classic concentration of feeling." He was speaking of Cézanne's work, and Cézanne is certainly one of the first of the unintelligible artists – one of the first artists to show, no doubt unwittingly, a will to unintelligibility. Such classic concentration of feeling is comprehensible in terms of Winnicott's concept of the "cul-de-sac communication (communication with subjective objects),"[11] who are charged with destructive and constructive, persecutory, and reparative connotations. Winnicott in fact describes the "abstract picture" as a cul-de-sac communication,[12] or, as I would call it, an incommunicado communication – the communication of an enigma. As he says, it "carries all the sense of real." It is a "true communication" involving "the core of the sense, that which could be called a true self."[13] Winnicott connects it with "the mystic's withdrawal into a personal inner world of sophisticated introjects . . . the loss of contact with the world of shared reality being counterbalanced by a gain of terms of feeling real"[14] and, we might add, authentic, that is, not compliant to the world of false selves. The destructiveness of unintelligible art may be an attempt to effect such withdrawal, and its exaltation may be an indication of communication with the introjects of the inner world.

The point is that such cul-de-sac communication implies what Fry calls the "impassioned and detached vision" involved in classic concentration of feeling. At the core of unintelligible abstract art is a sense of true self, that is, of a self that is really human – only it is in an incommunicado condition. The unworldliness or withdrawn quality of unintelligible abstract art – its nonrepresentationality, that is, refusal to represent the world of shared reality, inseparable from the turn to abstract art – is at bottom a defensive regression to a primitive world of authentic selfhood in the face of the modern world,

which has made us all too false to ourselves. The falsification of ourselves by modern reason is counteracted by unintelligible abstract art. When we have become all too compliant to modern reason, all too accepting of its administration of our existences, all too emptily social and accommodating, we rebelliously revert to the archaic condition of authenticity. Artistic withdrawal to unintelligibility is one "mystical" way of doing so. The cul-de-sac communication of unintelligible abstract art is a relatively social means of withdrawing, but it remains a mode of exalted humanness out of reach for most human beings, for it is too sophisticated and paradoxical a means – too inhuman in tone and appearance. It neither represents human beings nor tries to communicate collective feelings. Nonetheless, it remains a socially approved if marginal way of re-identifying oneself.

10

An Alternative Psychoanalytic Interpretation of Jackson Pollock's Psychoanalytic Drawings

Is there a way of psychoanalytically conceptualizing the so-called psycho-analytic drawings Jackson Pollock produced during his treatment with the Jungian Dr. Joseph Henderson other than the unavoidable Jungian one? I am not alluding to all the drawings Pollock made during his treatment (1939–40), but the sixty-nine sheets (thirteen with drawings on both sides) used by Henderson to understand the workings of Pollock's psyche.[1] While, as Claude Cernuschi says, it is unlikely that "Pollock drew especially for his analytic sessions," but rather "brought Henderson examples from . . . his normal pro-duction,"[2] Pollock nonetheless probably believed that psychoanalytic sense could be made of them, which is why he brought them to Henderson to be interpreted.[3] Psychoanalytic understanding of the drawings has been colored not only by Henderson's Jungian orientation but by Pollock's professed Jung-igianism. Whatever the trendiness of Jungianism at the time and however superficial Pollock's understanding of it, in my opinion he was motivated by the need to hide his personal pathology from himself. By identifying it as "archetypal" he could sublate it into larger, indeed universal, significance. It was not unlike what an ostrich did when it buried its head in the ground, imagining it was completely hidden and safe.

I suspect that Pollock's attempt to convince himself that the bizarre figures of the drawings represented Jungian archetypes was an intellectual way of saving face. It was a way of redeeming the stylistically problematic figures, at their best an almost uncanny mix of traditional representational and abstract modernist means (Figure 7). They represented a struggle between the old and new in Pollock's sensibility – an effort at change that I do not think Pollock thought was entirely successful. The idea of their Jungian significance com-forted him in his uncertainty about their artistic significance. Also, it probably raised Pollock's self-esteem to believe that he could make art that was self-evidently profound. He was in an uncertain process, as well as generally insecure, and he needed whatever succor he could get. But basically his idol-ization of the Jungian archetype – in itself an idol – was defensive avoidance

Figure 7. Jackson Pollock, *Untitled* (ca. 1939–40). Colored pencil. 15 × 11 in. Collection of Ellen and Saul Dennison. Copyright © 1992, the Pollock–Krasner Foundation/ARS, New York.

of his urgent, particular, very personal problems. It was a way of hanging on to something that seemed absolute when inwardly he was anxious to the point of disintegration. In declaring his access to the archetype he unwittingly admitted that his own psyche was inaccessible and puzzling to him. Indeed, the flight to the universal – which includes the hermeneutic compulsion to find profound symbolic meaning everywhere, as though the significance of things was instantly apparent – is a species of intellectualization. Such deep meaning, found for the asking on the surface of things, invariably turns to fool's gold.

Henderson's ideas about the drawings, which Pollock presented to him almost as new symptoms, while interesting and no doubt to some extent descriptive of Pollock's psyche, do not seem to me adequate either to the drawings or to Pollock's psyche. To identify archetypes is not the same as to understand the operation of the dynamic unconscious, which is ultimately the issue of both the drawings and Pollock's psyche. If we accept Charles Brenner's

view that all verbal behavior is compromise formation, then we must accept the idea that all visual behavior also is. The question is thus what the visual behavior of the drawings tells us about the structure of Pollock's intrapsychic conflicts, however inconclusively. I am not saying that the drawings are a straightforward expression of Pollock's psyche, but that they are indeed testimony to the complexity of its workings and his general character. To take the drawings alone as a clue to his psyche, or to regard them as the most representative or relevant clue, is methodologically foolhardy. Nonetheless, understood in the context which led Pollock to seek treatment, they make a powerful argument, as it were, for a certain consistent, if not exhaustive, understanding of him and his art. Like every other human being and every other art, he and his are overdetermined. One can at analytic best – I am speaking not only of psychoanalysis but of any kind of analysis – acknowledge the variables at play in both, if not always and easily trace their dynamic interaction. In general, my overall effort is to make Pollock's drawings psychoanalytically, if also flexibly, intelligible, not to cast them once and for all in psychoanalytic bronze. I also want to signal, in however incomplete a way, their art historical as well as psychohistorical importance for Pollock's oeuvre as a whole.

I want to review the art historical understanding of these drawings, initially ignoring the fact that they were first made public, that is, given an audience, if only of one, in the context of therapeutic treatment. In fact, they were a mode of self-communion, whose only possible audience, apart from the artist himself – whose other eyes would such exploratory, tentative drawings be made for? – could be a sympathetic therapist. Then I want to review the situation that brought Pollock to a therapist. If we accept Peter Gay's assertion that the work of art has equally relevant roots in tradition, craft, and privacy,[4] then the art historical understanding of Pollock's drawings should locate them in the context of some modernist tradition and tell us something about their artistry and place in Pollock's total oeuvre. The psychoanalytic use of them to tell us something of Pollock's private pathology should coordinate and converge with this art historical understanding. That is, the specific way in which Pollock's drawings are "modern" and "pathological" should co-imply one another.

Lawrence Alloway thought that their

> main style is the Mexican version of Cubism, a ponderous meshing of mechanical, totemic and organic form sources, heavily contoured and greasily shaded in crayon. When a lighter scattering of images occurs, there are frequent shreds of Arp, Miró, Henry Moore, and Picasso. The drawings are mostly heavyhanded and banal, the work of a man who did not get going as an artist until 1942, at the age of 30. He was, if not exactly a late starter, an awkward one.[5]

Stephen Polcari is more specific about Pollock's stylistic sources. He notes that

> at the end of 1939 and at the beginning of the war, Pollock was drawn to modern art, especially Picasso's work such as *Guernica* and drawings

for it shown at the *Picasso: Forty Years of His Art* exhibition at the Museum of Modern Art in 1939. In the early 1940s Pollock expressed his admiration for Picasso. . . . Pollock's notebooks in the late 1930s, some of which were done while he was under Jungian therapy and are known as the 'psychoanalytic' drawings [*sic*], contain innumerable sketches of torn and rent horses, bulls, and warriors.

"These drawings, many of which appear to be doodlings rather than full drawings," suggest that "Pollock draws from Picasso's art figures ripped by the overpowering forces of the world" and show his "turn to subjects of psychological and inner life."[6] Polcari also points out that "it is probably at least in part through Graham that Pollock became interested in Jung, Picasso, and the value and relationship of the primitive and the unconscious." Indeed, "Graham went with Pollock to his Jungian analyst's office in 1941."

There are in fact a fair number of drawings in which representations of horses and bulls or parts of their anatomy appear. They seem derived from similar figures in *Guernica*. Plate 8 shows the head of a bull with a knife/spear tongue similar to one that appears in *Guernica*. (All plate references are to C. L. Wysuph's edition of the drawings.) That same spear appears in Plate 79. Plate 78 shows a bull and female figure in a conjunction not dissimilar to the one that appears in *Guernica*. There is particularly a proliferation of horses' heads and bodies, the latter usually in a convoluted, agonized position, the body turned in on itself, if partially flattened, so that it becomes emblem-like (Plate 31). In contrast, the bull's head, if also emblematic, tends to be presented confrontally and threateningly, as in Plate 28. Of course, Pollock represented horses in the Benton-inspired *Going West*, 1934–38, and the drawings do show a number of horses that are as intact as those in that painting. There are also Picasso-like distorted figural anatomies, which seem loosely related to those Picasso did in the mid-1930s. In general, the dominant influence on the drawings is Picasso, even if they are not Picasso-like in every detail.

According to Wysuph, in 1937 Pollock "underwent about eight months of psychiatric treatment for acute alcoholism."[7] In a letter of July 1937, Pollock's brother Sanford described him as "having a very difficult time with himself" and "as mentally sick." The "past year has been a succession of periods of emotional instability for him . . . to the point where it was obvious that the man needed help."[8] Sanford took Pollock to a psychiatrist, whom Pollock saw for at least six months. Apparently the treatment was unsuccessful, that is, Pollock continued drinking heavily and was "irresponsible." In a letter of February 1938, Sanford wrote that Pollock was again "in serious mental shape." In June, Pollock was hospitalized, voluntarily, "at the Westchester Division of New York Hospital for treatment of acute alcoholism; he remained until September. Soon after his release he suffered another relapse and, early in 1939, was referred for treatment by Mrs. Cary Baynes, through his friend Helen Marot, to Dr. Henderson," who was in his first year of practice. Apart from Graham, who had a professional as well as personal interest in Pollock, it was probably Marot, apparently his close personal friend until her sudden

death in 1940, who made Pollock aware of Jungian psychology. She was an advocate of it, at least as a general "philosophy." They first met in 1934 at the City and Country School, where she was a teacher and Pollock worked as a janitor while studying with Benton at the Art Students League. Soon after Marot's death, Henderson left New York for San Francisco – a double loss for Pollock.[9] Pollock was referred to Violet Staub de Lazlo, another Jungian psychoanalyst, with whom he worked for the next few years (fall of 1940 to the winter of 1942–43).

Whether or not Pollock made the drawings he showed Dr. Henderson specifically for the purpose of being interpreted or in order to understand and assimilate Picasso and thus become a modern artist of sorts – why not both? – the fact of the matter is that by presenting them in a psychoanalytic context they acquired psychoanalytic consequence. Wysuph tells us that Pollock thought they were revelatory of his psyche. Pollock apparently had difficulty following the basic rule, namely, free verbal association. He has been described by Sanford Pollock's wife Arloie and Pollock's own wife Lee Krasner as becoming so depressed and "withdrawn as to be impenetrable"[10] and inarticulate – which is the way he was also described as a boy.[11] This was followed by alcoholic binges, probably manic in character, as the notion of "binge" implies, and a defense against the depression and its unconscious content. Whether bipolarity is implied is hard to say, but Pollock apparently lived in a pattern of oscillation between depression and binge throughout his life. In a sense, the allover paintings are an amalgamation of both, if at first glance looking more like a manic binge.

Pollock probably came to Henderson in a state of depressive withdrawal, that is, between binges. To draw him out and to establish a therapeutic alliance with him, Henderson probably talked with Pollock about his drawings, loosely rather than didactically interpreting them, and perhaps asked for Pollock's opinion about the interpretations – anything to get him to verbalize. Clearly Pollock was too depressed to benefit from interpretation and insight in the classic psychoanalytic sense, and clearly this was not a classic Freudian psychoanalysis, not only because Henderson was a Jungian but because parameters were necessary to reach the patient. At best, it was a species of supportive psychotherapy – a holding environment for Pollock. Indeed, Dr. Lazlo explicitly described her treatment of Pollock as "supportive."[12] Certainly it was not like Samuel Beckett's treatment with Bion as reported and analyzed by Didier Anzieu, at least because Beckett was verbal.[13] In fact, however indiscreet Henderson was in making public Pollock's psychoanalytic drawings, much else about the treatment remained private. We do not know how often Pollock saw Henderson or whether Pollock was on the couch. Above all, we do not know Pollock's associations to his own drawings – or if he had any – only Henderson's interpretations of them and his diagnosis of Pollock as "schizophrenic." This was standard for the time but, as I hope to show, not far off, in that it acknowledges a psychotic dimension to Pollock's psyche. My account of the treatment is of course surmise, but it seems likely that Henderson spoke more than or at least as much as Pollock.

In any case, what seems clear is the inadequacy and failure of Henderson's treatment, by his own admission. He was too fascinated, in Jungian fashion, by the symbolism in Pollock's drawings, as Henderson himself acknowledged, "to find out, study or analyze his personal problems", and attempt "to cure his alcoholism."[14] In my opinion Henderson attended to the symbols more than to the person who produced them because he did not have the psychological knowledge to understand and deal with Pollock's severe problems. In other words, Henderson intellectualized as much as Pollock probably did, in Henderson's case in countertransferential defense, as he acknowledged. He did not seem to know how to analyze his countertransference to Pollock, let alone Pollock's transference to him. There was clearly very little working through on either side. Henderson never seemed to consider the possibility that Pollock may have been unanalyzable, as contemporary criteria suggest.

I want to approach Pollock's drawings not in terms of their symbolism but in terms of their formal structure or style and what that implies, however inconclusively, psychodynamically. Whatever else it is, style, from a psychoanalytic perspective, is a signifier and encoder of psychic organization. William Rubin has understood Pollock's style art historically as a kind of epitomizing convergence of modernist tendencies ranging from Impressionism through Cubism to Automatism and Surrealism.[15] But this does not tell us the psychodynamic significance of allover or almost allover flatness, distorted and/or fragmented and generally grotesque representations, and spontaneous or seemingly uncontrolled gestures, almost a kind of visual parapraxis in the context of representation. I assume such psychodynamic significance because I assume the unavoidability of projection in any artistic act. The question of Pollock's art psychodynamically understood is the question of what it projects and what the projection defends against.

D. W. Winnicott has stated that "through modern art we experience the undoing of the processes that constitute sanity and psycho-neurotic defence organisations, and the safety-first principle." That is, through modern art we are "able, so to speak, to flirt with the psychosis."[16] (Winnicott saw the humor in this flirtation, that is, the importance of humor – one of the most mature defenses – as a defense against psychosis that nonetheless acknowledged it. To laugh in the face of insanity is the ultimate saving grace. It is worth noting that Pollock had little if any sense of humor. Certainly his art shows none. In a sense, he was chronically psychotic, and his art a kind of "sublimation" of his psychosis.) Winnicott was speaking to the obviously more sane, safe, resolved look of traditional representation, even when it pictures or evokes the insane, and the somewhat less than integral character of the modern art look in general. Theodor Adorno has argued that the modern work of art presents itself as fragmented and as a sum of fragments that do not add up to a coherent whole either conceptually or formally, while the traditional work is preconceived as a whole, that is, "full" by reason of its ideological and stylistic integrity, before it is anything else.[17] Peter Bürger argues, in a not unrelated way, that the traditional work of art presents itself as a self-evident, "naturally" given illusion, while the modern work of art declares its own

constructed character or, as a phenomenologist would say, affords an epoche of art as making.[18] (Bürger's conception of the traditional work is hardly adequate to it. Indeed, he grossly simplifies it, all the more so in view of the self-conscious idealization in much traditional art, that is, its deliberate construction of the ideal.) Whether one thinks the way Adorno does or Bürger does, the point is that the modern work of art seems to undo itself in the very process of being done, and to be about undoing. It involves a kind of ingenious disorganization, which we may read as an uncanny organization, the way Adorno tells us that modernist dissonance comes to be read, in an act of accommodation and habituation, as hypermodernist consonance, but that it in fact remains unresolved and undone – permanently unfinished and incoherent, not simply by the technical standards of tradition, but as idea and form.[19]

It is worth dwelling on Winnicott's distinction between psychosis and neurosis, because I want to show that only when Pollock abandoned the safety-first principle in perception – gave up on what Joseph Sandler calls "perception work," or realized that it could not make him feel safe (I will return to Sandler's concept later) – was he able to become a modern artist. But in a sense Pollock became a modern artist in unconscious acknowledgment of his inability to construct his sanity, that is, to build up a relatively stable defense organization against instinctive wishes, particularly aggressive, indeed, hostile ones, which threatened to destroy or undo his psychic organization, such as it was. Pollock's drawings, which occur at the crossroads of his career – as Polcari said, before them he was not modern, after them he was modern – show this double process of Pollock's realization of the futility of perception work, which was still important for Picasso (as he himself implied),[20] and Pollock's attempt deliberately to construct and take charge of his insanity rather than have it totally destroy him. It is as though he meant to take possession of it – get some kind of hold on it – before it took complete possession of him. To put this another way, my thesis is that the drawings show the beginning of Pollock's effort to take his insanity literally in hand before it took him entirely in its hands.

This was finally and triumphantly achieved in the famous allover gestural paintings of 1947–50, when Pollock created the non-space of what Heinz Kohut calls pre-psychological flux, that is, the unspace of pre-structure (Figure 8). It was, as has been much noted, a time when Pollock stopped drinking. Such "nihilism" – the articulation of undoing to the point of annihilation, that is, of the feeling of being overwhelmed by annihilation anxiety, or the representation of the feeling of no-thingness and not-being that is at the gist of what Michael Eigen calls the psychotic core – is an amazing and rare artistic feat.

According to Winnicott:

In psychosis there is a disorder involving the structure of the personality. The patient can be shown to be disintegrated, or unreal, or out of touch with his or her own body, or with what we as observers call external reality. . . . By contrast, in psychoneurosis the patient exists as a person,

127

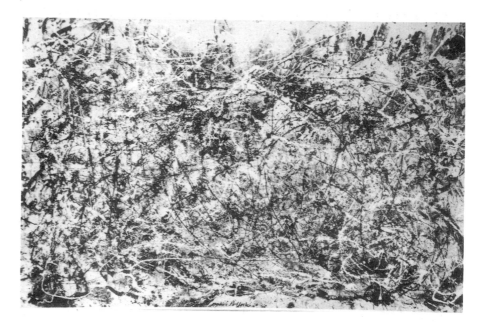

Figure 8. Jackson Pollock, *Number 1* (1948). Oil on canvas. 68 × 104 in. Collection of the Museum of Modern Art, Purchase 1950. Copyright © 1992, the Pollock–Krasner Foundation/ARS, New York.

is a whole person, recognizing objects as whole; the patient is well-lodged in his or her own body, and the capacity for object relationships is well-established. [The patient's] difficulties arise from the conflicts that result from the experience of object relationships. Naturally, the most severe conflicts arise in connection with the instinctual life, that is, the various excitements with bodily accompaniment that have as their source the body's capacity for getting excited – generally and locally.[21]

That is, the psychotic has problems of selfhood; the neurotic has ego problems. Or to use Kohut's distinction, the psychotic is a Tragic Self, enfeebled and disintegrating, the neurotic is a Guilty Self, his ego in conflict with his id, superego, and reality. The psychotic is incompletely or irresolutely structured – always breaking down – while the neurotic is sufficiently structured to be conflicted and, above all, to tolerate and survive conflict.

From what we know from those close to him, Pollock seemed to be per-petually breaking down or on the verge of breakdown, as his much noted "instability" suggests. That is, he tended more to the psychotic than the neurotic. He seemed more or less regularly to disintegrate and reintegrate, probably by working at his art. He never conquered his alcoholism, although, as noted, he was able to suspend it for a time. I want to suggest that his pathology was borderline. Using Otto Kernberg's characterization of bor-derline personality organization, Pollock had impulse control problems, almost

overwhelming anxiety, and, apart from art, few developed sublimatory channels.[22] As Kernberg states, alcoholism, among other addictions, typically involves "chronic eruption of an impulse which gratifies instinctual needs in a way which is ego dystonic outside of the 'impulse-ridden' episodes," that is, binges, "but which is ego syntonic and actually highly pleasurable during the episode itself."[23] Pollock's depression was ego dystonic, to say the least. It is hard to know whether it had a "quality of impotent rage, or of helplessness-hopelessness in connection with the breakdown of an idealized self concept," or indicated a depressive-masochistic character,[24] or involved depersonalization. The latter seems likely, in view of the fact that his totemic figures can be understood not simply as representations of demonic, that is, unregulated drives, but as depersonalized objects. (The turn to the archetypal is a strategy of depersonalization and also archaic idealization.) Nonetheless, it seems likely, on the basis of Pollock's behavior, that his depression involved what Winnicott called "an anti-social tendency" and, like all depression, indicated "difficulties" handling "the destructive impulses and ideas that go with the experience of object relationships."[25]

This destructiveness surfaced during his binges. As Bryan Robertson wrote, in a book approved by Krasner, "When [Pollock] was drunk and unhappy, and involved in trivial bar squabbles, weapons were sometimes thrust into his hand by avid onlookers."[26] We know one of the objects of his displaced destructiveness from his art: his mother, as his family portrait, with all-powerful phallic-aggressive *Woman*, ca. 1930 (naked except for fetishistic high-heeled shoes and earrings), suggests. The binges were clearly destructive and self-destructive as well as impulse discharging – a futile revolt against low self-regard and a devouring bitch-goddess mother. (A self-portrait, ca. 1930, shows him depressed, disintegrated and anxiety ridden.) Neither Benton, who was his first, traditionalist artistic godfather, no doubt associated with the West, where he was born (Cody, Wyoming), nor Picasso, who was his second, modernist artistic godfather, representing international artistic success and greatness – the drawings occur at and signify a transition from one artistic father figure to another – could stay the self-destructiveness and destructiveness. For the absence of Pollock's real father as a family force to counterbalance his powerful mother – who by reason of his father's weakness was seen by Pollock as all-powerful and became inescapable – had already done its damage.

Winnicott, among other psychoanalysts, points out that the real father represents integrity of self for the infant and child, helping it separate from the mother. For the father's difference represents the autonomy and world beyond merger and intimacy with the mother. Pollock never could make the separation and achieve psychological autonomy, because his father was emotionally missing, or diminished – indeed, apparently swamped and shipwrecked – by his mother. Pollock's father was in fact a farmer who, in the words of Robertson, "left little mark on life and was defeated by the Depression" and, we might add, by Pollock's mother, who is described by Francis O'Connor as "strong-willed" and ambitious and "the dominant force in the family."[27] Pollock's wife, Lee Krasner, was similarly strong-willed, dominant, and ambitious for

him, and no doubt unconsciously represented his mother to him. Neither Benton nor Picasso – good, that is, strong substitute fathers in their different ways – could stabilize Pollock sufficiently, and Pollock's turn to Picasso and modernism can be understood as an acceptance of his instability and the beginning of his attempt to make the artistic best of it, in view of his failure to conquer it in his life.

There is one additional, and crucial, factor in psychosis. According to Kernberg:

> There are two essential tasks that the early ego has to accomplish in rapid succession: (i) the differentiation of self images from object images which form part of early introjections and identifications; (ii) the integration of self and object images built up under the influence of libidinal drive derivatives with their corresponding self and object images built up under the influence of aggressive drive derivatives.[28]

> These two processes fail to a great extent in the case of psychosis, and to some extent in the case of borderline personality organization.[29]

In my opinion the animal representations of the psychoanalytic drawings and the later totemic figures of the paintings – they appear together in several works of the early 1940s – are evidence for the failure of the differentiation of self-images and object images. The animal and totemic objects are handled as self-projections by Pollock, as the "messiness" – which is how I would characterize their ponderous doodling character, which extends to the early 1940s paintings – of the representation indicates. This suggests a psychotic dimension to these object representations, for they imply, in Kernberg's words, "a regressive refusion of self and object images . . . in the form of primitive merging fantasies, with the concomitant blurring of the ego boundaries in the area of differentiation between self and nonself."[30]

In Pollock's case, it is perhaps better to speak of a failure to develop self-image and object image differentiation in the first place, or at least of a very unstable differentiation of them, rather than of their regressive refusion. In any case, whatever differentiation Pollock achieved was perpetually threatened by collapse, as his seemingly constant anxiety suggests. This collapse occurred when Pollock broke down into the disorganization of a binge, his depression failing him, as it were. That is, he was no longer able to use his depression to deny the aggressive attachment to or determination of the object that precluded differentiation of himself from it. The allover gestural works confirm and complete the blurring process. They lyricize his uncontainable aggression, as though libido at last rose to the challenge of aggression, refusing it total domination of the field of the painting, as in the past. But the sense of wholeness and comprehensiveness that results from the orgasmic fusion of aggression and libido in the allover paintings is an illusion. For aggression and libido are not so much purposively reconciled in them as mindlessly merged in a "metaphysical" flux, as it were. Their overmuchness, as one psychoanalyst termed it, ironically signals a lack. For all the presence their painterliness gives them,

the allover paintings show a complete absence of ego, or at best fitful, fragmentary traces of it, as in Pollock's handprint. This represents his artistic ego: the ego that made art was the only viable shred of ego he had. But for all its creativity it could not stabilize Pollock sufficiently to keep him from committing suicide.

In the allover paintings all internal boundaries are lost, implying the lack of any ability to differentiate self-image and object image. The re-emergence of the differentiated object in *Blue Poles, 1952,* is at the same time a pathetic articulation of the undifferentiated self. It is a limbless, barren stick figure – a scarecrow stripped of its rags – in paradoxical contrast to the desperate assertiveness of the rest of the painting. It suggests Pollock's diminished, barely articulate sense of body ego. The pole is an undifferentiated body, defiantly present to no purpose, existentially intense but otherwise ineffective. Pollock's relative lack of body ego is what gives him leave to be so driven in the allover paintings. Thus, what may look like a synthesis of libidinal and aggressive drives in their gesturalism not only acknowledges his inability to effect any differentiation of self-image and object image, but his relative lack of a sense of bodiliness or of being embodied, and thus of being real. Hans Namuth's photographs of Pollock painting seem to show him as all body, but psychologically understood they show him dissipating his body in sensorimotor action or else trying to evoke – with ambiguous success – a sense of bodiliness through such action. Self, object, and body representations virtually disappear from Pollock's painting of this time, which shows us only the massive hemorrhaging of organization in dedifferentiation. It is their absence that makes the allover paintings so "abandoned," that gives them their deceptive air of "license," and that, ironically, makes them so original. A Pollock allover painting is typically a composite of rhythms, but all are interrupted and broken – fragments of rhythm that trail off into inconsequence, like shooting stars.

Winnicott's and Kernberg's concepts lend themselves particularly well to an interpretation of the drawings. If *Guernica* is indeed the point of departure for Pollock's modernism, Pollock, in his drawings, seems to undo or unravel the figures, be they horse, bull, or warrior, that Picasso created. Pollock did this not just out of experimental curiosity, that is, the wish to improvise on them in order to see what he himself could make of and become through them, but also because of his inability to comprehend the strong togetherness and integrity they had, for all their peculiarity. Picasso's figures are highly resolved, however bizarre they may be. Pollock's drawn figures are more fragmented and grotesque than those of Picasso. Indeed, certain heads by Pollock are much more destructively brutalized, to the point of disintegrative incoherence or breakdown, than any by Picasso. That is, Pollock did not so much copy Picasso as cope with Picasso's integrity by undoing what he created. Pollock carried Picasso's figures – distorted by conventional standards but clarified and idealized by stylization and schematization – to a violent reductio ad absurdum, in which they become so disorganized as to seem altogether unstructured and impossible to structure. It is not only that Picasso was a threat as well as a challenge to Pollock – that Pollock was the son in search

of his own artistic integrity, finding it by taking on the father with the intention of castrating him in order not to feel castrated himself – but that Pollock could not comprehend the kind of integrity and representational harmony that Picasso offers, for all the unusualness of his figures.

They in fact derived from his familiar, mature style and, within modernism, were by the late 1930s hardly novel. Indeed, they were canonical – absolutely authoritative. Pollock could not appreciate and comprehend the "classical" clarity and certainty of modernist purpose that Picasso's *Guernica* represented, because Pollock was too psychotically disorganized to do so. Indeed, he was probably such an internal mess that he did not believe he "really" was an artist, the way Picasso was. The fact that he was a late starter probably also contributed to his self-doubt and uncertainty. The psychoanalytic drawings show him catching up to and attempting to master a modernism that was already second nature for his contemporaries Arshile Gorky and Willem de Kooning. In fact, the awkwardness and ponderousness Alloway notes, and the doodling character Polcari remarks on, suggest that Pollock could not even be genuinely improvisational, that is, play freely and dynamically with a given theme. For he was insufficiently organized to tolerate the tension involved in such play, that is, the coherent conflict that would emerge through it – through free gestural association. Instead, Pollock's drawings suggest raw aggression, implying what Kernberg calls the "vicious circles involving projection of aggression and reintrojection of aggressively determined object and self images" that Kernberg thinks "are probably a major factor in the development of both psychosis and borderline personality organization."[31]

Indeed, from another psychoanalytic perspective, Pollock's drawings seem to confirm Kohut's controversial idea that aggression – random, global, isolated aggression – is a disintegration product of self. One could argue that Pollock globalizes this disintegrative aggression in his allover paintings, making the aesthetic best of it by fusing it with libidinal energies in the sexual act of painting, involving the sexual choice of color and tone. But that would be to gloss over the unequivocally destructive character of the gestures of those paintings, already evident in those of the drawings. Certainly those paintings seem to reify non-organization and/or the inability to organize, that is, develop an organization. One might want to call on Melanie Klein's idea of the paranoid-schizoid position to explain Pollock and his proto-modernist drawings and full-blown modernist paintings – that is, one might want to take the death wish and hatred in Pollock's art seriously – if only to acknowledge what art historians tend to ignore, the unresolved and unremitting dedifferentiating violence of Pollock's works, which first appeared explicitly in the psychoanalytic drawings.

I want to conclude by dealing with what I alluded to earlier but did not develop, namely, the issue of perception work in Pollock's drawings, more particularly, the failure of perception work in them. I think the moment of failure of perception work occurs in every modernist artist, particularly those who finally make the leap to non-objectivity. In my opinion to recognize, tolerate, and artistically survive the failure of perception is part of what it

means to be a modern artist. The traditional artist never imagined that perception could fail, or should even show its failure – which is what I think is implicit in the modernist undoing and correlate demonstration of the construction of representation and presentation. (Modernist representation differs from traditional representation in that the former uses conventions of representation to frame the articulation of affect-laden sensorimotor reality – ineffably self-evident in non-objective or presentational art – while the latter uses such conventions to obscure or repress such fundamental experience of being, however much all visual art depends on it.) In Pollock's psychoanalytic drawings we see the beginning of his recognition of the failure of perception and his struggle to accept this failure and make it, paradoxically, the foundation, as it were, of representation. That is, in the drawings we see the beginning of what the allover paintings later ratify: the failure of perception work that is read as the self-undoing of perception – including of introspective perception (possible only with a strong observing ego, which Pollock did not have) – as the basis of art. Indeed, in my opinion part of being modern is recognition and acceptance of the failure of perception, that is, its insubstantiality.

As Sandler notes, Freud suggested, in *Beyond the Pleasure Principle* (1920), "that perception was not in fact an altogether passive process," but is in fact

> a very active process, a part of the ego's essentially integrative activity. It seems clear that there is a very real qualitative difference between incoming sensory stimulation that has passed the external protective barrier, and the percept that we actively construct to modify and confine the sensory excitation.[32]

Moreover, as Sandler writes, "Perception need not be tied to states of consciousness" but can be pre-conscious as well as unconscious. The important point is "that the act of perceiving constitutes an attempt to add 'meaning' to incoming excitation: meaning, that is, in terms of past experience and future activity." Also, "Instinctual drives and the ideas attached to them (so-called unconscious phantasies) can substantially modify the form and content of our perceptions; . . . unpleasant and threatening cues can be suppressed and incongruities overlooked in the act of perception." (Modern art tends to signal rather than overlook them.) There is in effect "a *qualitative organizing component,* related to instinctual wishes and to past memories and to the whole body of organized concepts and schemata built up within the ego, that constitutes an internal frame of reference by which the outside world is assessed." There is thus "a 'perception work' corresponding to the "dream work' " in that the ego modifies "incoming stimulation in exactly the same way as it modifies latent dream thoughts and transforms them into manifest content."[33] This point, incidentally, is not dissimilar to Brenner's idea, mentioned earlier, that verbal behavior is a compromise formation, which I extended to visual behavior, that is, so-called perception.

Now for Sandler the important point is that "the successful act of sensory integration" in perception affords a feeling of safety or security, that is, a reassuring "feeling of well-being, a sort of ego tone," which Sandler thinks

is not only necessary for and an accompaniment of the smooth and effective functioning of the ego, but "reflects ... some fundamental quality of living matter that distinguishes it from the inanimate,"[34] which idea may no doubt be a species of biological mysticism. In any case, it involves the elimination of "trauma, danger, and anxiety" that threaten to "reduce the safety level."[35] Indeed, so important is perception to the safety level, that Sandler argues that "perhaps the most convenient way of heightening safety feeling is through the modification and control of perception."[36] (Such modification and control can be regarded as the essence of art. Art is socially sanctioned modification and control of perception. It is held in high esteem because at its best art affords a profound feeling of safety, as Oscar Wilde said.) "Perception can be said to be in the service of the safety principle"[37] and "secure perceptions" indispensable for a sense of meaningfulness, that is, the conviction that the world is organized according to stable meaning structures, which afford emotional and intellectual safety.

Now one way of understanding what began to happen when Pollock found himself compelled to become a modern artist by turning to Picasso – that is, what began to happen in his psychoanalytic drawings (indeed, what finally makes it permissible for us to regard them in a specifically psychoanalytic light) – is that the process of transformation of latent dream thoughts into the manifest perceived dream miscarried, as it were. One might say that where Picasso was able to sleep sufficiently soundly to produce dream pictures, Pollock's pictures are those of an insomniac suffering from waking nightmares. That is, Pollock was too excited by instinctual wishes – too disorganized to defend against them – to perceptually organize incoming stimulation, so that he became overexcited to the point of total disorganization. That is, he became unable to organize his perceptions. It is this inability that we begin to see in the psychoanalytic drawings and that becomes a full-fledged phenomenon in the allover paintings, which, as I have suggested, objectify the disorganization that first became explicit in Pollock's oeuvre in the drawings, whose most interesting figures barely hold together or suggest a fragile, difficult holding together. Art historically they can no doubt be seen as a positive stylistic development or so-called advance, but psychodynamically they bespeak Pollock's psychotic tendency and traumatic overstimulation (as evidenced by his rapid, rabid gesturalism). This discrepancy is one of the joys of intellectual understanding.

I think it was only in the safety of the treatment situation with Henderson, which in my opinion unconsciously became the model of the modern studio situation for Pollock, that Pollock could begin to articulate his profound and profoundly disintegrative feeling of unsafety – to feel comfortable with and accepting of his disorganization, as it were. This, of course, suggests that he was organized enough and had enough of an ego to make art, for which we are grateful. In general, his perceptual work process failed to do its job, which led him to a sense of the meaninglessness of what he perceived internally – that is, his fantasies – and externally. (I think his conception of them as Jungian archetypes was an all too convenient way of having meaning when there was

none.) In my opinion this sense of meaninglessness becomes dominant and overt in the allover paintings, which is what makes them truly untranslatable and uninterpretable. This state of uninterpretability is ignored by art historians, who find safety with an art in interpreting it and who, like all sane people, have low tolerance for meaninglessness, even when, as Winnicott implies, it may be the most meaningful thing about a modern art, especially when taken with good humor, turning the pain it unconsciously causes into conscious pleasure. Art historians cannot stand to gaze into the abyss of nothingness – nor have it gaze into them – that modern art, to our good fortune, shows us. That is, they cannot tolerate the idea, let alone threat, of going insane, because they cannot imagine surviving it.

Pollock's drawings, then, are about feeling unsafe to the extent of literally being unsafe, that is, not being able to defend against either one's own instinctual wishes or the external world, every sensation of which seems fraught with danger. It is the undoing of Picasso's meaning, and the danger – the sense of being permanently unsafe, of having no external and internal barriers – that surfaces through this undoing, that to me are the most remarkable features of Pollock's drawings. They are features that can be felt only with a psychoanalytic sensibility and conceptualized only psychoanalytically.

11

Art and the Moral Imperative

Analyzing Activist Art

The suspiciousness and evasiveness which is thus mixed in with the all-or-nothing quality of the superego, this organ of moral tradition, makes moral (in the sense of moralistic) man a great potential danger to his own ego – and to that of his fellow men.

Erik H. Erikson, *Childhood and Society*, 1950

SINCE the beginnings of Modern art, it has been assumed that the artist has a special moral authority, which allows him to criticize society with impunity. In a sense, he is a kind of Cassandra, warning of impending disaster – more often announcing that one is living in the midst of disaster, that it is staring one in the face – but not taken seriously, not believed. For example, Manet's *Olympia* is often assumed to have such prophetic, dooms-day, moral import. It supposedly functions as a kind of social conscience, exposing the moral rot of Paris. The picture was experienced as scandalous when it was exhibited in 1865, that is, it aroused anxiety by frankly ac-knowledging the existence of prostitution in the city – implicitly as wide-spread as the image is candid. But Manet's picture does not damn prostitution as a social disaster, nor even present it in a particularly moral light. It does not suggest that because of one moral failing all of bourgeois society is damned and must be swept away. The painting is not about sin, whether of the individual or society.

Rather, Manet's picture deals, nonjudgmentally, with the psychological subtleties of the relationship between the bourgeois prostitute and her bour-geois customer, implicitly the spectator. (Indeed, the work makes the invisible spectator – the subjective viewer – its secretly central subject matter as much as Velázquez's *Las Meninas* does.) She clearly dominates him with the arrogance of her regal nakedness and glance. She will give him what he wants on her terms, that is, without losing her dignity and emotional insularity. She has power over him, because she coldly understands the need which brings him

to her. He, regarding her only as a sexual instrument, and otherwise of no human interest, inadvertently reveals his general attitude to life, that is, his bourgeois inability to form more than a transient, instrumental, exchange relationship with anyone.

Manet has no moral opinion about the participants in the scene, nor can his work be intepreted as a revelation of the abysmal inhumanness of bourgeois society in general – a kind of allegorical microcosm of its limitless cruelty. No doubt it is a society in which each person is simultaneously victimizer and victim, unwittingly oscillating between the roles. Rather, Manet describes, with observational skill suggesting profound insight, a very particular social situation. He does not generalize about society as a whole. His ironical method – the reprise and modernization of Titian's *Venus of Urbino* – is coolly analytic in tone. He is the neutral observer rather than the impassioned moralist or prophet of social doom. There is no sense of righteous indignation, no Zolaesque note of accusation – no moral echo or apocalyptic reverberation – in this work. In the end, Manet's picture seems of greater aesthetic than moral interest. Indeed, its moral interest is filtered through an aesthetic of ironical indifference which informs its every sensuous detail.

I dwell at some slight length on this psychological aspect of Manet's picture to indicate that all is not what it seems in ostensibly moralizing art. The artist's attitude to his social content is as important as that content itself, indeed, more important artistically. Manet's ironical indifference not only embodies his intention toward sexuality in general, but determines his construction of the particular erotic scene. Ironical indifference permits him to have his sexual cake while seeming not to: the picture seems simultaneously to forcefully exhibit and nonchalantly distance us from Olympia's sexuality. In the end, that sexuality is evident in the fetishistic character of her body rather than in its stark nakedness – in her body's firmness and her superior alertness, even as she reclines, and especially through the fetishistic neckband, armband, and shoes that ornament it.

I would hardly deny that a society may be morally faulty in its very structure – organized in a less than humane way for all its members. But why should the artist become obsessed with the problems of society to the extent that they come to dominate his art? No doubt art can and perhaps should be a vehicle for social commentary, even exposé and editorializing – how responsible or irresponsible, effective or ineffective such disclosure and advocacy are must be debated – but the question is whether it does not compromise art in some fundamental way. Moreover, why should the artist claim, as I think he implicitly does, moral superiority to society? Why does he morally privilege himself, a privilege which allows him to feel, with little discomfort or ambivalence, justified in his opposition to society? What allows him to label it, without much social observation or insight into its institutions, let alone reflection on its character as a whole – indeed, in gross, preconceived overgeneralization – morally bankrupt, a moral failure? What leads him to imagine that he stands on a higher moral plane than society, in effect outside of and beyond the social heap? What leads him to elevate himself as its judge, pre-

dictably damning society from above? What makes him believe he knows what is good for society better than its other members?

Manet, along with Courbet, the official father of Modern moral realism, does not in fact morally privilege himself the way later self-proclaimed neo-moral realists – so-called activist artists – do, largely because he remains concerned with aesthetic issues. This hardly denies the moral meaning of his work; but it does subsume it in aesthetic meaning. Indeed, the moral, because it is aesthetically mediated, becomes equivocal – less a matter of passing judgment, according to preconceived standards, on the individuals depicted in the human scene, than of recognizing the complexity of their relationship, which exists beyond good and evil. But Manet's idea of a moral situation seems old-fashioned – all too hesitant – to neo-moral activist artists, who are not at all reluctant to pass moral judgment on society.

What is of interest to me is the cast of mind that leads the artist to attribute unique moral grandeur to himself. He is of course hardly the only member of society who does so. And, in his case, as in those of the others, moral pretentiousness serves an indispensable psychic function. But his case is different, for his emphasis on the moral purpose of art is at odds with the assumption that its essential purpose is aesthetic. Whatever else it might articulate, and as important as that may be, is secondary to its goal of achieving aesthetic importance. In other words, the moralizing artist uses art in a fundamentally inappropriate way. He misapplies it, as it were. No doubt art can and does have moral implications, but these are beside the point of its aesthetic intention. However, the moralizing artist thinks righteousness is more important than aesthetics. The latter, he believes, must serve the former, not vice versa. How does he come to believe this? Why does he perversely justify art in moral rather than aesthetic terms? Why, psychologically speaking, does he stand the meaning of art on its head, making a secondary meaning it might have primary and its primary meaning secondary?

In asserting that "today art is absolutely a secondary affair," of import only to the extent that it works "by opposition," convincing "this world that it is ugly, ill, and hypocritical,"[1] George Grosz was arguing that moral concern must be made prior to aesthetic concern in bourgeois society. He was, I might add, attempting to shame it into suicide, which would undoubtedly facilitate his revolutionary cause. Art must serve humanity and the truth, both betrayed by capitalism. Presumably neither is of interest to aesthetically oriented art. Notice that there is no room for a mixed picture here, no tolerance of ambiguity – no recognition that capitalism simultaneously does and does not serve humanity and the truth, and that aesthetically oriented art, in its own indirect way, also does. Many of John Heartfield's works appeared in a magazine called *Pleite (Bankrupt)*, a supplement to a monthly paper named *Der Gegner (The Opponent)*, and show a similar punitive moral rectitude – oppositionality, to use the preferred word.

Grosz said that he preferred "the tendentious painters, the moralists: Hogarth, Goya, Daumier, and such artists" to those who "strove to portray the beauty of the world."[2] Is the beauty of the world less important because of

the moral horrors of society? Are those moral horrors the exclusive truth about society? Why should Grosz think that "if art was still to have a meaning, it had to submit"[3] to – participate in – sociopolitical reality? Grosz was hardly the first artist and person to discover the misery of the world and to attempt to make it a better, more humane place, whether by revolution or reform. But he may be one of the first to assert that art is of no value unless it does. After all, Hogarth, Goya, and Daumier thought it was of value for aesthetic reasons as well. Moreover, it is not clear that they were sitting in moral judgment on society, and concerned to change it. It can be convincingly argued that they criticized it by satirically observing it, with great wit and acuteness, but did not think it would ever change altogether for the good. They accepted its moral rottenness as part of the human comedy, without overgeneralizing either. They had a more discriminating attitude to it. Grosz's enlistment of them in his revolutionary cause is generally false if partially true to their spirit. For they have indeed, ironically, turned out to be Cassandras – that is, incidental prophets of the foreordained – rather than revolutionaries or reformists. Indeed, so have Grosz and Heartfield. Today we value their art for its psycho-aesthetic qualities, not the revolutionary cause it served, which has come to seem just as inhumane, corrupt, and power-hungry as the social authority it aimed to overthrow.

The social protest of the moralizing artist, and his general conception of art as inherently moral – which he thinks makes him a more authentic, authoritative artist than the aesthetically oriented artist – is necessary to his self-regard. This is especially so in the Modern situation of artistic decadence, so-called pluralism, indicative of stylistic insecurity and, even more fundamentally, basic uncertainty about the character and necessity of art. Nothing any longer seems innately artistic – perhaps the basic meaning of artistic decadence. Decadence is an ambiguous concept, traditionally having to do with the dialectic of decay and rejuvenation. But it can also be regarded positively: the splitting of art into a variety of conflicting factions, seemingly weakening it as a whole, in fact signals its healthy differentiation, that is, the discovery of new artistic possibilities. But the fragmentation of art is no doubt also an enfeeblement of it, and suggests general uncertainty about its effect on the individual and society – its impact. It is as though art must try out a variety of stylistic and conceptual strategies in the hopes that one will hit the psychosocial mark – take hold in human as well as art history.

The activist artist's moral intention is not simply the latest instance of the old belief, traceable to antiquity, that art must have a moral purpose to be socially credible, but the facile answer to a complex epistemological and narcissistic crisis – to art's seemingly unresolvable self-conflict and undefinability, inherent uncertainty and lack of self-identity, leading to its ambiguous fragmentation. Activist art is one subliminally anxious response to the modern inability to achieve a totally cohesive, seemingly self-adequate work of art, whose parts are decisively equilibrated – an art emblematic of ego strength and self-integration. In lieu of what increasingly looks like a modern incapacity to achieve a work of art that seems integral in itself – a seamlessly whole yet

subtly differentiated work, ripe despite the incommensurateness of its parts –
activist art offers a totalitarian conception of art as moralistic. That is, it totalizes
art as morally responsible or dispenses with it as next to nothing at all. Activist
art believes in effect that the only hope of putting the pieces of the Humpty
Dumpty of art together again is by giving it an exclusively moral deter-
mination.

The artist's claim to moral authority has escalated in the last decade. He
presents himself as though he alone was sufficiently fit to wear the mantle of
moral authority. He in effect exhibits himself as society's superego – its most
authentic moral force. Indeed, in the last decade we have seen the virtual
institutionalization of moralizing activist art. In certain quarters it is assumed
that an art without an overt moral mission is necessarily immoral. This is the
current version of the artist-moralist's case against doggedly aesthetic art. So
influential is this view, that art without an overt moral point feels compelled
to insist that it has a covert one, as in the case of Richard Serra's steel plate
sculpture. Supposedly a moral protest against capitalistic society, especially in
the way the sculpture presumably "defeats" the capitalistic skyscraper, if Ser-
ra's work must have sociomoral meaning, it can in fact be said to epitomize
rather than resist the social order. For its crudity and delusional grandiosity,
and especially the contradiction between its heroic look and inner shakiness –
bold, self-confident appearance and structural unsoundness, giving one the
sense of its inner insecurity – are exactly the traits of capitalistic society.

Similarly, Ross Bleckner declares his black paintings memorials to people
with AIDS, as though their aesthetic elegance was insufficient to give them
artistic credibility. The need Bleckner feels to wrap his refined pictures in the
cloak of moral concern suggests the defensive posture aesthetic artists must
take to survive in today's self-righteous art world. Support for the victims of
AIDS is without doubt an important moral, sociopolitical cause, and one is
grateful for an artist's sensitivity to it. But to use it to justify an art that needs
no justification is another matter. Bleckner feels compelled to apologize for
producing an essentially aesthetic art, as though that is not good enough. In
fact, he admits that the idea of associating his melancholy images with people
who have died from AIDS occurred to him after he painted them. It was
presumably a way of adding to their inherent gravity, and above all giving
them a social weight and moral credential they did not originally have or need.
No doubt if an artist says so his work can spontaneously acquire an overlay
of moral meaning – a specious moral depth – at will. Such determination to
give art moral meaning seems to allow for spurious superegoism, that is,
conscience as an adaptational, art-politically judicious afterthought.

Moreover, it should be noted that in finding social targets the artist often
avoids the most psychosocially consequent ones, e.g., the entertainment in-
dustry, with its mass production of false subjectivity. Perhaps this is because
the contemporary artist unconsciously regards himself as an entertainer man-
qué – the persona of Warhol seems to imply as much, seems to generalize
itself over the scene like a blight. Is he envious of entertainment's mass appeal
and enormous social effect? I suggest the art of Barbara Kruger and Jenny

Holzer, among others, is the confused result of such emulative, even identificative envy, as well as the wish to make an explicitly public, socially influential, and communicative art. Similarly, ecologically concerned art, while intending to be socially catalytic, deals with an issue that has become not just an urgent matter of survival but entertaining, "popular." It seems that part of the motivation of moralizing activist art is its wish to be socially accepted – to belong – as though that, perhaps in and of itself, will make it credible.

The activist argument is that if art is not explicitly in the moral opposition, it finds itself naively in the service of the immoral status quo. Activist art has not only become a standard part of the art scene – mainstream rather than marginal – but ruthlessly passes judgment on it. Even though, as Lucy Lippard acknowledged in her 1980 review of "The Times Square Show," most "political art" is aesthetically "ineffective" – at best an exorcism of "individual esthetic taboos and cultural constrictions, maybe to pave the way for a more directly powerful statement" – the fact is that most people, like her, are "so encouraged that such things exist at all they find it hard to be harsh on them."[4] Thus, what Lippard elsewhere called artistic "fragments of opposition" (to what?) are acclaimed simply for their oppositionality. "A constituency for activism" wishfully accords them some artistic as well as enormous critical credibility – as though they were profoundly thoughtful, carefully considered evaluations of society – while wondering whether they do in fact have any credibility.[5]

Indeed, most superegoistic art, whether pseudo-high art, such as that of Leon Golub, or pseudo-intellectual (conceptual), such as that of Adrian Piper, or pseudo-populist, such as that of Jerry Kearns (perhaps all in the end neo-comic strip hectoring), among other examples, is aesthetically minor. It is not simply stylistically derivative in an all too overt way, but tends to neutralize the assertiveness and power of its original aesthetic sources, rather than extend and intensify them. But "sticking out like a sore thumb," in Lippard's words – no doubt their aesthetic inadequacy helps them to do so – they do seem to stick it to society, at least according to the true activist believer. To make gestures of defiance – often of little impact except on the emotions of those who make them and those who are predisposed to believe in them – is an old way of seeming avant-garde.

In fact, contemporary activist art is a caricature of avant-garde art. For, while avant-garde art originates in antagonism to existing society and art, as Renato Poggioli remarks, its value ultimately resides in the stylistic innovation which is the aesthetic result of its antagonism – its answer to some sense of the questionableness of existing society and art. In contrast, contemporary activist art, however antagonistic, is more avant-gardistic than avant-garde, for its eschews aesthetic innovation – it is not stylistically challenging. Indeed, the activist artist cannot truly call his style his own. He uses conventionalized avant-garde styles, so simplified and stereotyped that they are no longer either a social threat or intellectual challenge – no longer provocative. He modifies them – with a shrewd sense of art world Realpolitik, so that his work will seem art-historically credible – to his facile communicative purpose. He offers

nothing artistically new, and indeed avoids stylistic experimentation as a threat to communication. This suggests that oppositionality and subversiveness – part of the standard expectation (catechism?) of avant-garde art, automatic guarantees of avant-gardeness – have become trendy clichés, very much in need of a critique. Activist art of course offers none, for it depends on the cliché of oppositionality and subversiveness. It necessarily falls back on superegoism as its justification. The question is whether that is enough.

What is the superego? For Freud, "it exercises the function of self-judgment . . . the censorship of morals. . . . In the same way as the child had no choice but to obey his parents, so the ego later submits to the imperative demands of the superego . . . tension between ego and superego is manifest as a sense of guilt and worthlessness."[6] Joseph Sandler's refinement of the concept of the superego is of special relevance, I think, in understanding the superegoism of activist artists. Sandler thinks "that what is introjected [in superego formation] is neither the personality nor the behavior of the parents, but their *authority*," which is the source of their status.[7] Introjection does not inevitably lead to identification, but in the case of superego formation, involving "introjections that are characteristic of the resolution of the Oedipus complex," it does. These introjections occur "when the child acts in the absence of a parent figure as if the parent were really present."[8] He in effect identifies with his parent figure, that is, he modifies his self-representation on the basis of his model of his parent figure.

By identifying with an adult important to him, the child acquires a sense of authority and status that makes him feel self-important. He feels guilty and worthless – that is, forfeits this sense of authority and status, in effect his adulthood – when his superego turns on him for acting in a way his parent would not approve. This includes ways that would directly threaten the parent's authority and status, in effect dethroning the parent. One might note that aesthetic innovation – a threat, indeed, an artist's overt attempt to overthrow and oust the style of his parent artist figures – is one such way.

The moralizing artist, by way of his opposition to existing society and aesthetically oriented art, reenacts the process of superego formation. For society is the parent of us all and aesthetically oriented art is the parent of every artist. It is because he makes art that an artist is regarded as an artist, not because he moralizes. But there is a crucial difference: where the aesthetically oriented artist identifies with an existing society and aesthetically oriented art which he experiences as good or potentially good, so that their authority and status are accepted, the moralizing artist identifies with an existing society and aesthetically oriented art he experiences as bad, even irreparably bad, so that their authority and status are rejected. That is, the aesthetically oriented artist regards the world as a good if not perfect parent, while the moralizing artist regards the world as an essentially bad and imperfect parent. The issue is perfection, which the aesthetically oriented artist thinks is possible but improbable. The moralizing artist regards it as impossible; he thinks it likely that the parental world will remain imperfect forever. Moreover, he forces rec-

ognition of its imperfection on it by holding up a utopian mirror to it, as though to indicate that it is even worse than it is by showing how immeasurably far from perfection it is.

The aesthetically oriented artist experiences the world as disappointing but desirable, which is why his art tends to imply that it is beautiful but flawed. It is not the best of all possible worlds, but it is a good enough world, at least good enough to enjoy in some ways. He accepts the fact that he must live in it, and makes the aesthetic best of that fact. But the moralizing artist is completely disappointed in the world; he disdains it altogether, and would rather not live in it. He gets no pleasure from it. He in effect degrades, even vicariously destroys it in his art, and in the process, fantasizes an alternative, more adequate world – one simultaneously more perfect in itself and perfectly attuned to his needs.

The moralizing artist acquires his authority and status, at least in his mind, by relentlessly opposing – indeed, violently repudiating – the world. This opposition reassures him that he is inherently more perfect – or at least has more authority and status – than it. His superego in effect locates itself above the world, in the judgmental position of the disapproving adult parent. He harshly judges the parental world as he imagines it once harshly judged him. That is, he has become, paradoxically, the bad disapproving parent he regards the world to be. Through identification, he has taken on its identity, as he unconsciously experiences it. He has internalized his feeling of the parental world's opposition to him, and then externalized this feeling in his opposition to the world. His punitiveness is the world's badness magnified and personalized. Unwittingly, he reveals himself as no more perfect than the world, indeed, as perfectly bad as it is. He is a no better – no more sensitive – parent to it than it was to him.

In contrast, the aesthetically oriented artist acquires his sense of authority and status by identifying with a world he regards as a hopeful if realistically difficult place. His superego tends to be more helpful and supportive than punitive and hurtful. It regards itself as neither more nor less perfect than the world. It is not in fundamental conflict with the world, as in the case of the moralizing artist.

Essentially, the authority and status of the parent come to one as facilitating or as frustrating – in positive or negative form – and this is registered in the difference between the aesthetically oriented and moralizing artist. This psychic situation is complicated by the fact that the moralizing artist unconsciously feels guilty because of his negative attitude to the world. However bad, it remains the parent from which he takes his identity – from whom he has learned his most fundamental attitude to life. His guilt is generated by the peculiarly circular conflict of internalizing a parenting world that he unconsciously experiences as opposed to him and that he consciously opposes, that is, would like to be liberated from but on which he is in fact emotionally dependent, indeed fixated, as his identification with it indicates.

He attempts to undo his guilt by changing the world in the name of a utopian vision of it, that is, a fantasy of it as perfect, or eternally – unreasonably

– good. But this is as maladaptive as his unreasoned, grandly generalizing opposition to it – the other side of the same uncritical, unrealistic coin. Moreover, his utopianism is paradoxical, for his opposition to the world ends up destroying rather than perfecting it. Like many other perfectionists, he implicitly believes that destruction must be total for reconstruction to be perfect. In practice, the perfectionist both begins and ends in destruction, getting nowhere near perfection in whatever reconstruction follows. There is no creation *ex nihilo,* especially no creation of perfection *ex nihilo.*

The utopian perfectionist is bogged down in the myth of radical new beginnings – the miraculous new start – from which many revolutions take courage. It is clearly a matter of psychotic self-deception and failure of reality testing. In his realistic artistic practice in contrast to his emotional theory of utopia, the oppositional artist in effect destroys the bad old world without giving much hint of the perfectly good new one. The oppositional artist in effect becomes the world's censor – to the point of unconsciously believing that he has the authority to destroy it should it not become good – under the guise of being its good conscience, concerned to perfect it. The oppositional artist never brings utopia – the revolutionarily good world – into true focus. It remains perennially vague, a numinous, sentimental alternative, hardly even an outlet for his outrage at the rotten old, profoundly fallen, world.

The oppositional artist sees no moral predicament in the contradiction between his relentlessly negative attitude to the world and his general utopian expectations of a new one. He does not realize that both are absurdly unrealistic. Even if he has a concrete program, he shows its lack of realism by insisting upon its instant implementation. All that finally matters is that his superego remain strong, that he exercise it ruthlessly, and that the world be damned as infinitely imperfectible. The oppositional artist is in effect trapped in a sadomasochistic relationship with his inadequate parent society. His self-styled subversiveness bespeaks that sadomasochism.

Part of the world's badness for the artist-moralist is that it presents itself as aesthetically seductive – beautiful, as Grosz says. Sandler has written "that those who most vocally proclaim moral precepts are often those who feel most guilty about their own unconscious wish to do what they criticize in others."[9] Aesthetic allure is the world's ultimate hypocrisy for the moralist-artist. It leads one to lower one's guard, to relax with the world in expectation of pleasure from it. In weakening the superego, beauty deprives one of one's major defenses against the world's evil. The moralist-artist is a Samson aware that if he succumbs to the beauty of Delilah he will have no need of his hirsute morality and virile outrage. For him, that amounts to superego self-castration. In short, his conflict spirals out of control.

One reason oppositional art tends to be stylistically simplistic or naive, indeed, aesthetically entropic, is that the artist-moralist is determined to make an art that will not be aesthetically seductive; he comes to believe this in and of itself is a judgment on the world. No doubt moralizing art's anti-aesthetics is regarded as a kind of aesthetics by its advocates. But even they, as noted, could not help but experience "The Times Square Show" as artistically in-

adequate, which suggests that the issue of aesthetics is not entirely dead for them. In any case, it is a truly harsh – suicidal – judgment on art to want to make it a completely moral matter.

The attempt to reduce art to exclusively moral meaning – to impose moral meaning on it to the point of making its aesthetic meaning seem to vanish, or seem so imperceptible as to be irrelevant, so unfelt as to be unessential – is a semiotic repression or neutralization of the desire embodied in the aesthetic. In Barnaby Barratt's words, "Freud's method demonstrates that mental life is composed not only by systems of *semiosis* (a lawful and ordered totality of signs such as traces, images, symbols, percepts, categories, beliefs, etc.) but also a movement bearing the impulsions of something that is not itself significatory," called "*desire* (and which is like a mysterious 'energy,' a temporality moving through, yet occluded by, the structuring of signs)." Furthermore,

> mental life is founded upon the *contradictoriness* of these dimensionalities. It is as if the passage of desire incessantly subverts the "identitarian" claims of every semiotic formulation or schematization to coherence, correspondence, and completeness. Moreover, the act of positing semiotic constructions is an immobilization of thinking and speaking as the passage of desire: as if establishing interpretations comprises an arresting point that stands ideologically against the freeing of desire as the recondite temporality of our being.[10]

The artist-moralist attempts to impose a moral limit or construction on art, as its most serious, ultimate meaning, in order to repress, even deny, its fundamental aestheticity, because that aestheticity is the emblem of desire. Aestheticity affords the illusion that desire can exist in a free, pure state – that there can be free passage of pure desire. It assumes that desire can be precipitated out of history by art, even as desire makes history happen, flow. This is an illusion, for desire always exists both constructively and subversively within the semiotics of events. But it is a necessary illusion, luring life on – indeed, justifying it to itself – with the belief that it can know its own depths, renew contact with what is most basic in itself, and as such revitalize itself.

The idea that one must perpetually renew desire to exist in the fullness of one's being – work with fresh desire, desire that has been liberated from its sedimentation in semiosis, and that can be a source of new semioticization of existence – is the motivation for art, or rather aestheticity, which at its best is experienced as desire rejuvenated and re-energizing life. Every aesthetic innovation is an attempt at the restoration of desire. The artist-moralist attempts to immobilize covert aesthetic desire – arrest its vital and vitalizing passage – by making stridently superegotistic art. In doing so, he reveals the conflict of his own mental life – the conflict, already described, implicit in his experience of bad beautifulness of the lifeworld.

The aesthetic articulates – embodies – the mobility or fluidity of dynamic desire, subversive of all constructions of meaning, all fixity of meaning. As Barratt says, dynamic desire of which we are unconscious is "a dimensionality

of meaningfulness *alienated within* the semiotic constructivity of meaning (conscious and preconscious)."[11] The moral, as a major semiotic construction, is an attempt to decisively end the alienation of desire from meaning – to reunify the inherent meaningfulness of desire (even in its pre-semioticity) and the social construction of meaning (assuming they once, in some mythical, primordial past existed in undifferentiated unity) – by specifying desire as having a certain preordained, superordinate meaning: it is implicitly moral, that is, its dynamic is basically directed toward realizing the good.

Unfortunately, like all semiotic constructions of desire, the moral undoes the mystery of dynamic desire – denies its unboundedness, its fundamental uncommittedness – and does so with special vehemence. In fact, desire – wishfulness – is neither good nor bad. Rather, it is morally indifferent – an unholy mix and intertwining of erotic and aggressive wishes, taking the form of impulses. Good and bad are conceptions derived from one's experience of the desire of the parent one is involuntarily related to. They are enforced by society, another parent one is involuntarily related to. Superego art is an attempt, like all efforts to reduce art to clear and distinct meaning and socially redeem it by giving it sociopolitical purpose, to turn art into a message, an obvious communication. To semioticize desire, which can never be fully communicated – certainly not in its fullness, which can only be suggested – is to ingeniously falsify it. To semioticize desire as specifically moral is to grossly falsify it.

Moral determination is one way consciousness resists and represses desire into unconsciousness and conformity, so that meaning will seem transparent and in control of desire, that is, able to name and stabilize it. But desire invariably erupts into – disrupts – consciousness, sooner or later deconstructing, desemioticizing, and demoralizing it. That is, desire undermines the authority of consciously determined – including moral – meaning. Indeed, it signals the self-contradictoriness – ambiguity – of all meaning.

While desire unlawfully erupts, sometimes expectedly, sometimes unexpectedly, in lawful society, art is the privileged site of its appearance. Indeed, it is the socially preferred space for the "difference" desire always makes and embodies. Desire is aesthetically embodied in and through art, that is, given, however tentatively and finally illusorily, a seemingly unfathomable immediacy and self-evidence.

Activist art, the latest version of moralistic art, is at bottom opposed to the free display and play of desire. Indeed, that is what oppositionality in general and opposition to the aesthetic in particular is fundamentally about. As such, activist art is inherently anti-art, for the task of art is to find new ways of articulating desire, freeing it all of all ideological – that is, didactic – predetermination. Desire has neither social, moral, nor generally ideological meaning, however much it may fuel such meanings – which it will revolt against when they become reified, as they invariably do, when there is an attempt to indoctrinate people with them.[12]

Now if art is the privileged site for the appearance of desire, it is at its best when it is decadent. That is, art – or rather, the aesthetic – always implies the

eventual decay and self-destruction of meaning, the collapse of every meaning into dissolute ambiguity and uncertainty, or, as one might say, the reabsorption of meaning into desire, the overwhelming of meaning by the force of desire. To put it another way, the aesthetic, as the representative of dynamic desire, undermines – overthrows from within – consciously held meaning. Mysterious desire – Barratt regards it as mysterious because it is inseparable from being – dissolves clear and distinct meanings in its forceful flux, making them seem fluid, that is, unclear, far from distinct.

In art's Modern period, which, following Arnold Hauser, I think genuinely began, however fitfully, with Mannerism – the first period when consciously held norms of artistic meaning were overthrown by perverse aesthetics, that is, by violently insistent, rebellious desire – art's decadence has accelerated. I believe this has to do with an unconscious effort by its best practitioners – and I don't mean only artists – to throw off the many meanings dogmatically imposed on it and the many uses to which society wants to put it in an effort to enslave the desire it embodies.

Aesthetic decadence is a revolt against the superego ideals and tasks the world wants to burden art with, whether they be philosophical, moral, decorative, economic – all of which cross-fertilize. Decadence, which in Mannerism was an intense but temporary outbreak of fever, became epidemic in the so-called avant-garde or experimental period, and continues to be, even more intensely, in the current Postmodern one, in which innovation has explicitly become an ideology. One sees in this relentless, clichéd determination to be novel the desperation of desire determined, like a blind Samson, to destroy the temple of art in which it is worshipped – and which it built. The aesthetic has become self-disruptive, wildly overthrowing every consciousness or formulation of it. Such self-disruption has become the overarching form and dynamic of desire, propelling the aesthetic out of any intellectual, social, and moral Procrustean bed that attempts to cut it down to size.

To put this another way, art's decadent uncertainty about its identity – its inability to make identitarian claims for itself any longer – has become its "method," as it were, of embodying desire. The chaotic state in which art exists today – not this or that art, but art production as a whole – is the ultimate revenge of desire on every interpretation of art. It destabilizes every meaning attributed to art, making it seem ingeniously absurd.

Of all these meanings, that of moralistic activist art is, as must be reiterated, perhaps the most simplistic and falsifying of art. For more than any other interpretation, it is blind to the fact that art exists, first and foremost, for delectation, as Poussin said. This delectation, as the zoosemiotician Thomas Sebeok argues, is biologically – more particularly, homeostatically – necessary. It is "a kind of cybernetic device for keeping the organism's *milieu interieur*, or . . . *Innenwelt* in balance with its surroundings (*milieu exterieur, Umwelt*)."[13] Or, as another semiotician, Lev Semenovich Vygotsky, writes, "Apparently the possibility of releasing into art powerful passions which cannot find expression in normal everyday life is the biological basis of art."[14] That is, art releases surplus or excess desire, signifying the abundance of desire – ultimately sig-

147

nifying the fact that desire can never be completely assimilated into normal everyday life. There is always some leftover desire, with no place or purpose in ordinary existence. Indeed, the abundance of desire implies that no object is ever completely adequate to it, an idea that Romantic artists, for example, Delacroix, explicitly acknowledged.

One might say that activist superego art impedes – stifles, censors – the release of surplus desire, attempting to convert it into moral fervor, in effect bringing all of desire under totalitarian control, that is, totalizing it for social use. But the moral attempt to channel desire never quite works; it cannot be contained, it spills its banks. Even the moralist-artist's fervor is excessive, in a sense indicating that desire more than righteousness motivates his art, or rather that his moral righteousness is a blind expression of desire. By its nature, desire reaches beyond any object, form, meaning – any fixity which might symbolize and eventually reify it. As noted, desire undermines moral fixation from within, but this turns it inside out to expose it as distorted passion.

In Freud's structural terms, activist art, insofar as it is art – that is, has aesthetic significance – has less to do with the particularities of the case the superego is ruthlessly making against the world, than with the passion of a superego out of control, a superego which has absorbed all id into itself and overrun the ego. In superego art desire has become deluded by its own grandeur. It fantasizes its omnipotence – that is, that nothing can resist it. No doubt nothing can resist desire forever, but that there is resistance is testified to by the fact of civilization – a space of semiotic consistency, as I would call it, however small and vulnerable that space. In it a balance of psychic forces is established.[15]

The absolutized superego of the moralist-artist plays the supreme authority, acts like a tyrant in control of the world – in total command, as though there is no counterforce in the psyche, and indeed the most rash superego art suggests none. As such, superego art is the sign of a completely unbalanced psyche, perhaps one in which a balance of forces will never again be possible. The passionately moral superego is desire at its most grotesque and, more interestingly and ironically, self-destructive. It shows, in effect, desire nihilistically consuming itself, as it were, which is an absurd way of attaining self-regard. It demonstrates that profound paradox – always implicit, always threatening – namely, passion or desire (the life force) at odds with itself, opposed to itself, and as such unwittingly in the service of death. Nonetheless, because of the excess of blind passion motivating it, superego art demonstrates – if in an especially ironical and perverse way – the fundamental truth that art is about the possibilities of desire. More particularly, art is a demonstration of the self-complication of desire, which can even reach such an extreme of self-entanglement – self-fixation – as obsessively moral, aesthetically inadequate art. Can we then say that superego art, because its badness is the sign of twisted desire, shows a kind of aesthetic conscience despite itself?

12

The Modern Fetish

WHAT do Max Klinger's glove, Georges Braque's guitar, Robert Delaunay's Eiffel Tower, Umberto Boccioni's bottle, and Marcel Duchamp's readymade have in common? How is it possible to say that they also share something fundamental with Picasso's *Head of a Woman*, ca. 1909, Raymond Duchamp-Villon's *Maggy*, 1911, and Constantin Brancusi's *Mlle. Pogany*, 1912? Is it important that all these latter are heads of women, that they are considered seminal works, that they were created relatively early in their makers' careers, that they were assessed as crucial to each artist's development, and that they earned each a reputation for originality and innovation?

All these objects, I want to claim, have a fetishistic function. They are whole works of art that function the way single objects function in certain pictures, like the candle in Max Beckmann's *The Night*, 1918–19, and the horn in his *Family Portrait*, 1920; like the various objects in Giorgio de Chirico's and René Magritte's pictures. From Man Ray's *Gift*, 1921, through Alberto Giacometti's *Disagreeable Object*, 1931, and Meret Oppenheim's *Fur-covered Teacup, Saucer, and Spoon*, 1936, to Louise Bourgeois' *Femme Maison* (Woman-house, 1981), and Meyer Vaisman's *The Whole Public Thing*, 1986, a strong streak of fetishism travels through Modern art. This has certainly been acknowledged, but it has not been adequately investigated. Does William Rubin, for example, realize the full import when he remarks, referring to Picasso's idiosyncratic collection of "visually interesting" materials "ranging from paintings, sculptures, and textiles to musical instruments (both tribal and modern), bibelots, souvenirs, and toys," that "Picasso held on to this material with fetishistic devotion throughout his life"?[1] Too often we have relied on the word "fetishistic" when we want to suggest an obsessive commitment. But what is the nature of the obsession itself? Do we really understand the weight of the word "fetishistic"?

The "invisible object" that Alberto Giacometti's female figure is holding in the 1934–35 sculpture of that title, the constellation of objects in Haim Steinbach's *Spirit I*, 1987, the equally highly sheened objects made by Richard Artschwager, R. M. Fischer, Rebecca Horn, and Jeff Koons – their intense

149

polish their most salient quality, making them vibrantly alert with a strange consciousness for all their inanimateness – all resonate with fetishistic significance. Thus it is important that Koons' vacuum cleaners and Steinbach's exercise machines look simultaneously brand new and age old. Steinbach in fact uses archaeological artifacts and decorative objects associated with "high art" alongside contemporary consumer products, suggesting a cross-pollination. For Modern art long ago discovered, in Jean Rousselot's words, that "there are no poetic objects as opposed to others that are not"[2] – indicating "the crisis of the object," as it was called in a 1936 issue of *Cahiers d'art*. But the reason for both the discovery and the crisis has not always been clear. It is because all objects, through stylistic transformation, can be given fetishistic implications, can be "assisted" to fetishism, like Duchamp's assisted ready-mades. All objects implicitly embody – again in Rousselot's words – "the harshnesses and impurities of the world,"[3] and so especially, we might add, the impurities of the psychic world.

What, then, are the fetish and fetishism? Though psychoanalytic theory has gone through a significant shift in orientation over the years, certain characteristics of the fetish object have been rather consistently defined. It is, first of all, as Phyllis Greenacre notes, "a non-genital object [used] as part of the sexual act without which gratification cannot be obtained."[4] Often, "not only the possession of the object but a ritualistic use of it . . . is essential."[5] According to Freud, the male fetishist regressively believes in the primal fantasy that woman – the mother, everybody's first woman, as it were – has a phallus. The fetishist clings to this infantile fantasy with unconscious tenacity. The fetish is a "compromise" construction – "such as is only possible in the realm of unconscious modes of thought"[6] – that provisionally resolves, by psychically functioning as a substitute phallus, the conflict between "the unwelcome perception" of woman's lack of a penis and "the opposite wish" that she have one.[7]

Recent psychoanalytic thinking argues in effect that the oedipal drives serve as a kind of symbolic camouflage for the pre-oedipal conflict, the ego-splitting of the body image, that occurs when the child confronts its individuation from the mother. The fetish, in this case, as Robert Stoller notes, is "a body part (or an inanimate related object such as a garment) . . . split off from the whole human object."[8] According to Greenacre, the fetish functions as a "new body, . . . a sublimely economic condensation"[9] of the mother's body that provides, "especially through vision,"[10] the illusory comfort of union with the mother and simultaneously disengagement, detachment, disidentification from her. The fetishist's transformation of prosaic objects into poetic symbols is convincing and binding because it reflects the relationship between mother and child, the most intimate, exclusive, and complete relationship there is. It serves to overcome separation anxiety, thereby satisfying a deeper need than the sexual, for it is implicit in these interpretations that the sexual is both the mask and medium of the self.

Greenacre has suggested that there are many social conditions "where the

fetish is not related specifically to the genital performance." It can function "as an amulet or magical object, as a symbolic object in religious rites, as a token in romantic love, and as a special property in children's play."[11] And, we might add, it can function in an artistic rite or as a special property in artistic play. Any object "capable of remaining intact outside the body so that it may at the same time be visually introjected"[12] can operate fetishistically, so long as "the . . . demand for indestructibility of the fetish" be satisfied to assure the fetish's "reliability" as a "supplement to fill a sense of lack in the body [and self] image."[13] In these terms, then, one way of compensating for a sense of lack in the body – of making a body unconsciously experienced as defective seem complete or adequate – is through the supplement of the work of art. In fact, what more reliable source can this fantasy demand than works of art, whose presumable immortality – "eternal presence," as it has been called – signals indestructibility?

It is essential to note that psychoanalytic theories identify the initial need for the fetish object as emerging out of the "anxiety-provoking situation" in which the conflict between dependence on and independence from the mother is most intense. In this situation, the fetish as "security prop" brings anxiety under "illusory control."[14] This idea finds its parallel in art, where, typically, we have seen the fetishistic artwork emerge in our century at similarly sensitive, conflict-filled moments in the artist's creative development, the times when he or she, bound to a nurturing tradition, struggles to assert independence from that tradition. Much as Antaeus renewed his strength through contact with his mother the Earth, the Modern artist has been acknowledged as most potent when he or she creates an object that taps the imagined power of the phallic mother. It is no wonder that in the 20th century, when tradition bears down so heavily, the creation of fetishistic works, works full of "still life" – repressed life – has become one of the signifiers of important creative achievement.

Here it must be remarked that while Freud discusses fetishism as essentially a masculine phenomenon – and Greenacre follows him, noting that "fetishism, like genital exhibitionism, is a condition limited almost entirely to males"[15] – yet the making of fetish objects is of course not confined to men. Given the oblivion to which history has consigned so much women's art, it is difficult to construct an ancestry for the female-produced fetish object. Yet such works have been and are being made, and a number of theoreticians, Janine Chasseguet-Smirgel foremost among them, point the way to some useful interpretations.

There is, first of all, sufficient clinical literature to corroborate the notion that the female as well as the male child may in some cases internalize severe anxiety at the recognition of the mother's penislessness. Equally important, as Chasseguet-Smirgel posits,[16] the penis may be understood symbolically rather than literally as the emblem of security and power for both men and women. Thus, artists of both sexes would gain strength by attempting to reify its power in their work. (This reading would not deny the importance of

vaginal imagery for some artists.) In this sense – as the phallus, rather than the penis – it can be associated unconsciously with people and things perceived as powerful, and thus we arrive at the fantasy of the phallic mother.

And so a kind of reversal, or shift, has taken place: where the oedipal consideration of the fetish in the early years of psychoanalysis emphasized its value as an instrument and support of masculinity, the more recent pre-oedipal consideration of the fetish emphasizes that, by evoking primary identification and union with the mother, it puts the child in her position. If we apply this understanding to the modern artist, this risky yet unavoidable position seems at once secure and safe, but also potentially self-annihilating, suicidal, and thus a position fraught with creative possibilities. The very threat of self-loss in the identification can serve as a spur to the Modern artist's *self*-creation. By fetishistically mimicking the phallic mother (the *Urkünstler*, the primary artist or creator) – often evidenced in identification with the female model, or in the emphasis on the female as subject matter – the artist may marshal the power to give birth, to bring a new object into the world. (An object, it should be noted, that, like a child, is "typical," is "traditional," yet also unique. For the artist as "first parent" – the mother – is, in fact, what the notion of the artist's "divinity" articulates in metaphoric disguise.) The fetish, in this case an idealization of origination and originality, reflects the artist's anxiety in creating that new object – the fear of impotence, inconsequence – at the same time that its production signals a triumph over that anxiety: potency and significance.

At this moment of creative anxiety, the Modern artists discussed in this article have been at their most "perverse," as it were. For just as Stoller has pointed out that "unconscious risk-taking" is "a prime component of the sense of excitement and sexual pleasure in perversion," is an antidote to "sexual boredom,"[17] the risk-taking implicit in producing a fetishistic work of art can be an antidote to creative boredom. Indeed, it is a cliché of Modern art that the risk-takers are the ones who produce the greatest art. In fact, the more perversely new and risky that art, the more we honor it. And further, the more those works of art seem to embody a perverse fantasy – seem simultaneously hostile and ideal, inhuman and erotic, cruelly destroyed yet reinvented objects[18] – the more unconsciously taken with them we are. (Andy Warhol's subtly abusive treatment of Marilyn Monroe is one exemplary case.) The modern artist's alternations between bouts of ennui and fits of spleen, to use Charles Baudelaire's distinction, can be seen as an expression of the predicament of the would-be phallic artist, whose struggle against the bourgeoisie – which will at first resist and then assimilate and master the rebel, quite easily, it seems, these days – has engendered an ever more regressive relationship to the phallic woman, and thus an inevitable intensification of fetishism in modern art. In a situation in which the artist must sail between the Scylla of social assimilation and the Charybdis of social groundlessness, a primary course can be unconscious appeal to the mother, the perverse use of the mothering medium or of the mothering tradition. It may be that the risk-taking modern artist is unwittingly acting out bourgeois fantasies of risk-taking and perversity, that works of art in general have become bourgeois fetishes, that is, construc-

tions rejuvenating and signaling the "brilliance" of bourgeois power. That still unsurpassed exemplary fetishization of the aggressive rebellious artist remains Auguste Rodin's *Monument to Balzac*, 1897. Balzac is literally phallic, and even beneath his robes, as preliminary models suggest, he has an erection, signaling his creative power. Even in public, he can walk around with an erection, invisible, yet communicated in his arrogant bearing. It is no accident, I believe, that this is a representation of a writer who so forcefully revealed the vicious psyche of the bourgeois – in fact, integrated its fantasies and realities into his own behavior – and was honored for this by the public he so violently barbed. For the bourgeoisie *will* honor those who reveal their pathology, so long as it is revealed as evidence of their excessive phallic power, and fetishized.

Chasseguet-Smirgel, however, lends an interesting twist to the interpretation of the fetish, arguing that it represents a fantasy of "an anal phallus which attempts to exclude the genital penis from the sexual stage."[19] This notion is relevant for the interpretation of many 20th-century works. Duchamp's readymades, for example, through their radical antiart stance, can be seen to mock the potency of the traditional artist's genital phallicness. *Fountain*, 1917, seems to do this explicitly. (Clearly, its point is to call attention both to the penis and to the lack of it. For by itself, the urinal is a penisless woman – a female receptacle in shape. With the imagined addition of the penis of the man urinating in it, it symbolically becomes a phallic woman.) The twisted composition of flattened objects in his *The Bride Stripped Bare by Her Bachelors, Even (The Large Glass)*, 1915–23, is a tour de force of fetishistic ritual: a radical bifurcation of masculine and feminine imagery in which the bachelors spill their seed as homage to the bride. This masturbatory fantasy indicates a perverse fascination with a regressive, implicitly incestuous, pregenital union with the mother. In fact, throughout his career Duchamp consistently offers us works of art based on anality, "the nipple in the mouth, the stool in the rectum," denying genitality, sweeping away the father "like a magic wand."[20] (Think of his nipple piece, *Please Touch*, 1947.)

Thus it hardly seems surprising that more recent artists such as Ashley Bickerton, Frank Majore, John Miller, and Cindy Sherman, who mock the decadence of art and society by linking them in a common destiny, utilize or feature our society's "objective" remains, fetishizing its hardened feces, as it were, bringing it to a bright, polished, expensive shine in works that seem to defy putrefaction in the act of vigorously, if ironically, asserting it (Figure 9). Like any fetish, these artists' objects are "essentially excremental," idealized excrement, excrement made "colored, bright, sparkling, glittering,"[21] cosmetically appealing, excrement glamorously "made up." In recent years, few more excremental objects have been made than Jeff Koons' silvered trophies.

Exploring another "magic wand" that sweeps away the father, Chasseguet-Smirgel proposes that "the practice of embalming... exactly produces a fetish," by recalling the frequent fantasy of the mother's "unspoiled beauty."[22] And indeed, through intense stylization, artists have embalmed that desired-for unspoiled beauty – think of all those radiant Italian madonnas glowing in the idealizing light cast by the infant's love for them, reflected in their own

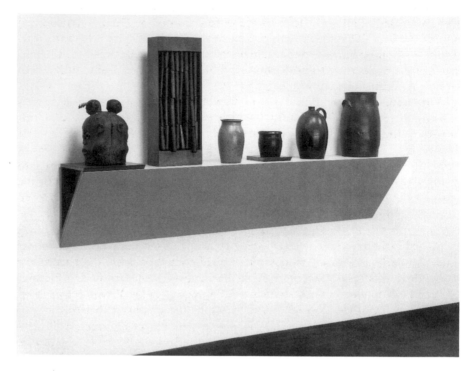

Figure 9. Haim Steinbach, *Untitled (African Mask, Pol Bury Box, Indiana Stoneware)* (1990). Mixed-media construction. 51⅜ × 94 × 15¾ in. Photograph by David Lubarsky, copyright © 1990. Courtesy of the Sonnabend Gallery and Jay Gorney Modern Art, New York.

eyes, lighting up at the very fact of his existence – and we might also smile, recalling Freud's interpretation of Leonardo's *Mona Lisa*. Ultimately, art in general might be understood as a kind of embalming of an important, deep content. Chasseguet-Smirgel writes:

> Puppets, mannequins, waxworks, automatons, dolls, painted scenery, plaster casts, dummies, secret clockworks, mimesis and illusion: all form a part of the fetishist's magic and artful universe. Lying between life and death, animated and mechanic, hybrid creatures and creatures to which hubris gave birth, they all may be likened to fetishes. And, as fetishes, they give us, for a while, the feeling that a world not ruled by our common laws does exist, a marvellous and uncanny world.[23]

One can't help but think of all the modern works involving the mannequin/puppet/doll, from Duchamp's dioramic last work, *Etant donnés: 1° la chute d'eau, 2° le gaz d'éclairage* (Given: 1. the waterfall, 2. the illuminating gas, 1946–66), to the "stage sets" of Edward Kienholz and the life-size plaster figures of George Segal, from the morbid mannequinlike prostitutes in Picasso's *Les*

Demoiselles d'Avignon, 1907, to Salvador Dali's violated mannequins of the '30s, from Hans Bellmer's dolls to the eerie creations of Duane Hanson and John de Andrea. The whole artificial cosmos that art is – its inherent theatricality, exhibitionism – is explicable in terms of fetishism, down to the tendency of the male artist to both abuse and idealize, dispute and identify with the female figure, often simultaneously.

In my opinion, we see this dynamic at work most notoriously in Matisse's four-sculpture series "The Backs," which was begun in ca. 1909, and culminates in the fourth, final, and emotionally as well as stylistically climactic piece of 1931. Matisse turns the female figure away from us so that we cannot see her lack of a penis. Then, in this series, head and spine transform into scrotum sac and phallus before our eyes. Something similar occurs with the figure of the bound and trussed woman in Beckmann's *The Night.* Her back is to us, but a candle is placed on the floor in front of her rigid body – at the level of her buttocks. In David Salle's paintings, his female figure is frequently embalmed by her fashionableness – she is typically a kind of mannequin/model – and is often seen from behind, while phallic rigidity is split off from the body image, assigned to/displaced on the inanimate objects in the picture. (One can't help but connect Salle's images with Dali's *Young Virgin Self-Sodomized by Her Own Chastity,* 1954, in which the phalluses that threaten to violate the woman are explicitly defined as her own, yet conspicuously rendered as independent of her body.) And primary identification with the phallic woman might be seen as the core of Francesco Clemente's "The Fourteen Stations" series, 1981–82, in which Clemente presents seemingly contradictory views of the female figure. In one picture, three hovering, witchlike – bewitching – spirits look down at us, reducing us to the child's position. In another, a woman, again in triplicate, is shown in a prostitutional pose: suggestively seen from the rear, with forbidden but enticing anal entry implied. I would argue that it is because the prostitute *permits* the forbidden pregenital acts desired with the mother that her image is wed in art to the fantasy of the anal phallus. The fact is that the infantile man rarely relates to the prostitute with the genital phallus, but generally practices the forbidden acts of fellatio and sodomy. Similarly, in the infantile position imposed by creative anxiety, it would be reassuring to the male artist to posit an image of woman that is also the mother in disguise. We have certainly seen mother/prostitute emerge as a typical binary pair, as a vision of woman as either/or, in Modern art. But through the lens of psychoanalytic fetish theory, we could see them as two sides of the same psychic coin.

Returning to Matisse, in his *Jeannette V,* 1910–13, the bulbous forehead and nose of the female face form a genital unity. Here again, Matisse's tendency to abstraction suggests a fantasy of the phallic woman, for his destruction of the integrity of the female figure is often inseparable from the phallic idealization of "suggestive" parts of it. In fact, it may be that the Ego Ideal of the fetishist, which, as Chasseguet-Smirgel says, "remains attached to a pregenital model,"[24] would be best realized through abstraction. (The fetish is of course an object abstracted from the body, and abstract in itself.) As she says, "Pre-

Figure 10. Max Klinger, *Anxieties* (1878–80), Plate VII from the portfolio *A Glove* (Berlin, Max Klinger, 1881). Etching, printed in black. Plate: 5⅝ × 10⁹⁄₁₆ in. Courtesy of the Museum of Modern Art, New York, Purchase Fund.

genitality, part objects, erotogenic zones, instincts: all must be idealized by the pervert so that he may be able to pretend to himself and to others that his pregenital sexuality is equal, if not superior, to genitality."[25] What distinguishes the modern fetish-art makers from the Freudianly defined pervert, of course, is that rather than being "threatened [by] the disclosure of the infantile, pre-genital nature of [their] sexual attributes,"[26] they have been willing, with both conscious and unconscious exhibitionism, to flaunt "the undifferentiated sexual dispositions of the child," diverting them to "higher asexual aims" to "provide the energy for a great number of our cultural achievements."[27]

At the same time, in *Jeannette V,* for example, and in the other female head pieces mentioned, we can also see at work the full violative implication of the male artist's treatment of the female. For to phallicize the head of the woman – the symbolic locus of self and mind – is to deny her any other identity than that of mother to the creatively ambitious artist. The problem is that in re-ducing woman to the phallic role, the artist and the public often think that this constitutes relating to woman more "authentically."

The grandfather of the modern fetish object is Max Klinger's glove (Figure 10). The ten etchings of his series *A Glove,* 1878–1880 (engraved in several editions, 1881 on), tell the story of a young man's traumatizing obsession with a lost glove. The seventh drawing, *Anxieties,* suggests the total irrationality of the young man's relationship with the increasingly obscene, grotesque glove: the intensity of ambivalent feeling he has invested in an object that clearly suggests a female body part.

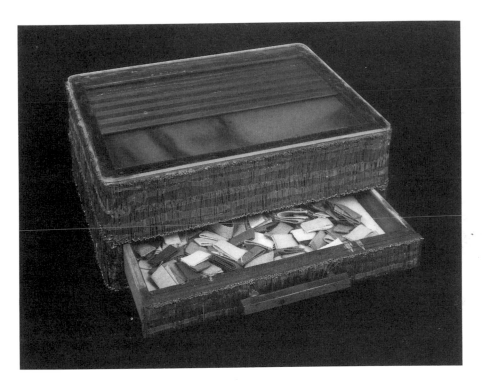

Figure 11. Lucas Samaras, *Box #13* (1964). Mixed media. 4 × 10¼ × 8 in. (closed). Courtesy of the Pace Gallery, New York.

Klinger's series had a profound influence on de Chirico, and through de Chirico on the Surrealists, and through the Surrealists on such artists who simultaneously adulate and punish the object as Jasper Johns, Robert Rauschenberg, and Lucas Samaras (Figure 11). (Joseph Cornell's boxes seem to be the bridge between the European and American surreally oriented object-artists.) The fragmentation that is central to Cubism, Dadaism, Surrealism, and Expressionism has been deployed in different ways in this century to divide and conquer the body. Each of these seminal Modernist styles is an apotheosis of destruction and idealization: dismemberment itself, we might say, through the ever-shifting balance between bodily substance and body shapes in the work, becomes a fetishistic ritual. Think of Picasso's *Girl with a Mandolin (Fanny Tellier),* 1910; Hannah Höch's *The Mother,* 1930; Victor Brauner's *The Morphology of Man,* 1934; Willem de Kooning's "Woman" paintings of the '50s. The aura of losing control, or of incomplete control – as in compositions that don't quite congeal, that retain a rawness, that seem arbitrary assemblages about to fall apart, that suffer from body image problems – is crucial to the work of the contemporary fetishmakers mentioned, to which list we might add the work of others, from the self-constructing, self-destructing machines of Jean Tinguely, to the huge and disjunctive compo-

sitions of James Rosenquist, to the smashed-plate paintings of Julian Schnabel. Though these approaches evolved independently of Klinger, nonetheless his conscious indifference to conventional technical excellence and solid unified structure, his grimness (for which he was both faulted and celebrated), and the harshness of his apparently ill-composed etchings, with their vertiginous, centrifugal look, suggest him as an important precursor of Modern disintegrative strategies.

Certainly Klinger's glove is the fetish object par excellence. For an item of women's clothing, Freud proposes, is generally "the last impression received before the uncanny traumatic one,"[28] and therefore typically becomes the fetish object. "Thus," he wrote, "the foot or shoe owes its attraction as a fetish, or part of it, to the circumstance that the inquisitive boy used to peer up the woman's legs toward her genitals. Velvet and fur reproduce – as has long been suspected – the sight of the pubic hair which ought to have revealed the longed-for penis; the underlinen so often adopted as a fetish reproduces the scene of undressing, the last moment in which the woman could still be regarded as phallic."[29] Kurt Seligmann's *Ultra-Furniture*, 1938, Magritte's *Philosophy in the Boudoir*, 1947, and Rosemarie Trockel's *Schwarzendlos Strümpfe* (Black endless stockings, 1987) certainly seem to commemorate this moment. Greenacre notes, from clinical studies, that "articles of clothing are the most common [fetishes] and include soft silky feminine undergarments. But the commonest fetish of all is the shoe."[30] A glove, in German, is a *Handschuh*, that is, a shoe for the hand. Both glove and shoe share another important quality – they contain and constrict part of the body. And as Greenacre writes, "thongs, laces, and straps"[31] – and other items that wrap and constrain – apotheosize skin-closeness with the mother, absolute bonding with or bondage to the phallic woman. Christo's wrappings of buildings might be seen as hyperbolic examples of such fetishization. Think also of collage – the preoccupation with the skin of the picture. Indeed, the works of Kurt Schwitters fetishize surface as much as they do the dregs of everyday life, their tactility suggesting the anal and excremental.[32] In line with this, soft sculpture, from Duchamp's *Traveller's Folding Item*, 1916, and Man Ray's *The Enigma of Isidore Ducasse*, 1921, to Claes Oldenburg's and Eva Hesse's soft sculptures of the 1960s, clearly disputes the genitally firm or hard.

Robert Mapplethorpe's flowers, such as *Tulips*, 1987, and *Calla Lily*, 1988, are perfect fetishistic gloves – metaphoric orifices that offer a tight, intimate fit for the fantasy anal phallus. Mapplethorpe's portraits of body parts – climaxing in his phallicization of Lisa Lyon's already phallic body in 1980 – are what gives rise to Susan Sontag's assessment of his ability to articulate the "quiddity or *isness* of something"[33] (Figure 12). Sontag's reliance on the medieval concept of concreteness indicates, I believe, a blindness to the possibility that fetishism in operation can project a seemingly perfect object – and one not just of beauty, but of a superior concreteness – in order to satisfy an illusion of (emotional) perfection. Sontag's interpretation, acknowledging the idealizing potential of fetishistic activity while disavowing its simultaneously destructive nature, only serves to confirm fetishism's dual nature, for it is

apparently as emotionally difficult to see both aspects of a fetish object at the same time as it is impossible to determine both the position of the electron and its velocity: only one or the other is observable at any given moment.

Greenacre also points out:

> Other leather objects [than shoes] . . . all have their place. . . . It is a usual requirement that the fetishistic leather object should not be new, and should have been worn by some woman even when it has a somewhat masculine form.[34]

Nancy Grossman's black leathered and zippered sculptures of heads from the late '60s through the '80s, and Richard Lindner's various prostitutional "leath-

Figure 12. Robert Mapplethorpe, *Lisa Lyon* (1981). Copyright © 1981, the Estate of Robert Mapplethorpe.

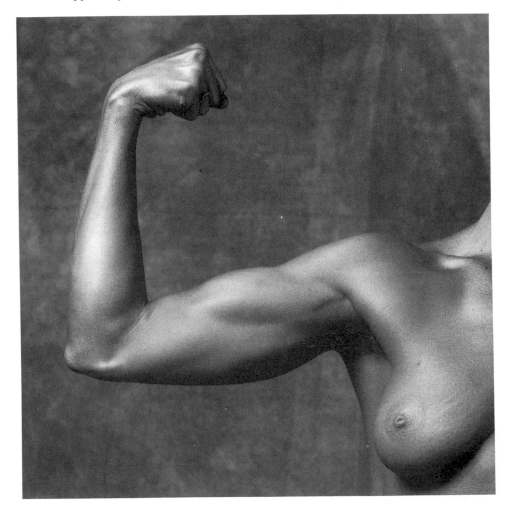

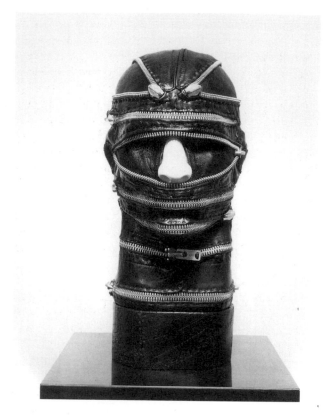

Figure 13. Nancy Grossman, *J.G.* (1969). Carved wood, lacquer, zippers, and leather. 16½ × 7 × 8 in. Private collection. Photograph by Geoffrey Clements. Courtesy of the artist.

ery" women, immediately come to mind, of course[35] (Figure 13). But more important is that the requirements Greenacre lists for leather point to the "janus-facedness in the fetish," as she puts it. "The fetish is conspicuously a bisexual symbol and also serves as a bridge which would both deny and affirm the sexual differences."[36] Brancusi's *Adam and Eve,* 1921, in which the twisted, compressed form representing the male is the support for the more curved, yet phallic prominence of the form representing the female, is a tour de force demonstration of this, as are many of Bourgeois' sculptures, *Femme Couteau* (Knife woman, ca. 1969–70), for example. Equally compelling in this respect is Picasso's *Girl before a Mirror,* 1932, in which the woman pictured hallucinating her dark phallic side in the looking glass is one among the many anatomically split ancestors of the mythototemic figures prevalent in the early 1940s work of such artists as Jackson Pollock and Mark Rothko. In recent years, increasing numbers of artists have devoted themselves to important explorations of that "bridge which would both deny and affirm the sexual differences." In her strange and compelling self-portraits of the 1930s and '40s,

Frida Kahlo, while explicitly rendering her female anatomy, simultaneously emphasized its "masculine" – that is, erect, rigid, severe – qualities. In his film *Conversions*, 1971, Vito Acconci "disguised" his penis between his legs, visually transforming himself into a female while still effectively announcing himself as male. In her films and performance pieces, Carolee Schneemann explores and explodes conventional notions of female sexuality. Hannah Wilke's simultaneous abuses and embellishments of her own body dramatize the power – as well as the victimization – of the assertive woman. Luigi Ontani's "impersonations" of Saint Sebastian, Daphne, and the Angel of the Annunciation, for example, are also metaphysical inquiries into the nature of androgyny. Rhonda Zwillinger's sequin-adorned medieval armatures, some with breasts, some with phalluses, some with swords, and some with several of these elements, combine a surface-fetishizing that recreates the illusion of complete binding with the mother and the upright, stiff structures that we traditionally associate with male aggression. And Joel-Peter Witkin's chillingly explicit photographic portraits of hermaphrodites and transvestites force us to question the very notion of sexual and gender difference.

It is certainly Duchamp, I believe, to whom we can look as the source for such explorations of this century. He gives us the phallic woman implicitly in *Nude Descending a Staircase, No. 2*, 1912 – erect at the top of the staircase, her body, in her descent, reduced in a series of ejaculative spasms from tumescence to detumescence. She then appears more explicitly in *L.H.O.O.Q.*, 1919 – by his conversion of the Mona Lisa through the addition of mustache and goatee. He offers her again in an unrealized detail for the bride of the *Large Glass* – the phallus of the phallic woman – that Duchamp himself called a *Pendu Femelle* ("female hanging thing"). And Duchamp finally, in his greatest, most conceptual work – his self-creation as Rrose Sélavy – presented himself openly as the phallic woman. Finally permitting, I believe, latent homosexual and transvestite desires to come to the forefront, Duchamp became his own fantasized mother.[37] We might, in fact, consider the silence for which Duchamp became famous as a declaration of his complete prostitution to art as, through Rrose Sélavy, Duchamp became the grand courtesan in the bordello of art, the only realm where he could openly enjoy and flaunt his fantasy relationships. And as Rrose Sélavy, Duchamp in the end became Art, that is, the mother of illusion.

Stoller has pointed out that perversion is at bottom "the erotic form of hatred," that behind the seductiveness of the fetish is the wish "to harm an object."[38] When we look closer at Duchamp's work with this understanding, and look particularly at his treatment of the human body, his fusion of that body with machines (think also of Picabia's *Universal Prostitution*, 1916–17, Oskar Schlemmer's mechanical dancers of the '20s, and Vettor Pisani's installation *Studies on Marcel Duchamp*, of 1970), we indeed find the object harmed. The fetishist artist/seducer, in harming the object, also succeeds in harming the spectator – who, after all, as Duchamp insisted, gives the work of art its meaning – by stabbing at his or her unconscious, cutting through stylistic expectations, offering something behind Baudelaire's notion of the

surprise of the new. In short, the fetish objects produced by such artists derive their power from stirring up the uncomfortable recognition, whether acknowledged or not, of the most repressed secrets of our psyche and our culture.

And, paradoxically, from the unconscious of Duchamp, history springs us to the self-conscious Warhol, whose assaults on the spectator may suggest the trajectory of the fetish in our century. Warhol, in fact, seeks to seduce us with images that have supposedly already seduced us. From his soup cans and Brillo boxes to his Marilyn Monroes and electric chairs, Warhol panders to us with the overfamiliar, the pervasive and cheap, the loved and limited, the ideal and actual. His work makes clear that the media creates seductive, thoroughly artificial fetish objects through its mechanical process. A genius at recycling the throwaway public fetish, Warhol reinforced the social hostility and indifference embodied in the media's self-promotion and supposed omnipotence. He made a high art of the delusions of grandeur implicit in the social star, be it person or object – or personified object, or objectified person. Warhol simply extended the star-making – the creative fetishizing process – of our media-oriented society, planting it deep into the art-making process. For the fetishizing process is eagerly – addictively – used by our society to support its performance, its functioning, as though the social body would falter without it. Perhaps this is why the products and the process of the mass media seem to have become the preferred security prop in today's art.

13

The Only Immortal

I shall soon be quite dead at last in spite of all. . . . Yes, I shall be natural at last, I shall suffer more, then less, without drawing any conclusions, I shall pay less heed to myself, I shall be neither hot nor cold any more, I shall be tepid, I shall die tepid, without enthusiasm. I shall not watch myself die, that would spoil everything.

<div align="right">Samuel Beckett, Malone Dies, 1955</div>

Consideration for the dead, who no longer need it, is dearer to us than the truth, and certainly, for most of us, is dearer also than consideration for the living.

<div align="center">Sigmund Freud, "Reflections upon War and Death," 1915</div>

MODERN art is fueled by a sense of death, unconsciously permeated with it. John Ruskin thought death was the muse of great art,[1] and by that standard Modern art as a whole is a great art, as great as the traditional art that consciously and overtly reflected on mortality. But the traditional and the modern worlds differ in attitude here, for in the modern world, which has lost the old belief in eternal life, death has become a newly pervasive pressure. Accordingly, there is a greater inward effort to constrain it – to inhibit awareness of it until it seems not to exist. The consequence is that the sense of death manifests itself indirectly as well as directly in Modern art. In traditional painting and sculpture, death is a subject matter elevated to a certain contemplative distance by style; in Modern art, though death appears sometimes with a declamatory, even demagogic bluntness worthy of Hans Baldung Grien, Pieter Bruegel, or Hans Holbein, the major zone of its appearance is style. Style, as it were, becomes pathological, incorporating the slips and slippages that have led such artists as Maurice de Vlaminck and Willem de Kooning to speak of "stylelessness," and other artists of "antistyle." Where traditional style was a distance defending against life, and at the same time bringing life into ideal focus, Modern style is a realm of parapraxis, an intimate space where what is unconscious becomes conscious as a symptom – an obscure but telling sign (Figure 14).

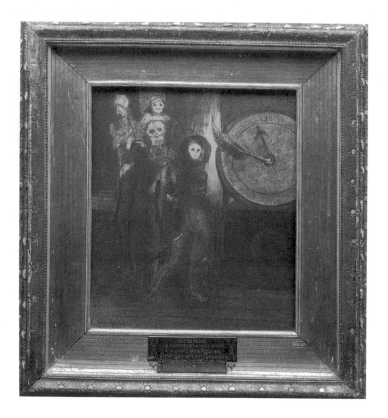

Figure 14. Odilon Redon, *The Masque of the Red Death* (in original frame) (1883). Charcoal on brown paper. 17¼ × 14⅛ in. Courtesy of the Museum of Modern Art, New York, John S. Newberry Collection.

If the driven, Faustian modern character can be understood as in part a defense against the special power of death in this age – the special way it has triumphed in the contemporary world – then Modern art, which is equally full of urgent, heroic ambition and is an aspect of modern character, must also be defensive. It too must reflect our sense of death, irrepressible despite all efforts to deny it. Precontemporary Western society may have lived more intimately, more comfortably, with death than we do, but that was because the old belief in immortality made it less fearsome. To a world deprived of that belief, death becomes far more unbearable,[2] and the knowledge of it is far more repressed – but we only need to repress it because it has become so nakedly visible, unmasked, and undeniable. It was possible once to imagine death as a rebirth into immortal life, a passage that, however painful, brought us into a world superior to our own. Today this fantasy's absurdity seems

apparent. The enhanced sense of human possibility and vitality that our science and technology have created does not avail us in this emotional situation; a nagging suspicion of the nothingness of existence undermines us from within, gnaws at our self-respect. We feel a general disillusionment with the idea of our everlasting existence. Death embodies this psychic sense of nothingness, or seems its instrument.

Modern ambivalence about death is intense: on the one hand, it seems less inevitable than in the traditional world, because of our greater control over nature; on the other, it is experienced as all the more merciless because no longer redemptive. At the same time today we see people who plan to survive forever, freezing their bodies in hope of scientific resurrection, and proliferating epidemics of wars and suicides, new holocausts and genocides, that seem to threaten daily (the current relaxation of tensions in Eastern Europe notwithstanding, detoxifying as it is). In our secular civilization, the belief that death is rebirth seems insane, even if ratified by the collective insanity of religion. (No doubt the fear of death has proven convenient to the powers of church and state that have manipulated this mass anxiety – though it is worth noting that in some societies, the church serves as an alternate institution and thus a refuge against the state.) It is part of the mind's modernization to strip itself of the faith in immortality, but the resulting explicitness of death arouses an unconscious sense of nihilism. Without the protective emotional security that the illusion of immortality afforded, to face or to intuit death may be emotionally annihilative, utterly destructive of the sense of self, as if in prelude to death's actual, physical annihilation. It is as though deep awareness of one's transience made one disown oneself – as though at the end of the tunnel of introspection one found one's nothingness rather than one's realized being. This is a madness antithetical to the madness of the belief in immortality, which gives one the illusion of an indestructible, indivisible self. Instead, we have the fear of imminent self-destruction.

Our subliminal awareness of the bluntness of death haunts our art as much as it does our life. It drives both more than we realize – sometimes like a car out of control. Much has been made of Modern art's dynamic, innovative character, which seems to signal the vitality of the life force, of the erotic. And this energetic newness has certainly proven strong enough to be surprising and shocking in the past, though today, when an increasingly manufactured-looking novelty is an invariable product of the culture industry – it is the most essential part of the spectacle (because Modern art cannot face its inner sense of growing old) – one must be in a special state of collective mindlessness to be stopped in one's tracks by it. Modern art's erotic life force should not blind us to its other, thanatopic side, which is less obvious but more insidious and far-reaching. One could even argue that in this art, erotic force is the facade of the thanatopic – a vital appearance that masks a morbid reality, a creative commitment and fruitfulness that hide an involuted preoccupation with nothingness, a dynamic external engagement that checks a passive internal disenchantment, an energy that obscures an inertia. Modern art is Perseus, mirroring, in style as much as in image, the active and passive forms of death

that combine in the Medusa's head of nothingness – the writhing snakes and the blank, literally petrifying stare, equally deadly and dreadful, that constitute Janus-headed death. And through that mirroring, art triumphs over death – but is turned to stone in the process. Modern art is a Potemkin village of lively, vibrant styles behind which lurks a sense of emptiness, of depression – the modern living death.

If, as Hegel and Heidegger argue, "Only death . . . can put the individual in authentic relationship with himself,"[3] then Modern art is ambiguously authentic, for it is only partially conscious of its being in relation to death. In its parapractic style, it compulsively rehearses its own end – an acting out of an unconsciously repressed intuition. This art may not be self-conscious about death, and thus may have an incomplete sense of self, but the thought of its own mortality appears repeatedly in its disequilibrated manner, its fascination with incongruity, ambivalence, and irony. Such psychic unease is detectable in art, of course, before the Modern period; in fact, although I believe that there are general conclusions to be drawn about what I have been calling "traditional art" – which I recognize as a vast, disparate body of work – I would question whether the Western artistic impulse has expressed itself in a truly intact style since the Renaissance. Where Renaissance artists idealized perfect form, and the perfect integration of content and form, the Mannerists who succeeded them distorted the picture space, rebelliously abandoning the earlier balance and harmony. Mannerism was a distraught style, an art of disequilibrium and fragmentation. For normative beauty was substituted the uncanny – revealing these artists' desire to hold on to traces of the beautiful, though it was no longer available to them entire. (One sees a similar rejection of a normative style in the revolt of diversity that followed Greenbergian formalism in the 20th century – though formalism as Clement Greenberg defined it was empty of anything except the painting, which he misconceived as a new integrity of art.)

No important art since the Mannerist period has been entirely untroubled, entirely undivided against itself, though art preserves an appearance of unity until the breakdowns and schisms of the 19th and 20th centuries. Yet traditional painting and sculpture are still reinforced by the belief in immortality. This is perceptible in their relative continuity – their moments of rupture are generally more material than ideological, their history involves more sustained ideas than abandoned ones, and they tend to integrate old and new in a fresh unity rather than constantly attempting to overthrow the old. Modern art, in contrast, suggests the lack of belief in immortality through its convulsive, rapid-fire development, its amazing profligate restlessness. It is as though its entire torturous, self-contradictory passage – its driven, desperately relentless inventiveness – were an agonizing labor to give birth to something unknown, something altogether beyond the art that used to be called "divine" (a term that not only expressed praise but conveyed an intention). Modern art wants to intimate the unknowable itself, as an alternative to divine immortality.

The alternative to immortality, however, is nothingness – the nothing that Ernest Hemingway has one of his disillusioned characters acknowledge in a revised, updated Hail Mary: "Hail nothing, full of nothing, nothing is with thee."[4] It is the same "nothing" that ends Joseph Conrad's ironically titled *Victory,* 1915, several of whose characters are parodies of Christ – losers in life, like Christ, but unlike him, also losers in death. Hemingway and Conrad neurotically struggle with their loss of faith in immortality. Their characters never triumph over life, but are irreparably wounded by it – are irreversibly tragic, for without our former godlike immortality, the sickness unto death that is life becomes irreducibly meaningless, a mode of nothingness. A similar struggle appears in Modern visual art, not just in imagery – in the compulsive repetitive presentation of morbid, grim, tragically flawed figures, of which there is an abundance – but in style itself. Cubist, Expressionist, and Surrealist styles – the major traditions of 20th-century art, and the starting points for all other stylistic innovations – are quintessentially disintegrative. This is what constitutes their newness. Modern style as a whole tends to become an articulation of discontinuity for its own sake. When it deals with objects, it "disillusions" them – treats them as what has been called an "as if" phenomenon. This tends to "nothing," to make into a no-thing, any and every object, giving it a stylistic kiss of death – hurling a death wish at it.

According to Freud's final formulation of instinct theory, we are all born with an instinct or wish for death, as well as with one for life. This death instinct is the force behind the principle of constancy, that is, the effort to establish a tensionless state, akin to inorganic existence – as opposed to the dynamic change inherent in the life appetite. To deal with this unconscious desire to die, we externalize part of the death wish in the form of aggression (Figure 15). At the same time, the ego retains part of it – the instincts are inalienable – as masochism.[5]

I submit that the quasi-annihilated appearance of so many objects and figures in Modern art is an expression of the death wish – all the stronger because of the loss of the belief in immortality, which is an expression of the life force, the instinctive will to live. More crucially, I submit that the generally disintegrated, unstructured, disorganized or incompletely organized, messy, almost chaotic, chance or accidental look of many works of Modern art has a masochistic dimension, whatever its erotic potential. This look is evident in Modern painterliness, in the discarded junk – dead object – look of certain sculpture, in works from Marcel Duchamp's readymades on through Surrealist poetic objects and Jasper Johns' bronzed pieces to the neo-assemblage "collection" works of contemporary appropriationists. Preferring the inorganic and often the manufactured object to the human or animal body, or, like Johns, fragmenting and then petrifying the body, such works seem to oppose themselves to organic life. Indeed, Duchamp's antiart, and related works by many artists, overtly signal Modern art's death wish – its wish to kill the very idea of art. Duchamp's replacement of art with nonart is in fact a destructive replacement, a demolition. For the nonart substitute, even if we label it "unconventional" art, hardly suffices even as that.

The antisublime, demystifying art of our century, including the work in the Duchampian tradition, engages in a deconstruction of art's sacredness – art's aura – that is itself a symptom of the loss of belief in immortality, the old center of faith. The illusion of immortality was the source of the old sense of the sacred, the numinous; it provided an ideal of transcendence, a faith that life was more than the sum of its material moments and could rise above its contingencies. The sacred is supposedly resuscitated, or renovated, in those Modern surfaces and images full of a hallucinatory sense of absence, surfaces and images that push the limits of the visible until a sense of the inchoate, the unspeakable, the inconceivable emerge – of the invisibility and emptiness that have been mistaken for the infinite and named the sublime. I'm thinking of the paintings of artists like Barnett Newman and Mark Rothko, who sought

Figure 15. Robert Arnason, *Joint* (1984). Mixed media on paper (4 sheets). 75 × 90 in. Photograph by M. Lee Fatherree. Courtesy of Frumkin/Adams Gallery, New York.

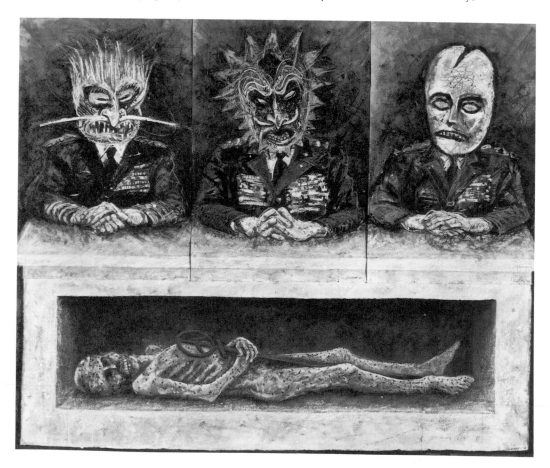

the sublime but found themselves fiddling while it burned. For in that emptiness is actually death, nothingness (Figure 16). And when Modern images deal with objects and figures, they generally lack the sanctified, "still life" look – the look of immortality – for which traditional art so often strived. In the passage from Caspar David Friedrich to Arnold Böcklin to Giorgio de Chirico to René Magritte, one finds the sublime progressively degenerating into the uncanny, almost to the point of bathos. The alternative is a petrified sublime.

The unfinished look of many Modern works of art does not have the same meaning as the *non finito* in some of the works of Leonardo da Vinci and Michelangelo. Those pieces are fully realized mentally; what is physically incomplete shows strong signs of being whole in concept. But the 20th-century *non finito* signals creative frustration, difficulty in conceiving whole, unannihilated forms – both the inability to do so and finally the lack of interest in doing so. The forms rendered in Cubism, Expressionism, and Surrealism are ruins that were never complete or intact in the first place. They suggest that we no longer know how to signal the necessity of completeness as the first requirement for being. The incompleteness of the Modern artwork – the much-remarked unfinished, fragmentary look – is thus another form of masochistic self-defeat. The very idea, quintessentially Modern, that the artwork should be a thing in itself, nonreferential, nonallegorical, separates and distances it from partaking in the vitality of life. (In traditional art, allegory was a crucial mediator of life experience in essentialized form; it has only recently been restored to credibility in 20th-century art, signifying a retreat – an advance? – from Modernism.) Modern art demonstrates the strange workings of death in life, especially when they are not counterbalanced by a confidence in the life in death.

The atmosphere of incomplete temporal process in Modern art reflects a morbid sensitivity to time. If there is no timeless, true, authentic being enduring beyond the contingency and incompleteness of human life, then art's temporal thrust has no sense of a destination to be reached. Furthermore, art must seem timely to seem credible. To make visible art's temporal process – as a multitude have done, from the Cubists through performance artists such as Vito Acconci and on – is to acknowledge art's transience while giving it the appearance of arbitrary life. This is a broad direction in Modernism: to Picasso, for example, art was a project to be abandoned rather than an object to be completed.[6] This general sense of incomplete process mirrors the sense of death as an abandonment rather than a fulfillment of life. And this recognition of both art's and life's inherently incomplete, abandoned condition – of their pathos – is in part responsible for the intense inner dissatisfaction that haunts Modern art's development (as well as for the dissatisfaction that initially greeted it in society). The dissatisfaction also appears in this art's masturbatory thematization of certain visual ideas – from geometry to the deranged figure, from the would-be spontaneous gesture to the ambiguously two-and-three-dimensional surface – which it elevates only to restlessly toy with and ironically manipulate their appearance. It is as though an intensely ambivalent effort were

under way to determine the theme as absolute, while at the same time undermining and disputing its axiomatic, or immortal, character.

The unconscious sense of vulnerability that comes with our heightened awareness of death has its dialectical structure. For implicit to me in Freud's thought is the idea that the death wish is actually a fantasy of death as a return to the moment of one's birth, of one's coming alive. The instinctive desire to return to one's inorganic origins, in order to erase the tension inherent in organic existence, disguises a desire to do something still more emotionally fantastic: to see oneself being born. Even more: our curiosity about the primal scene reflects the wish to see our parents not only in the act of intercourse, but in *the* act of sexual intercourse that conceived us. And the bed of life, the bed in which one was conceived, bears an uncanny resemblance to the deathbed. If just that sperm and just that egg had not fused, then one would not have been born; someone else would have, or no one else. One would have been nothing – just as one will be on the deathbed – and no one would have known the difference.

The doubly taboo desire to see our parents copulating and to see ourselves conceived or born – coming to life – is profoundly akin to the desire to be spectators at our own death.[7] The one involves the wish to witness the moment when we became separated from nothingness and became something – separated from death to become alive. The other involves the wish to watch our return to nothingness from being something. At its most fundamental, creativity is a compulsive recapitulation of these spectacular, tricky, unconsciously linked instants, fraught with chance: the moments of coming into being, coming alive, and of dying, becoming nothing. Our unconscious coupling of these moments becomes an unconscious feeling of seeming to exist between life and death, nothing and something, or, even more deeply, as we will see, of seeming to be alive and dead, something and nothing simultaneously. The awareness of death incorporates this deeply buried fantasy, which in Modern art takes the form of repetitious birth of art in every new style.

If the sense of death has been intensified in the contemporary age, the sense of life must also intensify, if death is not completely to dominate. The issue becomes: How is one to feel alive in a world of death – in a world that actually seems dead, because, as a last despairing measure, we have projected our unconscious sense of death on it as a way of defending ourselves from it, after the defense of immortality has failed? The trick is to make the world seem as dead as oneself or more so, so that one is alive in comparison. And in fact, the modern world blindly pursues death: it has been said that more people have been destroyed by society in the 20th century than in any other. (Previously, nature was the leading destroyer of human life.)

The modern self is generally uncertain how alive it is; it often feels dead.[8] And the sense of living death pervades the contemporary world. Whatever the reasons for this – and many have been projected, from industrialization, which makes us feel like drones in a hive, to the associated collapse of the idea of individuality (reinforced by the contemporary mass media), to the frenzy

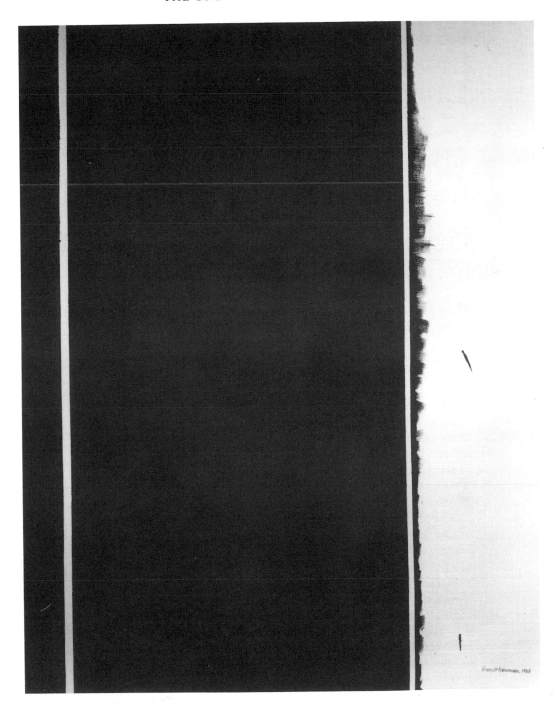

Figure 16. Barnett Newman, *Twelfth Station* (1965). Acrylic on canvas. 78 × 60 in. Courtesy of the National Gallery of Art, Washington, D.C., Robert and Jane Meyerhoff Collection.

of analysis that has reduced life to a maze of codes – Freud's fantasy of the death scene as, in my interpretation, a perverse "extension" of the primal scene reflects our uncertain sense of life: one wants to see oneself being conceived or born in order to confirm that one is indeed alive. It is like pinching oneself to make sure that one is awake – that one's life is more than someone else's dream, that one is not living someone else's life, a very common feeling, associated with the forced compliance (to which there seems no alternative for survival) that is an everyday condition in the modern world. But the fantasy of the death scene also acknowledges that we experience ourselves as half dead and half alive, in effect hovering on the border between the two states. This is the quintessential experience of modern life. Art also struggles with it.

D. W. Winnicott's distinction between the True Self and the False Self can help us understand this experience. From the "True Self," writes Winnicott,

> comes the spontaneous gesture and the personal idea. The spontaneous gesture is the True Self in action. Only the True Self can be creative and only the True Self can feel real. Whereas a True Self feels real, the existence of a False Self results in a feeling unreal or a sense of futility. The False Self, if successful in its function, hides the True Self, or else finds a way of enabling the True Self to start to live. . . . There is but little point in formulating a True Self idea except for the purpose of trying to understand the False Self, because it does no more than collect together the details of the experience of aliveness.[9]

Winnicott's True Self embodies the experience of the body's aliveness and "the idea of the Primary process," that is, a process "essentially not reactive to external stimuli, but primary."[10] The False Self, on the other hand, exists as an organization of reactions to external stimuli. It is entirely a derivative extension of the outer world, even if it is partly devoted to shielding the inner world and to integrating manifestations of that world into a protective coherent form. The False Self cannot escape feeling dead, a feeling articulated through its sense of its own futility and unreality, and especially through its intuition of not being primary.

When the feeling of death in life is not counteracted by an awareness of life's ultimate reality and worth – an awareness previously supplied by the illusion of immortality – the sense of life's transience, with its associated feelings of the falseness, inauthenticity, and futility of being real, tends to dominate. One gives up looking for signs of life, traces of the experience of being alive. And art, which is in part an activity of the False Self, also becomes false – false to itself, for it no longer collects together the details of the experience of aliveness. Art becomes pure style, style stylized. Self-sufficient and hermetic, it supposedly remains a cabalistic code, a secret system of "higher" signifiers, but there is no kind of consciousness to which it is the key, no inner or outer reality it signifies, and whose significance it suggests – except the consciousness of making art, the superior (but unspecified) significance of art as such. It tends to become emotionally problematic, issuing in repressive styles that struggle to show no affect, to be "disembodied," that shy away

from the struggle to embody an attitude to reality and to take an emotional stand within it. Attitudelessness – "selflessness" – is the danger that haunts Modern style.

The ambition to make style eternally new is an attempt to overcome this danger. The avant-garde compulsion toward perpetual stylistic revolution once reflected a dissatisfaction with traditional modes of articulation and the supposedly shallow level of experience they signified. Avant-garde style was in part an attempt to signal more subtle, complex states of experience, making them articulate and ingeniously accessible. But it soon became a substitute for experience of any kind of reality, and above all an opium against depth experience. (The experience of revolutionary style alone is supposed to suffice as "experience.") The supposedly regenerative cycles of avant-gardism merely replace one stylistic code with another, none a guarantee of true selfhood. However much artists have tried to bring signs of spontaneous life back into art (in Abstract Expressionism, say, or in Surrealist automatism, two deliberate – self-defeatingly self-conscious – attempts to make manifest primary process), they have ended up systematizing them back into indicators of style. The avant-garde's self-consciousness is all that remains of its intention to articulate the revolutionary experience of being alive in the modern world. What began as a concern to find the right style for a subtle experience quickly became a concern with the right style for the experience of style.

Modern art is a Sisyphean effort to restore signs of spontaneity to an art entropically running down into pure style because it reflects no belief in its own immortality. A truly vital Modern art would not only collect the details of the experience of aliveness but would integrate them into a new kind of living whole: not a kind of god, or a surrogate for one, as much traditional art implicitly was, but an analogue of the True Self, of authentic inner being. Yet Modern art rarely offers images of such true selfhood, except indirectly, in that it often proffers the body of the work of art as the True Self. Modern works of art in fact tend to fall into two categories: those representational images that offer us images of False Selfhood – of bodies that seem (inwardly) dead, futile, unreal, implying self-obliteration or an extinction of self-image[11] – and those abstract works that offer us the body of art as the true self-representation, that is, as the space where signs of aliveness converge and are given sanctuary. Of course the irony is that these abstract works of art are "dead" to the world. If they are inwardly alive, articulating an inner world of objects, they are externally incommunicado.[12]

Manet's *The Dead Toreador*, 1863, and Degas' *Fallen Jockey*, ca. 1896–98, typify works in the first category. They seem neutrally descriptive, but the bodies rendered are charged with understated futility. The clinical detachment of Manet and Degas – their sense of these bodies as specimens – is a subtle mask over the flat affect typical of depression. I see the literal deadness of the bodies as emblematic of inner deadness – the deep feeling of not being alive, covered over by the intellectual knowledge that one looks alive from the outside. Thus the bodies exist in a peculiar state of irreality rather than either pure unreality or reality. (This is especially true of Manet's static, passive

figures in general.) The tension between the outer look of aliveness and the inner feeling of death becomes explicit in the dramatic, allegorically tinged images by George Grosz, Otto Dix, and other Modern German masters up to Anselm Kiefer, whose paintings' surfaces are full of self-consciously parapractic articulations of death. What counts in all these works is the sense of external death as a morbid kind of internal life, that is, a living death.

The carnival spirit characteristic of many works by Max Beckmann and James Ensor is an antidote to the sense of living death. But these paintings tend to synthesize the life and death instincts, each infecting the other, so that the life energy vigorously articulated through the carnival is corrupted by the wish for death implicit in its excesses. The aura of menace in the works suggests as much. And Ensor's alternation between the mask and the skull – as though, between the False Self of one's social facade and the truth of mortality, there were no room for the true identity of the face – is explicitly morbid. Freud held that life is an unwitting working out of death, implying an inescapable, spontaneous oscillation of life and death impulses. The manic-depressive character of Beckmann's secular dances of death points to the modern inability to regulate this oscillation, to bring it under any kind of emotional control.[13] This lack of internal mastery is responsible for the air of fatalism that haunts his images. (Two of Beckmann's heirs in this respect are George Segal and Edward Kienholz.) Edvard Munch's paintings, whether or not they overtly deal with depression – like the sickroom pictures and such works as *Melancholy (Laura),* 1899 – are stylistically manic-depressive. I would venture that any work that does not show a manic-depressive tension is not part of the Modernist mainstream.

The sense of being simultaneously alive and dead reflects this lack of regulation, the unconscious experience of wild oscillation. Self-regulation is basically the attempt to restrain the death instinct in order to advance life, and such control is the core of selfhood. Biologically, death always wins in life – only human self-consciousness softens nature's victory, by reading it ironically – but successful inner restraint of the death instinct leads to the love of life, and to the ambition to prolong it. Modern society does not consistently encourage this kind of control, however; to do so would imply belief in the self's "ultimacy," a notion related to the illusion of immortality. It is precisely because of the self's apparent transience and irreality in the contemporary world that the death impulse becomes violently irrepressible, dangerously contagious, "depressive." In compensation, the life impulse becomes correspondingly erratic, or "manic," and both threaten to overwhelm the ego's defenses, even annihilate it entirely.

Through abstraction, the best works of art in the second category propose a true selfhood that seems beyond the reach of death. Yet they only simulate the look of immortality, rather than convincing us of its reality. Indeed, a conflict haunts abstract art: immortality is felt to be an insubstantial idea, but is also experienced as inwardly necessary for emotional survival. This seems the case in early as well as late abstraction. For example, it is possible to argue that both Piet Mondrian's transcendence of Symbolism and Robert Ryman's

transcendence of Abstract Expressionism indicate a heroic effort to overcome the death instinct, yet no trust in immortality replaces it, although there is, no doubt, a wishful, regressive desire for that trust's renewal. The illusion of immortality is a regression truly in the service of the ego, but the modern ego cannot let itself be fortified by illusion. (That is its tragedy.)

Abstraction's disillusionment with mimetic representation involves a disillusionment with the false essentialization – immortalization – of objects, and to abandon images of objects is in part to abandon memory, the storehouse of internal pictures of what one has seen in the world. To transcend memory is in some sense to enter eternity. The paintings of an artist like Mondrian can be regarded as a militant forgetfulness of the world, replacing emotionally charged memories of it with irreducible primary colors and forms that supposedly possess a unique, intransitive immediacy. (In contrast, memory is always transitive, which is part of its morbidity.) Mondrian's vividness is part of his struggle against the death instinct: his paintings completely evade nostalgia (for the world), which is always infected with a sense of death, indeed is a manifestation of it. Similarly, Ryman brings under control the aggressive impulse toward which expressionist gesture in general tends. He merges it with his white plane, whose silence is an anticipation of transcendence. Like Mondrian, Ryman seems to move beyond instinct without reaching ego-strengthening belief in immortality, although the idea is a necessary one in the art of both. The deathly symbology of the white monochrome is multifold. Indeed, the absence of color – the reliance on white and black, in, for example, German Expressionist woodcuts, the works of Franz Kline, certain paintings by de Kooning, or Ad Reinhardt's black series – can often in itself be taken as a sign of morbidity.

Many abstract works manage to be less manic depressive than Modern art's more explicit dances of death, precariously balancing the life and death instincts so that they seem to exist simultaneously, each tinging the other, impossible to separate. These works seem to articulate living death and to advocate spiritual rebirth in the same breath, as though they were aspects of the same indescribable, unnamable thing. Such works are remarkable double entendres, psychic Gordian knots, and a short list of the American artists who have produced them might include Adolph Gottlieb, Eva Hesse, Newman, Jackson Pollock, Rothko, and Robert Smithson. Robert Motherwell's elegies and Robert Morris' so-called apocalypses deserve special mention for the deliberateness and urgency with which they articulate the entanglement of the life and death instincts.[14] Morris' works tend to the manic, Motherwell's to the depressive. Both groups of works seem as fraught with the ambition to hold on to signs of life as they are anguished by signs of the absence that is death. Marvelous articulations of that absence, they do not foreclose on the possible presence of life.

In concluding, I would like to call attention to the numerous images of skulls in Modern art, including a recent revival of such imagery – in effect a revival

of the traditional genre of the *vanitas* (Figure 17). The skull is of crucial importance for an understanding of the death-in-life syndrome of Modern art as a whole. Paul Cézanne's *Still Life with Skull and Pitcher*, 1864–65, *Still Life with Skull and Candlestick*, 1866–67, *Three Skulls*, ca. 1902, and *Three Skulls on an Oriental Rug*, 1904, are well known,[15] as is Georgia O'Keeffe's use of the desert (deserted) skull as a symbol of sterility – or, rather, of the oscillation between sterility and creativity, the one haunting the other, as in *Horse's Skull on Blue*, 1930, among many such works. But because human life seems more problematic than ever – even as it becomes socially unendurable, it seems less likely that it will naturally endure – the skull has once again become topical. (In some cases it is a political symbol – telling us we can't take our toys with us, it is one in the eye for the greedy '80s.) Particularly noteworthy are Karel Appel's *Running Through*, 1983; Robert Arneson's various skull images of the mid 1980s, loosely associated with holocaustal death and the "martyrdom" of Jackson Pollock; Jean-Michel Basquiat's *Untitled (Skull)*, 1982 (many of his

Figure 17. Francesco Clemente, *The Fourteen Stations, No. III* (1981–82). Encaustic on canvas. 78 × 93 in. Courtesy of the Saatchi Collection, London.

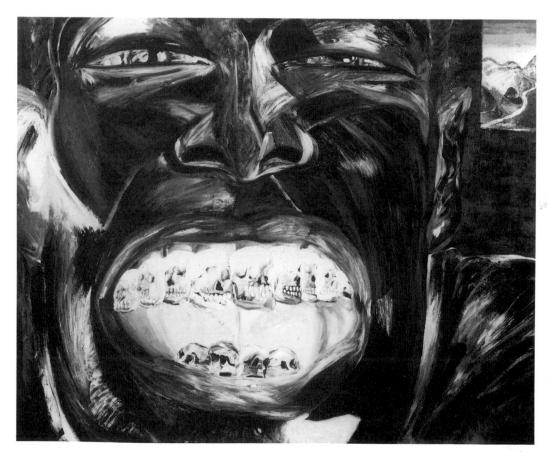

heads are implicitly skulls, or show a skull coming through the skin of the face); Maura Sheehan's *Mayarama* wall, 1987; and many other works, by artists from Ashley Bickerton to Francesco Clemente, from Werner Büttner to Andy Warhol. More is at stake in these images than simple acknowledgment of a convention, or a standard meditation on death. We must go back to Freud to understand their import.

The skull is the ultimate spectator, watching life and art go by. To be the spectator of one's own death, as Freud said, is to survive one's death, which in a sense we do — but only in the form of the watchful skull that testifies to it. In the last analysis, this knowing, testimonial skull symbolizes art itself, as Büttner's *Moderne Kunst* series ("Modern art," 1981) suggests. Yet art, as the cliché says, is an enhancement of life — not of death. And by its very nature, death resists enhancement, idealization, sublimation. The skull is recalcitrant, intransigent; it cannot be subsumed by art. (Cézanne did not simply estheticize the skull into one more still life subject matter, as art historians have said; in the very attempt to estheticize it, he revealed it to be beyond estheticization.) The skull breaks through style the way Samson broke through the ropes that bound him. Spotting it in an image, we emotionally forget the work, and the subtleties of the stylistic rendering. Primary, beyond art, the skull is the ultimate spectacle, the ultimate vulgar object, and makes fascinated philistines of us all. (Georges Ribemont-Dessaignes, at the opening of Max Ernst's 1921 Paris show, gave a disruptive cry of recognition: "It's raining on a skull!")[16] At the same time, art wants to be like the skull: hard, obdurate, implacably there, "living" beyond life. Artists who render the skull are unconsciously articulating a deep generic wish. If their art is to last beyond the day of its making — to be immortal — it must be as definitive as a skull.

I submit that the artist unconsciously envies the skull without fully realizing that it embodies the perverse paradox of art itself. To the unconscious, the skull represents *the* moment of self- and art-recognition: to depict a skull is an ironic fulfillment of the wish to be an immortal self and to make an immortal art. Authentic art arises from an infantile creative impulse, from an emotional regression to preverbal existence. The etymological root of "infant" is "without speech"; the apparent ineffableness of the best art involves a tacit recognition that it has reached the infantile, preverbal, unverbalizable — incommunicado — depths of the self. Paradoxically, the passage to those inchoate depths results in works that seem stunningly adult, amazingly "progressive" psychically, irrepressibly articulate. But it is just this apparent self-assurance of being that indicates how brilliantly false to themselves these works are. For though the authentic work of art originates psychically as a profound "protest against being forced into a false existence," to use Winnicott's language,[17] a protest necessitating a return to the "creative originality" inherent to the True Self of childhood, it is itself in part a dead object. To be sturdy and enduring, it must, skull-like, be a relic of the life force it intended to articulate (even replicate); it must be false to the original, regressive, life-saving impulse that led to its creation. Creativity at its deepest is a return to primary process rather than a response to external stimuli. But external stimuli nec-

177

essarily figure in the artistic process of formalization and stylization, and the sense of primary process that the authentic work of art means to recover tends to be usurped by this secondary elaboration into the work of art. The artwork seems to become a realm of external stimuli rather than a primary space.

This is a familiar enough paradox, but it is all too often forgotten. It helps explain why most works of art become boring, dated – why reputations come and go, few of them truly lasting through the decades. Artworks initially serve as what Winnicott, in another context, has called "a basic ration of the experience of omnipotence"[18] for their makers and for their admirers, but sooner or later they come to seem external to the inner process they mean to signify, the process that affords the infantile sense of omnipotence – of one's own primariness – so bracing and necessary in the disillusioning modern world. They invariably come to seem more dead than alive. (It is not always clear whether critical theorizing about them is an attempt to find new signs of life in them or to confirm their death.) With no malevolent effort on anybody's part, they come to seem false to themselves, no longer to believe in themselves. This strange condition is the consequence of their achievement of what their civilization regards as the look of immortality. But the look makes sense only as long as the civilization does; it is as transient as the civilization. And in the modern period, civilization changes rapidly. The work of art quickly comes to seem timebound. Where once it was timely, now it seems merely a matter of time.

The skull represents this cycle of psychosocial events. It is simultaneously a True Self and a False Self. The artist who represents it turns it into his or her personal idea and makes it seem to exist as spontaneously as possible, but at the same time implicitly acknowledges that it is a false form of existence – it is existence as absence. The skull is the hard ironic truth of immortality – real immortality – rather than some vapid, vague illusion. And those who depict it have their ironic immortality in the form of works of art that, like the skull, were once full of creative life but are now empty shells. Like the skull, art is the strange death in life, all along present under its surface – the morbid "depth" of life's falseness, self-betrayal, at last nakedly revealed. Like the skull, art simultaneously represents innate authenticity and inevitable inauthenticity – the inauthenticity that is unavoidable, even necessary, in life, and that destroys it.

However ironically, the skull represents art's inner conviction of its own immortality, the inner, narcissistic necessity to believe that it will endure forever (if only in the form of an eternal return of attention). This is the ultimate fantasy of infantile omnipotence, the ultimate delusion of grandeur, the ultimate form of belief in the omnipotence of thoughts. At the same time, the skull represents – without irony – the recognition that immortality is a fraud, or, rather, that one can only achieve it by being false to the original creativity out of which it arose. Immortality is simultaneously the glamorous package and the dregs of what was once a living creativity. Thus the desire for immortality is both an authentic affirmation of life and a self-betrayal. To

make art is to be caught in a trap, or, rather, in a vicious closed circle of creative birth and death – the rebirth of authentic selfhood and the living death of self-falsification. At its best, art is a way of playing for and with time; at its worst, it is a socially successful creation of the illusion of immortality.

14

Tart Wit, Wise Humor

Mr. Furniss has shown that the one thing lacking in [the Royal Academicians] is a sense of humour, and that, if they would not take themselves so seriously, they might produce work that would be a joy, and not a weariness, to the world. Whether or not they will profit by the lesson, it is difficult to say, for dulness has become the basis of respectability, and seriousness the only refuge of the shallow.

Oscar Wilde, "The Rout of the R[oyal] A[cademy]," 1887

For all that however we would still like to ask whether the savage's belief in his holiest myths is not, even from the beginning, tinged with a certain element of humour.

Johan Huizinga, *Homo Ludens,* 1944

AVANT-GARDE art has been taken very seriously, and has been described in a variety of serious ways. I want to suggest, seriously, that it be taken comically – that at its core it is an eloquent rearticulation of the comic spirit. The violence that avant-garde art does to the modern view of things is basically comic, for it opposes the weariness and misery that modern seriousness has made of life – the inward catastrophe and shallowness that life has become. The cunning tools of the opposition are wit, humor, and an upbeat sense of the comedy of it all. To be avant-garde is to pursue, through the deliberate development of a comic sensibility, psychic rebirth – optimism rather than pessimism, despite recognition of the world's unpleasant reality.[1]

The comic interpretation of the world has the last word on it, a view that thinkers as different as Marx and Kierkegaard shared, honoring the understanding of life embedded in Greek and Elizabethan drama. Every Greek tragedy was followed by a lewd and funny satyr play, and Elizabethan tragedy, almost always, by a comic jig. (Sometimes the comedy was included in the tragedy.) And these plays end not, or not only, with the tragic individual's fated death, but with a comic return to social normalcy. It is as though their message were that the real task of life is not heroically and fatally to assert

oneself against impossible social odds, but ingeniously to endure, even to flourish, in society, while seeing all its faults and failings, indeed while burdening one's conscience with them. In both style and substance – if the two can be separated – avant-garde revolt has more to do with this subtle kind of courage than with the nihilistic and oddly naive heroism usually attributed to it. Otto Freundlich, in fact, called avant-garde art a "laugh-rocket," differing "from the usual rocket in its shrilly howling laughter while climbing." He thought its sporadic, unexpected occurrence allowed it to accomplish the purpose of its ephemeral existence: to provoke comic terror. Its carnival consciousness illuminates the world.[2]

To treat the inhumane world with ridicule is to make it emotionally tolerable. The self sustains itself through its comic sense of things. Indeed the clown is a witting survivor, as the tragic hero is an unwitting suicide. The self that experiences life as comic, even to the extreme of perverse farce, is not traumatized by the world. Comedy is a way of rolling with the world's shocks rather than meeting them head-on. Tragic heroes are brilliant and conceited, but doomed, and profoundly unfulfilled, as their premature deaths suggest. The unheroic heroes of comedy may seem dumb in comparison, and hardly as proud and provocative, but they have the ready wit and good humor to outsmart the world and enjoy life. Comic unheroes are brilliant in practice, tragic heroes only in theory, and their theory lets them down, especially in its conception of their own importance. The comic unheroes know that nobody is important to the world, which is why they won't die for it, and why they play the nobody, getting out of harm's way.

The world, of course, has always been harsh and indifferent, as the tragic vision has protested at least since Job. But the 20th century's avant-gardes are a response not only to the built-in hardships of the human condition but to the particular social form of modern living – to the bourgeoisie. By "bourgeois" I mean a state of mind, an attitude, not membership of a class, and I refer to the "miserabilistic" life created for us through bourgeois "mathematization," that is, through reification of the world by the rationalizing and demystifying of every aspect of existence.[3] Simply put, avant-garde art has responded to the unconscious need for comic relief in a society that has tried to compel its members to take everything seriously. Bourgeois seriousness is epitomized by Comtean positivism, which assumes that coldly, unimaginatively, "objectively" facing the facts is the only authentically adult attitude, the only real maturity. But such behavior is actually lopsidedly serious – unbalanced in its seriousness. Through the perversity of hilarity, the avant-gardes have tried to restore society's balance.

If, as Horace Walpole said, "the world is a comedy to those that think, a tragedy to those that feel," then avant-garde art treats the world as a comic idea despite feeling it to be a tragedy. Avant-garde art triumphs over tragic feeling by comic thought. A comic attitude is obvious in Dada's antic sense of absurdity, but it also exists, if covertly, in the best nonobjective art. Strange as it may seem, Kasimir Malevich and Piet Mondrian – even Mark Rothko and Robert Ryman – have a comic dimension, or, rather, we see in their work

the struggle to transcend a tragic sense of things with a comically refined art, an art in which formal relationships are both objectively and subjectively ironic. These artists' esthetic, mystic, and idealist revolt against bourgeois materialism – so powerful an avant-garde motive in general – is a search for refuge from the world, and an oblique revenge on it. It is comic to want a coign of vantage on the tragic banality of bourgeois life, a place from which to mourn it in irony.[4] The result is ambivalent – abstract art, tragicomically, is ambiguously bourgeois and antibourgeois, physically profane and inchoately transcendental – but it is nonetheless a determined effort to rise, through good humor, above depression. Indeed, abstraction offers a subtle articulation of the inner struggle between the bourgeois and antibourgeois components of the contemporary self, a struggle evident in Modern art from the first – from Courbet, Manet, and Impressionism on. Later, this struggle is enacted explosively in the best post-Modern comic art.

There is a strange restlessness to avant-garde development. Its rapidly changing theories and means, one successively replacing the other, bespeak a kind of despair, with nonobjective sensation, the readymade, the collage, the stylized unconscious, the colorless or colorful flat plane, all serving as ulti-mately failed refuges from and assaults on banality. But these attempts to undo profane, authoritarian objectivity are in the end comic. They try to transform the profane and commonplace into the marvelous through art's comic white magic – an antidote to the tragically effective black magic of bourgeois al-chemy, decried by Marx at the start of the Communist Manifesto. When Marcel Duchamp, for example, turns a banal readymade object into art, de-bunking the conventional ideas of both, he gives it an illogical preciousness quite outside its mundane functional purpose. Avant-garde antagonism – aggression – has been much commented on, as though the avant-garde critique were a kind of all-out, ruthless attack on modern life.[5] But that aggression has a farcical aspect. In 1912, Apollinaire described Pablo Picasso's "sometimes cruel jokes."[6] Picasso is hardly alone in making jokes on the world, and the avant-garde joke comes to us with the force of a liberating revelation. However temporarily, we feel relieved.[7] The spell of rational seriousness is lifted, and we see the world with comic freshness.

Whether taking a bird's-eye or a frog's-eye view on the world (the dis-tinction is Nietzsche's), the avant-garde joke upsets our sense of it by seeing it differently from the way it sees itself. Indeed, to take an incongruous view is implicitly to be skeptical. The frog's eye sees the bourgeois world from below, as Expressionism and Surrealism do, calling attention to "low" truths about it, realities it has kept hidden even from itself, such as the aggression that underlies its seriousness and the sexuality it fears will undo it. This kind of vision reminds the bourgeois that their seriousness does not make them superior to life. The bird's-eye view from above locates the bourgeois *sub specie aeternitatis,* as it were – as in abstract art, which imagines a higher plane and a more ideal existence (if only inwardly) than the world allows. Such a view suggests that seriousness is not a means of transcendence, as we tend to think.[8]

The numerous, conflicting theories of comedy, taken together, suggest a continuum of at least five phases: irony, buffoonery, caricature, wit, and humor. In distinguishing between them, I follow in part Freud, who wrote that humor has "something of grandeur and elevation. . . . The grandeur in it clearly lies in the triumph of narcissism, the victorious assertion of the ego's invulnerability. The ego refuses to be distressed by the provocations of reality, to let itself be compelled to suffer. It insists that it cannot be affected by the traumas of the external world; it shows, in fact, that such traumas are no more than merely occasions for it to gain pleasure."[9] I suggest that in humor the capacity for affectionate feeling, lost in the wounding world, is recovered.[10] "The aim of wit," on the other hand, "is either simply to afford gratification, or, in so doing, to provide an outlet for aggressive tendencies."[11] And irony, buffoonery, and caricature are all components of wit, stages in its development. Freud thinks that the least humorous kind of humor, irony – "representation by the opposite" – is "no longer a joke,"[12] but remains comic, as the "ironical man who seemed to be less than he was" in comedy of all periods suggests. The ironical man coexists at the beginning of the comic continuum with the buffoon, who "also pretended to be less than he was" and who helps the ironical man play "tricks on everybody." Both types attack the "man who pretended to be more than he was" – the " 'imposter,' "[13] debunking this bourgeois pretender through jokes that puncture his surfeit of self-esteem.

One such joke is to de-idealize the imposter by turning him into his opposite – artistically tricking and trivializing him, as when Daumier represented King Louis Philippe as a homely pear, in 1833. A more famous example is Duchamp's *L.H.O.O.Q.*, 1919, which suggests that however ideal Mona Lisa seems to be, she is a sexual creature and has a vulgar side. (All Duchamp's blasphemies are attempts at de-idealization, whether of women or of art.) As the 18th-century philosopher Frances Hutchinson said, ridicule is an attack against "*false Grandeur*" and interferes with "excessive Admiration." Humor restores honesty. The result is a caricature, funnier than irony and more pointed than buffoonery, an instrument of honest realism: the impostor is shown as more banal than he thinks he is. At the top of the comic continuum is humor, but genuine humor is difficult to achieve; most avant-garde art tends toward wit.

Actually most comedy in general begins and ends in wit, because wit is a readier "comic resolution" than humor. It is also more public, easier to share. Wit is a kind of regression in the ego's service: by convulsively repeating and discharging the childhood traumas that are reactivated by the wrong done us in the world, the witty joke purges those traumas by projecting them outward. (Freud saw Charlie Chaplin as a great comic because he played to perfection the timeless child hurt by modern life, his films thus functioning like the audience's own screen memories.) But there is no regression to infancy in humor. Wit is an aggressive reaction to a world that threatens to infantilize and humiliate us; it is a defensive response to an implicit attack. The humorist, on the other hand, infantilizes the world without for a moment questioning his or her own adulthood. Wit resomatizes the self into a pratfall where humor

reconceptualizes the world as folly. Indeed, humor is a kind of perverse praise of the world's foolishness.

In keeping with its basically conceptual character, humor tends to be largely verbal. But wit involves acting out, a kind of instinctive body language, and even its clever words are often quasi-physical in their allusions to bodily functions. The language of wit is the instrument of an enactment. (Rabelais' witty infant Gargantua is the perfect example.) And wit often resorts to the body language of the infant – because an infant lacks the words an adult might use to rise to the occasion. It is significant, then, that Cubism, Futurism, Dadaism, Suprematism, and Abstract Expressionism, in their different ways, have something of the infant's uncertain, uncoordinated, off-balance but dynamic movement about them. As Baudelaire suggested, the best art restores the magical freshness and strange reflectiveness of peripatetic childhood perception. When avant-garde art loses its awkwardness and becomes sophisticated, of course, it can hardly be called avant-garde any longer, and is unlikely to be witty. Avant-garde art is at its best when it reinstates the comic tentativeness of the infant. The infant is excited about movement, which supports its curiosity about the world. In contrast, the adult moves in a practical, businesslike, bourgeois way.

The bourgeois regard their "mathematical" attitude as truly adult, and thus superior to everybody else's "poetic" attitude to life, which they dismiss as childish. Avant-garde wit not only suggests that imagination is equal to the world, but that the bourgeois themselves have a hidden poetic side. Humor transcends both wit and the bourgeois, for it dialectically integrates them: the humorist is a poetic self who is mathematically clear about the world. If wit is a manic, aggressive attempt to recover from a depressing regression, humor creates a self strong enough to deal with the world without denying it or backing down from it. More subtly, humor generously forgives the world for being the bad thing it is. Humor conveys gratitude for life despite recognizing its hardships and injustices. Yet humor is finally more critical of the world than wit is, for in turning the tables on the world, humor never turns against the self; humor is beyond hurt. Freud's ironical recommendation of the Gestapo to everyone, after it almost killed him and forced him to leave his home, was an act of humor. To say the truth to the enemy's face, as he did, is to show rare strength and freedom.

In its witty rebellion, much avant-garde art is chaotic and irrational in appearance. It lacks decorum, or comically dissolves it. Kurt Schwitters' Merz pictures, Analytical Cubist caricatural portraiture, Jackson Pollock's allover paintings, Willem de Kooning's caricatures of women – all are a kind of ritualized, ironically indecorous chaos. In general, the fragmentation and violence of avant-garde art from Cézanne on are directed, however unwittingly, toward the same end: it is as though to be baptized in quasi-infantile, poetic chaos were the only chance one had to renew oneself in the claustrophobically closed bourgeois world.

Bourgeois pretensions are comically represented by their opposites through-

out avant-garde art. Duchamp's ironic indifference is a subterfuge of self-importance. Dadaist disgust is bourgeois hostility turned inside out, or taken to its logical and absurd conclusion. The representation of sexuality as mechanical, in Dada, and as putrefying, in Surrealism – in Salvador Dali's decaying objects, Hans Bellmer's broken dolls, the tacky instinctiveness of the exquisite corpse – subverts the bourgeois pretension to erotic idealism and to an exaggerated potency. The pansexual gesturalism of Expressionism, on the other hand, both representational and abstract, implies the bourgeois' lack of sexual intensity, even of desire.

Avant-garde wit attacks the dishonesty not only of bourgeois existence but of bourgeois art. This is the gist of the readymade, an unpretentious object that is declared an artwork, making it pretentious – bourgeoisifying it. But to intimidate us into believing that the readymade is art is to suggest the absurdity of the conception of art as ideal. Similarly, Expressionism's and Surrealism's revelation that disruptive sexuality and aggression can never be transcended – that the self can never rise above them – subverts the bourgeois pretension to pure, unperturbed, godlike selfhood. In general, avant-garde wit aims to demoralize the bourgeois impostor by shattering the defensive pretense of being superior to life. The bourgeois are revealed in all their ironical nakedness.

One reason for avant-garde art's constant changes of strategy is its failure to rise to the height of humor, and to humor's psychic security. Also, of course, wit is inherently short-lived – famously, brevity is its soul. Wit always risks becoming one-dimensional and mechanical. This often occurs in post-Modern art, which tends toward specious irony – irony cynical, stylized, and affected. (Examples abound, from David Salle to Jeff Koons, from Meyer Vaisman to Mike Bidlo.) In post-Modernism, wit cannibalizes art itself. Many appropriationist works end up as labored, pseudowitty treatments of past art. Wit made "epic" loses its lyricism and flexibility. It becomes a caricature of itself, a joke that turns on its maker. This kind of artmaking is cruelly cannibalistic, and cannibalism has been analyzed as the ultimate infantilism, for it involves a literal internalization of primary objects or their surrogates.

Modern joke-playing on past art began in earnest with Picasso's 1957 caricatures of Velázquez's *Las Meninas*. Bidlo's more recent caricatures of Picasso's and other Modernist works are hardly as comic. They are too didactic, too concerned to make a theoretical point: to privilege reproduction over invention in artmaking, declaring the obsolescence of originality. The phony-elegant works of Sherrie Levine and Philip Taaffe, among others who "copy" or make "assisted copies," fall into the same category of facile, pseudosubversive caricature. Indeed, copying is a kind of dumb wit – a readymade ironic way to make art inauthentic. It is also profoundly melancholy, for it indicates that copyists are haunted, inwardly dominated, by artist parent-figures.

Picasso's melancholy is not absolute. Transposing the work of his artist elders into the terms of his own art, he reveals his insecurity, but does not completely abort his identity by submitting to that of his sources. Indeed, the insecurity evident in Picasso's protean changes of stylistic identity bespeaks

his comic genius. In his art, as in no other in this century, the comic transcends a depressing sense of tragedy. In contrast, contemporary copyists lack a style of their own that could transform their sources. No doubt they avoid such a style as much as fail to achieve one, in the belief that identity is a social construction they do not need – a belief that sanctions them to become parasites on the hard-won identities of other artists. But the truth is that their sense of self is insufficient for them to realize that the struggle for individuation is a major issue of artmaking. Perhaps they are more masochistic than sadistic, for quotation art involves submission, however ironic, to the host art. Can we say that Modernist wit tends to be sadistic and post-Modernist wit tends to be masochistic? The classical distinction between copying and assimilation is very much to the point of recent quotation art.[14]

The copyists (along with the deadly serious protest artists) are the Royal Academicians of today, but a sense of humor, happily, is alive and well in some quarters. As Johan Huizinga said, art takes the holiest myths with a grain of humor. It reminds us that we have been duped by our own beliefs, including those about artists, many of whom have themselves become bourgeois impostors pretending to be more than they are. One of the pleasures of the successful post-Modern wits is that they are not inflated by seriousness. Indeed, they eschew the excessive self-belief expected of artists since the Renaissance. The current time has introduced a modest, ironical sense of what it is to be an artist – a kind of clown, rather than a tragic hero in the Pollock or Rothko mold. Such unpretentiousness is a welcome relief, as is the sense – presaged by Duchamp – of art and society as farce.

The contemporary humor undoes both credulity and cynicism. Often when we look at art we willingly suspend disbelief; otherwise there is no magic to art and life. As Huizinga said, "one chooses to be the dupe" so that the "sorcery" will work.[15] But the new comic art says that we have come to believe too blindly. By investing our all in an art, we project into it our desire for an intrinsically meaningful life. The art or ideology – and much art today seems little more than ideology, in handsome but thin disguise – becomes the medium of self-legitimation, and of unconscious communion with fellow believers. The trouble is that this fantasy is a narcissistic game – from which the new comic spirit delivers us by renewing our skepticism. But this art also debunks blind disbelief, debunks the playfulness about belief that makes us unsure what we believe, what we stand for, what is holy to us. This secular cynicism is credulity's other side, for it is only the general lack of belief that makes us grasp at the straw of blind faith. Yet it is faith that makes the world emotionally endurable. The new comic spirit tells us that we can believe even while disbelieving, that we can think out of a true sense of play.

The best post-Modernist wit is less serious than Modernist wit, which, in the vehemence of its attack on bourgeois attitudes, ended up as solemn as what it opposed. Post-Modernist wit has no belief system, but shows the interplay of belief and unbelief. The ultimate coolness, after all, is neither to believe nor to disbelieve, but to study the way belief and unbelief work together

– how one inevitably evokes the other. In the Modernist world, belief in the self meant disbelief in the other, expressed as alienation; in the post-Modernist world, both belief and disbelief in both self and other coexist in every self. We post-Moderns are cynical not just about the other, but about ourselves. We are a sum of anxious dialectical relationships, with ourselves and with others, that add up to no whole. Post-Modernist wit articulates this peculiarly farcical self.[16] Post-Modernist humor does the same, but it also mythologizes that perversely distraught self, with a fine irony. It elevates and degrades the self all at once, as in William Wegman's works. The self becomes a kind of joke, but also seems to have integrity.

Martin Kippenberger's *Wenn Sie mit der Freiheit nicht klar kommen, versuchen Sie es doch mit Frauen* (If you can't figure out what freedom is, give it a try with women, 1989) is an impetuous piece of witty buffoonery, equally obscene and hostile. The casualness of this group of photographs – blown-up or inflated snapshots of ordinary scenes and objects are held toward us by a face-making, clowning artist/impostor – harshly mocks the artist as well as the audience. Everyday life becomes deliberately pretentious art. We are in effect invited both to believe and to disbelieve what we are shown: a credible, all-too-actual world – a dumbly secure Germany in which life has no risks – is shown to us through the medium of phony-looking, naively realistic images. To take this work as serious art is to dissolve the world it presents in the laughter of nihilistic exhibitionism and idiosyncratic crankiness, and to take the world pictured seriously is to do the same to the art. In either case the work becomes a laughable disaster. You just can't win, is Kippenberger's message.

A similar sense of irony appears in Peter Fischli and David Weiss' works, especially their film *Der Lauf der Dinge* (The way things go, 1986–87). There, a suspenseful but pointless Rube Goldberg process of chemical and physical chain reaction is set in quasi-perpetual motion, describing and spoofing both the banal course of things in the bourgeois world – and also artmaking, the "work" of art. Like Kippenberger, Fischli and Weiss use the apparently un-predictable to state the predictability of banality, and to debunk it; and like his, their irony tends to buffoonery.

Post-Modernist wit in general falls into two categories. One group of works takes off from the banality of the mass media, following the example of Pop art, which at its best was transitional from Modernist to post-Modernist wit. Other works show avant-garde art itself as a familiar and predictable habit. The point is to use the banal perversely, undermining it from within. The former category includes, among many others, works by Glen Baxter, Steve Gianakos, Keith Haring, Mike Kelley, Kenny Scharf, Julie Wachtel, and Robin Winters – all of whom have used the comic strip or cartoon in a pointedly satirical way, wresting it from its conformist purpose (Figure 18); and by Guillaume Bijl, Sandy Skoglund, and Boyd Webb, who take the everyday furniture of the world and make it into a witty furniture of the mind (a notion implicit in Duchamp and in the later Marcel Broodthaers). In the latter category

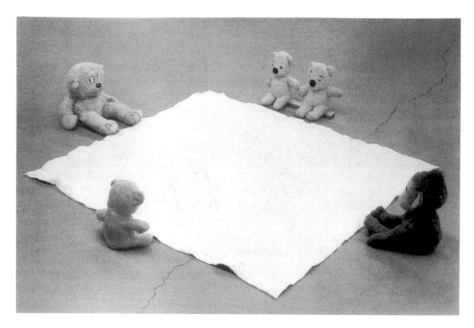

Figure 18. Mike Kelley, *Arena #7 (Bears)* (1990). Mixed media. Installation view. Courtesy of Metro Pictures, New York.

there is the work of John Armleder, George Condo, Vaisman, and Pino Pascali, all of whom have caricatured clichéd avant-garde styles or images (Figure 19). The work of Laurie Anderson, Jenny Holzer, and Barbara Kruger also has a caricatural element, in the second category. The one uses performance art, the other Minimalism, the third clichéd Modernist fragmentation to achieve an effect of solemn wit. Cindy Sherman's caricatures – lately involving takeoffs of the wise old men portrayed in old master art – and Richard Prince's spoofs of abstraction are more insidiously malevolent in their wit (Figures 20 and 21), while Sigmar Polke's, and Gilbert and George's, work hovers between self-mocking grandiosity and ironic ingenuity. All these works vigorously counteract not only the social insults of the present but what the artists see as the artistic insults of the past. As Ad Reinhardt's clowning diagrams of the art world – almost like a patient's charts – and Fluxus' general irreverence show, the art world has always been able to take itself with a certain amount of laughter, as though the refusal of seriousness were a creative act in itself.

One distinction between post-Modernist and Modernist wit is that much of the latter, with exceptions in Dadaism and elsewhere, plays its irony straight. Indeed, Modernist wit is often so deadpan it isn't funny. (Jasper Johns' early work is extraordinarily witty, especially in its Magrittean incongruities, but his comic sense has been neglected, as though to acknowledge it would detract from his intellectual seriousness.) Post-Modernist wit, on the other hand, is

Figure 19. George Condo, *Crazy Cat Combination* (1990). Oil, paper, and charcoal on canvas. 12 panels, overall: 135 × 99¼ in. Courtesy of the Pace Gallery, New York.

explicit. Kippenberger and Fischli and Weiss may convey a sense of the seeming insurmountableness of dullness, but they overcome it by presenting what is dull as actually perversely amusing. Banality is finessed when made blatant. A defender of the post-Modern copyists might argue that this is what they do too – respond to the banalization of avant-garde art by quoting it, at once admitting and overcoming its dullness. I would respond, however, that in much of this work, whatever is quoted tends to relapse entropically into its unexciting prequoted state.

Dullness is the problem of our fin de siècle post-Modernist sensibility. The early Modernists of the 19th-century fin de siècle also sensed the dullness of the world, but their ennui was subjective – its artistic victims blamed themselves for the banality overtaking life. The contemporary dullness, however, seems to be objective. The world seems matter-of-factly banal, the self is bored,

Two friends ran into each other at the door
of a psychiatrist's office.
"Are you coming or going?" asked one.
The other replied, "If I knew, I wouldn't
be here."

Figure 20. Richard Prince, *Untitled (Joke)* (1987). Silk screen on canvas. 24 × 18 in. Photograph by Ivan Dalla Tana. Courtesy of the Barbara Gladstone Gallery.

and the subject falls absent. In 19th-century ennui, the subject is present, and secretly enraged, and ennui can be uprooted when it openly changes to rage. The current sense of dullness can never be erased, only joked about. It is part of bourgeois truth. Furthermore, behind the ennui of the last fin de siècle was the belief that the self could never completely become bourgeois, that some

Figure 21. Richard Prince, *Another Opinion* (1989). Acrylic and silk screen on canvas. 75 × 58 in. Photograph by Larry Lame. Courtesy of the Barbara Gladstone Gallery.

kind of refuge and resistance would always survive. The post-Modernist wit, on the other hand, knows that the self has in fact become bourgeois, that its inward life is in dull earnest, that it believes in the world more than it believes in itself. Behind the morbidity of post-Modernist wit is the dullness of the completely manipulated self – so successfully manipulated that it does not

know it is, though it suspects. Post-Modernist wit taps into that irony, beyond good and evil.

The contemporary avant-garde tries to irritate the bourgeois world – to get on its nerves like a rash. The point is to get under its skin, not to confront it directly. That would never work; it would be dull. The world today is too confident to think twice about itself, to recognize its banality, as Modernist wit forced it to do. The bourgeois world never questions itself now; it thinks history has proven it right. But it can be unconsciously irked, and given bad dreams. Post-Modernist wit aims to poison the well of the bourgeois imposter's self-belief, to make him a hypochondriac. This is as much self-doubt as can be induced in him. There is no escape from banality in this comedy, then, only a softening of its blow.

Humor is another matter. When Wegman treats his dogs like human beings, he creates an ironic reversal: our best friend displaces us, indeed becomes us, or at least dresses like us, and is made to look as foolish. But Wegman's dogs at the same time look more dignified and honest than most people posing for photographers (Figure 22). Humans become imposters simply by sitting for the camera, but whoever heard of a dishonest dog? The Rays, Man and Fay, of the family canine, cannot help but be sincere. Yet they too are imposters, affected ham actors theatrically gotten up to be people. Wegman gives us dogs who keep their integrity but are also incredible poseurs, pretending to be more than they are – playful hybrids of human and beast. In none of their different roles can they be said to be themselves. Yet they are true dogs. This is sublime humor. It gives us a nonbourgeois role model – no matter how pretentious the dogs become in costume, they remain comically honest – but admits we can only escape the bourgeois by changing species. The process works in the other direction as well, for the ambitiously attired dogs in these pictures are undeniably genuine selves. Wegman shows the self as a compliant actor, a false self, but also as somehow true to itself at the same time.

Wegman's photographs play on the narcissism aroused by the camera, which makes imposters of us all, and makes us wonder whether our honest selfhood can ever be pictured. Cindy Sherman is as expert in this as Wegman, but in her portraits no true self seems possible. Every figure is false to itself and to the audience – the figure pretends to be a self it will never be. Photography turns us all into unhappy role players, not knowing our true selves even as we try to appear as we really are. The camera makes clumsy narcissists of everyone: it creates the illusion that we can capture our true selves, when all it does is confirm our falseness. Perhaps only animals can be true to themselves in front of it.

Yet post-Modernist wit never unequivocally shows us as imposters. It may not name the truth, but it is ironically true, and its playful suggestions subvert bourgeois modernity's tendency to banality. Because we are all post-Modernists, preferring the facade to the truth behind it (Modernism was a kind of stripping of the facade to get at the truth, but post-Modernism has

Figure 22. William Wegman, *Man Ray Contemplating the Bust of Man Ray* (1982). Silver print. 14 × 11 in. Courtesy of Holly Solomon Gallery.

busily reerected it), we are sensitive to the equivocal character of these works, to their simultaneous doubtfulness and seduction, implausibility and persuasiveness. Indeed, they suggest that the truth is always equivocal: a modern idea, which post-Modernism can live with.

The avant-garde, in acting out bourgeois ambivalence about art, generally acts out its own ambivalence about itself. It would not exist unless the bourgeois existed. If it consciously believes in itself, then, it unconsciously believes in the bourgeois. It may play the perverse child to the adult world, but it implicitly accepts and believes in that world. Avant-garde art exists at the

Figure 23. Tom Otterness, *Rolling Penny* (1989). Bronze cast in 1990. 23¾ × 21 × 7½ in. Photograph by D. James Dee. Courtesy of Brooke Alexander, New York.

largesse of power. Nonetheless, the novel styles of Modernism are emblematic of novel, nonbourgeois attitudes. The question that the triumph of the bourgeois mentality raises for art is whether the avant-garde has been reduced to preying playfully but wittily on banality, or whether, instead of humoring us, it will bring us back to humor (Figure 23).

Contemporary European Art

15

Joseph Beuys
The Body of the Artist

I had far too long a time dragged a body around with me.

Joseph Beuys, 1956

Suffering
Warmth
Sound
Plasticity
 Fulfillment of time
entered the thalidomide child's room
Does the music of the past help him????

Joseph Beuys, text accompanying a drawing
of a pentagram, 1966

IN *Lebenslauf Werklauf* (Life course, work course), Joseph Beuys lists two "exhibitions" that contain in their titles, as though in simple conceptual seed, all that follows in his art. One, *Kleve Ausstellung von Kälte* (Kleve exhibition of cold), occurred in 1945, the year Germany was defeated and Beuys was repatriated after being a prisoner of war in the USSR. The other, *Kleve warme Ausstellung* (Kleve warm exhibition), occurred in 1946, the year Beuys finally decided to become an artist rather than a scientist. Kleve was Beuys' home town. Returning to it after the war, he renewed his relationship with his parents, which, as he once said, "cannot be characterized as a close one." This failure of intimacy and warmth was surely not helped by the fact that "times were hard and had a tremendously threatening and oppressive effect on me as a child."[1] Thus, for whatever combination of subjective and objective reasons, Beuys' parents failed him in the first responsibility of parents to their children: to make them feel safe.[2]

Beuys did have "a very lasting attachment to the lower Rhine region and to Kleve," and to certain men there whom he regarded as "models,"[3] and who no doubt compensated for his distance from his parents, especially his remote father. But his major compensation was fantasy. In playing shepherd

– with a staff (the ancestor of his "Eurasian staff," as the artist acknowledged), and "an imaginary herd gathered around me"[4] – Beuys became his own parent. If, as Erik H. Erikson writes, children's first psychic task is to develop trust, usually through a warm relationship with their parents, then Beuys taught himself trust through his fantasy of himself as a shepherd, a parent for his sheep. In trusting their parents, children learn self-trust, the basis on which they develop autonomy, initiative, and industry, and overcome such self-denying feelings of hurt as shame and doubt, guilt and inferiority.[5] Thus Beuys, by trusting himself through his fantasy, soothed and ultimately healed himself. It was a form of convalescence, as it were, in which he undid and reversed the self-undermining feelings his parents' apparent coldness had induced, and acquired the building blocks of a secure self.

Beuys' art too was a convalescent fantasy – the kind of Sisyphean convalescence in which the emotionally disturbed patient, struggling to reach the mountaintop of health, always threatens to tumble down again, yet always keeps on climbing. Beuys' fantasy of symbiotic warmth and intimacy between shepherd and sheep became the model for his conception of the necessarily personal relationship of artist and audience. The artist was to care for his audience, which would reciprocate by flourishing under his protection, just as Beuys, feeling the warmth of his imaginary herd, did actually become healthy and independent. This psychic drama of warmth and intimacy between artist and audience bespeaks the healing intention of Beuys' art – its therapeutic mission. He wanted to give his German audience the care that would cure it of its postwar feelings of deprivation, isolation, and hurt, inflicted on it by the desperate failings of the parent state.[6]

Beuys did not see the herd as all bad. Unlike Nietzsche, who was so perpetually anxious about his autonomy that he asserted it vigorously and megalomaniacally against a social herd he imagined as dumb and passive, Beuys found his autonomy in symbiotic merger with his audience rather than in opposition to it. He moved fluidly, and in both directions, along the continuum between herd and autonomy, intimacy and individuality.

Beuys' "totalized concept of art" involved the sense that what had become "hardened" by life originated "out of the fluid process" and could be returned to it to be re-formed. What had "solidified," like congealed fat or wax, had only to be softened by artistic warmth to be given a more human form. Beuys intended this principle to be applied "not only to artistic forms, but also to social forms or legal forms or economic forms, or also agricultural problems . . . or educational problems." For him, art brought together "every man's possibilities to be a creative being and . . . the question of [the form of] the social totality."[7] The idea that individual and social health are inseparable is crucial to this concept. For Beuys, art was a process of simultaneous self- and social healing. He meant to cure, through artistic warmth, Germany's pathological hardening into a totalitarian regime during his childhood.

Beuys' personal need to save himself from self-deprecating feelings fused with the German people's identical need. They had given their trust to a leader, a shepherd, who had betrayed them – a false and bad parent. Now, on top of

the profound effects of defeat, destruction, and shame, they had to face the world's cold hatred. Beuys would help them. He understood quite clearly, however, that his art was essentially psychosocial, deriving as much from his unhappy childhood experience and fantasy as from the needs of the moment. "Titles such as 'Stag Leader' or 'Ghengis Khan's Grave,' " Beuys said, "can be interpreted as fundamentally psychological." They allude to "early experiences, some of which are dreams, which one really experiences as a child."[8] *Kinderbadewanne* (Child's bathtub, 1960) testifies to Beuys' strong memories of his childhood, and to art as a kind of curative child's play.[9] Such objects – they proliferate in Beuys' art – are memento mori and have been transformed into signs of hope. One can be reborn or rebaptized in the child's tub – one can be made as fluid as the water of life again – just as Beuys meant the piles of old newspapers he later used in his art as symbolic batteries generating the warm and warming energy of life.

When Beuys returned to Kleve after the war, he had been seriously hurt five times in the fighting, receiving a gold-ribbon decoration awarded the wounded. He had also experienced the warmth of the Tartars who had rescued him after his plane was shot down over the snowy Crimea in 1943. They had cared for him, Beuys claimed, for about eight days, saving his life by wrapping him in fat and felt, until a German search group found him. Doubts have been raised about what Beuys' experience among the Tartars actually was.[10] There is no question, however, that it was seminal for his art and life, and stood between him and complete physical and mental breakdown, the clinical depression that he in fact suffered for a while a decade after the war. (This breakdown was for him, as he acknowledged, the war's real – emotional – end.)[11] Beuys' preoccupation with warmth and intimacy to renew body and self, with concrete physical experience of life-giving material,[12] dates from his nursing by the Tartars, whom he regarded as family.[13] No doubt he idealized them and internalized them too eagerly, out of desperate need, but in emotional fact they were indeed a family, a tribe, a herd, that he was invited to join. And they were Beuys' good parents, affording a total environment of care that repaired the devastating emotional damage done him by his bad parents and later the actual, physical injuries he had suffered for his bad government. Healing Beuys, and teaching him to heal himself, the Tartars gave him another, lucky chance, as an adult, to receive the warmth and intimacy he had earlier been denied.

Such "secondary" closeness is never as good as the "primary" closeness one should receive as a child, but it is better than nothing. It keeps one operational, despite the ineradicable feeling that one was broken by life just after one began it. One's life becomes a contradiction between inner feelings of inadequacy and outer activity. That is better, however, than feeling all victim. In psychological fact, Beuys' art was a kind of compensatory acting out of his childhood feeling of personal hurt. Needless to say, he also had a strong ego, consciously making art of great intellectual stature and esthetic originality. His art was a dialectic between childhood dream and adult social intention. (What is always of interest in an important artist is the convergence

of unconscious and conscious intentions.) Perhaps he exaggerated the hurt – perhaps it was as much of a dream as his shepherd fantasy, a case more of a delusion of his parents' wrongdoing than of anything they actually did. In any case, it was a narrative that justified his utopian social goals. And it is well known to psychoanalysts that grandiose fantasies of social utopia, expressing as they do an implicit reluctance to face reality as it is, compensate for painful narcissistic deficits.

The Tartars taught Beuys how to make his own warmth and intimacy – how to be close to himself. As an artist, he never forgot their lesson. The 1945 *Kleve Ausstellung von Kälte* acknowledged the coldness of returning to the dead home and dead society, but the 1946 *Kleve warme Ausstellung* signaled that Beuys had learned how to warm himself to life by making art. As early as 1945, he knew his artistic need for warmth, making a revealing, quasi-prehistoric drawing of three naked figures around a fire – surely a fantasy of primitive Tartars huddling against the cold. By 1946 Beuys had been nourished by his closeness with the sculptor Walter Brüx and the painter Hanns Lamers, both resident in Kleve. They took him under their wing, and convinced him to become an artist. Brüx's 1946 bust of Beuys shows the depth of the sculptor's affection for him, and of Lamers Beuys said, "He was the only one to say, 'For you this is the only possible way.' "[14] Without these substitute good fathers, Beuys might never have become an artist, let alone one of major significance.

I cannot think of Beuys' art without thinking of Heinz Kohut's observation that "narcissistically disturbed individuals tend to be unable to feel warm or to keep warm. They rely on others to provide them not only with emotional but also with physical warmth."[15] One element of Beuys' performance works was his use of the heat of the crowd to make him feel alive and strong, and his sculpture uses materials – animal fat, sheep's-wool felt – meant to keep a creature warm or to symbolize warmth. In his art, then, he switched back and forth between the roles of shepherd tending the herd – the source of warmth – and herd needing a shepherd to keep it warm. Sometimes he encouraged the herd to generate its own warmth, as when he argued that "every man can be an artist,"[16] and sometimes he took it to task for its lack of warmth toward him – a projection of his feeling of his parents' indifference. Discussing *Wie man dem toten Hasen die Bilder erklärt* (How to explain paintings to a dead hare, 1965), Beuys said that he preferred to speak to a dead hare because the public was not sufficiently alive to him, and did not understand him.[17] That is, it did not care for him, or for itself, nor did it feel his care for it.

Ultimately Beuys' art was inseparable from his body and his body image. Art for him was a means to remake an injured body, and the sense of self that depends on it – and in so doing to remake art, to root it once again in the body. Art was to be a radiating symbol of body heat. (In 1927, as a boy of six, Beuys held a *Kleve Ausstellung von Ausstrahlung,* a "Kleve exhibition of radiation.") The body, of course, has always been fundamental to art, in more than a metaphorical way.[18] When we speak of a body of art, we mean something quite tangible. When a sculptor turns a stone into a body, or when a

painter renders one as a flat image, they are always drawing on their own physical experience, their intimate sense of being a body, from which the sense of being a self invariably follows, as Freud observed.[19] What is above all at stake in bodily art is the feeling of the body's warmth or coldness – the sense of being close to or detached from the body, especially one's own. In his art, Beuys was always in transition from cold to warm body. He was doomed to repeat this transition compulsively because he found it hard to stay warm, both inwardly and outwardly. In a sense, he rapidly lost his warm feeling, his love for himself, a characteristic sign of narcissistic injury.

Trying to find a proper relationship to the body, Beuys never quite did. Always searching for the one truly warm body that would "fit," he was obsessed with physicality from the start of his career, trying on or identifying with various bodies, as it were, both animal and human, female and male, in a protean way through his work. In *Coyote: I Like America and America Likes Me*, 1974, for example, he lived and identified with an animal – a coyote – trying to assimilate its animal warmth. Like a latter-day Saint Francis – and there is a will to the sacred in Beuys, a sense of profound respect for the multiform possibilities of life – he preached to the animal, and learned from it. As he said, "The teaching–learning relationship must be totally open and constantly reversible."[20] In his sculpture he tested, as it were, inorganic materials, such as iron and copper, and organic materials, such as earth and wood, as possible sources of physical warmth. His figural sculpture suggests that he even tried to fashion surrogate human bodies out of raw material. But no body was ever completely satisfying: he could never feel completely warm in any skin, especially not the one nature gave him.

Using art to undo the life-denying traumas that had been inflicted on him, without denying their reality (it is this kind of activity that constitutes art's so-called "spiritualization of life," its fundamentally reparative task), Beuys was returning to the primordial sources of warmth, that is, to the warmth of the beginning, the warmth that, in the formative stages of life, encourages healthy growth. In effect, he tried to regrow himself. In artistically inducing "healthy chaos, healthy amorphousness" – whether by immersing himself in such materials as honey and earth, or through actions and Fluxus pieces which put his psyche and body in flux, in elemental process – he returned not only to the dream state and fantasies of childhood but to the warm, shapeless, formative period of life. In using such chaos and amorphousness to "consciously [warm] a cold, torpid form from the past, a convention of society,"[21] for example a grand piano, Beuys returned it to the formative period and released the warmth crystallized in it, finding new life in it. The grand piano is no doubt a sophisticated symbol for Beuys' own self, representing his grandiosity and remoteness, and suggesting that, childlike, he unconsciously identified with the bigness and remoteness of his parents. He treated such objects and forms – formal objects – as though they were ill, and had to be physically changed from solid to fluid, so that their warmth could become accessible and do human good. As Beuys said, "the things inside me" – the feelings and psychic configurations that can be symbolized by external cultural things –

"had to be totally transplanted; a physical change had to take place in me. Illnesses are almost always spiritual crises in life, in which old experiences and phases of thought are cast off in order to permit positive changes."[22]

For Beuys, the bee's metamorphosis of honey into honeycomb was the "primary sculptural process," and as such the model for all artmaking, personal and social. In this belief he followed the anthroposophist Rudolf Steiner, who saw the life process exemplified in the bee's transformation of honey – "chaotic, flowing" material, the embodiment of "spiritual warmth" and as such an inexhaustible source of energy – into "crystalline sculptures . . . regular geometric forms." The honeycomb was for Beuys "the negative of a rock crystal."[23] It was as geometrically exact – frozen – as the crystal, but could, by the bee's physical warmth, be melted back – "regressed" – to a fluid state, making its own primary warmth available as nurture. The geometrical honeycomb was spiritual warmth in negative form; fluid honey was spiritual warmth as a positive force for life. Beuys' masses and corners of fat can be seen as stand-ins for honey, energy-filled matter in a state between warm liquid and cold crystal. His piano was a crystal, to be melted down by being wrapped in warming felt, like the many other cultural objects he wrapped to restore to life. One of his last social-sculptural "acts" was to try to "wrap" Andy Warhol in his warmth, which failed, because Warhol was irremediably cold – frozen, a black hole of nothingness in which everything disappeared. It is as though Warhol remained the cold child that Beuys felt his own parents almost made him. Beuys' art was an endless compulsion repetition of the same act of warming the unwarmable.

For Beuys, vital warmth, inherently spiritual, was a source of fullness of bodily and spiritual being. To try to regress to it was to become full in his being, to know a paradisiac experience of plenitude he had never known in childhood, although he undoubtedly experienced it as a productive artist. Indeed, the magic of Beuys' oeuvre as a whole – an incredibly variegated body of work – is that it seems to have been produced out of abundance, as though he were in perpetual art motion. He clearly lived his art and it lived him. Yet he also suffered from a profound feeling of inward lack, of self-absence. Nietzsche distinguished between artists who work out of a sense of inner abundance and those who work out of a sense of limits, that is, the maximalists and the minimalists; in this sense, Beuys was inwardly a minimalist, outwardly a maximalist. He had to make art all the time to replenish a body and spirit that seemed empty. Nietzsche's distinction reflects differing senses of the body – the self-maximalizing warm body in contrast to the self-minimalizing cold body. Beuys was inwardly a minimalist – cold – but he was able, like a bee, to maximalize his resources – to become warm. This is why he invariably experienced cold "minimalists" like Marcel Duchamp and Robert Morris as a threat, criticizing them to distance himself from them.[24] Both those artists tried to effect the transition from minimalist to maximalist that Beuys did, but with less, or with more equivocal, success.

The sense of damage speaks everywhere in Beuys' art. As one critic wrote of a 1971 exhibition of drawings and objects, "From the bandaged archaic

little feet and the dirty dark red gloves of a child, to the moldy page with many crossed out numbers, his own childhood comes alive."[25] Beuys' 1976 installation *Strassenbahnhaltestelle* (Tramway/tram stop) has been understood as reflecting his experience "as a five-year-old [who] would get on and off the tram . . . and cross over to sit on one of the low iron shapes beneath the column. He did not know what they were, but their mystery told him they could only be something good. . . . What attracted the child was an intuition of his own history and time and the presence of something that nobody noticed."[26] Beuys was in effect that nobody, just as, in my opinion, he was the dead hare in *Wie man dem toten Hasen die Bilder erklärt* – he was explaining the paintings he made as an adult to the dead child within him, in order to breathe life into it. (The hare could double as dead child and indifferent audience because in the infinitely protean unconscious, where Beuys was quite at home, there is no contradiction, as Freud observes.) Similarly, in Beuys' 1976 installation *Zeige deine Wunde* (Show your wound), the wound is that inflicted in childhood. And his wagon train of rescue sleds in *Das Rudel* (The pack, 1969) suggests the need to be rescued and healed from childhood's wounds.

Sometimes the only way to recover from the trauma of childhood is to be reborn, which recapitulates the trauma but gives one a fresh start. Symbolically, this is what seems to have occurred in the 1970 action *Celtic (Kinloch Rannoch) Scottish Symphony*. After spilling gelatin over himself – to signify a return to fluidity – and standing unmoving, as though dead, for over half an hour, Beuys went into a tub filled with water and had water poured over him. This was a symbolic return to his childhood tub. In Beuys' 1982 ecological sculpture made for Kassel, hard, unmoving, dead rocks lay tumbled on the ground, and living, growing trees were to be planted in the earth to replace them. Rocks and trees stand to each other as crystalline honeycomb and liquid honey do. (The rocks also represent the steppes over which Beuys was shot down during World War II.) Again, the transition of metamorphosis is the issue. That sense of transition – of being between states and thus in process – is especially evident in Beuys' extraordinary sense of surface or texture, of the different "touches" that materials have – soft or hard, fluidly smooth or harshly rough. For him, texture seems to have indicated the state of the warmth latent in the material and waiting to be released by sculptural process, thus becoming available to life.[27]

All of Beuys' works can be interpreted as an attempt to return to and re-present the beginning in order to escape the deep hurt that brings one close to death. The social dimension of Beuys' work – including his political and educational activities, which he regarded as inseparable from his art – reflects his attempt to teach other sufferers the lesson of his wound and its cure by warmth. Beuys wanted to wrap them in perpetual warmth, to cradle them like wounded babies, just as he, with his signature felt suit, tried to keep himself warm against inner and outer pain. He understood that the personal is, indeed, the political, that is, that one's attitude to other people profoundly informs, even creates, sociopolitical reality.

Exhibition, as Masud Khan ironically observes,[28] is a primitive mode of

narcissistic gratification, and as such a way of seeming to relate and give to others while not actually doing so. Yet Beuys made artistic exhibition a sacred social service rather than simply self-serving. Once again, he showed his importance by his ability to reverse an expectation dialectically, eluding defeat by a psychological reality. Beuys' exhibition of himself and his art – of his body self as art – was a profound act of giving.

The Hospital of the Body

e Id

hange beds.

Paris Spleen

in paint what
vent school in
ng is her way
ost time when
t damage the
sense of what
ough painterly
elingless? Did
y's shape? She
ody ego. That
ses the objec-
d outside her
She represents
for her.
lem of figural
is never com-
of a certain (in
a reality that
resentation of
reason of the
more at stake
subjectively in its representation. Narcissistic factors are invariably implicated in the representation; that is, the representation implicitly articulates the artist's own attitude to his or her body. These factors may be denied, as in the attempt to articulate a completely objective body – a body that seems to be seen with

scientific detachment, as simply another material to be described – or anxiously flaunted, as in the distorted, hyper-expressive bodies of Expressionism, but they must be dealt with in some way. In Maria Lassnig's case, the Expressionist goal of body-ego representation is carried to an extreme: she attempts to eliminate external representation of the body entirely; nothing must obscure its internal representation – come between her and her sense of the way her body feels. Even more than in Francis Bacon, the body's external appearance is a husk to be discarded, so that its internal appearance may appear in all its ripeness. She in effect essentializes what seems inherently vague. Theodor Adorno thought that one of art's tasks was to "raise into consciousness diffuse and forgotten experiences without 'rationalizing' them." Lassnig attempts to raise into consciousness a diffuse, forgotten – finally fundamental, primitive – experience of the body, without rationalizing or explaining it. It is up to us to do so.

Art historically, her project of subjective portraiture, giving unconditional priority to the internal body image, makes explicit what was all along implicit in Expressionist self-portraiture. It brings us to an emotional place intimated by early Expressionist self-portraiture – van Gogh's, and even more strongly, Ludwig Meidner's – but never fully stated. To more or less completely forfeit the realistic external appearance of the body – to scramble it almost beyond recognition – is to seem completely mad. However, as Lassnig's body ego portraits imply, such psychotic articulation of the body is the only way its archaic reality – habitually blocked by everyday consciousness of the objective body – can be represented. However, what makes Lassnig's subjective bodies even crazier, as it were, is that they do not seem so much derived from the objective body by way of distortion, but original in themselves. She does not seem to violate, with cool calculation – as in early-20th-century German Expressionism – accepted conventions of body representation, but rather never to have known them in the first place. She never had any sense of objective body to overthrow, because, by reason of her convent experience, she was never able to objectify her body – get a "perspective" on it by learning its objective givenness through touch. Feelings arose within it, but they could not be "confirmed" by – integrated with – the feelings that arose from touching it. Her body was a disorganized mess of internal sensations, not an external sensation. Her painterly touch became their surrogate, mediating them, in all their unintegrated givenness.

It should be noted that internal representation has been a latent goal of Northern portraiture in general, at least since the portraits and self-portraits of Dürer and Rembrandt. They aimed to show the inner as well as the outer self but did not realize that these could be separated. Nor did they comprehend that the conscious sense of self is deeply rooted in the unconscious sense of the body. The representation of the inner self is in effect an attempt to make manifest this latent sense of the body. Lassnig is one of several contemporary Austrian artists who intuitively understand this; Hermann Nitsch and Arnulf Rainer are other major examples. She is the only woman among them. It is

not clear that her personal sense of her body can be generalized to other women, but it seems highly relevant that her body ego is a woman's. In 1949 Lassnig described her paintings as "introspective." What they introspect is the female body ego before it has been objectified – falsely integrated – by the conventional male vision of the female body as a sexual object. To be excruciatingly true to herself, Lassnig never shows the body as an integral whole or as successfully sexual, so to speak.

No doubt one of the reasons the girls in the convent school were forbidden to touch their bodies was because the nuns did not want them to experience their sexuality. More particularly, they were not supposed to masturbate. This may have led to a general inhibition of sexuality; it also probably damaged their sense of self. Masturbation – emotionally speaking – can be a strategy of self-healing for the hurt self. It recovers from its traumas at the hands of the world by renewing contact with the body ego through masturbation. I want to suggest that Lassnig's painterly handling – fairly staccato, choppy, and crude when used to articulate the body, while smoothly neutral when articulating the field (in effect the "world") in which it exists – is a quasi-masturbatory articulation of the body, regressively enlivening it. Again and again she presents aggressively painted bodies against a relatively bland field. Her harsh, abrupt gestures hardly hold together, so that the body seems on the verge of disintegration – diffuse beyond recognition. In fact, it has never been integrated in her inward perception of it. *Kopf* (Head), 1980, *Selbstporträt mit Sperber* (Self-Portrait with Sparrow Hawk), 1986, *Tschernobyl Selbstporträt* (Chernobyl Self-Portrait), 1986, and *Gelbe Linie* (Yellow Line), 1987, are particularly noteworthy examples. When the intense gestures are forced together, more or less deliberately, the effect is so grotesque – the figure seems so monstrous, absurdly twisted – that the body ego seems inherently crippled, incurably pathological. The extraordinary *Gartner in Schnee* (Gardener in Snow), 1986–87, and *Korkenziehermann* (Corkscrew Person), 1986, are major instances.

Such articulations of the body are the important thing in Lassnig's pictures. The allegorical or socially meaningful overlay she gives them – largely by way of her titles – is secondary, even superficial. They serve only to make the works accessible on a banal, objective level. They do not seriously function there; they are too disruptive to be simple moral statements. It is no doubt helpful to know that a particular figure is supposed to be the Sphinx of Death – the point of the title *Der Tod ist eine Sphinx* (Death Is a Sphinx), 1985 – but it is of only secondary importance to the picture's subjective necessity, which has to do with its violent painterliness. In a sense, the title is a premature objectification of that painterliness, foreshortening – predetermining – its meaning. It is the grotesqueness of the gestures that counts more than – and sustains – the grotesqueness of the figures, which is, after all, clichéd in comparison. The meaning of these gestures is harder to fathom than that of the image, which becomes obvious once it is named. At the same time, Lassnig's titles indicate that she identifies – rather spontaneously – with morbid situations, from the Sphinx – its femaleness is made emphatic by the breast behind

the arm – to the doomed people of Chernobyl. This gives us a clue to the intention of her painterliness.

Lassnig's images usually imply catastrophe. In the most interesting and intense, the catastrophic character of the painterliness converges with the image of catastrophe. This convergence occurs with special vigor and personal import in the group of pictures that show the act of painting as catastrophic self-confrontation. It also occurs in the paintings dealing with sexual encounter, suggesting its catastrophic, tortured, traumatic character. (How could a woman who was not permitted to touch her own body let a man touch it? She had first to feel it to know it was alive, before letting a man bring it to the life of feeling.) The former works include *Innerhalb und ausserhalb der Leinwand I* and *II* (Inside and Outside the Canvas I and II), both 1984–85, *Mit der Kopf durch die Wand* (With One's Head through the Canvas), 1985, *Bildtransport* (Carrying the Picture), 1986, *2 Maler, 3 Leinwande* (Two Painters, Three Canvases), 1986, *Die innige Verbindung von Maler und Leinwand* (The Inner Connection of Painter and Canvas), 1986, and *Bemalung* (Painting), 1986. The latter include *Tragisches Duett* (Tragic Duet), 1987, and *Zeit danach* (Time Afterwards), 1984.

The most interesting aspect of these works as images is that they deal with a split – between artist and canvas, between lovers. Lassnig's sense of herself as split is explicitly articulated in the horrific image – essentially of self-castration, the core of masochism according to some thinkers – titled *Mann sich entzweischeneidend* (One Cuts Oneself in Two), 1986. The idea of the doubleness of the self reappears in *Spiegelbilder* (Mirror Image), 1987. It is an explicit – if not always explicitly acknowledged – theme early in Lassnig's career, as the drawing *Weibliches und Männliches Selbstporträt* (Female and Male Self-Portrait), 1973, and the painting *Doppelporträt mit Kamera* (Double Portrait with Camera), 1974, make clear. The sense of the self as fundamentally split – usually with no hierarchical determination of the parts, and sometimes with wild oscillation between the opposites – is an age-old motif of thought and art. Lassnig gives the split a modern slant by suggesting its violence – the alienation, even hostility, between the sides.

Again and again Lassnig shows herself torn in two – indeed, into many parts. A fierce destructiveness rages through her work from the start – a consequence, I believe, of her not being able to feel her body in the convent. This made it seem destroyed – incapable of ever being made whole. *Selbstporträt als Prophet* (Self-Portrait as Prophet), 1967, shows her split in two, her head shriveled into a separate amorphous part, about to disappear. *Last des Fleisches* (The Burden of the Flesh), 1973, shows female bodies bearing some of their parts. In a 1963 self-portrait she shows herself as an animal, and in two 1964 self-portraits as a "monster" (her own word). Always there is the sense of self-alienation, self-splitting, the horror of the self. These reach a kind of climax in *Herz-Selbsporträt im grünen Zimmer* (Heart Self-Portrait in the Green Room), 1968, and *Pfingselbstporträt* (Pfingsten Self-Portrait), 1969, where the mon-

strousness of the isolated self spreads to the world it inhabits, which becomes the space of disorientation.

But in the '70s something astonishing, unexpected occurs: Lassnig comes to show her body as whole, "healthy." In image after image – among them *Mit einen Tiger schlafen* (Sleeping with a Tiger), 1975, *Selbsporträt mit Hund* (Self-Portrait with Dog), 1975, *Woman-Laokoon* (Woman-Laocoön), 1976, *Fliegen lernen* (Learning to Fly), 1976, perhaps climaxing in *Rosenselbstporträt* (Rose Self-Portrait), 1981, where she joyously licks a rose – she shows herself as a recognizable, intact person rather than a freak of her emotional nature. The source of her new body ego is shown in *Womanpower,* 1979: feminism. It suggests the great distance Lassnig has traveled from *Bedrohung der Frau* (Threatening the Woman), 1962, where the female figure is shattered into a pile of anxious fragments by the threat to her from man. Lassnig seems to be suggesting that her self-devaluation, as indicated by the self-fragmentation of the pre- and post-'70s self-portraits, was the result of living in a man's world, where women were treated "monstrously" and broken on the rack of their relationships with men. They internalized this sense of themselves as monsters, and pathologically accepted their suffering – their hurt – as though it was self-inflicted. In the '70s, Lassnig turns to animals, as symbols of "instinctive" integrity, body-ego wholeness – now possible for Lassnig, and implicitly all women, with the support of feminism. She clearly feels better about herself, and her body.

But the change is not lasting. In the '80s, her body ego becomes monstrous again (Figure 24). She comes apart. Work after work shows the old self-horror, the familiar tortured self-representation. Men are not to blame for Lassnig's suffering; at most they are a secondary cause. It was the nuns with their notion of female purity – even bodilessness (complete "transcendence" or spiritualization of the body) – that caused her self-image problem. Since they are parental figures, she must displace her hatred of them onto men. In a sense, for the nuns the body did not exist: it was inconceivable, or at most conceivable as an anonymous form, not clearly identifiable as a body. Early in her career, when she painted in the manner of *Art informel,* as European abstract expressionism was called, she made a number of works titled *Informel,* all in 1951, in which she placed a convoluted and involuted, violently painted and erratically shaped – but always self-contained – form in the canvass's center. This central form evolved into an abstract head – her first explicit self-portrait, as in two 1955 self-portraits and, also from 1955, *Runder Kopf* (Round Head) and the 1956 *Kopfheit* (Headness). In *Körpergefühl* (Body Feeling), 1958, this centralized abstract image-form metamorphoses into a whole body – but an undifferentiated one. This same sense of formless bodiliness continues in *Körperteilung* (Body Division) and *Quadratisches Körpergefühl* (Square Body Feeling), both 1960. They show an elementary, very uncertain and abstract, differentiation of the body. In 1961 and 1962 the abstract body begins to take familiar shape, but it never quite differentiates into a recognizable body. There is little to distinguish the U-shaped body of *Uformige Figuration* (U-form Figure) from *Tod mit Ohr* (Death with Ear), both 1961, or *Harlequin Selbstporträt*

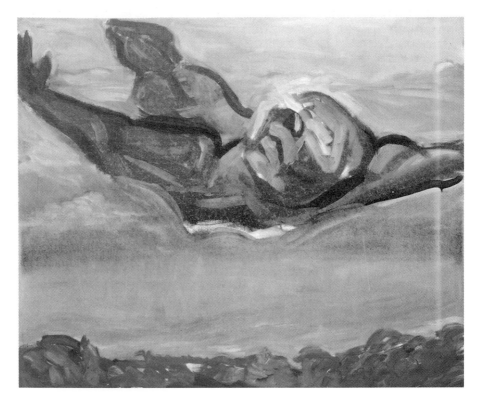

Figure 24. Maria Lassnig, *Dream of Flying* (1987). Oil on canvas. 39½ × 78¾ in. Courtesy of Ulysses Gallery, New York..

(Harlequin Self-Portrait) from *Spannungfiguration* (Tension Figure), also both 1961. These works, as well as others from 1962, done in a looser informal style than the completely abstract works of the '50s, can hardly be said to articulate a clear and distinct sense of the body. Indeed, they show an almost blind groping for at least a minimal primitive – barely preliminary – bodiliness, and by extension, self. These early bodies always seem to be about to de-differentiate – to regress into formlessness and complete abstractness. Clearly, from the beginning Lassnig had a difficult time getting "hold" of her body ego – conceiving her body as having any form, any ego. In my opinion Lassnig's fundamentally formless sense of body ego – her peculiar "selflessness" – makes a disguised return in the late '80s, in such visual punning works as *Angesaugete Kuh* (Cow Jet Stream), 1988, *Gelbes Bild mit Messer* (Yellow Picture with Knife), 1988–89, *Artefaktum (Rücken)* (Artefact [Back]), 1989, and *Kartoffelpresse* (Potato Press), 1989. In these pictures the undifferentiated central form of the earliest paintings makes a cunning return. But its import remains the same. It signals Lassnig's fundamental lack of self, the result of her early lack of touch, and so of a major source of the sense of self. The restriction

against feeling herself probably reflected the nuns' lack of feeling for her – and the other girl students – as a particular person. Lassnig's individuation into a strong figure, catalyzed by feminism, was transient. It never undid the early harm done her by the denial of her body that was forced upon her by a pathological ideology.

Nonetheless, for all her basic lack of "clarity" about her body – even her suspicion that it may not really exist – Lassnig's usually bright, sensuous color gives her body ego portraits an unflagging vitality. She is acutely aware of what she calls her vernacular, Slavic sense of color, remarking that it is general to Austrian modernism, appearing with the first modernists. Her extroverted color more than compensates for her introverted figures. More crucially, the expressive difference between color and figure articulates, in a basic way, Lassnig's split self. She feels vitally alive, but unconsciously her body does not seem good enough to contain her vitality, giving it form. This is because in her formative years she was not allowed to know what it is to truly have a body, that is, to enjoy the body in the fullness of its being, experiencing it as simultaneously an inside and outside, as affording one a sense of confidently being oneself as well as existing in the world. Lassnig's body ego portraits show her as a permanent invalid – her body invalidated, or at best a sick, Sisyphean project. For Lassnig, to be a healthy animal – to have a valid body – was never more than the wishful thinking of a dream. Her feminism was a subjective fantasy of wholeness of being, not an activist critique of patriarchal society. She is stuck in narcissistic plight.

17

Mourning and Melancholia in German Neo-Expressionism
The Representation of German Subjectivity

FOR all its international acceptance since its emergence in the 1980s, German Neo-Expressionism remains under a cloud of suspicion. An openly German art, in style and theme, it is haunted by the question of its relation to the Nazi past. Indeed, one of the most prominent of the artists, Anselm Kiefer, engages this past directly, and another, Georg Baselitz, indirectly but still recognizably. Using their work as a touchstone, I would like to frame the question of German Neo-Expressionism in terms of Freud's distinction between mourning and melancholy: is it more a matter of mourning for the German disaster in World War II or of melancholy attachment to a mythically heroic Germany – a bygone, "prelapsarian" Germany?

Is it the symbolic mourning of young Germans, born after the war but willing to pay its emotional price, or is it the melancholy of old Germans, attached to the dream of Germany's omnipotence and special destiny, outlasting the historical reality that casts doubt on it? Is it an art that conceives the Third Reich as the most telling event in German history, making explicit what was always immanent and powerful in German character, or an art that treats the Nazis as an unsightly blemish, hardly the most important detail in the German picture? Is it an art that attempts to liberate Germany from its Nazi past by a kind of soul searching, or is it an ideological defense of that past, an artistic apology that presents it as a temporary lapse of German integrity, an anomaly that will never be repeated? In other words, is German Neo-Expressionism a morally responsible or a morally irresponsible – a morally revelatory or moral obfuscating – art? In a sense, these questions arise because the German Neo-Expressionists, born during or shortly after the collapse of the Nazi regime, are caught between the generations. They do not know whether to identify with their parents, who, having wrought the devastation of World War II, are full of bad conscience, or their children, born into the paradise of the *Wirtschaftswunder* – which the *Kunstwunder* validates – with clean consciences.

In psychoanalytic terms, is it a kind of painful working through of the

unhappy Nazi past, or fixation on it, masked by nostalgia for an ideal Germany that never existed except in legend? Is it an idiosyncratic artistic way of facing a sordid collective reality or is it the wish-fulfilling fantasy of a Germany unsullied by history, a vision that speaks for all Germans who, born after the war, disclaim an inhumane catastrophe they did not create? Whichever it is, German Neo-Expressionism is a survivor's art. The survivor is compelled to understand why he survived, and to work through the guilt of surviving, when so many are dead. He may resist doing so, but the defensive vigor of his denial amounts to an admission of guilt, and perversely intensifies it even as it pushes it out of sight into the depths of the unconscious. The survivor also feels compelled to connect the present to the past that existed before the catastrophe that changed his world. He must make sense of the difference – extraordinary discrepancy – between then and now. He must make sense of the fact that what was supposed to be a victory became a defeat, and that he is heir to that defeat. He must make sense of the fact that, contrary to expectations and predictions, Germany victimized itself as well as others: Germany was not simply defeated, but brought defeat on itself. He must also acknowledge the possibility that such self-defeat was Germany's perverse way of privileging itself.

Working through the guilt of surviving is essentially a hermetic, intrapsychic task; establishing continuity between the past and present is a narrative, interpersonal task. In the first case the survivor attempts to become reconciled to himself; in the second case he attempts to become reconciled to history. Neither task can be separated from the other, although they need not be carried out simultaneously. To become reconciled to history does not necessarily mean one will no longer feel guilt at surviving. To become reconciled to one's survival does not necessarily mean that one will accept the history that made one's existence seem a matter of dumb chance. Nonetheless, both psychosocial tasks are motivated by profound frustration and loss – by the unfulfillable wish for another kind of existence, and the unalterable sense of being a victim of history, more particularly, of being vulnerable to a historical past one cannot change. The survivor's feeling of helplessness is made all the more oppressive by the realization that, had he been alive in the past, he could not have changed its course. His existence would have made no historical difference: no one individual could have averted the social catastrophe. The survivor experiences the misery of history as fated, intensifying his personal misery. As the psychoanalyst Charles Brenner says, anxiety anticipates catastrophe, misery acknowledges catastrophe that has already happened. For the survivor, all history, personal and social, seems a nightmarish repetition of a foreordained primal catastrophe.

Working through the guilt of survival involves mourning; working through history is a melancholy task. The attempt to come to terms with subjective reality on the one hand and objective reality on the other, and to grasp their dialectical connection, are the activities of a damaged subject determined to heal itself, to recover psychomoral wholeness and strength. But I think that German Neo-Expressionism, rather than being an indication of a complex

will to health – as I once thought – is through and through morbid. Indeed, it is a kind of objectification of the pathology of melancholy, unwittingly true to the German sense of self. It is almost as though the German – or at least the German artist – prefers feeling sick to being healthy, prefers the state of pathology to that of health.

What at first glance looks like an effort to purge, through mourning, the painful past of World War II and recover a sense of pride in German identity, is in fact a kind of artistic reification of melancholy – a melancholy which is the affective core of German selfhood. Indeed, if German art is any testimony, the German seems to take pride in suffering, which he imagines makes him superior – an example of defensive reversal. Thus, inherent in the German sense of self is the sense of being a damaged subject, always on the verge of disintegration. German Neo-Expressionism, and before it German Expressionism, for all their stated concern for convalescence and healing, articulate an ingrained sense of being damaged and disturbed.

The therapeutic mission of German art, proclaimed officially by Joseph Beuys, a self-styled shaman, masks a fascination with and absorbtion in pathology, especially the pathology of German history. But German Neo-Expressionism implicitly acknowledges that there is no recovery from it. The artist is no longer a shaman, effectively making psychic reparation for it through his magical practice. He is another patient, terminally ill with history. Indeed, no doubt overstating the case I want to make, German Neo-Expressionism perversely revels – if that is the right word – in pathology. It has learned the lesson of history – especially of the World War II defeat – namely, that there is no subjective escape from and alternative to socially objective pathology. In accepting their Germanness, however bitterly, the Neo-Expressionist artists argue, as it were, that there is no escape for anyone from the pathology of history. Articulating this universal truth with artistic brilliance, they achieve greatness.

Foucault speaks of the absent subject of postmodernism as though it was an intellectual inevitability. In fact, the shadow subject, as I prefer to call it, was not created in an epistemic alembic, nor does it exist in an epistemic vacuum, but is a historically created reality. The shadow subject is the self damaged by history. The subject is a shadow – an unhappy substance – because it has rarely if ever been respected by history. Rarely if ever have the subjective rights – the inner life – of the individual been respected by the so-called makers of history. The suffering of the individual has been given lip service, but there has been precious little empathic attunement to it. The individual has been treated like an eccentrically shaped peg that must be forced into a neat, historically destined hole. The subject has even been denied self-belief – deprived of the emotional power to believe in his possible happiness, come historical hell or high water. He has been victimized by the historical reality principle. History has too often been conceived in terms of objective rather than subjective necessity. It has been seen from the outside, not from within the individual.

It is history that threatens to erase man, not some abstract epistemological

necessity. German Neo-Expressionism is especially sensitive to this threat of erasure of the subject by history. In a sense, it records or rather enacts the erasure, depicting the subject either as disfigured – blurred and/or fragmented, as in Baselitz – or "unfigured," a barely latent ghost, even ultimately unrepresentable, because permanently missing in action, as in Kiefer. The former gives us figures on the verge of becoming corpses, and the latter implies that no corpses will ever be found, so complete is the devastation. For Kiefer, the earth has become permanently black with the ashes of the dead. Both he and Baselitz present Triumphs of Death, deliriously abstract – the fragments of Baselitz's figures often seem to be caught in a frenzied dance of Death – very much in the German tradition.

The Neo-Expressionist figure functions as an index of the pathological damage to the subject's sense of self. Baselitz's figures are obviously damaged, and the landscape or architecture of history – a space simultaneously claustrophobic and agoraphobic – Kiefer depicts is desolate because man has eliminated himself from it. His catastrophic absence is not the result of some abstract historical necessity, but of his own insanity. Both seem to artistically render Adorno's sense of the dialectic between social and individual reality:

> The disproportion between the all-powerful reality [read: history] and the powerless subject creates a situation where reality becomes unreal because the experience of reality is beyond the subject's grasp.... By slaying the subject, reality itself becomes lifeless.[1]

In a statement that seems tailor-made for German Expressionism and Neo-Expressionism, Adorno remarks that "in art, the point of reference continues to be the subject," which "can and does continue to articulate itself through things in their alienated and disfigured form," rather than through "the language of immediacy," that is, of instantaneous and spontaneous perception. However, the alienated scenes of Kiefer and the disfigured personages in Baselitz's pictures are the language of immediate history, even as they mediate the German past. For that past, not having been laid to rest – it perhaps never can be, because it seems inherently unforgettable, at least as long as there is a conception of humane behavior—is still and will always be inwardly immediate, at least in the self-aware German subject, and in general in the collective German unconscious. Art, while rejecting the "blatant ideology" inwardness has become – the "mock image of [the] inner realm in which the silent majority tries to get compensation for what it misses out on in society" (an image manufactured by media culture) – continues to be occupied with "the helplessness of the independent subject." For "it is impossible to conceive of art as wholly divorced from interiority." Indeed, art – especially the new history painting of Baselitz and Kiefer – can be regarded as a way of internalizing the traumatic effect of objective history and re-externalizing it without the trauma, if with reminders of it.

Germany is especially attuned to melancholy, for historical reasons. This is suggested by the perennially ambivalent relationship between the Germanic and the Mediterranean – the barbaric and the ideal, the savage and the soothing,

the overintellectual and the oversensual. Because Germany missed the narcissistically gratifying experience of being able to idealize, it yearns for an ideal it can never quite have, symbolized by the Mediterranean. Winckelmann is one case, Goethe another, with their equally distorted – oversublime – conception of the ideal and equally perverse relationship to it. In a sense, Germany never became truly civilized: in successfully resisting conquest by Mediterranean Rome, it put itself beyond the Greco-Judeo ideal of civilized behavior that Rome came to embody. It yearned for this ideal, but never quite measured itself by it. (Civilization can be regarded as a social space in which the ego is in consistent control or, more subtly and impossibly, in which the reality and pleasure principles are reconciled. More conventionally, in civilization the drives are regulated by and in the service of reason, which includes consideration for others. Such a social space is clearly rare, even mythical.) Thus, Germany won a Pyrrhic victory over Rome. It lost more than it gained: the independence it heroically maintained was not as valuable as the civilization it would have gained had it become integrated into Rome. The attacks on Germany by such Germans as Heine and Nietzsche are in part based on this recognition. These masochistic attacks bespeak the German contradiction: they uneasily balance low and high self-regard, showing the German psyche lurching from one extreme to another.

This dialectical oscillation between the sense of vulnerability and of grandiosity – resentful enfeeblement and illusory grandeur – animates the self-consciously Germanic art of Baselitz and Kiefer. The self-contradictoriness of their images suggests Germany's narcissistic pathology. Their attempt to renew a sense of German integrity – the German ideology of radical autonomy, fiercely insisted upon since Germany's Pyrrhic victory over Rome – in the face of Germany's defeat and disintegration in World War II leads them to represent, no doubt unwittingly, self-defeat as the core of German selfhood. In a sense, Germany's defeat in World War II confirmed its ancient sense of itself: it is always put upon by self-styled civilizers, invaded through no real fault of its own. It must defend its state of nature – its purity, as it were. The attack humiliates it in more ways than one: it makes it think less of itself. Germany is forced to see itself in a mirror of civilization that makes it seem less than it seemed to be in the mirror of nature it held up to itself. Thus, it becomes melancholy and self-doubting; at the same time, it idealizes its original state of isolation, which now seems melancholy in its own way. Such complex melancholy, indicative of narcissistic pathology, seems basic to the German sense of self. Germany does not entirely willingly work through its sense of injured self, for without it Germany would have no sense of self. Selfhood and catastrophe are inseparable in its mind. However, this gives Germany a certain psychosocial advantage over other countries: by reason of its history, it is better able to recognize the pathological threat history is to the subject.

In conversation, Baselitz insists that he is not simply a painter but a "German painter." Kiefer has also described his art as specifically German, more particularly, as an effort to "transpose [German] history directly into . . . [his]

life."[2] As Mark Rosenthal has said, "Sensing the presence of World War IIeverywhere in contemporary Germany, Kiefer found its resonance powerful and inescapable. . . . Although he was born in the year the war concluded, he accepted and embraced the event as a touchstone of the inherently German cosmography, a framework that he, regardless of inclination, must accept."[3] The same holds true for Baselitz, who, while born in 1938, was also emotionally formed by awareness of World War II. The point is that a sense of catastrophe − fundamental catastrophe, catastrophe as a starting point one cannot get beyond, catastrophe as origin that is end − pervades their art (Figure 25). The psychoanalyst D. W. Winnicott observes that a preoccupation with catastrophe − the perpetual feeling that it is imminent − indicates in psychological fact a catastrophe that has already inwardly occurred. The final pages of the two books entitled *The Flooding of Heidelberg,* both 1969, are a series of black painted pages, and blackness − symbol and embodiment of catastrophe − has remained the staple of Kiefer's art ever since (Figure 26). His formula "Painting = Burning" − a scorched-earth policy of painting − should be called "Painting = Blackness," for the blackness of ashes appears more often in Kiefer's paintings than the brightness of flames. He obsessively deals with the already destroyed, inwardly and outwardly, not the eternal cycle of destruction and recreation, as is usually thought. The signs of re-creation that appear in his art − a rainbow, the branch he holds in several images, the nude, very fleshy female that appears in others − seem, both in number and execution, secondary to his compulsively repetitive, grandly scaled images of destruction. The signs of life are few and far between in his work and less aesthetically effective. Moreover, they are not what they seem, as I will soon make clear. Death is a much more realized, recurrent − indeed, overwhelming − presence in his work than life, which always exists ironically.

While, as Rosenthal emphasizes, many of Kiefer's images ostensibly use the symbolism of rebirth after death, derived from various mythological sources, both Germanic and non-Germanic (Egyptian, for example) − *Reclining Man with Branch,* 1971, is an early image, derived from a famous medieval source, the 14th century Ashburn Manuscript − he makes subtle changes in the symbolism, perversely reversing its meaning. Thus, the branch in *Reclining Man with Branch* is barren, just as, in his image of his wife *Julia,* also 1971, the marble heart she holds is broken. Both works are supposed to reflect Kiefer's early and ongoing interest in alchemy, through sexual as well as other metaphors involving the reconciliation of opposites. For example, *Julia* supposedly offers Kiefer's spiritual presence in the funnel shape, symbolic of the male-yang, associated with light and heaven. The more concrete presence of Julia, dressed in black, represents the dark, passive, earthy female-yin principle. She is in effect an underworld witch. The bit of white she holds is Kiefer's artificial phallus − epitome of the principle of light − making her Isis to his Osiris, a theme that recurs a decade and a half later in *Brennstäbe,* 1984−87, and *Osiris und Isis,* 1985−87. In all these works the negative, death-infected female has much more substance than the positive, life-signalling male. Whatever the sexist connotations of life and death, it is death not life that interests Kiefer.

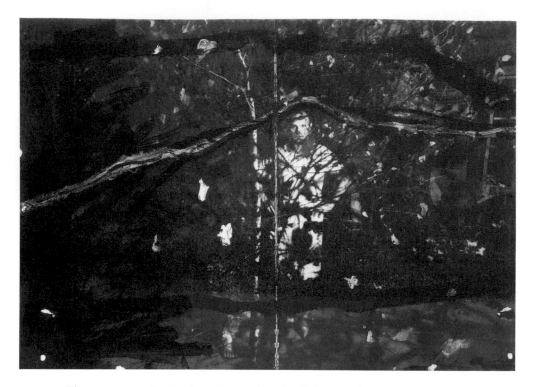

Figure 25. Anselm Kiefer, *Gilgamesch und Enkidu im Zederwald III* (1981), page 1. Oil, acrylic, and shellac on original photo on cardboard. 57 × 43 × 15 cm. 46 pages. Private collection. Courtesy of Marian Goodman, New York.

Indeed, his necrophilia is suggested by the fact that life almost invariably makes an attenuated appearance.

Kiefer's work is saturated with literary allusions, but in perverse form. Many of his images are abstract, hermetic transcriptions of basic ideas about existence that appear discursively in literature. He reconcretizes them in elemental, "irreversible" visual language – their true form. That is, they cannot be put into words again without doing them an injustice – without falsifying them. To trace them back to their literary source would be to miss the point of his deverbalization of them. Kiefer voids discursive language to restore intuitive recognition – conveyed through abstract texture and improvised image – of their elementary existential truthfulness. He presents the existential truth as untranslatable – unintelligible – material substance rather than in intelligible, intellectual form, emotionally unconvincing. He holds the idea incommunicado, as it were, in tactile matter, conveying it in a primary rather than secondary way, as words do. (*Heidegger's Brain*, 1982, with its tumor – implying its hypertrophy – suggests the pathological character of excessively philosophical, discursive communication. It betrays its truths in the process

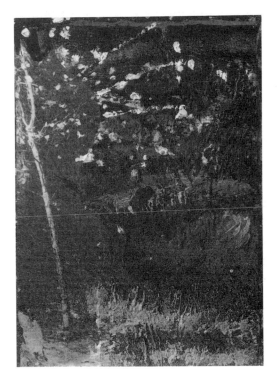

Figure 26. Anselm Kiefer, *Gilgamesch und Enkidu im Zederwald III* (1981), back. Oil, acrylic, and shellac on original photo on cardboard. 57 × 43 × 15 cm. 46 pages. Private collection. Courtesy of Marian Goodman, New York.

of rationally communicating them, which turns out to be a rationalization obscuring their power in the lifeworld.)

The preference for covert visual to overt literary communication is of crucial importance for understanding Kiefer's profoundly Germanic belief that the sense of death is inseparable from a sense of selfhood. That is, the will to death – to risk and face death, as though it is the consummate experience of life – supposedly strengthens the sense of self, if without strengthening its will to life. More subtly, the will to death dialectically gives the self identified with death – infused with it, determined to inflict it on others, ostensibly in revenge for some wrong – the illusion of indestructibility before doing it in altogether. Just as the will to death strips life of its social facade making for a new existential rawness of self, so covert visuality strips art of its representational facade to give vision a new presentational immediacy and intuitive power. That there is self-defeat – the death of the self and communication – in both enterprises is part of their irony, which is not entirely unwitting. The death wish, for all its expression as aggression against oneself as well as others, as Freud said, is recognized with open eyes by those with a sense of their special destiny, for only death can confirm it.

It should be noted that Winnicott has described abstract art as a process of primal sensuous communication.[4] Kiefer's completely abstract *Die Frauen der Revolution,* 1987, based on Jules Michelet's homage to women on both sides of the French Revolution, is an important example of this process of deliterification, if I may use a horrible neologism. It supposedly leads to a reprimalization – to use another one – of communication by way of revitalized sensing. Anti-narrative, it aims at an effect of telepathically intimate and instantaneous communication in a consummate visionary flash – what might be called a Eureka kind of communication. Kiefer has called himself a conceptual *painter* for good reason.

Like Kiefer, from the first, Baselitz's imagery is suffused with a sense of German disaster – the fundamental catastrophe which it is to be German. Whether in the *Amorphous Landscape* of 1961 or the *Saxon Landscape* of 1962– 63 there is a sense of the disgusting, grotesque foulness – the inwardly soiled and outwardly monstrous character – of the German landscape. German figures are also disasters, survivors marked by catastrophe, as the so-called Hero images of the early sixties, and later figural works, indicate. Perhaps the most notorious of them is the 1962–63 *The Great Piss-Up,* as *Die Grosse Nacht in Eimer* has come to be called in English. This painting of an isolated German male who looks as though an attempt to graft new skin onto his face and body has failed, so that he remains hopelessly disfigured, and whose growth has been stunted except in his huge penis, which has been mutilated as though in an abortive attempt at self-castration, was one of two confiscated as pornographic by the Berlin police when it was first exhibited. Clearly the Germans have a different sense of pornography than we do.

This work, and others not unlike it in their gruesomeness and forced crudity, appeared in the so-called *Pandemonium* exhibition, one of two Baselitz held with Eugen Schönebeck, a painter Baselitz was close to at the time. For the 1961 exhibition they issued a *Pandemonium* manifesto. Its language has been described as oscillating "between ecstasy and apocalypse." Or rather it articulates the ecstasy of apocalypse, that is, the perverse pleasure of being trapped in an inescapable process of destruction, indeed, of existing in a ruined state. The "poets lay in the kitchen sink / body in morass. / The whole nation's spittle / floated on their soup / . . . / Their wings did not carry them heavenward – / . . . not a drop wasted writing – / but the wind bore their songs, / and those have shaken faith." In 1962, a second *Pandemonium* manifesto appeared, more devilish than the first one.

Negation is a gesture of genius, not a wellspring of responsibility. . . . With solemn obsessiveness, autocratic elegance, with warm hands, pointed fingers, rhythmic love, radical gestures – we want to excavate ourselves, abandon ourselves irrevocably – as we have no questions, as we look at each other, as we are wordless, as we, most noble profanity – our lips kiss the canvas in constant embrace – as we . . . carry our color ordeal over into life, . . . what our sacrifice is, we are. In happy desperation, with inflamed senses, undiligent love, gilded flesh: vulgar Nature,

violence, reality, fruitless. . . . I am on the moon as others are on the balcony. Life will go on. All writing is crap.[5]

Note the stylized assertion of madness – the formulaic sense of madness's inevitability and chaos, ultimately regression to uncontrollable sensuousness. Note especially the aggressivity of the texts, especially the aggression against writing and the state. A distrust of the state is implicit in the distrust of words as so much lying shit. Writing is self-betrayal, for it gives the self away to society. In contrast, images, especially profane, antisocial – abstract – images, affirm the existentially basic self to itself. They keep it for itself without hiding it from itself. Like Kiefer, Baselitz has a horror of describing feeling, turning it into literature. It must be shown in all its rawness, not written about, which invariably falsifies it, making it more elegant and judicious – less impelled – than it in fact is. Writing distances the subject from its own feeling, which becomes trivially public, that is, illusorily accessible, disseminated in an indifferent – unempathic – world. In the visual image, feeling remains irreducibly fresh and intense. It has a fighting chance of remaining intact, its subtlety not lost to conventions of discursiveness. Indeed, the advantage of visual over verbal art is that it can bring us closer to the sensory-instinctive source of our being. It simultaneously negates the discursive conceptualization of experience and restores a sense of its primitive integrity and immediacy.

Like Kiefer, Baselitz implicitly regards visual art as a kind of madness – to return to the sensuously primitive is a kind of insanity – that negates the false sanity of facile literary rationality. Visual art simultaneously carries out this negation and embodies it, that is, it conveys the catastrophic character of the return to sensory-instinctive chaos while giving it some kind of form. It is the chaos of the pre-psychological flux that antedates the historical formation of the core self, to use Heinz Kohut's language. Their art attempts to return to the amorphousness that Beuys regarded as the necessary condition for self-healing. This chaos or amorphousness is magical in effect. That is, it is the ultimate hallucination – a wish-fulfillment that restores us to the innate expressivity that articulates our primitive sense of being. Kiefer and Baselitz are motivated by the pursuit of the fundamental, nonverbal expressivity lost through language – through the linguistic rationalization of existence. Such rationalization – reification – is an attempt to completely control and totalize it. More deeply, their chaos has political import, indeed, an ironically double, contradictory political meaning: not only does it bespeak the destruction the Nazi state wrought, but it restores freewheeling fluidity as an alternative to the totalitarian regimentation – complete administration – of life that the Nazi state represents. In a sense, they insist that there is no "final solution" to life – no way of fixing it once and for all. Every attempt to deny its dialectical complexity does violence to it. Moreover, they suggest that, pushed to a hyperrational extreme – a kind of decadent insanity – life will dialectically revert to a pre-rational extreme, that is, its "original" insanity.

Technically, Kiefer mediates chaos through cosmic blackness, Baselitz

through human brokenness, that is, the representation of an inherently fragmented and enfeebled human being. While neither directly suffered catastrophe – they were not active participants in World War II – they successfully embody it in an allegorical abstract art, suggesting perverse yearning for firsthand knowledge of it.

Mourning, then, bogs down in a peculiar melancholy in the art of Baselitz and Kiefer. Freud distinguishes between mourning and melancholia – depression – in the following terms:

> Mourning is regularly the reaction to the loss of a loved person, or to the loss of some abstraction which has taken the place of one, such as one's country, liberty, an ideal, and so on. In some people the same influences produce melancholia instead of mourning and we consequently suspect them of a pathological disposition. It is also well worth notice that, although mourning involves great departures from the normal attitude to life, it never occurs to us to regard it as a pathological condition and to refer it to medical treatment. We rely on its being overcome after a certain lapse of time, and we look upon any interference with it as useless or even harmful.
>
> The distinguishing mental features of melancholia are a profoundly painful dejection, cessation of interest in the outside world, loss of the capacity to love, inhibition of all activity, and a lowering of self-regarding feelings to a degree that finds utterance in self-reproaches and self-revilings, and culminates in a delusional expectation of punishment . . . with one exception, the same traits are met with in mourning. The disturbance of self-regard is absent in mourning. . . .
>
> In what, now, does the work which mourning performs consist? . . . Reality-testing has shown that the loved object no longer exists, and it proceeds to demand that all libido shall be withdrawn from its attachments to that object. This demand arouses understandable opposition – it is a matter of general observation that people never willingly abandon a libidinal position, not even, indeed, when a substitute is already beckoning to them. This opposition can be so intense that a turning away from reality takes place and a clinging to the object through the medium of hallucinatory wishful psychosis. Normally, respect for reality gains the day. Nevertheless its orders cannot be obeyed at once. They are carried out bit by bit, at great expense of time and cathectic energy, and in the meantime the existence of the lost object is psychically prolonged. Each single one of the memories and expectations in which the libido is bound to the object is brought up and hypercathected, and detachment of the libido is accomplished in respect of it. Why this compromise by which the command of reality is carried out piecemeal should be so extraordinarily painful is not at all easy to explain in terms of economics. . . . The fact is, however, that when the work of mourning is completed the ego becomes free and uninhibited again.[6]

In contrast:

The melancholic displays something else which is lacking in mourning
– an extraordinary diminution in his self-regard, an impoverishment of
his ego on a grand scale. In mourning it is the world which has become
poor and empty; in melancholia it is the ego itself. . . . it is the effect of
the internal work which is consuming his ego.[7]

As Freud writes, the melancholic has "a delusion of (mainly moral) inferiority,"
"heightened self-criticism," and at the same time an "insistent communica-
tiveness which finds satisfaction in self-exposure."[8] The key to melancholia is
"that the self-reproaches are reproaches against a loved object which have been
shifted away from it on to the patient's own ego." More particularly, it

proceed[s] from a mental constellation of revolt, which has then, by a
certain process, passed over into the crushed state of melancholia.

There is no difficulty in reconstructing this process. An object-choice,
an attachment of the libido to a particular person, had at one time existed;
then, owing to a real slight or disappointment coming from this loved
person, the object-relationship was shattered. The result was not the
normal one of withdrawal of the libido from the object and a displacement
of it on to a new one, but something different. . . . The object-cathexis
proved to have little power of resistance and was brought to an end. But
the free libido was not displaced on to another object; it was withdrawn
into the ego. There, however, it was not employed in any unspecified
way, but served to establish an *identification* of the ego with the abandoned
object. Thus the shadow of the object fell upon the ego, and the latter
could henceforth be judged by a special agency, as though it were an
object, the forsaken object. In this way an object-loss was transformed
into an ego-loss and the conflict between the ego and the loved person
into a cleavage between the critical activity of the ego and the ego as
altered by identification.[9]

The standard interpretation of Baselitz and Kiefer argues that their art,
speaking in the name of a Germany that has recovered its sanity, signals
mourning for the collective insanity of Nazi destruction. It is a backward look,
full of regret for the past. The difficulty of the withdrawal of affection from
Nazi Germany is suggested by the agonized look of their figures and land-
scapes. There is no pathological inability to mourn in their art – in contrast
to German society, as the psychoanalyst Alexander Mitscherlich argued – but
a healthy admission of guilt for a deep attachment to an inhumane regime.
The mourning has a secret mission in mind, the indirect point of their art: the
re-cognition of Germany's normalcy. This is meant to suggest that Nazi Ger-
many was a freakish aberration rather than the inevitable political expression
of a pathology endemic to German society. Baselitz and Kiefer monumentalize
and stylize the aberration, treating it like a curiosity whose abnormal appear-
ance must be preserved for posterity, and at the same time discrediting it by
making it seem peculiarly hollow – a facade with nothing behind it. It is the
dead symbol of a faith which no longer has any worshippers.

However, their art is better understood in terms of melancholy than mourning. They "represent" Germany's low self-esteem, the product of its ambiguous relationship with the rest of the world, beginning with Rome. This ambiguity echoes in Germany's sadomasochistic aggression, that is, its perverse identification with a world it would like to destroy. Its intention is no doubt inseparable from the fact that this world implies that it has something – civilization, with its power of integration – that Germany does not have. Rome meant to bring to Germany the civilization it presumably did not have. But the gift was experienced as an intrusion. Civilization was forced upon it against its will and, worse yet, seemed to weaken its will. Germany successfully resisted civilization but became uncertain of itself in the process, reflected in its fragmentation and aggression. That is, it split in two: physically, it remained enfeebled – divided against itself – despite its technical victory over civilization; spiritually, it developed an attitude of perpetual revolt against civilization. For unconsciously Germany became resentfully aware that by winning militarily it lost out spiritually. It began to suspect that it should have accepted Roman rule and, in its later idealization of the Mediterranean, it in effect did.

The psychoanalyst Heinz Kohut regards aggression as a "disintegration product" of the fragmentation of self that occurs in narcissistic pathology. Germany's political fragmentation has remained constant, from the Holy Roman Empire through the postwar period, with the brief interlude of its modern imperial period, a comparatively small duration. In a sense, Germany's history of aggression has been an acting out of the sense of injured self – the fragmentation of self – that developed during its formative years. Its narcissistic troubles began with its shattered relationship with ancient Rome, which, like all early relationships, made an indelible impression, insidiously determining its subsequent history.

To understand the dialectic of this ironical relationship, which figures prominently in Kiefer's oeuvre, it is necessary to know something of its history. Augustus seemed to have accepted Caesar's view of the Rhine as the frontier of Rome, but in 12 BC he sent his stepson Nero Claudius Drusus to lead the Gauls and Romans in a campaign against the Germans, the traditional enemies of both. It is not clear whether Augustus intended to annex Germany. Drusus did reach the Elbe, where he died in 9 BC. His brother, the future Emperor Tiberius, continued the campaign (8–7 BC). However, an empire of sorts was growing under Maroboduus in the territory of the Boii, a German tribe. At the same time, between 7 BC and AD 4 several Roman expeditions crossed the Danube into Germany. And in AD 5 Tiberius subdued the Cimbri in the Danish peninsula. A grand, presumably conclusive campaign was intended for AD 6. But it was forestalled by a revolt in Pannonia. In AD 9 there was another revolt, this time in the west, led by Arminius. In a famous battle in the Teutoburger Forest, he defeated the Roman governor P. Quinctilius Varus, completely destroying three Roman legions. Augustus, realizing the great cost of conquering Germany, decided that the Rhine and the Danube should remain the frontiers of the empire. It was a realistic and civilized decision, saving Roman lives.

Arminius – the German Hermann – features prominently in three Kiefer paintings, *Piet Mondrian – Hermanns Schlacht*, 1976, and the two versions of *Wege der Weltweisheit – Hermanns Schlacht*, 1976–77 and 1978–80, and indirectly in a fourth painting, *Varus*, 1976. Hermann is presented conceptually – a name around which the cause of German unity organized itself in the 19th century – as well as in association with the forest in which he fought his successful battle against the three Roman legions. An ironically black, charred – ruined – forest in Kiefer's paintings, it signals the devastation German nationalism brought upon Germany. Kiefer, then, deals with Hermann's victory, the quintessential, formative moment of German identity – a moment of self-assertion and independence.

Almost all of Kiefer's subsequent landscapes recapitulate the desolate scene of this slaughter. It is an ambiguous landscape, all the more so because the Germans lost more than they gained. Kiefer's archaic, usually ruined architecture is equally emblematic and desolate. In general, he invites us into the picture of plain and building – equally deserted – through a perspectival vector. Trapped in their space – it has no exit, however implicitly infinite (sublime space masks the abysmal nothingness of death) – we experience claustrophobia and agoraphobia simultaneously. Kiefer's German space suggests the emptiness of uncivilized strength, as well as the fact that Germany is an outcast country. Indeed, while having defeated the Romans in its wasteland, the very fact that Germany is a wasteland – in Kiefer's representation of it – suggests that the Romans should have rejected it as a place unfit for civilized life. Not only does Baselitz also paint forest scenes – even foresters – but his sculptured figures are carved from thick tree trunks, and his painted ones look as though they ought to be. His figures have the same peculiarly injured, desolate look as Kiefer's landscapes and architecture, hidden under a similar harshness and grimness.

In all these *Urnatur* images, the general air of violence and destruction suggests German self-punishment – tending toward self-destructiveness – for the ancient victory over the Romans. The intense melancholy of these images implies German identification with the Romans, who disappointed – indeed, profoundly frustrated – them by not conquering them. That is, unconsciously the Germans wished to be conquered – civilized – however much they resisted the thought consciously. The depression that results, with its mixed feelings of inferiority and superiority, almost does them in. It certainly reflects intense self-conflict – self-torture which turns outward in sadistic aggression.

I am saying that the attraction of opposites held between the Romans and the Germans – the civilized and the barbarians. The two were always trying to integrate, with mixed results. Indeed, historically, the Chatti, the most civilized German tribe, inhabiting the upper Weser River and Taunus Mountains, became agents of Rome after being conquered by Domitian in two campaigns (AD 83 and 88). The Roman line of defense was shortened to the crest of the Taunus. It was extended southward and eastward to join the Danube near Regensburg. By the time of Hadrian (emperor 117–38) and Antoninus Pius (emperor 138–61) Roman dominion and even the outward signs

of Roman civilization reached to the central German or Hercynian forest. In many of Kiefer's images we see tokens of civilization – for example, the book – set in a desolate space which seems to absorb them rather than which they seem to dominate. Kiefer suggests that Germany perversely puts the book to barbaric use, just the way it used the railroad to transport victims to Auschwitz – Kiefer shows its tracks in *Iron Path,* 1986 – and the way Hitler used the bathtub to plan his invasion of England, as *Operation Sealion,* 1985, shows. Again and again Kiefer implies that Germany is fundamentally barbaric, for it uses the advances and amenities of civilization for a regressive destructive purpose, dirtying them, blackening civilization with shame. No doubt this is part of the black mood – deep melancholy – of his pictures.

Finally, the famous German forest features prominently in the neo-archaic images of Baselitz and Kiefer. Both are fascinated with the inner and outer texture of its freshly cut wood, affording a primitive sensation they attempt to articulate abstractly. In *Wilhelm Meister* Goethe wrote:

> I drew my friend into the woods. While shunning the uniform fir trees, I sought those beautiful leafy groves which admittedly do not extend far and wide throughout the region but are still of such size that a poor, wounded heart can hide itself there. In the inmost deep of the forest I had sought out for myself a solemn place where the oldest oaks and beeches formed a splendidly large, shadowed area. The ground was rather sloping and rendered the contour of the trunks all the more noticeable. All around this open radius the thickest bushes merged together, through which moss-covered crags loomed in their strength and dignity and provided a swift fall for a voluminous stream.
>
> I had hardly forced by friend to this place when he, who preferred to be in an open landscape beside a river and among his fellowmen, laughingly assured me that I had demonstrated myself to be a true German. He recounted to me in great detail from Tacitus how our forebears had delighted in the feelings with which nature inspires us so magnificently and yet so unaffectedly in such solitudes. He had not held forth long when I cried out: "Oh, why doesn't this charming place lie in some great uncharted forest, or why may we not put a fence around it in order to sanctify it and ourselves and cut both off from the world! Surely there is no more beautiful way in which to revere the godhead than that with which no picture is needed but which simply springs from the heart when we commune with nature!"

The German forest symbolizes German xenophobia. The Nazis used Hermann, identified with it, as an ancestral totem figure to incite hatred of foreign influences. They in effect repeated his "rejection" of Rome's foreign influence, his ousting of the alien in the name of German purity and integrity.[10] As Rosenthal notes, tree rings prominently recur in Kiefer's images, almost always in association with dramatic destruction in isolated nature.[11] Kiefer repeatedly asserts the lack of any "alternative to the one-dimensional, German 'wisdom' afforded by the single path seen in the landscape."[12] This path is always burnt

. or violently cut through it, confirming its destroyed – self-destroyed – character. Kiefer's landscapes and architecture, and Baselitz's figures represent the German death wish. The "instinct of destruction," as Freud said, is "directed against the external world and other organisms."[13] Its task is "to lead organic life back into the inanimate state."[14] Kiefer's death-infected scenes have an inorganic or ambiguously organic – death-in-life – look to them. Similarly, Baselitz's figures are in the last analysis more suffused with death than with erotic life, which seems like a bright veil to distract us from the grim reality underneath.

Freud notes the fusion of libido and aggression that occurs in the sexual act, with aggression in the service of sexuality. There is a similar fusion in the artistic acts of Baselitz and Kiefer, but with the erotic in the service of aggression. More particularly, they suggest the perverse narcissistic satisfaction death gives the German. This is inevitable in melancholy; there is consummate narcissistic pleasure in the self-punishment of guilt. In general, melancholy is not the working through of a loss, as mourning is, but a crippling stasis of self-conflict. To put this another way, the art of Baselitz and Kiefer shows mourning gone amiss, ineffective. Their Germany remains haunted, to the point of oppression, by the hidden thought of the civilized world that has rejected it, leading it to reject itself, and finally aggressively rebel against its self-rejection and the civilized world. But by committing crimes against civilization, causing it to suffer, Germany in the end only increases its own suffering and confirms civilization's belief in its barbarism – the perversity of its independence. Baselitz and Kiefer render the dialectic of German aggression and depression – the dialectic of German sadomasochism – with great subtlety. Their art bespeaks the vicious circle of depression in which the German psyche seems trapped.

18

Anselm Kiefer's Will to Power

ANSELM KIEFER is a literary, philosophical, and spiritual artist, usually understood as attempting to restore the validity of meta-narratives, those myths that offer a ready-made framework of meaning for our lives. But Kiefer's oeuvre effectively begins with his very personal photographic series entitled *Besetzungen (Occupations,* 1969). In these works he depicts himself making the Nazi salute, the salute of and to power – power absolutized, fetishized, and embodied in a single emblematic figure. Does Kiefer want to become that emblematic figure? Is he a neo-Nazi in spiritual/artistic disguise? Is the myth of absolute power *the* meta-narrative subsuming our lives? Is devotion to and identification with the Great Man embodying Power the basic way of making our lives meaningful? Does Kiefer's art encourage such slavish devotion and uncritical identification?

Some critics find these photographs to be quixotically comic. Trafficking ironically with a forbidden gesture from the repressed German political past, Kiefer supposedly ridicules the Hitlerian gesture he emulates, and his blatant use of the salute becomes a critical comment on that past. Some critics also interpret the *Occupations* series as Kiefer's outspoken way of declaring himself a history painter. In a sense, the greatness that was Germany ended with Adolf Hitler, so why not institute a new German art with the sign that is directly associated with him?

Whichever the case, the series is surely an attention-getting device. The Hitler salute remains notoriously recognizable; its meaning is instantly and universally clear. However, this suggests that what it stands for is still a hot issue. Thus, while Kiefer's use of the salute may be sardonic, it inevitably raises the question of his attitude to and artistic usage of the power the salute embodies.

I submit that preoccupation with power is fundamental to Kiefer's art. Manifesting one aspect of what he calls the "spiritual/psychological" ambition, Kiefer's art attempts to reconcile worldly and spiritual/artistic power. Like the work of Joseph Beuys, it focuses on the need for "spiritual purification" or regeneration of the spirit of life. This is to be brought about by a dialectic of

self-knowledge, in which the historically objective past, at once collective and individual, is worked through subjectively and intellectually. Ostensibly, this justifies Kiefer's melancholy obsession with the power of art as well as of German power. But where the former may have spiritual/psychological effect, the latter can hardly be said to have any. Perhaps Kiefer's art, like Beuys's, is a test – a last-ditch defense and demonstration in one – to determine whether art in general can effect a spiritual/psychological transformation of German society and the German self. Hitler claimed spiritual justification for his material abuses of power; he also had strong artistic interests. Is Kiefer unwittingly regressive, a Nazi wolf in sheep's clothing, or simply a German artist consciously using ready-to-hand nationalistic imagery, including that of the Nazis, to investigate power, a universal issue?

In the catalogue accompanying Kiefer's first American retrospective (the show, organized by the Art Institute of Chicago and the Philadelphia Museum of Art, closes out a thirteen-month, four-city tour with its appearance at New York's Museum of Modern Art), curator Mark Rosenthal raises the Nazi issue early on in his fine essay. Alluding to Kiefer's 1969 book *Du bist Maler (You're a Painter),* Rosenthal remarks:

> The title of the work is an exhortation to himself and to the figures on the cover: to create ideals, shape the world, and, above all, seize his destiny as a painter and vehemently take action. It is only after one learns that the sculpture depicted on the cover of this book is by one of the Nazi-approved artists (possibly Josef Thorak) that one begins to sense the ambiguity of Kiefer's approach. If he, like the Nazis, wants to jettison international art so as to explore his own roots, is he, then, a Nazi heir at heart?

Hitler exhorted the German people to action, with goals ostensibly idealistic and noble but in fact self-serving and violative. The Germans have been known for their sophisticated reflection, for their hyper-civilized music and philosophy, as well as for their military might and barbarism. However, for the Nazis, who burned books and works of art, action was more to the point than reflection. Is Kiefer trying to heal this split in the collective German psyche?

Let me rephrase and intensify Rosenthal's question: Does Kiefer's dabbling in the black magic of *echt deutsch* imagery, his use of German historical and mythological associations, make both his appropriation of Beuys's conception of art as a redemptive healing process and his position as a major spokesman for conscience in contemporary Germany just big lies masking a neo-Nazi lust for power? This question signals my sense of Kiefer's ambivalence about German power: his apparent desire to restore it, yet his abhorrence of the destructive Nazi form it took. As I hope to show, Kiefer's art is a compromise: he is reluctant to give up the German sense of power, but he knows that German power has to take a new form. More precisely, by alluding to the dubious glories of the past reality of German power, Kiefer's art presents a complex fantasy of its possible future. He transforms the symbols of a faded yet still-resonant national and military power into symbols of potential spiritual

power. Kiefer's compromise – the split identity of his art – is emblematic of Germany's "compromise formation." Relatively impotent compared to what it was under Hitler's rule, Germany still wishes for great power but recognizes the impossibility of having it. It knows it can never again use power in the same aggressive, malevolent, and tyrannical way it did when it was Nazi; rather, it must become a positive spiritual rather than negative secular power. Kiefer means his artistic power to be a form and demonstration of such spiritual power. Like military power, spiritual power flaunts itself and makes sweeping claims, but in a different, supposedly superior, realm. Kiefer shares the new Germany's seemingly strong will to power, which, in its frustration, necessarily takes "otherworldly" form. Power makes an erotic, mournful appearance in the textures of Kiefer's art. These textures suggest devastating impotence, romantic yearning for absolute power, and militant assertion of a ghost of power.

In the course of his lucid account of *Occupations,* Rosenthal, alluding to a photograph in which Kiefer is seen "occupying" the Roman Colosseum, remarks, "By means of the ruined grandeur of the Colosseum, Kiefer shows that once-meaningful symbols of power and obedience can lose their content altogether." (It should be noted that *Occupations* is a conceptual photographic piece that sets the tone for the conceptual painting and mixed-media works that follow. Kiefer's ideas remain constant, but his means vary as he restlessly explores ingenious new expressions of them.) But this does not mean that the content is dismissed altogether. Rather, it goes underground, changing form. The problem of Kiefer's art is to give new symbolic form to an age-old German (no doubt age-old human) will to power and the obedience that is its correlate and confirmation.

Scientists and psychologists have shown that ontology recapitulates phylogeny (that is, the individual's development follows in condensed form that of the species). Similarly, Kiefer's "historical quest," as Rosenthal calls it, can be said to recapitulate German conquest. In other words, Kiefer's sense of heroic individuality uses as its springboard the collective history of German conquest, whose climax was Hitler's conquests and imperial ambition. Kiefer can pose in isolated grandeur, making the Hitler salute as though to himself because he identifies with imperialist Hitler. It was Hitler who stood in isolated grandeur, making the salute of power to himself and receiving homage in the form of salutes from the German masses. The collective Nazi past is the narcissistic core of Kiefer's personal identity; his primary sense of himself is as the heir to the Nazi past. Full of the artist's special brand of grandiosity, of narcissistic belief in the omnipotence of artistic thought, Kiefer spontaneously identifies with and imitates the Nazi leader himself. For if the artist is to be a leader – even if only a spiritual leader – he must learn the manners, the public bearing, of a real leader of the people, a man of blood and soil and iron. No doubt the identification and emulation involves an effort to transform these primitive materials and symbols of primordial power into purer spiritual substance, but one can carry out the alchemical transformation only if one knows in one's very being what it feels like to have power. As with Beuys,

art to Kiefer is perceived as a homeopathic process, demanding immersion in an alien element. What better form of immersion than modeling oneself on a leader who had absolute temporal power?

Freud once wrote that "identification is a substitute for a lost human relationship," or, as the psychoanalyst Harry Guntrip said, "one that was urgently needed and unobtainable." In *Occupations,* the touchstone of Kiefer's oeuvre, he courageously externalizes the German identification with Hitler, whose representation is deeply internalized in the Nazi psyche, in effect acknowledging Hitler as a serious part of his identity, indeed, as the very basis of his grandiose sense of himself as an artistic leader. The externalization is both an acknowledgment as well as an attempted purge of the unavoidable ancestor. However, it also expresses a yearning to merge with the father figure, for Hitler was the last truly powerful German.

Much has been written about the German inability to mourn – most notably by the psychoanalysts Alexander and Margarete Mitscherlich – but it has not been realized that for the Germans seriously to mourn their crimes against humanity they must acknowledge their previous elevation of, indeed love– yes, love! – for Hitler, the father of their country and, ironically, of postwar Germany. He is the person who had the greatest influence on German history, who seemed to be a perverse culmination of German nationalism and destiny, and whose own perversity symbolizes what has come to be understood as generic German perversity. Kiefer's unconscious and conscious engagement with Hitler symbolizes the entire thrust of his art. It involves an embrace of Hitler and his power, either openly, as in the early *Occupations,* or in the later, wiser, and more discreet *Unternehmen "Seelöwe"* (*Operation Sea Lion,* 1975) and *Unternehmen Wintersturm* (*Operation Winter Storm,* 1975), among other works. (The former deals with the unrealized Nazi plan to invade Great Britain by sea. The latter deals with Hitler's ill-fated invasion of endless Russia.) When Kiefer makes a work called *Ein Schwert verhiess mir der Vater* (*My Father Promised Me a Sword,* 1974), and works in which a mythological sword awaits the hero who can bear it (*Notung* [*Nothung,* 1973] is a well-known example), it is the sword of power that the father Hitler – as mythological as the legendary German chieftain Hermann, whose dead blood and dead soil is the substance of *Wege der Weltweisheit* (*Ways of Worldly Wisdom,* 1976–77) – is passing to his true German son, Anselm Kiefer. Indeed, artists such as Kiefer and Georg Baselitz vie to demonstrate their genuine Germanness. Kiefer's homage to and identification with the dreary German landscape is, however ironic, perhaps the ultimate form of such grim German rootedness.

I contend that Kiefer wants us to believe that Hitler's military conquests, or plans for conquest, were really a spiritual conquest in disguise – a new plan to unite Europe into a spiritual empire. This is supposedly suggested by the daffy, ineffective character of the Sea Lion operation and the boundless, romantic ambition Hitler showed. It is indicated as well in such works as *Vater, Sohn, heiliger Geist* (*Father, Son, Holy Ghost,* 1973), which overtly declares the spiritual character of the sacred fire kept alive by *Deutschlands Geisteshelden*

(*Germany's Spiritual Heroes,* 1973), the exact same fire responsible for the burn-
ing of earth and bodies that the Nazis practiced and that Kiefer regards painting
to be – and not just metaphorically, as *Malen = Verbrennen (Painting =
Burning), Malen (To Paint),* and *Malerei der verbrannten Erde (Painting of the
Scorched Earth),* all 1974, make clear. (Kiefer may also be alluding to the
"burning" of modern painting accomplished by the Nazi destructive labeling
of it as "degenerate.") It is the scorched earth of *Ausbrennen des Landkreises
Buchen (Cauterization of the Rural District of Buchen,* 1975) and of *Maikafer flieg
(Cockchafer Fly,* 1974), which has inscribed as part of its deadly surface the
German nursery rhyme: "Cockchafer fly, / Father is in the war, / Mother is
in Pomerania, / Pomerania is burnt up." Kiefer conceptually performs – acts
out in the displacement of art – such destructive Hitleresque acts as the *Die
Uberschwemmung Heidelbergs (Flooding of Heidelberg,* 1969).

In general, Kiefer celebrates the destructiveness of imperial madmen, as in
Nero malt (Nero Paints, 1974), where painting clearly represents the burning
of earth. Rosenthal remarks, "Just as Nero and Hitler might have imagined
that their acts followed the pattern established by various gods, Kiefer carries
out a theoretical flood." Let us recall that Nero and Hitler were unsuccessful
artists and successful emperor/tyrants and that artists and emperor/tyrants have
customarily been regarded as simultaneously madmen and gods. (From our
human point of view they are not always distinguishable.) Both madmen and
gods can violate human norms without compunction. Such regressive acts of
violation often are dubiously regarded as "transcendence" of the human con-
dition and order of being, as well as of ordinary law-abiding society. They
implicitly appeal to, and are justified on the basis of, "higher law." Such higher
law, however, clearly has some unusually low aspects.

Kiefer is a successful artist and would-be emperor/tyrant. There is an in-
teresting convergence here: artist, emperor/tyrant, madman, god. Kiefer un-
consciously imagines himself to be all in one. All four arrogate to themselves
outsider positions (including the supposedly insider emperor/tyrant). All four
make a virtue of seemingly absolute difference from the generically human.
This is the paradoxical core of their perversity, for on the basis of their absolute
difference they abolish all differences, as destructive burning does. Perversion,
as the psychoanalyst Janine Chasseguet-Smirgel writes, is an attempt to oblit-
erate all differences, especially between the sexes and the generations. The
pervert – the artist, emperor/tyrant, madman, and, yes, god – destroys or
abolishes the law, which, as Chasseguet-Smirgel points out, in Greek means
" 'that which is divided up into parts.' . . . The principle of separation is the
foundation of the law." That being who is most ostentatiously separate has
the power to abolish the principle of separation. Indeed, that is exactly what
this being's power consists in. It has been argued that society as a whole
regularly needs – to again use Chasseguet-Smirgel's language – that "recon-
stitution of Chaos" that occurs in (individual) perversion, regularly needs to
destroy the principle of separation, so that "a new kind of reality, that of the
anal universe," can arise. This is why society tolerates and at certain moments

elevates artists, emperor/tyrants, and madmen – that is, those who pretend to be, and unconsciously may even be convinced they are, gods.

"At a certain level," writes Chasseguet-Smirgel, this "anal-sadistic universe of confusion and homogenization constitutes an imitation or parody of the genital universe of the father . . . a rough draft of genitality." Kiefer gives us, in his burning and burnt-looking paintings, the destructive and destroyed, confused and homogenized (universally blackened), anal-sadistic universe of chaos. And the apparent healing moment of re-creation in Kiefer, the rebirth of the principle of separation – the moment Kiefer has described as *Saturnzeit* (*Saturn Time,* 1986), associated with *Jerusalem* (1986) and the rebirth of *Yggdrasil* (1985), the Nordic tree of life, and depicted in the nuclear catastrophe/creativity pictures *Osiris und Isis* (*Osiris and Isis,* 1985–87) and *Brennstäbe* (*Burning Rods,* 1984–86) (in these the mystical destruction and resurrection of Osiris is presented through the metaphor of nuclear energy) – is a parody of the genital universe, where law and order reign. In fact, separation (basic differentiation) hardly exists and seems hard-won in these pictures, if obviously more evident than in (to take an extreme example of perverse chaos) Jackson Pollock's all-over paintings. Kiefer offers us a parody of creation and re-creation. This is perhaps most explicit in the various palette and book works, where the separation of these signs of art and thought from the canvas surface is either highly equivocal or, in the book works, sardonically exaggerated. In Kiefer's hands colorless palette and leaden book are ironical, self-defeating symbols of phallic power. There is at once pathos and parody in his treatment of these personally as well as socially important symbols.

This element of parody is clearly related to Kiefer's own reference to the "irony" and "absurdity" – his own words – of his works. Kiefer is more at home with destruction than creation, more comfortable with the anal-sadistic universe of destruction and catastrophe than with the universe of separate functions and beings created by the genitality of the father. This shows the depth of his desire for primary power (anal-sadistic, destructive power, the power to constitute chaos, to wreak havoc, to violate) and how much he regards genital power (the power to create binding distinctions, clear and distinct separations) as secondary. In this, he shows himself a quasi-Nazi. Nonetheless, the contradiction between the dominant destructive impulses and the submissive reconstructive impulses in Kiefer's work remains, giving his works a special tension.

In this perverse desire for power, which is at the root of Nazism in particular and fascism in general, exists the crippled, shadowed side of romanticism. The chaotic universe it posits – a world without law and order – is false freedom. The impotent attempt to re-create the universe according to a new principle of separation, or to establish a utopian society on the basis of a new kind of law and order, is the bright side of romanticism, even though it is an unrealizable and false side. Kiefer is bogged down in this romantic ambivalence of feeling and meaning, much as Hitler was.

It may be stretching things, but there is a peculiar parallel between Hitler and Kiefer. Both – the one in the sociopolitical realm, the other in the artistic/ spiritual realm – epitomize what Morse Peckham calls the anti-role of the romantic. They represent the regressive climax of nineteenth-century romantic history. Peckham identifies the romantic anti-roles as the poet-visionary or visionary-artist, the bohemian, the virtuoso, and the dandy. Peckham notes that the romantic tradition is historicist, especially in its architecture. We know that Hitler was obsessed with creating the architecture for a new thousand-year empire and that he conceived of himself as a visionary. He was also, as paradoxical as it may sound, a bohemian, virtuoso, and dandy. Like such types he demonstrated the pointlessness of the conventional limits of society. That is, in their different ways all the anti-roles perversely attempt to destroy the separations and differences in existing society by attempting to establish a mythical, heroic society in which there are no constraining rules – only great individuals and those who obey them. Those who choose the anti-role do not want to live in a well-proportioned, regulated society, but in anal chaos. Kiefer is historicist, indeed, militantly so. This is particularly evident in his archaic architectural imagery, generally monumental and loosely primordial in feel, especially the wooden structures. Sometimes it is even ruined Nazi architecture. Kiefer's work also claims to be visionary; it is certainly virtuoso, as well as dandyish and bohemian in its feeling for the absurdity of the ordinary social order.

In his romanticism Kiefer is as nihilistic as Nietzsche, whose work, as Peckham writes, "is the triumph of Romanticism, for he solved the problem of value and returned the Romantic to history, by showing that there is no ground to value and that there is no escape from history." For the romantic, "reality is history, and only the experience of reality has value, an experience to be achieved by creating illusions so that we may live and by destroying them so that we may recover our freedom." For Nietzsche, art created the supreme illusion – the one necessary to restore our failing will to live, to eliminate our despair or "sickness unto death," as Kierkegaard called it in a famous phrase. This is what we see in Kiefer's art: the romantic recognition of the inescapability of the misery of history and the attempt to create artistic illusions, which give us the will to live in the face of such misery. Kiefer wants to reinforce the recognition of history and to seduce us into another "recognition," namely, that life is worth living despite its misery (a misery presumably experienced more deeply and consciously by romanticists than by others). Ironically, art's illusions keep us in the miserable historical game. Works of art are enticing objects, seducing us to life without really giving us a better one. They are made to prevent us from believing that there is escape from history in eternity, that special form of suicide and anesthesia. Art stands between history and eternity; where it once may have pointed the way to eternity, in the romantics in general and Kiefer in particular it points the way back to history – it restores our appetite for life.

Kiefer is covertly successful at restoring our will to live by his artistic illusions. Overtly they seem full of historical misery. But their surfaces have

a voluptuous negativity, a dark sensuality celebrated by many American critics, who are always on the lookout for heirs to Pollock, whom they understand as little as they understand Kiefer. Typically formalist, these critics swoon over the chaotic textures without understanding their connotations – the mire of death they are ecstatically immersing themselves in. Nonetheless, that deadly texture is lushly sensual. That rich, painterly surface – evident especially on the pages of Kiefer's books – is the illusion of life that lures us, that restores the appetite for life, the desire to embrace it. Unfortunately, in embracing it we also embrace death.

But above all, what we are embracing is power and the devastating results of its operation – the power of life and its ability to create death. As Nietzsche said, the will of life is really the will to power, which is the only true will; in his account of "What is Noble" in *Beyond Good and Evil,* he makes a famous distinction, later appropriated by the Nazis, between "*master morality* and *slave morality,*" a distinction that can exist "even in the same human being, within a *single* soul." According to Nietzsche, "the noble human being separates from himself those in whom the opposite of such exalted, proud states finds expression: he despises them. . . . The exalted, proud states of the soul [that] are experienced as conferring distinction and determining the order of rank," are, finally, special states of power. In them the soul is experienced as having limitless power, able to overcome all opposition and dominate completely.

Kiefer implicitly wants to demonstrate his master morality – his nobility – and above all to rescue, as it were, the master morality of the Germans. Although they have been defeated, they will not be reduced to a slave morality.

This preservation of the German master morality necessarily remains repressed and transformed, since it has failed for all practical and psycho-social purposes. The will to power must take a non-Hitleresque or non-Nazi form: its form must be spiritual and artistic – the form of a grand spiritual style. The philosopher Alfred North Whitehead has written that "above style . . . there is something, a vague shape like fate above the Greek gods. That something is Power. Style is the fashioning of power, the restraining of power. But after all, the power . . . is fundamental." Kiefer's extraordinary stylistic strength derives from his recognition of power as destiny, and German power as fundamental to the fate of Germany. This power, which once was dangerously manifest, bringing Germany almost to the point of complete destruction and dismemberment, must now be disguised, given "civilized" form, artistic style. (It should be noted that dismemberment is a leitmotif of Kiefer's Wagnerian art. His very first book dealt with the fragments of a vase; *Isis and Osiris* deals with these same fragments, three-dimensionalized and transposed into symbols of Osiris's dismembered body.) Kiefer's remarkable, romantic stylistic virtuosity – in emulation of Beuys – not only functions as a restraining disguise on the German will to power, but locates this power on a higher (spiritual rather than physical) level. Style is the means of transition from the physical to the spiritual. Indeed, physical sumptuousness becomes confused with spiritual aspiration in Kiefer.

Nietzsche has written that

the priest wants it understood that he counts as the highest type of man, that he rules – even over those who wield power – that he is indispensable, unassailable – that he is the strongest power in the community, absolutely not to be replaced or undervalued. . . . What gives authority when one does not have physical power in one's hands (no army, no weapons of any kind –)? How, in fact, does one gain authority over those who possess physical strength and authority? . . . Only by the belief that they have in their hands a higher, mightier strength – *God*. Nothing is sufficiently strong: the mediation and service of the priest is *needed*.

Style – the instrument and sign of artistic power – mediates spiritual power. More precisely, style makes the physical power of the work spiritually *suggestive*. Germany has lost its physical strength and authority: it has been defeated, rendered powerless. Its military might is insignificant. It exists at the mercy of East and West, caught in the pincers they make. What will keep it from being destroyed, or being trivialized even more than it has been already? The answer lies in its spiritual power, on which it has always fallen back when its physical power has failed it. Its will to power lives on in spiritual form.

The slaves became masters over their physical/military masters by proclaiming their special access to a higher power, such as the god of art. While Kiefer is stylistically disobedient, restlessly ranging through various stylistic disciplines, taking what he wants from each, he remains rigidly Germanic in his obsession with and desire for power. At this time, the Germans can have only spiritual/artistic power, which itself becomes a kind of political power. Kiefer presents himself to us as an artist-priest, as in *Mann im Wald* (*Man in the Forest,* 1971), or a warrior-priest, as in *Chuwawa/Gilgamesch* (*Chuwawa/ Gilgamesch,* 1980). He is the keeper and mediator of spiritual power – vulnerable in his simple white frock and in his isolation (he has no armies). He makes a bohemian, dandyish, and altogether theatrical appearance. From making the theatrical Hitler salute, a symbol of physical/military power and authority, he has come to make a theatrical spiritual salute by holding a burning branch (sometimes a torch), a symbol of spiritual power. He has recouped the German loss of physical power by proclaiming German spiritual power – the power of the German forest. All of Kiefer's highly varied iconographic and stylistic apparatus exists for one purpose: to disguise the rawness and fundamentalism of his German will to power, and to give it spiritual form, to transform it into socially reputable and intellectually respectable form. He shows us a German reappropriation of the will to power on a new level, the Germans falling back on their supposedly unique spiritual gifts, their military prowess – from Hermann to Hitler – having finally left them in the lurch. In a sense, Kiefer is a con artist, like all priests (as Nietzsche suggests). No priest will ever mourn for the death of God, and no German will ever mourn for the loss of power. Instead, each will attempt to reconstitute the object of his belief – the object that is the very basis of his existence – in a new way and form. Germans cannot afford to mourn or forget the will to power, for to do so is in effect to forfeit their history and collective identity.

19

Gerhard Richter's Doubt and Hope

Everything unknown frightens us and fills us with hope at the same time . . . even representative paintings have this transcendental aspect. . . . This is the source of the new continually increasing fascination . . . that so many old and beautiful portraits exert upon us. Thus paintings are all the better, the more beautiful, intelligent, crazy and extreme, the more clearly perceptible and the less they are decipherable metaphors for this incomprehensive reality.

Art is the highest form of hope.

<div align="right">Gerhard Richter, 1982</div>

I N an interview with Benjamin Buchloh, all the more revealing in that the artist and the critic are completely and hilariously at odds – Buchloh tries to enlist Richter's art in the cause of the notion "that art should realize a political critique" and serve ideological ends, and that painting is dead, and Richter quietly but insistently resists both attempts to predetermine its meaning – Richter describes "the fundamental issue as the 'loss of the centre.' "[1] This is an allusion to Hans Sedlmayr's important, now neglected book, *Art in Crisis: The Lost Centre,* an allusion which Buchloh, who throughout the interview operates with the loaded dice of authoritarian leftist assumptions (not to speak of his stagnant notion of revolution), finds astonishing. (In general, Buchloh, like a commissar, attempts to re-educate Richter, forcing his art to conform to the rigid Procrustean bed of Buchloh's own preconceptions. This amounts to a "liquidation" of Richter, a term that Buchloh uses in a way reminiscent of Communists and Fascists. It is in effect the final solution to the bourgeois problem; history has taught us the reality behind the euphemism "liquidation." Buchloh does greater violence to Richter's painting than Buchloh thinks is done by those who find "continuity of the death motif" in it. Richter thinks that this "absurd construction," as Buchloh calls it, may be "just a little exaggerated," but that his pictures "have something to do with death and with pain." Richter accords the interpretation of his art in terms of the "death

<div align="center">237</div>

thematic" more credibility than Buchloh's deterministic deconstructivist/ideological interpretation of it.)

"Surely, you're not serious?" Buchloh asks Richter, who responds, with absolute conviction, "I am. Because with this term he (Sedlmayr) said something really true." However, continues Richter, "he drew false conclusions from it. He wanted to restore the lost centre." "I don't want to restore it at all," says Richter, suggesting that it is impossible to restore and futile to attempt to do so: "Very definite, new, real facts . . . have changed our consciousness and our society, have overturned religion, and have thereby also changed the function of the State. There are only a few necessary conventions that still exist, regulate things, keep things practical. Otherwise everything is gone." This sense of loss – of the world gone gray (a German gray?) – pervades much of Richter's work, which often seems to be mourning for the loss of the centre while refusing to restore it, and regarding belief in it as a false consciousness. But there is another side to Richter, a more positive, hopeful side, invariably neglected by self-styled tough-minded ideologues like Buchloh, who cannot help but be indifferent to it, and even find it incomprehensible, for to them it is naïvely tender-minded. This other position is stated hard on the heels of Richter's acknowledgment of the loss of the centre, and amounts to both an acceptance of, and response to it. Astonishingly – this is my happy astonishment – it is associated with psychoanalysis: "I think so highly of psychoanalysis," asserts Richter, "because it removes prejudices and makes us mature, independent, so that we can act more truly, more humanly, without God (a former centre), without ideology" (the statement of a new belief that can be a centre). Psychoanalysis encourages "enlightenment," Richter says, because it makes no attempt to restore the lost centre or give us new beliefs, but rather encourages the "autonomy" necessary to endure "lack of closure," which has "more to do with our reality" than closure. It is this quality of "openness," sometimes achieved by chance – "a universal condition . . . thoroughly positive" for Richter (reversing the ironical, negative meaning it had for Duchamp and Dadaism in general) – that Richter aims for in his work.

He wants "to bring together, in a living and viable way, the most different and the most contradictory elements in the greatest possible freedom. Not paradise," which would imply a life and art built around a centre. Richter refuses to accept Buchloh's notion that he is "making the spectacle of painting visible in its rhetoric, without practicing it," because he "introduce[s] anonymity and objectification into the painting process" (by means of photography in his Figurative or so-called Capitalist Realist works and through the use of "a house painter's brush or another instrument like a rake" in the Abstract Paintings, and by his use of color charts and socially given (found) compositions in his Constructive Work, as he calls it). "What sense would that have?" Richter indignantly responds. "That would be the last thing I'd want." Richter thinks that his art, through its contrasts and combinations, "works emotionally . . . occasions moods," which are part of its content. It is a personal content, as well as, in the pictures of "dead cities and Alps . . . rubble heaps in both cases, mute stuff . . . a more universal kind of content." He refuses

Buchloh's notion of his Abstract Paintings as "the negation of content . . . an ironic paraphrase of contemporary expressionism," an "ironic" "perversion of gestural abstraction," "simply" an assertion of "the facticity of painting." "No," Richter vehemently responds. "Never! What sort of things are you asking? How is it that my pictures are supposed to be without content? What content is it that the Abstract Expressionists are supposed to have in contrast to me?" His paintings also have "mood," "explicit emotional, spiritual, psychological quality," in Buchloh's words. "That's just what's there," says Richter. His works are not simply a "demonstration of material," but "express some kind of yearning . . . for lost qualities, for a better world; for the opposite of misery and hopelessness . . . I could also say salvation. Or hope." No doubt Richter's work expresses this yearning in somewhat less than the "unashamed" way he admired in Pollock and Fontana – the two "bourgeois decadent" artists who "made a great impression" on him when he visited the 1958 Documenta – but it still means to express it. What Buchloh dismisses as "a private dilemma" – to avoid calling it an ideological, bourgeois "error" (to avoid thinking of Richter as having a dimension of bourgeois decadence) – is inseparable from Richter's art.

There is clearly a depressing and a hopeful side to Richter's painting. It is, on the one hand, an articulation of the epistemological and existential doubt generated by the loss of the centre. On the other, it attempts to build, on the basis of that doubt – which creates an opening in a world once thought to be closed – a sense of autonomous selfhood, able to live without belief (closure) yet to cope with the openness. The major reason Richter repudiates Buchloh's emphasis on political means of reconstruction is because politics presupposes the possibility of a centre, that is, it wants us to believe in a centre and implicitly aims to organize society "centrally." (Richter rejects conventional – popular – culture, which also tries to instill belief, that is, a single idea around which to organize [one-dimensionally] life. Similarly, he rejects any one ideology of art – photography in preference to painting or vice versa, abstraction in preference to representation or vice versa, etc.) Richter had enough experience of that in East Germany, where he lived until 1961 (he was born in 1932). And of course such attempted centralization is an aspect of the Fascism – in part responsible for its attempt to clean up society, re-organize it along "clear" lines – that forms the background of every German's experience. "Nothing can be expected from politics because politics operates more with belief than with enlightenment," says Richter, damning Buchloh as another centralist, another authoritarian forcing belief on people when there is nothing to believe in.

The problem of Richter's art is how to make of this nihilistic condition – often connected with the "nihilism" of Richter's famous "blurred" look – a mature freedom. That is, Richter's art means to articulate and respond to nihilism in an enlightened, mature way, acknowledging the openness it affords, and that is inherent in it, as genuine freedom. The problem is how to transform the terror and depression associated with the nihilism resulting from the loss of the centre – the terror and depression informing Nietzsche's famous idea

that "God is dead and everything is possible" – into the joy and elation of liberation from the false centre, from all the falseness represented by the authority – tyranny – of the centre. The initial response to the openness that comes from the collapse or death of the centre – the loss of closure – is not relief, but a sense of persecution, suggesting that the old centre – the old God – still exists in memory. It becomes the Nemesis haunting the new centreless existence, making it difficult to conceive of its openness as freedom. The dread that follows the collapse also implies guilt at the new possibilities afforded by the new-found openness. The nihilistic – annihilative – terror also implicitly acknowledges the difficulty of actualizing these possibilities – mastering the new freedom.

If we can say that Richter's use of photography and other supposedly anonymous, objectifying, mechanical methods of art making implicitly confirms the loss of the centre – as well as encourages the abandonment of any impulse to establish a centre – then it seems that we must say that his continued "conservative," or rather conservationist, use of painting implies an unconscious desire to retain a centre. But since he uses photography (an objective means that calls attention to the instrumentation of art as an end in itself) and painting simultaneously – dialectically – then we must say that in his work photography transforms painting and painting transforms photography. What is the result of their convergence, the character of the transformation? It generates that sense of enlightened openness – of mature acceptance of openness – that we spoke of earlier, and that implies a repudiation of nihilism. (Emotional nihilism, the characteristic, initial response to the openness disclosed by the loss of the centre, implies not only experience of the loss as catastrophe rather than emancipation, but the experience of lostness – a sense of abandonment – in the new openness. It articulates the narcissistic injury – the loss of the sense of one's own self as central – caused by the loss of the centre and the consequent openness. Nihilism exists more in the subject experiencing the loss of the centre than in the objective fact of its absence. In a sense, the loss of the centre simply acknowledges the openness that was all along the case.) Richter views himself "as the heir to an enormous, great, rich culture of painting, and of art in general, which we have lost (like the centre, which it reinforced and with which it is identified), but which nonetheless obligates us" to be mature (as mature as this past culture of painting is) in the new psychosocial conditions resulting from the loss of the centre.

This is why Richter can say, repudiating Adorno's famous dictum, quoted to him by Buchloh, that "after Auschwitz lyrical poetry is no longer possible": "No. Lyrical poetry does exist, even after Auschwitz." Indeed, it is a sign of maturity, autonomy, and ego strength, to write lyrical poetry after Auschwitz. Richter's painting – from beginning to end, I think, but no doubt especially the quasi-expressionist Abstract Paintings – are his lyrical poetry. Is it a good lyrical poetry – a lyrical poetry that truly articulates the subject, or as I would argue, reconstructs its damaged core? I have no ready answer to this question. It seems to me enough that Richter's lyrical painting, whether authentically lyrical (impulsive) or not – the blur suggests that it is always at least latently

Figure 27. Gerhard Richter, *Abstraktes Bild* (1987). Oil on canvas. 260 × 400 cm. Courtesy of the Marian Goodman Gallery, New York.

lyrical, or has a lyrical tendency – articulates the problem of openness and hope in an age of absolute doubt, that is, in an age when it is impossible to close, to forfeit one's openness. Just as it was traditionally thought that the existence of the centre made it impossible to open the closed cosmos of nature and consciousness, so the modern absence of the centre makes it impossible to organize nature and consciousness around a single belief – to find a privileged, "organic" centre to them – and thus to close them down. It is this that Richter's seemingly dangerous, perverse contradictoriness articulates.

The paintings in Richter's three categories of work, named by him the Figurative, the Constructive, and the Abstract, all share a similar look of reflected immediacy, or rather, of the unmediated and mediated in one. *Mirror* (1981) makes this point succinctly, but the blur in both the Figurative and Abstract – grey and colorful – works, however different in kind, suggests the same ambiguity: it generates an effect of immediacy, and at the same time of mediation. This synthesis of the intelligible and unintelligible can be connected with Richter's intellectually trendy 1982 assertion that "every time we describe . . . we create a model; without models we would know nothing about reality. Abstract paintings are fictitious models because they visualize a reality which can neither see nor describe but which we may nevertheless conclude exists" (Figure 27). It is a reality to which "we attach negative names; the unknown, the un-graspable, the infinite."[2] In my opinion Richter's ambiguous surfaces have less to do with problems of "perception" of reality – the wish to ac-

knowledge the indefinite and seemingly ineffable within that which is fixed and made definit(iv)e by apparently being known – than with his preoccupation with – indeed, continuous rumination on – mood and emotion. Buchloh is eager to deny that this "Romantic element" is significantly operational in Richter's painting, for it is a major sign of bourgeois decadence. It is worth emphasizing that Richter in turn denies that this expressive factor is "Romantic." Rather, he claims that it is a basic part of pictorial factuality, if not something that "people (who) put forward social models" would be interested in. Nonetheless, it is socially necessary: Richter regards his "abstractions as parables, as images of a possible form of social relations," if not the "models of society" which Mondrian's paintings can be understood as.

Richter's ambiguous surfaces are, if not the "decipherable metaphors" alluded to in the epigraph of this article, then indecipherable metaphors for the emotional ambivalence which I think is the subjective key to his production. It is reflected in his attempt to articulate the contradictions of openness, and inseparable from his attempt to come to grips with the emotional nihilism that results from the loss of the centre, as well as his attempt to transform this emotional nihilism into an emotionally (and intellectually) mature response to the openness disclosed by the loss of the centre. (The intellectual aspect of this maturity is reflected in the attempt to articulate and transmit the "incomprehensible reality" of "transcendental" openness by abstract rather than representative means, or to make clear, as Richter obviously does in his representative paintings, that representation can be a kind of abstraction.)

The poles of Richter's ambivalence are what I would call a mood of deprivation and asceticism – a sense of shyness, even involution – and a mood of unashamedness, to allude once again to the "unashamedness" which Richter found so "fascinating," so remarkable in the work of Pollock and Fontana. As he said, he was "really taken aback" by this unashamedness: "I might almost say that these pictures were the real reason for my leaving East Germany. I noticed that there was something that was wrong with my way of thinking." What was wrong was that a morbid, "gray" East German deprivation outlook – a kind of forced emotional as well as material asceticism, having a kind of inhibitory, souring, punitive effect on life and thought, not to speak of art – had colored his mentality so completely (or rather, rendered it completely colorless). Thus he was shocked by recognition of the "other," the unashamed, the colorful, the impulsive – that such uninhibitions (if not exhibitionism), lack of restraint, was allowed in the world. By realizing that "those 'slashings' and 'blotches' were not a Formalist gag, but rather the bitter truth, liberation, and that here a completely different and new content was expressing itself," he realized what had been emotionally repressed in him by living in the centralized (and thus inevitably authoritarian) East German state. The move from East to West Germany was a move from a closed to an open society, from emotional closedness to emotional openness, from mundane representation to transcendental abstraction, from self-censorship to self-expression, from control to freedom. Of course, each side qualified the other, and the East German "economy of scarcity" – a psychic as well as material

Figure 28. Gerhard Richter, *Untitled* (1985). Oil on paper. 23¾ × 34¼ in. Courtesy of the Marian Goodman Gallery, New York.

economy – was too ingrained in Richter's mentality for his art not to continue to reflect it, to infect his new discovery of Western society's "economy of abundance." (I am using Nietzsche's distinction.) In my opinion his early gray, Capitalist Realist works show him working through his East German mentality – attempting to dissolve its residue in his existence – even as it engages a Western content, or a content more easily engaged in the West, such as sexuality (*Student* and *Olympia,* both 1967) and sex crimes (*Eight Student Nurses,* 1971). I even think that Richter's cityscapes, such as *Cityscape Madrid, Cityscape F* (both 1968), and *Cityscape PL* (1970), have to do with his Eastern German heritage, in that he deals with cities that have never been destroyed by bombing, or have been rebuilt. I think particularly his *Forty-Eight Portraits* (1971–72) shows a restrained obsession with Western accomplishment and types, as it were. He chooses the dull, anonymous, mass reproducible photograph for emotional reasons – because of his repressed Eastern German emotionalism (Figure 28).

Beneath the gray of these works an obsessive mess is stewing. The brooding quality in Richter's work is a constant; the well-known blur is its materialization, its objective correlative. It exists obviously in the landscapes, and still lives, less obviously, in the Abstract Paintings. It may derive from his beloved Caspar David Friedrich, but it is informed by an East German melancholy and rigidity. In fact, Richter's landscapes are neither so intense in their contrasts nor as subtly atmospheric as those of Friedrich, but rather have a certain dull

243

modern solemnity – the solemnity of modern nondescriptness – which is also operational in the gray Capitalist Realist works. It also pervades the gray abstract paintings of the first half of the Seventies.

Richter's respect for psychoanalysis has to do with his recognition of the emotional effect of his early East German upbringing on his outlook. His art in general is concerned to bring emotional enlightenment – enlightenment about the emotions, encompassing both the freedom to admit to having them (lack of shame), and to be able to express and understand their meaning. In general, the emotional aspect of his painting has been underestimated and downplayed, even though he insists on it and has connected it to the general effect of the loss of the centre in the modern world, which in a sense affords greater possibilities of emotional experience than in the closed traditional world. (In it, all emotions are directed towards the centre – vertically – rather than allowed to spread horizontally, work themselves out in the interpersonal or intersubjective field, the emotions themselves becoming fields of operation, in which events and things occur and are generated by them.) I am not sure that Richter succeeds in articulating his sophisticated emotional content – his emotional ambivalence – in a truly unashamed way, although it is a genuine presence in his work. There is a certain stultified look to Richter's work, even to his quasi-expressionist Abstract Paintings. Perhaps this is due to the anonymous, objectifying dimension – now recognizable not just as appropriate to the modern world, but as East German in import, that is, suggestive of its grim, obedient mentality – in the Paintings. It may also have to do with Richter's tendency to intellectualize emotion (separate affect and idea) – not the worst crime, for as Heinz Hartmann has said, intellectuality is not just a defense but an attempt at mastery, at adaptation to intense inner feelings and conflicts. Perhaps it is due to the fact that Richter was already emotionally fully formed when he came West, and could not completely undo his early attitudes.

But I think it also has to do with the general failure of modern painting to convey emotional intensity and depth with complete adequacy. For all its many apparent – "unashamed" – successes, there is always the sense of a certain "failure" of pathos, even when it is at its most expressionistic extreme. This is partly due to its elimination of the objects with which emotion is usually associated – although the picture as object has become equally invested with emotion. But I think it is a problem signalled by Barnett Newman, whom Richter greatly admires. It is the problem of how far you can go expressively with the less-is-more aesthetic towards which all modern art tends. Richter's shallow surface, like Newman's, attempts to be evocative with a minimum of means. This goes only so far: there are diminishing expressive returns in this situation.

Richter, who like Newman makes both smooth – even polished – and gestural surfaces, and often combines them, has reached a point where pathos seems empty just because it is absolute. The power of Newman's pathos depends on the contrast he works out – and repeatedly re-works – between the smooth surface and the painterly gesture, which articulates emotional

ambivalence in a clear-eyed (indeed, perhaps all too obvious) way. Richter has passed beyond this point of no return. Such contrasts are too obvious for him; they seem at once pseudo-"organic" and mass-reproducible, that is, doubly manufactured, artificial. He is stuck with the modern heritage: surface as an obvious manipulation, which means that surface always "betrays" the pathos it means to articulate.

Is this the unconscious reason the deconstructivists rage at painting for not dying quickly enough? No, for they disbelieve in the primacy of pathos, while Richter still seems to believe in it, as the route to "incomprehensible reality." But implicitly they acknowledge the inadequacy of art, which is why they are so eager to show it as self-deconstructing (as they think Richter does). They do not realize that the modern sense of art's inadequacy reflects the improbability of modern human relationships, all of which raises great storms of emotion. No relationship seems adequate when there is no centre to relate to, and to bind those who relate – to relate through. Thus, Richter's expressive inadequacy, despite all his efforts in the quasi-expressionist Abstract Paintings, is another effect of the loss of the centre, whose impact has still not been entirely worked through. (The less-is-more aesthetic is one of its consequences, for such an aesthetic allows for unconditional expressive openness.)

His expressive inadequacy suggests that he has still not achieved full emotional enlightenment or maturity. But at least that is better than Barnett Newman's pretense of having done so. Perhaps it is harder to achieve emotional enlightenment after having gone through the German version of the experience of the loss of the centre than after having gone through the American version, in part because there was more of a transcendental centre in Germany than in America to begin with. Also, America still seems to have the myth of the centre – America itself – while in defeated and neutralized Germany there cannot even be the ghost of a belief in a mythical centre. Not even art can function as a restored centre, or as the source of an illusion of the centre, or as an illusion that can restore a sense of centre. It is this illusionlessness about art – this disbelief that it can supply a centre in any way, shape, or form – that Richter's art reflects. Richter's illusionlessness is responsible for his art's apparent lack of pathos, which is exactly why it ultimately seems so full of pathos.

20

All Our Yesterdays

All philosophy has now fallen forfeit to history.
Friedrich Nietzsche, *Human,*
All Too Human, 1878

I<small>N</small> the modern world, as Nietzsche suggests, history is the only legitimate scene for speculation about life – the place where the truth about life will sooner or later be told. But the study of history can never lead to the development of a metaphysics of humanness. Not only would such a theory never be adequate to its subject, but it would betray the harsh empiricism implicit in looking at history in a modern way, that is, with no preconceptions about what one will find. The study of history leads not to a successful theory of what's necessary to being human but at best to a "successful" attitude to life – a "philosophical" reconciliation with it by way of skeptical, ironic contemplation of its vicissitudes. Yet this seemingly detached, superior attitude masks an inner sense of hopelessness and helplessness in the face of history: the hidden feeling that nothing one can do will change its course, which seems fated, and furthermore that much of it will remain mysterious, unknown, forever. Such consciousness is suppressed because it could devastate one's sense of self, for it implies that the self cannot ground itself in the world, which exists as a quicksand of uncertainty and historical unreliability.

Fifteen paintings by Gerhard Richter – works dealing with the deaths, in West Germany's Stammheim prison on October 18, 1977, of Andreas Baader, Gudrun Ensslin, and Jan-Carl Raspe, the last surviving members of the German Red Army Faction (the so-called Baader-Meinhof gang) – show modern history painting at its most trenchantly philosophical. The relative unclarity of Richter's images, their descriptive uncertainty, conveys the full weight of philosophical ambivalence toward history: apparent transcendence of it, until it seems unreal; but also a sense of impotence that implicitly acknowledges its forbidding reality. In 1982, Richter said that "everything unknown frightens us and fills us with hope at the same time. . . . Thus paintings are all the better

246

... the less decipherable metaphors they are for this incomprehensible reality."[1] Richter's *18. Oktober 1977* paintings are indecipherable metaphors for the incomprehensible reality of history.

That reality is epitomized by the mystery and doubt reflected in these paintings from 1988 – sometimes precise, sometimes blurred images, in black, white, and the grays between, derived from photographs relating to the Red Army Faction in both life and death. Did the prisoners commit suicide, as was officially held, or were they killed by the German state, which may remain in part a police state, at least toward those who threaten its existence? The answer will probably never be known, but Richter's "subversive" handling suggests suspicion of the official version and uncertainty about the social and political situation exemplified by the deaths. Richter has said that he regards his "abstractions as parables, as images of a possible form of social relations."[2] His *18. Oktober 1977* images can be said to articulate the problematic character of social relations in Germany, especially between society and the agencies of the state, and, more intimately, between the disaffected youth of the country – including, at one extreme, the Red Army Faction – and the older generation, still affiliated, at least in the emotions of postwar generations, with the Nazi terror.

In a sense, all of Richter's works are history paintings: abstract art, still life, landscape, and portraiture were already history when he took them up. (The *18. Oktober 1977* works are all of these, and Richter has alternated more or less consistently among the same modes over the years.) His elegantly "indifferent," anesthetizing surface handling suggests the existence of these genres at an unbridgeable temporal distance. It is an authentic historical patina, for it makes whatever it touches apparitional, indecisively given, as hallucinatorily elusive as memory. This technical strategy has its moral, philosophical use: it brings out what is hidden and implicit behind the official scene to which it is applied. That is, it turns a scene into an ob-scene; a pictorial closed case, such as a photograph, into an emotionally open one. It gives access to the pathos implicit in the scene, buried under its "realistic" establishment rendering.

Through his surface treatment of photographs of and about the Red Army Faction – a street arrest, a police mug shot, a prison cell and its furnishings, the three corpses, their funeral – Richter defeats these official versions of the reality of the prison victims. They are metamorphosed into simultaneously abstract and representational paintings conveying a subtle, excruciating pathos. (Richter's indefinite handling of the photograph's hard outlines makes one struggle for the figurative content of these images; the works cut new inroads into both abstraction and representation, showing that even after long exploration each is a terra incognita, and that the border between them remains indeterminate.) "Art is always to a large extent about need, despair and hopelessness ... and we often neglect this content by placing too much importance on the formal, aesthetic side alone," Richter wrote in a 1983 diary entry.[3] Despite the distancing of emotionality in, for example, his reworkings of Abstract Expressionist brushwork, he insists that he "works emotionally," that his art "occasions moods," that his paintings are "fictitious models ...

visualiz[ing] a reality which we can neither see nor describe but which we may nevertheless conclude exists." It is a reality to which "we attach negative names – the unknown, the ungraspable, the infinite" – but it has a "transcendental aspect" that Richter wants to articulate as a "positive" presence.[4]

Among Richter's many works, the *18. Oktober 1977* paintings realize to perfection this basic goal of his art. Moreover, they make clear that the goal – in effect, the making visible of invisible affect – is that of modern history painting as such, indeed, its only viable purpose, especially when photography has taken over the purpose of documenting the look of the times. What counts in modern history painting is the reality of the feeling aroused by history, not the naively given reality of the presumably historical scene. Jacques-Louis David's incomplete *Oath in the Tennis Court*, 1790–91, is perhaps the first true modern history painting, for not only is it realistic but it attempts to render the emotion of the parliamentarians in the tennis court;[5] its realism, that is, is an openly subjective one. Ever since, the problem of history painting has been to render the collective, transient emotion in seemingly world-historical events. This emotion goes incognito in the events themselves, but the painting attempts to make it as explicit as possible, without completely objectifying it. Indeed, Richter's simultaneously abstract and realistic images maintain an insecure middle ground between the extremes of absolute subjectivity and absolute objectivity.

By keeping this imbalance, Richter precludes a complete transfiguration of the deaths. For him, no death has "sublime" significance. Yes, he gives a kind of perverse emphaticness to the head of one of the corpses in the three versions of *Tote* (Dead one), each of a different size, so that they can be read as either an ascending or a descending series. Yes, the three versions of *Gegenüberstellung* (Confrontation) – all the same size – have an almost lyrical chiaroscuro in comparison with the harsher contrast of black background and luminous head in *Tote;* a chiaroscuro that levitates the smiling woman to another plane of existence, as though she were a benign angel. (The youthfulness of all the victims is a key issue of these pictures, as *Jugendbildnis* [Portrait of a young woman] makes transparently clear. In a sense, history painting is always about the recovery of a lost youth, or, rather, its conversion into a screen memory, so that it remains eternal in the collective unconscious.) And yes, many of the other works – *Erhängte* (Hanged), *Zelle* (Cell), the two versions of *Festnahme* (Arrest), and especially *Beerdigung* (Funeral), which will take its place with Courbet's *Burial at Ornans* of 1850 as a modern masterpiece dealing with the collective significance of individual death – have what might be regarded as a transcendentalizing blur, as though lifting the event out of historical context into esthetic exquisiteness. But all of the images share in the dialectic of factuality and imprecision, clarity and obscurity. And some – the two versions of *Erschossener* (Shot one; Figure 29) and *Plattenspieler* (Record player) – tend more to the side of precise representation than to that of imprecise, "sublime" abstraction.

This dialectic of concreteness and hazy suggestiveness emphatically articulates the major fact about the deaths: their incomprehensibility, the suspicion

Figure 29. Gerhard Richter, *Erschossener 1* (1988). Oil on canvas. Ca. 39 × 58⅝ in. Courtesy of the Marian Goodman Gallery, New York.

that surrounds them, for all the publicity they were given, photographically and in print. This is what makes them catalytic of "infinite," morbid speculation, including pessimistic observation of how seemingly "open" images of events can in effect be used to rewrite history by closing it down. This incomprehensibility issues in the slippery, hidden mood of the paintings. Their emotion lacks specificity; they are not so much a form of mourning for the traumatic past (with which the Germans seem never to have finished, if also never to have really started) as an effort to articulate the transient pathos of the past before it has dissipated, before events move on, forcing forgetfulness of our intense feelings about them. In a sense, Richter's painting these pictures, over a decade after 1977, keeps the deaths of the prisoners current, topical. But if the pictures' ambivalent surfaces place the historical event in a kind of representational limbo that can be regarded as the space of memory, they are also touched with more than a hint of amnesia, loss, insecurity. Moreover, they attempt to fix a collective emotion in public communicative form, which is always an uncertain matter. Indeed, uncertainty pervades the *18. Oktober 1977* pictures, as if emotion were somehow held incommunicado in them – as if it were defended against, even as the discreet whisper of the symptomatic surface confessed it.

In Richter's works, the pervasive affect is depression: he has in effect given us mental representations of figures he has internalized, or, rather, his pictures show them in the process of being internalized – made part of his, and the

German, conscience. But there is more to them than that: behind the comatose gray of these pictures, which implies the incomprehensibility and therefore the literal meaninglessness of the event (though the meaning is profound, it is uncertain, hidden, unknowable), lurks a furious rage. It is all the more furious because it has no target, because it does not know whom to blame for the deaths. It is an impotent rage, shamelessly expressing vulnerability to history. The colorlessness of Richter's palette in these works conveys the sense of not being master of one's fate, symbolizes one's exposure to some indeterminate (yet clearly social) force beyond one's control. Certainly the ignorance about the deaths nourishes that feeling of helplessness. Furthermore, Richter's series implies or encourages his and the viewer's identification with the victims – makes their victimization clear, whatever their terrorist acts. Perhaps they were victims of themselves as much as of the state: victims of their own ideological beliefs, which they embraced with a rigor mirroring the state's defense of its own. Whether they committed suicide, realizing the futility of their situation and cause, or were murdered, they conjure the very primitive feeling of being at the mercy of history. As James Joyce wrote, that is a nightmare from which it is impossible to awaken, however much one might try.

In these paintings Richter submits to history without reconciling himself to it. He turns history painting into the depiction of fate, much as Goya did. How much an advance *18. Oktober 1977* is in the modern tradition of history painting can be seen by comparing the series to Pablo Picasso's *Guernica*, 1937, with which it shares certain elements: both Richter and Picasso attempt to show us how profound a hold history has on our inner as well as our outer lives, both use the same strategy of colorlessness to convey the grimness of history, and both work with "the experience . . . of defeat" and "a vision of evil," as John Berger writes of the Picasso painting.[6] But in Richter's pictures the evil is indeterminate, the personal relevance of the defeat unclear. The images are as "profoundly subjective" as *Guernica*, but they are more insidious – despite their closer relation to reality, through the photograph, than Picasso's painting. The devastating emotional effect of *Guernica* derives largely from its violation of the body's integrity, its strident rendering of "sensation in the flesh"[7] – a prerogative of the painter's imagination. *18. Oktober 1977* involves no representational distortion – the violence pictured is not imagined, as in the Picasso, but actual, photographically current.

This might make the works merely "pornographic" but for their surface. The relationship of Richter's paintings to photography has been much debated; I believe that for Richter, it is the painting's surface that gives it greater power than the photograph to render emotion, to make emotion immediate. His surfaces are a way of getting inside what the photograph renders from the outside, and to articulate its obscene emotional meaning. I think Richter has gone farther inside than Picasso. Picasso's violent articulation of the bombing of Guernica is defiant of the event, of history, in the very act of showing its catastrophic effect. In contrast, Richter shows us that behind such defiance is a depressive submission to history as fate, an internalization of history's ca-

tastrophe, and a blind rage at oneself for not being able to do anything about it, for not knowing whom to turn to, whom to turn against, which thus makes one, in some strange emotional way, a collaborator with history.

Contradicting Theodor Adorno, Richter has declared that "lyrical poetry does exist, even after Auschwitz." His series on Stammheim seems to suggest that the events there have the same kind of importance for Germany that Auschwitz does, the same kind of weight of profane meaning; yet these works are a lyrical apotheosis of the history painting, just by reason of their incomprehensible sobriety in the face of incomprehensible history. In his poem "Musée des Beaux Arts," W. H. Auden wrote, "About suffering they were never wrong, / The Old Masters." With his *18. Oktober 1977* paintings Richter has become an old master – indeed, in more ways than one. Clement Greenberg remarks that "the Old Masters always took into account the tension between surface and illusion, between the physical facts of the medium and its figurative content – but in their need to conceal art with art, the last thing they had wanted was to make an explicit point of this tension."[8] The point of the relationship between painterly surface and photographic illusion in Richter is simultaneously to assert the tension of surface and illusion *and* to conceal it with art – a true sign of old masterism. In that concealment Richter has hidden the emotion of history, making it just as unknowable, as incomprehensible, as actual history itself.

21

Christian Boltanski's Art of Gloom

One often hears the stereotyped lament, 'It is all a play, artificial, made up,' etc. A dream of a 'schizophrenic' is most significant; he is sitting in a dark room which has only a single small window, through which he can see the sky. The sun and moon appear, but they are only made artificially from oil paper. (Denial of the deleterious incest influence.)

C. G. Jung, *Psychology of the Unconscious*

The burial of the dead in a holy place . . . is restitution to the mother, with the certain hope of resurrection by which burial is rightfully rewarded.

C. G. Jung, *Psychology of the Unconscious*

PALL, penumbra – that space of partial illumination between full shadow and full light – intense enough to evoke inner ambivalence, deep conflict: this seems the gist of Christian Boltanski's art. Yet the chiaroscuro is a bit too theatrical, the gloom is irreducible but a well-groomed artifice; this solemnly demonstrative surface, ever so slightly ironical, is also typical of Boltanski. His melancholy is not innocently self-inflicted, but invented. Installations such as *The Shadows* (1984) and *The Angel of Accord* (1986) are little theatre, even children's theatre, for all their bitter morbidity, their chilling celebration of the shadow world. Boltanski imprisons us in the Platonic cave, but lets us know the play of shadows is an illusion. He tells us that those horrendous, grotesque shadows are cast by silly toys. They are the large phantoms of our small minds, the fantasies of our reason, always ready to fail us at the least shadow. He debunks his images in the very process of giving them to us, but we still cannot laugh his absurd theatre off. We know its sense of nightmare is a bad joke we play on ourselves, but we still suffer. We are enlightened, but still superstitious and trapped.

Boltanski's art remains uncanny, however much he lets us into its secrets, however knowing we become about its mechanisms, which after all are simple and obvious: a neat arrangement of recurring photographs, usually drawn

from the same archive and uniformly framed in metal, sometimes with equally redundant tin biscuit boxes, and the little candles or lamps clamped on, further conveying the sense of the portable character of the composition. It can be taken apart and reconstituted, its elements placed differently in the arrangement. The arrangement itself is open to change, so long as it remains logical, geometrical. Boltanski's works evoke mystery, even though it is clear that they are made in a far from mysterious way: no uninhibited personal touch, no convoluted combination of objects. Mystery is direct; there are no metaphoric leaps of faith between varying levels of meaning, no insidious concatenation of connotations that disrupt the self-evident structure of the works. The figures/faces remain what they are, the irrational point of it all. They may finally be interchangeable, one as good as another, but this sticking point stubbornly remains. Whether obviously hierarchical in structure or not – some are serial – the works have the quality of medieval portable altarpieces meant for private worship, self-communion as well as communion with the spirits of the dead, recovered from the oblivion of time, yet tainted with and corroded by it. His altarpieces are holy places in which the dead can be resurrected. Spirit resides in memory for Boltanski, in a sense of lost and irrecoverable relationship, if not lost and irrecoverable flesh.

The mix of static, fated figures/faces, and of the lively, if equally fated, play of light and dark is theatre at its simplest, most minimal. The fixed and the unfixed interpenetrate, making for a heady sense of the uncanny: the figures/faces become fluid chiaroscuro, and chiaroscuro becomes a blatant constant. Both are treated with easy familiarity; there is no psychic distance in a Boltanski work. Indistinctness and unclarity are theatricalized, made projective, and fetishized, made absolute. We are watching a staged tableau, a frozen drama. Yet the air of gloom is all too thick, suggesting that it must have some other function than to serve simply as atmosphere. There must be something more to it and the figures/faces. The gloom is the curtain hiding an inner stage, a curtain too heavy for Boltanski to lift. The sanctified figures/faces we see are not the real issue of the works, just as the real point of the medieval altarpiece is not this or that particular image of Christ or the saints. They are after all variable representations, changing with history and culture, and with convention. Any figure/face will do for Boltanski, any smouldering chiaroscuro, any uncanny gloom. It is what is embedded in that gloom, what exists in solution in it, that counts. The figures/faces are already partially dissolved in the gloom; we must dissolve them further, to see who they really are: there are too many of them, almost to the point of indifference, for them not to be surrogates for another figure/face. Boltanski can't really be interested in all sixty-two members of the Mickey House and how they looked in 1955 – the subject of a 1972 work. Nor can he be seriously interested in the individuality of all the figures/faces in the *Archives* and *Detective* of 1987, or all the children of Dijon, the subject of a 1986 work, or the students in the 1931 photograph of the Chases High School in Vienna he has utilized in various works. Every last figure/face has to "represent" a missing, "ultimate" one. It

is so completely missing – invisible, forgotten – that there is no photographic record of it, no documentation. The only inkling of its existence is in the blur of the hundreds of other faces (Figure 30).

Gloom is an end in itself for Boltanski, but it is also a disguise. It is a grand manner, but also provokes an indecisive inwardness, a depth in which something has been hidden for so long that it has been completely forgotten, and seems never to have existed. Boltanski's murkiness, conveying futility, is also the tomb chamber of an embalmed pharaonic figure, preserved in hope of resurrection. This is why his "expressivity" is theatrical: to distract us – and himself – from the full depth of the intimacy articulated. This is why the surface of the gloom is glamorous: to deny its full depth, the unpredictable abysmal character of the gloom. Boltanski only glides over the gloom, he does not want to plunge into its emptiness. The gloom suggests uncontrollable anxiety, for all its theatrical magic.

I emphasize that there is a mystery within the mystery of Boltanski's altarpieces – a secret to the gloom – to force Boltanski's fans to work harder for an understanding of his work. They are eager for an art of obviously "deep meaning" in our shallow age, of up-front depth in a world of fake surfaces, of urgent seriousness in frivolous times, and so they take the self-evident gloom at face value, neglecting to question its import. They are happy for enigma, which supposedly redeems art. (The same can be said for all those who blindly worship Kiefer's gloom, with its different textures, but equally obvious resonance.) Desperate for a depth that has taken possession of the surface, the sense of abandonment and desolation clearly manifest in Boltanski are celebrated as a sign that tragic art still lives, that an important reality like death can still be "probed" in art, that art can still make a serious statement about serious things. The gloom becomes a sacrament of seriousness. But what is the content of the seriousness, the tragedy, the gloom – *that* is never asked. The gloom has become the pure form of tragic seriousness, but why is Boltanski so obsessed with it, why is it relentlessly repeated in work after work? Is he a formalist manqué? This hardly seems the case. The face can never become a formal gesture; not even Warhol could make it one, a failure that is part of the unconscious appeal of his work. (We sigh with gratitude at the failure of his art to completely depersonalize his impersonal world.)

The generalized sense of loss that pervades Boltanski's works is idolized, but nobody asks what is lost, who is lost, why it is lost. From the perspective of these questions, Boltanski's gloom is a sophisticated defense against something more irreal than itself. It is a conscious, theatrical melancholy masking a more real loss than Boltanski can admit to himself, can make public. He is probably not even aware of how truly personal it is. It is certainly more personal than the illusory aura of the personal his works generate. Boltanski is indeed aware of death – as all his interpreters say and applaud – but he is not aware why he is. The gloom tells a half-truth about Boltanski's obsessive interest in death, emptiness, tragedy, nothingness. One must attempt to determine why the gloom is so conspicuous, blatant, redundant, for the very extravagance of its givenness seems to direct us to some invisible, quieter place. Also, it must

Figure 30. Christian Boltanski, *Reserve of the Dead Swiss (Large)* (1990), detail. Photographs, lamps, tin biscuit boxes. 80 in. × 26 ft. 11 in. × 44½ in. Photograph by Michael Goodman. Courtesy of Marian Goodman Gallery, New York.

have an ulterior motive to it, for if it does not it would become emptily decorative – de-subjectified, for all its obvious display of subjectivity. This is something its celebrants would not allow. The gloom must hide more than it reveals if it is to be saved from itself. If it is not repressive as well as expressive, it is a simple numbness. It may be that the key to Boltanski's gloom has been buried so long that it seems rusted beyond repair, but I hope to show that it is still recognizably a key. What is the nature of the Proustian madeleine in Boltanski's biscuit box?

What, then, is the lesson of Boltanski's darkness, to allude to "Lessons of Darkness," the title various 1987 works share? Allusions to dead Jews, victims of the Holocaust, and simultaneously to Boltanski's own dead youth, are said to be the conceptual background for his collection of figures/faces, and the grim ambivalence of the works. The early, often aggressive works of the Seventies – there are numerous small, handmade knives, not unlike zip guns, as well as ruthless stockpiling and inventorying – supposedly confirm the personal source. Yet the Seventies works seem, today, merely propaedeutic to the Eighties melancholy works, which subsume and subtilize the earlier intention. In the Eighties works, aggression is indirect, like a slow-working poison, a venom that infects us with a fever, and consumes our substance the way that of the figures/faces is consumed. It is easy to recover from the bite of the Seventies works, which is like that of puerile, first teeth, but impossible to suck the insidious poison of ambivalence from the wound which the Eighties works make in our psyche. The Seventies works are in the end novel and vain, curiosities of a case history of a callow narcissist, imagining his experiments with himself will build his ego, the way a bodybuilder mechanically builds a body. The Eighties works are both more public and more subjective. The Seventies works may haunt us for a little while, but the Eighties works invade us in an attempt to take over our psyches. The accumulated aggression of the Seventies works is insignificant next to the dispiriting gravity and contagious inertia – a negative of the world – of the Eighties works. Their figures/faces may be quarantined within the grand structure of altarpieces, but they transcend its hierarchy through their refusal to be transparent, for all their obviousness. The pervasive gloom is even less transparent and projects even more, soiling our sight. Where the figures/faces offer themselves as radioactive interior images for which there is no true objective correlative, the gloom offers itself with paradoxical objectivity. Both Seventies and Eighties works have an air of catacomb-like containment, of insular quietism – that Proustian biscuit box again, like the unclaimed Pandora's box of the psyche, whose contents are prettily arranged in a kind of perverse show-and-tell – but the Eighties works are also perversely assertive, performative, acrobatic, while increasing the sense of secrecy and reticence.

Boltanski achieves his grand manner of gloom by re-photographing found photographs – many are used again and again – enlarging and blurring them until they seem inherently overblown, whatever their literal size. This method announces the inadequacy of the photograph as a document of fact, a visual

proposition. Mechanical reproduction is in a sense mocked by being made a "production" and by producing far from mechanical effects. The blurring debanalizes – "expressifies?" – the ordinary human subject matter, as well as becomes an expressive effect in itself. In Boltanski's use the photograph is neither true nor false, but a qualification of mood. This has always been one of its implicit purposes, neglected in favour of the sheer fact of reproduction. Every photograph has an affective charge, whether obviously or not. Boltanski's re-photographing simultaneously destroys the seeming facticity of the photograph – deconstructs it, showing its failure as a record – and constructs a mood. The photograph becomes a zone of memory – the memorable as such – whatever the specificity of the figure or face that is finally remembered. In fact, the partial eclipse that prevails in Boltanski's pieces is the direct result of the collapse of commonplace, historical specificity, however tied the images are to a specific history. (That tie becomes increasingly elusive until in the *Altar to Chases High School, 1988*, it becomes a general allusion to lost childhood, to lostness in general.)

Boltanski's gloom emanates directly from his photographs. Even if the dim illumination created by the candles and lamps did not exist, the gloom would strongly exist. It is the very grain – inner substance – of the work. It constitutes the ghostly figure/faces, essentializing them – neutralizing their specificity without altogether denying it. But making it somewhat less than the penumbra is important not just for its symbolic character, but in itself. The gloom is finally more important than the photographs it constitutes, than the grand composition which tries to control and shape its force.

This indwelling gloom so essential to the works, their major achievement and subject matter, refined and refined again in work after work, is a burial ground. I submit that it is the gloom of the Paris basement in which Boltanski's Jewish father hid during World War II: it is the gloom associated with his father. It is Jewish melancholy that is embodied in the very material gloom of Boltanski's art – the ingrained melancholy of the eternally persecuted. It is through the gloom that Boltanski incestuously identifies with his father, but it is also the gloom that represses recognition of this identification, that keeps it hidden. And it is in the gloom that the father's hiddenness is confirmed by all the figures/faces that rise up to replace him, that through their strange gloominess and equally strange casual presence – their odd familiarity – evoke him, renew him. It has been pointed out that Boltanski's photographs are the casual, intimate snapshots of the family album, sometimes cropped and enlarged to dramatic effect, but always oddly innocent and ordinary. One family figure/face always evokes another.

But there is more to the gloom. Boltanski was born on September 6, 1944, the day Paris was liberated. (His middle name is Liberté, in memory of that day.) His parents must have copulated to produce him. I submit that unconsciously – a basement territory also – he fantasized that they copulated in the gloom of the basement. The gloom is the haze in which this primal scene is fantasized. It is the nakedness of mother and father in their "monstrous" act, a confused blur of nakedness which hides as much as it reveals. Boltanski

already possessed his Catholic mother – he lived with her upstairs – but not his father, who lived in the basement. His photographs reflect a so-called negative Oedipus complex.

Boltanski, who grew up in the years just after the war, "when anti-Semitism was still strong in France," as he has said, felt "so different from the others" that he "fell into such a state of withdrawal that at age eleven I not only had no friends and felt useless, but I quit school, too." In his isolation – an isolation that sits on the surface of his figures/faces, that is embodied in the gloom of his works – he began making art, particularly "religious or historical subjects (for instance, the Turkish massacre of the Armenians), with lots of figures in large formats and on plywood, wanting no doubt to deal directly with the massacre of the Jews." Boltanski has continued to work in a large format, and with ordinary materials, if not plywood. Making art simultaneously confirmed his difference, and enabled him to express the sense of isolation and persecution it gave him. His figures/faces are part of his imaginary massacred family, but are also their tormentors. This contradiction – ambiguity – is crucial, and typically Jewish for Boltanski.

He has said, speaking about his "Jewish culture/non-culture," that

> a strange relation to the divine, the feeling of being simultaneously part of the 'chosen' and the last man, drove me to affirm then contradict myself, to cry and laugh at myself, to say that I paint without painting. In the Jewish culture, I am drawn to the fact that one says one thing and its opposite at the same time, or this way of answering a question with another question and constantly mocking that which one does . . . I imagine that my ambiguous relationship with painting and my use of photography are linked to this Jewish consciousness, if I so much as have one. I do photography, considered a less noble art than painting, as if I were afraid to confront myself with this very sacred art.

The ambiguous relationship Boltanski has to painting is most evident in his photographing of "abstract" decorative paper, used for wrapping Christmas gifts, and incorporating the photographs as an autonomous border in his altarpieces. This ambiguity reflects his larger ambiguity: his double identification as Catholic and Jewish, mother's boy and would-be father's boy, religious and secular artist. It is significant that in his statement Boltanski speaks as a Jew, and in effect acknowledges the Jewishness of his art, or the Jewish "motivation" behind his art. Ambiguity implies confusion between apparent opposites, and the implicit desire to fuse them, carried out in fantasy. It also implies a perpetual doubt of the world – questioning it – and self-doubt, or questioning oneself. Both world and self are ironically and theatrically doubled in doubt, and merged through doubt. It is the inherent ambiguity of Boltanski's art, embodied in its gloom, that permits me to regard every figure/face that Boltanski presents as that of the invisible father, and that gives his figures/ faces a double function, that of victim and victimizer. His father in reality was a victim, and victimized Boltanski through his hiddenness. Boltanski's gloomy

ambiguity is the burial ground for his father. It is restitution of the father that he wants; the mother is already implicitly his, if less deeply than the father.

Boltanski's art is an art of the hidden father and of hiding the father. The father may represent the Law, as has been psychoanalytically suggested, but the Jewish father represents and teaches the secret law of cunning survival – of taking on the world intellectually and not being destroyed by it emotionally and realistically. It is in the ambiguity of art – in the hidden law of art – that the deepest emotions survive, and even find theatrical expression.

22

By Kitsch Possessed

Jiri Georg Dokoupil's Satiric Art

The essence of kitsch is the confusion of the ethical with the aesthetic category; it does not want to work "good" but "beauty"; it has to do with beautiful effects. . . . He who produces kitsch is not someone who produces inferior art, nor someone who has little or no ability; he is not at all to be measured by aesthetic standards; rather he is ethically depraved, the criminal who wills radical evil. And because it is radical evil that manifests itself in kitsch, evil in itself, existing as the absolute negative pole in every system of value, kitsch is evil not only in art but in every system of value . . . for he who works for the sake of beautiful effects, who seeks nothing more than the satisfaction of feeling that arises from the momentary effect of "beauty," that is, the radical aesthete, will use, without inhibition, every means to achieve such a goal of beauty: it is the gigantic kitsch of the fireworks that Nero arranged with the burning bodies of Christians, while he played the lute – it was not for nothing that Nero's ambition was the theatrical.

Hermann Broch, "Evil in the Value System of Art"

If any of us were not able to have the illusion that all was well, to play at feeling and acting as if the world and we would go on forever, as if we and our loved ones would not end as dust, it would be hard to go on, and the reverberating circuits of existential angst might turn us all into creatures shrieking on a Munchian bridge.

Simon Grolnick, *The Work and Play of Winnicott*

I

IN conversation, Jiri Georg Dokoupil identifies with both the good soldier Schweik and the Buddha. (He also identifies them with each other.) One doesn't know, Dokoupil says, whether Schweik was smart or stupid. Similarly, for all the Buddha's enlightenment, there is something stupid about his smile. Their smartness is a kind of defiant dumbness in the face of the world, or their seeming dumbness about life is a kind of wisdom about it. What is

important for Dokoupil is that this peculiar mix of dumbness and cunning, evolved by Schweik and the Buddha in a hit-or-miss way in response to a world not of their making and liking, a dumb world in which they found themselves dumbly thrown, is a strategy of survival, a kind of self-reliance and self-help: a way of making emotional ends meet in oppressive, impossible, ungratifying circumstances. This dumb cunning, or cunning dumbness – playing dumb, or dumbly playing – is a lesson taught by experience, learned in the harsh school of hard knocks, forced upon one by the persistent, obscene pressure of contingency. Schweik and the Buddha were artful dodgers, as it were – experts in adaptive defense: artists at outsmarting reality, at avoiding the subtle feelings of victimization and futility it sooner or later arouses in one. (Existence itself is inherently oppressive, impossible, ungratifying, as the Buddha's determined struggle for detachment from it suggests. His success was ambiguous: is transcendence simply sublimated isolation?)

Schweik is of course the comic hero of Jaroslav Hasek's novel (1920–23), one of the major works of Czechoslovak literature. In Dokoupil's mind, the Occidental Schweik and the Oriental Buddha have a similar attitude to the lifeworld; the Buddha is Schweik in a different society, Schweik is the Buddha in different form. As Dokoupil has stated in a text entitled, tongue-in-cheek, *i search for nothing and i also find nothing!* (ich such nicht und ich finde auch nicht!), "I am fascinated by Buddha's soft squeaks" (leisen Quieken).[1] Schweik's soft squeaks are also the nihilistic purr of knowing innocence, the ingenious dissemblement that is a means of surviving. Dokoupil, like Schweik, is Czech. He was born in 1954; in 1968, after the so-called "Prague spring" – an attempt to create "Communism with a human face," Communism without the authoritarian rigidity so often mistaken for firmness of spirit and rigor of mind – was ended by Russian invasion, Dokoupil fled Czechoslovakia with his family. After going to Vienna, they settled in West Germany. He has been a displaced person ever since, resettling on the island of Tenerife (Spain) in 1987 – a year of great crisis for him (more on this later) – while continuing to move and work restlessly around the world. His art, I believe, is his way of handling his displacement – generalized into a feeling of displacement in the modern world, which for him exists through the image-signs that bespeak, essentialize, and ultimately reify its interests – by means of his Czech attitude. Dokoupil ostensibly lost his Czech identity, but he has clearly retained a Czech – Schweik – attitude, generalized into a Buddhist one. It profoundly informs his art, in letter as well as spirit.

II

Dokoupil's art treads a fine line between aesthetic cynicism and ethical irony – a line epitomized by the issue of kitsch that haunts it. To be modern is sooner or later to become kitsch, that is, a cliché – a collectivized meaning. As part of the reductive streamlining of being that goes with the modernization of meaning, every self and object will sooner or later be simplistically symbolized – abbreviated – into an image-sign whose aesthetic appearance is

(mis)taken for its ethical reality. Objectified as a cliché, the self and its objects seem completely open, accessible. They seem to confess themselves candidly, seducing us to believe that there is no mystery and strangeness to them – that they exist unself-contradictorily – and that experience can be painless because knowledge of them is effortless – a matter of clichés.

But this illusion of the existential serviceability of experience indicates what Broch calls "anarchy of value." This is not simply a matter of uncertainty as to whether, within a given system of value, for example, the artistic, something is or is not of great or little value. Rather, anarchy of value means the collapse of the hierarchy of value systems, creating confusion as to which has priority over the other, a confusion which is resolved by the forced, cynical integration of one with the other, falsifying both. This is what kitsch represents. Artistic value – anxiety about appearances – is confused with ethical value – anxiety about the good. Kitsch, affording relief from such anxiety by creating an "effective" appearance, that is, an appearance full of "sensational" effects, is taken to be generally good, that is, vaguely life-enhancing.

In fact, for Broch the collapse of the hierarchy of values – the loss of any sense of which takes precedence over the other – and their subsequent confusion, is a sign that life itself has lost absolute value. Indeed, as he says, kitsch, epitomizing the anarchy of value by making momentary aesthetic effect the sum and substance of value – a blurring of values which is all but nihilistic – is a kind of triumph of death. To radically aestheticize the life of the self and its objects is to radically devalue them – to cheapen their consequence until they seem to have none. For Broch, the process of kitsch that accomplishes this is not simply an artistic matter, but basic to modernity. Radical aestheticism sets the tone in every field of human endeavor. Kitsch is not only the wax fruit of the attitude of art for the sake of art – art as the idolization of beautiful effects – but of modern life in general. As Broch says, the modern aesthetic credo that "art is art" has its equivalents in the modern commercial credo that "business is business" and the modern political credo that "war is war." (For Broch, Huysman's bejeweled turtle is the epitome of modern kitsch not only because it is radically aesthetic in the artistic sense, but because it is a novel commodity and a crime against nature, decorative violence arbitrarily done to it.)

If art is only art, and business is only business, and war only war, they are not of ethical interest. They have no intention of working good, only of being themselves. As they become more fixed in their identities, more exclusively and unmistakably themselves, their value in and for the lifeworld becomes confused. However, the tautologization, idolization, and radical aestheticization of art, business, and war that occurs in modernity – that streamlines them into self-sufficient kitsch enterprises – creates the illusion that they are ethical as such, good in themselves. They are in fact determined to be "good"; but this means that they have to be what they are as efficiently as possible. They aspire to be themselves – radically self-identical – with ever greater precision. But this is a profound confusion of ethical meaning, which has to do with the good or bad effect of artistic or commercial or martial activity on the lifeworld,

not their mystical realization of themselves. They misconceive ethics: it is not what is good for art, business, war – what essentializes them – but for existence. Kitsch embodies this misconception. In pointing to its pervasiveness in the modern world, Broch signals the basic misunderstanding – narcissistic understanding – of ethics in modernity.[2] Art, business, and war will use any means to justify themselves, an amorality of means which confirms their ethical naïveté – or is it a deliberate indifference, ultimately self-defeating? Kitsch is the sign of ethical nihilism, the result of the folly of disregarding ethical consequence.

For Broch, kitsch is especially important for its seductiveness. It seduces us into aestheticizing our feelings as ends in themselves, as arbitrary subjective effects with no relation either to the self in which they arise or the objects to which they are a response. Nero's theater accomplishes this in an exemplary way, implicitly setting the standard for modern art. For Broch he is the model radical aesthete, sacrificing ethics to aesthetic effect. (Broch tends to conceive of tyrants as the purest aesthetes, and pure aesthetes as tyrants.) At the core of the momentary beauty of kitsch – indicative of the modern ideology of living for the moment (living for eternity having disappeared with the loss of faith in the gods) – is the credo of instant gratification, with its denial of the need for reflection on consequences. What counts is emotional efficiency, which is what kitsch provides: it triggers unqualified and uninhibited emotion, regressively direct and simple.[3] Kitsch is implicated in what may be the core issue of modern value: the celebration of machine-like efficiency as the measure of value, the value of values. Anything that is inefficient – such as human life – is self-devaluing, as it were. Kitsch conveys the idea that efficient functioning, in one's person and in the world, is all that counts in life. That an efficient inner life is emotionally regressive, and that efficient functioning in the world necessitates the (pseudo-progressive) mechanization – deorganicizing – of behavior, are beside the modern point. Kitsch is comprehensively efficient, which is why it is so seductive: it looks organic but it is mechanical, and it generates a mechanical reflexive response. Kitsch thus outsmarts life, like a good joke. But its sensational instant effect – its illusion of spontaneous liberation of feeling from oppressive reality – is indeed momentary, that is, temporary. The true self inwardly recognizes its triviality and hollowness. The excitement of kitsch is quickly followed by the subtle depression of boredom, which is hardly emotionally liberating. At the bottom of the angry loneliness of boredom is the feeling of having been taken in, deceived. Kitsch, we retrospectively realize, makes deceptively simple sense of existence and experience, anesthetizing us to them. This is its ultimate amorality.

III

Dokoupil's art is a playful, satiric revolt, using the ironical Schweik/Buddha strategy of dumb cunning or cunning dumbness, against the kitsch mentality that fixes the experience of existence in a cliché so that it seems to have no ethical character of consequence. (No doubt the kitschification of existence

and experience is intended as a collective solution to the unsolvable problem of their painfulness and oppressiveness, that is, the angst signalling fate.) At the same time, Dokoupil knows there is no escape from kitsch in the modern world, which is why its blandishments pop up everywhere in his art. It sometimes seems like an endless encyclopediac catalogue of visual clichés, not unlike that of literary clichés in Flaubert's *Bouvard et Pécuchet*. Even more paradoxically, Dokoupil uses the clichéd means of modern high art (implicitly acknowledging that it too has become kitsch) – from painterliness to virtually every modern style, including that of the naive and insane art appropriated by modernity (all of them somewhat "surrealized," that is, given an ironical twist that makes them seem novel and second nature at once) – in order to satirize and undermine the clichéd themes of kitsch. By being treated with the same irony both high style and low kitsch lose their clichéd character and seductiveness. Indeed, in Dokoupil's satiric hands they become peculiarly terrifying, uncanny – fraught with unexpected existential import. He counters the implicit cynicism of kitsch – its fast, addictive fix of aesthetic sensation, as though to insulate the self once and for all from the basic angst of existence – with the playfully ironical ethics of Schweik, leading to a certain satiric detachment from kitsch without denying its omnipresence. To put this another way, Dokoupil's art stops just this side of cynical acceptance of cynical kitsch by the way it smiles to itself, Buddha-like. (The Buddha's smile seems to reflect his ironical sense of himself as well as his ironical relationship to the world.) Dokoupil's art is more than just another conceptual case of intellectual irony; it involves transcendental humor, even compassion for the clichés it subverts.

However, it should be noted that Armin Zweite thinks much of Dokoupil's art is "through and through cynical," in Peter Sloterdijk's sense of the term. That is, his works are the products of "an enlightened false consciousness."[4] If this is so, then either Zweite has missed the playful ethical irony and general satirical intention of Dokoupil's art or I have overstated it. Or else the ethical determination implicit in his Schweik/Buddha attitude – in my opinion the last possible emotional stand against kitsch – has failed at its task of redifferentiating, however ironically, what is confused in kitsch, namely, the ethical and the aesthetic. A Dokoupil work of art should give us the sense of seeing double: seeing a kitschy aesthetic representation which suddenly becomes an ethical substance. It should catalyze an alternative consciousness of being than that mediated by kitsch even as it presents that of kitsch. It should seem to use kitsch against itself even while looking like kitsch. If Dokoupil's art does not accomplish this conceptual trick – if it seems inexorably kitschy rather than ironically ethical or profoundly satiric – then not only has it failed at its task of teaching us the Schweik/Buddha attitude necessary for emotional survival in the modern world of abbreviated being, but it implies that the attitude is no match for kitsch – that it is a foolish, absurd, futile rather than smart response to kitsch's dumb "vision" of existence. If there is no way out of the kitsch mentality – if it is an impasse modern consciousness always ends up in (as suggested by the modern notion that all of life is coded or predestined, as

it used to be called, which makes life a kind of secondary kitsch) – then the ironically ethical existence the Schweik/Buddha attitude makes possible in the kitschified lifeworld, the wedge of authenticity it seems to drive into that inauthentic world, is an illusion.

In 1981 Dokoupil said, "That I want no program (Programmatik) in my art is perhaps connected to the fact that I grew up in Czechoslovakia. That has made me mistrust every attempt to fix and pre-determine things" (misstrauisch gemacht gegenüber allen Festlegungen und Vorherbestimmungen).[5] This mistrust of any authoritarian attempt to program art and life – to force ideological conformity on them – is at the bottom of Dokoupil's Schweik/Buddha attitude, which is a way of putting the mistrust to good use. Dokoupil does not think professing a single program as an absolute – rigidly adhering to one stylistic and ideological orientation – automatically guarantees authenticity, as some artists think. Rather, to become an art or life ideologue means to end up making kitsch – programmed art implying a totalitarian program for life. Dokoupil's Schweik/Buddha irony exists to deprogram – dekitschify – both. He is in fact a moralist, as every comedian is, and his extraordinary technical versatility and the democratic, protean variety of his works – his denial of any technical and stylistic center to art – are part of his comic refusal to be nailed down in an *idée fixe*. In such sculptures as *MOMA* and *Guggenheim*, both 1986, we see him mocking the museum as a place where art is nailed down, ideologized, and kitschified. Moreover, Dokoupil is consistent enough to turn his mockery on himself – implicitly on the artist in general – as in *Awake, Sardine! I Am Painting*, 1984, and *The Dog of the Painter*, 1985.

Significantly, Dokoupil's most basic means of satire is derived from Czech literature. Thus, Dokoupil's 1982 *Portrait of a Young Artist* turns his friend Walter Dahn into a drumming robot, with a hatchet in his head. (Dahn and Dokoupil worked together for at least half a decade.) Dokoupil shows him programmed to make art – percussive music – and at the same time tries to destroy the brain which has programmed him to function like a machine. (Dokoupil is also commenting on the robot-like character of rock music, which makes us behave and feel with robot-like predictability – with predictable wildness. This may be an ironical comment – a self-satire – on Dokoupil and Dahn as two of the new "wild ones," as the emerging German artists of the early eighties were called.) It was the Czech writer Karel Capek's 1920 play *R.U.R.* (Rossum's Universal Robots) that introduced the word "robot" to the world, and that remains a major satirical examination of 20th-century centralized, machine society, that is, the modern world of fascist efficiency, the fascist idolization of the machine that means to turn us all into efficient robots, dumbly functioning in the service of centralized social authority. Dokoupil's painting is in the spirit of Capek's play; his art in general – from his images to his word and object sculptures (which "imagify" words and objects) – carries Capek's critique of the robotization of man and of society forward, going into greater detail, as it were. Dokoupil's exploration of kitsch, the robotization of meaning, and as such the ultimate robotization, shows its ability to infiltrate every corner of mind as well as matter.

Dokoupil's intention is not simply to deprogram kitschified or robotized image-signs by seemingly wild, arbitrary satire of them, but to suggest and reconsider the experience of existence immanent but obscured in them. His irony is an instrument of metamorphosis as well as disillusionment: it is meant to restore a sense of the feeling for existence frozen in the form of the cliché by repersonalizing it. Whether representing still life objects such as fruit, or cute latter-day putti, or clichéd folk images of Christ, or the names of institutions that dominate the art and capitalist worlds, or nuclear holocaust – to mention only a few of the themes treated in extended series – Dokoupil gives them an ironical twist that does not so much deride and dismiss them, as suggestively reconstruct their lifeworld significance. He uses bananas to build a serial architecture; by being used as a modular building block, the elemental necessity of this fruit of life is playfully implied. He gives Christ unusually intense eyes, resupernaturalizing him, as it were, and suggesting his strange inner life. He rescues bananas and Christ from banality and sentimentality, giving us an inkling of their inner meaning by treating conventional images of them ironically. He treats the letters of the names of banks and museums – no doubt equivalent in his mind – like weeds growing wildly, suggesting that these institutions are not as grand and eternal and immune from criticism as their authoritarian self-representation – totalitarian advertisements for themselves – might lead us to belief (Figure 31). Dokoupil always toys with our beliefs, artistically standing them on their heads – using style to playfully introduce a sceptical note, to irritate us into sensing the profane truth behind the image-sign that represents the sacred belief. Art for him is a kind of gadfly stinging statues to life. He turns the mushroom cloud and victims of nuclear disaster into anamorphic visual jokes, implying the horrific mutations a nuclear holocaust is likely to inflict. He shows comic strip putti playing with the globe of the earth as though it was a toy they might drop or discard at any moment. They are allegorical figures – infant gods – used to convey the perilous character of earthly existence, the irrelevance of the earth in the cosmic scheme of things. Dokoupil constantly uses commonplace, redundant kitsch image-signs, shaking them up as he repeats them ad infinitum. Through his aggressively playful Schweik/Buddhist treatment of kitsch image-signs Dokoupil cuts through their predictablity, making them freshly suggestive, incalculable in effect, and reindividualizing them. He deconventionalizes them into teasing reflections on the possibilities and folly of existence, and as such as implicitly ethical statements.

Two ideas recur again and again in Dokoupil's massive oeuvre (he has compulsively made literally hundreds of works, for example, 500 candle paintings and 200 water paintings): the melancholy of the artist and the folly of existence, which can be made good only through art – even if the artist is melancholy because he is not sure whether he can in fact make existence good through his art, and unhappy that existence is made good only in artistic illusion not in reality. Dokoupil is not only concerned to adapt to kitsch, but to adapt it to articulating the existential dilemma of the artist, his paradoxical position with respect to reality. He is especially sensitive to the absurdity and

Figure 31. Jiri Georg Dokoupil, *Guggenheim* (1986). Bronze (cast of 3). 9⅝ × 16⅛ × 4⅝ in. Courtesy of the Sonnabend Collection, New York.

folly and angst of existence, but he is not certain that his art can really do anything about it – change it fundamentally. Art is a superficial but necessary response to it, a generic existential means of, to paraphrase Grolnick's epigraph, creating the illusion that all is well by playing that it is well. Is it anything more than an ostrich hole in which one hides one's head, leaving the rest of one exposed to folly and reality?

For me the most striking works in Dokoupil's oeuvre are his self-portraits, many of which show him in the traditional posture of melancholy – sagging head held up by the artist's hand, literally the hand that makes the art. In a sense, Dokoupil presents himself as another Albrecht Dürer, caught between heaven and earth, reason and sense – imperfect in his understanding and self but perfect in his power of imaginative transformation of reality, so that it appears good, that is, better than in ordinary experience.

Dokoupil fully came to this conception of art in the crisis of 1987. Feeling he could do anything but did not know what to do, he decided to start from scratch, as it were, by working directly from the model, thus abandoning programmed, pre-given kitsch representations. One could interpret this crisis as his recognition of his previous art's lack of inner necessity – or rather the

lack of inner necessity in the kitsch on which his art relied, which is what led him to reject it as a starting point. Indeed, he came to regard it as a point of departure from which one could never in fact get far, which tainted every effort one had to give the kitsch representation visionary import: it always relapsed back into the condition of a cliché. Dokoupil in effect decided that kitsch was a kind of false popular realism, a false consciousness of the real. He wanted to create a truly popular realism, freshly redefining himself, or rather, at last being true to himself, not to collectively given image-signs in which there was no trace of true self.

Dokoupil says that in his ideal studio he would fill a variety of techniques – paintings made entirely of candle soot and water are recent examples – with his own person. Can technique alone support a self? Who is the self that is supported? These are some of the questions he asks himself. In any case, he uses a particular technique to give a standard representation a new particularity. How much does the particularity of the self invested in the representation have to do with the particularity of the technique? The technique is impersonal, but the representational result is peculiarly personal – and yet the selflessness of the technique must in some way rub off on the self lurking in the representation. In fact, despite the new method and obsession with technique, Dokoupil is still Schweik/Buddha, gaining a sense of self by playing at selflessness. That is, he gives the "totalitarian" technique – the work is totally determined by the technique, completely pure in its means (all water, all soot, etc.) – a Schweik/Buddha twist, signifying that there is a self in control of it. Dokoupil's selfless self – the self that is a form of irony, that exists through its ironical relationship with reality, that is a strategy of survival rather than a substance in itself – was present in his art from the beginning. But from 1987 on it could no longer take itself for granted, and it had to find signs of itself in reality itself, that is, had to directly engage and transform reality rather than indirectly engage and ironically transform the secondhand reality of the kitsch representation. For in 1987 Dokoupil realized that unless there was some direct relationship with reality his sense of self, which was always tenuous – always the by-product of a reaction to a kitsch representation – would completely disappear. Unless art was the product of a self in direct contact with reality neither the art nor self could seem primary, and as such "good," that is, truly "real," in D. W. Winnicott's sense – bodily, spontaneous. Indeed, the struggle to be bodily and spontaneous – to articulate a spontaneous sense of body and a sense of the spontaneity of the body – is the issue of Dokoupil's drawings.

It is in them – they seem compulsive, spontaneous, and deliberate all at once – that he conveys a sense of the realness of the self and reality, the elemental simplicity of being. These drawings – seven volumes have recently been published – are, as I have said, directly from the organic model, be it a figure or an object in nature. Dokoupil says that in 1987 he consciously turned away from the mechanical to the organic, from dead kitsch to the living model. It is a turn from necrophilia to biophilia, from collective representation to individual representation, from irony to innocence – a turn that is equivocal,

because irony is never far from Dokoupil, collectivity haunts every individual, and death infects life. But irony is not the whole of the self, and collectivity and death incompletely determine individuality and life. Dokoupil is trying to disinfect himself from the morbidity of the kitsch sensibility, free himself from clichés – a struggle with no doubt ambiguous results, but a necessary, and emotionally heroic, struggle. His drawings are full of the brightness of the Tenerife light, and the strong shadows things cast in it. This brightness is like a saving grace compared to the German gloom of many of his earlier works.

There is a strange – dare I say Spanish? – concreteness to the organic life in Dokoupil's drawings, many of which are peculiarly domestic. To my mind, this special concreteness – this unique articulation of materiality implying what can only be called a mystical experience of it – is not unrelated to the unusual concreteness of things in the paintings of Juan Sanchez Cotan and Zurburan. They are presented as meditational objects, not unlike the skulls that saints contemplated to remind them of their mortality – but also their rebirth, resurrection in Christ. Dokoupil is striving to achieve the same effect of transcendent concreteness, as I would call it, concreteness imbued with eschatological significance, concreteness that speaks of first and last things. It is certainly a concreteness far from robotic kitsch. Dokoupil not only deliberately turned to organic subject matter in 1987, as he acknowledges, in order to get away from the inorganic or pseudo-organic world of kitsch, smelling of living death, but, more positively, to resurrect his art and perception – to sharpen his senses, which had been dulled by accepting the collective sensibility implicit in kitsch. Matisse has become freshly important to him – Matisse who was not only resolutely life-affirming but had a kind of ontological perception, a way of articulating the realness of the really given with a minimum of artistic means. Such ontological perception is not interested in aesthetic effects – theatrical sensations – but in subtly articulating the sense that "what is is good." As Winnicott says, this implies that external objects and internal objects "mystically" converge into one object, that sight and insight unite, generating a sense of the sacred. It is this that the best representational art can accomplish – can "re-present." Dokoupil is determined to represent sacred objects—in the sacredness of the act of representation, which can transform outer reality so that it seems to have an inner presence, as though seen with the inner eye, and transform inner reality so that it seems to have an outer presence, be seen with the outer eye. Dokoupil says that Polke is the only important artist for him, and Polke, also, is interested in mystical perception, that is, the "mystique" of perception, long an object of fascination to artists, as Leonardo's advice to "see" images in old walls indicates. Since 1987, Dokoupil has been struggling, in his own way, to take his place in this long tradition of imaginative perception, in which the object of perception and the self of the perceiver become peculiarly reciprocal, filling out each other's being without reducing it to a cliché. Direct perception, rather than irony, has become Dokoupil's dominant mode of art-making, but of course the irony of direct perception is that it is imaginative, that is, transforms its object into a sign of self, making

it good. The real melancholy of the artist is that he does not know whether the self that exists through his technique and the re-presented object will be taken up by the spectator, and if it is whether it will be of use to him, that is, whether the playful, technically cunning, imaginative representation can help him come to his mystical sense of self.

Theoretical Considerations

23

Sincere Cynicism

The Decadence of the 1980s

Cynicism requires a disbelief in the possibility of sincerity.

Richard Rovere

IN a sense, avant-garde art is an attempt to be sincere in art or, if one wishes, to renew sincerity through art. Sometimes it issues in a sense of the special truthfulness of art to inner experience of the world and self; sometimes, in formal renovation, giving art new immediacy and expressive power. The two tend to converge, for formal renovation at its best creates a fresh feeling of inner truthfulness; a new style implies new insight. Whatever its form, avant-garde art achieves an aura of authentic identity through its struggle to be sincere. Indeed, sincerity expresses the wish to be irreducibly, unmistakably authentic.

Moreover, sincerity in modern times – and it is, as Lionel Trilling has shown, a modern concept[1] – exists as a critique of the inauthenticity of society. Sometimes, one thinks, of the social contract itself. Modern sincerity means throwing off the shackles of society, symbolized by tradition, convention, norms, and the institutions that embody and enforce them. Art that seems not to belong to any tradition, art that seems to stand outside of all institutional structures, art that seems inherently unconventional and "abnormal" – un-controlled by society – is automatically regarded as sincere. Indeed, its hostile, unaccommodating, near-anarchistic opposition seems sufficient to make it authentic. Whatever form the modern opposition between sincere individual identity and insincere social reality takes – honest art against hypocritical so-ciety, "savagely" crude art against sophisticated society, art true to the self against the society that falsifies it, nonconformist art against social conformity, hyperindividuality against false togetherness, art that protests society against society that rejects art – the point is that neither side shows respect and mercy for the other. No reconciliation between them seems possible.

This, it should be noted, is why avant-garde art has no compunction in

confronting the spectator. For, representative of society at large, he or she is presumed guilty of insincerity until proven innocent by art. Avant-garde art perpetrates its "outrages" – shocks – on the spectator for society's good. By awakening the spectator to the necessity of sincerity and the possibility of authenticity, avant-garde art implicitly revolts against, and works to change, society as a whole.

This is the case even when society comes to institutionalize rebelliously assertive avant-garde art, making a place for it in the "system." This does not mean that society has found its own authenticity through experience of the art's authenticity, only that it acknowledges the good faith and seriousness of avant-garde art. This acknowledgment is not love, only recognition that the art has a certain point, which has to be admitted to general social discourse. To do so does not mean the reconciliation of authentic art and inauthentic society. It only means that they seem – deceptively – less irreconcilable. Institutionalization is a veneer of yea-saying on a basic nay-saying to the art.

The reason the '80s were remarkable is not because they produced remarkable avant-garde art – although much of it was – but because, at long last, avant-garde art and society reconciled, in however perverse a way. This reconciliation is at least one meaning of postmodernism. Until the '80s, avant-garde art and society remained irreconcilable in principle; in the '80s, they finally fell into each other's arms, each welcoming the other almost as though its life depended on it. Avant-garde art was openly appropriated by society. This occurred through a variety of means; not simply through intense economic and academic interest in the art, nor because avant-garde art clearly became a culture industry, but more insidiously and ironically. Avant-garde art was valued for exactly what it claimed to be – critical, oppositional. It was not asked to change, only to continue to be its exciting, uncompromising self. But that antagonistic self was reinterpreted as a display of creativity – the creative spectacle of the society in which the art developed. Avant-garde creativity became part of society's self-justification – its apologetics. Criticality and opposition were regarded as indications of creativity "as such." They were now social assets – artistic signs of a feisty, vital, exciting society. They were stripped of their anti-social import, or rather, socialized as typical signs of sublime creativity. From Van Gogh to Gilbert and George, old and new avant-garde artists were revisionistically celebrated as "socially significant," their estrangement and nonconformity being understood as a necessary part of social creativity. Nobody blinked at the perverseness, anger, and basic harshness of their art – at its "obscene," unmasking effect, that is, its power to turn the social scene inside out, showing its regressive guts. The distress in their art was simply creativity in action. Thus, avant-garde art became an important example of the vaunted superiority of Western civilization, taking its place alongside the West's self-proclaimed superiority in science and technology. A flourishing avant-garde art became part of the last-ditch defense of the West, an indication of its continuing power and viability – its amazing power of self-renewal.

Society was able to carry off the farce with no resistance from the avant-

garde artists, who no doubt thought they were getting away with murder. In fact, they were being murdered – castrated – without realizing it. Indeed, avant-garde artists flattered themselves that they were unquestioningly and profoundly important because they were so broadly taken up. They had little if any comprehension of the reason why they were approved – why they were suddenly so socially useful. Apart from Hans Haacke and a few others, the artists did not even bother to question their appropriation, taking it as a long overdue tribute and success. That avant-garde artists accepted this socially imposed, inflated role of creative saviors is in fact proof of the power of society – of how it can convincingly change the meaning of anything. It can convince even those whose meaning it changes. In the '80s the history of avant-garde art was rewritten, in a way not unlike the Soviet Union's rewriting of socio-political history. The result was a self-proclaimed successful society and art – with no questions allowed to be asked, no eyebrows allowed to be raised.

This extravagant heroizing of avant-garde art destroyed it from within, for it ingeniously undermined its most important purpose. Its animosity no longer seemed to communicate "real experiencing," to use Carl Rogers's term.[2] Whatever "diffuse and forgotten experiences" – as elusive as they are subjectively important and profoundly real – avant-garde art raised into consciousness, they were stripped of their inner texture and stereotyped in form and meaning, a rationalization that falsified them, not to speak of the falsification of the avant-garde means used to communicate real experiencing by their conventionalization into the façade of a "manner." No longer were avant-garde criticality and opposition testimony to the durability of the subject at odds with a society determined to objectify it, indications of resistance to a society that asserts its rule by turning the subject into an instrument. Instead, they were signs of the creative cunning of social reason itself.

In accepting the role assigned to it as emblem of social creativity, avant-garde art loses its power to make us aware of "our deeper level of experiencing," that is, to make us sincere. In the '80s, avant-garde art became part of the "conscious façade" that hid this deeper level, indeed, cynically denied its existence. (Such cynical staying on the surface – it is familiar from, say, Robbe-Grillet – is an attempt to defend an art that conveys no depth of experience.) In the '80s, avant-garde art almost completely lost its power to put us in touch with our authentic selves – in terms of Rogers's distinction, the self implied by the deeper level of experiencing that the social façade we consciously construct keeps unconscious – and with that it lost, or at least compromised, its avant-gardeness and sincerity. Avant-garde art became part of the social problem, rather than a solution – however relative and incomplete – to it.

"The experiencing organism senses one meaning in experience, but the conscious self clings rigidly to another, since that is the way it has found [social] acceptance." The experiencing organism replaces the living meaning it senses with the approved, officially assigned meaning, denying its sense of the truth in order to be socially accepted. The subjective result is a sense of isolation – a sign of self-estrangement. In the '80s, avant-garde art, however

unwittingly, served the self-alienation – the estrangement from one's own deeper, organismic level of experience – epidemic in our society.[3] The individual feels like nothing; his or her real feelings are hidden behind this socially induced feeling of nothingness. However, society knows that we cannot emotionally survive without some sense of being authentic. So, after encouraging us to betray our deepest sense of self, rooted in real organismic experience, it encourages us to accept pseudo-organismic experience – a façade of real experiencing. This is the task of entertainment in our society.

In the '80s, the avant-garde culture industry became part of the entertainment industry – in some instances, e.g., Laurie Anderson and Philip Glass (but also Barbara Kruger and Jenny Holzer), seamlessly fused with it. Like the products of the entertainment industry, those of the postmodernist avant-garde filled inner emptiness with false subjectivity. This occurs perhaps most conspicuously in '80s Neo-Expressionism, however unintentionally. Schnabel is a salient example, by reason of his exploitation of broken crockery and used tarpaulin – his manufacture of the "brutal look" (Figure 32). Both materials are pseudo-organismic in effect. They create an aura of instant authenticity. Kiefer accomplishes the same thing through his complexly textured blackness. He is more convincing than Schnabel, because his violence is indirect, less forced. He evokes catastrophe rather than blindly participating in it. Kiefer's blackness is truly organismic.

In general in the '80s, avant-garde art was less a means of critical opposition to the social façade than a part of it. It tended to betray the deeper level of experiencing rather than evoke it. The social façade necessarily includes an illusion of depth of experience, as a placebo for the misery of self-betrayal. This façade of depth is a repressive desublimation rather than expressive sublimation of it. Depth comes to seem shallow, and thus easily plumbed and mined, rather than inexhaustible and ultimately unfathomable. The modernist avant-garde tended toward expressive sublimation of depth, after the breakthrough to it. The postmodernist avant-garde of the '80s tended toward repressive desublimation of depth, in effect bankrupting it.

Social acceptance of the avant-garde made it blind to itself. It came to believe that it was authentic whatever it did, and that it did not have to make the effort to be authentic because it already was. It in effect gave up its sincerity. Socially idealized, it betrayed its own idealism. To put this another way, the legitimation of the modernist avant-garde was also its reification, and this reification became fully operational, as it were, in the postmodernist '80s. Appropriated, modernist authenticity became a socially appropriate ideology, indeed, a preferred, even fashionable, mode of authenticity. Postmodernism is avant-gardistic, not avant-garde – repressive not expressive. Postmodernist avant-gardistic art appropriated, exploited, and mummified avant-garde authenticity, modernist sublimations of depth. They were made ceremonial. In the '80s the avant-garde became another "ism" – an orthodoxy and a dogma. Postmodernist avant-gardism has no authenticity of its own, but depends on the modernist avant-garde vision of depth of experience. Postmodernism does

Figure 32. Julian Schnabel, *Physician Heal Thyself* (1989–90). Patinated bronze. 9 ft. 2 in. × 11 ft. 3 in. × 5 ft. 3 in. Courtesy of the Pace Gallery, New York.

not truly understand this vision and the suffering – sincerity – involved in its realization, the realization of authenticity: postmodernism does not realize – and has no interest in realizing – how difficult it is to reach the deeper level of experiencing.

The avant-garde's Achilles' heel is its wish for social acceptance. By the nature of the logic of sincerity, to convince society of one's authenticity is to forfeit it, or at least endanger it. It is a mistake to imagine that because one has been accepted as authentic one in fact is. To be socially accepted as authentic is not a shortcut to authenticity, nor does it sustain authenticity. One's authenticity is not determined by whether one is or is not socially accepted, and one's wish to be socially accepted is likely to make it difficult to be authentic. For authenticity means owning oneself, not defining oneself socially, which always involves becoming a shell of oneself, that is, putting up a front of authenticity.

277

Sincerity is the struggle to reach the real, experiencing self hidden behind the façade of one's own consciousness, the internalized social façade that hides the depth of one's own experience from oneself. There is no guarantee that one will in fact reach this authentic self. The '80s represent the decisive end of modern art because during those years avant-garde art made a mockery and near shambles of the idea of sincerity, despite the professed sincerity of much of it. There are two basic kinds of '80s avant-garde art: one that argues, in effect, that today art can be almost instantaneously sincere, without great effort; and the other that sincerity is obsolete in art as well as in society in general. One kind of art believes that to be sincere these postmodernist days all one needs are the old signs of modernist sincerity — believes that the ashes of modernist authenticity, skillfully raked, can be made to yield a sincere-looking fire. The modernists can save one a lot of trouble, if one knows how to use them. Of course the result is peculiarly insincere, cynical, blasé: to revive or ape an old sincerity is necessarily insincere, and means one has none of one's own. The other kind of art thinks that the effort to be sincere is absurd, even stupid, for the subject that sincerity means to articulate is a social construction and fiction, and is thus inherently inauthentic. For this kind of art there is no such thing as a depth of experience, or subjectively valid experience as such. The subjective is meaningless, or can be explained away in objective terms.

The one kind of art is Neo-Expressionism, the other kind is Neo-Conceptualism. Both appropriate modernist attitudes as well as manners: the one is "subjective" in orientation, the other "objective." It is the difference between, say, Baselitz, Kiefer, Clemente, and Fischl on the one hand, and Koons, Steinbach, Levine, and Halley on the other. More crucially, it is the difference between an art of seemingly deep organismic experience, and art that endorses and elaborates the social façade, indeed, is as manipulative as it is. Neo-Expressionist art is suspect because it does not involve serious renovation of modernist formal means, and, perhaps more importantly, because it does not so much bring diffuse and forgotten feelings — indicators of deep organismic experience — to consciousness as manipulate foreknown, even preconceived, feelings to new expressive effect. It presupposes a generic kind of feeling rather than opening itself to whatever particular feelings might spontaneously rise from the organismic depths. Neo-Conceptual art is suspect because it accepts the social façade too readily, suggesting complicity or at least compliance, even identification, with existing social authority. This is especially the case with so-called commodity-object art. It implicitly endorses consumerism, the major social façade repressing and blocking real experiencing. Its unabashed use of media modes of representation — including the mediazation of high art (Steinbach, Taaffe) — also implies such endorsement, for they cement the façade in place. Neo-Conceptual object-art emulates advertising, which "hawks possessions and celebrity routinely, as if they were cultural imperatives."[4] Koons is a salient example.

Thus, on whatever artistic front the avant-garde battled in the '80s, it tended to betray itself, that is, its avant-garde sincerity. This was done either by being unconsciously insincere about authenticity, or by consciously abandoning it

as socially unrealistic – just plain silly. Disbelief in the possibility of sincerity and ultimate disillusionment with authenticity is the core of postmodernist cynicism, whether unwitting or witting. Sincerity and authenticity seem futile because, while possible for individuals, they are impossible socially. It was the great modernist expectation that they could become socially viable – that it was possible to create a society in which everyone was sincere, and could become authentic, have integrity. Postmodernism is based in part on the painful recognition that sincerity and authenticity effect no significant social change: they do no significant damage to the social façade.

Neo-Expressionism constructs its face-saving façade of sincerity in response to this postmodernist disillusionment. But like all social façades, it falsifies what it means to flatter. That is, by reifying sincerity – creating a set style of sincerity, as though its appearance was frozen forever in a face-lift, and made typical – Neo-Expressionism destroys it as an ideal to be aspired to with all one's existence. Neo-Expressionism is unconscious of its cynicism; Neo-Conceptualism is consciously cynical and inauthentic. To give up even the social semblance – cosmetic pretense – of sincerity, and with that the last vestige of the ideal of authentic experience, is to be existentially bankrupt – totally decadent. Such bankruptcy – suggesting the ironical state of sincerity today – is self-evident in Cindy Sherman's female portraits.

In general, cynicism is a matter of disappointed idealism, expressing itself as world-weary disillusionment, as though the world was to blame for one's own insincerity and inauthenticity, or indifference to sincerity and authenticity. The postmodernist '80s were a time of disappointment with modernist ideals, masked by virtuoso appropriation of modernist methods. On the whole, Neo-Expressionism can be said to be conflicted: it struggles to sustain belief in a sincerity it regards as ineffectual in the world. In contrast, Neo-Conceptualism surrenders to what it regards as a stylish disillusionment. It is uncompromisingly cynical. When it copies high art, rendering it as banally given, it shows that copying is not only the sincerest form of flattery but the sublimest cynicism, that is, the blindest acceptance of what appears as a conscious façade with nothing behind it. Mike Bidlo is the example par excellence. Copying is façadification, if I may be allowed a clumsy neologism.

Cynicism and the decadence of postmodernism are rooted in a widespread psychosocial phenomenon. People today know language – especially in its streamlined, schematic, populist form – but they hardly know what they experientially mean. The postmodern cynical artist knows the languages of modern art, and usually has complete mastery of them, but does not know what to say with them experientially. He or she is a revivalist, but it is not clear to what communicative purposes the revival exists. (Postmodernist revivalism may be a last-ditch strategy of modernist novelty.) The postmodernist artist knows styles, but not their meanings, and has no meaning of his or her own – no authentic experiential meaning to communicate. He or she is a well-trained mechanic who thoroughly understands the workings of different styles but has no idea where to go with any of them. He or she has little sense of

279

the road of life and experience the style might travel on. Even more insidiously, the postmodernist artist is no longer able to count on the language to generate experiential meaning, to cover for his or her "inexperience" – to disguise the fact that he or she has nothing to say that is experientially relevant.

In the '80s it was implicitly realized that style has limited power. Style and meaning were sundered, signaling art's failure of communication. Not that the phenomenon is unique to art, but it is especially evident there. No style seemed to have inherent meaning, and no meaning seemed best communicated by a particular style. The connection between language and meaning not only seemed arbitrary, but impossible to establish. (Modern art reached the end of its tether in Conceptual art, where it in effect announced that it had lost the power to communicate. Its separation of the material and ideational aspects of art – and the dismissal of the one as irrelevant and the overestimation of the other, correlative with the defensive masturbation of the concept of art into near meaninglessness – registers its communicative impotence. Conceptual art haunts postmodernism, which is in part a response to it, especially post-modernism's fresh emphasis on materiality, and its restoration of the old idea of art as the consummate integration of mind and matter.)

It has been said that language speaks one rather than the other way round, but it can do so only so far. There is a certain bankruptcy and cynicism in relying entirely on language for one's sense of experience. Language is not experience; trusted, it can give one a strong illusion of real experience, but it can be trusted only so far, and not ultimately to tell the experiential truth. One cannot really have a full experience solely through language, however much it may seem to stir the deeper level of one's experience. Its effect of experiential verisimilitude depends more on the context of communication – whom the language addresses, and the intimacy of the situation of commu-nication, which would include the receptiveness and attunement of the listener (spectator) – than on the language per se. It is never adequate to real experi-encing, however much it may seem to be. It seems adequate for a while, but it has to be re-adequated, as it were – retuned to experience. This is why styles always change – why the need for a new language to make our real experience intelligible and communicate it to ourselves and others perpetually recurs. Language may seem to give one a self to speak, but after a while that self seems as rhetorical and hollow as it does.

In the case of the Neo-Expressionists – would-be sincere artists – there is dissatisfaction with expressionistic language even as it is mastered. In a sense, they attempt to undo their mastery – to make it seem as though they were using expressionist language awkwardly or wrongly, as though that in itself makes for sincerity. But the Neo-Expressionists remain skillful even in their apparent unskill. They do show the way to achieve an effect of authenticity today: a system of language must seem to be unraveling, seem to have a loose thread by which it can be pulled apart. Ironically, its disintegration makes it seem fresh. A style seems most alive when it is in its death throes or when it is a new blossom on the tree of art – when it blazes with autumnal colors or glistens in the sun like a freshly hatched butterfly. However, irrational linguistic

form is no truer to real experiencing than rational linguistic form (apart from the fact that both are ultimately inadequate to it). Whatever the form, if the artist starts out from language he or she can never expect to arrive at real experiencing. The real struggle is to start out from real experiencing and find a language that seems adequate to it – ecstatic – if only for a short time.

In a nutshell, the question is how the postmodernist artist rhetoricizes the modernist language of his or her choice, the modernist language "quoted." Does he or she create, in T. S. Eliot's important distinction, a rhetoric of manner or a rhetoric of substance? To my mind there is no question that the Neo-Conceptualists are "mannerists." Manner – conscious façade – is every-thing to them; nihilistically, they believe there is no substance behind the façade. This is why there is no substance in their manner. In contrast, it is not clear whether the Neo-Expressionists create a rhetoric of manner or substance, or a peculiar hybrid. That is, it is not clear whether they give us a clichéd artistic language that functions as, in Eliot's words, a "vicious rhetoric" au-tomatically triggering predictable feelings; or a differentiated articulation of real experience – what Eliot calls a "progressive variation of feeling" – bound to a real situation.[5] The Neo-Conceptualists are explicitly vicious in their rhetoric, especially those who manipulate the linguistic façade of society. They are in fact as manipulative as it is. In contrast to them, the Neo-Expressionists do seem to offer a rhetoric of substance – but in our relativistic situation there are no ready standards to determine if they really do. Also, we have become so habituated to façade – so cynical – we no longer know what substance is, or want to face the struggle to experience the difference between substance and façade. In a sense, the ambiguity of the Neo-Expressionists makes them profounder postmodernists than the Neo-Conceptualists, for it makes their self-estrangement explicit. Also, their rhetorical undecidedness makes the masochism in cynicism explicit. (Are the Neo-Conceptualists, then, sadistically cynical?) Salle, it might be noted, is admirably both. The cynicism of his juxtapositions exemplifies Neo-Expressionist undecidability, and his fashion-ably cynical image of the female as the perfect commodity/object is perhaps the ultimate example of Neo-Conceptualist cynicism. He is the perfect post-modernist cynic, down to his rabid modernist appropriations. To welcome the Neo-Expressionists, as I do, is to make the best of a bad choice – of a decadent artistic situation.

<center>*24*</center>

The Problem of Art in the Age of Glamor

WE live in a special age of art, special not because of its stylistic revolutions, or because of its new sense of artistic truth, or even because of a new sense of the irony of art's existence, but because it is the age of the capitalist understanding and dominance of art. The simplest sign of this is that art has been completely commodified. This means that the history of art has become the history of art auction prices, confirmed by textbooks that are auction catalogues in all but name. Vincent Van Gogh is currently worth $50,000,000 of art history, and Jasper Johns is currently worth $17,000,000 of art history. Every art has its historical price. One invests in history, which is what it means to be cosmopolitan today. Any art that does not command a historical price is provincial.

But there is more to this capitalist situation than meets the eye. The exchange value of art has unofficially become its ultimate value; art has taken on the glamor of money. On the black market of thought, art is worth only what it is worth financially. The open intellectual market exists only to justify the price. But it is the glamor part of the equation that interests me – the way glamor rubs off on art because of its high price. While it is true that the more economic value an art has the more glamor it seems to have, the point is not only that art functions as a kind of money today – some art bonds seem to afford the security of municipal bonds – but that art is a more basic form of glamor than money, indeed, the ultimate form of contemporary glamor. When one is economically investing in art one is emotionally investing in glamor. The second investment in the end counts more than the first one. In our time, art is reified as absolute glamor; it is in fact the most glamorous of all social phenomena – the most desirable of objects. Thus, the identification of art with money confirms its glamor rather than causes it. Money is simply the price one pays for glamor – *the* high value and conviction of our age. Art looks glamorous the way nothing else can, not even the most glamorous woman. One might say that the aura and sheen of money are worn by art the way a victor wears a laurel wreath, confirming the victor's transcendental glamor.

<center>282</center>

Or one might say that in the hierarchy of glamor, the low glamor of money worships the high glamor of art.

What is glamor? Georg Simmel has pointed out that an object begins to acquire aesthetic value when

> we no longer want anything from that object. In place of the former concrete relationship with the object, it is now mere contemplation that is the source of enjoyable sensation; we leave the being of the object untouched, and our sentiment is attached only to its appearance, not to that which in any sense may be consumed. In short, whereas formerly the object was valuable as a means for our practical and eudaemonistic ends, it has now become an object of contemplation from which we derive pleasure by confronting it with reserve and remoteness, without touching it.[1]

In glamor, there is regression from a contemplative to a practical and eudae-monistic relation to the object, but it is not a complete regression. The object is consumed, but not in the old practical way, and our sentiment remains attached to its appearance, but not in the old contemplative way. That ap-pearance is no longer an end in itself, but has a kind of eudaemonistic purpose: it exists to make us feel good about ourselves. It has narcissistic use: it is the mirror that makes us conscious of the fact that we are unconsciously so fair to ourselves. Thus, we consume the glamorous-looking art object to satisfy a deep psychic need, an especially pressing one in our barren world, which offers few narcissistic consolations, certainly no transcendental ones. Art fills the vacuum left by the loss of the socially approved narcissistic consolation of religion – something that is well known, but without understanding of its full import. For aesthetic value is not simply narcissistic by default, but at root; and as with all narcissistic enterprises, the sense of glamor is inherent to it – at the core of the relationship between art and the self. It mediates between them: aesthetic perception involves the transference of glamor from art to the self. The love of art is self-love in disguise; the loved art affords a glamorous sense of cohesive self – an illusion of integrity – to a self that has none. Art is a prosthetic self, compensatory for a problematic self.

When, as the psychoanalyst John Gedo tells us, today's artist focuses "more and more upon himself, with less and less pretension of offering aspects of his own experience as specific examples of certain human universals,"[2] Gedo is in effect saying that the contemporary artist is basically and narrowly, and perhaps inescapably, narcissistic. Art is first and foremost a symbolization of this narcissistic condition, whatever else it might be. It has little human interest apart from what it tells us about the artist, and he or she can no longer be taken as an exemplary human being, or rather, as having a universal human voice. Art today is too narcissistically particular to be essential for humanness – except, no doubt, for the humanness of the artist. It has little general sig-nificance for other human beings, since it hardly speaks to universal human concerns.

Glamor is narcissism socially refracted – sheepish narcissism in wolfish social

disguise. Glamor is a socially approved manifestation of the deluded grandiose feeling of narcissistic completeness. The beautiful people seem beautiful because they have perfected the illusion of narcissistic integration. Their narcissism has become a successful way of being-in-the-world – the only way they are seriously in it. Every detail of their person bespeaks their narcissistic self-privileging. In general, the sense of glamor fills the vacuum left by the social abandonment of human universals. In a sense, the contemporary artist's narcissism is only a symptom of this abandonment. The artist's – and everyone else's – desire for glamor becomes overwhelming when larger human relevance fades – when the human inwardly comes to seem trivial, for all its social yea-saying. The difference is, the artist is supposed to give us a consummate sense of humanness – a more-than-everyday sense of humanness – while the narcissism of the "little man" is expected and accepted.

Put another way, narcissistic glamor represents a collapse of human interest, that is, interest in the humanness of others. It implies a denial of shared humanness. This consummate narcissist implicitly privileges himself or herself as more than human, when in fact he or she is very far from being fully human. Indeed, we regard consummately narcissistic art as divine, that is, we refuse to see it as "merely" human – an idealization of the all too human. What is unconsciously most admired in art is the successful rendering of narcissistic completeness of being, whether directly, for example, in the *Apollo Belvedere* and Michelangelo's *David,* or indirectly – symbolically – as in Dutch and Impressionistic landscapes. In modern art narcissism has gone underground, becoming a matter of the aesthetic – "basic" – unity of the work. The history of art has perhaps always been more the story of the metamorphoses of narcissism than of universal human interests, but what makes the narcissism of art special today is that it has combined with capitalism's narcissism – self-satisfaction.

Today, under capitalism, art functions socially like a charity ball – an ambiguous benefit for others. Those for whom the ball is thrown are never invited to it. Those who give the ambiguous charity of art do not want to meet those who are eager to receive it – who think it is a well-intentioned, beneficial gift. They are kept at a safe (aesthetic) distance. More than ever, the narcissistic interests of those who make art count for more than the human needs of those who desire and supposedly benefit from it – and how much they benefit from it is *the* contemporary question about art. At best, capitalist art's charitable attitude is the narcissistic one of noblesse oblige. Nobility has never been known to completely satisfy the needs of the people. On the contrary, it robs them of their substance – exploits them, in subtle emotional as well as overt material ways. One feels that even art that claims to speak in the name of the people, such as the presumably noble political art of Leon Golub and Jenny Holzer, takes more from them than it gives to them. The one exploits the popular awareness of violence, the other flaunts her superior insight – superior to that of the people.

Thus, when the artist has lost all sense of what it means to try to speak in a universal human voice – one that everyone will implicitly recognize as their

own, whether or not they like what it says – he or she begins making works of art that are explicitly glamorous, that have nothing but their narcissistic glamor to fall back on. To get down to a few cosmopolitan cases, artists as stylistically different as David Salle and Peter Halley have the same conceptual point: to make art that is super-glamorous. Their art is essentially a gesture of glamor. They glamorize whatever they touch – style and content – the way Midas turned whatever he touched into gold. Nonetheless, they profess the human interest of their art. Salle's pictures are supposedly full of dead passion and Halley's pictures supposedly evoke postindustrial bleakness. But these meanings are subsumed by their glamorous mediation. The human interest in their art seems tenuous compared to its stylistic glamor. Indeed, their glamorization of known styles follows from their inability to have an authentic human content. Or rather, they do not convince us that they are dealing with the universally human, which always seems inauthentic when it is glamorized. Salle's female figures are a long way from those of Max Beckmann, with whom he claims an ironic affinity; and Halley's abstraction seems to completely betray the human universality of absolute art from Piet Mondrian to Barnett Newman. Indeed, the implicit purpose of the work of the appropriation artists is to strip the human voice from the art they appropriate. Or else, as in appropriation art which pretends to give pride of place to that voice, such as that of Julian Schnabel – who is always painting the wounded heart – it is aped. The dregs of the human voice are visible, not its substance.

Perhaps, given the capitalist circumstances of art, that is the most that one can expect from it. In a sense, we are witnessing the de-evolution of the human in art: the artist has become a postmodern ape. In capitalist society humanness always seems compromised, although previous twentieth-century artists have found ways to make it seem viable. And real, in the psychoanalyst Donald Winnicott's sense of the truly real as an effect generated by communion with inwardly real introjects. That is, previous twentieth-century artists, working before capitalism seemed so absolute and unconquerable, were able to give us a sense of the interiority of the human, and of communion with this inner humanness. In any case, except for Eric Fischl, little of appropriation art seems to have an authentic, full-bodied human voice. What is left in appropriation art is the shell of style and image.

Such art is implicitly an admission that the human voice – so strong in the Old Masters, so integral to their art, for all its narcissistic qualities – means nothing in art any more. This is the perverse realization of a certain version of what it means to have a modern aesthetic. The human voice becomes completely inappropriate when art becomes completely narcissistic. Appropriation art, then, is shallow, by which I mean a specific quality: it does not bespeak human universals, and makes no attempt to do so, regarding any such attempt as unsophisticated – provincial, outside the mainstream – and the human voice itself as trivial. The ultimate point of such narcissistic aestheticism is to deny that human universals exist. The world is entirely an artistic invention – constituted by universal aesthetics – which is one of the points of Marcel Duchamp's readymades, that is, the whole notion of conferring aes-

thetic value on everyday objects. To do so is to deny them their human relevance. Duchamp's readymades nullify human interest as much as they nullify aesthetic interest. They are the consummate nihilistic objects. The absolutization of nihilism, I want to suggest, is the implicit goal of modern art. Duchamp has set a high standard of nihilism, which few artists have reached. But the commodification of art – its annihilation into money – confirms it.

Once upon a time, to say an art was important meant that it seemed inevitable, which also meant that it seemed to speak with a universal human voice. It did not exist just for itself. The experience of the art's inevitability involved the feeling that it articulated what seemed impossible yet necessary to articulate. It also meant that what the art made articulate was something that we felt we were just about to make articulate ourselves – that the art was on the tip of our own tongue, as it were. It gave us a sense of making spontaneously articulate what was inarticulate yet that we felt we knew "naturally." It articulated what we could not quite articulate but were perpetually on the verge of articulating. The sense that art did not simply address people from the outside but spoke to them from the inside and spoke for their innermost being, which it seemed to grasp better than they themselves could, articulated their desire and sense of reality better than they knew them, was once basic to high art, giving it its special human value and social respect. The attempt to create the sense of speaking from the inside of the universally human has been abandoned by high art. Art that even pretends to do so loses face. (Popular art continues to pursue this ideal – which is partly why it is so popular – with less subtle means and a less subtle sense of what is inherently human than high art, but with great vigor. Soap operas are a major example.)

Indeed, today, as Gedo says, "the mandarinate is embarrassed about professing any value system at all,"[3] that is, about making any art that has inner relevance to human universals. Some of it undoubtedly does, and recently certain – mostly German – art has been elevated because it transparently has such relevance. But this elevation – for example, of Anselm Kiefer's work – is not carried out in deep appreciation of its universal human voice, but rather because humanness is chic today. It adds to art's glamor. Art that helps create the illusion that capitalism has a human face is highly valued by it. Such art becomes part of capitalism's social as well as economic capital. It seems particularly glamorous. Thus, the universal human voice in Kiefer's art is regarded as just another narcissistic feature of it – a kind of surplus narcissism, capitalistically useful. Indeed, Kiefer's brooding upon German destiny can be understood as a sign of revived German narcissism, that is, the German sense of once again having the fairest, greatest culture of all. Thus, universal human value is another lead that is converted into the gold of glamor by commodification, which is the instrument of capitalism's narcissism. Indeed, Kiefer's deep German works sell for big American money, that is, German narcissism is appropriated by American narcissism which wants to look good to itself. But of course to look all too human is just more narcissistic glamor. It is very

glamorous to seem to be caring and aware of suffering in an uncaring, inhuman world.

The artist himself has become glamorous: he or she has been reified as a creature of fame. This justifies his or her narcissism. The famous person is supposedly superior to other human beings. He or she supposedly does not have the same humanity as they do. Thus the famous modern artist can justify his or her indifference to human universals. He or she does not feel compelled to try to give his or her art a human voice. In fact, his or her aestheticism masks his or her art's incapacity to have a human voice. From its start, modern art was split between the sense of art as such and the sense of human universals – a true dissociation of sensibility, to renew T. S. Eliot's term. Obsession with the mechanisms of art ousted its human voice, and the art in which that voice remained seemed trivial because of it: Art has repeatedly tried to put these seeming opposites – call them, metaphorically, the difference between art as a closed system and art as an interpersonal phenomenon – together again, never completely succeeding, at least convincingly. Their relationship has never been stabilized; uncertainty and imbalance remain everywhere in modern art. While art eager to pursue stylistic innovation – experiments with itself in a kind of masturbatory fury – has been regarded as more important than art that attends to human universals, in a no doubt all too obvious way, it is equally absurd to pursue artistic innovation for its own sake and to want to state age-old human universals for their own sake.

In this double bind situation, attention refocuses on the artist's creativity. The seemingly insolvable problem of modern art – to reconcile the artistic and the universally human in a viable new way – is cut through by celebrating the artist's creativity. It becomes of interest in its own right, implicitly in compensation for the inadequacy of his or her art, whether it be an artistic or human inadequacy. The artist's creativity is regarded as the heroic side of his or her narcissism. His or her narcissistic struggle to be creative at all costs comes to count more than his or her ability to reassociate the artistic and the human. The artist doesn't really seem to have the power to do so, only the power to be creative as such.

Creativity becomes glamorous in its own right. It serves the narcissistic purpose of the public as well as the artist. His or her creativity satisfies the public's narcissism. The artist's creativity is an enactment of the public's repressed narcissism. By vicariously sharing the artist's creativity, the public can feel glamorously alive. Moreover, it is because of the public's servile attention to every move of the artist's creativity that he or she feels that it is glamorous to be creative. Creativity becomes the ultimate narcissistic glamor. Everyone wants it, and everyone can have it, as artists as different as Duchamp and Joseph Beuys have told everyone, in a share-the-creative-wealth spirit. Creativity is going to save us all from ourselves, when in fact it has degenerated into the narcissistic phenomenon which most bespeaks our problematic humanity – the inadequate humanity of the narcissistic self. Forgotten in the wake of the fame and commodification of creativity is the old idea of creative art as a subtle rearticulation of human universals.

The glamor of art and the artist testifies to their hyperreality; they are the simulations of a public narcissism. The capitalistic success of art, which is the "proof" of this glamor, as it were, is the major social instance of the ecstasy of narcissistic consumption, that is, consumption which feeds the self's sense of its glamor. It is an endless, relentless, restless consumption. Should the rabid consumption of art stop, capitalistic authority would be devastated by a sense of blankness: without its artistic glamor, the capitalist self would be spontaneously experienced as empty. Capitalist society prides itself on its support for art, which becomes a superior source of narcissistic gratification in capitalist society. Art in general is the last frontier of narcissistic hunger, and under capitalism this hunger becomes insatiable and unsatisfiable, because of the human failings and inherent inadequacy of the capitalist system.

The hecticness and excitement of the art scene are notorious. The artist makes works with electronic ease, and the public consumes them with the same ease. This hecticness and excitement, and electronic ease, reflect an undertow of narcissistic dissatisfaction. They are signs of the imperative need for turnover – a headlong search for alternatives. The art objects don't reflect one quite properly; they must be constantly replaced by new objects. The artist – the whole art scene – obliges. Criticism obliges; it exists to confirm the glamor of the transient objects of art, to insist that they can be narcissistically satisfying, at least temporarily. Criticism helps make the glamor of the scene. It creates the ecstasy of communication – the ecstatic dissemination – of art. (Authentic criticism should de-glamorize the scene, should point to its psychopathological character – the reality underneath its hyperreality.) To speak of contemporary art's cosmopolitanism or internationalism is to speak of this all-consuming narcissistic glamor.

The problem is, the human universals remain. The other problem is, the artist's narcissism carries him or her only so far. It eventually suffers a crisis. It is the crisis of individuation that Jung spoke of: the so-called mid-life crisis in which the self's sense of omnipotence and grandeur must be reconciled with its dawning recognition of the legitimacy and autonomy and rights of others – the recognition that it is only one form of the human among many others, which is perhaps the genuine beginning of the recognition of humanness. Moreover, the artist's creativity can never keep up with the rapacious public, hungrily feeding its narcissism. It eventually becomes indifferent to the artist, whose work it consumes more and more quickly, and which it eventually does not even bother to consume. Very few artists become permanent fixtures on the scene, and those who do criticism must busily prop up by prolonging ecstasy about what they supposedly communicate. Cynicism is built in to the complex narcissistic situation of art under the capitalistic condition, with its insatiable appetite for glamor to justify itself.

In the zone of the provinces – the zone defined by the absence of art money and thus of art history – mid-life crisis is perpetual for the artist. The delusion of narcissistic grandeur cannot be sustained for long without the confirmation of money. Far from the mainstream of glamor, the human voice presses in

upon art, but to no clear point. It is more demoralizing than exhilarating in a situation in which there is no public mirror to consummate one's narcissism. One's creativity seems insignificant; it is no longer even much of a consolation. When not a burden, it is a routine. The provincial artist carries on, producing work that is equivocally artistic and human.

Yet there is an opportunity in the provincial situation – which, to remind you again, I regard as any situation that lacks capitalist glamor. In the provinces, there is the same belief in glamor that exists in the cosmopolis, but not its realization. Belief in glamor is basic and pervasive in advanced capitalism – a necessary part of its working. Belief in glamor is the necessary belief of a self that has been narcissistically weakened by having unnecessary needs foisted upon it. The common quality of all these needs is their insatiability – their fundamental unsatisfiability. Glamor creates the illusion that these insatiable needs can be consummately satisfied by the same capitalist society that encouraged them. The ideology of glamor is the major demonstration of the inhumaneness and self-contradiction of capitalism. Capitalism thrives on narcissistically weakened selves – selves with no ego strength, no power to criticize the authority of the capitalist society that foists illusory needs and satisfactions upon the self. In a sense, the only difference between the cosmopolis and the provinces is sophistication, which means the conceiving of ever new ways to give the illusion of consummate satisfaction, which nonetheless always remains out of reach, elusive.

There is, of course, the myth of suburban satisfaction – the everyday glamor of the suburban, that American version of paradise on earth – which has become so pervasive, and for many makes more sense and has greater human validity than the myth of artistic and cultural glamor. But of course it is equally inhuman – as much of a capitalist lie, a narcissistic fraud and folly. In general, capitalist society thrives on tantalization, and the suburbs, like cosmopolitan art under advanced capitalism, is simply another, if less sophisticated form, of capitalist tantalization – another part of the lure of glamor.

To get back to the opportunity that exists in the provincial situation: it is, as you probably gathered from what I have so far said, the opportunity to reunite art and the human voice – to find the universally human and correlate it with art, giving art a new universality. The problem is that the reconciliation is necessarily eccentric and erratic in capitalist society. Moreover, it is always improvised, and so unstable – perhaps necessarily unstable, to be a genuine alternative to glamor, which is always solidifying and stabilizing its position. Inherently, the reconciliation can never be glamorous – narcissistically attractive – for that would make it self-contradictory. Provincial art is the search for the authentically eccentric: that which can never be reified as glamorous style. It is only in and through such eccentricity that art can retain its role as the sanctuary of the alternative, which is what I think was really meant by the old avant-garde conception of it as the zone of opposition and rebellion. It is alternative awareness which is always improvised and unstable, which must always be reinvented. Glamor – the simulation of narcissistic unity of

being, the illusion of narcissistic contentment – seems to last forever. Eccentric art is unsimulated art. It in fact is critical: it reveals the psychopathological underside of hyperreality – of hyperreal capitalist society.

The psychopathology of not being able to reconcile the sense of sublimity implicit in art with the sense of suffering implicit in being human is a basic feature of the psychopathology of capitalism, with its narcissistic hyperrealization of life and simulation of ecstatic satisfaction. Art must stop tantalizing us with delusions of narcissistic grandeur the way capitalism does. To stop being tantalized by commodities – including commodified art – is to begin to be cured of capitalism. The contemporary problem of art is to show a way beyond human suffering – to suggest healing – while fully acknowledging it, for human universals hide in it. In a sense, art under capitalism – glamorous art – necessarily rejected the universally human, because to accept it meant that creativity had to serve suffering, both by articulating it and suggesting alternatives to it. (The very notion of an alternative is eccentric, that is, a minor psychopathological [infantile, escapist] phenomenon – a kind of social parapraxis – from a capitalist point of view. Indeed, the idea of the glamor of art can be understood as a way of nullifying the idea of art as an alternative by declaring that idea a trivial parapraxis or lapse.) Also, to accept human suffering as the implicit theme of art would mean to admit that capitalism had not solved the problem of human suffering, as it thinks it has by promising the bounty of commodities to everyone for life – that is, by locking life into an endless dumb cycle of pseudo-satisfaction of artificial needs. The provincial artist knows suffering – knows the separation of his or her art from his or her humanity in a way the cosmopolitan artist does not, and does not care to know. This is why the provincial artist is in a perpetual crisis of individuation. It is just his or her awareness of this crisis that gives him or her the opportunity to produce authentically eccentric art.

On November 9, 1988, there was an article on page A16 of the *New York Times* titled "Rural Recluse Collides with an Unnatural World." I think this story is a moral fable for our times, and an allegory of the provincial artist at his or her best. It seems that in Tomball, Texas, one Elmer Krebs owns some 119 densely wooded acres where, in the words of the article, he "lives in relative contentment without electricity, telephone service, heat or running water in the cluttered farmhouse where he was born 81 years ago." Krebs "has been a lifelong loner whose best friend for years was a pet vulture." Mr. Krebs's problem is that he has not paid taxes to the civilized city of Houston. These taxes, together with the legal fees spent trying to get them, amount to about $170,000, which can apparently be settled by selling off two tracts of his land, so valuable has it become as civilized Houston expands to encompass it. But Krebs, again in the words of the article, views the taxes "with blithe unconcern." He wants his land "left alone as a wildlife preserve," which pleases his relatives as little as it pleases Houston. As one of his relatives said, it was no use explaining to him that he was living in the twentieth rather than eighteenth century. Houston is not trying to force the penniless Mr. Krebs from his land, even though he seems to have no unnecessary needs, and would

probably not suffer much being homeless in a capitalist society. Krebs, who acknowledged that all he knew about the Presidential campaign was that there was a candidate named Bush Quayle, and who was more concerned about the fate of "a 700-pound pig that Houston officials decided to banish from a downtown neighborhood" than about Bush Quayle, thinks that what is called progress is really "going to the bad" – that is, the bad capitalist environment, which is not much given to facilitating the human.

Krebs, who "has always gotten on better with the animals than with people," and for whom "it's too late . . . to change now," seems to me an exemplary provincial artist. His art is his natural homestead, and his creativity has gone into maintaining it as an alternative to capitalist society. It is an unglamorous sanctuary. Indeed, he has not glamorized nature; he has not turned his homestead into a botanical garden, in which every plant is given a civilized name and place, and reduced to elegant insignificance. The old notion of a return to nature remains viable, not because nature is the mythical and magical place of origination, but because it is the place where one can recover one's sense of humanness after being victimized by capitalist society, in more subtle ways than I can say here. Capitalism inflicts extraordinary narcissistic injury by toying with human needs and claiming to glamorize human life, which is never glamorous, even if art is. Life, in fact, does not follow art as closely as Oscar Wilde thought. Authentic provincial art becomes a way of uncivilizing oneself, not necessarily by making uncivilized, pseudo-spontaneous expressionistic gestures nor by a postmodernist cacophony of means, but by representing a zone where the universally human is still resonant. The director of the Houston Audubon Society, to which Mr. Krebs has willed his land, thinks Krebs is "a misunderstood Rousseauian figure in resonant balance with nature in an unnatural world." So must the provincial artist be, not because nature is sacred, nor because man is inherently more authentic when he is close to nature than when he is cosmopolitan, but because nature is the last space of humanness left in capitalist society.

The return to nature necessarily produces an eccentric art, because nature seems like an eccentric space to an expansionist capitalism. The real reason we need a new provincial art of nature is not to remind us, as was the case in the past, that society has become overrefined – glamorous – but that capitalist society is barbaric. Its lack of authentic civilization makes uncivilized nature look like the only human universal. Provincial art at its best is about tran-scendental eccentricity – the eternal return of the eccentric union of art and life.

25

The Good Enough Artist
Beyond the Mainstream Avant-Garde Artist

ONCEPTIONS of the artist come and go through the ages, some exaggerating the artist's significance more than others – my assumption is that the more oppressive everyday life seems in a society and the more a society lacks a transcendental conception of life, the more it falsely conceives of the artist as a beacon of imaginary liberty, a spurious alternative – but the twentieth-century conception of the avant-garde artist has a particularly pernicious hold on the imagination. Actually, the avant-garde artist is a multiple personality, a two-headed monster. That is, there are two types of avant-garde artist, both equally vainglorious and mythical, equally self-justifying and grandiose, what might be called the artist-re-educator and the personalist artist. They do not have to diverge, there are in fact clear cases of their convergence – Joseph Beuys is an exemplary one – but generally do. They are opposite sides of the same coin, but their opposition is more telling than the fact that they are chips off the same block. Each in fact has a basically different attitude to art – a different sense of its role in life – than the other. However, they are born of the same matrix of discontent and anxiety. They are contrary responses to the same uncertainty about the destiny of art in the modern world of instrumental reason and contractual relationships – the world of rationalized existence. At the same time, they both attempt to restore a sense of the charismatic and messianic to life. Indeed, each offers a magical solution to a perpetual problem, the dialectic of togetherness of self and world, if emphasizing one at the expense of the other. Instead of offering art as a way of adapting to the mundane, given world – with all the masterful cunning that requires – the artist-re-educator argues that it can be changed into a higher world. This is the position underlying the work of Mondrian and Gropius, among others. The artist-re-educator takes his place among the twentieth-century's revolutionaries, visionaries who propose to destroy the given world – which no doubt has its miseries and problems – to proclaim a brave, new one, which of course has trouble arriving, leaving us living in the wreck of the old world. And instead of offering art as a means of integral selfhood, the personalist

artist argues that art is a special way of suffering, one that assures us – demonstrates – that if one suffers properly one can have a higher self. The personalist artist offers himself as the exemplary sufferer. He takes his place among religious teachers; he is a kind of secular preacher of painful salvation. Kirchner and Marc on the one hand, and Kandinsky on the other, reveal the two dimensions of this position: the suffering, and the higher self that is its end. Thus, the artist-re-educator puts us in critical relationship to the world, promising its salvation through art, and the personalist artist puts us in critical relationship to the self, promising its salvation through art. Implicit in both is recognition of the precariousness of artistic existence, and existence in general.

Essential to the development of my idea of the good enough artist – the ideal post-avant-garde artist – is the notion that the avant-garde artist has become passé, more precisely, an establishment conception of artist. The artist-re-educator and the personalist artist are modes of being-an-artist that have become institutional, conventional, even cynical – mechanisms of artistic selfhood that automatically assure one a place in the sun of the mainstream, but no longer imply inner necessity. To be an artist-re-educator or a personalist artist is no longer to have a calling but rather a career. Each is an academic strategy for marketing oneself as an artist, not the manifestation of a sense of artistic destiny. The art the current crop of artist-re-educators and personalist artists produces is rarely, in Rilke's sense, an offering to the attuned spectator – he who has elected himself to have an affinity with it, to be sensitive to it – but a token of careerist narcissism. At bottom, it appeals to no one – at least to no true self, in Winnicott's sense of the term, which I will later elaborate – except those who have a similar careerist pathology as the establishment avant-garde artist, those who get their sense of self more from their external than internal relations. Today there is a new necessity for a good enough artist, if no guarantee that one will be historically realized with any adequacy, although I think some are clearly around. In any case, what early in the twentieth century were daring conceptions of the alternative artist have become self-serving stereotypes at this late moment in it. What originally represented an attempt to articulate, in an artistic way that seemed appropriate to the modern world, a universal existential problem, has become an avant-garde mandarinate.

Thus, a new conceptualization of being-an-artist is necessary, more precisely, a re-conceptualization of being-an-artist-outsider in a society in which the artist has become an insider. This re-conceptualization must forego the notion of the artist-as-hero – as more than good enough, as the possessor of a larger-than-life surplus of being. Not only has this never been the case – our overestimation of the artist is, as Otto Rank has suggested, a reflection of our own desperate need for self-esteem – but our making it the case blinds us to the human sense of artistic purpose. In my opinion today's mainstream of conventionalized avant-garde heroism has as its ulterior motive the repression of recognition of this sense, for such recognition would instantly undermine the sense of avant-garde purpose which has become socially successful, thus

leading to great commercial loss as well as loss of critical face for those who have propagandized it. But of course the question is whether the good enough artist, who recovers the sense of human purpose in art making, produces a good enough art. All one can say at this point is that the art he produces impinges upon – challenges – the avant-garde sense of good art. These days it is enough to be suspicious of much art that is proclaimed to be avant-garde to have a fresh sense of artistic possibility.

Today, the outsiderness of the good enough artist is more of a personal than social matter. Its pre-condition is the solitude that is created by lack of mainstream success. The solitude generated by not being an avant-garde personalist artist or artist-re-educator can lead to depression, but it can also lead to the production of good enough art. The pre-condition of such production is transcendence of the irony of being avant-garde. For to be avant-garde involves at first being deviant, nonconformist, and heterodox, and in the end the same, conformist, and orthodox – that is, a new status quo, academy. This perverse dialectic points to the fact that the avant-garde artist wants more success than he openly claims to. That is, he wants acceptance by the system he rejects, implying that he cannot abide his own insecurity – the insecurity of being avant-garde. In his heart of hearts, the avant-garde artist wants his outrageous art to become official and sacrosanct. His subversive innovations, symbolic of alternative values, end up serving his narcissistic desire for success. One might even dare to argue that avant-gardism is the contorted way of achieving success that a pathological narcissist necessarily takes. This is not to discount the genuine artistic and ideational achievements of avant-gardism in its heyday, but only to call attention to its shadow side – a shadow side which has become its major substance today. That is, what was once a repressed infantile wish for success, involving the use of one's own authenticity as a means of becoming successful, has become an up-front adult wish for success, leading the artist to lose sight of, even obliterate, the distinction between authenticity and inauthenticity. In a sense, wanting to be a good enough artist is to want to restore the distinction, while recognizing the inseparability or dialectic of authenticity and inauthenticity, that is, the necessity of having both a true and false self, or of being both true and false to oneself – without losing a sense of the difference.

The good enough artist gives up the avant-garde artist's sense of the omnipotence of his own artist thoughts. Where the avant-garde artist wants success on his own grandiose terms, implicitly dismissive of those of the world, the good enough artist rises above his sense of his own exclusivity as well as of the world's domination. What is at stake in the difference between the avant-garde artist and the good enough artist is an entirely different sense of being in the world, more precisely, of being a particular self in a particular world. That is, the avant-garde artist conceives the world in the same grandiose terms as he conceives himself, pitting himself against it as one giant against another. In contrast, the good enough artist is less interested in doing battle to the death with the world – or until successful in it – as in finding a satisfactory way of relating to it, a way at once critical and intimate. The world is neither

friend nor enemy, but the ground of self-realization, that is, self-differentiation or individuation. This is not so much a matter of reconciling with society, as of realizing that there is no sense of self without it.

Avant-gardism is an ironical recapitulation of the familiar issue of the alienation of the individual from society, the irony coming from the fact that the avant-garde artist wants to be rewarded for his alienation, which he mistakenly thinks is a way of being uncompromising. That is, the avant-garde artist thinks that because he is disaffected with society it is illegitimate, but at the same time he wants it to legitimate him. The good enough artist moves beyond the paradox of this unconscious position, beyond the vicious circle of being consciously subversive for the unconscious purpose of success. The good enough artist accepts the fact that one is always, in some sense, part of society, which does not so much hinder a critical relationship to it as make that relationship particular rather than sweeping in its conclusions, as in the case of the artist-re-educator. The avant-garde artist thinks that society is never good enough, which may indeed be the case, while the good enough artist, also knowing this, does not think it precludes producing a good enough art, as an alternative society or environment. It may seem peculiar to say this, but the avant-garde artist ends up destroying his own art, for it always seems tainted by society. This confirms his sense that there can never be a good enough environment, a truly self-facilitating society, not even in art. It also perversely confirms his sense that he is radically different from other people, indeed, superior to them – more of a self, more aware, more critical. The ultimate nihilism of avant-gardism has been much noted, from Poggioli's study on. It must be emphasized that it is a nihilism of the self as well as the world. In a sense, avant-gardism is a demonstration that alienation takes one only so far towards adequate selfhood, becoming in the end disruptive of the sense of self, even completely self-defeating. In contrast, the good enough artist attempts to reconstruct, as it were, his sense of both self and world, in however cautious and tentative a way. He does not regard himself as better than the world and/or better than other selves, but in the same existential dilemma and difficult worldly relation as them. With other selves, he shares the vicissitudes of the world, rather than claiming superiority to them, or the ability to use the power of art as a springboard to a position of privilege above them, and the world. The good enough artist does not appoint himself as the avant-garde artist-leader of the world and other selves, a megalomaniac fantasying a superior knowledge and affect than them. This is why the good enough artist is beyond the dialectic of conformity and nonconformity, recognition and nonrecognition, acceptance and nonacceptance, success and non-success, charisma and absence of charisma. The good enough artist is self-accepting in a way that the avant-garde artist can never be. The good enough artist has both the advantages and disadvantages of self-acceptance, that is, he gains a sense of embeddedness in existence, but also acknowledges self-limitation. The gain in the sense of the profundity of particular existence seems worth the price of the loss of avant-garde grandiosity, with its pseudo-profound generalization of existence.

The good enough artist in effect creates a new kind of personalist art. To call it a postmodernist personalist art, in contrast to avant-garde or modernist personalist art, is a mistake, since good enough art is an attempt to restore the generic human purpose of art. It also exists in avant-garde personalist art, but in hyperbolic form, and finally, with its assimilation and domestication, in a mock way, as the false consciousness of art buried under the supposedly true consciousness of it as style. Good enough personalist art has nothing to do with avant-garde expression of grandiose self, taking its final suicidal form in a sense of absolute style. Stylistic considerations are secondary to good enough personalist art, which has as its first priority symbolic maintenance of contact with the true self, in Winnicott's sense of the term. More precisely, good enough personalist art is a way of striking a balance between the true and false selves, allowing each to press its claims to recognition without denying those of the other. Expression of the grandiose self in avant-garde personalist art is also an attempt to articulate the true self, but a confused one, because it involves the impossible ambition of destroying, or at least transcending, the false self, and thus to live completely true to oneself. By definition that is to be self-destructive, for it involves destroying the self as a whole. It is composed of both true and false selves, the latter existing to protect the former, that is, to mediate between true self and the world, which is external social reality.[1]

The attempt, by good enough personalist art, to dialectically balance the realities of true and false selves, is implicitly socially critical – critical of the false world, in defense of the true self – but it does not involve offering a grandiose utopian critique of the world, as the avant-garde artist-re-educator does. Such a critique is always implicitly punitive, always involves blaming the world for what it is – an outrageous place to live in – which becomes annihilative – devaluative – of both the self and world. The one is beside itself with rage, the other maddeningly ridiculous. At the least, the re-educative critique leads to the loss of the sense of the world as specific place – a place with many specifics. Like the avant-garde personalist artist, the avant-garde artist-re-educator tends to produce an autistic art – one that is a kind of hectoring autism, as it were. Both kinds of artist unwittingly reveal the blind, arrogant demands of the psychotic self, that is, the self which, as Freud said, has lost its sense of reality – of itself as well as the world. Avant-garde art lives by the unreality principle, as it were. This gives it a certain revolutionary power but is finally terrorist, which is a much more serious matter than simply being absurd. It is fascinating social analysis to understand the full implications of modern society's assimilation of nihilistic, terrorizing authentically avant-garde art. Does modern society idolize avant-garde art in order to express its unconscious sense of its own absurdity and potential unreality, that is, its unconscious recognition that it barely holds together, or, what is the same thing, tends to fall apart – become pathologically disturbed – because it repeatedly changes (necessarily so, by reason of its modernity)? In any case, good enough personalist art establishes a transitional relationship to society,

where "transitional" has the weight of the special meaning associated with Winnicott's concept of the transitional object. That is, the good enough artist is in perpetual transition between society and himself, sometimes tending towards the one, sometimes the other. It is a reversible relationship, relying on no one style, for that would give it a preferred orientation, for some styles are oriented more to – represent – the self, others the world.

It must be emphasized that this is quite different from the narcissistic authoritarianism, with its correlative stylistic and ideological dogmatism, implicit in avant-garde art. And from what might be called the art-wishfulness implicit in it – the wishful belief in the special power of art, magically superior to all other social means in effecting human ends. Nor is the good enough artist interested in the higher suffering or vulnerability of art proclaimed by avant-garde personalist art, nor its superior powers of social leadership, proclaimed by the avant-garde artist-re-educator. The good enough personalist artist, it must be emphasized, is completely beyond any such manifestations of pathological narcissism. It is in a sense remarkable to propose, in today's art world, the possibility of an artist who lacks any narcissistic pretension to superiority, but then the good enough personalist artist is not in the art world, and indeed seems provincial and naive compared to the avant-garde sophisticates that inhabit it. Nonetheless, the necessity of the good enough personalist artist is an urgent matter. For this century has seen the social catastrophes wrought by all manner of sociopolitical re-educators, and the great spread of personal psychopathology, in part contributed to by the sense that serious suffering is inevitable in, and in some mysterious sense necessary to, life. The attempt to make superior sense of suffering by regarding it as *the* context of significance for life only betrays the possibilities of life, including the possibility of realistic happiness.

The avant-garde artist-re-educator and personalist artist have contributed to this disastrous state of psychosocial affairs, however obliquely. They are instances of pernicious types of modern commissars: one who believes that social change can be imposed from above, and one who believes that suffering is *the* necessary sign of authentic selfhood. Both have led the world and self astray, causing much unnecessary misery with their "radical measures." The artist types who reflect this larger cultural syndrome have their stylistic radicality – their reconceptualization of art – as their only justification. But in the end all style becomes obsolete decoration, that is, loses its original purpose of signalling mastery, or giving form, and becomes an empty symbol of such mastery. In the last analysis, the avant-garde personalist artist offers a dangerously archaic sense of selfhood, and the avant-garde artist-re-educator a dangerous delusion of the world. Their simplifications are signs of deep resistance to the complex realities of both. The old avant-garde alternatives, which once seemed viable paths to authentic art, must be discarded, not only because they have become institutional and conventional, but psychosocially poisonous. They may still have their old justification – catalyzing artistic innovation – but such innovation no longer seems necessary to authentic art.

Moreover, to believe in art's comprehensive power of self and world transformation is to give it a noble but highly improbable – completely unrealistic – identity. Avant-gardism, as a doctrine, is a form of madness.

Instead of conceiving of art as total transformation, it is best conceived, more subtly, as a mode of transition or mediation between the self and the world. It is a very circumstantial affair, circumstance in Ortega y Gasset's sense of "Circum-stantia! That is, the mute things which are all around us. Very close to us they raise their silent faces . . . as if they needed our acceptance of their offering. . . . We walk blindly among them, our gaze fixed on remote enterprises. . . . We must try to find our circumstance, such as it is, and precisely in its place in the immense perspective of the world."[2] Circumstance is always local, insistently particular; one might say that the good enough artist is in perpetual transition to local circumstance, that good enough art is a constant search to find and orient one's self to circumstance. In contrast, the avant-garde artist tends to be involved in remote stylistic enterprises. While the transitive role of art is generally the case, it is most evident in art that has been abandoned by the mainstream avant-garde world of art and that has in turn abandoned it, especially its pretentious stylistic enterprises. The dregs of the avant-garde's claim of presenting a radical sense of self and society survives only in the form of its claim to produce ever new, ever more "radical" style. No one will dispute this claim; what is highly debatable is the continuing necessity of novelty and self-styled radicality (as well as the higher self and truth it presumes to symbolize). The ambition of neo-avant-garde art, that is, establishment avant-garde art, is beside the generic point of art, which is to be a good enough mediator or transition between self and world, in the process helping to create a good enough sense of self and world, which involves creating a shareable self and world. Such generically good enough art is in a sense a mode of solitude, in Anthony Storr's sense of the term.[3] Only the solitary artist, attempting to intimately interact with particular circumstance – environment – can realize an adequate sense of self and of world, that is, a sense of self good enough for a world that seems good enough, partly because art made it seem so.

The good enough artist has a modest sense of the work of art. It is a way of, in Winnicott's words, relating "subjective reality to shared reality which can be objectively perceived," that is, it is a transitional object.[4] The goal of such a transitional relationship is self-healing and world-healing, that is, generating the sense that one is good enough to be alive and that the world is good enough to live in. The artistic, transitional point is to relate "the inner world's richness" to the "reliably objective" world,[5] without losing a sense of inwardness and the world's reliability. Only then do the inner self and the outer world seem good enough. In the artistic, transitional state, the outer world is experienced as both invented and discovered, and the self and world seem to exist in easy simultaneity, which, it should be recalled, is hardly the case for the avant-garde artist. Out of such simultaneity comes a sense of inhabiting a good enough environment, that is, one good enough for – facilitative of – the self. Using Kohut's language in a perhaps extravagant way,

one can say that the objectively given world becomes a self-object. Indeed, this seems to occur in the best non-mainstream landscape or nature-oriented art. This is in stark contrast to the pseudo-landscape art currently prevalent in the mainstream. Such art seeks to re-invent objective nature, as though there was no moment of subjective discovery – and thus self-discovery – in its articulation. Much good enough art has a deep interest in nature, which since Romanticism, if not before, has become a sign of longing for the good enough environment – bringing with it a sense of being a good enough self – that modern society has failed to create, despite all its promise. In general, I submit that the enormous dissatisfaction with mainstream art that exists outside the mainstream – the sense that it is a subtle fraud, faux art made by a faux elite – has to do with the fact that it does not conceive of art transitionally. We now have an avant-garde style establishment, which is almost completely beside the generic human point of art making, however historically significant its products, and a world of artist outsiders struggling to create a good enough art. The credo of the one is style for style's sake – art with no true self – and the credo of the other is art that is facilitative of humanness, which suggests an art with no falsity – an equally impossible art.

In conclusion, it should be noted that only as a transitional phenomenon can art become what John Dewey thinks it is, the building up of "an experience that is coherent in perception while moving with constant change in its development."[6] As Dewey wrote, "to perceive, a beholder must *create* his own experience,"[7] which is not unlike the notion of transitional experience, that is, the sense of experience in the "zone of illusion" or "potential space," as Winnicott also calls the psychic space of transition uniting inner and outer worlds. Art is about the character of the relationship between these two worlds, reflected in the character of the art's integration of its parts. It is not about the imposing of the inner world on the outer world, as in avant-garde personalist art, nor the imposing of a preconceived notion of the outer world on the inner world, as it is for the avant-garde artist-re-educator. Life is also about the character of the relationship between the inner and outer worlds – the endless effort to strike a balance between them, which is in fact the only way of physically as well as psychically surviving. Such a balance is in effect between the true and false selves. By accepting the inevitability of the relationship between these seeming opposites, the good enough artist puts himself in a position to change both worlds, that is, make them seem less harmful places to live in.

26

Visual Art and Art Criticism
The Role of Psychoanalysis

I

So much has been written about the psychoanalytic interpretation – call it re-cognition – of visual art, so many psychoanalytic insights about artist, art work, and art audience have become incorporated in art discourse, if often as unwitting assumptions, that it seems redundant to review the various modes of psychoanalytic understanding of art. Such a review would entail an account of the growing sophistication, sensitivity, and self-reflection of psychoanalysis itself, for the sensibility and subtlety it brings to art depend to a large extent upon its own nuanced response to its concepts. To lift these concepts out of clinical context and bring them to bear upon such a complex, varied subject as art is an intellectually dangerous adventure. Among artists, it has often been suspect to the point of arousing nihilistic scepticism – a no doubt defensive, self-preservative response, perhaps necessary to creativity in the circumstances, if at the same time a reductio ad absurdum of resistance, not to speak of its anti-intellectualism.

The psychoanalysis of art – of any cultural phenomenon – can be carried out in a responsible manner only with the ironical, self-conscious, self-questioning ego that is the optimum result of self-analysis. Such a self-analytic ego, secure in its self-doubt, is necessarily aware of psychoanalysis's own critical, conflict-ridden, varied, even pluralistic history – what is increasingly regarded as its postmodernist character, in which each theory is regarded as a signifier with no comprehensive power of signification, and so as a perpetually heuristic gambit, in a Sisyphean situation with respect to the psychological truth. Such a self-critical ego is all the more necessary for a psychoanalyst of art, for the notion of a hierarchy of works of art, each having a fixed value – the assumption of criteria that permit the absolutization of one at the expense of the other – has collapsed. It has been recognized both as an epistemological fallacy and as ideologically motivated. The collapse of the idea

of a hierarchy of artistic – and generally cultural – value is no doubt in part due to psychoanalysis itself, that is, its levelling of art, by way of its implication that every example of art is of more or less equal psychological value, equally useful as a demonstration of depth psychological truth. Because of this cultural situation, and its own history, the psychoanalysis of art has many theoretical options, and must take advantage of them all. This openness is deceptive, for none are completely satisfactory and none privileged over the other, unconditionally secure in its priority.

Thus, much as Baudelaire wrote, in "The Salon of 1846," that art criticism should be "passionate, partisan, and political" while utilizing the widest possible horizon of understanding, so psychoanalytic interpretation of art can be regarded as passionate, partisan, and political, however unwittingly. It often involves unconscious advocacy of an artist or kind of art, as well as conscious advocacy of a theory. This was the case with Freud, who preferred Renaissance to modern art, and who had greater affinity for literature than visual art, while making undoubtedly important analyses of painting and sculpture. His affinity has haunted the psychoanalysis of art ever since, leading to the treatment of visual art as a form of literature. This overlooks the different effects possible in and seemingly proper to each medium, a preoccupation of art criticism since Lessing's *Laocoön*. The tendency to reduce visual works of art to literature – to automatically assume their readability – is not helped by the semiotic belief that the visual work of art is a kind of writing.

In any case, the choice of one psychoanalytic theory over the other is a heroic intellectual – and political – act, but piety towards one theory is likely to foreclose some area of understanding of art. Moreover, without ironical self-consciousness the psychoanalyst of art lacks intellectual conscience, and can become simultaneously all too speculative and all too dogmatic. He or she can advocate one theory as the royal road to understanding of art, unexpectedly reducing art to less than royal status – simplifying it into a plebeian example. Moreover, self-irony alone can preclude the naïveté that comes of self-righteous extension of theory to an object that by romantic self-definition is infinite in its implications. In its modern self-definition the art object actively resists efforts at comprehension: it establishes itself as paradoxical.

But psychoanalysis can no longer be regarded as intellectually problematic. Its insights have validity, if not always testable by naively conceived scientific standards. However, fear of its seemingly overwhelming reductive power – its power to reduce the object of its investigation so completely to the terms of its theory of material subjectivity that the object seems nothing but an epiphenomenon of that theory, insubstantial and meaningless apart from it – remains among art lovers. One must heed their objections, especially when made in intellectually cogent form – however much such form may mask narcissistic upset at the sight of a precious object being "slandered" by psychoanalytic reduction. Indeed, it is well known that for all Freud's protestations to the contrary – they have been shown to be tongue-in-cheek, strategic responses to anticipated rejection – his psychoanalysis of art undermines its sublimity, deconstructing that sublimity in a way that makes it seem impossible

to reconstruct. It could be said that the critics of psychoanalytic interpretation of art I will discuss mean to restore this sublimity, which no doubt seems like hollow defiance in view of what psychoanalysis has taught us exists in the basement, as Freud called it, of sublime structures. But these critics are concerned with something more crucial than the mysterious sublimity of art, if related to it.

As a form of dialectical comprehension of the role of psychoanalysis in visual art and art criticism I want to examine the criticism of that role by aesthete-aestheticians who have spent much of their existence and consciousness on art. Privileging it in the belief that investment in art is the one expenditure most worth making in life – especially because all other depth commitments seem to fail and frustrate one, as the best art never does – they have come to question a psychoanalytic understanding of it they once believed in. But they do not so much reject psychoanalysis out of hand, as an unwittingly malevolent intrusion in the process of artistic production and art critical contemplation – the latest, most elegant kind of murder of art, ostensibly carried out to facilitate the appreciative dissection of its life. Rather, they have come to believe that the logic of psychoanalysis itself leads to transcendence of its understanding of art, and with that transcendence a fresh sense of its aesthetic importance. They have worked their way through psychoanalytic theory to a supposedly post-psychoanalytic understanding of art and art appreciation – to a new aestheticism, informed by psychoanalytic thinking, in fact necessitated by it, but indicating something about art it is apparently blind to. Psychoanalysis supposedly misses the very essence of authentic art: its transcendence of all interpretations of it, inseparable from its transcendence of the desire it manifests; and its dialectical, critical relation to human suffering and society. More particularly, these aesthete-aestheticians do not want to blindly worship at the altar of art, as those of old supposedly did, but they do see art – at its best – as both peculiarly ("perversely?") and deliberately unanalyzable or uninterpretable ("obscure"), and as having a profound non-subjective import that psychoanalysis is blind to, perhaps as an artefact of its insistent emphasis on the depth psychological factor in art – the tendentious primacy it gives the profoundly subjective, however that might be conceptualized.

These neo-aesthetes regard psychoanalysis's two blind spots to art as serious shortcomings. Blind to "true" art's impenetrability and density – its determination to be impenetrable and opaque (which psychoanalysis reads away as narcissistic "mysticism") – psychoanalysis destroys its specificity as art, in effect locating it in a zone of subjectivity in which it has no weight of its own – no self-identity. And blind to art's dialectical character psychoanalysis undermines its objective social power. To see the role of psychoanalysis in art – ultimately visual art – through the eyes of friendly critics is to understand that role in a clearer – or at least less self-congratulatory, narcissistic way – than psychoanalysts may. You tend to look more realistic in your critic's eyes than in your own. Or at least you can understand your power and effect better by

302

analyzing your critic's response to you than by looking in your own mirror, especially when your critic has an ambivalent affection for you.

II

In general, every advance in psychoanalytic conceptualization has led to a new application to art, if "application" is the right word. As Sarah Kofman writes in *The Childhood of Art, An Interpretation of Freud's Aesthetics,* Freud does not so much "apply to art, from the outside, a method belonging to a supposedly alien sphere," as show that, on the inside, art is "but a different repetition of the same. For Freud, works of art are like all other psychic productions insofar as they are compromises and constitute 'riddles' to be solved."[1] Applying psychoanalysis to art, then, amounts to demystifying and unmasking it – detheologizing and demetaphysicalizing it, as Kofman says. This might be called its psycho-secularization. For Freud, the work of art is a kind of dream – if a social one – and the poet and, *pari passu,* the artist, a daydreamer. Art cannot sustain its sublimity in the face of the psychoanalytic stare which turns it into a symptom. Its roots are in common psychic phenomena, and it skirts, if ultimately outwits, psychopathology – neurosis.

Dare one even say psychosis? Freud described it as the "outcome of a . . . disturbance in the relation between the ego and its environment (outer world)," noting that in some cases of psychosis "the ego creates for itself in a lordly manner a new outer and inner world" while in other cases it "lose(s) all interest in the [real] outer world."[2] Both aspects of psychosis seem to occur simultaneously in every work of art of consequence, for a certain loss of interest in the real world allows the lordly artist – that neo-imperial infant – to create an intriguing new world. In art, reality is lost, only to be regained – "remodelled," to use Freud's word, which is why it generates the illusion of omnipotence, especially for the artist.[3] Indeed, art's tendency to psychosis is a basic reason for its fascination and seductiveness. It tempts us with a forbidden freedom from reality in the very act of seeming to mediate it.

But I am not interested in offering yet another psychoanalytic interpretation of art – a narcissistic interpretation which makes it something other than substitute gratification or ego mastery through form. Rather, I want to suggest the great flexibility of psychoanalytic interpretation – especially in situations of uncertain evidence, such as art, which, as has been said, cannot be put on the couch. While seeming to bring an art into subjective focus, psychoanalysis may be an elegant way of losing sight of it – as art. This is certainly one reason for neo-aestheticist disaffection with it. Moreover, as practiced, the psychoanalysis of art has tended to view it as an exemplification of theory, as though the more it can turn the object of its inquiry into an exemplification of its theory the more it proves that theory's universality, or at least generalizes it. For Freud, Sophocles's Oedipus and Shakespeare's Hamlet are intuitive, awkward anticipations of psychoanalytic theory, not invented characters existing in their own artistic space. In other words, psychoanalysis subverts the vaunted

"uniqueness" of art. Indeed, a peculiar effect of psychoanalytic theory is that whatever it touches comes to seem "thin" without its supplement of subjectivity. Thus, psychoanalysis of art privileges and elevates psychoanalysis while sharply delimiting and diminishing art. From its start, there was a tension between psychoanalysis, determined to prove itself a science, and art, which, as Freud said, spontaneously anticipated its insights without clinical labor.[4] This tension is not yet resolved, and may never be.

As I have said, the neo-aesthete-aestheticians are not the old-style ones Freud outsmarted and dismissed[5] – Freud's aesthete is in fact a straw man invented for polemical purposes – but appreciative interpreters of art attuned to both psychoanalysis and art. Their aestheticism emerges from a sense of the reciprocity of – fit between – psychoanalytic sensibility – attunement – and that necessary for appreciation of art. For one kind of neo-aesthete-aesthetician, the psychoanalytic idea that the work of art is a kind of dream and thus has a latent meaning rooted in an ultimately irrepressible, eternally recurring, primitive wish implies the irreducible density of desire in it. This density of desire is by its nature beyond interpretation, being a fundament and ultimate of existence. For another kind of neo-aesthete-aesthetician, the psychoanalytic idea that the work of art is as distorted as a dream – that like a dream it is in part a product of primary process activity – and that its manifest content is thus publicly enigmatic and provocative, suggests that it functions as a form of public scandal and transgression (which is what the Surrealists explicitly wanted it to be), and as such evocative and critical of social ideology. That is, in Rosemary Jackson's words, of "the imaginary ways in which men experience the real world, those ways in which men's relation to the world is lived through various systems of meaning such as religion, family, law, moral codes, education, culture."[6] Art becomes a means of making these "profoundly *unconscious*" ideologies disruptively conscious, in the process implying that they are not unconditionally constitutive of the human subject. The way is opened to criticism of them and, however indirectly, to social change. Post-psychoanalytic yet psychoanalytically grounded aestheticism gives the subjective understanding of art new hyper-subjective import on the one hand, and new objective import on the other. This neo-aestheticist reconceptualization of psychoanalytic subjectivity is of special import for visual art.

From either neo-aestheticist position psychoanalytic interpretation of art seems both inadequate to and far from completely constitutive of its object, to use Joseph Margolis's distinction between two kinds of interpretation.[7] But psychoanalytic interpretation is more adequate to and constitutive of the literary than visual work of art, for it cannot come to terms – or at least has not, as it has been practiced – with the power of visuality in the best works of visual art. This power is untranslatable into literary terms, at least not directly. It is inseparable from the special erotic character of seeing, privileged by Freud, after touch, as the major vehicle of libidinous excitation.[8] Psychoanalytic interpretation may constitute literary art by interpretive act, but it cannot do so with visual art because of its almost unmanageable power of sensuous/erotic excitation. I believe this is why there have been more psycho-

iconographic than psycho-stylistic studies of visual art, for stylistic form en-
codes – that is, simultaneously masters and heightens, brings under more or
less systematic control and makes more or less excruciating and poignant, that
is, threateningly uncontrollable – the exciting sensuous/erotic power of art,
most evident in the best visual art. In my opinion iconographic studies tend
to repress or deny the sensuous/erotic power of visual art, which is what
ultimately moves – gives it power over – the spectator. It subverts or breaks
the frame of the work's conventions and norms of meaning – the narrative
readability iconography is interested in – implying its secondary significance.
As it has been practiced, psychoanalytic interpretation of visual art has not
dealt satisfactorily with its spontaneous appeal to the sensuality of seeing,
instantaneously overcoming all repressive barriers. Unexpectedly, this sen-
suous/erotic transgressiveness, evoking bodiliness, is a major source of the
visual work of art's disturbing, critical social power. This deep sensuous/erotic
appeal both precedes and outlasts the more superficial psychic influence of the
work of art's narrative and ideological meaning structures.

III

Two literati, Leo Bersani and Richard Poirier, exemplify the "density of art"
position. T. W. Adorno, a major figure of the Frankfurt Critical School and
a major music theorist and aesthetician – his *Aesthetic Theory* is in my opinion
the most important book on aesthetics and art written in the 20th century –
exemplifies the dialectical position. They are perhaps the best spokesman for
the two sides of the subtly defensive neo-aestheticism that I think affords a
unique avenue of approach for understanding the role of psychoanalysis in
visual art and art criticism. For Bersani, Mallarmé is the exemplary dense
artist. (I myself think that density is most unequivocally realized in abstract
visual art, especially that of Malevich, Kandinsky, and Mondrian, and to a
certain extent Pollock, Rothko, and Ryman.) Mallarmé's subversion and dem-
onstration of immediacy as "an ontological error" issues in "the moving sense
of a thought continuously proposing supplements to the objects abolished by
its attention." He particularly exemplifies Poirier's notion of "a kind of writing
whose clarities bring on precipitations of density." Poirier, as Bersani says,
"distinguishes between density and the more familiar and comfortable notion
of difficulty," which, in Poirier's words, "gives the critic a chance . . . to treat
literature as if it were a communication of knowledge," rather than, as Bersani
says, "an enigmatic display of being."[9] Visual art, I would argue – especially
abstract visual art, which aims to liberate seeing from meaning, if not un-
equivocally succeeding – is even less of a communication of knowledge than
literature, and more of an enigmatic display of being, for its meanings are
more readily dispensable. What is indispensable and undismissable is its sen-
suous/erotic charge, a component which in the case of literature seems to
dissolve, like a will-o'-the-wisp, in the course of analysis of its narrative/
ideological structure of meaning. In visual art this charge tends to exist in-
dependently of such meaning, which makes it seem primary.

From this point of view, psychoanalytic interpretation of art has hitherto dealt with its difficulty not density. It has interpreted art, not responded to its density – and it is hard to find a proper "critical" response to its density, which seems beyond "criticism." Psychoanalysis disbelieves in what Bersani calls the "apparent impenetrability" or "certain unreadability" of Mallarmé's poetry, "which has less to do with a hidden and profound sense than with a dissolution of sense in a voice which continuously refuses to adhere to its statements."[10] For psychoanalysis, such impenetrability and unreadability are a new mystification – even theological essentialization and sublimizing – of art. In any case, it seems easier to argue for the impenetrability and unreadability of visual than of literary art, which never seems to completely outdistance – resist – a penetrating reading. This impenetrability and unreadability are inseparable from the sensuous/erotic power of visuality, which, as I have said, abides after what has been seen has been given narrative/ideological structure, assigned symbolic significance – given its message character or communicative function. This power is the source of our sense of authentically visual art as impenetrably dense and ultimately unreadable – as an enigmatic display of being.

But is this enigmatic display of being as immune to psychoanalytic interpretation as Bersani thinks it is? Not at all: it leads right back to psychoanalysis, to the radically subjective. It is the sublimest difficulty of the work, as it were – but Bersani is no doubt right in regarding it as an uninterpretable density rather than an interpretable difficulty, that is, as inherently obscure, to mention the quality that once preserved the integrity of art, resisting and rescuing it from reductive interpretation. Nonetheless, this obscure density is a quality of the erotic, and emanates directly from the sensuous body of the art object. This body, thoroughly permeated – even one – with the density of desire, is receptive, as it were, to psychoanalytic sensibility if not completely penetrable by psychoanalytic interpretation.

A quotation from the playwright and novelist Max Frisch makes the point succinctly, even though Frisch and I would disagree – after we agree about dance – which art has most sensuous/erotic resonance, depth.

> There is no art without Eros. There is eroticism in its widest sense in the very urge to live and the urge to demonstrate one's existence. Acting and dancing – that is to say, representation by means of the body – these are surely the most direct ways of giving shape to this urge, seen most clearly and in its least translated form in natural eroticism, which likewise expresses itself through the body and through the voice. Other artists, who are obeying the same urge to demonstrate their existence, do so more indirectly; they do it on paper or on canvas or stone; they are obligated to translate it, in a way that, though it does not hinder, does make more difficult the insidious mingling of an artistic with a natural urge; they transfer it outside their own physical being; they sublimate it – because, besides the erotic urge to demonstrate their existence, they

are equally dominated by another urge: the intellectual one – the urge to know.[11]

This eroticism no doubt opens art to a number of psychoanalytic interpretations, but my point is that none is absolutely credible: only attunement to art in the spirit rather than letter of psychoanalysis is convincing. The point is, there is no escaping psychoanalytic attunement to art, but art sidesteps any definitive psychoanalytic interpretation. Psychoanalysis has become inevitable and inescapable, like the weather: it has become a permanent climate of opinion. But weather changes, climate varies. This does not mean that psychoanalytic interpretations cannot be more "bisexual" – simultaneously receptive and penetrating – than they have been, particularly in the area of visual art, where, as I have suggested, they have submitted to Freud's preference for literary – obviously communicative – art, which I believe has less sensuous/erotic body than visual art. Indeed, Freud makes scant mention of the herculean body of Michelangelo's Moses, or of the figura serpentina that is the artist's greatest accomplishment, and that is both the most immediate and lasting source of his work's impact and interest, leading us to invest deeply in it. The meaning of Moses's relationship to the tablets of the Law is secondary, for all its significance, to his body's tension, just as the biblical story on the Sistine ceiling is secondary to the bodies exposed in it. It is they that have carrying power after the story is no longer convincing – carrying power even for the unbeliever.

Bersani must be aware that the impenetrable density he calls for and celebrates is the density of desire. Just as he wants the boundaries of meaning in a work of art to be blurred – ambiguous to the point of no return to "objective" meaning, that is, to the signified – he blurs, as Jackson says, the conceptual boundaries of desire, making it denser and less specific than it may be, and denying it any object and stability. Desire, he writes, gestures towards "an area of human projection going beyond the limits of a centered, socially defined, time-bound self, and also goes beyond the recognized resources of language and confines of literary [in general artistic] form."[12] This formulation belongs to "speculative psychoanalysis," as Bersani describes his activity in *The Freudian Body*. Speculative or not, Bersani's impenetrable, unreadable, decentering density of art may press beyond language and conventional selfhood, but it is hardly beyond psychoanalysis.

IV

T. W. Adorno, in a unique and brilliant comparison of Kant and Freud on art, notes that "Kant was the first to have gained an insight that was never to be forgotten since: namely, that aesthetic conduct is free of immediate desire."[13] No doubt there is deferred – infinitely deferred – desire, which is what sublimation might be understood to be. While arguing that Kant's concept of aesthetic disinterestedness has its validity in the idea "that the dignity of works

of art depends on the magnitude of interest from which they were wrested," his aesthetics in the end "presents the paradox of a castrated hedonism, of a theory of pleasure without pleasure." That is, aesthetic gratification is all too substitutive or artificial, or rather, a substitute gratification that is no longer convincing, that no longer seriously affects the psyche and body of the spectator. For Adorno, "material-corporeal interest, i.e. repressed and unsatisfied needs" are at the core of "aesthetic negations – the works of art," making them "something more than empty [stylistic and communicative] patterns" or codes.

Now Freud seems to return material-corporeal interest to art, but he also "has moved interest beyond particularity," for his conception of the dissatisfaction, unhappiness, and unpleasure – frustrated desire, a compound of the wish to intensely sense as well as to erotically possess (if they can be differentiated in theory and practice) – that informs the work of art, that is its latent substance but that it overcomes by being manifestly (superficially) satisfying, pleasurable, is even more unconditionally subjective than Kant's. What Kant, and especially Freud, ignore, according to Adorno, is that the "negativity" inherent in the work of art is essentially social in character. The work of art is a substitute gratification for social objectivity rather than emotional subjectivity: "Objectively, the interest in constituting an aesthetic totality entailed an interest in the proper arrangement of the social whole." Thus, "by placing works of art squarely into a realm of psychic immanence, Freud's theory loses sight of their antithetical relation to the non-subjective, which thus remains unmolested, as it were, by the thorns pointed toward it by works of art." This applies even to idealizing works of art, for their *promesse du bonheur,* as Adorno calls it, using the phrase in Baudelaire's poem on Cythera, calls attention to the obvious lack of happiness in the world, and as such has a critical function. Indeed, what Freud and Kant altogether miss is the thorniness of the work of art's existence in the world, which survives the attempt to make it into a eunuch – neutralize and domesticate it – implied by the conceptualizing of it as a priceless triumph of civilization, to be kept for eternity in those temples of culture called museums, and as a very expensive commodity, making the temple of culture literally a treasure house. As we know, these days a museum is a bank in all but name.

Psychoanalysis entirely ignores, and thus in effect dismisses, the social critical function of art, tied to its inherent negativity – its aesthetic articulation of the negativity that is constitutive of society. For Adorno, art offers resistance to the status quo of unhappiness, by whatever means seem artistically convincing and powerful at a particular historical moment.

> Art is like a plenipotentiary of a type of praxis that is better than the prevailing praxis of society, dominated as it is by brutal [barbaric] self-interest. This is what art criticizes. It gives the lie to the notion that production for production's sake is necessary, by opting for a mode of praxis beyond labour. Art's *promesse du bonheur,* then, has an even more emphatically critical meaning: it not only expresses the idea that current

praxis denies happiness, but also carries the connotation that happiness is something beyond praxis. The chasm between praxis and happiness is surveyed and measured by the power of negativity of the work of art.

For Adorno, even the traditional contemplative attitude towards art has greater validity than Freud's conception of a substitute – temporary and lukewarm – happiness, inasmuch as this attitude "underscores the important posture of art's turning away from immediate praxis and refusing to play the worldly game."

Adorno overtly opposes "psychologistic interpretations of art" as "in league with the philistine view that art is a conciliatory force capable of smoothing over differences, or that it is the dream of a better life, never mind the fact that such dreams should recall the negativity from which they were forcibly extracted." But negativity is socially if not personally psychologistic. Adorno is arguing in effect that by emphasizing art's appeal to the individual Freud ignores its socially realistic import. But that is a psychological import, as Adorno acknowledged in other works, such as *The Authoritarian Personality*. That is, Adorno's argument derives from and utilizes a psychoanalytic framework, but it is a social psychoanalytic one: he is interested in normal unhappiness, which is more pervasive – epidemic – than neurotic unhappiness. According to Adorno, the work of art refuses normal unhappiness – which Freud pessimistically takes for granted – in the process revealing its social origin.

For Freud, normal unhappiness is a structural intrapsychic necessity, as it were – the affective tone (the odor of "good" repression?) and general attitude signalling mastery (always tentative) of inner conflicts. Reason is built on and a form of normal unhappiness. But according to Adorno the work of art repudiates reason, that is, the world and its "reasons" – its self-rationalizations – and as such refuses to accept normal unhappiness. The authentic work of art is "uncompromising," in the deepest sense: it refuses the compromises, inner and outer, that are necessary for adaptation to the world. It is deeply and insistently maladaptive. To reduce it to a pseudo-pleasurable plaything, as Freud in effect does according to Adorno, is to profoundly falsify it, for "in a false world all *hedone* is false." As some psychoanalytic thinkers argue, art is perverse, but its perversity – in both appearance and substance – is authentic social rebellion, a social necessity in a false world. Art is all the more socially "necessary" because it articulates that falseness – the world's perversity – in its own perverse negativity.

Adorno is interested in the social causes of normal psychological unhappiness. He regards art as a kind of critique unveiling these causes by refusing normal unhappiness. This is implicitly psychoanalytic: it calls attention to art's relation to the social surround that it interacts with, dialectically represents, and ironically identifies with. More importantly, it demystifies normal un-, happiness – to regard it as intrapsychic in origin is for him a kind of mystification of it – while acknowledging that it permeates the individual psyche. Art is an unusually sensitive articulation of the profound suffering implicit in

the so-called normal unhappiness necessary for civilization. Indeed, as Adorno elsewhere argues, art is profoundly attuned to – in the service of – the subject, for "it is now virtually in art alone that suffering can still find its own voice, consolation, without immediately being betrayed by it."[14] Adorno in effect resubjectivizes art overobjectified – betrayed – by interpretations, including psychoanalytic interpretations. Inwardly art is about victimization, its basis is socially real trauma, which also shapes – "distorts" – its sensuous/erotic character. It is subjective in import, and while, like modern art, it may be "one big comedy about the tragic individual, comingling the sublime and play"[15] – Adorno was thinking of Samuel Beckett's work – it is invariably, if not always apparent immediately, a critical response to historical pain, which precludes reconciliation with society.

Adorno's sense of art as an articulation of social misery locates it interpersonally, with the interpersonal broadly conceived as the widest possible horizon – that of the institutional reality formative of ideology, the administered society, as Adorno calls it, the System that shapes personal substance. This is a not unpsychoanalytic idea, if not a Freudian one. When Alfred Lorenzer observes that the "basic forms of subjectivity" are socially constructed – that the content of desire is determined by "socially specific" interactions – he implies that interpersonalist social psychology can adequately describe normal unhappiness, that is, socially realistic suffering.[16]

Adorno has made a remark extremely pertinent to visual art. Commenting on Schonberg's *Survivor of Warsaw,* he remarks that "by turning suffering into images, despite all their hard implacability, they wound our shame before the victims. For these are used to create something, works of art, that are thrown to the consumption of a world which destroyed them."[17] Apart from this philistine inevitability, from which there is no escape, especially in a consumer society which reduces even cultural products to falsely pleasurable commodities – facilely turning their negativity into affirmation – Adorno implies the basic imagistic character of all art. Even music is implicitly imagistic. Whatever the complexity of this concept of image, this suggests that genuine art moves away from the verbal towards the preverbal, even the resolutely non-verbal – towards relentless silence. This is commensurate with its primitive sensuous eroticism: genuine sensuality needs no words, in contrast to the manufactured sensual glamor of popular imagery.

The psychoanalytic relevance of this is clear. It has been argued that earliest interactions and identifications are visual; they thus necessarily take imagistic form. Freud wrote that "a presentation that is not put into words . . . remains thereafter in the *Ucs.* in a state of repression."[18] If this is true, it can be argued that visual art, which never puts anything into words, presenting experience in images rather than verbal symbols – images which are ambiguous because they imply the unsymbolized, and thus can hardly be regarded as codifying experience however much they may evoke symbolizations – deals with more repressed material-corporeal interests, as Adorno calls them, than literary art. It is in effect a kind of sensorimotor articulation of these repressed sensuous/erotic interests. This is the level of normal unhappiness, socially induced.

Visual art seems to demand more sensorimotor attunement than literary art. It is more difficult to achieve such attunement than intellectual, scholarly awareness of communicative meaning structures and narratives, except, perhaps, for the all-encompassing social narrative – necessary to understand the full intricacy of artistic communication – which also requires special attunement, for like sensory eroticism recognition of it is deeply repressed. This is why visual art, at its best, has usually been thought of as more mysterious – "ineffable" is a term frequently used – than literary art. Visual art has a more subtle sensuous/erotic charge and social history than literary art, which depends more obviously on communicative meaning structures and narratives. This point is resoundingly made by modern abstract art, which implies that art is properly seen only when it is seen "abstractly," that is, as a sensorimotor image. The music metaphor customarily used to conceptualize abstract art calls attention to the spontaneous sensorimotor and erotic character inherent to its imagery.

V

Baudelaire once said there are two kinds of criticism, the poetic and the mathematical. The poetic attempts attunement to the density of desire in the work of art – to the sensuous/erotic charge specific to a given "abstract" sensorimotor image. Such attunement can only be articulated poetically, that is, by way of analogy. The mathematical attends to the character of meaning and narrative in – the communicative "difficulty" of – the work. Poetic criticism is more subtle and asocial – involves fewer shareable "meanings" – than mathematical criticism. Psychoanalytic interpretation has generally been more mathematical than poetic in character. It tends to deal with difficulties of meaning rather than densities of affect in the work of art.

Geoffrey Hartman has written that the "psychology bypass" in criticism was "partly removed by Freud . . . he made it clear that the artist has a psychology, that the artist was compelled to deal with a dependence he could not forego."[19] There is no question that the critic also has a psychology – a dependence he cannot forego, including dependence on the work of art. But the poetic critic, especially of visual – overtly imagistic – art, can triumph over his psychology by turning it into an instrument of poetic criticism, that is, using it to articulate the sensuous eroticism latent in the work, making it metaphorically manifest. The mathematical critic, eager to turn the image into a message – objectify it – rather than experience it subjectively, is less likely to understand his psychological relationship to the work than the poetic critic. Freud, the mathematical psychoanalytic critic par excellence, eschewed a poetic approach to art – the transferential and countertransferential internalization of its images. He preferred to examine its communications rather than articulate its evocations. I suggest that the only hope for psychoanalytic interpretation today – the only thing that can save its interpretations from becoming mechanical and standardized, that is, mathematical psychology – is a poetic psychoanalytic criticism, and ultimately the dialectical integration of the

mathematical and poetic, perhaps an illusory possibility. Only this can avoid the pitfalls of literary criticism, falling into the old interpretive trap of turning primitive images into communicated ideas.

The Prague School semiotician–aesthetician Jan Mukarovsky has written:

> The artistic sign in contrast to the communicative sign is non-serving, that is, it is not an instrument. The understanding that the artistic sign establishes among people does not pertain to *things,* even when they are represented by the work, but to a certain *attitude* toward *things,* a certain attitude on the part of man toward the *entire* reality than surrounds him, not only to that reality which is directly represented in the given case. The work does not, however, communicate this attitude – hence the intrinsic artistic 'content' of the work is also inexpressible in words – but *evokes* it directly in the perceiver. . . . the visual arts are the most effective of all in performing this basic task of art in general.[20]

Mathematical psychoanalytic criticism deals with art's communications; poetic – aesthetic – psychoanalytic criticism would deal with its evocations. It would utilize analogy to articulate repressed sensuous erotic and ideological interests. (Psychoanalysis can be regarded as a kind of poetics of subjectivity. From its Aristotelean beginnings, poetics has attempted to articulate the characteristic subjectivity evoked by each art.) Psychoanalysis lends itself to aesthetic criticism, because, like the aesthetic itself in Mukarovsky's conception of it, psychoanalysis dialectically subordinates communication in all its aspects – the representational, expressive, and appellative – to its unconscious attitudinal import. To put this another way, the aesthetic is constituted by an artistic act of subversive defiance against the conventions and norms of communication and the social world and ideology they constitute. This attitude of resistance is the source of aesthetic density, and informs whatever art signifies. Psychoanalysis is constituted by a similar act of subversive defiance. Thus, psychoanalysis and aesthetic criticism seem meant for each other. The aesthetic derivatives of psychoanalytic theory articulate its unexpected implications for art, and afford insight into the density of the theory itself.

27

The Use and Abuse of Applied Psychoanalysis

MARSHALL EDELSON describes "applied psychoanalysis [as] the appli-
cation of psychoanalytic knowledge to explanatory, methodological,
or technological problems arising in disciplines or human endeavors other than
psychoanalysis."[1] Psychoanalysts use those other endeavors to "provide evi-
dence for the *existence* of fantasy systems and mental operations in realms other
than the clinical situation."[2] However, the non–psychoanalysts of those "other
realms" have rarely been completely happy with the results of the application
of psychoanalysis to them, even though they initially encouraged and sup-
ported it. Exhilaration at the demystifying effect of psychoanalytic knowledge
was quickly followed by the sense that it had subverted and discredited the
other realms' own knowledge. Psychoanalysis seemed to comprehend the
object a particular discipline studied better than the discipline itself did. Thus,
the discipline's knowledge seems inadequate and superficial compared with
psychoanalytic knowledge. Psychoanalysis even seemed to marginalize the
discipline by becoming indispensable and eventually central to it. Like a par-
asite, it slowly but surely took over the host, to its detriment, even death.

Worse yet, psychoanalytic knowledge seems to trivialize the phenomenon
it is applied to by showing that the phenomenon is not what it seems to be.
This means that the discipline that studies it becomes equally illusory. The
practitioners of the discipline cannot help but regard this as abusive and de-
structive. They come to regard applied psychoanalysis as an instrument of
psychoanalytic imperialism, and its ultimate effect as nihilistic. Psychoanalysis
seems to curse whatever it is applied to. It seems to undermine the normalcy
and significance of whatever discipline it enters, or at least puts the discipline
into serious question. Thus, its practitioners feel profoundly betrayed by psy-
choanalysis. Hans Kung, describing "the *repression* of religiousness," that is,
"religion in the subjective sense, as a devout view of life, attitude toward life,
and life style"[3] – or, as I would say, religion as a way of acknowledging that
sanity is incomplete without a sense of the sacredness of life – unhappily



observes that "religion is for the most part treated only as a *pathological* or *marginal* phenomenon" by psychoanalysis as well as academic psychiatry.[4]

Similarly, the literary critic George Steiner, while respecting the spirit of "Talmudic exegesis from which so much of . . . Freud's hermeneutics was derived"[5] – Freud's sense that "there are always further layers to be excavated, deeper shafts to be sunk into the manifold strata of subconscious inception," that "the filaments of associative congruence, of occlusions, of covert or declared suggestions, are limitless"[6] – believes that because of this interminability of interpretation, "the process of psychoanalytic decoding and reading in depth can have no intrinsic or verifiable end."[7] Moreover, "by peeling away the onion-skin layers, the inauthentic accretions which smother the core of vital expressive need, psychoanalysis readily undermines the status of the word."[8] This is epistemologically paradoxical, for, as Steiner says,

> psychoanalysis is, *in toto,* a language art, a language *praxis.* There can be neither mute patients nor deaf analysts. Psychoanalysis is as immediate to word and syntax as mining is to the earth. The Freudian mapping of the individual psyche and of civilization, Freudian interpretation and the resulting therapy, depend wholly on the Hebraic-Hellenic postulate and legacy of discourse and of text. Human consciousness is "scripted" and made intelligible by semantic decipherment.[9]

Thus, betraying the word, psychoanalysis betrays itself.

According to Steiner, this paradox follows from "Freud's sovereign nonchalance in regard to the problematic nature of language itself." Psychoanalysis, taking language for granted, as though it was bedrock rather than quicksand, not only neglects the implications of "the underlying issue of semantic unendingness"[10] for interpretation and therapy, but unwittingly shows it can never serve "the enactment of answerable understanding, of active apprehension" of art – the "acting out" of the work "so as to give it intelligible life."[11] Instead, the application of psychoanalysis to art – especially to avantgarde art, which problematizes its own language, calling it into unanswerable question – results only in more "high gossip" about it.

Psychoanalytic interpretation can never disclose aesthetic immediacy – indeed, seems to foreclose on and (a)void it. Aesthetic immediacy is no longer an indication of the seductive symbolic plenitude of the work of art, compensating for the missing plenitude of life, but obscures the psychosocial reality of both art and life. For Steiner, the apprehension of aesthetic immediacy is the primary end of the experience of the art. Because psychoanalytic interpretation cannot help us realize it, psychoanalysis – no doubt like Marxism – belongs to the politics of the secondary surrounding art. I am playing on Steiner's idea of a society of aesthetes in which the "politics of the primary" dominates, stimulating them to "learn anew what is comprised within a full experience of created sense, of the enigma of creation as it is made sensible in the poem, in the painting, in the musical statement."[12] The linguistic, cultural, and performative conventions of art "implicate the mystery of the human condition."[13] But psychoanalytic interpretation of them, by reason of its ex-

egetical rather than philological character (to use Steiner's distinction), impedes rather than facilitates – and may even, by its very nature, forgo – comprehension of the way these conventions make the human mystery aesthetically immediate.

Whatever one thinks of Steiner's critique – and I believe he is completely wrong about Freud's sense of language and misunderstands Freud's frustrated acknowledgment of interminability – it points to what is perhaps the most crucial issue of applied psychoanalysis: the question of its epistemological validity. Edelson's six methodological canons of applied psychoanalysis[14] speaks to this issue, but these canons are intended – apart from the sixth, which advises would-be applied psychoanalysts to "avoid grandiosity," that is, to not use psychoanalysis prescriptively in value-laden situations, for example, to not make assumptions about "what a mature adult should be like"[15] or, as I would add, what good art should be like – to turn "applied psychoanalysis [into] a source of steady pressure on psychoanalysis as a science to make its causal claims explicit, and to devote itself to establishing through empirical tests the scientific credibility of these claims."[16] That is, Edelson's canons are not simply cautionary; they involve the use of applied psychoanalysis to further the claims of psychoanalysis to scientificness, in which it is often found lacking.

But this does not solve the problems of the non-psychoanalytic practitioner of applied psychoanalysis, who while not misdepicting psychoanalytic knowledge (Edelson's number one stricture), is concerned about the epistemological validity of applying psychoanalysis to the primary (cultural) data of his or her field, especially about the peculiar way it seems to change, even falsify, them. Such a practitioner is not concerned simply with the misapplication of psychoanalysis, as Edelson is, but with the misconceptions it may give rise to about the data it is applied to – misconceptions not only in the detail of interpretation, but in the sense of their general meaningfulness.

Steiner notes that all art "supposes a passage . . . from meaning to meaningfulness."[17] (I would extend this to all cultural phenomena and what contains them, that space of mutuality and consistency that we call civilization and that is inevitably endangered and tentative, always on the verge of breakdown and inherently short-lived, that is, decadent and in perpetual need of avant-garde regeneration to sustain its meaningfulness.) The issue that non-psychoanalysts who practice applied psychoanalysis face, as distinct from psychoanalysts who do, is that psychoanalytic interpretation of cultural phenomena and civilization seems to reverse this passage, to return us from hard-won meaningfulness to mere meaning, that is, desubstantiates and devalues what it interprets rather than deepens our sense of its intrinsic meaningfulness and value. Thus, those who are eager to import psychoanalytic understanding into their discipline in the belief that it can in fact function philologically, freshening the sense of the aesthetic immediacy of cultural phenomena, reinforcing the sense of their meaningfulness and thus renewing their power of "substantiation," to use Steiner's word, find that psychoanalytic understanding not infrequently seems to do just the opposite: to altogether wither them on their aesthetic vine. Thus, non-psychoanalysts who practice applied psychoanalysis become peculiarly

uncertain and ambivalent about its use – self-contradictory in their application of it. This self-contradictoriness is not simply their particular objective and subjective problem; it tells us something about the problematic of applied psychoanalysis itself. The question is what such self-contradictoriness has to teach us about applied psychoanalysis – what that harrowing, yet peculiarly rigorous, self-contradictoriness tells about the dialectical problems (to use that much overworked but inescapable word) of applied psychoanalysis.

And more insidiously, the question concerns the unconscious attitude to culture and civilization latent in psychoanalysis, at least the Freudian version of it. It is an attitude that has rarely been consciously questioned – brought out of the Freudian closet – by psychoanalysts, yet it infects applied psycho-analysis. Indeed, it is the repressed psychic premise of psychoanalysis – the joker in its deck. Kung questions this attitude from the perspective of religion, and Steiner from that of art – two areas that preoccupied Freud, at times almost morbidly, I would suggest. But rarely – with the important exception of the British Independents – has it been questioned from within psychoanalysis. To ignore it will not make it go away. I do not think such questioning can be dismissed as the usual hostile resistance to psychoanalysis that Freud expected.

Freud's ambivalence about, and at times destructive contempt for, religion and art, which I will partly document and which no doubt reflected his famous pessimism about civilization – contempt, as Ernest Jones has written, is the "form" in which "the sense of power is in adult life usually manifested,"[18] and no doubt Freud's contempt reflected his sense of psychoanalysis's power or will to power – has unconsciously affected the practice of applied psycho-analysis. In my opinion the unexamined influence of this ambivalence is re-sponsible for the sense, among non-clinical psychoanalytic interpreters of culture, that applied psychoanalysis has not simply castrated and murdered but dismembered the cultural object of its inquiry in such a way that it cannot be put back together again, made aesthetically whole and resonant as well as socially relevant – relevant for civilization – again.

The emotional ambivalence and intellectual uncertainty – are they separable? – of those who want to apply psychoanalysis in their discipline but are sus-picious of the results, both in particular and in general, has been summarily articulated by Peter Brooks, with reference to literary criticism:

> Psychoanalytic literary criticism has always been something of an em-barrassment. One resists labeling as a "psychoanalytic critic" because the kind of criticism evoked by the term mostly deserves the bad name it largely has made for itself. Thus I have been worrying about the status of some of my own uses of psychoanalysis in the study of narrative, in my attempt to find dynamic models that might move us beyond the static formalism of structuralist and semiotic narratology. And in general, I think we need to worry about the legitimacy and force that psycho-analysis may claim when imported into the study of literary texts. If versions of psychoanalytic criticism have been with us at least since 1908, when Freud published his essay on "Creative Writers and Day-

Dreaming," and if the enterprise has been renewed in subtle ways by post-structuralist versions of reading, a malaise persists, a sense that whatever the promises of their union, literature and psychoanalysis remain mismatched bedfellows – or perhaps I should say playmates.[19]

Brooks, after detailing some of the difficulties, goes on to say:

Part of the attraction of psychoanalytic criticism has always been its promise of a movement *beyond* formalism, to that desired place where literature and life converge, and where literary criticism becomes the discourse of something anthropologically important. I very much subscribe to this urge, but I think that it is fair to say that in the case of psychoanalysis, paradoxically, we can go beyond formalism only by becoming more formalistic.[20]

Brooks in effect turns the "hermeneutics of suspicion" that Paul Ricoeur described psychoanalysis as, back on itself – was there ever a time in its short history when it was not split into barely commensurate schools, suggesting that as a whole it has always been suspicious of itself? – raising questions about the motivation of applied psychoanalysis. Indeed, for Edelson it has, as noted, primarily to do with psychoanalysis demonstrating its scientificness to itself and secondarily with enlightening us about some civilizing cultural discourse. More crucially for my purpose, Brooks is at bottom concerned, I think, not simply with what psychoanalysis can "tell us . . . about the structure and rhetoric of literary texts," but with the fact that the "precious little"[21] it does tell us suggests its detrimental effect on sensibility. That is, he implies that it inhibits rather than enables sensibility, providing little if any help in determining the aesthetic significance of cultural phenomena and, even more importantly, in determining their significance for civilization, which is what their aesthetic significance points to. It is perhaps the most important critical issue of all. These issues subsume Edelson's methodological canons and the general methodological debate as to whether applied psychoanalysis is a matter of analogical thinking or wild psychoanalysis, both of which presumably render it illegitimate – and both of which, of course, Freud indulged in extensively.

I want to begin properly, then, by examining Freud's attitude to civilization and its two important, consciousness-shaping instruments and expressions, art and religion. For applied psychoanalysis has been especially attentive to them, as inescapable in every civilization. In the end applied psychoanalysis is an attempt to understand the problems of civilization. As Donald M. Kaplan has said, "Freud's first excursions into a psychoanalysis of art were to verify that his clinical interests were representative of a general psychological predicament of being civilized."[22] This of course raises the question of what being civilized means and why it is so meaningful, and also the question as to whether any instrument and institution of civilization can be understood exclusively and exhaustively on the model of the case history.

Freud's psychoanalytic demystification of religion and art is not unrelated to Marx's equally materialistic socioeconomic demystification of them, as the

Frankfurt school has shown. Phil Slater has written that for the Frankfurt school, Freud explicated the "ideological deflection of consciousness," demonstrating that religion and art not only mask the reality of social authority and power, and function to reinforce its status quo, but also explain the psychopathological workings of society, that is, the reasons why "the suppressed classes can be emotionally attached to their masters."[23] In "The Question of a Weltanschauung" in the *New Introductory Lectures on Psycho-Analysis* (1932), Freud writes:

> From the standpoint of science one cannot avoid exercising one's critical faculty . . . and proceeding with rejections and dismissals. It is not permissible to declare that science is one field of human mental activity and that religion and philosophy are others, at least its equal in value, and that science has no business to interfere with the other two: that they all have an equal claim to be true and that everyone is at liberty to choose from which he will draw his convictions and in which he will place his belief. A view of this kind is regarded as particularly superior, tolerant, broad-minded and free from illiberal prejudices. Unfortunately it is not tenable and shares all the pernicious features of an entirely unscientific *Weltanschauung* and is equivalent to one in practice. It is simply a fact that the truth cannot be tolerant, that it admits of no compromises or limitations, that research regards every sphere of human activity as belonging to it and that it must be relentlessly critical if any other power tries to take over any part of it.[24]

Freud then goes on to remark:

> Of the three powers which may dispute the basic position of science, religion alone is to be taken seriously as an enemy. Art is almost harmless and beneficent; it does not seek to be anything but an illusion. Except for a few people who are spoken of as "possessed" by art, it makes no attempt at invading the realm of reality. Philosophy is not opposed to science, it behaves like a science and works in part by the same methods; it departs from it, however, by clinging to the illusion of being able to present a picture of the universe which is without gaps and is coherent, though one which is bound to collapse with every fresh advance in our knowledge. . . . But philosophy has no direct influence on the great mass of mankind; it is of interest to only a small number even of the top layer of intellectuals and is scarcely intelligible to anyone else. On the other hand, religion is an immense power which has the strongest emotions of human beings at its service.[25]

Freud's dismissive contempt for religion, art, and philosophy is palpable; it is undoubtedly a pre-emptive attack anticipatory of their inevitable self-defensive criticism of psychoanalysis. But this struggle for power is of less interest than the fact that Freud seems to have thrown his own intellectual caution to the winds. According to Kaplan, Freud "counseled great care in carrying over psychoanalysis to cultural issues. 'We should . . . not forget,' he wrote, 'that,

after all, we are only dealing with analogies and that it is dangerous, not only with men but also with concepts, to tear them from the sphere in which they have originated and been evolved.' "[26] In the passage just cited – and in another, even more important one I shall soon note – Freud indicates that he is not only prepared to tear religious, artistic, and philosophical concepts from their contexts, and to tear the contexts themselves out of the overarching context of civilization, but to dismiss both concepts and contexts out of hand as unscientific. That there may be equally legitimate, other than scientific purpose – that they may serve the idea of civilization without which science could not exist – is of no interest to him. He implicitly assumes that scientific understanding is the only mature understanding and, more importantly, that a kind of generalized scientific approach to life is the civilized one. Religious, artistic, and philosophical interests – all wish-fulfilling illusions, that is, insufficiently critical and reality-testing – detract and distract from it. Freud presumably needed none of their comfort and consolation.

However, we know that he admired the psychological insight of many artists, even writing Arthur Schnitzler that "he envied him his 'secret knowledge' of the human heart."[27] Psychoanalysts ever since have admired, in Winnicott's words, the "flashes of [psychological] insight that come in poetry,"[28] even while relegating them, as Kohut says, to unscientific anticipations and illustrations of psychoanalytic ideas.[29] We are coming, as Michael F. Frampton has recently written, to appreciate the influence of the "concept of 'intentionality' of the philosopher-psychologist Franz Brentano," with whom Freud studied two years.[30] Freud, we know, did not develop in a vacuum, but my point is that he was more dependent than he sometimes cared to acknowledge on non-clinical, broadly cultural sources for his ideas. In fact, analogical thinking, not simply clinical observation, was part of his method of developing psychoanalytic concepts. Indeed, I believe that Freud's theorizing was stimulated by and mimics what Jean Laplanche has called the "metabolizing action" of metaphor and metonymy[31] – relationships of similarity or contiguity between signifiers (Laplanche believes they are inseparable) – which he found in abundance in literature. Unconscious process is metaphoric and metonymic, as is well known. In other words, Freud was not as scientific methodologically as he later insisted psychoanalysis was. He no doubt covered his tracks, assimilating insights first recognized in literature and philosophy into psychoanalytic discourse as examples – which of course decontextualized them – and also as proof of the universality of psychoanalytic ideas.

What has this got to do with applied psychoanalysis? First, it necessitates that we recognize, as Peregrine Horden writes, that "psychoanalysis was not first evolved and then applied. Its application contributed greatly to its evolution."[32] This suggests that from the start of psychoanalysis, clinical and applied psychoanalysis had parity. Indeed, Edelson states that "strictly speaking, psychoanalysis as treatment is also applied psychoanalysis, for it involves the application of psychoanalytic knowledge to technological problems."[33] It is also why Laplanche regards the clinical as only one of four "sites of psychoanalytic experience," applied psychoanalysis – which he prefers to call

"export" or "extra-mural psychoanalysis," for " 'application' suggests that a methodology and theory are abstracted from a privileged domain, namely, that of clinical psychoanalysis, and then almost mechanically applied as they stand to another domain"[34] – being an autonomous and equally pertinent site. In fact, Laplanche thinks the "notion of applied psychoanalysis . . . makes a mockery" of its richness and sheer quantitative importance in Freud's works, noting that the Schreber and Leonardo cases were "so vital to the development" of his thought.

More particularly, writes Laplanche – and particularly relevant to my discussion – "when psychoanalysis moves away from the clinical context, it does not do so as an afterthought, or to take up side-issues," but "in order to encounter *cultural phenomena* . . . in works of so-called extra-mural psychoanalysis, *psychoanalysis invades the cultural,* not only as a form of thought or a doctrine, but as a *mode of being.*"[35] We are unexpectedly in another uncomfortable paradox: psychoanalysis can recognize itself as a mode of being – as much more basic than a method – only by becoming extramural, more specifically, by invading culture. But it is exactly this invasiveness that is experienced by the friends of culture – as we might call those who devote themselves to appreciatively or philologically re-enacting it – as unfriendly, indeed, abusive of culture. (This is the "abuse" of my title, which does not imply methodological misuse of psychoanalytic knowledge. But of course, if those on its receiving end feel abused, it must in some subtle way be misused.) Strangely enough, it is this peculiar experience of abuse – this feeling of being manipulated for extra-cultural purpose – that makes psychoanalysis so seductive to culture. The trauma psychoanalysis causes culture by revealing its hidden psychological sources and effects, experienced as a kind of judgment on it, gives psychoanalysis a position of power over it. Psychoanalysis seems to know culture better than it knows itself. Thus, culture analysts privilege and submit to psychoanalysis by accepting it as the necessary start, even catalyst of, cultural analysis. But equally necessarily, they eventually revolt against psychoanalysis in the name of a higher conception of culture. That is, they regard the destiny of culture as more than psychomimetic. (I have alluded to some of these rebellions [Kung, Steiner].) For culture will come to experience the seduction as humiliating, even self-effacing to the point of self-destruction, that is, culture will experience its acceptance of the psychoanalytic mode of being as a denial of its own, as compromising its autonomy and purpose.

At the same time, let us not forget that for whatever reasons – self-discovering or self-denying (or both) – culture turned to psychoanalysis, and psychoanalysis turned to culture and continues to do so, not just "because of the paucity of case-histories,"[36] but because it needed ideas. It found them in culture, if in impure or unrefined form by its scientific standards. Freud, then, turned to culture not only to confirm his ideas, but to find them. For him, culture was reified – imagistically or formally – psyche. For him, applied psychoanalysis was a way of mining culture for psychoanalytic knowledge as well as a kind of feedback on it, a way of keeping it an open system. On the

one hand, he used clinically derived ideas to make cultural material intelligible; on the other, he used culturally derived ideas to make clinical material intelligible. As long as the lines of communication and border between psychoanalysis and culture were open – as long as free passage between them was allowed – psychoanalysis would flourish. In reading Freud, one sometimes has the sense that he thinks it would lose its creativity – its power of theoretical innovation – if it became entirely clinical, forgetting its roots in culture. He recognized that culture had a metabolic effect on psychoanalysis, as it were. (In a sense, the question is whether psychoanalysis has an equally metabolic effect on cultural studies, or only an initial catalytic and ultimately inhibiting and debilitating effect on them as well as on cultural production. That is, the issue is whether psychoanalysis has replaced culture, as some critics have argued, or whether, as Laplanche suggests, in becoming "culturally marked by psychoanalysis"[37] modern man cannot make culture without being psychoanalytically aware. Culture that is not thus made is unconvincing in the long interpretive run.)

The hermeneutic circle that psychoanalysis and culture form brings into question Kaplan's assertion that "whereas clinical psychoanalysis furnishes the technical meaning of the terminology of psychoanalytic discourse, the psychoanalysis of such matters as social institutions, historical events, and literary texts entails a dislocation of such discourse and a trial of its meaning,"[38] making applied psychoanalysis a "boundary problem" for psychoanalysis.[39] If this is so, why is it that clinical psychoanalysis has generated such a variety of psychoanalytic discourses, often contradicting one another? Also, why is it that applied psychoanalysis, even when practiced by non-clinicians, can generate new psychoanalytic knowledge? One could as well say that psychoanalysis is a boundary problem and trial of meaning for the disciplines in which it is applied. That is, it brings their manifest meaning in question by cross-examining it for a latent psychological content. (This is certainly the way it has come to be experienced, even when it is put to intertextual use as a mode of reading.) Clearly, there is cultural continuity between technical psychoanalytic and cultural non-psychoanalytic discourse, as Freud implicitly recognized. Even his clinical concepts are in part an elaboration and refinement of culturally implicit recognitions, understandings, ideas, and even values.

Thus, the charge of reductionism hurled at applied psychoanalysis is simplistic and partly spurious. The real charge that can be made against it is that it exhibits a failure of dialectic – of reintegration of cultural and psychoanalytic discourse. This is ultimately Freud's own failure, for self-contradictorily he regarded art, religion, and philosophy – modes of culture – as inevitably meaningless from a scientific point of view, however many meanings he found in them. No doubt they are unrealistic illusions, but Freud seemed blind to the fact that an illusion can be civilizing and as such healthy, which makes it realistically necessary. Perhaps Freud did recognize this but rejected artistic, religious, and philosophical illusions because he believed they ultimately failed in their civilizing effect – as though science has succeeded in its civilizing

purpose, if it has one. (One wonders if Freud didn't displace his disappointment with the therapeutic limitations of psychoanalysis onto disappointing civilization.)

Neither art, religion, philosophy, nor science binds people durably and peacefully. Rather, they reverse themselves, unexpectedly turning into the opposite of what they appeared to be. That is, originating as instruments of Eros, they became instruments of the death instinct. Freud has described civilization as "a process in the service of Eros, whose purpose is to combine single human individuals, and after that families, then races, peoples and nations, into one great unity, the unity of mankind. . . . But man's natural aggressive instinct, the hostility of each against all and of all against each, opposes this programme of civilization."[40] Freud, speaking as though with *sub specie aeternitatis* authority, presented himself as the witness and reporter, in a ringside clinical seat, of this "struggle between Eros and Death, between the instinct of life and the instinct of destruction, as it works itself out in the human species."[41] Because of this psychobiological war, the civilizing process, as it is represented, in different ways, by art, religion, philosophy, and science, seems doomed to failure. An implicit part of the task of applied psychoanalysis is to demonstrate this, that is, to show that under the civilized surface there is an uncivilized depth resistant to civilizing – an impacted, even imploded, and seemingly intractable infantilism, destructiveness, and self-destructiveness. The question is whether such a critique can help art, religion, philosophy, and science serve Eros, for they can easily be put to destructive use.

And the question is whether an applied psychoanalytic critique is not in fact destructive and debunking of civilization, as when it explains "The Madonna's Conception through the Ear" as an infantile fantasy of, in Ernest Jones's words, "a Father incestuously impregnating his daughter . . . by expelling intestinal gas, with the help of the genital organ, into her lower alimentary orifice, one through which her child is then born,"[42] or when it argues for the anally perverse character of art, denying and dissolving boundaries of all kinds, as Janine Chasseguet-Smirgel does.[43] I am not disputing the psychoanalytic soundness of these interpretations, but rather pointing out that the application of psychoanalytic theory to the myth of the Annunciation and to art undermines their credibility as civilized and civilizing by showing just how infantile and fantastic they are underneath their sophistication and sublimity. They are shown to be peculiarly foolish and absurd. In fact, they ultimately justify themselves not in terms of their realistic believability, but their socially useful consequences. In a sense, neither denies that it is "mythical." Rather, they imply that mythical illusions are the necessary vehicle of civilization, as Ernst Cassirer has argued. If there is reductionism in applied psychoanalysis, it is one that reduces culture not only to its psychoformative stage, but to social purposelessness and uselessness. This is why many engaged in examining just what makes cultural phenomena civilizing and socially convincing (for all their infantile and fantastic character), and who initially welcomed psychoanalytic knowledge as a way of furthering their efforts, became disappointed by it. They realized that while psychoanalytic knowledge shows, accurately, that

culture is tied to the barbaric beliefs beneath its civilized surface, it does not show how that surface came into being, why it has a civilizing effect, and why it is socially valued. However much the surface of a cultural object resembles a manifest dream from the psychoanalytic point of view, and is even generally recognized to be a kind of dream, it is regarded as of greater intrinsic value than an individual dream and, as such, is treasured and preserved by civilization as individual dreams are not. Thus, cultural critics come to regard the psychoanalytic idea of sublimation as ingeniously debunking cultural phenomena. They do not believe that low origins necessarily bring down high ends.

They think that psychoanalysis, in regarding cultural phenomena as symbolizations of unconscious processes and content, misses the point that symbols are not simply substitutions but reformations and transformations, creating a new space of civilized discourse. One might say that for the psyche to metaphorically-metonymically link the socially inappropriate anus and the socially appropriate ear is for it to create a new enigma of meaning, potentially catalytic of cultural innovation. To put this another way, to associate anus and ear is to make each uncannily meaningful, catalyzing a new cultural curiosity about each. Who knows what idea will spontaneously generate between the poles of anus and ear by reason of their emotional convergence? No doubt as initially bizarre as the association is, it may ultimately be the springboard for a new sense of being civilized. By putting the anus and ear in explosive symbolic relationship, the psyche creates new food for art and thought.

Chasseguet-Smirgel's defense of the psychoanalytic reduction of culture as no different in kind than any other and as epistemologically inevitable [44] misses the fact that the specifically psychoanalytic reduction of culture to its subjective grounds blinds one to its objective civilizing power. Psychoanalytic reductionism strips away the civilizing effect of symbolization, which is after all a movement from unconsciousness to consciousness. Culture enlists the symbol produced by the psyche in the cause of civilization, that is, puts it to "artistic" use. Art may help us be civilized only so long – it is certainly not as long as the saying "Art is long, life is short" suggests – but that may be long enough for a lifetime. The question is not whether, in Horden's words, "works of art . . . originate in universal 'archaic' processes of the mind such as condensation, displacement and symbolization"[45] but whether that is the most salient feature about them, as psychoanalysis seems to think. The way they encourage creative cognition and help socialize us may count for more. In a criticism not unrelated to that of Steiner, Charles Rycroft says:

> Characteristically, such explanations . . . fail to address themselves to the specifically aesthetic issues raised by imaginative activity: the nature and origin of the artist's and writer's ability to organize his imaginings into forms or patterns that feel "right" to him and are satisfying to others; and to transmute personal experience and private imaginings into objects of public and universal appeal.[46]

In other words, the psychoanalysis of art should address the issue of its general credibility, not only that of personal expressiveness. To argue that this

is because the archaic processes that inform it are universal is to miss its social point. Norman Mailer once wrote that "perhaps the measure of the best art is that it doesn't excite envy."[47] This is an indication that it has achieved complete "sociability," in Georg Simmel's sense of the term. To reduce this sociability to a mass delusion, a matter of lemmings foolishly marching into the archaic sea of a wish fulfillment, is to falsify it. Simmel defines sociability as "a *symbol* of life as life emerges in the flux of a facile and happy play; yet it is also a symbol of *life*," that is, "feeds on a deep and loyal relation to . . . reality."[48] Art and religion, and even science, writes Simmel, must induce the "faith, or feeling [that] assures us that the intrinsic norms of fragments or the combinations of superficial elements do possess a connection with the depth and wholeness of reality,"[49] or they will not be experienced as "sociable" and, as such, supportive and enabling. The "depth and wholeness of reality" implies that psychological reality is one among many realities. Simmel does not privilege it, as Freud seems to, as the reality that moves the other realities, as though it itself was unmoved by them. Also, Freud seemed to have had little sense of and tolerance for the playfulness of culture, which is one reason he may have rejected music, which seems to be in perpetual play. He preferred reified art to art still in play, which is why he was at his best with the masterpieces of Leonardo and Michelangelo and why he was unresponsive to the avant-garde art of his day, which set art into fresh play.

I think the issue of whether we should examine cultural phenomena more from the point of view of the way they symbolize the civilized mind or from the point of view of the way they symbolize the infantile mind – while acknowledging that both are involved in their making – has been eloquently articulated by Alfred North Whitehead, if not in psychoanalytic terms.

> It is a general principle that low-grade characteristics are better studied first in connection with correspondingly low-grade organisms, in which those characteristics are not obscured by more developed types of functioning. Conversely, high-grade characters should be studied first in connection with those organisms in which they first come to full perfection.
>
> Of course, as a second approximation to elicit the full sweep of particular characters, we want to know the embryonic stage of the high-grade character, and the ways in which low-grade characters can be made subservient to higher types of functioning.[50]

Translating Whitehead for my purpose, cultural phenomena are high-grade – highly and subtly organized – organisms, that is, phenomena in which the idea of civilization has come to a certain perfection. In contrast, infantile phenomena are low-grade and, while subservient to high-grade cultural phenomena, can, if pursued in their own right as the essence of these cultural phenomena, lead to a misconception of them. Thus, as Whitehead says, "The nineteenth century exaggerated the power of the historical method, and assumed as a matter of course that every character should be studied only in its embryonic character. Thus, for example, 'Love' has been studied among the

324

savages and latterly among the morons,"[51] making it seem savage and then moronic. It may well be both in its embryonic stage, although "savage" and "moronic" are of course terms that a high-grade, civilized organism would use to describe infantile, low-grade love. Certainly Freud, who was nineteenth century in outlook – fascinated by the embryonic stages of the psyche – seemed to think that the only kind of love was neurotic love, which was regressively savage and moronic at once. While love may be reducible to those terms, it can be something else. There can be high-grade love, however low-grade it is in origin.

Freud's difficulty in accepting high-grade culture in other than low-grade psychological terms is self-evident in a statement he made near the end of his life. I think this statement has become the unwitting credo of much applied psychoanalysis. Writing to Binswanger with bitter insistence, Freud asserted:

> I've always lived in the *parterre* and basement of the building. You claim that with a change of viewpoint one is able to see an upper storey which houses such distinguished guests as religion, art, etc. You're not the only one who thinks that; most cultured specimens of *homo natura* believe it. In that you are conservative, I revolutionary. If I had another lifetime of work before me, I have no doubt that I could find room for these noble guests in my little subterranean house.[52]

Freud's followers have in effect attempted to accomplish what he would have if he had had that other lifetime. (Steiner's observation that "the Freudian tripartite scenario of the psyche [is] so beautifully a simile of cellarage, living quarters and memory-thronged attic in the bourgeois house"[53] is worth noting here. So is Jones's psychoanalytic observation "that the close relation of aesthetics to religion is due to the intimate connection between their respective [low-grade] roots."[54] That is, they are "merely different components of a biologically unitary instinct,"[55] involving "the unconscious memory of infantile coprophilic interests," for Jones "the inner meaning of the phrase 'Art is the handmaid of Religion.' "[56] With one memory, they are reduced from sublimity to perversity.)

To deny the existence of a building's upper stories because it also has a basement suggests a somewhat skewed view of it. No doubt the above-ground structure of a building has to take its foundation into account and is continuous with it. But it can and does often rise to heights that, if dependent on foundational principles, indicate as well an organization according to other principles. Also, we eventually live as much if not more above than below ground. Freud levels the building of civilization in the very act of describing it. For him it was never really more than subterranean, a kind of catacomb in which art and religion live on a subsistence diet, or perhaps a Kafkaesque burrow whose inhabitants live an anxious existence. For Freud religion and art seem to be perverse rituals of gratification in ungratifying circumstances.

However, Freud's shattering of the Humpty-Dumpty of culture on the hard ground of psychoanalysis – to change my metaphor – in such a way that it seems impossible to put it together again, can be regarded as his version of

what Adorno calls "negative dialectic." That is, as Barnaby B. Barratt argues, it is Freud's way of denying culture's identitarian claims.[57] The denial of the self-identity and unity of sexuality is the essence of his "critique" of it and ultimately the basis for his denial of the self-identity and unity of art and religion. Nonetheless, however many times "psychoanalytic discourse demonstrates the way in which a movement of contradiction displaces and dispossesses the hypostatizing notions of totality, unity, and identity" and shows that "the development of things themselves" as well as thought "is determined by contradictoriness," which is both "a way of knowing and . . . the being of beings,"[58] Freud's contradictoriness with respect to culture has a perverse flavor. Looked at carefully, it is a way of totalizing culture as a failure, that is, incapable of civilizing. He undermines the belief that art and religion are unequivocally civilized by showing that they have an uncivilized basis in instinct. However, because of what can be called his suspicion of heights, amounting to a profound distrust of them, he does not, in the case of culture, stop with the recognition of the resulting contradiction – the conflict/compromise between civilizing intention and uncivilized instinct – but hypostatizes the uncivilized basis. This in effect one-dimensionalizes art and religion, that is, gives them a fixed identity. Even in his treatment of Michelangelo's *Moses*, it is the force of Moses' aggression that seems to matter more than his effort to restrain it. Because Freud tends to absolutize instinct, he doubts and finally disbelieves in culture, which, on theoretical grounds, must entropically devolve toward instinct. Culture, by Freudian definition, can never be an adequate defense against it.

To say this another way, Freud does not explore the space of contradiction that culture is as fully as he explores the space of contradiction that the dream and neurosis are. In fact, he reads the contradiction of culture away by prioritizing its uncivilized basis, not only because his method demanded that he do so, but probably in unconscious anger at culture's failure to morally improve the world. Moses may not destroy the Ten Commandments, inhibiting his rage – comprised of his own struggle with them as well as his disappointment with the children of Israel – but the world does not obey them and unconsciously has no intention of doing so. Read carefully, then, Freud not only articulates the contradiction between civilized semiotic structure and uncivilized desire in culture, a generic contradiction that appears, one might say plays itself out, in the polysemy of contradictory detail that constitutes every cultural phenomenon – Jones noted "that the grandest psychological effects are achieved" through "extreme contrasts"[59] (of meaning as well as form) – but also articulates the collapse of the contradiction into undialectical desire, that is, instinct. For Freud, *homo cultura* is a thin veneer on *homo natura;* the veneer changes over time, presumably because of the increasing repressiveness of civilization – Oedipus becomes Hamlet – but nothing changes underneath, and culture nevertheless is an endless superficial repetition of the same depth psychology. (I think the veneer changes in part out of sheer social entropy.) In the last analysis Freud describes culture uncontradictorily as abortive sublimation or, at best, as a Sisyphean effort at sublimation. One cannot help

wonder if he is not, at least in part, projecting his frustration with psychoanalytic treatment, that is, his sense of it as a Sisyphean enterprise – clearly evident in some of his later papers and letters – onto culture. His negativism seems to have an irrational component, however much it seems to follow from his rational analysis of the neurotic conflict that goes with being civilized.

Freud, then, presents a half-truth about civilization as its whole truth. Conscious culture *is* futile and unstable; it is not much of a barrier against unconscious infantilism, into which civilization tends to relapse, especially as culture becomes overtly subjective, as John Gedo thinks it has. This is why it is in a constant state of repair, as the interminability of cultural creativity suggests. Breakthrough follows upon breakthrough, and tradition tries to catch each one in its safety net before it becomes trivial and stale, falling into oblivion. Even before it became conscious in modernity, the dominant idea of culture was the dialectic of the avant-garde and decadence, epitomized in Duchamp's view that no work of art lives for more than thirty years, these days unusually long-lived. Freud had no understanding of the principle of the avant-garde as the guarantor of the perpetual mobility of the cultural machine, but he understood cultural decadence very well. Indeed, he must have known the source of the classical conception of decadence, Paul Bourget's *Essais de psychologie contemporaine* (1883). (Bourget's name is mentioned only once in his oeuvre, early on, in *The Interpretation of Dreams* as a figure, among other Parisians, in a young woman's dream.)[60] The imaginary conversation between a decadent artist and a normal and sound moralist and politician, must have especially influenced Freud, always political in his defense of psychoanalysis and a former would-be politician, although perhaps Freud split his sympathies and identity between the politician and artist. One wonders, also, what Freud thought of Max Nordau's theory of degeneracy, and later Spengler's.

I have dwelt on the abuse of culture that psychoanalysis is often felt to be, among the friends of culture, even those who are advocates of psychoanalysis – the double bind applied psychoanalysis puts them in. Now I want to talk about what the psychoanalytic re-articulation of cultural phenomena can positively effect. Psychoanalysis can be expansive as well as reductive. A general, paradigmatic epistemological distinction, rooted in the Hegelian distinction between understanding and speculation, has to be made between uncritical reductionism and critical expansionism. Most applied psychoanalysis involves the former, that is, the reduction of the relatively unique cultural to the unique mental mechanism. (For Hegel every understanding involves such reduction to undialectical categories.) But authentic criticality, after performing this abstractive operation of analytic understanding on the cultural phenomenon, in effect simplifying it, must re-complicate it in order to re-concretize it in all its particularity and individuality, generating a new sense of its existence and presence. (For Hegel "speculation" is this re-dialecticizing of the phenomenon, through the interplay of the categories that afford understanding of it, and their interplay with our sensibility, that is, our originative sensuous and imaginative response to the phenomenon.) The former step is relatively easy to learn to take; its mechanical results are what Brooks deplores. The latter step

is more difficult to take, and ultimately more subtle. The question is whether applied psychoanalysis can advance from uncritical reductionism to critical expansionism, or whether it is doomed to remain the former.

I think such an advance can be conceived only if there is a modification of the sense of what psychoanalysis is. Following Laplanche, I suggest that it be regarded as not only a method of analysis but a way of experiencing. The application of the psychoanalytic method to cultural phenomena must become a psychoanalytic re-experiencing of culture. That is, after discovering psychoanalytic meanings in culture – and they are certainly there, as connotations or implications, rather than as mechanical causes of culture – one must experience the psychoanalytic meaningfulness of culture, a speculative experience that re-culturizes culture after its psychoanalytic reduction to non-culture. (The error of applied psychoanalysis is to suppose it is an analysis of psychological cause rather than a disclosure of psychological implications. Applied psychoanalysis at its best is implied psychoanalysis.) This involves restoring the sense of culture's presentational immediacy, to use Whitehead's term, that is, a sense of "enhancement of the importance of relationships . . . already in the datum [here of culture], vaguely and with slight relevance."[61] Whitehead roots presentational immediacy in "complex genetic process," regarding it as a mode of prehension that rarely occurs apart from other modes (it would be ecstatic if it did), especially that of "symbolic reference": "Language almost exclusively refers to presentational immediacy as interpreted by symbolic reference."[62] Aesthetic experience – creative "feeling" of novel immediacy arising out of the realization of "contrast under identity," where identity is the consequence of a sense of relevance – is the characteristic instance of presentational immediacy, however integrated with symbolic reference or relevance in a larger sense of artistic identity.[63]

Now to move from a reductive to an expansive – an understanding to a speculative – approach puts a special strain on the applied psychoanalyst. It means that he or she must become a participant, not simply a scientific observer, of culture – "passionate and partisan" about it, if within the "widest possible horizon," as Baudelaire said. This is quite different from what the psychoanalyst is in the clinical situation. In fact, applied psychoanalysis is inherently speculative. Rycroft points out what we all well know, that while interpretations of a patient are made after long consultation with him or her, the interpretations the analyst-critic, to use Rycroft's term, makes of the culture producer or cultural product "are in no sense the result of a mutual endeavor," so that there can be no "critical monitoring" of them.[64] Nor do they have a therapeutic purpose: it is absurd to think culture can be cured. Thus, the applied psychoanalyst must do his or her own free association, not simply to the culture producer or cultural product, but to the feelings they induce in him or her. Applied psychoanalysis of culture necessarily involves self-analysis, if, as Gedo has suggested, there is to be some control on its results. Without self-critical self-analysis, applied psychoanalysis threatens to become simply a demonstration of the analyst-critic's belief system, that is, the ideologization (and idealization) of a particular psychoanalytic paradigm, or at least the expression

of a prejudice in favor of it; conceived even as a necessary prejudgment, in Gadamer's sense, such prejudice not only is self-limiting but casts little hermeneutic light on its object. Without analyzing the character of his or her unconsciously passionate and partisan engagement with culture, the applied psychoanalyst is asserting a prejudice in favor of this or that psychoanalytic system. My Hegelian point is that only through re-concretizing himself or herself by uncovering the transformative effect of the experience of culture on his or her own psyche – on the way it is organized and organizes experience – can the psychoanalyst-critic truly prehend it psychoanalytically. Thus, applied psychoanalysis at its best always catalyzes fresh self-consciousness, reminding the analyst-critic that the cultural product expands civilization's consciousness of itself. It is a social context of consciousness waiting for individual use. Indeed, it is a kind of symbol of the insistence on consciousness implicit in being civilized.

In examining the effects of the cultural product on himself or herself, the analyst-critic must move from an interpretation of its subject matter to an interpretation of its form, for it is the cultural transformation and framing of psychonatural subject matter or motifs that makes it significant for civilization – seemingly universal and civilizing in import. Just as *homo natura* must become *homo cultura* to live in civilization – no doubt he never completely does (no one can and does and wants to always live in civilization) – so psychologically raw subject matter must become sophisticated cultural form to make civilized sense. (Paradoxically, acculturating the subject matter in and through form is a way of speculatively re-concretizing it. The least significant art – art using reified form – suggests simply a mechanical understanding of its subject matter.) The failure of applied psychoanalysis is that it has not yet become an adequate psychoformalism, as Brooks implies. But that failure is inevitable, for cultural form fails to completely civilize psychonatural subject matter. Refined cultural form exists in unresolved dialectical tension and play with unrefined subject matter in the best – most true to the depth and wholeness of reality – cultural phenomena, neither dominating the other.

Indeed, this irresolution is the indication of a particular phenomenon's truthfulness to the generality and depth of reality. The point of applied psychoanalysis is to philologically prehend this tension without trying to polemically resolve it on the side of psychonatural subject matter or of psychosocial form. That is, authentic psychoformalism is dialectical. This non-invasive approach to culture, respectful of its inevitable imperfection, has the added advantage of making psychoanalytic interpretation seem less formulaic to the friends of culture. Also, it permits – indeed, necessitates – the interplay or dialectical use of more than one psychoanalytic paradigm. (Indeed, if, as Laplanche says, man is a self-theorizing being, and no theory of man can ever totalize the human, by reason of the epistemological inevitability of the incompleteness of every theory – like the human itself – then psychoanalysis can never be theoretically whole, a monolithic totality. It must remain a conflictful interplay of theories, even of incommensurate theories. It is only out of clinical necessity – the prioritizing of therapy over theorizing – that theory is regarded as hard-

and-fast knowledge. Of course, this does not mean that theory has the closure of illusion, that is, that it is wish-fulfilling; nor does it mean that theorizing is infinitely open, which would make it a defense against evidence. However, evidence always exists on the dialectical cusp between reality and theory.)

But what if the analyst-critic believes that there is cultural perfection, for example, perfect works of art, completely integrated masterpieces? What if he or she should attempt to rise psychoanalytically to the heights of their perfection? But that would only mean, as it did for Freud, to fall further into their depths, becoming ruthlessly invasive. The unconscious notion that works of art are perfect – exaggerated respect for their unity – is a stumbling block to applied psychoanalysis. Not even those possessed by art are so deeply in love with it, as their constant critical carping at it and generally playful relationship with it suggests. They know it always has a loose thread, which they are eager to spot and pull. The resulting unraveling is the beginning of speculative understanding, the critical re-concretization of the work. As Clement Greenberg said, a good critic can and must find as much to fault in a work of art as to praise, otherwise he or she wouldn't be a critic and wouldn't do the work justice. The good critic is necessarily discontented and contented, simultaneously. A critical relationship to a work of art is as important as aesthetic experience of it, indeed, the *only* path to genuine aesthetic experience. Analyst-critics are more deadly serious than critic-aesthetes, for they tend to believe in the implicit perfection, or at least perfectibility, of culture – as if in compensation for life – and will thus inevitably violate it more, which is I suppose an alternative way of understanding Freud's ambivalence to it. They seem to unconsciously suspend their belief in the universality of psychopathology when it comes to culture, even as they conscientiously discover it there. Moreover, it is as if, in practicing applied psychoanalysis, with however much methodological rigor and responsibility, they want relief from the rigors and responsibilities of the clinical situation.

As Robert Stoller says, "as a cure for trauma, aesthetic excitement is as effective as scratching is for poison oak. It bears repeating."[65] Does the clinical psychoanalyst turn to the excitement of applied psychoanalysis as a way of scratching the itch caused by the subtly poisonous effect of the clinical situation? Art seems much less poisonous and, by comparison with a patient, ideal. In contrast, critic-aesthetes know that even the most seemingly ideal culture is not compensation for the rottenness and difficulty of reality but is symbolic representation and stoic witnessing of the lifeworld in all its imperfection and negativity, that is, contradictions.

28

A Psychoanalytic Understanding of Aesthetic Disinterestedness

PSYCHOANALYSIS has had much to say about art since Freud's study of Leonardo (1911). However, it has been more interested in expanding the sense of art's content to include unconscious material than in analyzing the psychological purpose and import of form. This is not simply because of the difficulty of understanding the nature and motivation of form, but in deference to Freud's assertion, in *The Moses of Michelangelo* (1914), that "the subject-matter of works of art has a stronger attraction for me than their formal and technical qualities. . . . I am unable rightly to appreciate many of the methods used and effects obtained in art."[1] He sets himself at odds – in my opinion deliberately – with the artist, whom, he acknowledges, "first and foremost" values the work of art's formal and technical qualities.

One can argue that he is juxtaposing his mature scientific interest in the psychology of art with the artist's unscientific – and so implicitly immature, "unrealistic" – aesthetic interest in form, but there is more to it than that. For his resistance to the analysis of form – which is what I regard his unappreciation of it to be – is a matter of principle. And yet, however reluctantly, he offers an analysis of sorts, for by psychoanalytic definition, as it were, the creation of form is on a par with symptom-formation and dream-formation. Its mechanisms are reducible to theirs, that is, to the automatism of condensation and displacement. In *The Claims of Psycho-analysis to Scientific Interest* (1913) Freud writes that the artist "represents his most personal wishful phantasies as fulfilled; but they only become a work of art when they have undergone a transformation which softens what is offensive in them, conceals their personal origin and, by obeying the laws of beauty, bribes other people with a bonus of pleasure. Psycho-analysis has no difficulty in pointing out, alongside the manifest part of artistic enjoyment, another that is latent though far more potent, derived from the hidden sources of instinctual liberation" (SE, 13, 187). Clearly, Freud is more interested in the latent than manifest content of art. The latter – the softening transformation – obscures the former. It is a

disguise that must be penetrated, a mask that must be torn off, an impersonal surface that must be stripped so that the personal depth can be seen.

Please note that Freud does not state that the mask of form is a Gordian knot, only that as a psychoanalyst he is interested in what is behind it. To study the mask for its own qualities makes little sense to him; it is what can be associated with its components and overall character that interests him. In other words, Freud's psychological realism, as it were, leads him to reduce the work of art, and what people seriously interested in art – people incorporating it into their existence on a regular basis, indeed, who cannot seem to live without it – regard as the essential part of it – its formal character – to a bit of clinical evidence.

It is not just that Freud is unappreciative of and reluctant to study form, but that the psycho-critical analysis of it as a phenomenon in and for itself would be beside the key psychoanalytic point. "Art," writes Freud, "is a conventionally accepted reality in which, thanks to artistic illusion, symbols and substitutes are able to provoke real emotions. Thus art constitutes a region halfway between a reality which frustrates wishes and the wish-fulfilling world of the imagination – a region in which, as it were, primitive man's strivings for omnipotence are still in force" (SE, 13, 188). Here Freud gives us a cursory, dismissive "analysis" of form, assimilating it to psychoanalytic preconceptions – it is a matter of symbols and substitutes, a zone of illusion. There is no way that anyone who conceives of form in this way – reducing it to wishful content – can begin to comprehend why anyone would establish a so-called "aesthetic" interest in it. And indeed, as Harry Trosman points out, for Freud "the reaction of persons moved by art resembled a 'narcosis,' "[2] which to my mind depreciates their response – into a chemical "reaction." Similarly, when Freud wrote that "the first example of an application of the analytic mode of thought to the problems of aesthetics was contained in my book on jokes" (SE, 14, 37), he in effect reduced aesthetics to a joke. Trosman remarks that "the dream resembles a bad joke whose point has been lost because the dreamer did not take sufficient care with the communicative effect."[3] Art, which presumably takes better care – although many people think modern art takes even less care than the dream with communication – is at best a good joke.

Trosman notes that psychoanalysis has moved beyond Freud in its understanding of form. Understood from an ego perspective rather than Freud's id perspective, it is the organizing and structuring factor in the work of art, and as such that which makes it consequential as art. It is the adult, as it were, rather than childish element in the work of art. In this sense it can be regarded as having a defensive function, affording, as Gilbert Rose says, a sense of mastery. Through form the artist exercises executive control of the work, as it were. But even the ego understanding of form, with its more sophisticated attitude to art than Freud's, still does not address the core of the issue for aesthetics: the way attention to form generates – indeed, the way form seems to exist to catalyze – what Trosman calls aesthetic response. The nature of form cannot be fully understood without understanding its intended function as the object of disinterested aesthetic contemplation. Trosman does not ad-

equately characterize aesthetic response, nor does psychoanalysis, which is why, I think, that it is unable to completely unravel the riddle of form.

The British aesthetician Harold Osborne points out that "the idea of 'disinterested' attention and 'disinterested' pleasure . . . has remained a key notion of all systems which recognize a special mode of experience called 'aesthetic.' "[4] Since Shaftesbury, who first articulated the idea, and Kant, who developed its necessary, basic logic, what Osborne called the "disinterested attitude" – an attitude which implies not "lack of interest in the object of attention but the absence of any 'self-interest,' any considerations of advantage or utility, and indeed any interest at all other than the direct contemplation of the object and satisfaction achieved from our awareness of it" – has remained the fundament of aesthetics. Indeed, as Osborne writes, it is not necessary to know "the iconographical significance" of a "human artifact" for it to "exert an aesthetic appeal upon us." In fact, attention to iconographic content hinders aesthetic "appreciation": "The aesthetic value we ascribe to many . . . 'denuded' art objects may be far higher than that which we find in other artifacts whose original significance and functions are known to us." Thus, aesthetics implies that psychoanalytic investigation of the latent meaning of a work of art's iconographic content is of secondary interest, the primary interest in the work of art being the quality of disinterestedness it arouses through its formal character. In a sense, psychoanalysis and aesthetics are necessarily at odds, for the former assumes there is no situation of perception that is free of human interest – even scientific observation is a sublimation of essential human curiosity about sexuality, as Freud noted in his study of Leonardo (SE, 11, 74–78) – while aesthetics regards the situation of perception of form as "disinterested." The psychoanalytic assumption, of course, is that hidden human interests lurk behind aesthetic disinterestedness, presumably the most disinterested of all modes of disinterest.

Before I offer what I hope are some valid psychoanalytic insights into aesthetic disinterestedness, and thus, however indirectly, into form – Osborne notes that "the concept of disinterestedness in theory of art had its analogue in the notion of 'fine art,' which came to prominence at the same time," *fine* art being art that seemed to exist largely as a matter of form, the inherently most "refined" component of the work of art – I think it is necessary to remark, in some detail, the theoretical characterization of aesthetic disinterestedness, about which there is an amazing consistency in aesthetic thought. As Osborne says, Shaftsbury's formulation of the concept of aesthetic disinterestedness was "more than just a new theory or a new twist to theoretical habits. It was more akin to the discovery of a new dimension of self-consciousness." The "aesthetic impulse" that had been latent in the making of artifacts became a "self-conscious motive." Indeed, it legitimated, for the first time, the concept of "art." In fact, the systematic study of art history, the development of fine art, the philosophical inquiry into art as an ontological puzzle, and the formulation of aesthetic disinterestedness, begin more or less at the same time, and are correlative recognitions of this thing called art. Aesthetic disinterestedness – interest in form – seems to be the horse that pulled

this heavy art cart, for without aesthetic disinterestedness – in the words of C. W. Valentine in *The Experimental Psychology of Beauty,* the apprehension or judgment of an object "without reference to its utility or value or moral rightness . . . when it is merely being contemplated" – there is no sense of the art in art, and thus no sense of art as such. In general, as Paul Weiss said, aesthetic disinterestedness occurs "when, by a mere shift of attitude, we hold something away from nature and outside the web of conventional needs." We radically "distance" ourselves from it, as Edward Bullough said, fixing our attention upon its "immediately presented features," its hereness and nowness. In general, the "doctrine of aesthetic apprehension" has had an elaborate history since its first formulation by Shaftesbury. Such apprehension has been elaborated as either a kind of sensation or feeling, both modes of cognition being manifestations of the "inner sense" of "taste." Osborne regards this as the true and high road of aesthetic understanding, as distinct from "the 'expression' [of emotion] doctrines which emerged from Romanticism," for him the low and misleading road.

The most influential, telling account of aesthetic disinterestedness is that of Kant. He held that aesthetic "judgment" was a "mode of direct awareness" rather than a form of conceptual thinking (theoretical judgment), moral judgment, and judgment about utility. It is inherently subjective. It is not a judgment of the object's apparent perfection or lack of perfection. Even more, and above all, disinterestedness means no "concern for the *existence* of a thing." "Kant," writes Osborne, "went further than his predecessors . . . when he excluded from the aesthetic attitude not merely considerations of advantage and disadvantage, desire for possession and use, but any concern for the existence of a thing." Ultimately this meant the exclusion of any desire for it; for Kant, like Hutcheson, Burke, and other aestheticians, thought that " 'interest' implies or involves *desire*": aesthetic disinterestedness was sharply separated "from the 'interested' pleasures of the senses on the ground that the latter are connected with desire."

With this assertion our psychoanalytic antennae clearly start picking up signals: the idea of aesthetic transcendence, as I would call it – I would further qualify it as transcendence of contingency – begins to come into psychoanalytic focus. But before we psychoanalytically judge and tune in to it, let us further refine and deepen our sense of what is implied by aesthetic transcendence. It suggests a kind of judgment on existence – a recognition of and response to its essential mediocrity and misery. It implies a need to emotionally distance oneself from it, to achieve what might be regarded as a quasi-Buddhist sense of desirelessness or detachment, desire being the root of attachment to existence, attachment always leading to emotional and practical problems. No doubt the pathos of aesthetic distance can ironically be regarded as part of the pathos of existence, but it is meant to articulate transcendence of the pathos of the human-all-too-human – which is exactly what psychoanalysis delves into. Indeed, some aestheticians regard aesthetic disinterestedness as a way of operationalizing the Silenian wisdom that it is better not to have lived than to

have lived. Certainly it seems one way of awakening from the (unending) nightmare of history, as James Joyce stated the problem. In general, taken on its own terms, the aesthetic attitude seems to afford a certain "superiority" to existence. The pleasure it affords is not simply a pale version of sexual pleasure, as Freud thought. The pleasure of transcendence is as strong and intense as sexual pleasure, as Pater implied, and as difficult to sustain, but they are different in kind. Roger Fry suggests as much in his critique of a Freudian approach to art,[5] as does Malevich, in his insistence that art must not serve the state or religion – they seem to have divided up existence between them – but rather articulate what he called nonobjective sensation and feeling, associated for him with the "spirit," that is, transcendence.

Moreover, while aesthetic transcendence, according to Kant and other aestheticians, is not the monopoly of art – one is able to take an aesthetic attitude to any experience, even an unpleasant toothache – art-created form (style) is a deliberately designed means of aesthetic transcendence. When Donald Kaplan quotes Lévi-Strauss's idea of art as "miniaturization" and Kris's view that it is "a simplification, a reduction of reality,"[6] or, in Kaplan's own words, "a real experiment with form, that is, with scale and reduction,"[7] and notes "the artist's reduction of interest to issues of form,"[8] Kaplan is pointing out the wide and finally unbridgeable gap that separates the artistic fiction generated by stylistic transformation – and its attendant aesthetic effects – from the actuality of the lifeworld.

We need to acknowledge one more element in the aesthetic equation to position ourselves to understand aesthetic disinterestedness psychoanalytically, if the aestheticians will allow us to so violate it. Assuming that art is a privileged zone of aesthetic experience – tailor-made, as it were, for the cultivation of aesthetic disinterestedness – we must ask what quality artistic form has that makes it so catalytic of disinterestedness, so conducive to the experience of aesthetic transcendence. Trosman tells us: "The aesthetic response to the form of a work is contingent on the perception of a constructed unity, which resonates with the coherence and form given to the self."[9] It is the uniqueness of particular modes of unity that Freud missed or ignored in his pursuit of the unconscious content of the work of art. Aestheticians and aesthetic critics, from Oscar Wilde through Roger Fry to Clement Greenberg, have emphasized the formal unity of the work of art as its salient quality. They never speak of form alone, but of formal unity. Greenberg preferred to attend to the work's literal order of effects rather than its preconscious and unconscious order of effects, as he called them, because it was in the literal order of effects that unity emerged, while in the preconscious and unconscious order of effects – which psychoanalysis attends to – no unity of effects is likely, or indeed, possible. Even modern dissonance or disunity comes to be experienced as potential or quasi-unity, as Adorno noted, that is, as delayed or "more difficult" (than traditional) unity. It is the experience of formal unity that catalyzes aesthetic disinterestedness. It should be noted that to describe unity as a unity of opposites, as is customarily done – as a miniaturization of lifeworld and

psychic conflict – is to simplify it, indeed, to undermine the complexity and subtlety of connection in a successfully unified work of art, in which all parts seem formally equivalent.

What, then, is one to psychoanalytically make of the aesthetic response of disinterestedness to formal unity? Trosman gives us one important answer in his correlation of the work of art's constructed unity with the self's struggle for coherence and form – "integrity." His assertion that the ego is the "locus" of aesthetic pleasure is a further elaboration of this.[10] His ideas make good sense, for the achievement of formal unity implies the reconciliation of conflicting formal elements – a balancing of formal forces, so to speak, which can no doubt be regarded as analogous to the balancing of psychic forces. Trosman also brings the superego into play in his analysis. He notes that there is a normative aspect to aesthetic appreciation, in that "standards of beauty . . . provide an ideal against which the worth of a work can be measured."[11] For Trosman such standards are connected to the artist's striving "for perfection of form . . . preserving some aspect of infantile narcissism in the work, which is an ideal extension of his or her self."[12] But, as Kant said, standards of beauty are not empirically provable, although making logical claim to universal validity. That is, they "ought" to be accepted but will not necessarily be. One artist's perfection is another artist's poison, as the history of art and taste readily reveal. Kaplan also notes the role of the superego in art, and culture in general. Freud, Kaplan writes, "did not regard the superego, hence culture, wholly as an imposition on autonomy . . . for the transpersonal aspect of the superego was, in Freud's view, a liberation of the individual from the tyrannies of personal history."[13] This seems to correlate with Kant's notion of the aesthetic judgment as "existentially" disinterested, that is, psychically liberating from personal, even sociohistorical, existence.

Certainly these, as well as other, psychoanalytic efforts to move away from a strictly psychosexual understanding of the psychology of aesthetic disinterestedness make good psychoanalytic sense. But I want to suggest that they ignore one phenomenological feature of aesthetic disinterestedness that provides a clue to an even more complete psychoanalytic understanding of it. Aestheticians agree that in aesthetic experience or appreciation there is hyperalertness or hypersensitivity to the formal elements of the work of art. There is an intense scrutiny of them which is indifferent to their iconographic identity or narrative function. They are apprehended – cognized, "realized" – in their nameless immediacy. I think that what occurs, psychoanalytically speaking, in the contemplation of nameless immediacy is the stripping away of the psyche's sedimented identifications. The desirelessness embodied in aesthetic disinterestedness has to do with the liberation of the aesthetic appreciator from identities that are not his own, or at least are recognized as alien through aesthetic disinterestedness. This is akin to what Osborne calls, as previously noted, the denuding of the work's iconographic interests to recognize its formal core. This is not so much a kind of disavowal as a kind of neutralization of their existence, especially of its toxicity. No doubt some de-cathecting is involved, but something more crucial is at stake: the recognition that their

existence is a fiction, at least in the psyche of the appreciator and in the state of aesthetic disinterestedness. In other words, an art "operation" is performed on them, on a par with the "operation" art performs on reality – attenuates and simplifies it, to the point where it finally comes to seem no more than a formal matter, even a kind of theatrical game, and thus under control. The aesthetic reduction of internal reality parallels the artistic reduction of external experience.

The upshot of this, for me, is the realization of a sense of invulnerability, which no doubt is connected with Freud's notion of omnipotence, only, as we will see, it has a different point. When Oscar Wilde said that the work of art was "the only shield against the sordid perils of actual existence"[14] he was making the aesthetic point succinctly. His statement epitomizes what is psychologically at stake in the aesthetic attitude. The sense of invulnerability is the grandest, and as I hope to show, the most necessary of all illusions – delusions. It is the illusion that the formal integration of the work of art catalyzes. From the aesthetic viewpoint, we go to art to remove our selves from life, not just as an empty exercise in distancing – a temporary emotional escape – but because distance contains within itself the germ and myth of invulnerability, untouchability. Out of this the idea of the sacred grows, that is, the idea of the divineness of art. Art – or rather, the formal element in art – is compensation for and relief from the personal feeling of vulnerability that invariably comes with the recognition of impersonal reality.

But that is not the end of a possible psychoanalytic account of aesthetic disinterestedness. The sense of what Kant called "purposiveness without purpose" inherent in formally adequate art (profound formal unity) implies not only a sense of the inner harmony – "the mutual subjective harmony of our cognitive powers," among other phrasings – that comes with a sense of the fittingness of our perception to its object – as Kant put it, the sense of the perceived thing and our cognitive faculties being "adapted" to one another – but the "free and unimpeded interplay of imagination and understanding," for Kant inseparable from the "vitality" which he held "to be an essential of great art." The psychic shield which aesthetic disinterestedness is not only protects against reality, but behind the aesthetic shield a zone of psychic freedom is established. The illusion of invulnerability permits the free functioning of the psyche – allows it to become extraordinarily vital – but something more – mind – than body is at stake. This zone of vital, free mentation – of fictive play – is akin to the zone of transitional phenomena, but something else is at stake in it: the free, seemingly irresponsible, imagination and conceptualization – they become simultaneous – of the lifeworld. It is the zone of so-called creativity.

Kant differentiated between rational or intellectual ideas, which are referred to transcendental concepts, to which experience can never be fully adequate – they "strain after something lying out beyond the confines of experience" – and aesthetic ideas, "representations of imagination" which "induce much thought, yet without the possibility of any definite thought whatever, i.e., concept, being adequate to it, and which language consequently can never get

they think it has merit – value in itself. Presumably only the latter are serious collectors, and are, along with the objects in their collections, honored by society for their seriousness. They are much more discriminating than the blind enthusiast, and society rewards them for it. But is there any serious collector who does not collect because of the demands of his emotions, however much their character may be obscured by reason of their spontaneous investment in the art object?

Let us, briefly, return to the social side of collecting, in order to suggest its complexity. Status is secondary recognition, for it is derived from the art object, which ostensibly has primary value. However, as we well know, these days – but also in the past – many works of art borrow their fame from that of their collector, often an important man in the community. If he is unimportant, then the objects get their fame by association with each other. That is, with the passage of time and the growth of a positive consensus about the collection, its fame as a whole will rub off on its parts. Rarely do art objects get their fame on their own. An object that seems independently famous – a text unto itself – is the precipitate of a long line of contexts on which it is dependent. These contexts are ignored when, for whatever private or public reason, the urge to idolize proves irrepressible, making the object seem irresistible, and creating the illusion that it is in a class by itself.

As for profit, the collectors expect more than the usual fair share, for the risk of collecting is enormous. It is a speculative enterprise in more than one way. Not only is the exchange value of the art object unpredictable, but its use value is negligible. (At least until it is appropriated and mythologized by society as profound, and seems to prove, in turn, the society's profound, timeless significance.) And for every theorist who grants it intrinsic value, there is a social observer who notes that in practice this value is compromised by the paradoxical dependence of the object on the fickle eye of the beholder. Thus, the art object has its vicissitudes. The collector wants some tangible payoff for betting on something that has no stable value. He would be very disappointed if he got only status from it. It would hardly compensate his anxiety.

I am interested not in these economic and epistemological vicissitudes, which make collecting an exciting game for those who can afford to play it, but the more obscure personal reasons for collecting – the peculiarly personal relationship a collector has with his collection. I submit that even the collector who seems most cold-blooded about his collection – who speculates in art objects the way a commodities broker speculates in futures – has some secret attachment to it. He values it not just because it brings him social attention, but because of the inner attention he gives it – perhaps unknown even to himself – and which, fantastically, he expects from it. It may be that the unconscious meaning of his collection – its role in his fantasy life – is secondary in his mind to its commercial potential, but it nonetheless exists, guiding the collection the way the Christ child guided the blind St. Christopher. That giant was dependent on the sight of a sacred child. Or, shall we say, following the popular wisdom, that every collector is guided by his instincts, his hunches.

340

This is what Freud meant when he said that the ego thinks it is controlling the id – much as rider thinks he is directing his horse – but in fact the id is going where it wants to. The ego later realizes this, especially when it finds itself in a spot it didn't expect to be in. When the collector finds he has a collection he didn't expect to have when he started collecting, he is face-to-face with his instincts. If he is shrewd and has some interest in understanding the character of his emotional investment in art, he will regard the works in his collection as so many tea leaves – dregs in the cup of his consciousness, omens from below, signs of his destiny and inner self.

I want to argue that collecting is psychologically a narcissistic matter, whatever it might be socially. It is the solution to a narcissistic problem – a certain kind of answer to self-doubt. It is a strategy of self-determination before it is anything else. The collector collects to satisfy himself; the approval of the world is a secondary matter. Why turn to aesthetic properties for an elementary sense of well-being, of self-completion, that might be had from other objects, and with less trouble? But the collector has unconsciously reached a point in life where he realizes that there are no other objects – no objects that can be as satisfying as art objects. Experiencing all other objects as failing him, even – especially – his most intimate ones, he turns to art objects as his last hope for a deep relationship. He establishes an intimacy with them based on the assumption that they will never fail him. They are a profound wish-fulfillment. He relates to them as though in a good dream. This regressive relationship is not unlike that of an infant to the nourishing breast, that marvellous part-object that seems like a world unto itself.

He treats them as he treats himself, for they are extensions of him: he merges with them. Moreover, the art objects he owns can never abandon him, but he can abandon them. They are his pride and pleasure, but he rules their existence. They endure at his mercy. If he wishes, he can neglect rather than preserve them, even give them away in a potlatch ceremony – which in a sense is what making a gift of them to a museum is – rather than delight in their presence forever. He attends to them or not, as his whim decrees. Once he has them, he can do what he wishes with them: that is narcissistic power.

I have met collectors who think of themselves as the temporary caretakers of their permanent objects, holding them in trust until they pass away and their objects pass on to a caring society, which will keep them in perpetuity for the edification of its members. The objects are thought to be of value in themselves, eternally enduring, and thus worthy of the glory society confers on them. The collectors think of themselves as of value only insofar as they protect the objects from the contingencies of the world, which include the indifference of the ignorant and the marks of time. The collectors think the ignorant – those who wonder what all the fuss about art is about – are beside the point, and that time might blemish but can never truly ravage the art object. It is beyond the reach of fools and transience.

I think such a collector is deceiving himself. The immortality and well-being of the art object is of less interest to him than his own. The direct attention paid to the art object is of less interest than the indirect attention

expecting an impossible reciprocity from it, a reciprocity difficult to achieve even with a human being – the detachment of disillusionment, he regards the art object as insubstantial. It is simply a symbol that must be interpreted, if it is to make realistic sense, like everything else ordinarily in the world; but he was never seriously interested in its realistic sense, never thought it existed in an ordinary way. Reduced to a cognitive rather than emotional relationship with it – a possible rather than impossible one – he dismisses it altogether. He never wanted to understand it, never wanted it to make sense. He wanted it to continue to exist in all its insinuating perfection – its emotional meaning for him. And so, not wanting – not emotionally able – to relate to it in an adult way, he at last sells it, removing it from his life altogether. Collections are sold – it is a kind of destruction of them – when they no longer sustain the collector emotionally, that is, when their contents have become all too real. In the end, intellectual and commercial investments in art win out over emotional investment. It becomes just like any other object.

30

Critical Reflections

Post-modernist art is decadent, not because it is a falling off or away – which is what "decadence" means etymologically – from Modernism, but because it signals the marginalization of all styles, past and present. The idea of any art as more central than any other is anathema in today's art world, which is so anxiously sensitive to the artistic rights of the "other," so eager to give anything a fair hearing, that all assertions of centrality are immediately stomped on as authoritarian hyperbole. But the decadence of post-Modernism means more than the laissez-faire of pluralism or multiculturalism. More subtly, it means the end of the debate between the old and the new that inaugurated consciousness of being modern. Both the old masters and the Modernist masters are now reified as post-Modern masters. That is, they are reduced to instances of a general art rhetoric. They lose all particularity of time and place – and of being and meaning – and become simply pieces in a perpetual chess-game of art.

It is a game in which no piece can ever take – dominate – another, except in heuristic make-believe, and in which every piece has the same power of movement: every piece is king, with the same royal significance. There are no pawns, for the post-Modernist art game denies any hierarchy. That is why it is not clear how to win the game. Yet the criteria of criticism depend on a sense of hierarchy, which may – must – be debated, but is inevitable, in practice if not in theory. Choices are made, and preferences emerge. The post-Modernist point seems to be not to win the art game with a style of one's own, but to bring as many passé pieces of style as possible into play in a single work – this is the new way of being outré – as though the rules of a new game might emerge out of their interplay.

More subtly, one of the meanings of post-Modernism is that no art can ever again be modern in the sense of modishly new, definitive of our "nowness." To be modern initially meant to refuse to define oneself by old authority – to insist that one could define oneself on one's own terms. The old world no longer exists, after all; why look to it to understand the modern

self? To be modern meant to try to look freshly, without presuppositions, at the world one was born into and the self one had. In a sense, all modern artists are like either Francis Bacon or René Descartes, 17th-century thinkers who claimed respectively to observe the world with empirical freshness and to uncover, unaided, a self fundamental to itself. In the Modernist movement, both world and self came to exist experimentally, that is, as hypotheses for which there was no final proof. Thus art relinquished the security of the traditional, absolute sense of world and self, and was free to take the risks of being modern. Shrugging off the past – Modernism is one of those revolutionary moments when the past seems overwhelming and must be dismissed as irrelevant – art could unapologetically find new methods of being and meaning. It could even aspire to make being seem all of meaning, or meaning adequate to being, producing works that seemed triumphantly immediate, definitive of the present – pure presence, truly modern and fresh.

All of this is by way of describing what I mean by decadence, which I see not as a "bad" state transitional from a "good" one, but as inevitable in a complex civilization, which offers as many choices as possible to as many of its members as care to accept them. Decadence complicates and makes life difficult; it is the antithesis of any sort of fundamentalism, which simplifies and makes life easy. Decadence is not the time between gods (the centers) – the time when the old fundamentalism is dead and the new one waits to be born – but a desperately divine moment in itself. No doubt the sense of decadence is a feeling rather than a truth, but then no truth exists without a feeling. As Freud said, even the most psychotic feeling about the world – including the art world, I might add – has more than a grain of objective truth to it.

The feeling of decadence is significant whenever and wherever it occurs – and it has occurred frequently throughout history (whether it is deplored as a loss of moral potency or valued as a "proof" of unique creativity) – because it indicates that those who experience it are sharply critical of the world. Indeed, they are skeptical of the world to the extent of implying not only that its products are unsatisfying but that they can never be satisfying. To experience an art scene as decadent is to give up expectation of significant satisfaction from art, which may be taken seriously as an objective cultural symptom, but is not expected to support and enhance anyone's subjective sense of self.

The critic must wonder, then, why artworks are needed, if in fact they are. Their disappointing character eventually makes one question one's desire for art in general. Unsatisfied, desire turns away from the object in which it has invested so much. This is not a philistine loss of interest because art is not instantly, sensuously gratifying, but the result of an experience of art as failing to afford the subtlest emotional gratifications, especially the sense of significant self. Post-Modern art may finally come to seem nothing but a method for the infinite deferral of gratification. From this perspective of radical dissatisfaction, it begins to look like a subtle force for the social control of feeling, an ingenious instrument of subjective conformity – a new way of stifling the sense of being a subject.

A critic working in a post-Modern art scene cannot help but experience its products as decadent, for they present themselves fascistically, as it were – overobjectified and undersubjectified. They seem reified to the point of no human return. Like a Potemkin village, they put on a good front, but are uninhabitable. They are the flattened relics of an indifferent socialization process, and cannot help but evoke a decadent response – matter-of-fact acknowledgment and subjective disapproval.

In these post-Modern days, the critic is necessarily as decadent as the art. Unlike the art, however, the critic also manifests a counterdecadent tendency, at least if he or she is truly troubled about the art of the time. If critics are really dissatisfied with art, if it makes no subjective sense to them, then they are ultimately faced with the choice of either abandoning it or trying to dereify it. In practice, this means renewing their desire for it – finding a subjective raison d'être for it, a subjective reason for investing mind and heart in it. I believe that every significant modern critic, from Diderot and Baudelaire to Harold Rosenberg and on, has been subliminally informed by a sense of the decadence of the art of the time, and by a desire to resist it. Critics are frustrated perceivers, but within that frustration they renew their faith in art as a whole, and they make a decision to desire.

The modern is inherently frustrating, for the moment art makes it concrete, describing its process in seemingly quintessential form, it seems to be reified. To name the present, after all, is to undermine its presentness, to suggest its spuriousness. When Diderot elevates Vernet, then, or Baudelaire elevates Delacroix, or Apollinaire elevates Picasso, or Roger Fry elevates Cézanne, or Clement Greenberg elevates Jules Olitski, or Rosenberg elevates Arshile Gorky, he is declaring that this artist's works are inherently desirable and satisfying in contrast to the undesirable, frustrating, decadent scene in which they are made. They save the scene from itself. To each critic, all the other art products in the scene are reifications of a general idea of art rather than renewed particularizations of it. The critic is declaring that the work of the artist he or she advocates is not based on a fetishized concept of art derived from its past history but is a fresh affirmation of art's being, a fresh modernization of it. Since the beginning of modernity, the critic has always tried to determine what is modern within a scene that always seems decadent – post-Modern. Post-Modernism has been around since the beginning of Modernism, which in a sense was a response to a post-Modern sort of decadence.

Such critical decisions invariably redifferentiate – and, worse yet, hierarchically reorder – the reified art scene. But the fact of the matter is that the ice of reification that is broken by the critic's desire quickly closes over the churning sea of art that criticism reveals beneath it. The sinking feeling of decadence returns. It is an eternal return, for the works of even the most truly modern artist eventually turn into pillars of salt – reduce into reified moments of immediacy. Sooner or later they fail desire, losing their sense of nowness and modernity. They lose presence and face. Modernism and post-Modernism exist in a cannibalistic dialectic: the latter invariably consumes the former, with increasing eagerness and rapidity. As the spectacle of art replacing art continues,

the critic comes to realize that by its nature the modern is impossible to specify. It has no core. Every hard-won critical description fades into the oblivion of a reification – becomes post-Modern. Why trouble to develop a "fundamentally" new stylistic sense or "definition" of modernity when it will quickly come to seem beside the point?

Critics of decadence are in a strange position: they are no longer clear whether they are fighting, with their desire, for an art that will articulate the modern with a new sense of fundamentality, or whether they are fighting against the post-Modernizing process. But decadence seems inevitable whatever they do; every theoretical revitalization of an art seems, paradoxically, to hasten its post-Modernization. Even subjective justifications of post-Modern art meant to remodernize it seem no more than delaying actions, stays of execution.

The only way out of this pessimistic situation is for the critic to practice a peculiar promiscuity. It's not that one must respond enthusiastically to the decadent pluralism of the art scene. One must, however, differentiate one's desire in the face of the short-lived satisfaction of entropic post-Modern art. The critic realizes that the opposed extremes of either total dissatisfaction with art or ecstatic, fundamentalist commitment to the "true" art are avoidable if one accepts the transience of every critical remodernization of art – every relation to art. One neither overcommits nor undercommits oneself to an art, but individuates one's desire in a way appropriate to it.

Implicitly, the critic's desire remains limitless, while seeming limited – as limited as the art. Desire's rediscovery of the limits of the object of desire save it from total bankruptcy. The critic is aided by the feeling that he or she is sidestepping the dialectic of decadence and rejuvenation. In fact, of course, the critic continues to participate in its operation. But the illusion of eluding it is psychologically necessary, and serves the basic concern of protecting the critic from deep and complete dissatisfaction. My critic turns on its head Nietzsche's Dionysian assertion that art's purpose is to keep desire alive, and thereby to keep strong the will to live: it seems that the purpose of desire is to make an art seem uncannily alive, for however short a term. Such perpetual reinvestment in art is a necessity of life and, no doubt, of art.

350

Notes

1. The Pathology and Health of Art

1. Paul Gauguin, *Writings of a Savage,* ed. Daniel Guerin (New York: Viking, 1977), 89, 70, 71. All page numbers in parentheses in this chapter are references to this book.
2. H. S. Sullivan, *The Interpersonal Theory of Psychiatry* (New York: Norton, 1953), p. 28.
3. E. Rieff, *The Mind of the Moralist* (Garden City, N. Y.: Doubleday, 1961), p. 292.
4. C. Baudelaire, *The Mirror of Art,* ed. Jonathan Mayne (Garden City, N.Y.: Doubleday, 1956).
5. Ibid., p. 206.
6. Ibid., p. 276.
7. Ibid., p. 204.
8. Ibid., p. 207.
9. Ibid., p. 204.
10. Ibid., p. 276.
11. E. Fromm, *The Crisis of Psychoanalysis* (Greenwich, Conn.: Fawcett), pp. 191–92.
12. Ibid., p. 192.

2. The Process of Idealization of Woman in Matisse's Art

1. Albert E. Elsen, *The Sculpture of Henri Matisse* (New York: Abrams, 1972), p. 26. Elsen's remark reflects, no doubt unwittingly, the use of lawful, ideal beauty to repress physical expression advocated by Lessing in the *Laocoön.* I suggest that for Matisse, in his Fauve phase, woman's body is the expressive equivalent of Laocoön's scream. It is not so much that the expressivity of both is unrepresentable as that representation must repress it, which is what Matisse finally accomplishes through his idealization of it.
2. Barbara Rose, ed., *Art-as-Art: The Selected Writings of Ad Reinhardt* (New York: Viking Press, Documents of 20th-Century Art, 1975), p. 208.
3. Pierre Schneider, *Matisse* (New York: Rizzoli, 1984), p. 96.
4. See Victor Tausk, "On the Origin of the Influencing Machine in Schizophrenia," *Psychoanalytic Quarterly* 2 (1933):519–56. As Michael Eigen says in *The Psychotic*

Core (Northvale, N.J.: Aronson, 1986), p. 329, "In the influencing machine de-lusion, the psychotic patient feels that his mind is being taken over and influenced by a distant machine."

5. Elsen, *Sculpture of Henri Matisse*, p. 48.

6. Ibid., p. 58.

7. Quoted in Jack Flam, ed., *Matisse on Art* (New York: Dutton, 1978), p. 82. See also pp. 93–95, Matisse's "Conversations with Aragon, 1943 (On Signs)."

8. Quoted in Flam, *Matisse on Art,* p. 113.

9. Ibid., p. 36.

10. Elsen, *Sculpture of Henri Matisse*, p. 58.

11. Schneider, *Matisse,* p. 63.

12. Elsen, *Sculpture of Henri Matisse,* p. 18.

13. Quoted in Flam, *Matisse on Art,* p. 37.

14. Henry Havard, *La décoration,* quoted in ibid., p. 21, who notes the "direct parallel" between Havard's ideas and those of Matisse in "Notes of a Painter."

15. Ibid., p. 42.

16. Elsen, *Sculpture of Henri Matisse,* p. 26.

17. Schneider, *Matisse,* p. 63.

18. Ibid., p. 67.

19. See p. 155, this volume.

20. Flam, *Matisse on Art,* p. 161, n. 7.

21. Quoted in ibid., p. 82.

22. Ibid., p. 66.

23. Ibid.

24. Ibid., pp. 42–43.

25. Ibid., p. 42.

26. Ibid., p. 38.

27. Ibid., p. 82.

28. Ibid., p. 38. See also p. 124, where, some forty years later (1949), he reiterates that "art should not be worrying or disturbing – it should be balanced, pure, tranquil, restful."

29. Quoted in Schneider, *Matisse,* p. 10.

30. Ibid.

31. Ibid.

32. Ibid., p. 671.

33. Ibid.

34. Elsen, p. 20.

35. Quoted in Flam, *Matisse on Art,* p. 82. See also p. 90.

36. Dominique Fourcade, "An Uninterrupted Story," in *Henri Matisse: The Early Years in Nice, 1916–1930,* ed. Jack Cowart (Washington, D.C.: National Gallery of Art, 1986; exh. cat.), p. 57.

37. Quoted in ibid., p. 57.

38. Quoted in Elsen, *Sculpture of Henri Matisse,* p. 78.

39. Ibid., pp. 18, 20.

40. Sigmund Freud, "On Narcissism: An Introduction" (1914), Standard Edition (London: Hogarth Press and the Institute of Psycho-Analysis, 1953), vol. 14, p. 94.

41. Sigmund Freud, "Group Psychology and the Analysis of the Ego" (1921), Standard Edition (London: Hogarth Press and the Institute of Psycho-Analysis, 1953), vol. 18, pp. 112–13.

42. See Flam, *Matisse on Art,* p. 62.

43. See ibid., pp. 106, 114.

44. Alfred H. Barr, Jr., *Matisse: His Art and His Public* (New York: Museum of Modern Art, 1974; exh. cat. 1951), p. 13.

45. Marcelin Pleynet, *Painting and System* (Chicago: University of Chicago Press, 1984), pp. 45–46.

46. See "Henri Matisse at Home, 1944" in Flam, *Matisse on Art*, pp. 96–98. See p. 85 for the seriousness with which Matisse, "whose colleagues at Jambon's had called him the doctor," took sickness, real or possible (or imaginary). See also Schneider, *Matisse*, p. 313. Matisse lived "in a sort of jungle" atmosphere (Flam, *Matisse on Art*, p. 95), a bright hothouse environment in which health was to flourish, or rather, a tropical paradise in which sickness was not allowed to enter. He once said, "Fauvism overthrew the tyranny of Divisionism. One can't live in a house too well kept, a house kept by country aunts. One has to go off into the jungle to find simpler ways that won't stifle the spirit" (ibid., p. 58). Only then can Matisse "release" and "render [his] emotion" (ibid., pp. 58–59).

 It is worth noting that Matisse's art became most innovative after he was seriously ill. It became freshly daring as part of a recuperative process, which was protracted psychologically. (What had to be healed was the damage done to his body ego, which was accomplished by identifying it with his mother's idealized body.) This occurred in his youth (1890), after his difficult appendectomy, which a decade later led to his Fauvist breakthrough; and in old age, after the January 1941 operation that almost took his life and that six years later led to the breakthrough of the cutouts. As he acknowledged in a letter to Pierre Bonnard, the latter operation "had a profound psychological effect upon him." (John Elderfield, *Matisse's Cutouts* [New York: Museum of Modern Art, 1984], p. 18.) In 1942 he wrote to Albert Marquet: "My terrible operation . . . has completely rejuvenated and made a philosopher out of me. . . . I had so completely prepared for my exit from life, that it seems to me I am in a second life." In 1952 – he died in 1954 – he wrote to Hans Jedlicka: "What I did before this illness, before this operation, always had the feeling of too much effort; before this, I always lived with my belt tightened. What I created afterwards represents me myself: free and detached." Both quotations are from ibid., p. 43.

47. Heinz Kohut, *The Restoration of the Self* (New York: International Universities Press, 1977), p. 56.

48. Elderfield, *Matisse's Cutouts*, p. 35, notes that while Matisse does not seem to have been aware of theories of color healing, many of his ideas about the healing effect of color were in accord with those of the color healers. Elderfield cites Roland Hunt's *The Seven Keys to Colour Healing* (London: C. W. Daniel Co., 1971; reprint) in particular. "Matisse's use of violet in a portrait of his studio and later in the Vence chapel would have been considered appropriate by Hunt," who regarded violet as "the ideal Purifier." Hunt cited Leonardo da Vinci, who said: "Our power of meditation can be increased tenfold if we meditate under the rays of the violet light falling softly through the stained-glass windows of a quiet church."

49. Quoted in John Elderfield, "Describing Matisse," *Henri Matisse, A Retrospective* (New York: Museum of Modern Art, 1992), p. 29.

50. W. Ronald D. Fairbairn, *Psychoanalytic Studies of the Personality* (London: Routledge & Kegan Paul, 1952), p. 38. In Freud's language, his mother's gift strengthened his attachment to or anaclitic love for her ("On Narcissism: An Introduction," p. 90). This love expressed itself in or was sublimated into his lifelong attachment to idealized color. (Shadowless color was the ultimately ideal color.) Color was

ideal because his mother had given it to him. In general, his religious awe of his mother, by reason of the gift of art she gave him, is expressed in his deep feeling for color.

Meira Likierman, "Clinical Significance of Aesthetic Experience," *International Review of Psycho-Analysis* 16, pt. 2 (1989):138–39, observes that "the term 'ideal' has been associated in psychoanalytic thinking with pathological mechanisms or 'manic defences' which are characterized by denial and omnipotence. The 'idealized' object is a too-good-to-be-true, false creation, a sham and a 'cover-up' for its denigrated, split-off counterpart. Excessive idealizing signals an attack on truth and an undermining of mental health. All psychological orientations emphasize the presence of 'idealizing' in pathological states such as perversions, narcissism and borderline states." However, Likierman (ibid., p. 139) points out that "far from being an illusion, the ideal is an aspect of reality which is integral to any experiencing of goodness. The ideal comprises the very essence and core of good-ness, and so remains an inevitable dimension of all good experiences. The indi-vidual's experiencing of the ideal, far from being defensive, could indicate his ability to lay himself open to the full impact of goodness, and allow himself to be stirred at the deepest levels by its very essence. An experience of this kind inspires awe for a 'good' that is greater than the self, as opposed to the omnipotent 'ideal' which magnifies the self." I think Matisse had it both ways: his mother's gift of art made her incestuously attractive, which he defended himself against by ideal-izing her; at the same time, the gift was in fact very good for Matisse and taught him the goodness of giving as such as well as the goodness that comes of giving art. This also made Matisse's mother ideal. She was ideal because he narcissistically aggrandized her apparent omnipotence and because her gift was the best, most maturing thing that had happened to him in his adolescent life. The gift also made him aware that there was a greater good than the self, namely, the art that could heal it. Art was a real good, and his mother was really good in giving it to him and showing him that it could be as mothering – inherently good – as she was.

51. See Schneider, *Matisse,* pp. 618, 737.
52. Fairbairn, *Psychoanalytic Studies,* pp. 135–36.

3. Cubist Hypochondria

1. John Golding, *Cubism: A History and an Analysis, 1907–1914,* Boston: Boston Book & Art Shop, 1968, p. 15.
2. Daniel-Henry Kahnweiler, quoted in John Berger, *The Moment of Cubism and Other Essays,* New York: Pantheon, 1969, p. 5.
3. Clement Greenberg, *Art and Culture,* Boston: Beacon Press, 1965, p. 97.
4. Ibid.
5. Berger, p. 13.
6. See Douglas Cooper, *The Cubist Epoch,* London: Phaidon Press, 1970, p. 59.
7. Georges Braque, quoted in ibid., p. 42.
8. Phyllis Greenacre, "Early Physical Determinants in the Development of the Sense of Identity," *Journal of the American Psychoanalytic Association* 6, 1958, pp. 612–27.
9. Berger, p. 10.
10. Ibid., p. 9.
11. Heinz Kohut, *The Restoration of the Self,* New York: International Universities Press, 1977, p. 271.
12. Ibid., p. 270.

13. John E. Gedo, *The Mind in Disorder: Psychoanalytic Models of Pathology,* Hillsdale, N.J.: The Analytic Press, 1988, p. 91.
14. Quoted in Cooper, p. 59.
15. Robert Rosenblum, *Cubism and Twentieth-Century Art,* New York: Harry N. Abrams, 1961, p. 34.
16. Ibid., p. 38.
17. Ibid., p. 60.
18. In "From Michelangelo to Picasso" (1912), Apollinaire compares the "sublime and mysterious" light in Picasso's Analytic Cubist works of the period with that of Rembrandt (*Apollinaire on Art: Essays and Reviews, 1902–1918,* New York: Viking Press, Documents of 20th-Century Art, 1972, p. 196). Similarly, in 1913, he notes with approval an exhibition of Picasso's and Braque's works next to Rembrandt's in an Amsterdam museum (p. 284). In general, Picasso's interest in Rembrandt reflects his preference for Northern manner, as evidenced in his assertion that he would "give the whole of Italian painting for Vermeer of Delft, who simply said what he had to say" (quoted in Dore Ashton, ed., *Picasso on Art: A Selection of Views,* New York: Viking Press, Documents of 20th-Century Art, 1972, p. 167). Picasso also admired the Le Nains, whose "awkwardnesses are almost proofs of authenticity" (ibid., p. 166). Analytic Cubism can be understood as a sum of awkwardnesses, refined into a whole in Synthetic Cubism. This confirms T. W. Adorno's principle that modern dissonance is quickly read as consonance, even by its own advocates. In general, Analytic Cubism can be understood as a kind of *maniera tedesca* in rebellion against the seductive charms of Mediterranean art. In Cubism, Picasso was not the Mediterranean artist he was before and after it.
19. Rosenblum, pp. 70–71.
20. Charles Baudelaire, "The Salon of 1859," in *The Mirror of Art,* ed. Jonathan Mayne Garden City, N.Y.: Doubleday & Co., Anchor Books, 1956, pp. 234–35.
21. Gedo, p. 95.
22. The bodily point of Picasso's art is made explicit by Berger in *Success and Failure of Picasso,* Baltimore: Penguin Books, 1965, p. 169. *Guernica,* 1937, is described as "a profoundly subjective work," making its effect through "what has happened to the bodies." Picasso offers "the imaginative equivalent of what happened to them in sensation in the flesh. We are made to feel their pain with our eyes. And pain is the protest of the body." The subjective, anxious body that *Guernica* brings to stylized fruition was first articulated, with amazing candor, in Cubism.
23. Edgar Levenson, "Real Frogs in Imaginary Gardens: Facts and Fantasies in Psychoanalysis," *Psychoanalytic Inquiry* 8 no. 4, 1988, p. 564.
24. Sigmund Freud, *Introductory Lectures on Psycho-Analysis,* Standard Edition, vol. 16, p. 332.
25. André Green, *On Private Madness,* Madison, Conn.: International Universities Press, 1986, p. 15.

4. Surrealism's Re-vision of Psychoanalysis

1. H. Kohut, *The Restoration of the Self* (New York: Viking, 1977), p. 285.
2. Ibid., p. 296.
3. A. Breton, *Surrealists on Art,* ed. L. Lippard (Englewood Cliffs, NJ: Prentice-Hall, 1970), p. 20.
4. Erich Fromm has analyzed the confusion between Freud's concept of psychological repression and the Marxist concept of social repression in his critique of Herbert

Marcuse. According to Fromm, ("The Crisis of Psychoanalysis," *The Crisis of Psychoanalysis* [Greenwich, CT: Fawcett, 1970], p. 28), Marcuse uses " 'repression' for both conscious and unconscious data," thus losing "the whole significance of Freud's concept of repression and unconscious. . . . indeed, the word 'repression' has two meanings: first, the conventional one, namely, to repress in the sense of oppress, or suppress; second, the psychological one used by Freud . . . namely, to remove something from awareness. The two meanings by themselves have nothing to do with each other. By using the concept of repression indiscriminately, Marcuse confuses the central issue of psychoanalysis. He plays on the double meaning of the word 'repression,' making it appear as if the two meanings were one, and in this process the meaning of repression in the psychoanalytic sense is lost – although a nice formula is found which unifies a political and a psychological category by the ambiguity of the word." Fromm goes on to say (pp. 28–29) that "the ideal of Marcuse's 'non-repressive' society seems to be an infantile paradise where all work is play and where there is no serious conflict or tragedy. . . . Marcuse's revolutionary rhetoric obscures the irrational and anti-revolutionary character of his attitude. Like some *avant garde* artists and writers from Sade and Marinetti to the present, he is attracted by infantile regression, perversions and . . . in a more hidden way by destruction and hate. To express the decay of a society in literature and art and to analyze it scientifically is valid enough, but it is the opposite of revolutionary if the artist or writer shares in, and glorifies the morbidity of a society he wants to change."

5. S. Freud, *New Introductory Lectures on Psycho-analysis,* trans. W. J. H. Sprott, rev. J. Strachey (New York: Norton), pp. 245–46.

6. Surrealism goes through many changes during its development, but the one element that remains constant – through ideological thick and thin – is its critique of the conception of "what is vulgarly understood by *the real*" (Breton, *Surrealism and Painting* [New York: Harper & Row, 1972], p. 2). As Breton says, for the Surrealists "reality is not only important theoretically," "but . . . it is also a matter of life and death" (Breton, "Surrealists on Art," p. 20). Breton is skeptical of those who pin "all their hopes on what they choose to call 'reality' " (*Surrealism and Painting,* p. 44) and argues for "a particular philosophy of immanence according to which surreality would be embodied in reality itself and would be neither superior nor exterior to it" (p. 46).

7. Breton, *Surrealists on Art,* p. 32.

8. Ibid., p. 19.

9. Ibid., p. 25.

10. Ibid., p. 15.

11. Ibid., p. 28.

12. K. Kraus, *No Compromise: Selected Writings of Karl Kraus* (New York: Ungar, 1977), p. 227.

13. In his critique of psychiatry, Breton anticipates Foucault, Guattari, Laing, and Szasz, among others. Breton's description of "Professor Claude at [the hospital] Sainte-Anne, with his dunce's forehead and that stubborn expression on his face" (Breton, *Nadja* [New York: Grove, 1960], p. 139) – the psychiatrist who puts words into his patient's mouth, "convicting" the patient of madness – is directly to the point.

14. Breton, *Surrealism and Painting,* p. 348.

15. Breton, *Surrealists on Art,* p. 15.

16. Ibid.

17. Ibid., p. 11.
18. L. Aragon, *Surrealists on Art,* ed. L. Lippard (Englewood Cliffs, NJ: Prentice-Hall, 1970), p. 37.
19. Breton, *Nadja,* pp. 142–43.
20. Ibid., p. 143.
21. Breton, *Surrealists on Art,* p. 11.
22. Breton, *Nadja,* p. 143.
23. Breton, *Surrealists on Art,* p. 26.
24. Ibid., p. 30.
25. Ibid., p. 29.
26. Ibid., p. 31.
27. Ibid., p. 23.
28. Breton, *Nadja,* p. 139. For an excellent account of the Surrealist attitude to women, see Xaviére Gauthier, *Surrealismus und Sexualität, Inszenierung der Weiblichkeit* (Berlin: Medusa Verlag, 1980).
29. Breton, *Surrealists on Art,* p. 11.
30. Ibid., p. 35.
31. R. Jacoby, *The Repression of Psychoanalysis* (New York: Basic, 1983), p. 10.
32. Ibid., p. 43.
33. Quoted in ibid.
34. Breton, *Nadja,* p. 111, describes Nadja as "a free genius, something like one of those spirits of the air which certain magical practices momentarily permit us to entertain but which we can never overcome."
35. Jacoby, *The Repression of Psychoanalysis,* p. 43.
36. Ibid.
37. Breton, *Surrealism and Painting,* p. 18.
38. Ibid., p. 2.
39. P. Rieff, *The Triumph of the Therapeutic* (New York: Harper & Row, 1968).
40. Quoted in J.D. Lichtenberg, "Is There a Weltanschauung to Be Developed from Psychoanalysis?" *The Future of Psychoanalysis,* ed. A. Goldberg (New York: International Universities Press, 1983), pp. 203–4.
41. Ibid., p. 219.
42. Ibid., p. 223.
43. Ibid., p. 203.
44. T.E. Hulme, "Reflections on Violence," *Speculations* (London: Routledge & Kegan Paul, 1936), pp. 255–56.
45. M. Jean, *The Autobiography of Surrealism* (New York: Viking, 1980), p. 304.
46. Freud, *New Introductory Lectures on Psycho-analysis,* p. 219.
47. Ibid., p. 218–19.

5. Dispensable Friends, Indispensable Ideologies

1. Victor Crastre, "Le Drame du surréalisme (1924–26)," *Les Temps Modernes,* no. 34, July 1949, p. 54. My translation.
2. André Breton, *Manifestes du surréalisme* (Paris: Pauvert, 1962), p. 285.
3. Breton, p. 342.
4. "Une Mise au point d'André Breton," *Le Figaro littéraire,* May 19, 1951, p. 3.
5. Quoted by Mary Ann Caws, *Surrealism and the Literary Imagination: A Study of Breton and Bachelard* (The Hague: Mouton, 1966), p. 74.
6. Clifford Browder, *André Breton, Arbiter of Surrealism* (Geneva: Droz, 1967), p. 17.

7. Letter of April 29, 1917, in Jacques Vaché, *Les Lettres de guerre de Jacques Vaché, suivies d'une nouvelle* (Paris: K Editeur, 1949).

8. Breton, *Manifestes du surréalisme*, p. 343.

9. Browder, p. 42, in paraphrase of Sartre. In section IV, "Situation of Writing in 1947," in *What Is Literature?* Sartre in effect denied that Surrealism was an engaged literature.

10. Theodor W. Adorno, *Negative Dialectics* (New York: Seabury, 1973), p. 49.

11. Claude Mauriac, *André Breton* (Paris: Editions de Flore, 1949), p. 345.

12. Mary Ann Caws, *André Breton* (New York, Twayne Publishers, 1971), p. 16.

13. The quotes in this and the next paragraph are taken from Browder, pp. 21–25, 34, 124, and 168–69.

14. Browder, p. 22.

15. Elisabeth Lenk, "Indiscretions of the Literary Beast: Pariah Consciousness of Women Writers since Romanticism," *New German Critique*, no. 27, Fall 1982, p. 106.

16. Browder, p. 14.

17. Annabelle Melzer, *Latest Rage the Big Drum; Dada and Surrealist Performance* (Ann Arbor: UMI Research Press, 1980), p. 184.

18. Lenk, pp. 106–7.

19. Browder, p. 146.

20. René Girard, *Violence and the Sacred* (Baltimore: Johns Hopkins University Press, 1979), p. 286.

21. Lenk, p. 107.

6. Choosing Psychosis

1. Elizabeth M. Legge, *Max Ernst: Psychoanalytic Sources* (Ann Arbor, UMI Research Press, 1989), chapter 3.

2. I am alluding to Jean Arp's remark, in a text dealing with Ernst's work, "that one doesn't consume Sir Father, except slice by slice: impossible to finish him off in a single picnic." Quoted by Legge, *Max Ernst*, p. 10. Arp is alluding to the primal cannibalistic myth of the sons devouring the father in Freud's *Totem and Taboo*.

3. In his autobiographic notes, Ernst wrote: "(1914) Max Ernst died on the 1st of August 1914. He was resuscitated the 11th of November 1918, as a young man aspiring to become a magician and to find the myth of his time." Quoted by Legge, *Max Ernst*, p. 2.

4. A good example is his account of his "first encounter with hallucination" in 1897, when he had measles. See Legge, *Max Ernst*, p. 78. As Legge (p. 8) points out, Ernst was determined to increase his hallucinatory powers by any means.

5. André Breton, *Surrealism and Painting* (New York, Harper & Row, 1972), p. 74.

6. Ibid., p. 129.

7. As quoted in Lucy Lippard, ed., *Surrealists on Art* (Englewood Cliffs, N.J., Prentice-Hall, 1970), p. 120.

8. Marcel Jean, ed., *The Autobiography of Surrealism* (New York, Viking, 1980), p. 77.

9. Lippard, *Surrealists on Art*, p. 126.

10. Legge, *Max Ernst*, p. 113.

11. Ernst, quoted in ibid., p. 128.

12. Quoted by James S. Grotstein, *Splitting and Projective Identification* (New York: Jason Aronson, 1985), p. 15.

13. Grotstein in ibid., p. 8.

7. Back to the Future

1. Quoted in John E. Bowlt, ed., *Russian Art of the Avant-Garde: Theory and Criticism, 1902–1934* (New York, Viking, Documents of 20th Century Art, 1976), p. 89.
2. Ibid., p. 102.
3. Ibid., p. 95.
4. Ibid., pp. 124–25.
5. Herschel B. Chipp, ed., *Theories of Modern Art* (Berkeley, University of California Press, 1968), p. 344.
6. Bowlt, p. 123.
7. Ibid., p. 133.
8. Ibid., p. 136.
9. Ibid., p. 25.
10. Ibid., p. 30.
11. Ibid.
12. Ibid., p. 45.
13. Ibid., p. 46.
14. Ibid., p. 47.
15. Hans L. C. Jaffe, ed., *De Stijl* (New York, Harry N. Abrams, 1971), p. 76.
16. Ibid., p. 77.
17. Bowlt, pp. 22–23.
18. Wassily Kandinsky and Franz Marc, eds., *The Blaue Reiter Almanac* (New York, Viking, Documents of 20th Century Art, 1974), p. 158.
19. Ibid., pp. 160–61.
20. Bowlt, p. 76.
21. Sigmund Freud, *A General Introduction to Psychoanalysis* (Garden City, N.Y., Garden City Books, 1952), p. 292.
22. Chipp, p. 345.
23. Ibid., p. 344.
24. Ibid., p. 346.
25. Bowlt, p. 119.
26. Jaffe, p. 164.
27. Chipp, p. 336.
28. Bowlt, p. 118.
29. Quoted in Jay R. Greenberg and Stephen A. Mitchell, *Object Relations in Psychoanalytic Theory* (Cambridge, Mass., Harvard University Press, 1983), p. 39.
30. Jaffe, p. 156.
31. Chipp, p. 338.
32. Jaffe, p. 164.
33. Ibid., p. 165.
34. Cited in Greenberg and Mitchell, p. 105. A diagrammatic fragment is a structural residue of a significant person or object from the past. I am using the term to describe a utopian residue of a projected but unrealizable future.

8. A Freudian Note on Abstract Art

1. Clement Greenberg, *Art and Culture* (Boston: Beacon Press, 1965), p. 7.
2. Clement Greenberg, "The New Sculpture," *Partisan Review* 16 (June 1949), p. 638.
3. Greenberg, *Art and Culture*, p. 53.

4. Ibid., pp. 37–45, on "The Later Monet"; Clement Greenberg, "Two Reconsiderations," *Partisan Review* 17 (May–June 1950), pp. 510–51.

5. See John Berger, "The Moment of Cubism," in *The Sense of Sight* (New York: Pantheon, 1986), pp. 159–188.

6. Greenberg, *Art and Culture*, p. 139.

7. Clement Greenberg, "The Role of Nature in Modern Painting," *Partisan Review* 16 (Jan. 1949), p. 78.

8. Clement Greenberg, "Art" (Piet Mondrian), *Nation* (March 1944), p. 288.

9. Greenberg, *Art and Culture*, p. 97.

10. Berger, *The Sense of Sight*, p. 185.

11. Ibid., p. 167.

12. Greenberg, *Art and Culture*, p. 97.

13. Ibid., p. 97.

14. As Freud said, "there is no recognition of the passage of time" in the unconscious, and "no alteration in its mental processes is produced by the passage of time." Sigmund Freud, *Standard Edition*, vol. 22 (London: Hogarth Press and the Institute of Psycho-Analysis, 1964), p. 74. On page 26 of the same volume Freud notes that "the dream-work changes temporal relations into spatial ones and represents them as such," suggesting that the treatment of space in a Cubist picture is more a matter of primary process thinking than its treatment in a conventional representation.

15. T. W. Adorno, *Aesthetic Theory* (London, Routledge & Kegan Paul, 1984), p. 476.

16. I am alluding to D. W. Winnicott's description of "the abstract picture [as] a cul-de-sac communication," in which there is a relation to "a subjective object . . . scarcely influenced by an objectively perceived world." D. W. Winnicott, "Communicating and Not Communicating Leading to a Study of Certain Opposites," *The Maturational Processes and the Facilitating Environment* (New York: International Universities Press, 1965), p. 183. Winnicott connects this condition of "incommunicado" with "the psychology of mysticism," in which the mystic is understood to withdraw "into a personal inner world of sophisticated introjects . . . the loss of contact with the world of shared reality being counterbalanced by a gain in terms of feeling real" (pp. 185–186).

17. Heinz Kohut, *The Restoration of the Self* (New York: International Universities Press, 1977), p. 285. Kohut argues that "significant changes in the human condition have been taking place since the decisive decade from 1890 to 1900 when the basic formulations that determined the direction in which [psycho]analysis developed were laid down." These changes have had significant detrimental effect on object relations, leading to an upsurge in narcissistic problems, which today have become dominant. It is worth noting that Harry Guntrip regarded Freud's theory of the "psychic apparatus" as the product of the dehumanizing currents in Freud's intellectual environment, which reflected the larger depersonalization of the world he inhabited. In *Personality Structure and Human Interaction: The Developing Synthesis of Psychodynamic Theory* (New York: International Universities Press, 1961), p. 29, Guntrip argues that Freud treated "personal relationships on a subpersonal level." Freud, Guntrip contends, was unconsciously guided by early modern machine metaphors.

18. Abraham H. Maslow, *The Farther Reaches of Human Nature* (New York: Penguin Books, 1976), p. 56.

19. Sigmund Freud, *Totem and Taboo* (New York: Norton, 1950), p. 90.

20. Sigmund Freud, *An Autobiographical Study* (New York: Norton, 1952), p. 126.

21. Sigmund Freud, *New Introductory Lectures on Psycho-analysis* (New York: Norton, 1933), p. 219.
22. Freud, *An Autobiographical Study*. p. 125.
23. Ibid., p. 123.
24. John E. Bowlt, *Russian Art of the Avant-Garde: Theory and Criticism, 1902–1934* (New York: Viking Press, 1976), p. 89.
25. Greenberg, *Art and Culture*, p. 97.
26. Bowlt, *Russian Art of the Avant-Garde*, pp. 90–91.
27. Ibid., p. 133.
28. Ibid., p. 133.
29. Ibid., p. 128.
30. Ibid., p. 128.
31. Ibid., p. 129.
32. Ibid., p. 123.
33. Adorno, *Aesthetic Theory*, p. 148.
34. Bowlt, *Russian Art of the Avant-Garde*, p. 122.
35. Ibid., p. 122.
36. Ibid., p. 123.
37. Ibid., pp. 122–123.
38. Ibid., p. 128.
39. Clement Greenberg, "Sculpture in Our Time," *Arts Magazine* 32 (June 1958), p. 22. It is worth noting that in *Art and Culture* this article is re-titled "The New Sculpture" and the citation becomes (p. 139): "It follows that a modernist work of art must try, in principle, to avoid dependence upon any order of experience not given in the most essentially construed nature of its medium. This means, among other things, renouncing illusion and explicitness. The arts are to achieve concreteness, 'purity,' by acting solely in terms of their separate and irreducible selves." Purity is clearly now possible, and has been actualized in certain work, no doubt in the "post-painterly abstraction" movement that Greenberg encouraged and named in the early sixties.
40. Donald Kuspit, "The Subjective Aspect of Critical Evaluation," *Art Criticism* 3 (Spring 1987), pp. 80–81.
41. T. S. Eliot, *The Sacred Wood* (London: Faber, 1927), pp. 58–59.

9. The Will to Unintelligibility in Modern Art

1. It should be noted that I will use "enigma" and "unintelligibility" interchangeably. In fact, it is through unintelligibility that art generates the sense of enigma.
2. Joseph T. Coltrera, "On the Nature of Interpretation: Epistemology as Practice," *Clinical Psychoanalysis*, eds. Shelley Orgel and Bernard D. Fine (New York: Jason Aronson, 1981). p. 85.
3. Theodor W. Adorno, *Aesthetic Theory* (London: Routledge & Kegan Paul, 1984), p. 476.
4. D. W. Winnicott, "Psycho-Analysis and the Sense of Guilt," *The Maturational Processes and the Facilitating Environment* (New York: International Universities Press, 1965), p. 25.
5. D. W. Winnicott, "Classification: Is There a Psycho-Analytic Contribution to Psychiatric Classification?" *The Maturational Processes and the Facilitating Environment*, p. 131.

6. Melanie Klein, "On Identification," *Envy and Gratitude* (New York: Free Press, Macmillan, 1985), p. 144.
7. D. W. Winnicott, "The Manic Defence," *Collected Papers* (London: Tavistock Publications, 1958), p. 132.
8. Heinz Kohut, *How Does Analysis Cure?* (Chicago: University of Chicago Press, 1984), p. 16.
9. Heinz Kohut, *The Analysis of the Self* (New York: International Universities Press, 1971), p. 30.
10. Kohut, *How Does Analysis Cure?* p. 16.
11. D. W. Winnicott, "Communicating and Not Communicating Leading to a Study of Certain Opposites," *The Maturational Processes and the Facilitating Environment,* p. 184.
12. Ibid., p. 183.
13. Ibid., p. 184.
14. Ibid., pp. 185–86.

10. An Alternative Psychoanalytic Interpretation of Jackson Pollock's Psychoanalytic Drawings

1. The drawings were first discussed in C. L. Wysuph, *Jackson Pollock: Psychoanalytic Drawings* (New York: Horizon, 1970).
2. Claude Cernuschi, *Jackson Pollock: Meaning and Significance* (New York: Harper Collins, 1992), p. 59.
3. Cernuschi notes that "it was Pollock who suggested that he use drawings as an aid to discussing himself," as quoted in ibid., p. 12.
4. Peter Gay, *Art and Act: On Causes in History – Manet, Gropius, Mondrian* (New York; Harper & Row, 1976), p. 17.
5. Lawrence Alloway, *Topics in American Art Since 1945* (New York: Norton, 1975), p. 61.
6. Stephen Polcari, *Abstract Expressionism and the Modern Experience* (Cambridge University Press, 1991), p. 244.
7. Wysuph, *Jackson Pollock,* p. 12. See also Cernuschi's account of Pollock's treatment, particularly with reference to the role of the drawings in it – their meaning is always "personal" according to Cernuschi – in *Jackson Pollock: Meaning and Significance,* pp. 58–66.
8. Ibid., pp. 12–13.
9. Ibid., p. 17.
10. Ibid., p. 15.
11. Ibid., p. 12.
12. Quoted in Cernuschi, *Jackson Pollock: Meaning and Significance,* p. 64.
13. Didier Anzieu, "Beckett and Bion," *International Review of Psycho-Analysis* 16, p. 2 (1989):163–69.
14. Wysuph, *Jackson Pollock: Psychoanalytic Drawings,* p. 14.
15. William Rubin, "Jackson Pollock and the Modern Tradition: Part One," *Artforum* 5 (February 1967):14–22; "Part Two" (March 1967): 28–37; "Part Three" (April 1967):18–31; "Part Four" (May 1967):28–33.
16. D. W. Winnicott, "Psycho-Neurosis in Childhood," *Psycho-Analytic Explorations* (Cambridge, Mass.: Harvard University Press, 1989), p. 71. I am using "psychosis" in the psychoanalytic rather than psychiatric sense. The *Diagnostic and Statistical Manual of Mental Disorders,* 3d ed., rev. (DSM-III-R), published by the

American Psychiatric Association (Washington, D.C., 1987), p. 194, lists as "diagnostic criteria for Schizophrenia" the "presence of characteristic psychotic symptoms in the active phase" of at least "two of the following: (a) delusions; (b) prominent hallucinations . . . (c) incoherence or marked loosening of associations; (d) catatonic behavior; (e) flat or grossly inappropriate affect." In contrast, Burness E. Moore and Bernard D. Fine, eds., *Psychoanalytic Terms and Concepts* (New York: American Psychoanalytic Association; New Haven: Yale University Press, 1990), p. 156, describe psychosis as a "form of mental disorder characterized by marked ego and libidinal regression with consequent severe personality disorganization." Distinguishing between organic psychoses, which are "secondary to physical disease," and functional psychoses, Moore and Fine observe that "the major functional psychoses are the *affective disorders* (manic depressive psychosis) and *thought disorders* (schizophrenia and true paranoia)."

J. Laplanche and J.-B. Pontalis, *The Language of Psychoanalysis* (New York: Norton, 1973), pp. 369–70, write that "in clinical psychiatry, the concept of psychosis is usually given a very broad extension covering a whole range of mental illnesses, whether they are clearly of organic origin . . . or whether their ultimate aetiology is obscure (as in the case of schizophrenia). . . . In psycho-analysis, . . . instead, interest was at first directed towards the conditions which were most immediately accessible to analytic investigation, and within this field – narrower than that of psychiatry – the major distinctions were those between the perversions, the neuroses, and the psychoses. Within this last group, psycho-analysis has tried to define different structures: on the one hand, paranoia (including, in a rather general way, delusional conditions) and schizophrenia; on the other, melancholia and mania. Fundamentally, psycho-analysis sees the common denominator of the psychoses as lying in a primary disturbance of the libidinal relation to reality; the majority of manifest symptoms, and particularly delusional construction, are accordingly treated as secondary attempts to restore the link with objects."

Edna O'Shaughnessy, "Psychosis: Not Thinking in a Bizarre World," in *Clinical Lectures on Klein and Bion* (London: Tavistock/Routledge and the Institute of Psycho-Analysis, 1992), p. 90, makes the psychoanalytic understanding of psychosis transparently clear in her account of Bion's "much more extreme version of the difference between psychosis and neurosis which had so struck Freud. According to Bion, in psychosis there is a difference in the entire condition of the mind and a difference also between the very constitution of what for the psychotic is the world." It is unlikely that Pollock had psychotic symptoms in the psychiatric sense – although it has been argued that he probably had alcoholic psychosis, that is, delusions accompanying delirium tremens (especially when he was hospitalized for alcoholism) – but it seems likely that he had relatively severe personality disorganization and an affective disorder. He was clearly depressed, and self-medicated with alcohol for his depression. He also clearly had great difficulties with object relations. As for his art, many of his figures seem more like delusional constructions than simulated fantasies à la Surrealism. The allover paintings suggest a very different "condition of mind," in O'Shaughnessy's words, as well as a very different sense of what constitutes a pictorial world.

17. Theodor W. Adorno, *Aesthetic Theory* (London: Routledge & Kegan Paul, 1984), p. 67, writes that "before he reaches [the] disintegrative truth, the artist must traverse the field of integration. . . . Akin to the concept of disintegration is that of the aesthetic fragment." On p. 184 he describes works of art as "fragmented transcendence," that is, "fragments disclaiming to be wholes, even though wholes

is what they really want to be." On p. 212 he announces that "art of the highest calibre pushes beyond totality towards a state of fragmentation."

18. Peter Bürger, *Theory of the Avant-Garde* (Minneapolis: University of Minnesota Press, 1984), p. 72, states that "the organic work of art seeks to make unrecognizable the fact that it has been made. The opposite holds true for the avant-gardist work: it proclaims itself an artificial construct, an artifact." Adorno, *Aesthetic Theory*, p. 299, writes, in a not unrelated way, that "no single work is ever a totality of the sort that was propagated by traditional idealistic aesthetics. Every single one is inadequate and unfinished, a fragment only of what it could be." Both Bürger and Adorno miss the psychological necessity of idealization that gives the work an aura of wholeness.

19. Adorno, *Aesthetic Theory*, p. 22, describes hypermodern wariness of "dissonance because of its proximity to consonance. . . . Dissonance thus congeals into an indifferent material, a new kind of immediacy without memory trace of its past, without feeling, without an essence."

20. Describing his work, Picasso remarked that "the first 'vision' [of the object] remains almost intact, in spite of appearances." "All traces of reality" seem to be removed from the work but "the idea of the object [has] left an indelible mark." In other words, perception is always working on some real object however much the final artistic result suggests that nothing has been perceived. *Picasso on Art, a Selection of Views*, ed. Dore Ashton (New York: Viking, 1972), pp. 8, 9.

21. Winnicott, "Psycho-Neurosis in Childhood," pp. 64–65.

22. Otto Kernberg, *Borderline Conditions and Pathological Narcissism* (Northvale, N.J.: Jason Aronson, 1990), p. 22.

23. Ibid., p. 12.

24. Ibid., p. 20.

25. Winnicott, "Psycho-Neurosis in Childhood," p. 65.

26. Quoted in Alloway, *Topics in American Art*, p. 59.

27. Quoted in Wysuph, *Jackson Pollock: Psychoanalytic Drawings*, p. 11. Claude Cernuschi, *Jackson Pollock: "Psychoanalytic" Drawings* (Durham, N. C.: Duke University Press, 1992; exh. cat.), p. 29, argues that "the attempt to integrate psychoanalysis and iconography" that Pollock's Jungian interpreters make "misfires," and suggests that in general "the psychoanalytic approach . . . contributes little to an understanding of his work." But Cernuschi contradicts himself in interpreting a drawing in which "a child, apparently wanting to nurse at his mother's breast, is unambiguously threatened, if not about to be violently struck, by a menacing and physically overwhelming woman" (*Jackson Pollock: Meaning and Significance*, pp. 177–78). Pollock not only "completely reverses traditional expectations about the relationship between mother and son" embodied "for centuries in the theme of the Madonna and Child," but suggests that the relationship is "anything but psychologically reassuring" (p. 178). Indeed, Cernuschi accepts Alfonso Ossorio's assertion that "all of [Pollock's personal] problems stemmed from his family, which centered around his mother – a large, firm, substantial matriarch, a dominating woman," Lee Krasner's recollection that "Pollock's drinking coincided with his mother's visits," and Henderson's observation that Pollock had "a frustrated longing for the all-giving mother," having "suffered from isolation and extreme emotional deprivation in early childhood," which "had not yet been adequately compensated" (pp. 175, 177).

28. Kernberg, *Borderline Conditions*, p. 26.

29. Ibid., p. 27.

30. Ibid.
31. Ibid.
32. Quoted in Joseph Sandler, "The Background of Safety," *From Safety to Superego* (New York: Guilford, 1987), p. 3.
33. Ibid.
34. Ibid., p. 4.
35. Ibid., p. 5.
36. Ibid.
37. Ibid., p. 8.

11. Art and the Moral Imperative

1. George Grosz, *Dadas on Art,* ed. Lucy R. Lippard (Englewood Cliffs, N.J.: Prentice-Hall, Spectrum Books, 1971), p. 78.
2. Grosz, p. 80.
3. Grosz, p. 81.
4. Anne Ominous (Lucy Lippard), "Sex and Death and Shock and Schlock: A Long Review of The Times Square Show," *Artforum* 19 (October 1980), p. 55.
5. Jerry Kearns and Lucy R. Lippard, "Cashing in a Wolf Ticket (Activist Art and Fort Apache: The Bronx)," *Artforum* 20 (October 1981), p. 73.
6. Joseph Sandler, *From Safety to Superego* (New York: Guilford Press, 1987), p. 20.
7. Sandler, pp. 21, 69.
8. Sandler, p. 54.
9. Sandler, p. 41.
10. Barnaby B. Barratt, "Reawakening the Revolution of Psychoanalytic Method: Notes on the Human Subject, Semiosis and Desire," *Psychoanalysis and Contemporary Thought,* No. 13, 1990, p. 140. It is worth noting that a parallel can be drawn between Barratt's conceptualization of the tension between desire and semiosis and T. W. Adorno's conceptualization of the tension between jazz and society. According to Adorno in "Sociology of Art and Music," *Aspects of Sociology by the Frankfurt Institute for Social Research* (Boston: Beacon Press, 1973), p. 113, the "syncopated rhythm" of jazz, which by "displacement inserts apparent beats within the regular measures, comparable to the intentionally clumsy stumbling of the eccentric clown," bespeaks "a helpless, powerless subject... ridiculous in his expressive impulses" (that is, articulation of desire). As such, jazz represents repressed – and thus seemingly impotent – desire. It can only appear in offbeat, irregular, improvised form, unintegrated into and as such disruptive of – introducing insecurity into – the semiosis of socially approved music, emblematic of society as a whole, a totally controlling process. This suggests the sociopolitical power the authentically aesthetic has in and over consciousness. Of course, jazz is eventually integrated into society, becoming a respectable, honored musical mode in its own right, that is, its irregularities come to seem predictable, measurable – another convention of music. Adorno thinks this is the reward the subject who makes jazz receives for acknowledging his "weakness and helplessness" in the first place – for daring to publicly express his hopeless desire, his blind wish for strength and integrity and self-determination. Similarly, the aesthetically expressed desire that is the manifestation of a subject rebelling against – throwing off the chains of – existing semiotic structures of art eventually becomes appropriated as "avant-garde," and finally becomes a generally acceptable mode of art-making.
11. Barratt, p. 146.

12. It should be noted that the aesthetic can also become a doctrine, as occurs in Clement Greenberg's formalism, which in effect denies – shall we say castrates? – the desire implicit in form, making it not a fecund source of gratification but a barren puritan ground. Greenberg's aestheticism sells aesthetics short, as the wish to decisively formulate and teach it invariably does. Paradoxically, aestheticism denies the *raison d'être* of the aesthetic as the most effective signifier of the character and quality of dynamic desire.

13. Thomas A. Sebeok, *The Play of Musement* (Bloomington: Indiana University Press, 1981), p. 232.

14. Quoted in Sebeok, p. 232.

15. One semiotic structure tends to dominate civilization – but every semiotic structure is eventually overthrown as tyrannical. Or rather, the particular semiotic structure is absorbed by another structure thrown forth by desire – another crystallization of desire, transforming its meaning. Not only does the new semiotic structure dialectically subsume the old one, if never truly reconciling with it, but extracts the desire sedimented in it for its own purpose. The old desire becomes the basis for the new belief in the new structure of basic meaning the world is supposed to have. In a sense, moral passion extracts the passion from the aesthetic for its own domineering purpose, and blind faith that the world must be made good before it can be pleasurably enjoyed, which is perverse nonsense.

12. The Modern Fetish

1. William Rubin, "Modernist Primitivism: An Introduction," *"Primitivism" in 20th Century Art,* 2 vols., ed. William Rubin, New York: Museum of Modern Art, 1984, 1:14.

2. Quoted in Janine Chasseguet-Smirgel, *Creativity and Perversion,* London: Free Association Books, 1985, p. 88.

3. Ibid.

4. Phyllis Greenacre, "Certain Relationships Between Fetishism and Faulty Development of the Body Image," *The Psychoanalytic Study of the Child* 8, 1953, p. 79.

5. Ibid.

6. Sigmund Freud, "Fetishism," 1927, in *Collected Papers,* ed. James Strachey, trans. Joan Riviere, London: The Hogarth Press and the Institute of Psycho-Analysis, 1950, p. 200.

7. Ibid.

8. Robert J. Stoller, *Perversion: The Erotic Form of Hatred,* New York: Pantheon, 1975, p. 14.

9. Greenacre, p. 89.

10. Ibid., p. 96.

11. Greenacre, "The Fetish and the Transitional Object," *The Psychoanalytic Study of the Child* 24, 1969, p. 144.

12. Greenacre, "Certain Relationships," p. 94. Greenacre notes that the fetish "often includes the quality of being smelly, so that it can furnish a kind of material incorporation through being breathed in, without loss, i.e., without diminution of its size or change of its form." See also Chasseguet-Smirgel, p. 88, who speaks of the fetish as "often smelly and shiny." This is because it is "the commemorative monument of intense anal exchanges between mother and son," as she remarks, paraphrasing Béla Grunberger (p. 81). I would argue that the rough, battered,

quasi-primitive surface of many modern fetish objects, suggesting the crudeness
of feces, is the visual equivalent of smelliness.

13. Greenacre, "The Fetish and the Transitional Object," p. 146.
14. Ibid., p. 150.
15. Greenacre, "Certain Relationships," p. 86.
16. See Chasseguet-Smirgel, *Female Sexuality: New Psychoanalytic Views,* eds. Chas-
 seguet-Smirgel and Frederick Wyatt, Ann Arbor: University of Michigan Press,
 1970.
17. Stoller, p. 114.
18. Ibid., p. 132.
19. Chasseguet-Smirgel, *Creativity and Perversion,* p. 87.
20. Ibid.
21. Ibid., p. 88.
22. Ibid., pp. 87–88.
23. Ibid., p. 88.
24. Ibid., p. 91.
25. Ibid.
26. Ibid.
27. Ibid., p. 89. It is worth noting, in this context, that the development of abstract
 art in our century is inseparable from the increasing idealization of so-called non-
 objective or formal elements (line, color, geometrical shape). I would argue that
 this idealization is essentially a fetishization. In the work that we consider stylis-
 tically progressive of such artists as Kasimir Malevich and Piet Mondrian, we could
 say that there is a regression from the genital intercourse with the world practiced
 by the representational artist, to pregenital intercourse with the geometry and pure
 color that formally underlie the world. Their union produces the phallic woman,
 the mother – the origin of the world and its first being. (In the combination of
 geometry and pure color, geometry supplies the phallic firmness, color the wom-
 anliness.) That is, as geometry distances and disidentifies one from the objects of
 the world – hence its "non-objectivity," as Malevich said – it may be unconsciously
 identifying one with the most primitive "preworldly" object of all. The pioneering
 geometric abstractionists' intellectual attachment to geometric form is, I would
 argue, an attachment to the phallic woman perceived as the mother of all form,
 and hence the most powerful, resonant – phallic, tumescent – form.
28. Freud, p. 201.
29. Ibid.
30. Greenacre, "The Fetish and the Transitional Object," p. 150.
31. Greenacre, "Certain Relationships," p. 80.
32. Rubin, p. 17, remarks that Picasso's "African carvings were generally less realistic
 and, above all, less 'finished.' " This was in opposition to the "pervasive Franco-
 Belgian hierarchy of preferences" that stressed "beautifully polished or patinated
 surfaces... in contrast to the rawness... that not surprisingly motivated many
 vanguard artists' choices in tribal sculpture." Rubin further notes that "some dealers
 and collectors have even gone so far as to remove the coarse and 'unpleasant'
 surface that African objects acquired from ritual use." I have suggested the un-
 conscious motivation for Modern collage artists' preference for this "coarse and
 'unpleasant' surface," which carries primitive texture to the contemporary Euro-
 pean world. In addition, as Freud has noted, touching is the most primitive way
 of sensing. It is most associated with the mother who handles one the most and
 with whom one has the most "touching" relationships. Thus primitive texture

could be seen as a way of associating with the phallic woman. Smooth texture would acknowledge her feminine skin, rough texture her phallic quality.

33. Susan Sontag, "Sontag on Mapplethorpe," *Vanity Fair* 48, no. 7, July 1984 p. 72.

34. Greenacre, "The Fetish and the Transitional Object," p. 150.

35. Greenacre also points out on p. 150 that "the color black may play an important part in the attractiveness of many fetishistic objects. . . . The black is associated with pubic hair and with the illusory fecal phallus. It may also add to the definite visible outline of the fetish object, causing it to stand out conspicuously against the background of the adjacent skin." Certainly the violent impact of many Expressionist prints owes a great deal to their stark black and white palettes; black and white clearly helped Franz Kline fetishize the gesture.

36. Ibid., p. 150.

37. Freud argued that the fetish "saves" the fetishist from being a homosexual by playing an important role in heterosexual gratification. However, M. Masud R. Khan, in "Fetish as Negation of the Self," *Alienation in Perversions,* London: the Hogarth Press and the Institute of Psycho-Analysis, 1979, pp. 139–76, has presented a case in which fetishism plays an important role in homosexual gratification. And Greenacre, "Certain Relationships," p. 81, and Stoller, p. 133, note the relatively direct connection of transvestitism and fetishism.

38. Stoller, p. 4.

13. The Only Immortal

1. See Elizabeth J. L. Sawin, "A Critical Meditation on John Ruskin's Fear of Death," Ph.D. diss., University of Iowa, 1980, p. 124. Ruskin presents this idea in the chapter called "The Lance of Pallas" in his *Modern Painters,* 1843.

2. This concept has been developed by Robert Jay Lifton in a number of important studies, especially *The Broken Connection: On Death and the Continuity of Life,* New York: Simon and Schuster, Touchstone Books, 1979.

3. See Hans Georg Gadamer, *Hegel's Dialectic: Five Hermeneutical Studies,* trans. P. Christopher Smith, New Haven and London: Yale University Press, paperback, 1976, p. 69.

4. Ernest Hemingway, "A Clean, Well-Lighted Place," 1938, in *The Complete Short Stories of Ernest Hemingway,* New York: Charles Scribner's Sons, the Finca Vigia Edition, 1987, p. 291.

5. Freud's concept of the death wish, formulated in part to explain persistent masochism (which implies a tendency toward self-destruction), is perhaps the most disputed aspect of his thought. See Erich Fromm, "Freud's Theory of Aggressiveness and Destructiveness," in *The Anatomy of Human Destructiveness,* Greenwich, Conn.: Fawcett, Crest Books, 1975, pp. 486–528, especially section 3, pp. 511–18, "The Power and Limitations of the Death Instinct." See also Fromm, *Greatness and Limitations of Freud's Thought,* London: Jonathan Cape, 1980, pp. 110–16. Nonetheless the notion of a death instinct remains a viable part of instinct theory, as has increasingly been acknowledged – if instinct theory is to be retained at all, which Fromm resists doing.

W. Ronald D. Fairbairn's object-relational reinterpretation of the death instinct is also relevant. In "Repression and the Return of Bad Objects (With Special Reference to the 'War Neuroses')," 1943, in *Psychoanalytic Studies of the Personality,* London: Routledge and Kegan Paul, 1952, Fairbairn argues that "what Freud describes under the category of 'death instincts' would . . . appear to rep-

resent for the most part masochistic relationships with internalized bad objects. A sadistic relationship with a bad object which is internalized would also present the appearance of a death instinct" (p. 79). But in fact such sadomasochistic libidinal manifestations do imply a wish for the death either of the ego or of the object.

6. See Dore Ashton, *Picasso On Art: A Selection of Views,* New York: Viking Press, "Documents of 20th-Century Art," paperback, 1972, p. 38: "Unfinished, a picture remains alive, dangerous. A finished work is a dead work, killed."

7. See Sigmund Freud, "Reflections upon War and Death," 1915, in *Character and Culture,* New York: Macmillan, Collier Books, 1963, p. 122.

8. Enid Balint, in her paper "Creative Life" (which I found described in a psycho-therapeutic newsletter), argues that many potential artists "have difficulty making contact with external reality and experience this process as traumatic," leading to difficulty "with feeling alive in the world." "To survive, they become older versions of passively-feeding infants, maintaining a constant silent relationship with a private world Balint calls 'imaginatively perceived phenomena.' " "Enid Balint Speaks," *Newsletter of the Society of the Institute for Contemporary Psychotherapy,* New York, Winter 1989, p. 1.

9. D. W. Winnicott, "Ego Distortion in Terms of True and False Self," 1960, in *The Maturational Processes and the Facilitating Environment: Studies in the Theory of Emotional Development,* New York: International Universities Press, 1965, p. 148.

10. Ibid.

11. See Bernard Brodsky, "The Self-Representation, Anality, and the Fear of Dying," *Journal of the American Psychoanalytic Association* 7, 1959, pp. 95–108. Obliteration of the self-image can lead to literal self-destructiveness, as apparently has happened in Lebanon, where prolonged war has destroyed the sense of self of Muslim militiamen; see Rod Nordland, "Playing the Death Game," *Newsweek,* 30 December 1985, p. 28. Another reference to living death is Alexander Solzhenitsyn's remark that "a man can cross the threshold of death before his body is lifeless." Quoted by Lawrence L. Langer, *The Holocaust and the Literary Imagination,* New Haven and London: Yale University Press, paperback, 1975, p. 74. Erich Kahler, in *The Tower and the Abyss: An Inquiry into the Transportation of the Individual,* New York: Viking, 1967, p. 151, remarks that "the most frightening aspect of our present world is not the horrors in themselves, the atrocities, the technological exterminations, but the one fact at the very root of it all: the fading away of any human criterion" – the fading away of any sense of (inner) self.

12. A number of interesting exhibitions have dealt with the imagery of death, among them "Ashes to Ashes: Visions of Death," organized by Geno Rodriguez at the Alternative Museum, New York, in 1983; "Memento Mori: Der Tod als Thema der Kunst von Mittelatter bis zur Gegenwart," at the Hessisches Landesmuseum, Darmstadt, in 1984; and "Memento Mori," organized by Richard Flood at the Moore College of Art, Philadelphia, in 1985. The many important studies of the sense of death as it is reflected in culture and philosophy include well-known works such as Phillipe Aries' *Western Attitudes toward Death,* 1974, and Jacques Choron's *Death and Modern Man,* 1972. It is worth noting that the Children's Museum in Boston, in 1984, held an exhibition about "death and loss" to teach children that "you don't come back again" from death. The exhibition was not well received. See "Children Learn That 'Dying Isn't a Vacation,' " *New York Times,* 26 August 1984, p. 25.

13. See Winnicott, "The Manic Defense," 1935, *Through Paediatrics to Psycho-analysis*

London: Tavistock Publications, 1958, pp. 129–44. Winnicott's "Use of Opposites in Reassurance" section, p. 134, is particularly to the point.

14. See Robert C. Hobbes, "Motherwell's Concern with Death in Painting: An Investigation of His Elegies to the Spanish Republic, Including an Examination of His Philosophical and Methodological Considerations," Ph.D. diss., University of North Carolina at Chapel Hill, 1975; and Donald Kuspit, "The *Ars Moriendi* according to Robert Morris," *The New Subjectivism: Art in the 1980s*, Ann Arbor: UMI Research Press, 1988, pp. 375–90.

15. See Theodore Reff, "Cézanne: The Severed Head and the Skull," *Arts Magazine* 58 no. 2, October 1983, pp. 84–100.

16. Georges Ribemont-Dessaignes, quoted in Malcolm Haslam, *The Real World of the Surrealists*, New York: Rizzoli, 1978, p. 72. Carl Sagan, in *Broca's Brain: Reflections on the Romance of Science*, New York: Ballantine Books, 1980, p. 12, points out that "cannibals in northwestern New Guinea employ stacked skulls for doorposts, and sometimes for lintels. Perhaps these are the most convenient building materials available, but the architects cannot be entirely unaware of the terror that their constructions evoke in unsuspecting passersby. Skulls have been used by Hitler's SS, Hell's Angels, shamans, pirates, and even those who label bottles of iodine, in a conscious effort to elicit terror." I suggest that artists who use skulls also want to do so – to intimidate the spectator – as well as to externalize their own sense of terror not only at the thought of their own deaths but of the death of their art, especially the fact that it eventually comes to represent nothing but itself, the artist being reduced to a name as hollow as a skull.

17. Winnicott, "Ego Distortion in Terms of True and False Self," p. 152.

18. Winnicott, "The Concept of a Healthy Individual," 1967, in *Home Is Where We Start From: Essays by a Psychoanalyst*, London: Pelican Books, 1987, p. 23.

14. Tart Wit, Wise Humor

1. Norman N. Holland believes that "tragedy . . . is only the first half of the death-and-rebirth pattern." Comedy is rarely given its due, Holland says, because of the social prevalence of narcissistic pathology. See Holland, *Laughing: A Psychology of Humor*, Ithaca, N.Y., and London: Cornell University Press, 1982, pp. 36–37, and Nancy McWilliams and Stanley Lependorf, "Narcissistic Pathology of Everyday Life: The Denial of Remorse and Gratitude," *Contemporary Psychoanalysis* 26 no. 3, July 1990, p. 431. Comedy expresses gratitude for rescue from the tragic flaw, and represents the psychic force that counteracts grandiosity – the unconscious illusion of omnipotence, which is what entraps and defeats the tragic hero. Society has a vested interest in pathological narcissism, for many people are unable to function without a sense of grandiosity. They lack drive unless they are narcissistically deluded. Capitalism encourages the pathologically grandiose self because it encourages the conspicuous consumption of possessions, which symbolize one's grandiosity.

2. Otto Freundlich, "The Laugh-Rocket," in *Dadas on Art*, ed. Lucy R. Lippard, Englewood Cliffs, N.J.: Prentice-Hall, Inc., a Spectrum Book, 1971, p. 136.

3. See André Breton, "Away with Miserabilism!," 1956, in *Surrealism and Painting*, New York: Harper & Row, Publishers, Icon Edition, 1972, pp. 347–48; and Charles Baudelaire, "The Salon of 1846," in *The Mirror of Art: Critical Studies by Charles Baudelaire*, ed. Jonathan Mayne, Garden City, N.Y.: Doubleday, Anchor Books,

1956, p. 39. Here Baudelaire distinguishes between a mathematical and a poetic approach to art, which I would extend to life. He also describes art as a means of restoring "the equilibrium of the soul's forces" in the bourgeois.

4. Richard Sheppard's "Dada and Mysticism: Influences and Affinities," in *Dada Spectrum: The Dialectics of Revolt,* ed. Stephen C. Foster and Rudolf E. Kuenzli, Madison, Wis.: Coda Press, Inc., 1979, pp. 91–113, makes a compelling argument for the mystical intention of Dadaism in particular and by implication of Modernism in general. It should be noted that T. W. Adorno, in *Aesthetic Theory,* London: Routledge & Kegan Paul, 1984, p. 466, suggests that the distinction between tragedy and comedy is merely "scholastic" today. For neither they, nor their synthesis in tragicomedy, are equal to the task of articulating the profoundly complex, ironic intertwining of suffering and the frantic pursuit of happiness, at the expense of others, in our society. At the same time, Adorno speaks of the tragic fate of the comic genre in our time – its appropriation and abuse by the entertainment industry – and of the need to rescue it by creating comedies about the tragedy of comedy. (He thinks Beckett's plays are about this.) As he suggests, this is the comic form appropriate to the recognition that the world is tragically unfunny. Adorno in effect grants tragedy and comedy validity as comments on the inadequacy of each, rather than as ends in themselves.

5. See Renato Poggioli, *The Theory of the Avant-Garde,* New York: Harper & Row, Publishers, Icon Editions, 1971, pp. 30–40.

6. Guillaume Apollinaire, *Apollinaire on Art: Essays and Reviews, 1902–1918,* New York: The Viking Press (The Documents of 20th-Century Art), 1972, p. 260.

7. As Holland remarks, there is a large class of incongruity-and-relief theories of humor, whether the incongruity is conceived of as cognitive or formal in character. That is, a situation or statement, including a work of art, has a comic effect if its incongruities lead to the relief of laughter. There are tragically constricting incongruities, of course, which can be relieved only by anxious tears. See Holland, pp. 21–29.

8. Another major theory of humor holds that, as Holland says (p. 44), the humorist is "really laughing at his own superiority." The idea was first articulated by Thomas Hobbes (1650): "The passion of laughter is nothing else but sudden glory arising from sudden conception of some eminency in ourselves, by comparison with the infirmity of others, or with our own formerly." Ernst Kris thought that Hobbes was "more akin to Freud than any later psychologist." However, I and others think that Freud combines incongruity and relief with superiority theory. For him, the traumatic experience of incongruity generates either the relief of witty laughter or a humorous sense of superiority to the experience, depending on ego strength. The psychic energy-saving aspect of Freud's theory, while justly famous and undoubtedly important, seems to me secondary to the state of the ego that faces the incongruity. I believe abstract art claims a superiority that implicitly laughs at the inferiority of the concrete world, let alone the attempt to represent it. As such, abstract art shows art at its strongest, that is, with the most self-believing ego.

9. Sigmund Freud, "Humour," 1927, *The Standard Edition of the Complete Psychological Works of Sigmund Freud,* London: The Hogarth Press and the Institute of Psycho-Analysis, 1961, 21:162.

10. See D. W. Winnicott, "Playing and Culture," 1968, *Psychoanalytic Explorations* Cambridge, Mass.: Harvard University Press, 1989, p. 203. In a sense, Winnicott

is arguing that cultural play at its best keeps intact the capacity for affectionate feeling that tends to become worn down in ordinary, humorless social and practical life.

11. Freud, "Humour," p. 162.
12. Freud, *Jokes and Their Relation to the Unconscious,* 1905, *The Standard Edition of the Complete Psychological Works of Sigmund Freud,* London: The Hogarth Press and the Institute of Psycho-Analysis, 1960, 8:73. Freud distinguished (p. 97) between "a *hostile* joke (serving the purpose of aggressiveness, satire, or defence)" and "an *obscene* joke (serving the purpose of exposure)."
13. Holland, pp. 37–38.
14. See E. H. Gombrich, "The Style *all'antica:* Imitation and Assimilation," *Norm and Form: Studies in the Art of the Renaissance,* London: Phaidon, 1966, p. 122–28.
15. Johan Huizinga, *Homo Ludens: A Study of the Play-Element in Culture,* Boston: Beacon Press, 1955, p. 23.
16. José Ortega y Gasset, in *The Dehumanization of Art and other Essays on Art, Culture, and Literature,* Garden City, N.Y.: Doubleday, Anchor Books, 1955, pp. 47–48, relates the idea of farce to the Modern avant-garde: it would be "a 'farce,' in the bad sense of the word... if the modern artist pretended to equal status with the 'serious' artists of the past, and a cubist painting expected to be extolled as solemnly and all but religiously as a statue by Michelangelo.... Instead of deriding other persons or things – without a victim no comedy – the new art ridicules itself."

15. Joseph Beuys

1. Götz Adriani, Winfried Konnertz, and Karin Thomas, *Joseph Beuys, Life and Works* (Woodbury, N.Y., Barron's Educational Series, 1979), pp. 9 and 11.
2. Joseph Sandler, in "The Background of Safety," *From Safety to Superego* (New York, Guilford, 1987), points out the indispensability of a primitive "safety feeling" for development, and its derivation from the relationship with the parents.
3. Adriani et al., p. 11.
4. Ibid., p. 12.
5. See Erik H. Erikson, *Childhood and Society* (New York, Norton, 1963; paperback ed.), pp. 247–61.
6. Adriani et al., p. 241, implies that Beuys turned to individual action as political action because, having experienced the Nazi regime, he could never again trust politicians – could never again leave the governing of society to their defective sense of human relations and values.
7. Quoted in Adriani et al., p. 283. It is because Beuys conceived of art as *the* method of social "re-form" – transcending conventional conceptions of revolution and evolution, if using both – that he was able to regard such activities as the founding on 1 June 1971 of the Organisation für direkte Demokratie durch Volksabstimmung (Freie Volksinitiative, e. V.) (Organization for direct democracy through referendum [Free People's Initiative, Inc.]), and on 24 June 1977 of the Frei Internationale Hochschule für Kreativität und Interdisziplinäre Forschung (Free international university for creativity and interdisciplinary research) as artistic – social sculptural – in character. Moreover, as Heiner Stachelhaus writes in his *Joseph Beuys* (New York, Abbeville, 1991), p. 91, Beuys' famous "Aufruf zur Alternative," which first appeared in the *Frankfurter Rundschau* on 23 December 1978, was the "fundamental document" of the social program of the Green Party. As Beuys said,

social "humanism can best be further developed through art" (Adriani et al., p. 255). It is also worth noting that Beuys' conception of direct democracy was modeled, as he acknowledged, on Rudolf Steiner's Bund für Dreigliederung des sozialen Organismus (Alliance for three structures of the social organism), founded in 1919. As Adriani et al. write (pp. 220–21), Steiner's "basic idea . . . was that the social life of mankind could only be healthy if it was consciously structured. The independently developed individual should no longer recognize the total power of the state. The working power of the individual should no longer be degraded as a commodity. . . . To attain these goals . . . there needs to be an independence of state, economy, and intellectual life," that is, "liberty in spirit, equality before the law, fraternity in economic matters." They add that Steiner proposed a revitalization of "the old ideals of the French Revolution." Beuys' Organisation für direkte Demokratie was explicitly intended to cure a sick society and to realize Steiner's conception of the ideal – healthy – social organism. For Beuys, art was in the service of social health, from which individual health would follow.

8. Ibid., pp. 11–12. Beuys also described his "actions" – so-called "happenings" – as "psychoanalytic" in intention.

9. For D. W. Winnicott, truly creative art is a form of play, and the inability to play suggests profound pathology. According to him, artistic, creative playing is a kind of self-cure. Beuys in effect sets dead – "unplayful" – objects into play, restoring them to the life process. Play involves investing dead objects with one's own life, bringing them to life – and displaying one's own inner life – for others. "Individuals," Winnicott writes in *Playing and Reality* (Middlesex, Penguin, 1971), p. 83, "live creatively and feel that life is worth living or else . . . they cannot live creatively and are doubtful about the value of living." Beuys' art can be understood as an attempt to overcome deep doubts about living – induced by the defective "quantity and quality of environmental provision [in] the early phases of [his] living experience" – through creative artistic play with the idea as well as the material of life.

10. See Benjamin H. D. Buchloh, "Beuys: The Twilight of the Idol," *Artforum* 28 (January 1980):35–43. Buchloh does not understand that Beuys' experience among the Tartars, even if the facts changed in Beuys' telling, was a kind of dream experience psychologically necessary for his survival, whatever it may have been in reality. There may have been an unconscious connection in Beuys' mind between the Tartars and the Jews, whose experience in the Holocaust he never directly and extensively addressed in his work. The Tartar experience was the touchstone of Beuys' personal mythology. According to psychoanalysis, we each have one, if not as (self-)consciously as Beuys.

11. Adriani et al., pp. 56–57.

12. "Fat," wrote Beuys, "infiltrates other materials, is gradually absorbed and brings about a process of INFILTRATION; *felt* absorbs anything with which it comes into contact – fat, dirt, dust, water or sound – and is therefore quickly integrated into its environment. FAT expands and soaks into its surroundings. FELT attracts and absorbs what surrounds it." Quoted in Caroline Tisdall, *Joseph Beuys* (New York, Solomon R. Guggenheim Museum, 1979, exhibition catalogue), p. 74.

13. Adriani et al., p. 19.

14. Ibid., p. 22.

15. Heinz Kohut, *The Analysis of the Self* (New York, International Universities Press, 1971), p. 64.

16. Adriani et al., p. 4.

17. Ibid., pp. 130–32. In this piece, truly exemplary of the poles of sculptural process

as Beuys conceived it, liquid honey played a prominent role: Beuys covered his head and face with it, counteracting the stiffness of the dead hare he cradled lovingly in his arms.

18. Maurice Merleau-Ponty, in *Phenomenology of Perception* (London, Routledge & Kegan Paul, 1962), p. 150, in effect identifies the body with the work of art, suggesting their emotional inseparability. "The body is to be compared, not to a physical object, but rather to a work of art." The reverse is also true. Indeed, Merleu-Ponty observes that " 'visual data' make their appearance only through the sense of touch, tactile data through sight, each localized movement against a background of some inclusive position, each bodily event . . . against a background of significance in which its remotest repercussions are at least foreshadowed and the possibility of an intersensory parity immediately furnished." This applies equally to the body and the work of art.

19. Sigmund Freud, in *The Ego and the Id,* Standard Edition (London, Hogarth Press and the Institute of Psycho-Analysis, 1961), 19:26–27, asserts that the ego "is first and foremost a body-ego," that is, a "projection" of the body.

20. Adriani et al., p. 223.

21. Ibid., pp. 107–108.

22. Ibid., p. 56.

23. Ibid., pp. 39, 41.

24. In the 1964 action *Das Schweigen von Marcel Duchamp wird überbewertet* (The silence of Marcel Duchamp is overestimated), Beuys criticized "Duchamp's antiart concept and . . . his later conduct, when he gave up art and pursued only chess and writing." He seemed to prefer Ingmar Bergman's warm, vitalizing "interpretation of silence" in the film *Silence* to Duchamp's cold interpretation of it as the death of art and death in general. Adriani et al., p. 119. Speaking of *The Chief,* 1956, a "Fluxus song" performed in Berlin by Beuys and simultaneously in New York by Robert Morris, Beuys compared his use of "childhood impressions and experiences [to] form an image and materials" with Morris' "merely minimal materials." They relate, he said, to "vanity," which Beuys' "actions and methods have absolutely nothing to do with." He in effect accused Morris of stealing materials from him without understanding their import. "It is clear what Morris has taken from me; he was here at that time and worked in my studio." Adriani et al., pp. 124–25. The reason Beuys dismissed Morris' work, saying "the concept of minimal art means absolutely nothing to me," is that minimal art lacked his commitment to therapeutic process.

25. Adriani et al., pp. 229–30.

26. Ibid., p. 279.

27. The importance of skin, as an osmotic, dialectical border surface, signaling profound states of feeling – at once narcissistic and object relational – through texture and touch, is discussed by Didier Anzieu in *The Skin Ego* (New Haven, Yale University Press, 1989).

28. M. Masud R. Khan, *The Privacy of the Self* (London, Hogarth Press and the Institute of Psycho-Analysis, 1974), p. 15.

17. Mourning and Melancholia in German Neo-Expressionism

1. Theodor W. Adorno, *Aesthetic Theory* (London, Routledge & Kegan Paul, 1984), p. 169. Subsequent quotes are from the same section on the "Dialectic of Interiority," pp. 169–72.

2. Mark Rosenthal, *Anselm Kiefer* (Chicago and Philadelphia, Art Institute of Chicago and Philadelphia Museum of Art, 1987), p. 14.

3. Ibid., p. 17.

4. D. W. Winnicott, "Communicating and Not Communicating Leading to a Study of Certain Opposites," *The Maturational Processes and the Facilitating Environment* (New York, International Universities Press, 1965), p. 185, compares the "silent communicating" that occurs in abstract art with the "mystic's withdrawal into a personal world of sophisticated introjects."

5. For a discussion of the circumstances surrounding the *Pandemonium* manifestos see Wieland Schmied, "Developments in German Art," *German Art in the 20th Century: Painting and Sculpture, 1905–1985* (London and Munich, Royal Academy and Prestel, 1985), p. 64.

6. Sigmund Freud, "Mourning and Melancholia," Standard Edition (London, Hogarth Press and the Institute of Psycho-Analysis, 1957), vol. 14, pp. 244–45.

7. Ibid., p. 246.

8. Ibid.

9. Ibid., pp. 248–49.

10. Rosenthal, p. 49.

11. Ibid., p. 72.

12. Ibid., p. 133.

13. Sigmund Freud, *The Ego and the Id,* Standard Edition, vol. 19, p. 41.

14. Ibid., p. 40.

19. Gerhard Richter's Doubt and Hope

1. Benjamin H. D. Buchloh, "Interview with Gerhard Richter," *Gerhard Richter: Paintings,* New York: Thames and Hudson, 1988; exhibition catalogue, p. 22. All subsequent quotations are from this source.

2. Gerhard Richter, "Statement," *Documenta 7,* Kassel: Weber and Weidemeyer, 1982; exhibition catalogue, pp. 84–85.

20. All Our Yesterdays

1. Gerhard Richter, "Statement," *Documenta 7,* 2 vols., exhibition catalogue, Kassel: D. & V. Paul Dierichs GmbH & Co KG, 1982, 1:84–85, 443.

2. Richter, quoted in Benjamin H. D. Buchloh, "Interview with Gerhard Richter," *Gerhard Richter: Paintings,* exhibition catalogue, New York: Thames and Hudson, 1988, p. 22.

3. Richter, diary entry for 27 January 1983, quoted in Gerhard Storck, "Untitled (Mixed Feelings)," in *Gerhard Richter: 18. Oktober 1977,* exhibition catalogue, London: Institute of Contemporary Arts, 1989, p. 12.

4. Richter, quoted in Buchloh, p. 22.

5. As Frederick Antal has written, David's *Oath in the Tennis Court* was a break with history-painting conventions in that it took "a contemporary occurrence and present[ed] it without allegorical trappings as an historical picture," in effect instantly historicizing a still hot, topical event. (See Antal, "Reflections on Classicism and Romanticism," *Classicism and Romanticism with Other Studies in Art History,* New York: Harper & Row, Icon Books, 1973, p. 10.) This is exactly what Richter does, if with an event whose topicality has cooled off. But the truly novel aspect of David's picture – rendering the meeting, on June 20, 1789, of representatives of

the "third estate" who swore to stay together until they accomplished their purpose, an event regarded as the "opening act of the Revolution," as Walter Friedlaender writes – was that it depicted the moment when the representatives stopped quarreling and emotionally embraced one another in fraternity. The intense emotionality of the work is indicated by the passionate embrace of two male figures at the extreme left and, at the extreme right, the strange seated figure turned in upon – hugging – himself, as though overcome by the drama of the event in which he finds himself a participant. These two especially charged human moments are like live parentheses marking the limits of the exciting stage on which history is being made.

6. John Berger, *Success and Failure of Picasso,* Baltimore: Penguin Books, 1965, p. 149.
7. Ibid., p. 169.
8. Clement Greenberg, "Cézanne," *Art and Culture: Critical Essays,* Boston: Beacon Press, Paperback, 1961, p. 53.

22. By Kitsch Possessed

1. Jiri Georg Dokoupil, "Extracts from 'i look for nothing and find nothing,' " *Zeitschrift Malerei, Painting, Peinture,* No. 5, 1988, p. 88.
2. Hannan Arenot, "Einleitung," Hermann Broch, *Dichten und Erkennen, Essays* (Zurich, Rhein Verlag, 1955), vol. 1, pp. 14–20.
3. Clement Greenberg, "Avant-Garde and Kitsch," *Art and Culture* (Boston, Beacon Press, 1965), p. 14, makes this point eloquently when he observes that in kitsch's seeming realism "identifications are self-evident immediately and without any effort on the part of the spectator."
4. Armin Zweite, " 'Verlerne dich, suche den Widerspruch in deiner Arbeit selbst,' Zu einigen Bildern von Jiri Georg Dokoupil," *Jiri Georg Dokoupil* (São Paulo, 18th Biennale, 1985), p. 8. Peter Sloterdijk, *Critique of Cynical Reason* (Minneapolis, University of Minnesota Press, 1987).
5. Ibid., p. 12.

23. Sincere Cynicism

1. Lionel Trilling, *Sincerity and Authenticity* (Cambridge, Mass.: Harvard University Press, 1972).
2. Carl Rogers, "Ellen West – and Loneliness," *The Carl Rogers Reader* (Boston: Houghton Mifflin, 1989), 157.
3. Rogers's emphasis on the essential role of the organism in depth of feeling is inseparable from Alfred North Whitehead's philosophy of organism. According to Whitehead (*Process in Reality,* New York: Humanities Press, 1955, 171–72), the philosophy of organism recurs to a pre-Kantian conception of experience in that it aspires "to construct a critique of pure feeling." What Whitehead calls "emotional forms" are "the most primitive types of experience." In general, "the process of feeling" is the fundament of being which, Whitehead says, is obscured by the façade of thought. The task of the philosophy of organism – and of Rogerian psychology – is to break through this façade in order to reestablish contact with basic organismic feeling, or what Whitehead calls "the definiteness of emotion." Without such reconnection with primitive feeling or one's sense of oneself as a feeling organism, one loses, as Whitehead says, the potentiality for individualized realization of one's being.

4. Donald L. Kanter and Philip H. Mirvis, *The Cynical Americans* (San Francisco: Jossey-Bass, 1989), 4.

5. T. S. Eliot, " 'Rhetoric' and Poetic Drama," *The Sacred Wood* (London: Methuen, 1920), 82.

24. The Problem of Art in the Age of Glamor

1. Georg Simmel, *The Philosophy of Money* (London: Routledge & Kegan Paul, 1978), p. 71.

2. John E. Gedo, *Portraits of the Artist* (New York: Guilford, 1983), p. 284.

3. Ibid.

25. The Good Enough Artist

1. See D. W. Winnicott, "Ego Distortion in Terms of True and False Self" (1960), *The Maturational Processes and the Facilitating Environment* (New York: International Universities Press, 1965), pp. 140–52. Winnicott asserts, p. 148, that the "True Self is the theoretical position from which comes the spontaneous gesture and the personal idea. The spontaneous gesture is the True Self in action. Only the True Self can be creative and only the True Self can feel real. Whereas a True Self feels real, the existence of a False Self results in a feeling unreal or a sense of futility. The False Self, if successful in its function, hides the True Self, or else finds a way of enabling the True Self to start to live. . . . There is but little point in formulating a True Self idea except for the purpose of trying to understand the False Self, because it does no more than collect together the details of the experience of aliveness." Winnicott thinks that the True Self comes from the experience of the body's aliveness and "the idea of the Primary process," that is, a process "essentially not reactive to external stimuli, but primary." In a sense, the trouble with mainstream art is that most of it no longer feels alive and implies primary process – no longer seems spontaneous and implies personal idea – and thus communicates a feeling of unreality and futility. It thus has nothing to do with the true self. If a work of art always tends to be a false self, then today's works of mainstream art militantly tend towards false selfhood, for they seem to refuse to collect and integrate the details of the experience of aliveness. This makes such works purely matters of style. Avant-garde personalist art, before it became stereotyped, institutionalized, and academic, attempted to articulate the sense of anguished aliveness that came from the experience of the disintegration of the true self – the ultimate kind of suffering. Sometimes the sense of true aliveness associated with integrative sexuality was also articulated, in defiance of the social repression – the collective false selfhood – which tried to deaden sexual bodily aliveness, but it was hardly a match for the sense of living death conveyed by disintegration of the true self. And the avant-garde artist-re-educator once tried to absolutize the false self, making its sense of futility and unreality the norm, in the form of aspiration to a world too perfect to live in.

2. José Ortega y Gasset, *Meditations on Quixote* (New York: W. W. Norton, 1963), p. 45.

3. Anthony Storr, *Solitude* (New York: Free Press, 1988), p. 169, argues that there comes a time in life when organic communication with others tends to become secondary to meditation upon the patterns of life. In my opinion these are always a matter of deciding upon what seems undecidable, the proper relationship between

inner and outer worlds. From this point of view, mainstream art is either overly concerned to communicate with others and insufficiently meditative, or has a preconceived sense of the proper balance between inner and outer worlds, that is, predetermines the pattern of their relationship.

4. D. W. Winnicott, "The Deprived Child and How He Can Be Compensated for Loss of Family Life," *The Family and Individual Development* (London: Tavistock, 1964), p. 143.

5. D. W. Winnicott, "Aggression in Relation to Emotional Development" (1950), ibid., p. 208.

6. John Dewey, *Art as Experience* (London: George Allen & Unwin, 1934), p. 51.

7. Ibid., p. 54.

26. Visual Art and Art Criticism

1. Sarah Kofman, *The Childhood of Art, An Interpretation of Freud's Aesthetics* (New York: Columbia University Press, 1988), p. 4.

2. Sigmund Freud, "Neurosis and Psychosis" (1924), *Standard Edition*, 19, pp. 149, 151.

3. Ibid., "The Loss of Reality in Neurosis and Psychosis" (1924), p. 185.

4. See Donald Kuspit, "Artist Envy," *The New Subjectivism: Art in the 1980s* (Ann Arbor: UMI Research Press, 1988), pp. 559–69.

5. Kofman, pp. 6–7.

6. Rosemary Jackson, *Fantasy: The Literature of Subversion* (London: Methuen, 1981), p. 61.

7. Joseph Margolis, "Reinterpreting Interpretation," *Journal of Aesthetics and Art Criticism*, 47 (Summer 1989):237–39.

8. Sigmund Freud, "Three Essays on Sexuality" (1905), *Standard Edition*, 7, p. 156. One should also recall, in this context, Freud's assertion, in *The Ego and the Id* (1923), that "thinking in pictures is . . . only a very incomplete form of being conscious. In some way . . . it stands nearer to unconscious processes than does thinking in words, and it is unquestionably older than the latter both ontogenetically and phylogenetically" (*Standard Edition*, 19, p. 21). The density of visual art is in effect that of the unconscious itself. Didier Anzieu, *The Skin Ego* (New Haven: Yale University Press, 1989), p. 38, remarks that "An original mode of functioning of the psychical apparatus exists, pictogrammatic in nature, which is more archaic than its primary and secondary functioning."

9. Leo Bersani, *The Freudian Body, Psychoanalysis and Art* (New York: Columbia University Press, 1986), p. 26.

10. Ibid., p. 27.

11. Max Frisch, *Sketchbook, 1946–1949* (New York: Harcourt Brace Jovanovich, 1983; Harvest/HBJ Books), p. 225.

12. Quoted by Jackson, *Fantasy*, p. 87.

13. T. W. Adorno, *Aesthetic Theory* (London: Routledge & Kegan Paul, 1984), pp. 14–18.

14. T. W. Adorno, "Commitment," *The Essential Frankfurt School Reader* (New York: Continuum, 1985), p. 312.

15. Adorno, *Aesthetic Theory*, p. 283.

16. Alfred Lorenzer, "Die Funktion von Literatur und Literaturkritik – aus der Perspektive einer psychoanalytisch-tiefhermeneutischen Interpretation," *Jenseits der*

Couch: Psychoanalyse und Sozialkritik, ed. Institutsgruppe Psychologie der Universitat Salzburg (Frankfurt am Main: Fischer, 1984; paperback), p. 216.

17. Adorno, "Commitment," p. 312.
18. Sigmund Freud, "The Unconscious" (1915), *Standard Edition,* 14, p. 202.
19. Geoffrey H. Hartman, *Criticism in the Wilderness* (New Haven: Yale University Press, 1980), p. 217.
20. Jan Mukarovsky, "The Essence of the Visual Arts," *Semiotics of Art: Prague School Contributions,* eds. Ladislav Matejka and Irwin R. Titunik (Cambridge, Mass.: MIT Press, 1976), pp. 237, 244.

27. The Use and Abuse of Applied Psychoanalysis

1. Marshall Edelson, *Psychoanalysis: A Theory in Crisis* (Chicago: University of Chicago Press, 1988), p. 157.
2. Ibid., p. 171.
3. Hans Kung, *Freud and the Problem of God* (New Haven, Conn.: Yale University Press, 1990), p. 127.
4. Ibid., p. 132.
5. George Steiner, *Real Presences* (Chicago: University of Chicago Press, 1991), p. 47.
6. Ibid., p. 46.
7. Ibid.
8. Ibid., p. 108.
9. Ibid., p. 107.
10. Ibid., p. 46.
11. Ibid., p. 7.
12. Ibid., p. 4.
13. Ibid., p. 6.
14. Edelson, *Psychoanalysis: A Theory in Crisis,* pp. 167–70.
15. Ibid., p. 170.
16. Ibid., p. 167.
17. Steiner, *Real Presences,* p. 11.
18. Ernest Jones, "The Madonna's Conception Through the Ear," *Essays in Applied Psychoanalysis* (London: Hogarth Press and the Institute of Psycho-analysis, 1951), vol. 2, p. 352.
19. Peter Brooks, "The Idea of a Psychoanalytic Literary Criticism," *Critical Inquiry* 13, 2 (Winter 1987):334.
20. Ibid., p. 337.
21. Ibid., p. 334.
22. Donald M. Kaplan, "The Psychoanalysis of Art: Some Ends, Some Means," *Journal of the American Psychoanalytic Association* 36, 2 (1988):267.
23. Phil Slater, *Origin and Significance of the Frankfurt School, A Marxist Perspective* (London: Routledge & Kegan Paul, 1977), p. 103.
24. Sigmund Freud, *New Introductory Lectures on Psycho-Analysis* (1932), Standard Edition (London, Hogarth Press and the Institute of Psycho-Analysis, 1964), vol. 22, p. 160.
25. Ibid., pp. 160–61.
26. Kaplan, "The Psychoanalysis of Art," p. 259.
27. Quoted in Peter Gay, *Freud: A Life for Our Times* (New York: Norton, 1988), p. 130.

28. Quoted in Murray Cox, *Structuring the Therapeutic Process: Compromise with Chaos* (Oxford: Pergamon, 1978), pp. 280–81.

29. Heinz Kohut, *The Restoration of the Self* (New York: International Universities Press, 1977), p. 285.

30. Michael F. Frampton, "Considerations on the Role of Brentano's Concept of Intentionality in Freud's Repudiation of the Seduction Theory," *International Review of Psycho-Analysis*, 18, pt. 1 (1991):29.

31. Jean Laplanche, *New Foundations for Psychoanalysis* (London: Basil Blackwell, 1989), pp. 131–32.

32. Peregrine Horden, "Thoughts of Freud," *Freud and the Humanities*, ed. Peregrine Horden (New York: St. Martin's, 1985), p. 12.

33. Edelson, *Psychoanalysis: A Theory in Crisis*, p. 157.

34. Laplanche, *New Foundations for Psychoanalysis*, p. 11.

35. Ibid., pp. 11–12.

36. Horden, "Thoughts of Freud," p. 12.

37. Laplanche, *New Foundations for Psychoanalysis*, p. 12.

38. Kaplan, "The Psychoanalysis of Art," p. 259.

39. Ibid., p. 264. In contrast to Kaplan, see Roy Schafer, *Retelling a Life: Narration and Dialogue in Psychoanalysis* (New York: Basic Books, 1992), chap. 10, "The Sense of an Answer: Clinical and Applied Psychoanalysis Compared." There, in a brilliant argument, Schafer virtually erases the distinction between clinical and applied psychoanalysis.

40. Quoted in Horden, "Thoughts of Freud," p. 14.

41. Ibid.

42. Jones, "The Madonna's Conception," p. 355.

43. Janine Chasseguet-Smirgel, *Creativity and Perversion* (London: Free Association Books, 1985), esp. pp. 4, 11, 90.

44. Janine Chasseguet-Smirgel and Béla Grunberger, *Freud or Reich?, Psychoanalysis and Illusion* (New Haven, Conn.: Yale University Press, 1986), p. 79.

45. Horden, "Thoughts of Freud," p. 16.

46. Charles Rycroft, "Symbolism, Imagination and Biological Destiny," in Horden (ed.), *Freud and the Humanities*, p. 30.

47. Norman Mailer, *Some Honorable Men, Political Conventions, 1960–1972* (Boston: Little, Brown, 1976), p. 339.

48. Kurt H. Wolff, ed., *The Sociology of Georg Simmel* (London: Free Press, 1950), p. 55.

49. Ibid., p. 56.

50. Alfred North Whitehead, *Symbolism, Its Meaning and Effect: An Anthology* (New York: Macmillan, 1953), p. 535.

51. Ibid.

52. Quoted in Horden, "Thoughts of Freud," p. 1.

53. Steiner, *Real Presences*, p. 109.

54. Jones, "The Madonna's Conception," p. 266.

55. Ibid., p. 268.

56. Ibid., p. 357.

57. Barnaby B. Barratt, *Psychic Reality and Psychoanalytic Knowing* (Hillsdale, N.J.: Analytic Press, 1984), pp. 255–56.

58. Ibid., p. 252.

59. Jones, "The Madonna's Conception," p. 355.

60. Sigmund Freud, *The Interpretation of Dreams* (1900), Standard Edition, vol. 4, p. 126.

61. Alfred North Whitehead, *Process and Reality* (New York: Humanities Press, 1955), p. 262.
62. Ibid., p. 263.
63. Whitehead, *Anthology*, p. 510.
64. Rycroft, "Symbolism, Imagination and Biological Destiny," p. 29.
65. Robert Stoller, *Observing the Erotic Imagination* (New Haven, Conn.: Yale University Press, 1985), p. 61.

28. A Psychoanalytic Understanding of Aesthetic Disinterestedness

1. Sigmund Freud, *The Moses of Michelangelo* (1914), Standard Edition (London: Hogarth Press and the Institute of Psycho-Analysis, 1964), vol. 13, p. 214. Hereafter, referred to in the text as SE followed by page number.
2. Harry Trosman, *Freud and the Imaginative World* (Hillsdale, NJ: Analytical Press, 1985), p. 145.
3. Ibid., p. 134.
4. Harold Osborne, *Aesthetics and Art Theory: An Historical Introduction* (London: Longmans, Green, 1968), p. 102. All subsequent allusions to aestheticians are from Osborne, chapters 6 and 7, on "Eighteenth-Century British Aesthetics" and "Kant's *Critique of Judgment*."
5. See Trosman, p. 137.
6. Donald M. Kaplan, "The Psychoanalysis of Art: Some Ends, Some Means," *Journal of the American Psychoanalytic Association*, 36 (1988): 285.
7. Ibid., p. 287.
8. Ibid., p. 286.
9. Trosman, p. 134
10. Ibid., p. 138.
11. Ibid., p. 139.
12. Ibid.
13. Kaplan, p. 290.
14. Oscar Wilde, "The Critic As Artist," *Intentions* (New York: Brentano's, 1912), p. 168.

29. Collecting

1. Sigmund Freud, "Three Essays on Sexuality" (1905), *Standard Edition* (London, Hogarth Press and the Institute of Psycho-Analysis, 1953), 7, 149.
2. Otto Rank, *Art and Artists* (New York, Norton, 1989), p. 11, argues that the core of the motive to make art, and its importance as an object of belief, has to do with the "urge to eternalization . . . inherent in the art-form itself, in fact its essence." It expresses the individual's longing for immortality, which, according to Rank, must sooner or later be renounced – and with it art – for the more mentally healthy effort to improve object relations.
3. Sigmund Freud, "On Narcissism: An Introduction" (1915), *Standard Edition*, 14, 94.
4. Janine Chasseguet-Smirgel, *Creativity and Perversion* (London, Free Association Books, 1985), p. 90.

Index

but

Being + time. Preoccupations

↓

Body art – non linguistic
Process, repetition, time
the emotional sphere

↑↗

Could link to e.g. Freud.

Here the "irrational" the uncon. which has a logic of
its own, but a different one. Which renders the
unsayable, sayable, but the manifestations of it
eg dreams, pathology.

but

pathologize. not

↓

emo. being true (false emo) incorrect.
R.L. articulated this schizo split which can
become pathology.

2 spheres – never being not adequate

and —— [eg therapy.
 Beck. Ellis. }

the continuum.

because we live in a body

(based on an evol. basis. Fact. Zajonc
 event. 2 continuum of pars.

re picture theory – many diff sorts of pics.
+ now (d. 1954?